Ancient Sichuan

Treasures from a Lost Civilization

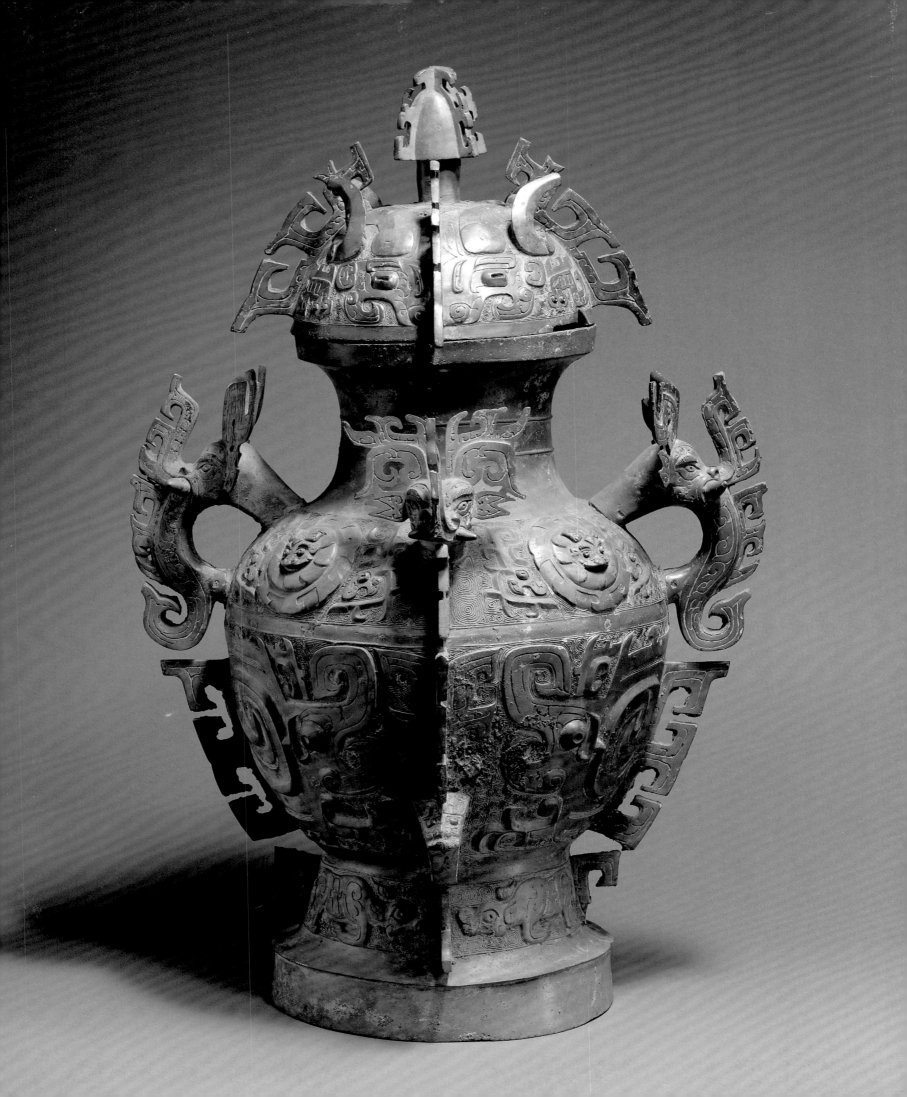

Ancient Sichuan

Treasures from a Lost Civilization

Edited by Robert Bagley

with contributions by

Jay Xu

Michèle Pirazzoli-t'Serstevens

Jenny F. So

Lothar von Falkenhausen

Alain Thote

Jessica Rawson

Michael Nylan

SEATTLE ART MUSEUM

PRINCETON UNIVERSITY PRESS

This book has been published in conjunction with the exhibition *Treasures from a Lost Civilization: Ancient Chinese Art from Sichuan,* organized by the Seattle Art Museum in collaboration with the Bureau of Cultural Relics, Sichuan Province of the People's Republic of China.

The Boeing Company provided the leadership grant for the exhibition, with major support from the E. Rhodes and Leona B. Carpenter Foundation. Generous funding for the project was provided by the Henry Luce Foundation, the Rockefeller Foundation, and the National Endowment for the Arts. Endowment support was provided by the Kreielsheimer Exhibition Endowment. Additional support was provided by contributors to the Annual Fund.

Published by the Seattle Art Museum in association with Princeton University Press

© 2001 by the Seattle Art Museum
All rights reserved.

Seattle Art Museum
100 University Street
Seattle, Washington 98101
 www.seattleartmuseum.org

Princeton University Press
41 William Street
Princeton, New Jersey 08540
 www.pup.princeton.edu
In the United Kingdom:
Princeton University Press
3 Market Place
Woodstock, Oxfordshire OX20 1SY

Library of Congress Cataloging-in-Publication Data
Ancient Sichuan : treasures from a lost civilization / edited by Robert Bagley, with contributions by Jay Xu ... [et al.].
 p. cm.
 Includes bibliographical references and index.
 ISBN 0-691-08851-9 (alk. paper)
 1. Sichuan Sheng (China)—Antiquities. 2. Sanxingdui Site (China)—Antiquities. 3. Excavations (Archaeology)—China—Sichuan Sheng. I. Bagley, Robert W.
 DS793.S8 A528 2001
 931—dc21 00-68782

EXHIBITION ITINERARY

Seattle Art Museum
May 10, 2001–August 12, 2001

Kimbell Art Museum, Fort Worth
September 30, 2001–January 13, 2002

The Metropolitan Museum of Art, New York
March 4, 2002–June 16, 2002

Royal Ontario Museum, Toronto
August 2, 2002–November 10, 2002

Project Director: Jay Xu
Editor: Robert Bagley
Copyeditor: James McKendry
Project Manager: Zora Hutlova Foy
Proofreader: Laura Iwasaki
Maps: Robert C. Forget
Index: Robert Palmer
Glossary: Jennifer Chen
Translations: Robert Bagley and Fabien Simonis
Primary photographer: Paul Macapia
Cover calligraphy: Ma Chengyuan
Production assistant: Laura Hulscher
Designed by Ed Marquand and Susan E. Kelly
Produced by Marquand Books, Inc., Seattle
 www.marquand.com
Printed and bound by C&C Offset Printing Co., Ltd., Hong Kong

Frontispiece: *Lei,* bronze, late eleventh or early tenth century BC (No. 65)
Page 6: *Horse and groom,* bronze, first or second century AD (No. 95)
Page 20: *Figure on pedestal,* bronze, twelfth century BC, detail of left side (No. 2)
Page 38: *Brick with chariot and horseman crossing a bridge,* ceramic, second century AD, detail (No. 100)
Page 58: *Head,* bronze, thirteenth or twelfth century BC (No. 7)
Page 152: *Blade with incised figures,* stone, twelfth century BC (No. 53)
Page 176: *Lei,* bronze, late eleventh or early tenth century BC (No. 64)
Page 202: *Chime of fourteen* niuzhong, bronze with gold inlay, fourth century BC, detail (No. 76)
Page 252: *Figure of a tomb guardian* (zhenmuyong), ceramic, first or second century AD, detail (No. 118)
Page 308: *Brick with scene of salt production,* ceramic with molded decoration, second century AD, detail (No. 104)

The Boeing Company is pleased to support the Seattle Art Museum as the Lead Sponsor of *Treasures from a Lost Civilization: Ancient Chinese Art from Sichuan.*

Partnering with the Seattle Art Museum is part of the long Boeing tradition of community involvement. We recognize that the arts play an integral role in enhancing the quality of life in our communities. For this reason, we support exhibitions and programs in Seattle and communities throughout the world where our employees live and work.

It is a pleasure to sponsor this fine exhibition of artifacts from the People's Republic of China. It is our hope that it will increase understanding and appreciation of China's long history, regional diversity, and compelling beauty.

Philip M. Condit
Chairman and Chief Executive Officer, The Boeing Company

The E. Rhodes and Leona B. Carpenter Foundation is proud to support *Treasures from a Lost Civilization: Ancient Chinese Art from Sichuan.*

Treasures from a Lost Civilization offers the opportunity to appreciate the art of ancient Sichuan, China, and the important role Sichuan played in the evolution of Chinese civilization. The E. Rhodes and Leona B. Carpenter Foundation applauds the Sichuan Provincial Government and the State Administration for Cultural Heritage of the Chinese Central Government for so generously sharing these treasures of ancient Chinese culture, and the Seattle Art Museum for its leadership in building a relationship with its Chinese counterparts and for bringing this extraordinary collection of Chinese treasures to the United States.

E. Rhodes and Leona B. Carpenter Foundation

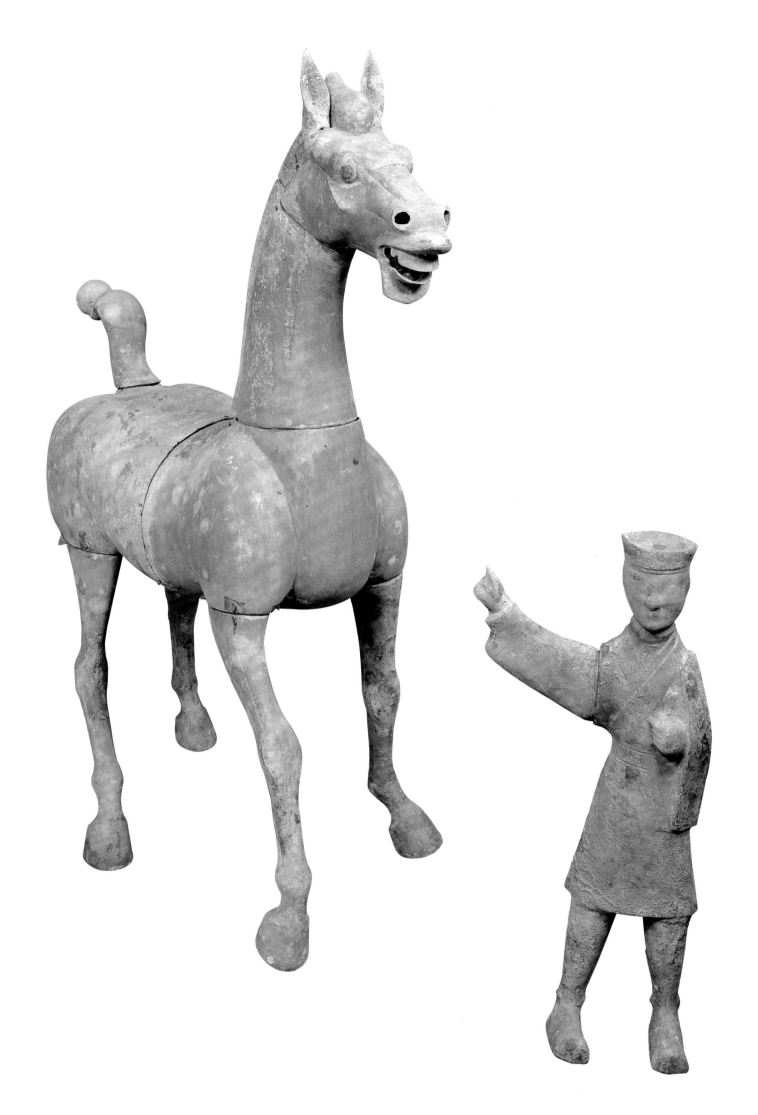

CONTENTS

The spectacular works of art being unearthed in China today attest to the brilliance, antiquity, and regional diversity of Chinese civilization. Past exhibitions of China's archaeological finds—from *The Great Bronze Age of China* (1980) to *The Golden Age of Chinese Archaeology* (1999)—were broad surveys spanning vast distances in time and space. This is the appropriate moment to begin to deepen our knowledge and take a closer look at regionalism. The present project is unprecedented in its focus on a single geographical locale, Sichuan province in southwestern China, and the role Sichuan played in the evolution of Chinese civilization from the thirteenth century BC through the third century AD.

Once considered a cultural backwater in ancient times, Sichuan produced in 1986 the most stunning discovery in Chinese archaeology, bringing to light a highly developed civilization that was theretofore unknown. Excavations at the site of Sanxingdui (*c.* 1200 BC) revealed an unprecedented sculptural tradition of great artistic strength. The Sanxingdui discovery also gave impetus to a reexamination of the Sichuan culture in following centuries, during the unification and early centuries of imperial China.

Moreover, this extraordinary archaeological find has contributed to a fundamental change in our understanding of how Chinese civilization evolved. For many years, the middle Yellow River valley, or Central Plain, was considered to be the center of Chinese civilization—its birthplace— while the peripheral regions were merely recipients of civilizing influences radiating out from the center. In this model, ancient China was a singular world with a nuclear center and a homogeneous culture.

During the second half of the twentieth century, this model was increasingly challenged by field archaeology in the "peripheral regions," especially the Yangzi River valley of south China. The Sanxingdui discovery conclusively proved the existence of multiple regional centers that interacted with one another, each with its own distinctive traits. Thus, a more complex sphere of cultural interaction replaced the simpler model of cultural diffusion from a nuclear center. In focusing on Sichuan, this project champions the approach of regional study and seeks to provide a firm foundation for the new model of multiple cultural centers in ancient China.

In the conceptualization and realization of *Treasures from a Lost Civilization*, the most ambitious exhibition project undertaken by the Seattle Art Museum, two respected scholars of early China deserve special recognition. Jay Xu, Foster Foundation Curator of Chinese Art, initiated the idea in late 1996 and gained the support of the Chinese State Administration of Cultural Heritage and the Sichuan provincial government. As project director, he worked tirelessly on every aspect of the exhibition, publication, and international symposium. During extended stays in Chengdu and travels throughout Sichuan province, he selected the works of art in the exhibition and visited archaeological sites, exchanging ideas with Chinese colleagues. Jay Xu's keen intelligence, boundless energy, and winsome passion for Chinese art were vital to seeing *Treasures from a Lost Civilization* through to completion.

Upon Jay Xu's invitation, Professor Robert Bagley, Princeton University, a distinguished art

historian specializing in early Chinese art, graciously agreed to take charge of the organizing and editing of the catalogue. A leading scholar in the study of the early bronze cultures of the Yangzi River valley, Professor Bagley was one of the first sinologists to recognize the significance of the Sanxingdui discovery. His strong commitment and rigorous intellectual discipline were essential to the scholarly excellence of the publication. We are profoundly grateful for his contribution.

The success of this project is a tribute to the spirit of teamwork. Curator Jay Xu and Professor Robert Bagley thank a host of other colleagues who made important contributions to this project. I can only underscore our appreciation for their contributions and for the superb efforts of the entire staff of the Seattle Art Museum.

In the People's Republic of China, the Chinese State Council, Ministry of Culture, and the State Administration of Cultural Heritage gave their unqualified support and approval to this project. From the outset Wang Limei, Director of Foreign Affairs, understood the significance of the project and was instrumental in its realization. The Department of Cultural Affairs, Sichuan province, was co-organizer and lender. Without their support this project would not have been possible. We thank everyone in the People's Republic of China who helped to realize this project, which will deepen appreciation in the United States and Canada for the extraordinary art and culture of ancient Sichuan.

Soon after its inception, the project was blessed with unprecedented support from The Boeing Company and the E. Rhodes and Leona B. Carpenter Foundation, which sustained its development. We are also most grateful for the generous support of the Henry Luce Foundation, the Rockefeller Foundation, the National Endowment for the Arts, and the Kreielsheimer Exhibition Endowment. A special gift from Mary Ann and Henry James made possible Jay Xu's initial research in China, and the Katherine Agen Baillargeon Endowment helped fund the international symposium associated with the exhibition. We are deeply indebted to all of our sponsors.

We are proud to share *Treasures from a Lost Civilization* with the Kimbell Art Museum, Fort Worth, Texas; The Metropolitan Museum of Art, New York; and the Royal Ontario Museum, Toronto, Canada. Throughout this project, the directors of these museums—Timothy Potts, Philippe de Montebello, and Lindsay Sharp—were most supportive. Thanks to their collaboration, the splendid artistic achievements of ancient Sichuan will enrich understanding of China, past and present, throughout the United States and Canada.

Mimi Gardner Gates
The Illsley Ball Nordstrom Director
Seattle Art Museum

CURATOR'S ACKNOWLEDGEMENTS

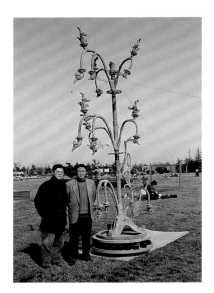

Chen De'an (right), principal excavator at Sanxingdui, standing with Jay Xu next to the bronze tree No. 27.

The exhibition *Treasures from a Lost Civilization: Ancient Chinese Art from Sichuan* celebrates the extraordinary art created in ancient Sichuan from the thirteenth century BC to the third century AD. First and foremost, I would like to express a profound sense of indebtedness to the Chinese archaeologists whose decades of fieldwork in Sichuan have made the exhibition possible.

In the course of the past four years, many individuals and institutions have helped to make the exhibition a reality. My deepest thanks are due to Mimi Gardner Gates, Illsley Ball Nordstrom Director of the Seattle Art Museum, and Professor Robert Bagley of Princeton University, editor of this book. Dr. Gates's encouragement and guidance throughout the project were decisive factors to its success, particularly in the crucial stages of negotiation and fund-raising, as well as in the production of the technology component. Professor Bagley was responsible for the conception and organization of this book, which is not only a record of the exhibition but also a thorough survey of our present knowledge of the material culture of ancient Sichuan. Without his effort and that of his team of distinguished contributors, the publication would not have seen the light of day.

In the People's Republic of China, on behalf of the Seattle Art Museum, I would like to thank the Chinese State Council, the Ministry of Culture, and the State Administration of Cultural Heritage for their kind approval of this exhibition. I am particularly grateful to Wang Limei, the State Administration's Director of Foreign Affairs, for her appreciation of the special significance of the exhibition and her effort to ensure its realization.

I would also like to thank the Department of Cultural Affairs of Sichuan Province for its collaboration in organizing this exhibition. Liang Xuzhong, Director, spearheaded and supported the joint effort at every stage. His staff, particularly Yang Kuiben, Deputy Director, Yuan Dajun, and Zhao Chuanrong, provided essential assistance throughout the project.

The lenders to the exhibition are the Sichuan Provincial Institute of Archaeology, the Sanxingdui Museum, the Guanghan Municipal Institute of Cultural Antiquities, the Sichuan Provincial Museum, the Mao Xian Museum of the Qiang Nationality, the Pengzhou City Museum, the Chengdu City Museum, the Mianyang Museum, the Xindu County Bureau of Cultural Antiquities, and the Pi Xian Bureau of Cultural Antiquities. The staff of these institutions were unfailingly helpful, especially Ma Jiayu, Director, Li Zhaohe, Deputy Director, and Yang Xiaowu, Conservator, at the Institute of Archaeology; Gao Dalun, Director, Wei Xuefeng, Deputy Director, Chen Xiandan, Deputy Director, Tan Xuejie, Administrator, and Chen Zhixue, Head of Collection Management, at the Sichuan Provincial Museum; and Xiao Xianjin, Director, and Zhu Yarong, Head of Collection Management, at the Sanxingdui Museum. I am immeasurably indebted to Chen De'an, one of the principal excavators at the Sanxingdui site, for his insights and help in research as well as with the logistics of the exhibition.

On the American side, I would like to express my particular gratitude to David Tang, attorney at

Preston Gates & Ellis of Seattle and trustee of the Seattle Art Museum, for his invaluable guidance in contract negotiation.

Many members on the staff of the participating museums and the Seattle Art Museum contributed their talents and energy. Colleagues responsible for local presentation of the exhibition at our sister museums include Jennifer Casler Price, Curator of Non-Western Art of the Kimbell Art Museum, Fort Worth; Judith Smith, Special Assistant to the Consultative Chairman of the Department of Asian Art of the Metropolitan Museum of Art, New York, and her colleague Jason Sun, Associate Curator of Chinese Art; Klaas Ruitenbeek and Chen Shen, Curators in the Department of Asian Art of the Royal Ontario Museum, Toronto.

At the Seattle Art Museum, Sara Cerrell and Jay Knox, former and present Government, Community, and Board Relations Officers, coordinated our diplomatic effort to win approval of the exhibition by the Chinese State Council. Maryann Jordan, Deputy Director for External Affairs, led the staff of her division in marketing and fundraising, which financially enabled this unprecedented project. Ashley Fosberg took charge of marketing, while Jill Robinson and Laura Hopkins were responsible for corporate and foundation grants respectively.

Zora Hutlova Foy, Manager of Exhibitions and Curatorial Publications, was the center of logistics for all aspects of the project, and managed such a multifarious responsibility with rigorous discipline and gracious humor. In the Department of Asian Art, Mary Hirsch, Curatorial Assistant of Chinese Art, was a constant help through the entire period of the project. At various times, valuable assistance was provided also by Sheba Burney-Jones, Nhien Nguyen, Liz Andres, Grace Meyers, and Elisabeth Bradley, Administrative Assistants.

Staff at the Museum Services division, under the guidance of Gail Joice, Senior Deputy Director, were essential to the presentation of the exhibition at our museum and its subsequent tour in North America. Michael McCafferty, Exhibition Designer and a perfectionist, conceived the striking installation; Phil Stoiber, Senior Associate Registrar, was in charge of insurance and transportation arrangements; and Paul Macapia, Museum Photographer, worked his magic with the images for use both in the publication and in the education programs.

Leadership on educational programming was provided by Jill Rullkoetter, Kayla Skinner Director of Education and Public Programs, and Sarah Loudon, Senior Museum Educator of Asian Art Programs. They developed an extensive array of programs and materials. David Lotz, Chief of Technology, coordinated an intriguing technology component. Curtis Wong, Senior Research Program Manager at Microsoft and a respected specialist in projects that intelligently combine art with technology, deserves special thanks for generously donating his time and expertise to the technology component; the Seattle Art Museum and I personally are exceedingly obliged to him for his contribution.

Indispensable to the project were skills of many other colleagues at SAM, including Jeff Eby (budgetary supervision), Gordon Lambert and Jack Mackey (mount making), Charles Friedman (art handling), Patricia Leavengood (conservation), Carrie Adams and Christina dePaolo (web design and management), Sarah Little (graphic design), Joe Shuster (computer technology), Carol Mabbott (grants management), Linda Williams and Melissa Mohlman (public relations), Kathleen Allen (school and teacher programs), Beverly Harding (art studio and family programs), Elizabeth deFato and Jan Hwang (library), Paula McArdle (international symposium), Laura Lutz (executive assistance), James McKendry (curatorial editing), Susan Bartlett (exhibition coordination), and Christine Titus (store sales). To all of these colleagues and others whose names are not mentioned, I would like to express heartfelt gratitude for their contributions. It is to the credit of such team effort that we succeeded in bringing to North America the glorious past of ancient Sichuan.

Jay Xu
Foster Foundation Curator of Chinese Art
Seattle Art Museum

EDITOR'S PREFACE

In the summer of 1986 the archaeology of ancient China was turned upside down by the discovery of an ancient city in the isolated western province of Sichuan. Located 40 km northeast of the provincial capital, near a small village called Sanxingdui, this astonishing site is the focus of the first half of the present exhibition (Chapters 1 and 2). Studied in detail in this book, it will occupy excavators and scholars for many years to come.

Until Sanxingdui came to light, ancient Sichuan seemed very simple. "Szechwan [Sichuan] is fundamentally a marginal area, and the culture of this province has never been a result of independent development. It has always been under the influence of some neighboring culture."[1] The distinguished expert who wrote those words in 1957 could have repeated them without fear of contradiction any time in the next thirty years. In the days before Sanxingdui, an exhibition devoted to ancient Sichuan might well have begun where the present one leaves off, with pictorial bricks from tombs of the second century AD (Chapter 5). With their engaging scenes of daily life, these bricks were for many decades the earliest well-known archaeological finds from Sichuan, and they are not especially old, dating from a time when the region had long since been incorporated into the first Chinese empires, those of Qin (221–206 BC) and Han (206 BC–AD 220).

Sichuan first entered the mainstream of Chinese civilization when it was colonized by the expanding Qin state in 316 BC. Over the next few centuries it was gradually transformed by Qin and Han armies and settlers, and since the settlers brought writing with them, from Han times onward Sichuan is illuminated for us by written sources (see the Afterword). But for earlier periods we are wholly dependent on what archaeologists can infer from material remains, and in the days before Sanxingdui, archaeologists had little to go on. Pre-Qin Sichuan, as far we knew, was a backward region on the fringe of main developments. Its inhabitants, perhaps more hunters than farmers, belonged to simple societies, probably tribes or confederations of tribes. The richest known archaeological finds were burials dating from the century immediately preceding the Qin colonization: these have distinctive local forms—some with boat-shaped log coffins, some in the form of stone cists—and their principal furnishings are fine bronze weapons, suggesting that the occupants were warriors of high status (Chapter 4). As to earlier times, archaeology could say little. A single tenth century find, a pair of hoards containing a mixture of local weapons and imported bronze vessels, was as isolated as it was spectacular (Chapter 3). The vessels are remarkable, but they show only that some warrior or tribe had contact, perhaps on a single quite exceptional occasion, with the civilized north. Until 1986 archaeologists had no reason to suppose that pre-Qin Sichuan was anything but a wild frontier region waiting to receive the blessings of civilization from the more innovative heartland of China.

Then a Bronze Age civilization three centuries earlier than the hoards came to light at Sanxingdui. Excavators had been investigating remnants of an earthen city wall there for several years, but the wealth, importance, and almost bizarre character of the site became clear only with the discovery of two staggeringly rich sacrificial deposits buried

1. Chêng Tê-k'un, *Archaeological Studies in Szechwan* (Cambridge: Cambridge University Press, 1957), p. xix.

around 1200 BC. Since this is about the date of the first known Chinese writing, the famous oracle-bone inscriptions from Anyang in the Yellow River valley, the discovery gave the Anyang civilization a rival in a most unexpected place. Moreover the rival was startlingly original; its strange artifacts have taken specialists completely by surprise. A few decades ago, when we knew much less, it was possible to imagine that the history of Chinese civilization was merely the story of a gradual outward spread from a birthplace in the Yellow River valley. Today things look much less tidy, and much more interesting.

The Sanxingdui finds raise large questions that only future excavations can answer. In the late second millennium BC, Sichuan was home to a city that had few rivals in East Asia. How did the city and its unique culture come into being? What happened to it? Did its civilization collapse and disappear? Or will some future archaeological find as rich and as unforeseen as the Sanxingdui deposits change all our ideas about later periods too? Discoveries like Sanxingdui make us acutely aware that our statements about the past are always shaped by what has *not* been found (and by what our texts do *not* record). Do we now have all the pieces of a very peculiar puzzle? Or does the puzzle look peculiar because we are still missing large chunks? Depending on which alternative we incline toward, we will construct very different hypotheses. When contributors to the present volume disagree as to how the pieces might fit together, they remind us that our researches are at a very early stage. What is certain at the moment is only that early Bronze Age China was a more complicated place than we used to suppose.

In thanking those who have made this book possible I must begin with the archaeologists of Sichuan province: the book and the exhibition it catalogues celebrate their achievements. The book itself is the work of seven specialists who have followed Sichuan archaeology closely. Their study of this deeply fascinating material supplies a comprehensive status report on one of the most important areas of Chinese archaeological research, and I am

most grateful to them for sharing their knowledge. Warmest thanks are due also to the many others who have contributed their time and talents to the book. Robert Forget prepared the maps, Dora Ching helped with bibliographic questions, and Robert Palmer compiled the index. Jennifer Chen took charge of organizing the illustrations, did much careful checking, and prepared the Chinese character glossary. Laura Iwasaki's meticulous proofreading saved us from many errors. Fabien Simonis helped me translate the French manuscripts of Michèle Pirazzoli-t'Serstevens and Alain Thote, and the authors themselves patiently answered countless questions about details of translation. My responsibilities as editor were much lightened by the expert project management of Zora Hutlova Foy and the careful copyediting of James McKendry, both of the Seattle Art Museum. Paul Macapia of the Seattle Art Museum took most of the color photographs, Jiang Cong supplied the remainder, and Luo Zeyun made drawings for us. Our debt to them will be obvious at a glance, as will our debt to Ed Marquand, Susan Kelly, Marie Weiler, and the staff at Marquand Books, who transformed a complicated manuscript into a sumptuous book. Finally I would like to thank the organizer of the exhibition, Jay Xu, Foster Foundation Curator of Chinese Art at the Seattle Art Museum, for inviting me to collaborate with him, and Mimi Gardner Gates, Illsley Ball Nordstrom Director of the museum, for her unwavering support for the project. Their enthusiasm and hard work have been a constant encouragement.

Robert Bagley

Professor of Art and Archaeology
Princeton University

Map of China

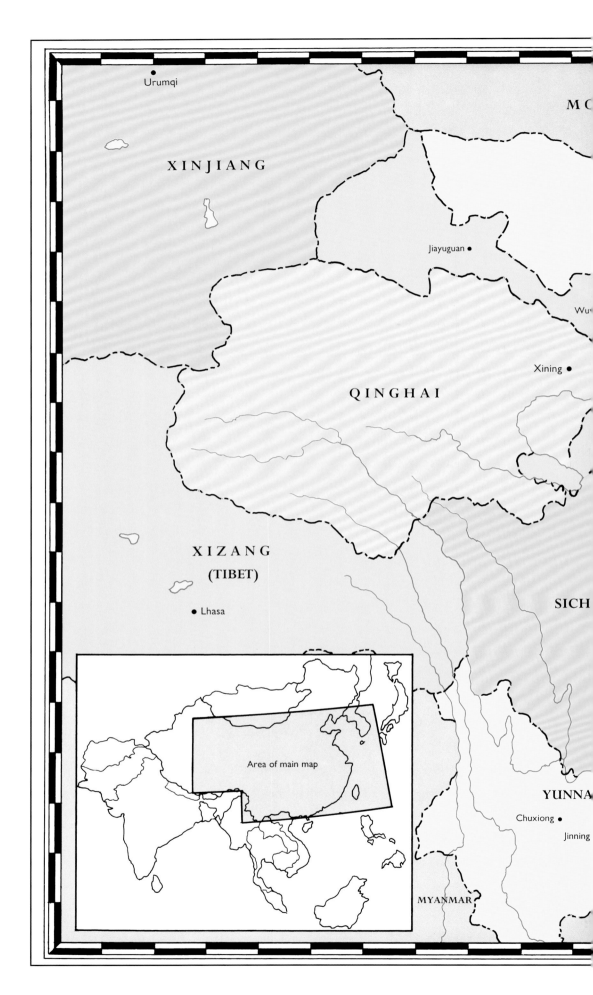

In Chinese place names, word order goes from the larger unit to the smaller: in Sichuan Guanghan Sanxingdui, the first name is the province, the second the county, and the third the name of the site within the modern county. When the county name is monosyllabic, place names include the word Xian "county" (e.g. Mao Xian). With a few exceptions—notably Sanxingdui—the maps show county names, not the names of smaller units.

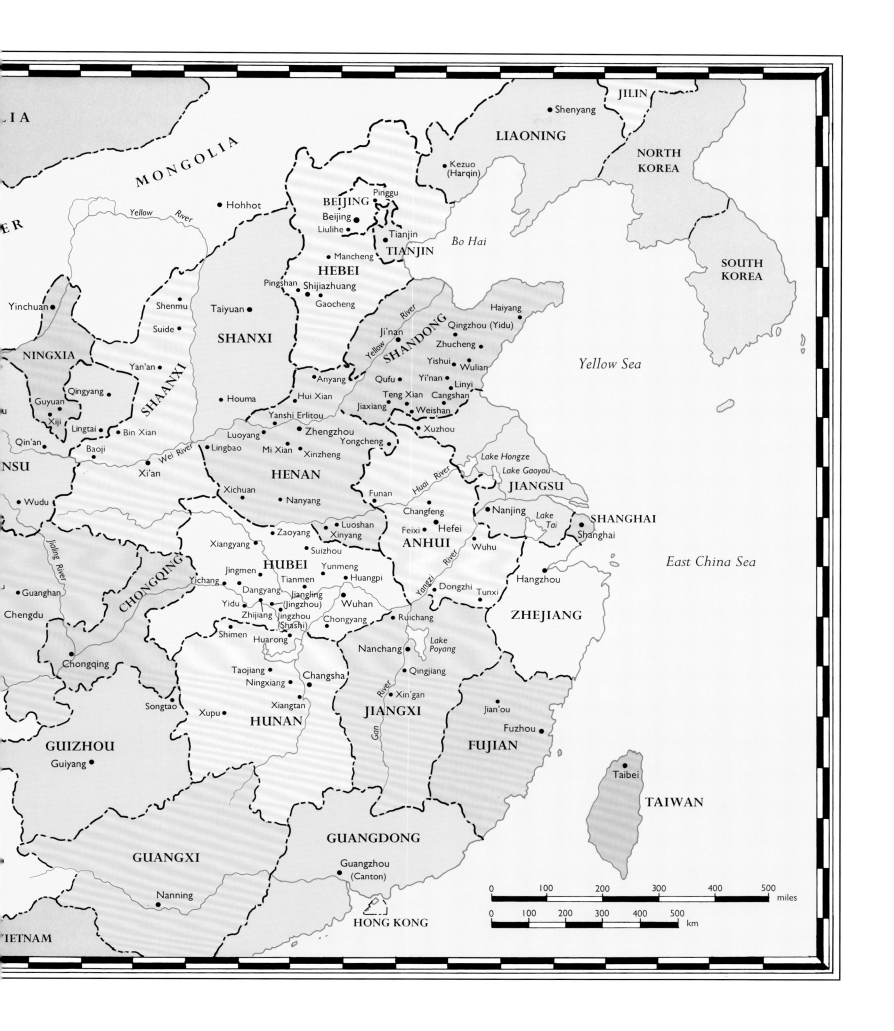

MONGOLIA

JILIN

• Shenyang

LIAONING

NORTH
KOREA

SOUTH
KOREA

Yellow River

• Hohhot

BEIJING
Pinggu
Beijing •
• Liulihe

• Mancheng

Kezuo
(Harqin) •

• Tianjin

TIANJIN

Bo Hai

• Yinchuan

NINGXIA

• Shenmu

Pingshan • • Shijiazhuang
• Gaocheng

HEBEI

River

Haiyang •

Yellow

Qingzhou (Yidu) •

• Suide

Taiyuan •

SHANXI

Ji'nan •

SHANDONG

Zhucheng •

Yishui •
• Wulian

Yan'an •

• Qingyang

Guyuan •

Xiji •

• Lingtai

Qin'an •

SHAANXI

• Houma

Anyang •

Qufu • Yi'nan •
Teng Xian • Linyi •

Hui Xian •

Yanshi Erlitou •

Jiaxiang • Weishan •

Cangshan •

Yongcheng •

• Xuzhou

Lingbao • Mi Xian •

• Xinzheng

Luoyang •

• Zhengzhou

NSU

• Baoji

• Bin Xian

Wei River

• Xi'an

HENAN

Lake Hongze

Lake Gaoyou

Huai River

JIANGSU

• Wudu

Xichuan •

• Nanyang

Funan •

Changfeng •

• Nanjing

Lake
Tai

SHANGHAI

• Shanghai

GANSU

Jialing River

• Guanghan

Chengdu •

CHONGQING

Xiangyang •

• Luoshan
Zaoyang • Xinyang •

• Suizhou

Jingmen •

HUBEI

Yunmeng •

Feixi • Hefei •

ANHUI

• Wuhu

East China Sea

Yichang •

Dangyang •
Yidu •
Zhijiang •

Tianmen •
Jiangling •
(Jingzhou)
Jingzhou
(Shashi)

Huangpi •

• Wuhan

Chongyang •

Ruichang •

Yangzi River

Dongzhi • Tunxi •

Hangzhou •

ZHEJIANG

Shimen •
Huarong •

Lake
Poyang

Chongqing •

Taojiang •

Nanchang •

Xupu •

Ningxiang •

Changsha •

Qingjiang •

JIANGXI

Gan River

Xin'gan •

Jian'ou •

GUIZHOU

Songtao •

Xiangtan •

HUNAN

Guiyang •

FUJIAN

Fuzhou •

Taibei •

TAIWAN

GUIZHOU

GUANGDONG

GUANGXI

Guangzhou •
(Canton)

Nanning •

HONG KONG

Yellow Sea

0 100 200 300 400 500
 miles

0 100 200 300 400 500
 km

VIETNAM

Map of Sichuan

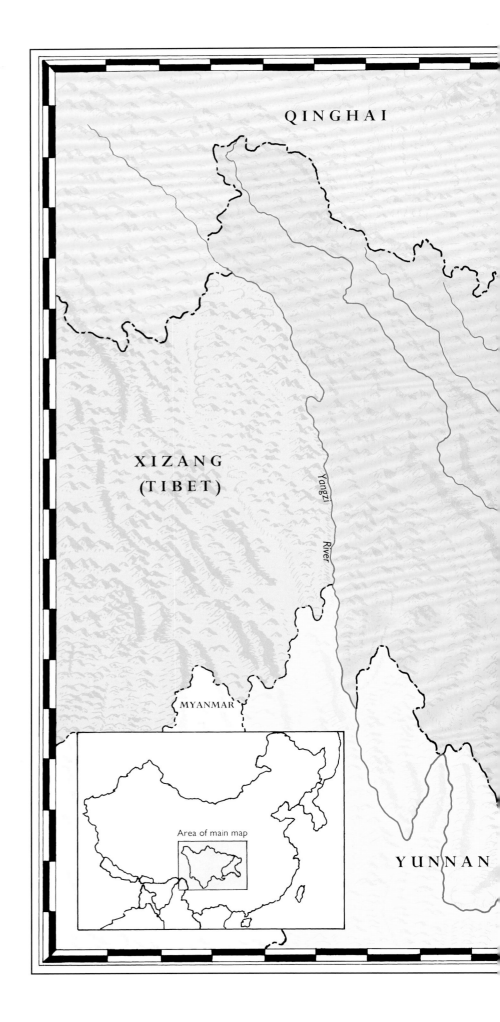

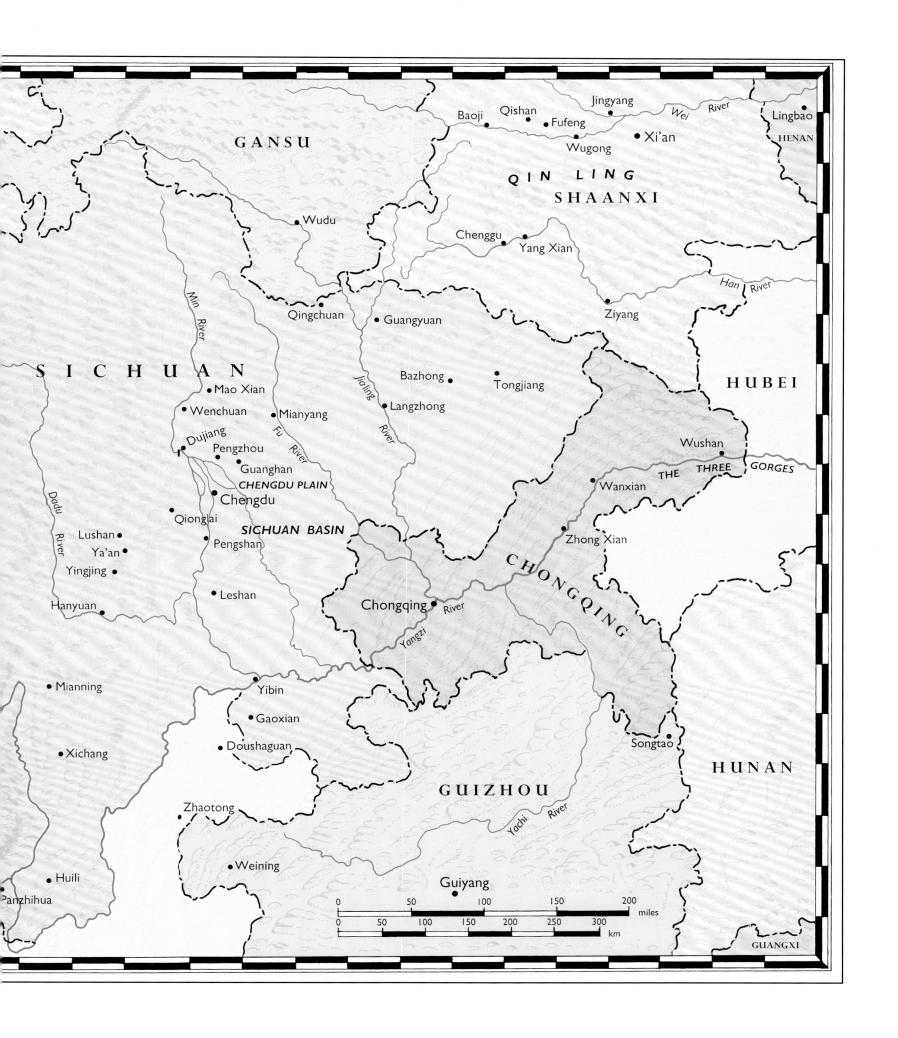

GANSU

Baoji Qishan Jingyang Wei River Lingbao
• Fufeng HENAN
Wugong • Xi'an

QIN LING
SHAANXI

Wudu Chenggu • Yang Xian

Qingchuan Han River

Qingchuan • Guangyuan Ziyang

S I C H U A N Bazhong Tongjiang HUBEI

• Mao Xian Langzhong

• Wenchuan • Mianyang Wushan
Dujiang Pengzhou THE THREE GORGES
• Guanghan • Wanxian
CHENGDU PLAIN
Chengdu • Zhong Xian
Qionglai
SICHUAN BASIN CHONGQING
Lushan • Pengshan
Ya'an •
Yingjing • Leshan

Hanyuan Chongqing River

• Mianning Yibin Yangzi
• Gaoxian
• Xichang Songtao •
• Doushaguan HUNAN

GUIZHOU
Zhaotong

• Weining Yachi River

Guiyang
0 50 100 150 200
 miles
Huili
0 50 100 150 200 250 300
Panzhihua km

GUANGXI

Map of Chengdu Region

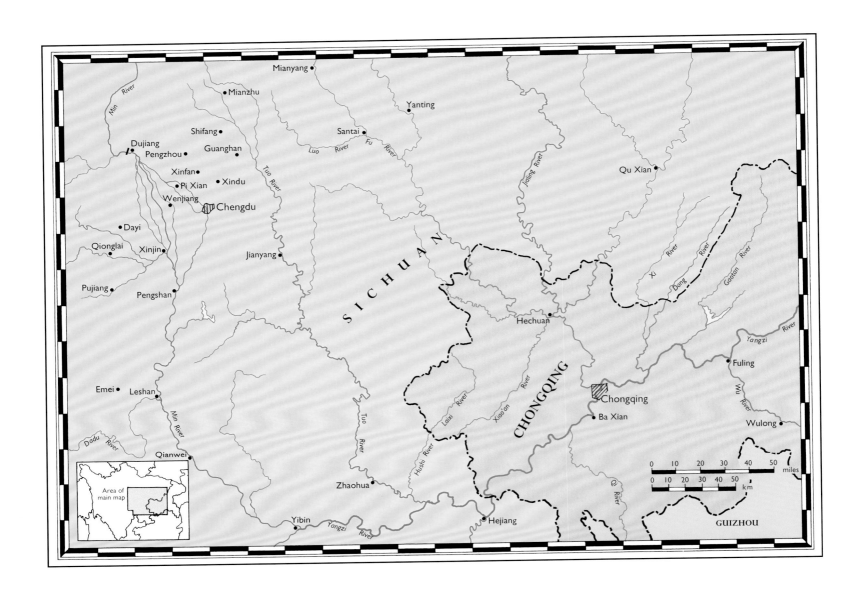

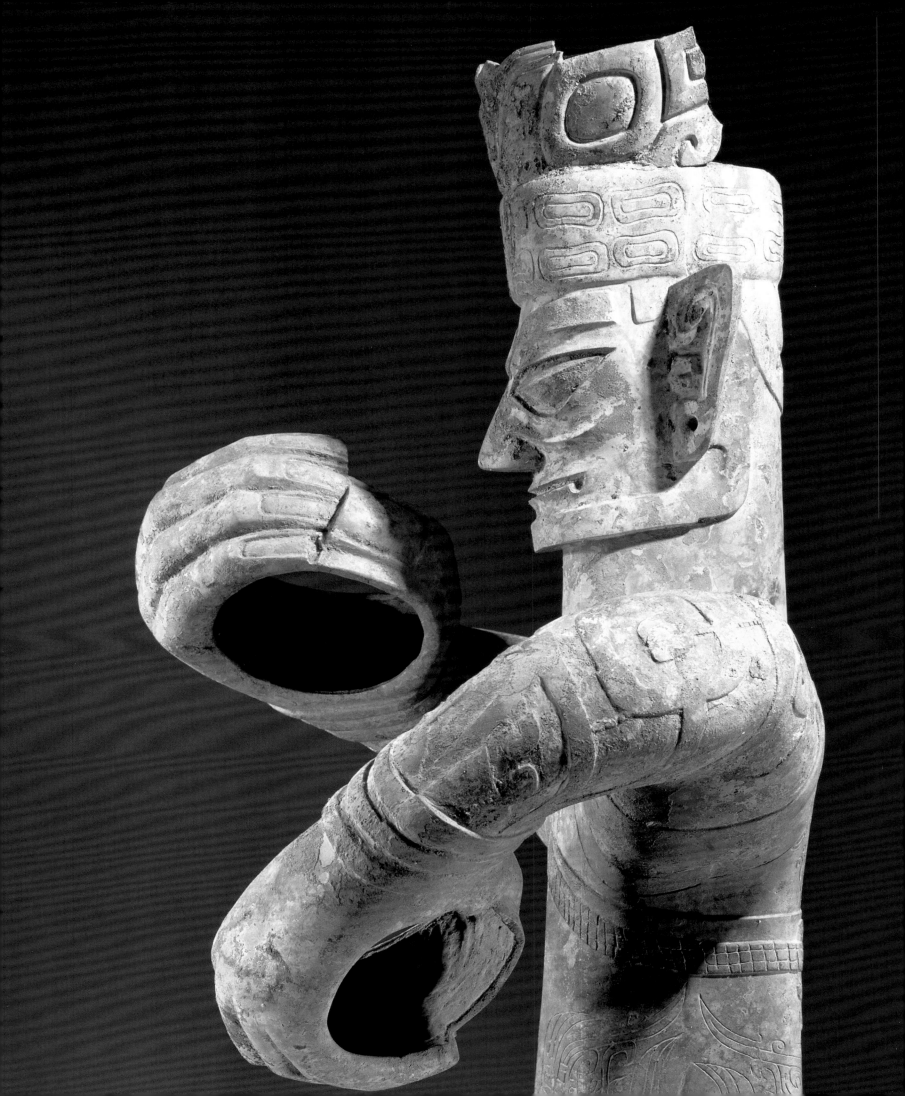

by Jay Xu

Sichuan before the Warring States Period

This exhibition begins in the second half of the second millennium BC, with the rise of bronze-using civilization in the Sichuan Basin, and explores cultural developments down to the third century AD, by which time Sichuan had long been firmly integrated into a unified China, the empire of Han (206 BC–AD 220). Throughout this ancient period, the Sichuan Basin was home to rich cultures that interacted with regions beyond the basin but remained individual, sometimes startlingly so. We know this chiefly from artifacts and traces of settlements. Before the Han period the people of the Sichuan Basin did not leave a written record of themselves, nor did their literate neighbors have occasion to mention them until about the fifth century BC.[1] Although written sources make it clear that in the Warring States period (fifth to third century BC) the Sichuan Basin was occupied by two states called Ba and Shu, for earlier periods they only recount myths and legends.[2] To understand earlier developments, therefore, we depend heavily on analysis of natural conditions and material remains. Let us begin with a survey of the unique geography of the Sichuan Basin and of the cultural context in which civilization arose there.

THE GEOGRAPHIC SETTING

Situated in southwestern China, the Sichuan Basin is a land of plenty sheltered by topography. The basin covers about 200,000 sq km. About seven percent of it is flat plains, the rest hills, the terrain ranging from 300 to 700 m above sea level (Map 2). The climate is mild subtropical with distinct seasons and monsoon rains. Running across the basin is a large network of rivers, comprising the Yangzi (known in China as the Changjiang, the "long river") and its many tributaries. In ancient times easy terrain, mild weather, and abundant water made the basin rich in vegetation and game, and hospitable to human settlement.

Of the various parts of the basin, the Chengdu Plain at the western edge accounts for the largest tract of flat land, amounting to about 6000 sq km (Maps 2 and 3). The plain is a rich alluvial deposit formed by the Min River in the west and the Tuo River in the east. It generally descends in elevation from northwest to southeast, from 700 to 400 m above sea level. Despite the menace of periodic flooding, the plain has been densely populated since Neolithic times, and it was the stage on which civilization first emerged in Sichuan.

1. The Chinese writing system was adopted in Sichuan only after the Qin conquest late in the fourth century BC. The only known writing before then takes the form of short, as yet undeciphered inscriptions on a small number of bronze *ge* blades dating from the end of the fifth century BC or the beginning of the fourth (see e.g. No. 82). Contemporary with these inscriptions are about a hundred pictographic emblems (Duan Yu 1991) found on bronze seals, weapons, and tools (see e.g. Fig. 77.1, Nos. 77, 84–8, 92; No. 82 shows both pictographic emblems and a line of the undeciphered writing). Half a dozen marks found on pottery vessels of the second millennium BC (Duan Yu 1991) are probably not writing.

2. Since the names Ba and Shu occur in oracle texts from the late second millennium Anyang site (for which see note 21 below), many scholars have been tempted to project the Warring States entities Ba and Shu (whether regarded as states or cultures or ethnic groups) back to that period or even earlier. It is unlikely that the Ba and Shu mentioned in the oracle inscriptions were located in Sichuan, however; attempts to attach the names to anything in Sichuan earlier than about the eighth century have been convincingly refuted by Gu Jiegang (1981, pp. 1–71). Nevertheless in many Chinese archaeological writings the late second millennium Sanxingdui culture discussed below has come to be known as "the early Shu culture," a label which implies that it is ancestral to the Shu culture of the Warring States period. Since currently available evidence does not justify connecting Sanxingdui and Shu in this way, in the present book the terms Ba and Shu will be applied only to cultures of the late first millennium BC. For a survey of the oracle inscriptions that mention Ba or Shu, see Dong Qixiang 1983, pp. 1–7. References in later texts—the *Zuo zhuan*, probably third century BC, and the "Mu shi" chapter of *Shang shu*, of uncertain date—that have been widely accepted as justifying the application of the two names to early archaeological cultures are discussed in Xu Zhongshu 1982, pp. 7–26. The name Sichuan, which was not applied to the region until the thirteenth century AD (Sage 1992, p. 2), is a neutral geographic designation without cultural connotations.

The Sichuan Basin is surrounded by land barriers. On all sides mountains or high plateaux mark it off from the outside world. In the west the Tibetan plateau rises more than 3000 m above sea level; the only avenues of westward communication are river valleys that dissect the plateau. In other directions the highlands are 1000 to 3000 m in elevation. In the south is the Yunnan-Guizhou plateau, which extends in an arc toward the northeast to embrace the basin. In the north the Qinling mountains run from the Tibetan plateau in the west to the Yunnan-Guizhou plateau in the east. These highlands and mountains were daunting obstacles to human traffic; the difficulty of reaching the basin was proverbial. Describing the journey to Sichuan from the north, the eighth century poet Li Bo (AD 701–762) famously said, "The road to Shu is harder than the road ascending to the blue sky." Another popular saying labeled the Sichuan Basin "the land in heaven," a description that evokes its combination of abundance and inaccessibility.

Yet despite this forbidding topography, mountain paths and waterways offered routes of communication with the outside world. One such route was the Yangzi, which runs south across the Tibetan plateau to enter the Sichuan Basin at its southwest corner. Once inside the basin, the river flows east along the edges of the Yunnan-Guizhou plateau to exit through the Three Gorges, a series of narrow passages between precipitous cliffs, where navigation is made perilous by rapid currents and submerged reefs. The Yangzi gave access both to the western high plateau and to regions downriver to the east. In the south, the Yangzi and mountain paths led into the Yunnan-Guizhou plateau and beyond, as far as Southeast Asia and India. Tributaries of the Yangzi, running southward to it from the north of Sichuan, enabled its traffic to spread throughout the basin and invited communication with regions to the north. The Min River led northwest to the Tibetan plateau. The Jialing River, which originates in the Qinling mountains, connects the Sichuan Basin with the upper Han River region (the Hanzhong Basin) and with the Wei River valley farther north. The Qin armies that conquered the Sichuan Basin in 316 BC came from this direction; later Li Bo traveled at least part of the route and captured its difficulty in his poem. The Han River runs southeast to join the Yangzi in the Jianghan Plain of southern Hubei. The Sichuan Basin could thus communicate with southern Hubei and regions further south or east either directly along the Yangzi or indirectly by way of the Han River.[3]

Thus while mountains isolated the Sichuan Basin, limiting communication to a trickle, rivers brought those trickles from all directions. This qualified isolation shaped the course of Sichuan's cultural development. The rise of a distinctive bronze-using civilization in the Chengdu Plain in the second half of the second millennium BC may well have depended crucially on the combination of geographical isolation and farflung contacts. The plain was isolated enough to escape being overwhelmed by any one outside culture, but open enough to be stimulated by outside contacts.

THE NEOLITHIC CONTEXT

Within the Sichuan Basin, the context from which Bronze Age civilization emerged was a distinctive local Neolithic culture that flourished in the second half of the third millennium BC. Named after the first major site where it was observed, the Baodun culture is characterized by a set of pottery vessels whose types give little hint of

3. Sichuan is also connected with southern Hubei by the Qingjiang, a Yangzi tributary that originates on the Sichuan-Hubei border and runs parallel to the Yangzi (south of it) until meeting it at Yidu, east of the Three Gorges.

contact with Neolithic cultures outside Sichuan. Though Baodun sites are scattered over much of the basin, the culture seems to have been centered in the Chengdu Plain, where five walled settlements have been discovered since 1995. The settlements are spaced at intervals of 20 to 33 km in an arc from southwest to northeast of Chengdu. They vary in size, the two smallest covering about 10 hectares each, the next two a little more than 30 hectares, and the largest 60 hectares. Four of the settlements are rectangular in shape, the fifth irregular. Walled settlements as large as these testify to an ability to mobilize substantial labor forces; they suggest a stratified society with a developed agricultural base.[4]

Several features recur at each of the five settlements. All were built on high natural terraces, and their walls were set along the edges of the terraces, making the ground surface higher inside than outside.[5] The walls were built of compacted earth: layer after layer of earth was poured on and tamped or beaten with timbers.[6] This produces a very thick wall with a flat central part and a gentle slope on either side; the cross section is trapezoidal, the wall being much thicker at the base than at the top. Baodun walls have the further peculiarity that the outer face slopes much more gently than the inner face, sometimes at an angle as low as 18 degrees. Since this slope would be easily scaled by an enemy, it is possible that the walls were meant to function primarily as dikes for flood control rather than as defensive ramparts. Deposits of sand and pebbles left probably by flooding have been found at several settlements, confirming a need for dikes, and the siting of settlements on high terraces was perhaps itself a defense against floods. The settlements are located along river banks, always in transitional zones where the terrain changes from hill to plain; their elevations range from 500 to 700 m. These locations apparently combined easy access to water with greater security from flooding than areas further downstream in the center of the Chengdu Plain.[7] Within the settlements, house foundations have been excavated. The largest, a rectangle 50 by 11 m, might have been a communal dwelling or a palace. The construction technique is unknown outside Sichuan: ditches were dug in the ground, wooden pillars were erected with their bases in the ditches, straw or bamboo mixed with mud was packed between the wooden members to form the walls, and finally a thatched roof was added.

Distinctive as it was, the Baodun culture evidently had some contact with regions to the east, the clearest indication being the walls of its settlements. Walls built in the same way are characteristic of the Shijiahe culture of southern Hubei (second half of the third millennium BC),[8] where urban construction has a history that can be traced back as far as the beginning of the fourth millennium. The largest Neolithic walled settlement so far known in China, covering about 100 hectares (1 sq km), was built at the Shijiahe site during the first half of the third millennium.[9] Baodun may well have learned wall construction from Shijiahe.

The Baodun culture was the foundation on which civilization was to arise in Sichuan. East of the five walled settlements, about 40 km northeast of modern Chengdu, there was a town of respectable size at a place today called Sanxingdui. In Baodun times the town was of secondary importance, for it had no walls and only small buildings, but it was soon to overshadow its neighbors.

4. For surveys and preliminary studies of the Baodun culture see *Chengdu wenwu* 1997.2, pp. 23–9; *Zhonghua wenhua luntan* 1997.4, pp. 8–14; *Sichuan wenwu* 1999.3, pp. 3–12; *Kaogu* 1999.8, pp. 60–73. The five walled settlements are the Baodun site in Xinjin county (*Kaogu* 1997.1, pp. 40–52; *Kaogu* 1998.1, pp. 29–50); the Yufu site in Wenjiang county (*Wenwu* 1998.12, pp. 38–56; *Dongnan wenhua* 1998.4, pp. 15–29); the Gucheng site in Pi Xian county (*Wenwu* 1999.1, pp. 32–42); the Mangcheng site at Dujiangyan City (*Kaogu* 1999.7, pp. 14–27); and the Shuanghe site in Chongzhou county (unpublished). According to a brief newspaper report in *Shijie ribao* (March 31, 2000), a sixth walled settlement has just been discovered. Called by the archaeologists the Zizhu site, it is 50 km southwest of Chengdu and apparently near the Shuanghe site.

5. *Dongnan wenhua* 1998.4, pp. 15–29.

6. In the more sophisticated rammed-earth technique commonly used in the middle Yellow River valley, earth was poured in thin layers between wooden forms and pounded to great hardness.

7. *Chengdu wenwu* 1998.4, pp. 39–44; *Dongnan wenhua* 1998.4, pp. 15–29; *Sichuan wenwu* 1998.4, pp. 34–7.

8. *Chengdu wenwu* 1997.2, pp. 23–9.

9. For the Shijiahe city and wall construction, see *Nanfang minzu kaogu* 5 (1992), pp. 277–80.

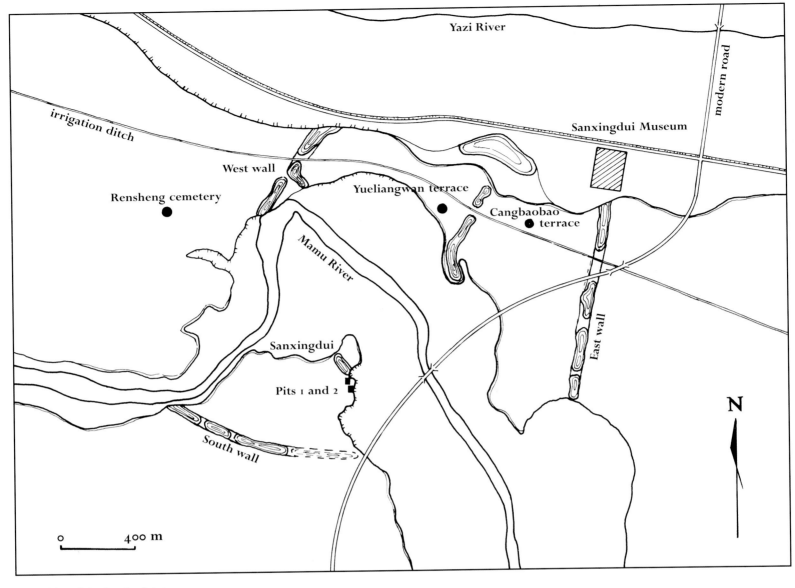

Fig. 1. Map of the Sanxingdui site.

10. The locus of the 1929 find was excavated in 1933; for information on the find and the excavation see Dye 1931, Graham 1934, Lin Minjun 1942, and Zheng Dekun 1942. A brief description of the Sanxingdui site and a history of the fieldwork there, including the latest results, is provided by Chen De'an in Taibei 1999, pp. 22–33 (and see pp. 198–9 for a list of major discoveries up to the beginning of 1999).

11. The 1951 survey is reported in *Kaogu* 1958.8, pp. 27–31; a survey carried out in 1961 is reported in *Wenwu* 1961.11, pp. 22–7; and a summary account of the 1963 excavation appears in *Nanfang minzu kaogu* 5 (1992), pp. 310–23.

12. Chen Xiandan 1989 gives a brief summary of fieldwork carried out between 1980 and 1986. Much recent fieldwork has yet to be published. Two formal excavation reports have appeared so far, one for the 1980–1981 excavation season (*Kaogu xuebao* 1987.2, pp. 227–54; Huang Jiaxiang 1990 is a critique of this report), the other for the two sacrificial pits excavated in 1986 (Beijing 1999a). In addition to these, a few preliminary reports have been published, and useful bits of information have occasionally been disclosed in short articles or news releases.

DISCOVERIES AT SANXINGDUI

Today Sanxingdui is a small village in Guanghan county. Hints that the place had greater importance in antiquity surfaced intermittently as early as 1929, when a pit containing three or four hundred jade and stone artifacts was found to the north of the village on a terrace called Yueliangwan (Fig. 1).[10] In 1951 a field survey revealed that ancient cultural remains were distributed over a large area, and in 1963 an excavation was undertaken at Yueliangwan.[11] After 1980 the pace of investigation accelerated. In five seasons between 1980 and 1985, jades, a pottery kiln, and large areas of house foundations were unearthed, indicating a settlement of substantial size.[12] The excavators were able to distinguish cultural layers ranging from late Neolithic to early Western Zhou, putting the bulk of the site firmly in the early Bronze Age. Using pottery typology and radiocarbon determinations, they distinguished four periods in the cultural deposits: Period I, second half of the third millennium BC; Period II, first half of the second millennium BC; and Periods III and IV, second half of the second millennium BC (with c. 1200 BC as a convenient though very approximate demarcation between the two).[13]

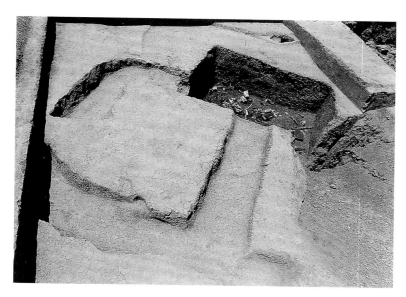

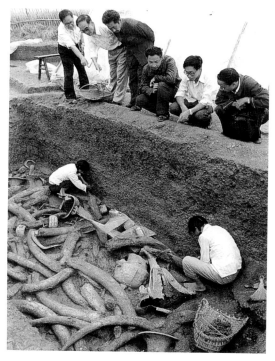

Fig. 2. Sanxingdui Pit 1 under excavation.

Fig. 3. Sanxingdui Pit 2 under excavation.

In 1985 it was realized that the "Three Star Mounds" from which the village of Sanxingdui takes its name are actually three remnants of a manmade wall.[14] Soon after, a section of wall to the east of the mounds and another to the west were located. Stratigraphic relations and potsherds mixed in the walls date their construction to Period II. The walls seem to have been maintained until the beginning of the Western Zhou period around 1000 BC, when the whole site was abandoned. In 1987 Sanxingdui was chosen as the name of the site and of its archaeological culture.[15]

Although the walls, foundations, and jades known by 1985 told the archaeologists that they were working at a site of considerable importance, nothing prepared them for the discoveries of the following year. In the summer of 1986, two pits containing hundreds of bronzes, stone and jade implements, gold objects, and elephant tusks were accidentally exposed.[16] The first pit, designated Pit 1 by the excavators, was discovered on July 18, two months after archaeologists and archaeology students had finished a season of excavation in the neighborhood. Workers from a local brickyard, digging clay to make bricks, came upon a dozen jades and reported their find to the archaeologists. The archaeologists began work on the same day and exposed a rectangular pit filled with sacrificial offerings whose excavation occupied them until August 14 (Fig. 2). Then on the day they were concluding that excavation, the brickyard workers came upon another pit, which proved to be still richer (Fig. 3). Excavation of Pit 2 began on August 20 and lasted until September 17.

Both pits had been dug into virgin soil. Above Pit 1 lay a stratum containing potsherds typical of late Period III, implying that Pit 1 was sealed before the end of Period III; above Pit 2 lay a deposit from early Period IV, implying a date before the end of Period IV.[17] Bronze vessels make it possible to estimate absolute dates for the two pits: they are probably within a few decades of each other, Pit 1 just before and Pit 2 just after 1200 BC.[18] The objects found in the pits were in many cases unprecedented, indeed bizarre. Together they attest a wealth and a level of cultural development

13. The first periodization proposed for the Sanxingdui site, published in *Kaogu xuebao* 1987.2, pp. 227–54, identified three periods but mentioned in its concluding section that a new stratum later than Period III had been discerned in a recent excavation; in Zhao Dianzeng 1989 this new stratum became Period IV. More specific dates for the four periods, proposed in Zhao Dianzeng 1992, are adopted and explained in Beijing 1999a. Since then, much effort has been devoted to refining the periodization; studies include Chen Xiandan 1989, Sun Hua 1992, Li Boqian 1997, and Wang & Zhang 1999, the one by Sun Hua having been particularly influential. For the purposes of the present discussion, the four-period scheme presented in Beijing 1999a is adequate and convenient.

14. Two of the three mounds had been dug away by farmers before archaeologists realized that they were manmade; the third is to be preserved, the entire site having now been designated an Important National Cultural Property (this is the highest ranking given by China's historic preservation administration).

15. *Kaogu xuebao* 1987.2, pp. 227–54. For reasons to be explained below, in the present book the term "Sanxingdui culture" will be used to mean Periods II–IV of the Sanxingdui site.

16. Throughout this essay, factual information about Pit 1 and Pit 2 is taken from the final excavation report, Beijing 1999a, which was preceded by preliminary reports in *Wenwu* 1987.10, pp. 1–15 (Pit 1) and *Wenwu* 1989.5, pp. 1–20 (Pit 2).

17. See Beijing 1999a, pp. 424–37, for detailed discussion of the dating of the two pits by Chen De'an, one of the principal excavators.

18. Bagley 1988; Bagley 1990a. For general discussion of the dating of bronzes of this period see Bagley 1987, pp. 19–32; Bagley 1999, pp. 146–55. It should be stressed that the figure of 1200 BC, based on correlations with the Anyang site (and on dating Fu Hao's tomb there to *c.* 1200 BC), is very approximate. In general, the dates for early Bronze Age sites and cultures assumed here follow Bagley 1999.

Fig. 4. West wall of the Sanxingdui settlement, looking south. After Tokyo 1998, p. 42 fig. 3.

in the Sichuan Basin that were previously unknown and unsuspected.

In the years since these extraordinary discoveries, exploration of the Sanxingdui site has been continuous. Though nothing as spectacular as Pit 1 and Pit 2 has been found, the city and its walls have been mapped and a certain amount has been learned about the layout of the site. In 1986, when Pit 1 and Pit 2 were excavated, they seemed to be situated outside the ancient city; they are south of the Sanxingdui mounds, and the mounds were thought to be the remains of the city's south wall. Between November 1994 and January 1995, however, traces were detected of another wall south of the mounds, significantly enlarging the walled area. The east wall of the city is now estimated to have been about 1.8 km long, the remnants visible today measuring about 1 km. The south wall measures about 0.6 km, the west wall about 0.8 km. These walls average 40 m thick at the base and 20 m thick at the top (Fig. 4). The highest surviving parts, belonging to the west wall, are 6 to 10 m high. It is not clear whether there was ever a north wall; the site is bounded on the north by the Yazi River, and some scholars believe that the river served there in place of a wall. Alternatively it is possible that a north wall was washed away by the river or submerged in it, for the present riverbed has formations of earth that might be wall remnants. On present information the city measured 1.6–2 km from east to west and about 2 km from north to south, enclosing an area of 3.5 sq km in a roughly trapezoidal plan, the south wall forming the base of the trapezoid. It was much larger than the walled settlements of the Baodun culture and comparable in size to the largest known city of the time, Zhengzhou in the middle Yellow River valley, principal city of the Erligang culture (c. 1500–1300 BC).

The layout inside the walls seems to have been complex. The three Sanxingdui mounds, together measuring about 200 m long but perhaps originally much longer, lie on an east-west axis several hundred meters north of the south wall. Other terraces bisect the city on a north-south axis; Pit 1 and Pit 2 in the south and the Yueliangwan pits in the north were dug into these terraces. An excavation currently under way at the northern tip of Yueliangwan has established that the terrace there was manmade, making it likely that the north-south terraces are the remains of another wall. The city was evidently divided into quarters by these walls, and a second river, the Mamu, zigzags across it. The layout gives the impression of a gradually growing settlement. Perhaps the walls were added at intervals to accommodate a growing population and to deal with the wanderings of the rivers.

Besides the walls, features so far excavated inside the city include a pottery kiln and more than 50 building foundations with rectangular, square, or circular plans. The average foundation occupies 20 or 25 sq m. The largest, still modest by comparison with the 550-square-meter building in one of the Baodun settlements, is a rectangle 8.7 m deep and 23 m wide, occupying 200 sq m.

Rectangular pits containing ritual objects seem to be a regular feature of the Sanxingdui site. Besides Pit 1 and Pit 2, five pits containing stone and jade artifacts, mostly

large disks but sometimes also rings, forked blades, or other shapes, have been found in the northern and northeastern parts of the site.[19] Three were on the Yueliangwan terrace, one on another terrace 400 m east of the 1929 Yueliangwan pit, and another at the south end of what remains of the east wall.[20] In addition to finished objects, the artifacts in these pits often include raw material, half-finished products, and apparently even waste material and stones used for grinding. Similar debris has been found in the neighborhood of the pits, suggesting that workshops for stone and jade were located here. No bronze foundry has yet been discovered.

Outside the walls, cultural remains have been found scattered over an area of 12 sq km; this defines the extent of the Sanxingdui site as presently known. Outside the west wall a group of 28 graves was excavated in July 1998. Small and poorly furnished, containing only a few stone and jade artifacts, these are the first burials found at Sanxingdui. So large and rich a city is likely to have buried the dead of its ruling class more ostentatiously. Further exploration outside the walls is obviously needed.

THE CHARACTER OF THE SANXINGDUI CULTURE

In the second millennium BC, when the Sanxingdui culture was developing in the Chengdu Plain, civilized societies existed in several regions of China. In and near the middle Yellow River valley, in a region traditionally called the Zhongyuan (Central Plain), urban centers had arisen during the first half of the millennium. Large-scale bronze metallurgy made its first known appearance at a Zhongyuan site called Erlitou, type site of the Erlitou culture. The influence of the Erlitou culture was felt over a wide area, reaching as far as Sanxingdui, as we will see. Toward the middle of the second millennium Erlitou gave way to Erligang (c. 1500–1300 BC). This archaeological culture seems to be the material residue of a powerful state centered at modern Zhengzhou, where the ancient city walls enclose about 3 sq km. The Erligang state rapidly expanded to regions well beyond the middle Yellow River valley, but it seems to have declined by about 1300 BC, for in outlying areas its culture was succeeded by a number of distinct local cultures. In the Zhongyuan itself power shifted from Zhengzhou to a new center, Anyang, about 1200 BC. The rulers of Anyang, kings of a dynasty called Shang, left us our first substantial body of writing in China, records of royal divinations inscribed on turtle plastrons and bovid scapulas.[21]

Archaeologists see Erlitou, Erligang, and Anyang as successive stages of a continuous cultural tradition centered in the Zhongyuan. A basic marker of this tradition is its bronzes, the most important of which were ritual vessels made by casting. The Erligang expansion carried the Zhongyuan bronze industry outward, sowing the seeds for the regional bronze cultures that sprang up after the retreat of Erligang power around 1300 BC.[22] On present evidence, the most important of these regional cultures were located in the middle Yangzi valley; in central Jiangxi; and in the upper Han and Wei River valleys of Shaanxi province. All had become distinctive by 1200 BC, their bronzes sometimes rivaling Anyang bronzes in quality. The century from 1300 to 1200, marked by regional diversification, is now commonly referred to by archaeologists as the "transition period."[23]

Growing out of the Baodun culture, the Sanxingdui culture evolved against the backdrop of these wider developments—the rise of Bronze Age civilization in the

19. It is possible that one or two of these pits were in fact burials.

20. Zhao Dianzeng 1996b, p. 93. The 1987 find east of the 1929 Yueliangwan pit is briefly reported in Beijing 1998f, pp. 78–90. For the contents of the 1929 Yueliangwan pit see Feng & Tong 1979, Gao & Xing 1995, Gao & Xing 1998, and note 10 above.

21. For a survey of archaeological cultures of the second millennium BC see Bagley 1999. For an introduction to the Shang oracle inscriptions and the Anyang dynasty see Keightley 1999. The very recent discovery of extensive thirteenth century remains north of previously explored areas at Anyang (Tang Jigen 1999) may signify the city's rise to importance earlier than 1200 BC, the date of the earliest known oracle bones.

22. Bagley 1999, pp. 171–80.

23. Bagley 1999, p. 150 note 38; Tang Jigen 1999.

Zhongyuan by 1500 BC, then its outward spread and regional diversification over the next three centuries.

Pottery, Periodization, and the City Wall

In dividing the history of the Sanxingdui site into four periods, archaeologists are guided by the pottery found in successive levels.[24] Shapes, decoration, clay color, and clay type all tend to change as time goes on, and they may change abruptly if outsiders (traders or immigrants or conquerors) introduce new types or new customs. Pots break, but the potsherds that result are virtually indestructible, and to the experienced archaeologist a potsherd may be instantly recognizable even if the shape of the vessel it came from is not obvious.

In the days when Sanxingdui was only a modest settlement, corresponding to the archaeologists' Period I (late third millennium), it belonged to the Baodun culture. The pottery from the lowest levels resembles pottery from the major Baodun settlements, and the similarities extend to the inventory of stone tools (small axes, adzes, and chisels) and the methods of house construction.

Ring-footed and flat-bottomed pots were typical of Period I. They continued in popularity in Period II, as did their brownish sandy fabric. Period II is distinguished, however, by the advent of several new types that would persist through Periods III and IV.[25] Two explanations for the new types are possible. First, it is conceivable that the appearance of sudden change is deceptive: perhaps the transition was more gradual than it appears, and archaeologists have not yet found the transitional material. Alternatively it is possible that the change was indeed abrupt and that it was caused by external contacts—the arrival of new people or at least of new artifacts and new ideas. The evidence for this second possibility—evidence that Periods II, III, and IV at Sanxingdui are the result of grafting new shoots onto a Baodun root—is fairly strong. Some of the pottery shapes new in Period II seem to be related to shapes typical of the Shijiahe culture (middle Yangzi region) and the Erlitou culture (middle Yellow River valley).[26] These could have spread upstream along the Yangzi into Sichuan.

The first walls at Sanxingdui seem to have been built in Period II. In some respects they point to continuity with Baodun: they have the same gently sloping sides as Baodun walls, and they too may have been built for flood control. Cultural deposits at Sanxingdui are interrupted several times by layers of blackish silt largely free of artifacts that might be alluvial deposits, and one such deposit lies immediately below the stratum to which the walls belong.[27] The earth used to build the walls was dug immediately outside them, leaving a ditch or moat 20–30 m wide and making the ground level higher inside than out in a way reminiscent of the walled Baodun settlements (Fig. 4). In construction technology, however, the Sanxingdui walls are somewhat more sophisticated. In cross section they can be seen to consist of three distinct parts, a middle part in which the pounded earth layers are horizontal and inner and outer parts in which the layers slope.[28] This tripartite structure might be another sign of external contact, since it is encountered in the Yellow River valley at least as early, for instance at Zhengzhou (where the layers are however thinner, more regular, and pounded harder). A layer of adobe brick—brick shaped in forms and sun-dried but

24. The following discussion of Sanxingdui periodization and pottery typology is based on Beijing 1999a, pp. 424–7.

25. Tripod *he,* high-stemmed *dou,* and *guan* with tapered profile and small flat bottom. Also new are handles in the shape of a bird with a hooked beak (Sun Hua 1992, p. 16 fig. 8; Tokyo 1998, no. 170), perhaps foreshadowing the bronze birds found in Pit 1 and Pit 2 (Nos. 27, 30, 31, 33).

26. For Shijiahe pottery see Zhang Xuqiu 1991 and Beijing 1999e; for Erlitou pottery, Beijing 1995f and Beijing 1999c.

27. At an elevation of 500 m, Sanxingdui is in the flood plain. The Mamu River, now a tiny stream, was large enough in the 1950s to require a passenger ferry, and both it and the Yazi River flooded periodically (Chen De'an, personal communication, October 1999). Sanxingdui archaeologists have not been able to determine the ancient course of the Mamu River; the possibility has been raised that a shift to a course cutting through the ancient city had something to do with the city's abandonment (*Sichuan wenwu* 1998.4, pp. 34–7). On an alluvial stratum at Sanxingdui, see *Nanfang minzu kaogu* 1 (1987), p. 81.

28. This feature has so far been observed only in the east wall; sections of the other walls have yet to be examined (Chen De'an, personal communication, October 1999).

not fired—has been found on the top surface of a section of the east wall (Fig. 5).

The changes in pottery that prompt the excavators to distinguish Period II from Period III and Period III from Period IV are relatively subtle. Here it need only be mentioned that shapes with pointed bottoms[29] came into use toward the end of Period III and enjoyed a great vogue in Period IV, which saw also a distinct change of fabric for most pots. The first stage of settlement at the Chengdu Shi'erqiao site, discussed below, has much the same pottery repertoire as Sanxingdui Period IV.[30]

Judging by the pottery evidence, therefore, the Sanxingdui culture had indigenous foundations in the Baodun culture, but in building on those foundations it incorporated significant contributions from outside. In particular, important influences came from both the middle Yangzi valley and the middle Yellow River valley. As we turn now to the material culture of Sanxingdui's elite class—preserved for us in staggering abundance in the two sacrificial pits—we will see that what arose on Baodun foundations was a civilization.

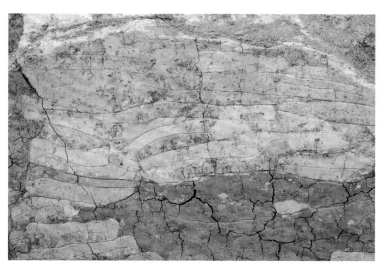

Fig. 5. Adobe brick atop the east wall of the Sanxingdui settlement.

The Sacrificial Pits

Pit 1, the first pit to be discovered, is a rectangular shaft approached by shallow entrance ramps (Fig. 2). About 1.5 m deep, it measures roughly 3.5 by 4.5 m at the top and 3 by 4 m at the bottom. Its corners point to the cardinal directions. The ramps entered the pit from the south and southeast, but they are incompletely known because parts of them had been dug away by the brickyard workers. The material buried in the pit must have been pushed in by way of the ramps, for it is concentrated in the south corner and along the southeastern and southwestern walls. Pit 1 contained more than 400 artifacts of bronze, gold, stone, jade, amber, and pottery, along with 13 elephant tusks, dozens of cowry shells, and 3 cu m of burnt animal bones mixed with wood and bamboo ash.[31] The 200 bronzes include 4 vessels, 13 more or less human heads, 107 rings, and 44 triangular dagger-axe *(ge)* blades with serrated edges. The objects of stone and jade, also numbering about 200, include more than 60 tools and more than 70 blades of various types.[32] There were 4 gold items, most notably a tube of sheet gold 142 cm long, originally the sheathing of a wooden staff (No. 1). And there were nearly 40 pottery vessels of four types. The contents of the pit seem to have been deposited sequentially: small objects of stone, jade, and gold first; then bronze heads and vessels; then the burnt bones and ashes and some small objects mixed with them; then elephant tusks; and finally the pottery vessels and large blades of jade and stone. The pit and ramps were then filled with earth pounded hard.

Pit 2 is only 30 m from Pit 1. It lacks the ramps of Pit 1, and it is a narrower rectangle, about 5 by 2 m, but it has the same depth and the same orientation to the cardinal points. Far richer, it contained 67 elephant tusks, 4600 cowry shells, and hundreds of artifacts (the excavation report—which numbers fragments individually—reaches a total of 1300). The bronzes include a wealth of figurative items, ranging in size from miniature to monumental and in type from heads to whole figures to strange bronze trees alive with birds and other creatures. A human figure on a pedestal is lifesized,

29. Especially a small bowl or dish, of which at least 22 examples were found in Pit 1 (Beijing 1999a, pp. 145–9).

30. Sun Hua 1992.

31. Elephant teeth were found among the bones and ash, suggesting that elephants were among the animals sacrificed.

32. The excavation report (Beijing 1999a) is confusing and contradictory in its classification of lithic materials. Its two basic categories are "jade" and "stone," the first understood in the general sense of "fine hardstone" rather than meaning nephrite specifically. Artifacts were assigned to one category or the other by visual inspection alone, without instruments; the more specific mineral identifications given in Tables 5-8 and 26-8 of the report were apparently made in the same way. However, the authors of the report's petrographic appendix (pp. 500–514) point out that nineteen samples studied under a microscope proved in almost every case to have petrographic structures at odds with the identifications made without microscopic examination, and they conclude that simple visual inspection is unreliable. The implication seems to be that the report publishes mineral identifications in which the investigators have little confidence. For different reasons, the report's sorting of the artifacts by supposed type or function is equally dubious. What is clear is only that a wide variety of lithic materials was used at Sanxingdui, ranging from fine nephrite to coarse sandy rock, and that no very clear-cut difference of workmanship or even of material separates the report's "jades" from its "stones." Hence the statistics given in the present essay lump "jades" and "stones" together, and they also follow the typological descriptions of Chapter 2 in this book rather than those of the excavation report. The reader will therefore find no simple correspondence between counts given here and counts given in the excavation report.

figure and pedestal together measuring 2.6 m high (No. 2). The largest of the bronze trees is 4 m high (No. 27). At the other extreme of size, a kneeling figure holding a forked blade is only 5 cm high (No. 51). At least 6 of the more than 40 bronze heads in the pit were originally partly covered with gold foil (Nos. 12–14). There are also 20 bronze masks, some very large and quite fantastic in appearance (Nos. 18–23), and a good many small bronze ornaments, some of which may originally have hung from the branches of the bronze trees. For many of these objects Pit 1 has nothing comparable to show, but among the less spectacular items there is considerable overlap between the two pits. Both yielded bronze rings, vessels, and thin triangular *ge* blades, and most of the lithic types were represented in both. Still, Pit 2 had nearly 500 small jade, stone, and ivory beads and tubes, types not represented in Pit 1; and Pit 1 had jade or stone blades of a curious hybrid type unknown in Pit 2 or anywhere else (e.g. No. 58). Pit 1 also contained pottery; Pit 2 did not.

In the case of Pit 2, the sequential filling of the pit was very obvious, for it produced three distinct layers. The bottom layer consisted of a wide variety of tree fragments, other small bronzes, jade and stone items, and cowry shells. The middle layer was made up entirely of the larger bronzes (Fig. 6). Strewn on top of these were the elephant tusks, forming the third layer (Fig. 7). Within each layer the objects had been scattered at random. As with Pit 1, the earth fill of the pit was pounded hard.

The reason for these deposits, not to mention the functions of the many strange objects they contain, is a mystery. No similar find has been made anywhere else, and no inscriptions have been found at the Sanxingdui site to shed light on its culture or to connect its people with people mentioned in later texts (though this has not prevented scholars from proposing connections). Nevertheless much that is of interest can be learned from close examination of the finds themselves.

Most of the objects in Pit 1 had been subjected to high temperatures; some of the bronzes show traces of melting, others had melted into unrecognizable lumps. Since the walls of the pit show no sign of fire or smoke, the burning must have occurred before the objects were dumped into the pit. A few items, particularly those of jade and stone, had been broken as well as burned. It is clear that the breakage occurred before burial, because different parts of a single object were sometimes found scattered. The bones had also been burned and broken (indeed pounded to fragments).

In Pit 2 a smaller fraction of the contents shows signs of burning, but the bronzes and jades show much evidence of deformation or breakage before burial. To take only one example, the bronze statue was broken diagonally across the robe (Fig. 2.7), and the two pieces were found in the pit lying in opposite directions: in Figure 6 the upper half is near the center of the pit, almost right side up, the head pointing toward the upper left corner; the lower half (the bottom of the robe, the feet, and the pedestal) is upside down, near the right wall of the pit, with the base of one of the bronze trees lying across it.

Pit 1 and Pit 2 are close together, comparable in size, and oriented alike; they were filled in an orderly way with a generally comparable range of bronzes and jades, most of which had been burned and/or hammered

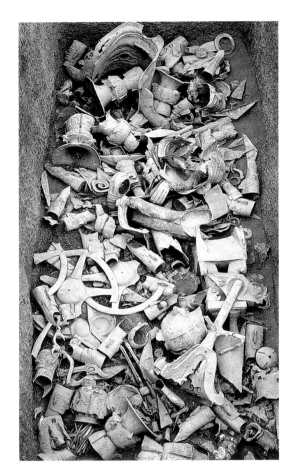

Fig. 6. Pit 2, middle layer.

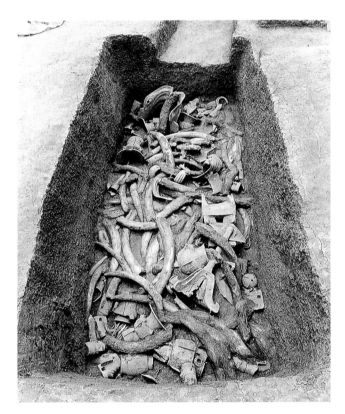

Fig. 7. Pit 2, top layer. The trench at the top of the photograph is not a ramp but an intrusive ditch dug in a later period.

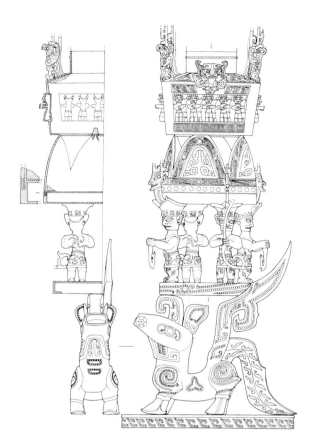

Fig. 8. Bronze altar? K2(3):296. Reconstruction drawing based on surviving fragments. Height about 54 cm. After Beijing 1999a, p. 233 fig. 129.

or battered before deposition, and with other valuables such as cowry shells and elephant tusks; and they were sealed with a filling of pounded earth. So many common features make it reasonable to suppose that the two pits represent two performances of a single ceremony, some sort of ritual in which offerings were first burned or broken and then buried. The ash and bones in Pit 1—mostly pig, sheep, ram, cattle, and buffalo—certainly suggest a burnt sacrifice, and it is conceivable that some of the artifacts in the two pits were actually made specifically for sacrifice: the bronze *ge* blades, at least, are too flimsy for practical use. Perhaps breaking and burning were ways of "killing" artifacts so that they could make the passage from this world to some supernatural realm.[33]

The pits nevertheless differ in several ways. First, as already noted, Pit 2 was much richer than Pit 1. Second, the offerings were more often burnt in Pit 1, more often broken in Pit 2. Third, Pit 1 contained pottery and a large quantity of bone and ash, Pit 2 none at all. And fourth, Pit 2 had a far greater wealth of images: heads, masks, trees, birds, even models of what might be temples or altars (Fig. 8). These differences are probably to be explained by the lapse of a few decades between the two pits, a lapse that might have seen changes in the city's wealth, in its bronze and jade industries, or in the ritual procedure itself. In Chapter 1 it will be suggested that the bronze trees sacrificed in Pit 2 replaced actual trees sacrificed in Pit 1, and similar replacement of the real by the bronze facsimile might apply to other offerings as well.

Whatever the exact nature of the offering ritual, it was quite different from sacrifices performed in the same period at the capital of the Shang kings at Anyang. At Anyang as at Sanxingdui, large animals were sacrificed. But Anyang offerings seldom included bronzes or jades, never in the abundance seen at Sanxingdui, and they often

33. Scholars have reviewed a number of other possible interpretations of the pits, suggesting for instance that they are burials of grave goods that accompany graves not yet located (despite careful search of the vicinity); cremation burials (but Pit 1 contained no clearly discernible trace of human bone, Pit 2 no bone at all); hoards buried with the intention of recovery at a later date (but why the breakage and burning?); the discarded furniture of burned or abandoned temples (but why discard valuables such as ivory and recyclable bronze?); or loot discarded (and neatly buried? on two occasions??) by invaders. None of these suggestions seems plausible.

included human victims, occasionally as many as several hundred. Perhaps the bronze heads at Sanxingdui were in some sense substitutes for human sacrifice.[34]

The differences between Anyang and Sanxingdui extend to artifact types and their uses. At Anyang bronze was used mainly for ritual vessels, which were made in enormous variety and deposited in tombs in large numbers. Lacking tombs at Sanxingdui, we cannot be sure that they did not contain such vessels, but in the pits at least, only a few vessels were found, and virtually all of them belong to a single type: they are the large vases today called *zun* or *lei*.[35] Moreover while at Anyang ritual vessels were used for wine and food offerings, the vessels found at Sanxingdui held jades, cowry shells, and other small objects.[36] As to the human, semi-human, and supernatural images found in such abundance at Sanxingdui, they have no parallel at Anyang. Images of men and gods played a negligible role in the material culture of the Zhongyuan, and sculpture scarcely went beyond a few tiny jade figurines. Indeed representation in general took second place to the elaborate ornamental system that provided decoration for ritual vessels.

If the Sanxingdui sculptures had forbears of any kind in Sichuan, it must have been in some perishable material like wood. Since no sculptural tradition developed enough to account adequately for their extraordinary character is known in China, a few scholars have speculated that they might reflect Mesopotamian influence.[37] The Mesopotamian comparisons do not seem very convincing, however, and on present evidence the sculptures must be regarded as local inventions that owe little to outside influence except bronze technology and a few motifs of surface decoration.

Contacts Suggested by the Bronzes and Jades

Though our knowledge of the Sanxingdui site and its culture is still very limited— we really cannot guess what a major Sanxingdui tomb would contain—the contents of the two sacrificial pits leave no doubt that we are dealing with a civilization radically different from that of the Yellow River valley. Nevertheless borrowings from other regions are present. The casting technology observable in the sculptures is one example; others are to be seen in the imported bronze vessels and also in the lithic inventory. These borrowings direct our attention to three regions in particular: the middle Yellow River valley (the Zhongyuan), the middle Yangzi valley, and a northern region comprising parts of modern Gansu and Shaanxi provinces.

The Zhongyuan was the ultimate source of Sanxingdui's bronze casting technology, as well as the source of certain jade types. Its bronze industry centered on the production of ritual vessels cast in section molds. The section-mold technique is first in evidence at the Erlitou site, about 1500 BC. In the Erligang period (*c.* 1500–1300 BC) it was supplemented by joining methods that allowed an object to be made from two or more parts cast separately.[38] Though vastly different in appearance from ritual vessels, the Sanxingdui sculptures were cast by the same techniques. Joining methods were used with particular freedom, the large tree being assembled from more than a hundred pieces.[39]

The Zhongyuan region was also the source for certain Sanxingdui lithic types, though to judge by their material, all or most of the examples from the pits were locally made. In particular, the Erlitou site has yielded the oldest known examples of

34. For an extended comparison of Anyang and Sanxingdui sacrifices see Bagley 1990a; for Anyang human sacrifice see also Bagley 1999, pp. 192–4. Although the Anyang oracle inscriptions mention burning and sometimes burying sacrificial offerings, Anyang archaeologists have not found burnt offerings.

35. Modern nomenclature distinguishes between *zun* (e.g. No. 47) and *lei* (e.g. No. 49) on the basis of different proportions, but there is no reason to suppose that ancient users made such a distinction or that the vessels had distinct functions. Confusingly, the term *lei* is applied also to another type, not represented at Sanxingdui, that differs not only in proportions but also by the presence of three handles and sometimes a lid (e.g. No. 66).

36. In the middle Yangzi region, where the vessels found in Pit 2 are likely to have been made, bronze vessels of several different shapes have sometimes been found with jades or other articles inside them (Chapter 1, note 32).

37. The suggestion was first made by Cui Wei (1989) and has been pursued in more detail by Duan Yu (1993 and a few other articles); see the bibliography in Chen De'an *et al.* 1998 for full references. The principal arguments are as follows: (1) Human sculpture had appeared in Mesopotamia by the beginning of the third millennium and was used there in ritual contexts. (2) The facial features of the Sanxingdui heads seem Caucasian; the exaggerated eyes recall Sumerian votive figurines (Strommenger & Hirmer 1964, pls. 50–60). (3) Gold and gold foil were used in Mesopotamia, sometimes for sculptural heads (e.g. the head of a bull on a lyre from Ur, Strommenger & Hirmer 1964, pl. 76) and masks (Tutankhamun's funerary mask is the example cited). (4) The "ram in a thicket" from Ur (Strommenger & Hirmer 1964, pl. 80) is a possible precedent for the metal trees at Sanxingdui. (5) And finally, the gold-sheathed staff from Pit 1 might be a symbol of authority comparable to the mace in Mesopotamia and Egypt. (One shared item that has not been mentioned is sun-dried brick, known much earlier in Mesopotamia and the Indus valley. It might also be noted that the Indian Ocean seems the most probable source for the cowry shells found both at Sanxingdui and at Anyang; see Peng & Zhu 1999 and the entries for Nos. 44 and 46.) Some of these parallels seem superficial, none is very compelling; nor do the authors suggest a mechanism by which Mesopotamian prototypes could have come to the attention of Sanxingdui artists and patrons. For the moment the question of outside influence should be left open.

38. On these techniques see Bagley 1999, pp. 141–6 and, for more detail, Bagley 1987, pp. 37–45; Gettens 1967; Gettens 1969.

39. Further detail will be found in Chapter 1 and in the entries for individual bronzes.

the jade *ge* blade as well as of the bronze weapon that the jade versions copy.[40] The *ge* blade remained a favorite jade shape in the north in the Erligang and Anyang periods; the tomb of Fu Hao, an Anyang royal consort who died about 1200 BC, contained 39, among which are examples very similar to No. 56.[41] The origin of the forked blade (Nos. 52, 54–5) is more obscure (see below), though it too is represented at Erlitou.[42] Another lithic type encountered at both Sanxingdui and Erlitou is the large trapezoidal knife with incised crisscross decoration.[43] The collared rings and disks from the Sanxingdui pits (Nos. 61–2) likewise have parallels in the Zhongyuan, but at Anyang rather than Erlitou, for instance in Fu Hao's tomb. Strangely, this shape was copied at Sanxingdui in bronze: the pits yielded 18 collared disks of jade or stone and 130 of bronze. No such bronze disks are known at any other site, nor is it at all common for a jade shape to be copied in bronze as opposed to the other way around.[44]

Downriver from Sichuan is the middle Yangzi region, in other words southern Hubei and northern Hunan. The downriver contacts evident already in the third millennium, in the Baodun culture's debt to the wall-building technology of the Shijiahe culture, persisted at the time of Sanxingdui. Moreover it seems likely that the Jianghan Plain was one route by which early influences from Zhongyuan sites reached the Sichuan Basin. The Erligang culture had at least one notable outpost in the plain, a walled city at Panlongcheng in Hubei province, and probably more.[45] Given a strong Erligang presence in the middle Yangzi region, diffusion of Erligang influences upriver to Sichuan is easy to imagine. With the northward retreat of Erligang power around 1300 BC, however, distinctive local cultures arose in the middle Yangzi region, giving the Sichuan Basin new neighbors there.[46] Among those new neighbors, it was metallurgical centers in northern Hunan that seem to have supplied most of the bronze vessels found in the Sanxingdui pits.[47] Metal provenance studies moreover reveal a trade in metals that not only covered large distances along the Yangzi but also reached far to the north and south: lead of an unusual isotopic composition that has been traced to mines in Yunnan province is found in many of the Sanxingdui bronzes (including heads, masks, trees, and the statue), in bronzes from Fu Hao's tomb at Anyang, and in bronzes from a rich thirteenth century tomb at Xin'gan in Jiangxi province.[48]

Contacts reaching northward into Shaanxi and Gansu are suggested principally by lithic types, notably the forked blades. The genesis of this shape is an unsolved problem.[49] Examples with deeply cleft tips (Nos. 54–5) are found almost exclusively at Sanxingdui.[50] They must be a local variant of the more widespread type with gently curved tip (No. 52). The latter are not only widely but also very erratically distributed; the earliest examples seem to be from late Neolithic graves at Shenmu in northern Shaanxi province.[51] The dark coating given to some of the Sanxingdui blades, noted by Jenny So in Chapter 2, might be an attempt to imitate the dark gray or black stone of the Shenmu blades. Chapter 2 also notes peculiarities of lithic technique that seem to connect the Sanxingdui industry with that of the Qijia culture in Gansu. Three squat *cong* from Sanxingdui, two plain ones and a third decorated with simple incised lines, have relatives in northwestern China but not at Erlitou or Erligang.[52] A final northern connection, this time with the upper Han region of southern Shaanxi, is provided by an early second millennium site located at Ankang on the upper course of the Han; some of the pottery here is said to resemble Sanxingdui Period II pottery.[53]

40. *Kaogu* 1976.4, pls. 5.5 (bronze), 6.1 (jade); Bagley 1999, figs. 3.12a, 3.14a. Bronze *ge* said to be of Erligang type have been found near Sanxingdui at Xinfan Shuiguanyin (*Kaogu* 1959.8, p. 408); examples found in the Sanxingdui pits by contrast are of a distinctly local type, with serrated edges (Tokyo 1998, pp. 134–5; Taibei 1999, pp. 126–7; Beijing 1999a, pp. 56–9, 290–91, 294–5, 529).

41. See the entry for No. 56. The excavation report for Fu Hao's tomb is Beijing 1984a. For a brief account of the tomb see Bagley 1999, pp. 194–202.

42. For Erlitou examples see Chapter 2, note 19.

43. Compare Chapter 2, Figure 1 (=Tokyo 1998, no. 129, and see also the fragment no. 154) with Fong 1980, no. 3. Note also a similar knife from Weigang in northern Hunan (*Hunan kaogu jikan* 4 [1987], p. 17 fig. 8.1).

44. Another peculiar instance of such copying is the bronze forked blades found in a hoard at Shaanxi Yang Xian Fanba (*Wenbo* 1996.6, pp. 73–5 and inside back cover; *Wenbo* 1997.2, pp. 13–14, 18). Yang Xian is located in the upper Han valley, just north of Sichuan; the blades might represent an influence of the Sanxingdui culture on regions north of it. A little further to the north, at Baoji in Shaanxi, the early Western Zhou cemetery of the Yu state has yielded two small bronze figures that look like miniature versions of the statue from Sanxingdui Pit 2 (Bagley 1990a, figs. 33–4; Lu & Hu 1988, vol. 2, color pl. 23). Dating from around 1000 BC, these seem to be a very isolated instance of later recollection of a distinctive element of the Sanxingdui culture.

45. On Panlongcheng see Bagley 1999, pp. 168–71; Bagley 1977. On the site of Shimen Zaoshi in northern Hunan, which testifies to Erligang influence south of the Yangzi, see *Kaogu xuebao* 1992.2, pp. 185–218.

46. For these regional developments see Bagley 1999, pp. 171–5, 208–12.

47. The earliest vessels in the pits belong to a very widespread transition-period style, and although they could be from Hunan, their place of origin cannot be pinned down (Chapter 1 and Nos. 44–5).

48. See Chapter 1, appendix. The Xin'gan tomb also yielded jade *ge* blades and collared disks like those from Sanxingdui and Anyang (Beijing 1997f, pls. 54, 56); by the thirteenth century BC these were widespread types.

49. See Chapter 2 and references cited there, in particular Deng Cong 1994.

50. One example is reported from Jingzhou Guanyindang in Hubei (*Wenwu* 1999.1, p. 18 figs. 2 and 4); the archaeological context is said to belong to the Shijiahe culture, though forked blades are otherwise unknown in Shijiahe. One or two further examples were found at Shenmu Shimao in Shaanxi, where they were much outnumbered by the more usual type with gently curved tip (for references see the next note).

51. Archaeologists assign the Shenmu site to the second half of the third millennium BC but do not agree as to whether the burials that yielded forked blades date from this period or from the early second millennium. For illustrations of the Shenmu blades see Dai Yingxing 1993, part 2; Deng Cong 1994, color pls. 7–8; and references given in Chapter 2 in this book. In the Yellow River valley forked blades, always rare, seem to have virtually disappeared after the Erlitou period; only one stray example is reported from the Zhengzhou area, none from Anyang.

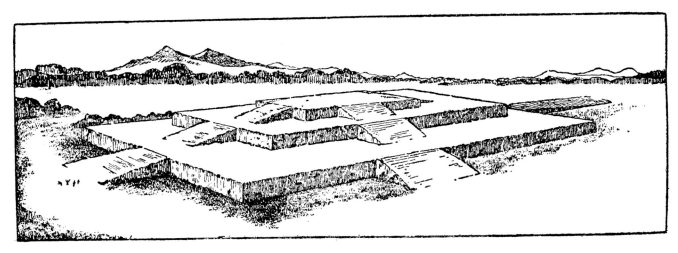

Fig. 9. Terraced mound at Chengdu Yangzishan.
Reconstruction drawing. After *Kaogu xuebao* 1957.4,
p. 20 fig. 3.

52. For the three *cong* from Sanxingdui see Deng Cong 1998, pl. 288; Tokyo 1998, nos. 146 and 152. For examples from Shaanxi, see Deng Shuping 1993, part 1; Mou & Yun 1992, nos. 43–4. The *cong* is a type that originated in the Liangzhu neolithic of the lower Yangzi region, where disks without collars were also made in large numbers; the occurrence of both types in the northwest is a reminder of just how far jade types might spread (and of the uncertainty of conclusions drawn from our very spotty archaeological sample of jade). The 1998 excavation of the cemetery outside the west wall at Sanxingdui is said to have yielded several Liangzhu-style jade awls (Taibei 1999, p. 199).

53. On the influence of Sichuan cultures in the upper Han River region see Wang & Sun 1992.

54. Bagley 1999, p. 180 fig. 3.19. On finds in the Chenggu area see Bagley 1999, pp. 178–80; Zhao Congcang 1996; *Wenbo* 1996.6, pp. 73–5. For a survey of finds of second millennium bronzes in Shaanxi see *Kaogu yu wenwu* 1986.3, pp. 53–63.

55. Surface surveys conducted in 1987–90 in Guanghan and Shifang counties identified about a dozen small sites (*Nanfang minzu kaogu* 5, 1992, pp. 295–309). Two others have been excavated, one at Xinfan Shuiguanyin and the other at Xindu Guilinxiang (*Kaogu* 1959.8, pp. 404–10; *Wenwu* 1997.3, pp. 24–34).

56. By way of acknowledging these similarities, archaeologists now assign Period IV (and the very end of Period III) at Sanxingdui to the first stage of the Shi'erqiao culture. (The Shi'erqiao culture extends down to the sixth century BC, in the view of Sichuan archaeologists, some of whom however prefer the term "Xinyicun culture," named after another Chengdu type site, for stages after 1000 BC.) In the present discussion, however, the expression "Sanxingdui culture" is retained for Periods II to IV at the Sanxingdui site, to avoid the confusion (and incongruity) of labeling the major archaeological find of the period—the Sanxingdui sacrificial pits—with a name taken from another, less important site. For fieldwork at Chengdu and periodization of finds there see Sun Hua 1996; Chengdu 1998, pp. 146–64; *Sichuan wenwu* 1999.3, pp. 3–12.

57. The excavation report is *Kaogu xuebao* 1957.4, pp. 17–31; for discussion of the date see Lin Xiang 1988 and Sun Hua 1993. The mound no longer exists, having been dug away for clay to make bricks in the 1950s.

The upper Han region deserves special mention as a crossroads where traffic from many regions met. It was in contact not only with regions further north (as far as the steppes) and east (including the Zhongyuan) but also with the middle Yangzi region by way of the Han River, a major Yangzi tributary. In the neighborhood of Chenggu, near the headwaters of the Han River, repeated finds of bronzes have yielded Erligang and transition-period types; bird and tiger images typical of the middle Yangzi region; vessels from the middle Yangzi region; and even peculiar faces recalling an example from distant Xin'gan.[54] Sanxingdui's contacts with any of these regions thus could have gone by way of the upper Han region as well as by more direct routes along the Yangzi.

THE CHENGDU SETTLEMENT AND SICHUAN AFTER SANXINGDUI

At the time of the two sacrificial pits, Sanxingdui seems to have been the main urban center on the Chengdu Plain; the only other sites known with similar pottery and stone tools are unwalled and much smaller.[55] This suggests a considerable change since the days of the Baodun culture, when the landscape had been dotted with settlements of moderate size rather than dominated by a single large one. But the pattern evidently began to shift again toward the end of Sanxingdui Period III, when a settlement at Chengdu began to grow. In later times Chengdu would become the dominant power in the plain and the capital of the state of Shu.

In its earliest stages, represented by a type site at Chengdu Shi'erqiao, the Chengdu settlement has the appearance of an offshoot from Sanxingdui; its stone tools are very similar, and its pottery repertoire, in which vessels with pointed bottoms are prominent, resembles that of Sanxingdui Periods III (late) and IV.[56] Since the ancient settlement lies beneath the modern city, systematic exploration has not been possible, but Shi'erqiao remains have so far been exposed at about a dozen separate places spread over an area of 6 or 7 sq km in the west and south of modern Chengdu, basically along the old course of the Pi River and its branches.

An earthen mound explored decades ago at Yangzishan in the northern part of Chengdu might be a Shi'erqiao construction of about 1000 BC.[57] The mound was square and terraced, with stairs leading from one terrace to the next (Fig. 9). It was constructed by building a wall around a square area and filling the enclosure with pounded earth, then building a larger and lower wall around the first and filling the

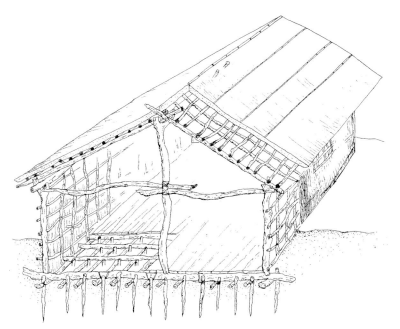

Fig. 10. House at the Shi'erqiao site, Chengdu. Reconstruction drawing. After *Wenwu* 1987.11, p. 8 fig. 11.

new enclosure with earth, and finally repeating the operation one last time. The walls were of adobe brick, recalling the brickwork found atop the east wall at Sanxingdui, and the mound was oriented with its corners to the cardinal points, like the Sanxingdui pits.

At the Shi'erqiao type site, on the western side of modern Chengdu, archaeologists have excavated a cluster of large and small houses.[58] Wooden beams and planks, bamboo slats from walls, and straw from roofs were preserved well enough to shed much light on building techniques. In one case, long beams had been laid parallel on the ground and drilled with holes at regular intervals, evidently to receive wooden pillars. In some of the smaller buildings the floor was kept off the ground, perhaps for protection against damp or flooding, by driving wooden stakes into the ground, lashing a grid of poles to the stakes, and laying a plank floor on top of the grid (Fig. 10). Although the buildings at Shi'erqiao were contemporary with Sanxingdui Periods III and IV, they seem architecturally more sophisticated than anything so far known at the Sanxingdui site.

Another difference from Sanxingdui is the turtle plastrons found at several Shi'erqiao sites. These have bored or chiselled hollows and were obviously used for divination. Divination plastrons reportedly are found at Chengdu all the way from the twelfth to the eighth century BC.[59]

Perhaps because of flooding, the city at Sanxingdui was abandoned around 1000 BC. Although the settlement at Chengdu was flourishing well before that time, and the Chengdu area was continuously inhabited thereafter, no tomb or deposit comparable in wealth to the Sanxingdui pits has yet been found there. Indeed the wealth represented by the Sanxingdui bronzes and jades has no known parallel anywhere in Sichuan for the next millennium. It is conceivable that the perennial problem of flooding, not alleviated until the completion of the great Dujiang waterworks in the third century BC, caused not just the abandonment of the Sanxingdui city but the collapse of its civilization and a reversion to simpler societies.[60]

For the entire first half of the first millennium BC, the only notable find of elite artifacts in the Chengdu Plain is an isolated pair of bronze hoards, of unknown

58. The preliminary excavation report is *Wenwu* 1987.12, pp. 1–23, 37.

59. *Kaogu* 1988.12, pp. 1122–9; *Chengdu wenwu* 1988.4, pp. 19–22.

60. Shi'erqiao strata at Chengdu often include layers of river pebbles and alluvial silt and sand (*Chengdu wenwu* 1988.1, pp. 10–16), and some houses at the Shi'erqiao site show signs of destruction by flooding (*Wenwu* 1987.12, pp. 1–23, 37). At the Fangchijie site in Chengdu, strata as late as Warring States have yielded actual flood-control apparatus, in the form of dikes made by filling bamboo cages with pebbles (*Sichuan wenwu* 1999.3, p. 5; *Chengdu wenwu* 1999.2, pp. 45–6). Analysis of pollen samples taken at the Zhihuijie site in Chengdu indicates that the area was dotted with lakes and swamps (*Nanfang minzu kaogu* 1 [1987], pp. 171–210). The disconnected pattern of the Shi'erqiao sites known today might thus reflect an ancient settlement pattern that built houses on patches of higher ground.

archaeological context, found at Peng Xian (now Pengzhou) Zhuwajie, about 10 km south of Sanxingdui.[61] These hoards are not related in any obvious way to the Sanxingdui civilization; on the contrary, the most notable items in them are conspicuous intrusions of early Western Zhou material culture. The two deposits are very similar in form and contents, and they were buried only 25 m apart; whatever their purpose, they look exactly contemporary. Each consisted of a very large pottery jar filled with bronzes. Together the two jars contained twelve vessels (nine of them *lei*) and 28 weapons and tools (*ge* blades, halberds, spearheads, axes, and an adze). The concentration on a single vase-like bronze vessel type, in this case the *lei* with lid and handles, is a peculiarity shared with the Sanxingdui pits. But while the vessels in the Sanxingdui pits were imports from the middle Yangzi region, the nine Zhuwajie *lei* represent early Western Zhou bronze casting at its most flamboyant, and they are likely to have been cast at some Zhou center in Shaanxi or Henan (Nos. 64–7, all probably made within a few decades of 1000 BC).[62] The two hoards are not typical Western Zhou deposits: the placement of bronzes inside large pottery containers is unparalleled elsewhere, and the bronze weapons are of local manufacture, so we cannot ascribe the hoards to some Zhou aristocrat far from home. But neither do they betray any significant continuity with the civilization that, ten kilometers and two centuries away, filled the Sanxingdui pits. They contained no jades, no sculptural heads or masks, none of the other artifacts that give Sanxingdui its extraordinary character. The Zhuwajie bronzes have the look of imported luxuries buried in accord with some local purpose by people whose culture had nothing of its own to contribute to the deposit except weapons. The impression of a comparatively simple society is hard to escape. If the Sanxingdui civilization had still been flourishing, it would surely have made its presence felt in hoards that do after all represent very considerable wealth.

Not only the *lei* but also the weapons in the Zhuwajie hoards point to contact with the Wei River valley of Shaanxi to the north. Perhaps the founding of the Zhou empire, which extended Zhou rule from Shaanxi eastward into the middle and lower Yellow River valley sometime shortly before 1000 BC, made Shaanxi weapons more available or more attractive to Sichuan patrons. Early Western Zhou weapon types were adopted in Sichuan and faithfully preserved there centuries after dying out in their homeland (see Chapter 4). The broad triangular *ge* blades (No. 68) that were to typify Sichuan weaponry from 1000 BC onward had been prevalent earlier in the upper Han valley as well as in the Wei valley.[63] The shape of the Zhuwajie axes (*yue* like No. 71) probably originated in the upper Han valley as well.[64] Meanwhile Sichuan pottery continued to find its way to Shaanxi; pots with pointed bases have been unearthed at Baoji Rujiazhuang.[65]

Apart from the Zhuwajie hoards, the archaeological record is a frustrating blank for six or seven centuries after the time of the Sanxingdui pits. The Sanxingdui lithic industry seems to have died out; Sichuan burials contain few jades even in the Warring States period (fifth to third century BC), a golden age of jade working elsewhere in China. The most luxurious grave goods are finely made bronze weapons, hinting at a society of warriors. It is possible that a few tombs, hoards, and artifacts from periods earlier than Warring States are known but have been misdated, and that the apparent dearth of archaeological finds is to some extent an illusion created by difficulties of

61. The Zhuwajie hoards are discussed in Chapter 3.

62. Similar though smaller and less spectacular *lei* have come from Shaanxi Qishan in the heart of the Western Zhou empire (Xi'an 1994, no. 179) and from Liaoning on its remote northeastern frontier (Chapter 3, Figure 9; Fong 1980, no. 55). It might be added that Sichuan bronze casters seem rarely to have made vessels. It is not clear that the necessary technical expertise was available even at the time of the Sanxingdui pits (see Chapter 1), much less later (but notice the local perpetuation, as late as the Warring States period, of a scantily decorated Western Zhou *lei* type and even of depictions of it, such as the one on the seal No. 84: see Chapter 4).

63. For a summary of finds in the upper Han region see Zhao Congcang 1996; for the Wei River valley, Huo & Huang 1989.

64. Li Boqian 1983; Zhao Congcang 1996.

65. Lu & Hu 1988, p. 9 fig. 6.

dating.[66] Yet even the most drastic redating of known material would not change our impression of the period very significantly; only new discoveries could do that. Our present knowledge of the archaeological record is so spotty and uneven that bewildering new discoveries are more than possible: before the Sanxingdui pits were found in 1986, the second millennium in Sichuan looked just as impoverished as the first millennium still does, and a single new find could overturn all our ideas again. But until that find is made, it is difficult to resist the impression that between Sanxingdui and the Warring States period, Sichuan was a cultural backwater, the splendors of the Sanxingdui culture having long vanished and been forgotten.

66. Chapter 3 and Falkenhausen 1999, p. 541.

by Michèle Pirazzoli-t'Serstevens

Sichuan in the Warring States and Han Periods

EASTERN SICHUAN IN THE WARRING STATES PERIOD
(FIFTH TO THIRD CENTURY BC)

Chinese archaeologists and historians use the term "Ba-Shu" for the eastern part of Sichuan in the pre-Qin period. The term brackets together two cultural and political entities known from ancient texts, the state of Ba in the east and the state of Shu in the west, which seem to have arisen between the eighth and the sixth century. For the whole period down to the third century we often combine their names, speaking of Ba-Shu weapons, Ba-Shu burials, and so on, because in the present state of our knowledge we often cannot distinguish their material cultures with any confidence.

What Traditional History Tells Us

The inhabitants of ancient Sichuan have left no written record of themselves. Except for what archaeology tells us, the little that we know of Ba and Shu comes from ancient texts written elsewhere. Preoccupied with the doings of other states—most often Zhou, Qin, and Chu—and written from their point of view, these texts mention Ba and Shu only incidentally. We have, in other words, only a biased record left by outsiders.

Themselves formed of diverse groups, Ba and Shu seem to have been constantly at war with each other. Moreover in the fifth and fourth centuries eastern Sichuan was caught in a pincer between Qin and Chu, both of which coveted it. The danger at first came mostly from Chu, which sought to grow at the expense of Ba and to outflank Shu on the south. Chu expansionism was motivated in part by a need for raw materials, above all copper ore and gold. At the same time, its brilliant culture must have held a sort of fascination for the chieftains of the various different groups in Ba and Shu. Toward the middle of the fourth century the whole southern part of Ba came under the suzerainty of Chu, and Ba leaders took refuge in the upper Jialing River region, around Langzhong, near Shu and southern Shaanxi.

A little later the threat came also from Qin, which reoriented its foreign policy southward as much for economic as for political reasons. In its ambition to replace Zhou, and faced with a hostile coalition of Zhongyuan states, Qin needed lands, peasants, soldiers, horses, cattle, salt, ores, weapons—it needed all these at once, but first

and foremost, grain. Sichuan symbolized these riches, real and potential, and Qin knew very well that if it did not take them for itself, the region, whose southern part already belonged to the Chu sphere, would be drawn entire into the orbit of its rival. In 316 BC Qin armies occupied Shu, the upper Han valley, and what was left of Ba in north and east Sichuan. This immediately gave a solid base for expelling Chu from eastern Sichuan, and then from the region of its own capital Ying in Hubei, which fell in 278 BC.[1]

In the longer term, the Qin colony in Sichuan—Shu above all—gave Qin a laboratory for almost a century in which to prepare its unification of China.[2] According to traditional history, the thousands of immigrant families forcibly resettled in Shu facilitated Qin control, changed the demography of Shu, and accelerated its integration into the Qin social and cultural order. We are told that the country was completely transformed; we can be certain at least that the establishment of a vast irrigation network was made possible by great engineering projects such as the Dujiang dam, the work of the governor Li Bing. These colossal undertakings, begun around 277 BC, bore fruit a few decades later, when Sichuan's production surplus enabled Qin to conduct continuous military campaigns instead of seasonal ones.

What Archaeology Tells Us

By contrast with earlier centuries left in obscurity by the absence of remains, the fourth century may seem well documented. We must not deceive ourselves: the harvest for Shu is spotty, for Ba almost nonexistent.

- For the time from the end of the fifth to the end of the fourth century, we have a number of tombs, all in the Chengdu Plain. Among them are the 25 tombs assigned to Periods I and II at the Shifang cemetery,[3] Wulong tombs 3 and 4,[4] Baihuatan tomb 10,[5] the Xijiao tomb nearby,[6] and finally the very rich tomb at Xindu Majiaxiang.[7] The Majiaxiang tomb, the richest Warring States burial yet known from Sichuan, is presently dated to the first half of the fourth century, or here, in the chapter by Alain Thote, to the years between 350 and 316 BC. It belonged undoubtedly to an important man of Shu who had close ties with Chu.

- For the period from the end of the fourth to the middle of the third century, presently known material is more widely distributed, though still limited to funerary remains. For Shu we can distinguish three regions: the Chengdu Plain, the west, and the south. Representative of the Chengdu Plain are the thirteen Period III tombs at Shifang and four pits at Chengdu Jinshaxiang.[8] A hundred kilometers to the west, in the mountainous Ya'an region with its dense network of streams, several cemeteries have been excavated around Yingjing. The cemetery at Nanluoba[9] and the one at Tongxincun, which has been explored twice,[10] are especially interesting because, located at the center of a district producing gold and copper,[11] they can tell us about exchanges between different ethnic groups on the frontier between Shu and western Sichuan. Finally, in the south, the modest cemeteries at Wulian and Jinjing in Qianwei county[12] may be early third century tombs of Shu refugees who fled Qin occupation.

1. The location of Ying remains in dispute; a location near modern Jiangling seems most probable, but strong arguments have been made also for the vicinity of Yicheng, on the Han River 150 km north of Jiangling. See Blakeley 1999 and references cited there.

2. For details of the Qin conquest and occupation of Sichuan see Sage 1992, chapters 4 and 5.

3. Beijing 1998f, pp. 112–85.

4. Wenwu 1985.5, pp. 29–40.

5. Wenwu 1976.3, pp. 40–46.

6. Kaogu 1983.7, pp. 597–600.

7. Wenwu 1981.6, pp. 1–16.

8. Wenwu 1997.3, pp. 15–21.

9. Kaogu xuebao 1994.3, pp. 381–96.

10. Kaogu 1988.1, pp. 49–54; Beijing 1998f, pp. 212–80.

11. Xu Zhongshu 1987a.

12. Kaogu 1983.9, pp. 779–85; Wenwu 1990.5, pp. 68–75; Wenwu ziliao congkan 7 (1983), pp. 169–71; Kaogu yu wenwu 1984.3, pp. 18–21.

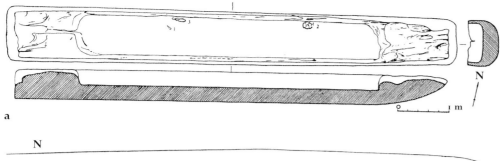

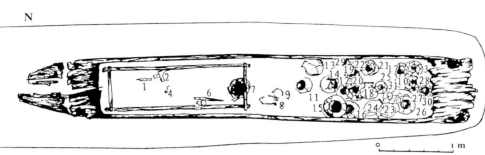

Fig. 1. Log coffins.
 a. From Shu: Shifang tomb 32 (Period II). Fourth century BC. After Beijing 1998f, p. 115 fig. 3.
 b. From Ba, with a small inner coffin: Guangyuan Baolunyuan tomb 17, c. 316–250 BC. After Beijing 1998f, p. 199 fig. 6.

For Ba the majority of known tombs date from after the Qin conquest of 316 BC. The main cemeteries are at Ba Xian Dongsunba,[13] Fuling Xiaotianxi,[14] and near the Sichuan-Shaanxi-Gansu border at Guangyuan Baolunyuan.[15]

Still in the first half of the third century, two cemeteries of people from Qin, probably officials or colonists, give us a standard against which to measure the degree of sinicization of the Ba-Shu population. One, with 72 burials, is located in the far north of the province, at Qingchuan Haojiaping.[16] The other, with 6 burials, is in the west, at Yingjing Zengjiagou.[17]

• In Shu the second half of the third century is best represented by Period IV at the Shifang cemetery, tombs 18 and 19 at Wulong,[18] and tomb 172 at Chengdu Yangzishan.[19] For Ba, tombs 1 to 7 at Fuling Xiaotianxi belong to this period.[20]

Cultural Elements Specific to Ba and Shu

Hitherto historians and archaeologists have been preoccupied with sorting out the various outside contributions to Ba and Shu culture—in other words, with deciding what came from where. Here we will try instead to describe Ba-Shu itself, to characterize this cultural entity.

• The societies of late Bronze Age Sichuan buried their dead in coffins hollowed from single logs, the ends of the coffin often suggesting a boat (Fig. 1a). This form of coffin, attested as early as the end of the fifth century, attained its widest use in the fourth century before being gradually abandoned in the third. It survived a little longer in Ba than in Shu, with a modification—a small coffin added inside the "boat" —that effectively turned the latter into an outer coffin (Fig. 1b). Nevertheless in both places the log coffin had virtually disappeared by the time of the Qin unification of China in 221 BC.

13. Beijing 1960.
14. Tomb 9: Beijing 1998f, pp. 186–96.
15. Beijing 1960; Beijing 1998f, pp. 197–211.
16. Wenwu 1982.1, pp. 1–30.
17. Kaogu 1984.12, pp. 1072–84; Wenwu 1989.5, pp. 21–30.
18. Kaogu 1987.7, pp. 604–10.
19. Kaogu xuebao 1956.4, pp. 1–20.
20. Tombs 1–3 (Qin): Wenwu 1974.5, pp. 61–80; tombs 4–7 (Qin or beginning of Han): Kaogu 1985.1, pp. 14–17, 32.

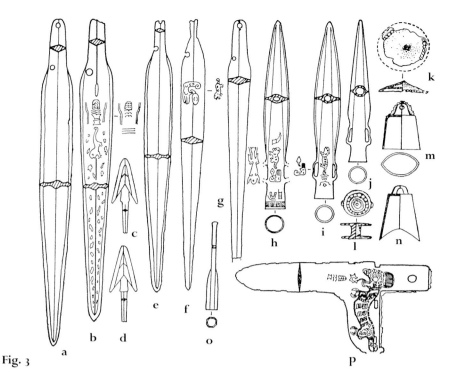

Fig. 2

Fig. 3

Fig. 2. Bronze cooking pots from Qianwei Jinjing tomb 1. First half of the third century BC. After *Kaogu yu wenwu* 1984.3, p. 20 fig. 3.

 a–c. *Mou.* Heights from 11 to 16.5 cm.

 d. *Fuzeng* (steamer). Height 19 cm.

 e. *Fu.* Height 15 cm.

Fig. 3. Bronze artifacts from tombs at Yingjing Tongxincun. Late fourth to mid-third century BC. After *Kaogu* 1988.1, p. 51 fig. 4.

 a–b, e–g. Swords.

 c–d. Arrowheads.

 h–j. Spearheads.

 k–l. Appliqué and button.

 m–n. Clapper bells.

 o. Chisel.

 p. *Ge* blade.

21. Alain Thote (see the entries for Nos. 80–81, 90) prefers to regard blades shorter than 30 cm as "daggers," longer blades as "swords." In the view of the present author, we are dealing with three distinct weapons—daggers, short swords, and swords—that have different patterns of distribution, at least in western Sichuan.

22. Sun Hua 1987, Li & Wang 1987.

- The pottery and bronze utensils for food preparation usually found at the foot of the deceased regularly include a sort of jar-shaped cooking pot *(mou),* a lower and wider cooking pot *(fu),* and a steamer *(fuzeng);* all three are round-bottomed and provided with one or two small ring handles patterned in imitation of braid or cord (Fig. 2). These three standardized shapes seem to have been a Shu specialty. After the Qin occupation they spread beyond Sichuan, first to Qin itself and then to territories it conquered.

- At the end of the fifth century or the beginning of the fourth, there appeared in eastern Sichuan marks or signs that have not yet been read and the interpretation of which still divides scholars. They include both emblems of an iconic nature (see Nos. 84–8) and a form of writing. The *ge* blade No. 82, found in a tomb said to postdate 316 BC, combines iconic emblems with a line of writing. The emblems, which would disappear soon after the Qin unification, occur chiefly on weapons, especially willow-leaf swords (Fig. 3), on bells (No. 77), and on seals (Fig. 4; No. 84).[21] On other types of object they occur very rarely. Only a few examples are known on vessels and, at Xindu, on the tools (Fig. 5).

The seals of eastern Sichuan are apparently a local invention inspired by the seals of the Zhongyuan, perhaps those of Qin, but adapted to the needs and beliefs of Ba-Shu chieftains. A single tomb may contain a number of seals, among them sometimes seals inscribed in Chinese characters with auspicious or hortatory formulas, tempting us to suppose that at least some of the Ba-Shu seals served the same purpose as the Chinese ones. More generally, it is possible that the Ba-Shu emblems, found above all on objects connected with war, were talismans intended to protect and encourage the warrior as he faced his enemy,[22] a hypothesis which of course does not exclude the possibility that an important component of the emblem was the owner's clan sign.

Fig. 4

Fig. 4. Bronze assemblage characteristic of Period II
tombs in the cemetery at Shifang (in Shu). Fourth
century BC. After Beijing 1998f, pp. 145, 149, 153,
155, 158–9, 161, 165.

 a. Shouldered socketed axe.
 b. *Ge* blade.
 c. Spearhead.
 d. Sword.
 e. Axe.
 f. Scraping knife.
 g. Chisel.
 h. *Fu.*
 i. Seals.

Fig. 5. Bronze tools from the Xindu Majiaxiang tomb.
First half of the fourth century BC. After *Wenwu*
1981.6, p. 10 figs. 22–3.

 a–c. Axes.
 d–e. Scraping knives.
 f–h. Chisels.
 i. Handsaw.
 j. Woodcarving knife.

Fig. 5

- Weapons are characteristic of Ba-Shu funerary assemblages, first by virtue of their sheer number and their seemingly very important place in society, and second because of forms and designs that make them quite different from the weapons used in the same period elsewhere in China.

The dagger-axes called *ge* predominate, especially in Shu. The most widespread type, a straight blade with no downward extension parallel to the shaft, was known in the region from Western Zhou times onward.[23] It may derive from a blade type widely distributed in eastern and southeastern Gansu (around Wudu) and southwestern Shaanxi (the Han River valley) and best known to us from tenth and ninth century examples found at the Yu state cemetery at Baoji in Shaanxi.[24] Another form of *ge*, in which the lower edge of the blade is drawn downward parallel to the shaft, had reached Sichuan by the fourth century (Fig. 4b). It copies a Qin model but is distinguished by its decoration, which most often features the head and body of a tiger placed at the back of the blade or straddling blade and tang (Fig. 3p, No. 82).

Second only to *ge* in the equipment of the pre-Qin Shu warrior are spears (Figs. 3h–j, 4c). Here again a connection with objects from the cemetery of the princes of Yu at Baoji seems clear,[25] and the same is true in the case of Ba-Shu daggers and short swords (No. 89). Another characteristic Ba-Shu type is the axe with sharply defined shoulders (Fig. 4a, No. 88). Deserving mention in connection with these weapons is a musical instrument typical of Ba and associated with warfare, the *chunyu*, a clapperless bell that was struck to assemble troops (No. 78).

Weapons frequently have speckled or marbled patterns produced by surface treatment after casting (Nos. 85–7, 89, 93). A high-tin alloy seems to be characteristic of Ba-Shu bronzes of the Warring States period.

- The large quantity of bronze tools deposited in Ba-Shu tombs is another feature specific to eastern Sichuan. The tombs contain a wide variety of axes (Figs. 4e, 5a–c), handsaws (Fig. 5i), scraping knives (Figs. 5d–e), chisels (Figs. 4g, 5f–h), and woodworking knives (Fig. 5j). Unsurprisingly, perhaps, in a culture that privileged coffins hewn from logs, all are tools for working wood. It is equally interesting that agricultural tools, by contrast, are extremely rare.

The foregoing list of characteristic local features is by no means intended to deny outside influence on Ba and Shu. On the contrary, influences were significant and the list emphasizes some of them, for instance the weapon types that Bronze Age Sichuan received from the north. Though certain anachronisms remain ill explained, the strong affinities in material culture between Sichuan and parts of Shaanxi may well signify the existence of a cultural continuum, composed of related but distinct groups, that persisted over a considerable area for centuries.

By contrast other cultural traits or artifacts did not appear in Sichuan until the fourth century, and then only in tombs of the ruling class. These new arrivals testify to exchange sometimes with the Zhongyuan (No. 73), sometimes with Chu. In addition to funerary practices (as seen for instance in the Majiaxiang tomb), Chu was a source

23. Huo & Huang 1989.

24. Huo & Huang 1989, Lu & Hu 1988, Zhang Wenxiang 1996, and the discussion by Alain Thote in entry No. 82 in this book.

25. Zhuyuangou type 1 spearheads (*Wenwu* 1983.2, p. 8 figs. 23–4).

of swords and, of course, ritual vessels. In Shu as in Ba, chieftains seem to have prized sacrificial vessels received from the Chinese world as objects of prestige (No. 73), and even had local copies made (see the entry for No. 75).

A Society Only Partly Assimilated

All specialists agree in visualizing fourth century Sichuan as a mosaic of related cultures, within which can be discerned two more developed and articulated ethnic entities, Shu and Ba. These two were composed of smaller groups, all probably having more or less the same way of life, some no doubt shifting their allegiance from time to time, dependent now on Ba, now on Shu.[26]

The almost total absence of iron artifacts is an indication that this society, still in the Bronze Age, had an economy little influenced by Qin, which was in the forefront of iron production. The absence of agricultural tools in tombs argues that farming did not employ metal tools, and perhaps also that farming was not an activity very highly valued. On the other hand the substantial number of woodworking tools found alongside the weapons may signify that woodworking had an important role in the subsistence economy.

What is not in doubt is the prestige of the warrior and the value placed on war and the chase, activities whose equipment had seen no dramatic change since the beginning of the first millennium BC. The beginning of the fourth century did however witness one notable innovation, the first use by the warrior class of signs or emblems on their weapons. Chinese archaeologists, who believe that the cultural assimilation of Sichuan proceeded very rapidly after the Qin conquest of 316 BC, note merely that these Ba-Shu emblems disappeared within a century or two.[27] In fact archaeology can tell us a trifle more: it seems clear that the century following the conquest saw efforts at cultural compromise—the development of seals, for instance, and attempts to create a writing system. The efforts were nevertheless destined to fail, and Ba-Shu emblems disappear, at least from surviving material culture, in the second century BC.

Apart from these compromises, we see a very considerable stability of material culture in both Ba and Shu down at least as far as the Qin unification in 221 BC. The tool inventory saw no significant change, and iron seems to have had little impact until after 250 BC, when the iron implements that begin to figure in tomb furnishings point to important changes in agricultural equipment.[28] As for pottery and bronze cooking utensils, they not only persisted until the first century AD or later[29] but also spread outward from Sichuan in the wake of the Qin conquest.

Thus even after the two centuries of the Western Han period, assimilation was not yet complete. In those two centuries, no matter how sinicized the culture of the elite and the most sophisticated urban life might be, archaeology shows clearly that the material culture of everyday life continued to be shaped by traditional choices. In Ba, where local traits persisted well into Eastern Han, acculturation seems to have proceeded even more slowly than in Shu.[30]

26. Beijing 1998f, p. 211.

27. Feng Hanji 1961, p. 34; Song Zhimin 1994, pp. 242–3; Song Zhimin 1998a, pp. 259–68.

28. Dayi Wulong tombs 18 and 19 (see note 18) and tombs assigned to the period 250–220 BC in the Yingjing Tongxin-cun cemetery (see note 10).

29. *Wenwu* 1982.7, pp. 28–9; *Kaogu* 1986.3, pp. 230–42; *Wenwu* 1981.12, pp. 38–43; Beijing 1998f, pp. 112–85.

30. *Wenwu ziliao congkan* 7 (1983), p. 32.

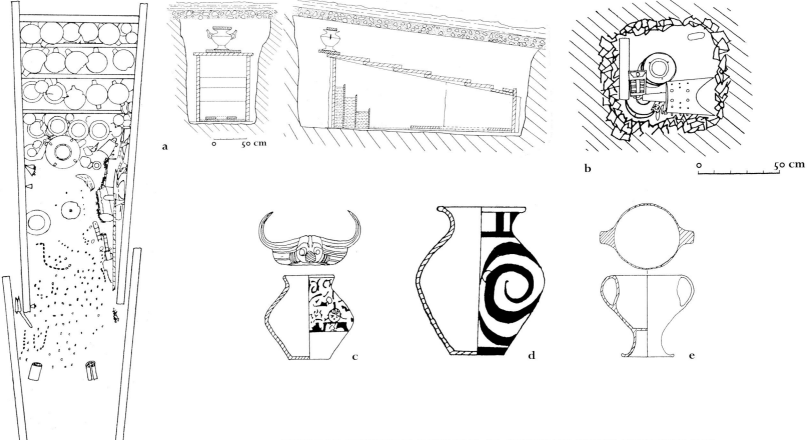

Fig. 6. Cist burial and pit at Mao Xian Moutuo. About
fourth century BC. After *Wenwu* 1994.3, pp. 7–9.

a. Tomb 1, plan and section.

b. Pit 1.

c. Pottery jar with lid. Height 14.8 cm.

d. Pottery jar with painted decoration. Height
19.1 cm.

e. Pottery footed cup. Height 17.5 cm.

31. For general discussions of these cultures see Pirazzoli
1988, Luo Kaiyu 1992, Orioli 1994.

32. *Wenwu* 1994.3, pp. 4–40; Falkenhausen 1996; Shi Jing-
song 1996; Falkenhausen 1999, pp. 541–2; Chapter 4 in
this book.

33. *Kaogu* 1981.5, pp. 411–21.

34. Shi Jingsong 1996, p. 81.

35. *Kaogu* 1981.5, p. 417 fig. 14; *Wenwu ziliao congkan* 9
(1985), p. 89 figs. 23–4.

THE FAR WESTERN REGIONS (*C.* FIFTH TO FIRST CENTURY BC)

West of Shu and—on the Chinese scale that runs from the cooked (civilized) to the
raw (barbarian)—still further from civilized norms, various groups of nomadic,
semi-nomadic, and sedentary peoples inhabited the vast mountain spaces of the high
Tibetan plateau in the second half of the first millennium. Some buried their dead
collectively, normally in dolmens, others individually, most often in cist tombs.
They had contact with Shu and also with a galaxy of other cultures to the northwest
(Qinghai, Gansu, Ningxia) and southwest (Yunnan).[31] The archaeology of this hinter-
land, still in its early stages and not much regarded, may well hold vital keys to under-
standing the ceaseless movement of people and goods that shaped the material culture
of western China. Here we confine ourselves to sketching, in connection with the
Moutuo site in Mao Xian, a few problems encountered by recent research.

At Moutuo an intact cist tomb and three pits were discovered in 1992 (Figs. 6a–b).[32]
As usual in cist burials in the upper Min region, the tomb included shelves at the head
of the coffin bearing pottery containers for meat, grain, and fruits (Figs. 6a, c–e).
Similar pottery is known from the nearby cemetery at Maowen Yingpanshan.[33] Fol-
lowing what seems to have been a common practice in the cist culture,[34] one of the
jars, painted in red lacquer, has on its lid a sculptured yak (or bull) head that is lac-
quered red and provided with horns of bronze (Fig. 6c). Also characteristic is a liking
for clothes with sewn-on ornaments, seen at Moutuo in the 362 beads of agate, tur-
quoise, and glass paste that seem to have decorated the silk and hempen shroud of the
deceased. The tomb contained other bronze appliqués for clothing, for a belt, and for
a shield, and an extraordinary openwork plaque whose decoration of animal proces-
sions recalls the art of the steppes in both theme and design (Fig. 7).

The attention of specialists has so far concentrated not on these distinctive items but on the Ba-Shu weapons in the tomb and on the vessels and bells imported from the Chinese world or made in imitation of imports. The Ba-Shu weapons, especially the *ge,* have decoration neatly paralleled on Shu weapons from fourth (Xindu, Chengdu Xijiao) and early third century (Qianwei) contexts (Fig. 8). But there are other weapons at Moutuo that owe nothing to eastern Sichuan, in particular short swords (No. 81) of a local type represented at Yingpanshan and elsewhere in the same valley[35] and bimetallic swords with iron blade and bronze handle (Fig. 9). As we will see in a moment, this latter sword type attests to contacts that reached all the way from Ningxia to Yunnan.

The Moutuo tomb, which undoubtedly belonged to a very important person, is the richest burial of the cist culture yet known, rich especially in exotic goods. Its excavators suggested a date for it in the neighborhood of 300 BC. In 1996 Lothar von Falkenhausen, basing himself on the burial goods imported from the Zhou cultural sphere, argued instead for a date prior to 450 BC. The dates favored by Shi Jingsong (fifth century) and in Chapter 4 by Alain Thote (*c.* 400 BC) are likewise earlier than that proposed by the excavators. One possible argument for an early date is the complete absence of Ba-Shu emblems from Moutuo weapons imported from Shu and in other respects very similar to weapons from Shu tombs (for instance from Xindu): perhaps they are absent because Moutuo predates the early fourth century sites in the

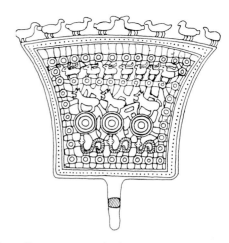

Fig. 7. Bronze openwork plaque. Height 13.5 cm, width 12.7 cm. About fourth century BC. From Moutuo tomb 1. After *Wenwu* 1994.3, p. 30 fig. 49.4.

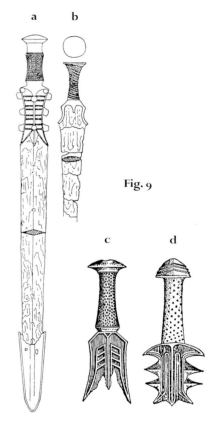

Fig. 9

Fig. 9. (a–b) Bimetallic swords (iron blade and bronze grip) of the Dian culture of Yunnan province, (c–d) sword grips from the cist culture of the upper Min region of Sichuan province. Second or first century BC. After *Kaogu xuebao* 1975.2, p. 141 figs. 46.1–2 (swords); *Kaogu xuebao* 1977.2, p. 51 fig. 16 (sword grips).

 a. Sword from Jiangchuan Lijiashan tomb 26. Length 68.5 cm.

 b. Sword from Jiangchuan Lijiashan tomb 21. Length 26.6 cm.

 c–d. Bronze grips from bimetallic swords.

Fig. 8

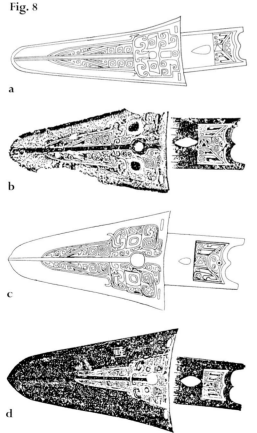

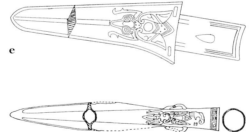

Fig. 8. Decorated Ba-Shu weapons from Moutuo and from Shu tombs.

 a. *Ge* from Moutuo pit 2. After *Wenwu* 1994.3, p. 35 fig. 54.5.

 b. *Ge* from Chengdu Xijiao. Fourth century BC. After *Kaogu* 1983.7, p. 600 fig. 5.1.

 c. *Ge* from Moutuo tomb 1. After *Wenwu* 1994.3, p. 18 fig. 26.3.

 d. *Ge* from Xindu. Fourth century BC. After *Wenwu* 1981.6, p. 9 fig. 18.

 e. *Ge* from Moutuo pit 1. After *Wenwu* 1994.3, p. 33 fig. 52.7.

 f. Spearhead from Qianwei. Early third century BC. After *Kaogu yu wenwu* 1984.3, p. 19 fig. 2.7.

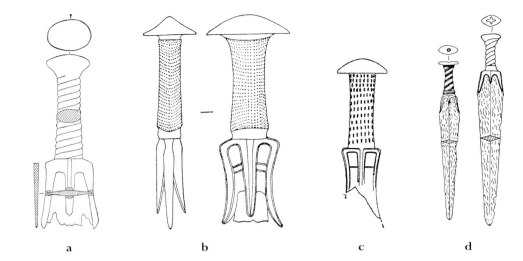

Fig. 10. Bimetallic swords from Gansu, Ningxia, and Sichuan (Moutuo tomb 1).

a. From Gansu Qingyang. Fifth to third century BC. After *Kaogu* 1988.9, p. 852 fig. 1.1.

b. From Ningxia Guyuan Yanglang IM12. Fifth to third century BC. After *Kaogu xuebao* 1993.1, p. 29 fig. 16.6.

c. From Ningxia Xiji. About third or second century BC. After *Kaogu* 1990.5, p. 404 fig. 1.4.

d. From Sichuan Mao Xian Moutuo tomb 1. About fourth century BC. After *Wenwu* 1994.3, p. 36 figs. 55.8–9.

a b c d

36. Pirazzoli 1988; Orioli 1994, p. 90.

37. Late second millennium Rong or Di tombs in Shaanxi Bin Xian (*Kaogu xuebao* 1999.1, pls. 3–4).

38. To the examples given in Pirazzoli 1988 should be added *Kaogu* 1989.11, p. 973 fig. 3, p. 974 fig. 4.4.

39. Lu & Hu 1988, vol. 2 pls. 58, 86, 97, 107, 114, 124, 129, 147 (Zhuyuangou tombs 3–4, 7–8, 11, 18–20).

40. Upper Min: *Wenwu ziliao congkan* 7 (1983), p. 45 fig. 13; *Kaogu xuebao* 1973.2, pls. 6.1–4; *Wenwu* 1994.3, p. 36 figs. 55.8–9; Dian: Tong Enzheng 1977, figs. 15.1, 16.4.

41. Song Zhimin 1997.

42. *Kaogu* 1988.9, p. 852 (Warring States period).

43. *Kaogu* 1989.11, p. 974 fig. 4.1 (Spring and Autumn period); *Kaogu* 1990.5, p. 404 fig. 1.4; *Kaogu xuebao* 1993.1, p. 29 fig. 16.6 (Warring States period); *Kaogu yu wenwu* 1993.4, p. 18 fig. 1.14.

44. In the Guo state royal tombs in Henan (end of Western Zhou), then in Spring and Autumn contexts in Shaanxi and Gansu. A few bronze weapons with meteoritic iron blades are known as far back as the thirteenth century BC (Bagley 1999, p. 177).

Chengdu region where the earliest known Ba-Shu emblems have been found. Yet the Moutuo and Shu weapons are so similar in decoration that the difference of date, if any, cannot be large (Fig. 8). It may rather be that the weapons are contemporary and that weapons made for or given to a foreign chief simply did not require emblems. Though it is not impossible that the Moutuo tomb belongs to the second half of the fifth century, the tomb does have features, as we shall see, that point toward a later date.

Moutuo and the cist culture as a whole are caught in a network of relationships as rich as it is complex. Northern affiliations are clear in the cist burial form itself[36] and equally in the ceramic inventory of the burials, which has parallels in the Bronze Age pottery of cultures in Qinghai, in Gansu, and in the case of footed cups (Fig. 6e), in the far west of Shaanxi.[37] The bronze knives and daggers are related to those of the so-called Northern Zone cultures of Ningxia and Inner Mongolia.[38] So are the various bronze ornaments for clothes and armor, which include small hemispheres of a type also much used in the Western Zhou state of Yu.[39] All these parallels demonstrate the cist culture's kinship with the Bronze Age traditions of a vast region that stretches from Qinghai to western Inner Mongolia, taking in parts of Gansu, Ningxia, and western Shaanxi.

At a slightly later time the existence of these privileged ties with the north, not to mention contact with the south, is confirmed by northern object types that spread as far south as Yunnan, mainly weapons. These include bronze daggers and swords whose spiralling hilts form a trident or claw where they meet the blade, and also bimetallic swords of a type encountered all the way from the upper Min region in Sichuan to Lake Dian in Yunnan.[40] With the exception of those from Moutuo, most of these swords, whether in Yunnan or in the upper Min region, have come from tombs of Western Han date (second and first centuries BC). Song Zhimin, who has recently taken up the problem of their origin,[41] draws attention to similar bimetallic swords found a decade ago in eastern Gansu[42] and above all in Ningxia[43] (Fig. 10). Given the very old history of bimetallic artifacts in north China,[44] it seems likely that the Gansu-Ningxia swords predate the ones from the southwest, in which case they must be the prototype. Were they always imported to the southwest, as Song Zhimin believes, or was their diffusion there followed by local production? The question remains difficult

a b

to settle. Whatever the answer, the Sichuan and Yunnan finds confirm the special ties that the non-Chinese cultures of the southwest maintained with those of the Qinghai-Gansu-Ningxia region. And they favor a late date for Moutuo, toward the end of the fourth century, as more consistent with the whole ensemble of sites, not just those in western Sichuan but the Yunnan sites as well.

EASTERN SICHUAN IN THE HAN PERIOD (206 BC–AD 220)

For the Han rise to power, just as for the Qin unification earlier, Shu provided a solid and docile rear base. Once the government was in place, the Sichuan Basin became a rich granary whose surplus made possible the development of other crops, the exploitation of natural resources, and a flourishing of crafts. Medicinal herbs, cinnabar, ginger, wood, bamboo, salt, copper and iron, sericulture, hemp products, and craftsmanship in bronze, iron, silk, and lacquer made the region's fortune. The two factories established by the Han state in former Shu territory sometime between 150 and 130 BC manufactured mainly bronzes and lacquers and reached a peak of production in the latter half of the first century BC.

c

Fig. 11. Figures of horses from tombs at Mianyang Shuangbaoshan. Second century BC. After *Wenwu* 1996.10, p. 9 fig. 18 (a–b); p. 20 fig. 18.2 (c).
 a. Wood, from tomb 1. Height 72 cm.
 b. Wood, from tomb 1. Height 112 cm.
 c. Lacquered wood, from tomb 2. Height 72 cm.

Thanks to two rich burials at Mianyang Shuangbaoshan, we have an interesting picture of lacquer production and of the material culture of the upper classes of Shu in the second century BC.[45] Tomb 2 belongs to the years 179–118 BC; tomb 1 dates from the end of the century.[46] Their furnishings—lacquers (including lacquerware for the table), pottery (often lacquered), and figurines and models made of painted earthenware, wood, or lacquered wood—resemble those of contemporary tombs in Hubei and Hunan, in particular those of Fenghuangshan tomb 168 at Jiangling.[47] For reasons of transport it seems likely that the wooden figures from the two tombs, especially the 107 horses, which range in height from 72 to 112 cm, were made locally. These figures, unlike the ones from the Fenghuangshan tomb, were often carved from a single block (Fig. 11). Does this preference for carving, for shaping an object from a single piece of wood, owe something to the value that attached to woodcarving in the same region two centuries earlier? Perhaps so; and perhaps we see here the beginning of the feeling for volume and plasticity that is so characteristic of Sichuan funerary sculpture in the second century AD.

45. Tomb 1: *Wenwu* 1996.10, pp. 4–12; tomb 2: *Wenwu* 1996.10, pp. 13–29.

46. The date proposed for tomb 1 by the excavation report, "end of Western Han," seems too late.

47. *Wenwu* 1975.9, pp. 1–7, 22; *Kaogu xuebao* 1993.4, pp. 455–513.

Fig. 12. Reconstruction model of Yangzishan tomb 1, a brick tomb decorated with carved stone slabs. Second half of the second century AD. After Lim 1987, p. 191.

Images of a Land of Plenty: the Eastern Han Period (AD 25–220)

The number of brick tombs and rock-cut tombs known from the Eastern Han period in Sichuan is impressive. Though they have been looted over the centuries, their internal structure and their wall decorations survive, as do some of the *mingqi* (models and figurines made for the deceased) that furnished them. These tombs of officials and estate proprietors testify to the prosperity of eastern Sichuan, a region whose economic development in fact made it into a proverbial land of plenty, *tianfu zhi guo*. They tell us also of the joys and preoccupations, material and spiritual, of the propertied classes in this affluent place. And finally, they help us to understand how assimilation proceeded—what the region kept of its own traditions, and what local coloring the elite gave to their participation in the dominant civilization.

Brick tombs appeared in the Chengdu Plain in the first century BC, but it was not until the middle of the second century AD that they began to be decorated with stamped bricks and, occasionally, carved stones (Fig. 12). In addition, from the beginning of the first century AD many tombs were cut into the cliffs above rivers, notably in the middle and lower Min valley and the middle Fu valley. In the lower Min valley the Leshan area alone has more than thirteen thousand of these rock-cut tombs.[48]

On the exterior the cliff tomb presents an open vestibule where offerings could be made (Fig. 13). From this vestibule one or more tombs were tunneled into the rock, each consisting of a series of rooms on axis and sometimes side chambers also. Internal features include a variety of alcoves, niches, and platforms, as well as gutters for draining seepage. The dead were laid in stone sarcophagi or, more often, in coffins of terracotta, brick, or wood; these might be placed either in a room or in a wall recess.

The tombs generally sheltered many members of a family or clan and could remain in use for generations. The first were cut under Wang Mang (r. AD 9–23), the last in the fifth century, but their construction was at its height, and their use most widespread, in the second half of the second century.[49] At that time the treatment of walls and ceilings imitated contemporary wood architecture,[50] and the stonework was enlivened with paintings.

Long ascribed to non-Chinese ethnic groups, the cliff tombs are today considered to have belonged to the "Han" ethnicity. Chinese historians believe that the population movements that followed on the Qin conquest of 316 BC changed the demography of the region completely within two centuries: they suppose that the original inhabitants

48. Tang Changshou 1997.

49. Luo Erhu 1988.

50. Examples in Beijing 1998f, pp. 375–9.

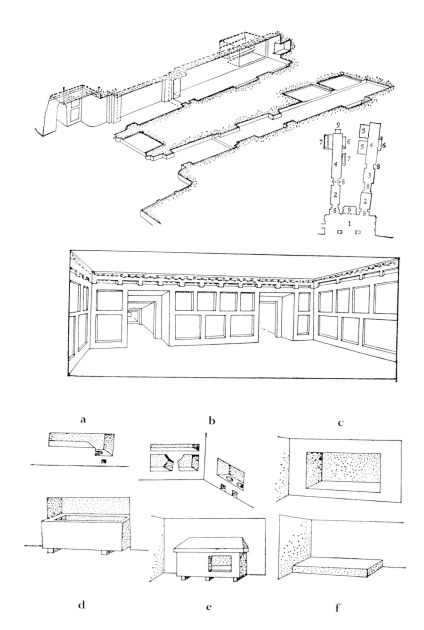

Fig. 13. Typical features of cliff tombs. Second or early third century AD. After *Kaogu xuebao* 1988.2, p. 135 fig. 1, p. 136 fig. 2.

Above, aerial view and plan.
Center, vestibule.
Below, internal features:
a–b. "Stove niches" (function uncertain).
c. Niche.
d. Sarcophagus.
e. Chest.
f. Platform for coffin.

either were wholly sinicized, or abandoned the towns to regroup themselves in agricultural villages or in the mountains, or emigrated to the west or the south.[51] In this view, little of the native population of Ba and Shu would still have been living in eastern Sichuan in the latter part of the Han period.[52] But it may be more realistic to draw the ethnic lines a little less sharply and to suppose that the cliff tombs belonged to a wealthy class sprung from generations of intermarriage between natives and immigrants.

As costly tombs came into vogue, the wealthy evidently sought locations for them that would be high and spacious and that would not encroach on the rich agriculture of the plain, which in any case was densely settled. The mountains were an obvious choice, with certain river courses, such as that of the Min, offering cliffs perfectly suited to the construction of tombs. Moreover the cliff tomb, which allowed cutting additional chambers as needed (sometimes as many as twenty), answered ideally the wish of the great landowners, entrepreneurs, and merchants—members of large and ramified families—to be buried with all their relations in a veritable clan cemetery.

51. Luo Kaiyu 1991, p. 453.
52. Luo Erhu 1988, pp. 157–8.

Sichuan escaped the turmoil that beset north China in the second century, and the stability and prosperity it still enjoyed at the end of Han surely help to account for the spread of this burial mode, which in the second half of the third century went into decline simultaneously with the economic and social situation.

The first cliff tombs had no decoration; stone carving was introduced only around AD 120. In the latter half of the second century, when architectural and wall decoration was at its height, each tomb was provided with a series of carved scenes that followed a consistent iconography. Besides the tomb's animal protectors (the animals of the four directions, *sishen*), the themes include Confucian anecdotes, scenes in the daily life of the wealthy, and finally, the first Buddhist images in China. The scenes appear mainly in the vestibule, around doorways, and, if the tomb contained sarcophagi, on them. In the vestibule, which played the role of offering chamber *(citang)*, auspicious objects, animals, and divinities *(xiangrui)* were generally placed on door lintels, guardians on the jambs, and scenes of upper-class life and historical anecdotes on the walls.

Inspired by the carved decoration of rock tombs, bricks stamped with pictorial decoration made their appearance around the middle of the second century. In the Chengdu region, which is poor in stone, stamped bricks predominate, but a few tombs there nevertheless have carved stone slabs as well as bricks.[53] The subjects are extremely varied, with the accent put on everyday activity: city life (markets, schools . . .); agricultural work, craft, and industry (Nos. 103–4, 106); convivial doings, both ritual and profane—guests arriving in vehicles or on horseback, banquets, *liubo* games, cock fights, dance, music, and variety shows (Nos. 100–102); and the universe of mythology and religion (Nos. 108–9).

Throughout China in the second century, local patronage, especially of funerary art, was strong enough to allow regional characteristics to flourish. The culture thus given expression was a mixed heritage peculiar to the given region; the patrons and artisans of Sichuan privileged a distinct style and a distinct repertoire of subjects. As Martin Powers has emphasized,[54] on the walls of Sichuan tombs pride of place is given to the manufactures, commerce, and manual labor from which the patrons derived their wealth, and indeed to the wealth itself, which is displayed without embarrassment. Confucian subjects, though not absent, are not particularly common. If it offers a moral discourse, this art, seemingly untroubled by taboos about sex, tenderness, or ugliness, does so in terms different from those to which Confucian discourse has accustomed us. The Sichuan bricks that depict copulation (No. 107) may be the earliest known manifestation of erotic art in China; alternatively it is at least possible that we should see in them an allusion to the sexual practices recommended by the Daoists. We know that Zhang Daoling, founder of the Five Measures of Rice sect (Wudoumidao, established in southern Shaanxi and Sichuan around AD 180 or 190), prescribed sexual rites not only to cure disease and secure long life but also to take away sins and ward off disasters.[55]

In style Sichuan stone carvings have close parallels in the art of Nanyang in southern Henan, and it is very likely that artists or designs from Nanyang played a role in the formative years of the Sichuan workshops. We see airy compositions with much open space, emphasis on silhouettes (which are often elongated and stylized), dynamism, and a technique of low relief against a striated ground, all of which were characteristic of

53. For example, Zengjiabao tomb 2 (*Wenwu* 1981.10, pp. 25–32; Lim 1987, p. 126).

54. Lim 1987, p. 60.

55. Maspero 1937; Stein 1963, pp. 57–8.

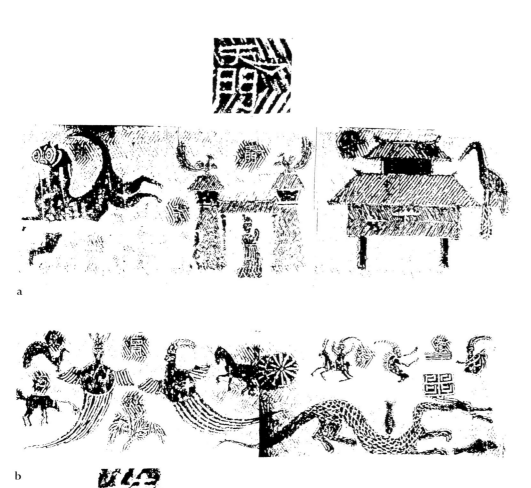

Fig. 14. Sarcophagus no. 3 from cliff tomb at Jianyang Guitoushan. Rubbings of decoration. Late second or early third century AD. After *Wenwu* 1991.3, pp. 23–4.
 a. Right side, with *tianmen* "Gate of Heaven."
 b. Left side, with money tree *(zhuzhu)* between the sun and moon.

a

b

Nanyang work from about AD 50. With these borrowings as their point of departure, Sichuan workers in both stone and stamped brick undertook experiments that nowhere else were pushed so far. A sense of volume was conveyed by means of subtly varied relief effects; energetic movement was greatly emphasized; and landscape was treated with feeling, not as a decorative motif nor as the mere signal for an outdoor setting but as something to be described, along with human activity, almost in the spirit of a naturalist. The taste here for the flavor of things, for scenes of amorous intimacy no less than for works and days, is rare indeed outside Sichuan.

The decoration of sarcophagi and coffins can be discussed together with the wall decoration of Sichuan tombs. In the second half of the second century and the beginning of the third, the sides of sarcophagi were often carved with the animals of the four directions and, at the head end, with the image of a gate flanked by *que* towers.[56] On one of the sarcophagi found in a rock-cut tomb at Jianyang Guitoushan, each element of the decoration is accompanied by an identifying inscription, the pair of *que* on one of the long sides being labeled *tianmen* "Gate of Heaven" (Fig. 14).[57]

Large gilt bronze ornaments that originally decorated wooden coffins in brick tombs have recently been found at Wushan, in the eastern tip of Sichuan (Fig. 15).[58] In iconography they agree exactly with the stone sarcophagi. Many of them have at their centers paired *que* towers labeled *tianmen,* and as at Guitoushan, a figure is depicted

56. Wu Hung in Lim 1987, pp. 72–81; Gao Wen 1987; and in the present book, Figure 12 on page 265.

57. *Sichuan wenwu* 1988.6, p. 65; *Wenwu* 1991.3, pp. 20–25.

58. *Kaogu* 1998.12, pp. 77–86.

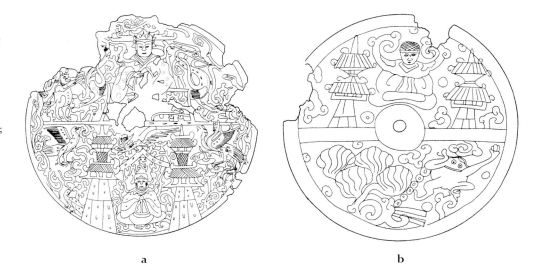

Fig. 15. Gilt-bronze ornaments for wooden coffins, from Wushan. Diameters of a–d between 23 and 27.5 cm; width of e 40 cm. Late second or early third century AD. After *Kaogu* 1998.12, pp. 79, 81, 83.

 a. Xiwangmu in the upper half; in the lower half, a divinity flanked by *que* towers labeled *tianmen;* auspicious plants and animals all around.

 b. In the upper half, divinity of the Gate of Heaven; lower half, toad and ginkgo.

 c–d. Divinity of the Gate of Heaven.

 e. Animals of the four directions, divinities, auspicious plants and animals, constellations.

a b

between the towers, perhaps the guardian divinity of the Gate of Heaven, or perhaps the Recorder of Fates, keeper of the registers of life and death. Other themes include Xiwangmu (the Queen Mother of the West) with her entourage of auspicious animals, some of which are also lunar (dancing toad, hare compounding the elixir of immortality) or solar (three-footed crow) symbols, the animals of the cardinal directions (each the protector of one quarter of the heavens), immortals, lucky objects, animals and plants, and finally, the constellations.

This iconography neatly superposes ideas that are complementary: the idea of Heaven as a sort of paradise, or at any rate as the region traversed by the sun, the moon, and the five planets in their courses; and the idea that the coffin or the sarcophagus oriented and positioned the deceased in perfect harmony with the system of resonances *(ganying)* that ruled the cosmos. The rather reductive interpretation that views the tomb as the sole dwelling and final prison of the deceased is contradicted by these schemes, which seem on the contrary to show that at least a component of him, his most spiritual part, had the power to come and go. Seen in this way, the tomb becomes a place of transit, one that required protection. It was a place where the spirit of the deceased might reside but was not imprisoned, a dwelling in which he was sometimes present in the same way that he was sometimes present in the temple of his lineage, or in the offering chamber built for him, when he went to receive the sacrifices presented by his descendants.[59]

Among the objects depicted on the Guitoushan sarcophagus is a money tree; the label inscribed next to it tells us that in Han times this strange artifact was called a *zhuzhu,* "coin pillar" (Fig. 14). A funerary object, it took the form of a stone or ceramic base holding a bronze tree with coins in its branches. The branches, veritable lacework in bronze, were cast individually by a process similar to that used to cast ordinary coins, then fitted together.[60] Money trees appear in numerous rich Sichuan tombs around the beginning of the second century AD; the most intricate examples date from the second half of the century, which was also the time of widest distribution (Nos. 97–8). Money trees are found only in six provinces of western China—Qinghai, Shaanxi, Gansu, Sichuan, Guizhou, and Yunnan—and so much more often in Sichuan than elsewhere as to suggest that it was the center of production (Fig. 97.1).

59. Pirazzoli in press.

60. Chinese coins of the period were cast in flat molds that produced half a dozen or more at once (Fig. 97.3). When the coins came out of the mold they were connected to each other by the narrow channels, now solid bronze, through which the molten metal had flowed into the mold; until the coins were filed apart, the casting was a thin openwork sheet somewhat like the frond of a money tree. The resemblance is noted in Zhu & Ma 1989, pp. 413–14.

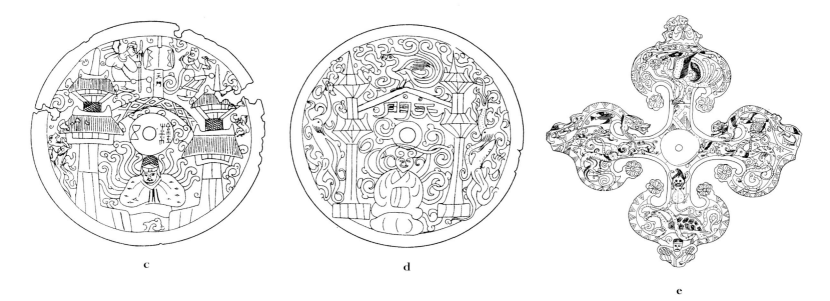

c　　　　　　　　　　　　　　　d

e

Lacking any text of the period that mentions these trees, we cannot be very certain of the various layers of significance that attached to them. Some scholars identify the tree as an *axis mundi*;[61] the identification is plausible enough but can hardly exhaust the significance of these objects.[62] Most obviously, it leaves unexplained the coins, which undoubtedly represent a wish for prosperity in the next world (and which in some tombs are actually depicted on the walls). The iconography of the money trees is also clearly connected with the apotropaic and auspicious imagery so popular at the end of Han: on the Guitoushan sarcophagus the tree is depicted in company with various protective signs and cosmological symbols (Fig. 14). The monkeys clinging to the branches or trunks of many of the trees call to mind the monkeys dangling from a ginkgo branch above the copulation scene on the Xindu tile (No. 107). The ginkgo itself occurs as principal motif on several of the Wushan coffin plaques (Fig. 15b),[63] as does the motif of the copper coin (Fig. 15c). Such combinations illustrate a characteristic ambivalence in the themes of funerary art toward the end of Han, neither wholly profane nor purely religious.

Until about AD 75, the figurines and models placed in Sichuan tombs were small (under 20 cm) and rather crudely made. In the course of the second century these *mingqi* increased in number, variety, and size, ranging from 40 cm to 1 m high or even more. By their means the tombs were staffed with large figures of peasant-soldiers (No. 117) and *zhenmuyong*, exorcists or divinities charged with warding off malevolent spirits (No. 118). In many of their attributes—fangs and pendant tongue, large ears, tamed snakes—the latter recall the guardian monsters of Warring States Chu tombs. The former show us the peasants attached to the great estates, who in times of danger constituted an armed militia that protected the estate. Evidently they protected the tomb as well, for on the wall of Shiziwan tomb 1 at Leshan we find a door with a *zhenmuyong* on one side and a peasant-soldier on the other (Fig. 16). The figurines standing around the deceased reinforced the magic of those depicted on the walls of the tomb. In a late Han society riven by social tensions and convulsed by millennarian movements, these *mingqi* testify to the omnipresence of spirits and demons, and to a reliance on exorcism to deal with them.

In spite of the troubled times, however, these were also years of opulence in

61. Erickson 1994b.

62. Several articles on money trees appear in *Sichuan wenwu* 1998.4; the one by Zhou Kelin (pp. 15–22) reviews the various theories that have been proposed by Chinese scholars.

63. *Kaogu* 1988.12, p. 80 fig. 3, p. 81 fig. 4.

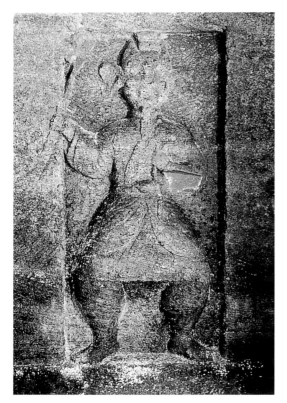

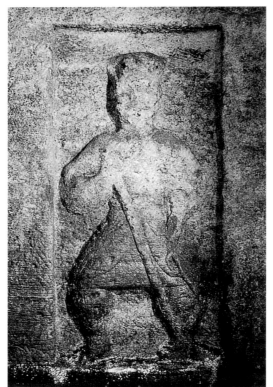

Fig. 16. Carved stone slabs from cliff tomb at Leshan (Shiziwan tomb 1). Guardians flanking the doorway to the rear chamber of the tomb: an exorcist (left) and a peasant-soldier (right). About AD 190–240. After *Orientations,* September 1997, p. 76 figs. 13–14.

Sichuan, at least for some. In the tombs of the wealthy the regular inclusion of model farm buildings, complete with livestock, shows the landowner's delight in his profitable estates. The pleasures of the moment, too, are everywhere evoked, in the countless musicians (No. 112), dancers (No. 113), storytellers (Nos. 110–11), and *liubo* players provided to entertain the deceased and to furnish him a banquet.

The terracotta statuettes were assembled from components made in molds, baked, and then painted, the most popular colors being red and black. The quality of the finished statuette depended on the quality and condition (more or less worn) of the molds employed. In the finest pieces, every shape and detail is legible; if the mold was worn, all the outlines are blurred. The statuettes in tombs are mostly terracotta, but wood, stone,[64] and bronze (No. 95) versions of the same subjects were sometimes made, using the same formulas, poses, and attributes.

What is special to Sichuan in this mass-produced art is, first of all, a certain number of figure types that elsewhere are not found treated the same way: the *zhenmuyong* exorcists or guardian spirits, the peasant-soldiers, the storytellers. These last, caught in the act of a half-spoken, half-sung recitation *(shuochang),* are so abundant in Sichuan tombs at the end of Han that we must suspect this form of entertainment to have been a regional specialty. Down to the present day the various Sichuan theatrical forms have maintained a tradition of clowns and comics who excel in delivering more or less improvised monologues in the vernacular.[65]

Other features of this funerary art special to Sichuan are its large size, variety, and above all a sense of volume, the echo, perhaps, of a Shu tradition of chiselled woodworking. Could the feeling for sculpture go back further still, to the south in general and to Sanxingdui in particular, as Jessica Rawson has suggested?[66] Perhaps so, but

64. *Wenwu* 1993.1, pp. 40–50; *Wenwu ziliao congkan* 4 (1981), pp. 239–41.

65. Darrobers 1998, p. 109.

66. Rawson 1992, p. 135.

perhaps instead of south and north we should contrast periphery and Zhongyuan. It is clear that the ancient Chinese of the Zhongyuan had little interest in the representation of people. They did not seek to illustrate their myths, to give visible form to their divinities, or to commemorate their heroes in images. The non-Chinese populations on the periphery, however, in particular those inhabiting a broad arc from the northeast to the southwest, gave the depiction of human beings a central place in the expression of their religious beliefs. The Sanxingdui heads, with their intense presence, are a striking example. Does the sculpture of Sichuan in the second century AD owe something to this far more ancient tradition? The question must be asked, even if the evidence still has too many gaps for us to give an answer.

Be that as it may, the taste for narration, the lively expressiveness, and the talent for caricature seen in Sichuan sculpture at the end of Han are unique. They are the product of observation without flattery, of a determination to capture the truth of the most fleeting gesture or grin, even at the risk of a contorted or comical result. This art that dares to record the intimacy of women breast-feeding, couples kissing, animals mating, is the opposite of the contrived discourse valued by the literati of the Jiaxiang region in Shandong. And perhaps this is what survives of the native culture when all the rest seems forgotten: a way of bypassing traditions, a certain outlook on things, a manner of feeling and expressing them.

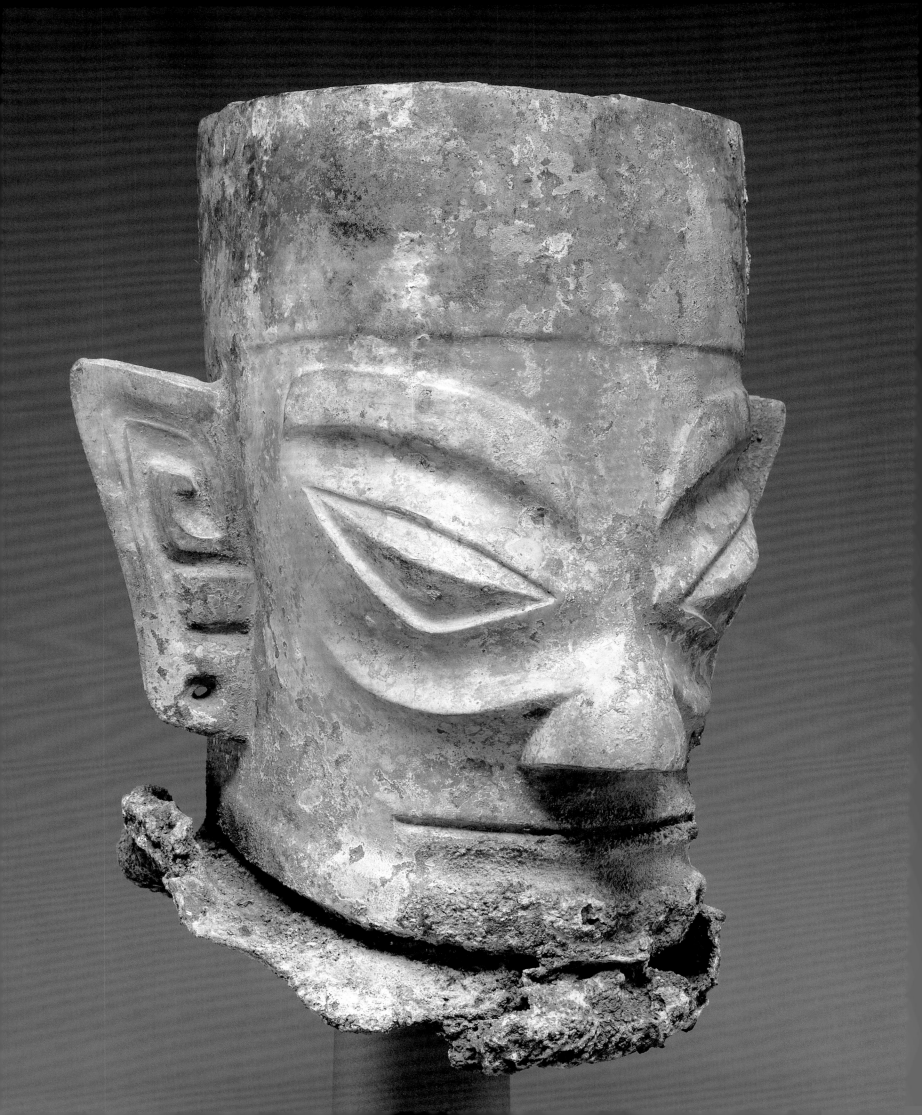

by Jay Xu

Bronze at Sanxingdui

The oldest bronzes yet found at Sanxingdui point to connections with the earliest major Bronze Age site known in China, Erlitou in the middle Yellow River valley, where a substantial bronze foundry was in operation by 1500 BC. Four bronze plaques, three from the Sanxingdui site and one found 10 km to the northwest at Gaopian, resemble plaques unearthed at Erlitou and might be imports from there (Figs. 1–2).[1] The three found at Sanxingdui come from a pit deposit on the Cangbaobao terrace inside the walled city; excavated in 1987, it is about 400 m east of the Yueliangwan pit excavated in 1929.[2] The plaques found at Erlitou by contrast come from tombs.[3] Though somewhat different in design from the Sanxingdui plaques, they are about the same size and shape, and they are inlaid with turquoise, as are two of the four from Sichuan. Neither at Erlitou nor in Sichuan is the function of the plaques clear (nor was the function necessarily the same in the two places). But it is easy to imagine these attractive and conveniently small objects circulating in networks of trade or exchange.[4]

Apart from the four Erlitou-type plaques, almost nothing of bronze has yet turned up in the neighborhood of Sanxingdui that is earlier than the two great sacrificial pits of about 1200 BC.[5] Given that the plaques are likely to be imports, we have no

1. Gaopian: *Wenwu* 1980.9, p. 76; Sanxingdui: Beijing 1998f, p. 81 fig. 3 and pls. 4.1–2; Beijing 1994a, pp. 55–6.

2. Beijing 1998f, pp. 78–90. Like the sacrificial pits 1 and 2, the Cangbaobao pit was found by brickyard workers digging clay. Unfortunately by the time archaeologists arrived on the scene the stratigraphy of the area had been too badly disturbed to allow relating the pit to other parts of the Sanxingdui site.

3. A total of three have been found so far; all three are illustrated in Beijing 1996a, pls. 20–22. The excavation reports are *Kaogu* 1984.1, pp. 37–40 (a photograph showing this plaque in situ appears in Beijing 1993d, p. 121); *Kaogu* 1986.4, pp. 318–23; *Kaogu* 1992.4, pp. 294–303.

4. In Chapter 2 Jenny So suggests that the plaques originated at Sanxingdui, and that the Erlitou examples were imported from Sanxingdui. For the moment, at least, it seems easier to believe that the plaques originated at Erlitou, since the evidence there for a bronze industry capable of manufacturing such items is plentiful, while at Sanxingdui we have no evidence apart from the plaques themselves of bronze casting at this early date.

5. A burial at Xinfan Shuiguanyin, about 25 km northwest of Chengdu, contained three bronze *ge* blades said to resemble Erligang types (*Kaogu* 1959.8, p. 408). The identification, if correct, would imply a date *c.* 1500–1300 BC.

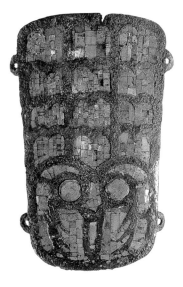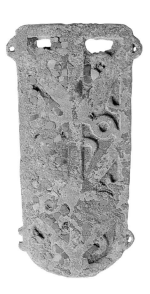

Fig. 1. Bronze plaque with turquoise inlay, from tomb 57 at Erlitou, Henan province. Height 15.9 cm. Assigned to Period IV at the Erlitou site, *c.* 1500 BC. After Beijing 1996a, pl. 22.

Fig. 2. Bronze plaque with turquoise inlay, from the Cangbaobao terrace at Sanxingdui. Height 13 cm. After Tokyo 1998, p. 175 no. 150.

evidence of any local bronze industry before the time of the pits. Then, however, we suddenly have overwhelming evidence, for the pits contained almost a metric ton of bronze.[6] With the exception of a few vessels imported from the middle Yangzi region, the bronzes in the pits are surely the products of a local industry, for nothing like them has ever been seen anywhere else. Since the few that have surface decoration seem indebted to widespread transition-period styles,[7] the industry probably arose during the thirteenth century. How long it survived after the time of the two sacrificial pits is uncertain. In the complete absence of local bronze finds later than the pits, we cannot say anything about its later history.

The vessels, being imports, have little to tell us about bronze casting at Sanxingdui, and discussion of them will be reserved for a later section of this chapter. Until then we focus on the local industry, as represented by the strange images and other unparalleled objects which account for the majority of the bronzes. In what follows, any mention of "Sanxingdui bronzes" should be understood to refer to the local castings from the two sacrificial pits, in other words to all the bronzes from the pits *except* the bronze vessels treated in the penultimate section.

LOCALLY CAST BRONZES: FABRICATION

At Sanxingdui as elsewhere in ancient China, bronzes were made by casting in clay molds of two or more parts. The only exceptions are miniature ornaments—birds, fish, animals, leaves, forked blades—made from very thin (0.1–0.2 mm) hammered sheet bronze.[8] Similar hammering techniques could easily have been used to make larger flat objects as well, such as the many animal plaques and appliqués of various kinds, but they were instead cast (Nos. 24, 41–2). Heavy reliance on casting, and on section-mold casting in particular, is the hallmark of the bronze industry that originated at Erlitou and Erligang, and to find the same reliance at Sanxingdui is strong evidence that Sanxingdui got its bronze technology from the Zhongyuan.[9]

In Zhongyuan foundries, moldmaking was greatly complicated by the intricate decoration customary on bronze vessels. Molds generally had at least three outer parts, along with a core for the vessel interior; often they had many more than three (and often cores not just for the interior but for a ring foot or inside the legs of a tripod).[10] Only when a caster felt that the mold assembly was becoming unmanageably complex would he cast an object in two or more successive pours of metal. The vessels Nos. 46–9, though cast in the middle Yangzi region rather than the Zhongyuan, are derived from Zhongyuan prototypes and can be taken to exemplify the sort of shape and decoration that required complex molds. The mold assembly used to cast No. 49 included two cores (interior and ring foot). On the exterior it was divided vertically on the axes of the four sets of flanges, and it may have been divided horizontally as well, above and below the belly of the vessel; including cores, the mold assembly thus had at least six components and possibly fourteen. To make these precisely fitted components and keep them in alignment during casting cannot have been easy; nevertheless the caster resorted to separate pours of metal only for the four large animal heads on the shoulder of the vessel.

Sanxingdui founders, making objects with less intricately detailed surfaces, seem never to have used so complex a mold assembly. Instead they built up complex shapes

6. Duan Yu 1992, p. 56.

7. See note 29, and remarks in the entries for Nos. 2, 24, 34, and 36.

8. Beijing 1999a, pp. 315, 319–25.

9. In the Zhongyuan it seems to have been abundant metal supplies that fostered the reliance on casting (Bagley 1999, pp. 141–2). Sanxingdui bronzes are comparatively thin (and in the interval between Pit 1 and Pit 2 became thinner: the heads from Pit 1 are generally thicker and heavier than those from Pit 2). There could be purely technical reasons for this; on the other hand it is at least possible that Sanxingdui founders had more limited metal supplies but used the Zhongyuan technology anyway because it was what they had learned.

10. For a basic description of Zhongyuan casting procedures see Bagley 1999, pp. 142–4.

Fig. 3. Bronze rings from Sanxingdui Pit 1. After Beijing 1999a, p. 44 figs. 27.1–3.

from pieces cast separately, in simple molds. Animal plaques (No. 24), appliqués (Nos. 41–2), and figures like No. 26 (which is hollow at the back: see Figure 26.1) are basically sheets of bronze; the molds used to cast them had two parts, a front and a back, the back following the contours of the front so that the metal would be uniform in thickness.[11] For these objects no core was needed. The mold for casting a bronze ring like those shown in Figure 3 would have required two outer parts and also a core for the central opening.

Surprisingly, molds with only two or three outer parts and a core seem also to have sufficed for casting many of the heads, masks, and other figurative items. On No. 8, for instance, only a single mold mark is visible: it runs across the top of the head and down the sides, on the axes of the ears (Fig. 8.1). The mold was thus divided into front and back portions which met at the ears; a core formed the hollow interior of the head.[12] In the case of No. 7, one mold mark runs across the top of the head and down the sides, just as on No. 8; but another mold mark runs from the top of the head down the central axis of the face, bisecting the front half of the mold (Fig. 7.2). The mold therefore had three outer sections. Where only a side-to-side mold mark is visible but the shape of the head makes it unlikely that the mold could have been withdrawn from the model in only two pieces, we may suppose that a mold mark down the central axis of the face has been ground away. In the case of No. 11, the flat top of the head had a mold section of its own (Fig. 11.1). The finned head No. 6 probably required a four- or five-part mold. Relatively few objects from the pits required molds more complicated than this (the pedestal for the statue No. 2; the seated figure No. 25).

Rather than build complicated mold assemblies, Sanxingdui founders clearly preferred using simple molds to cast simple components, which they then assembled into finished objects by making as many joins as necessary. The most spectacular illustration of this approach is the bronze tree No. 27, which consists of at least a hundred separate components, almost all of which seem to have been cast in two-part molds.[13] Before attempting to describe its multifarious joins, however, we might profitably review the joining techniques standard in Zhongyuan foundries, where the principles involved are more simply illustrated (and where Sanxingdui casters must have learned the principles they applied with such exuberance).

From the Erligang period onward, founders in the Zhongyuan routinely made the join between two pieces of metal in the process of casting the second piece.[14] In general, the casting that produced the bulk of an object is called the main pour. A small part made before the main pour could be embedded in the mold for it in such a way

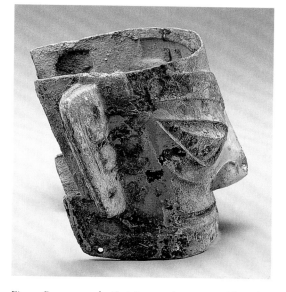

Fig. 4. Bronze mask, K2(2):331, showing mold mark on top of ear. Height 15.4 cm, width 18.2 cm. After Tokyo 1998, p. 79 (below).

11. Uneven thickness results in uneven cooling of the metal, which can cause defects.

12. The molds for masks were also divided at the ears (Fig. 4; No. 21) except when the ears were made separately (Nos. 20, 22–3).

13. The tree was found badly broken and cannot be completely restored. The figure of a hundred components is the author's very approximate count.

14. The discussion here follows Bagley 1999, pp. 142–4, and Bagley 1987, pp. 43–4.

Fig. 5. Bronze tree No. 27.
After Tokyo 1998, p. 94.

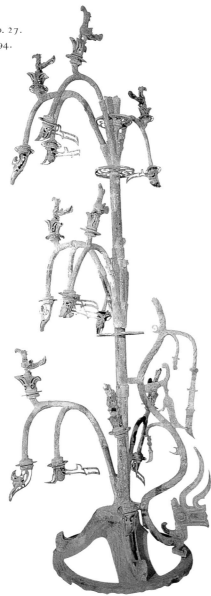

that, when the main pour was done, the two would be locked together. Parts so joined are said to have been precast. Alternatively, parts could also be added after the main pour, by building small molds for them against the already cast object. Such a process is called casting on.

Precasting and casting on were Zhongyuan founders' standard methods of making complicated shapes, accounting for virtually every join we see on Zhongyuan bronzes. More rarely encountered is the joining of two major components of an object by casting a small piece between them. Sometimes called running on, this might be thought of as a variety of precasting in which the two major components are the precast parts, and the tiny "main" pour is only the join between them.[15] We might even think of a soldered or brazed join as a join of this kind, in which the "main" pour was so small that it did not need a mold to enclose it.[16]

All these methods were employed by Sanxingdui casters—though of course their idea of a complicated shape was utterly unlike anything ever attempted in the Zhongyuan. The mask No. 23, for example, was made by the following sequence of steps. The projecting pupils for the eyes were cast first, by themselves, then inserted at the appropriate locations in a mold designed to produce all the rest of the mask except its ears and flamboyant elephant-like trunk; when that mold was filled, the pupils were locked in place.[17] Afterwards, the trunk was cast on and locked through the opening left for the purpose on the central axis of the face.[18] As for the ears, a Zhongyuan founder might well have decided to add them by casting on; but in a conspicuous departure from Zhongyuan workshop practice, they were cast separately and soldered or brazed on.

Returning to the tree No. 27, most of the joins were made by running on, soldering, or brazing (Fig. 5). In the absence of analyses to tell us the composition of the join metal, it is difficult to be sure how some of these joins should be best described. In what follows, the term running on will be used if the area or quantity of join metal is comparatively large; smaller joins will be described as soldered or brazed. The extent to which the fabrication of the tree also involved precasting and casting on is uncertain. A few minor instances seem clear (the cast-on bird's wings in Figure 6), but at some of the larger joins it is difficult to decide between precasting/casting on and running on.[19]

Soldering/Brazing

Figure 6 shows a bird standing on a flower that sprouts from one of the branches. An Anyang caster would probably have cast this bird in one piece, using a rather complicated mold. The Sanxingdui caster seems to have cast it in four separate pours of metal, each pour using only a simple two-part mold. The bird's wings, now broken stumps, appear to have been cast onto its shoulders. Its head is joined to its neck by a collar of solder (clearly visible in Figure 6), and solder beneath its claws joins it to the flower on which it stands. Further down, below the petals of the flower, a flat openwork ring encircles the calyx. In Figure 8, which shows the underside of this ring, a

15. Bagley 1987, pp. 43–4, 163; Gettens 1969, pp. 94, 96.

16. The evidence for solder in the Zhongyuan in this period is clear but very limited; see Bagley 1987, p. 43. "Soft solder" is the term for an alloy with a melting point much lower than that of the objects being joined; "hard solder" refers to an alloy with a melting point close to that of the objects being joined. "Brazing" means joining with hard solder.

17. Interestingly, the join between the pupils and the mask was further reinforced by solder on the outside.

18. Casting on was also used for patching damaged or defective objects (No. 4) at Sanxingdui as in the Zhongyuan (indeed this may actually have been the purpose for which the method was invented). This way of patching defects, which would be regarded as highly eccentric by metalworkers almost anywhere else in the world, is one more indication of the dependence of the Sanxingdui metal industry on the Zhongyuan.

19. The description of joins given here, based on the author's inspection of the tree and conversation (October 1999) with Mr. Yang Xiaowu, the conservator who restored the tree, is unavoidably tentative. No scientific study has yet been undertaken, nor have radiographs been made.

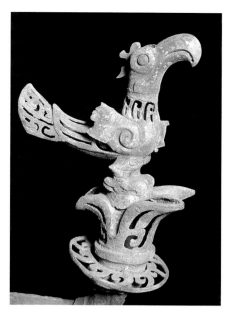

Fig. 6

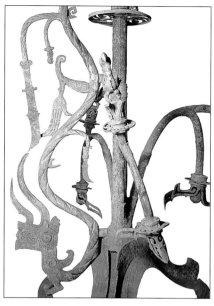

Fig. 7a

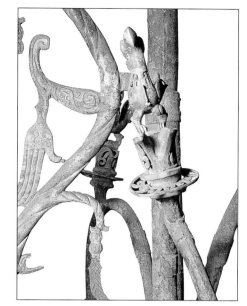

Fig. 7b

Fig. 6. Tree No. 27, detail of a bird. After Tokyo 1998, p. 96.

Fig. 7.
 a. Tree No. 27, detail showing the dragon. After Tokyo 1998, p. 95.
 b. Central part of Fig. 7a.

Fig. 8. Tree No. 27, detail of a calyx.

Fig. 9. Tree No. 27, detail of one of the four struts joining the dragon to the trunk.

Fig. 9

Fig. 8

wad of metal (now much corroded) can be seen holding the ring in place; this too is probably some sort of soldered or brazed join. Still further down, where the flat underside of the calyx sits atop the stem projecting from the branch, calyx and stem are joined by another collar of solder. Thus within the boundaries of Figure 6 there are at least half a dozen soldered joins.

Running On

Standing on the circular foot of the tree, facing outward, is a peculiar dragon whose rope-like body and tail rise in an undulating curve up the trunk of the tree (in Figure 7a the dragon's head is at the lower left).[20] The upper half of the dragon's body is lost. The surviving part is attached to the trunk by two struts; both are included in Figure 7a, but the upper one, partly obscured by a bird nearer the camera, is more fully visible in Figure 5. This strut was cast in a two-part mold: Figure 9 shows the mold mark on top of it, and a second mold mark can be found on its underside. The mold marks

20. The body of this dragon was cast in several separate sections that were soldered or brazed together; the joins resemble the one seen on the bird's neck in Figure 6. Many similar joins are visible in smaller parts of the tree.

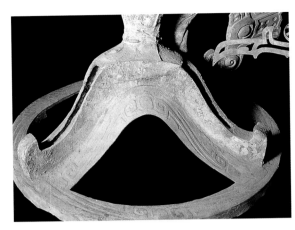 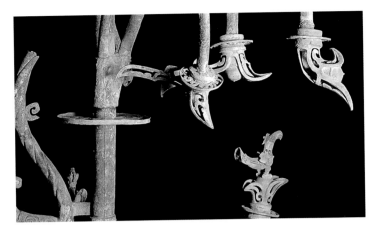

Fig. 10. Tree No. 27, detail of base. After Tokyo 1998, p. 97 (below).

Fig. 11. Tree No. 27, detail of join of branches to trunk. After Tokyo 1998, p. 97 (above).

do not continue onto the tree trunk or the dragon's body, showing that the strut was cast separately from them. (At the left side of Figure 9 the metal of the strut can be seen to flow onto and overlie the metal of the trunk.) This seems to be a clear case of running on; the procedure would have gone as follows. The dragon and the tree trunk were clamped in position the desired distance apart; the mold for the strut was built between them; and the strut was cast. Almost certainly it was held in place not by metal fusion (not easily achieved in bronze alloys) but by mechanical interlock, which the founder achieved by providing either tenons on trunk and dragon for the strut to lock over, or holes in trunk and dragon for the metal of the strut to flow into. Joins made by precasting and casting on depended in the same way on mechanical interlock.

Running on is seen again at the point where the trunk of the tree meets the base: a large irregular patch of metal that does not belong either to the trunk or to the base makes the join (Fig. 10; the lower edge of the patch is particularly clear in this illustration). The trunk was set in position on the base, a mold was built around the point of contact, and metal was poured in to make the join. The stump of a pouring inlet remains in the patch, showing where the metal entered the mold (the tree was lying on its side when the join metal was poured). On the smaller tree No. 28 the base and trunk are joined in the same way.

Running on may also have been used for major joins in the branches and for joining the branches to the trunk; this is the opinion of the conservator who restored the tree (and who was able to look inside broken parts). Consider first the joining of the branches to the trunk. Branches issue from three points on the trunk, one visible near the top of Figure 11. At each such point, a zone of thicker metal encircles the trunk, and the branches emerge from this thicker metal, looking as though they were held in tubes. The zone of thicker metal seems to belong to a run-on pour. It is puzzling, however, that mold marks (one of which is clearly visible in Figure 11) seem often to continue from the trunk onto the thickened area. A truly continuous mold mark would mean that the thickened zone was not run on but is part of the trunk, cast in the same mold, in the same pour of metal. If so, the branches would have to be described as precast parts, while the trunk and thickened area would constitute the main pour.

Each branch was made in several pieces; Figures 7b and 12 show joins in branches. In Figure 7b, a sleeve-like thickening in the branch is most easily interpreted as the run-on metal that joined two separate pieces. Puzzling again, however, is the fact that

the mold mark visible in the figure seems to continue from the branch onto the sleeve and back onto the branch; this would argue that there is no join at this point at all (but in that case, why the sleeve?). Figure 12 shows the point at which one branch forks into two: here a sleeve seems to attach the upper branch. The sleeve may again be the metal of a run-on pour, though the possibility that the upper branch was cast on cannot be dismissed without closer study. It is worth remarking that, if these are run-on joins, they are much more neatly done than the join that connects the trunk to the base.

A final observation to be made about the joins in the tree is that all were permanent. The tree was not made ever to be disassembled and reassembled.

Fig. 12. Tree No. 27, detail of join in branch.

The same joining techniques account for other Sanxingdui bronzes of complicated shape. The seven large pieces that compose the statue No. 2, for instance, were soldered or brazed together. All the techniques just described were invented by Zhongyuan founders, indeed they surely came to Sanxingdui from the Zhongyuan, but their inventors used them very sparingly. The Sanxingdui bronze industry is technically distinctive not because it used different techniques but because it used the same techniques with unparalleled abandon. Complex mold building may have been beyond the capacities of Sanxingdui casters; it is likely that they would have been quite unable to cast the sort of bronze vessel that their patrons imported from the middle Yangzi region (No. 49). To cast an object so wildly complicated as a bronze tree they simply dissected it into components that individually were easy to cast. Complexity was achieved by relentless joining.

LOCALLY CAST BRONZES: CHARACTER AND FUNCTION

The figures, trees, and other strange bronzes from Sanxingdui have no parallel elsewhere in China. The city where they were made and the people who made and used them are known from archaeology only sketchily, from inscriptions and texts not at all. This puts severe limits on what we can hope to understand about these objects. The lack of any written information about Sanxingdui and its culture is especially crippling. What could an archaeologist of the distant future, equally short of pertinent information, sensibly say about a crucifix? All that can be hoped for here is to combine the evidence provided by the archaeological context (in other words, the presumed sacrificial purpose of the pits) with the evidence supplied by the objects themselves (they are sometimes interrelated in suggestive ways), and on that evidence to venture a few speculations.

We might begin by noticing that the bulk of the bronzes can be sorted into two loose groupings. The first consists of figures, heads, and masks, most of which share a striking physiognomy characterized by sharply cut features and enormous eyes. These faces are distributed along a scale that ranges from comparatively human (No. 4) to more animal-like or simply weird (Nos. 22–3).[21] The second grouping consists of trees, ornaments for trees, and creatures associated with trees, birds especially. Though neither exhaustive nor mutually exclusive (human figures appear for instance on the tree base No. 28), the two categories are a convenient aid to discussion.

21. Excluded from consideration here are plaques like No. 24, which, however eccentric, seem to make recognizable allusions to the *taotie* designs of bronzes from the Zhongyuan and the middle Yangzi region (compare No. 24a with the *taotie* on No. 48). It is hard to see any such allusion in the masks Nos. 18–23, whose features relate them instead to the heads Nos. 4–17.

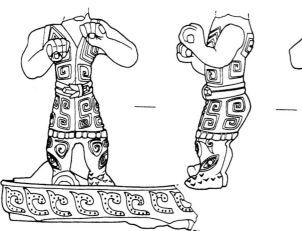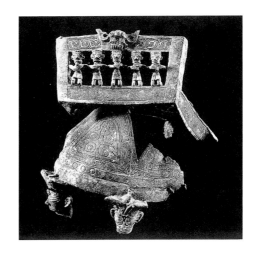

Fig. 13. Bronze miniature standing figure. K2(3): 296-1. Height 10.8 cm. After Beijing 1999a, p. 234 fig. 130.1.

Fig. 14. Upper part of bronze altar(?), fragment with kneeling figures. K2(3):296. After Beijing 1999a, p. 236 pl. 86 (below). Upper and lower parts are shown together in Introduction Part 1, Figure 8.

22. Figure 8 of Introduction Part 1 is a drawing that reconstructs a larger portion of the same object. The standing figures visible in the lower part of that illustration might also be presenting offerings, though the objects they hold are difficult to identify.

In the first category we might start with the statue No. 2 and a few simpler figures of humans, and ask what light they throw on each other. Assuming that the statue represents a man rather than a god, then its crown, richly decorated robe, and high pedestal surely signify a man of high status. If its arms and hands mimic the attitude taken during an offering ritual, then—recalling the 67 elephant tusks found in the same pit—we might guess that the hands held out a tusk. A number of miniature figures might similarly be understood as presenting offerings. The hands of a small standing figure hint that it too held a (miniature) elephant tusk (Fig. 13). No. 51, by contrast, kneels and holds a forked blade oriented vertically. Such forked blades, made of stone or jade, are prominent among the offerings in the pits (Nos. 52, 54–5). We see the same kneeling posture and vertically placed fists in the rows of figures depicted on the peculiar fragment shown in Figure 14.[22] Posture and gesture are again consistent with the idea that the figures are making offerings; we might go further and guess that the fragment belongs to some sort of altar. Kneeling figures are seen again on the rim of the tree base No. 28, where they are framed by the sweeping arches of the base, while both standing and kneeling figures are depicted on the stone blade No. 53, there with arches below them. It seems reasonable to guess that these figures are participants in rituals in which elephant tusks and forked blades were presented as offerings. The figure No. 3, which holds its hands somewhat differently from the ones mentioned so far, might be presenting something else.

Since all these figures, the large statue included, were found in the pits, they were themselves offerings. Here we might note the possibility of some sort of equivalence between the statue and the more than 40 bronze heads from the pits (Nos. 4–17), which with a few exceptions share the statue's facial type. One odd feature of the heads is their sharply tapering necks, which come to pointed ends at front and back: these pointed necks match exactly the part of the statue exposed above the collar of his robe (the robe leaves bare a V-shaped area in the back as well as in the front). It may be that the heads were mounted on wooden bodies (dressed in real clothes?) and thus were essentially equivalent to the statue. Indeed since Pit 1 had no statue, only heads, and Pit 2 had only one statue alongside many heads, we might suppose that heads with wooden bodies were the norm, and that the statue in the later pit was simply an extravagant attempt to translate the entirety of a familiar object into the

medium of bronze. If we imagine that Sanxingdui ritual required the sacrifice not only of objects but also of the officiants, and if we judge from their rich costumes that the officiants were of high status, we may see a motive for making images and an explanation for the lack of human remains in the pits. Elite self-sacrifice, symbolic or real, is not an entirely implausible idea; we might recall legends of kings who volunteered to sacrifice themselves, or who had priests sacrificed, to placate gods and bring rain or end plagues. At Sanxingdui the objective might have been gods who controlled floods. If symbolic sacrifice of persons of high status was indeed the function of the heads, it is utterly different from anything known at Anyang. Human sacrifice at Anyang was real, and the victims were not of high status, to judge by their burial, but commoners or war captives sacrificed like cattle.[23]

Angular features and downward gaze give many of the heads a superior, supercilious, or downright supernatural look, a look that their enlarged eyes make hypnotically powerful. The eyes and eyebrows may originally have been painted (No. 10); on the small figure No. 26 the pupils of the eyes are painted black. The ridges below the eye sockets sometimes give the impression that the face wears a mask (see the entry for No. 6), but this is far from clear. The heads differ in their hairdos (Nos. 11, 14), headgear (Nos. 6, 15–17), in the gold foil that covers several faces (Nos. 12–14), and in the softer, more naturalistically modelled features of one example (No. 4), but what these differences were meant to convey is unknown.

All but one of the 21 bronze masks come from Pit 2 (Nos. 18–23). They show the same facial features as the heads but lack distinguishing headgear (which of course might have been supplied in another material). The masks are shells of bronze, U-shaped in horizontal cross section. Their open form and the holes in their foreheads and sides suggest attachment to pillars or other architectural members, but their extreme variation in size, from 15 to 138 cm wide, only adds to the difficulty of guessing exactly how they were displayed.[24] Three of the largest have animal-like ears and monstrously protruding pupils (No. 22); two of the three have in addition an ornate trunk (No. 23). It is hard to know what to make of these startling images. It may be that many more of them existed in perishable materials, for about a hundred bronze pupils, eyes, and eyeballs, not attached to anything else, were found in Pit 2.[25]

The second major category of bronzes consists of trees and associated images and objects. Whatever their exact significance, trees obviously had great importance in the ceremony that filled the second pit and perhaps the first as well. The largest single item from the two pits is the four-meter-tall tree from Pit 2. The same pit yielded fragments of at least two smaller trees, including bases, branches, and creatures that once perched on branches (Nos. 28, 29, 31). Among the fragments of branches were two strung with bronze rings (Fig. 28.1) and a third with a jade collared disk encircling the calyx of a flower (Fig. 27.5), suggesting that at least some of the many bronze and jade rings found in the pit belonged to the trees. No bronze tree was found in Pit 1, but it contained more than a hundred collared disks in bronze and a few more in jade. Perhaps in Pit 1 real trees rather than bronze ones were burned and sacrificed, their branches hung with bronze disks. In Pit 2 the trees were particularly badly broken, and they seem to have been among the first things dumped into the pit.

23. Bagley's description, in his account of Anyang sacrificial burials (Bagley 1999, pp. 192–4). These victims must of course be distinguished from the concubines, military escorts, etc., found in tombs of the highest rank—specific people or classes of people who followed their lord in death. Hu Houxuan has supplied useful surveys of Anyang oracle inscriptions mentioning human sacrifice (*Wenwu* 1974.8, pp. 56–67, 72) and of archaeological evidence for human sacrifice at Erlitou, Zhengzhou, and Anyang (*Wenwu* 1974.7, pp. 74–84).

24. Even the mask 138 cm wide (No. 22) may not have been the largest. Pit 2 yielded two mask fragments of enormous size: one, part of an ear, is 48 cm high; the other, part of a mouth, is 48 cm wide (Tokyo 1998, p. 74).

25. Beijing 1999a, pp. 201–17. Later texts describe a ruler of Shu who had *zong mu* "vertical eyes"; on the evidence of these two words, some scholars have proposed identifying No. 22 as an image of this ruler. Such attempts to force a connection between artifacts from Sanxingdui and legends recorded a thousand years later seem unilluminating.

Apart from the dragon whose body rises up the trunk, the only creatures on the large tree from Pit 2 are birds like the one shown in Figure 6; whatever once stood on the top end of the trunk is now missing. At least one of the smaller trees carried instead bird-man hybrids like No. 29. The bird head No. 33, too large to have ornamented a tree, is provided with small holes in the neck, suggesting that it was attached to a body made of some perishable material. Found in great variety in Pit 2, birds, like trees, had some deep significance to the Sanxingdui ritualists.

VESSELS

Pit 1 and Pit 2 contained altogether about 25 bronze vessels, but only 10 were in a condition to be restored.[26] The shapes of the damaged vessels are in most cases recognizable, however, and it is clear that the inventory of shapes in the two pits was narrow indeed. With only two exceptions, both from Pit 1, all the vessels were tall vases of the types today called *zun* (Nos. 44–7) and *lei* (Nos. 48–9), types that differ only in the wider flare of the *zun*'s mouth. The 10 restored vessels comprise 7 *zun* and 3 *lei*. Of the total of 25 vessels, 4 are from Pit 1: two *zun* (No. 44 and one other), a *pou*, and a *pan*.[27] The remainder, all *zun* and *lei*, come from Pit 2.[28]

The time spread of the vessels is also very narrow, probably less than a century, perhaps only a matter of decades. All the vessels from Pit 1 and a few from Pit 2 (e.g. No. 45) have decoration belonging to a widespread style characteristic of the transition period (thirteenth century); these are undoubtedly the earliest of the vessels.[29] The remainder, from Pit 2, are slightly later and belong to types long recognized as coming from the middle Yangzi region, in other words from southern Hubei and northern Hunan.[30] Though not the only vessel types cast in the middle Yangzi region, *zun* and *lei* are probably the ones most often encountered there, and the limited repertoire of shapes at Sanxingdui might thus partly reflect the limited selection that was available to Sanxingdui patrons from their trading partners down the river.[31] Unlike these imported vessels with their dense surface decoration, most of the bronzes mentioned in the previous section have no surface decoration at all. Those that do, most notably the statue No. 2, bear intaglio patterns that were comparatively easy to cast. Insofar as these patterns betray an outside debt at all, they depend on transition-period designs rather than on the intricate high relief of Hunan/Hubei *zun* and *lei*.

Curiously, many of the vessels have small holes drilled in their foot rims, some directly through the decoration (e.g. Nos. 45, 48–9). These must be modifications carried out at Sanxingdui to adapt the vessels to a local purpose or placement different from the one their middle Yangzi casters intended them for. On the other hand local users did share with users in the middle Yangzi region one idiosyncratic idea about the purposes to which bronze vessels might be put. In the Zhongyuan, where bronze vessels originated, they were containers for offerings of food and wine. In the Yangzi region, where bronze vessels seldom or never carry inscriptions to inform us of their contents, they are occasionally found full of jades or small articles of bronze.[32] We encounter the same practice in the Sanxingdui pits, where at least seven of the vessels contained jades, cowry shells, ivory beads, and miniatures made of thin bronze sheet. On No. 43 we see a kneeling woman bearing on her head a *zun* with a high lid. Perhaps she, like the men in Figures 13 and 14, is bringing an offering for deposit in the pit.

26. Even some of the restored vessels were so badly broken or melted that restoration required the addition of large missing portions. The *zun* No. 44, for instance, is said to be two-thirds modern material (Chen De'an, personal communication, October 1999).

27. Beijing 1999a, p. 41 (the second *zun*); p. 42 (the *pou*); p. 43 fig. 26.1 (the *pan*); all fragmentary. There was also a fragmentary lid (p. 43 fig. 26.2), perhaps from a *lei* or *zun*.

28. Also found in Pit 2 were a lid (Beijing 1999a, p. 280 pl. 100.4) and a lid knob (p. 281 pl. 101.1). Again these may have belonged to *lei* or *zun* vessels.

29. On bronze styles characteristic of the transition period see Bagley 1999, pp. 149–54, 171–80.

30. Bagley 1987, entry no. 43 (also pp. 32–6, 539–51, especially the discussion of middle Yangzi bird motifs on pp. 546–8); Bagley 1992; Bagley 1999, p. 213 and references cited there, p. 217 fig. 3.34.

31. Nevertheless the other types most characteristic of the middle Yangzi region, animal-shaped vessels and large bells, are not represented at Sanxingdui (as noted in Bagley 1999, p. 213). Perhaps Sanxingdui buyers did exercise some choice.

32. Fong 1980, pp. 129–31 (no. 25); Bagley 1987, p. 337 fig. 57.4, pp. 373–4, p. 380 note 4.

Table 1. Elemental Composition of Bronzes from Early Bronze Age Sites

Site	Date (BC)	Number of samples analyzed (number of objects sampled)	Range of percent Cu	Range of percent Sn	Range of percent Pb
Erlitou[33]	c. 1500	32 (32)	35–99+	0.04–23	0.03–61
Zhengzhou[34]	c. 1500–1300	5 (5)	53–80	0.53–18	6–41
Sanxingdui[35]	c. 1200	27 (24)	64–98	0.03–12	0.03–33
Tomb at Jiangxi Xin'gan[36]	c. 1200	6 (6)	75–84	4.6–18.4	0–7.8
Fu Hao tomb at Anyang[37]	c. 1200	89 (89)	72–88	9–20	<8
Guojiazhuang tomb 160 at Anyang[38]	12th c.	19 (19)	69–99	0–19	0.41–22
Yinxu Xiqu tombs of Periods II and III at Anyang[39]	12th c.	18 (18)	72–94	0–20	0.5–22

APPENDIX: ELEMENTAL ANALYSIS AND LEAD-ISOTOPE RATIOS

Throughout the Bronze Age in China, both binary (copper-tin or copper-lead) and ternary (copper-tin-lead) alloys are commonly encountered. Elemental analyses have now been reported for a considerable number of archaeologically provenanced bronzes. They show a wide range of compositions among objects from a single site, indeed from a single tomb. The table above gives some idea of the range of compositions reported from the Sanxingdui pits (24 bronzes, vessels excluded) and from sites earlier than the pits (Erlitou and Erligang), contemporary with them (Fu Hao's tomb at Anyang and the Xin'gan tomb in Jiangxi), and slightly later (a twelfth century tomb at Anyang Guojiazhuang and more modest twelfth century burials in the Yinxu west sector at Anyang).

Only the Fu Hao bronzes show any appreciable control of alloy composition. Otherwise the limits are very wide, at Sanxingdui as elsewhere. This should not be surprising. Even assuming an unrestricted supply of the constituent metals, alloy composition is very difficult to control, and no ancient bronze founder would be likely to take the trouble to purify his metals and mix them in specific proportions unless he had some good reason to do so. In the case of metal used for weapons, where mechanical properties are important, alloy control might have been attempted (though analytical data show little sign of it). For vessels and statuary, however, all that was needed was an alloy that would cast well, and this is not a severe constraint. More important, surely, was the need to recycle a material as valuable as bronze, and the founder who tossed miscellaneous artifacts (for instance captured bronze weapons) into the crucible relinquished control of composition. It seems likely that the only control normally exercised came at the stage when the bronze in the crucible was molten: if the color or viscosity of the molten metal did not seem right, the founder added copper or tin or lead as required to achieve a look that his experience told him would pour well.

It is not clear that elemental analysis has much of archaeological interest to reveal. Lead-isotope analysis by contrast does seem to say something useful about the trade in metals. The lead from a given lead mine has a distinctive isotopic composition that does not change during the smelting and casting processes. (Nor does recycling change the isotopic composition, provided that all the bronzes being melted together drew

33. Beijing 1999c, p. 399 (table 2).

34. Beijing 1999f, pp. 125–7. Another object from Zhengzhou is reported to be 91 percent copper, 7 percent tin, and 1 percent lead (*Wenwu* 1959.12, p. 28).

35. The analyses tabulated here come from Beijing 1999a, p. 495, and from two articles by Zeng Zhongmao (*Sichuan wenwu* 1989, special issue on Sanxingdui studies, pp. 76–80; *Sichuan wenwu* 1991.1, pp. 72–4). Copper contents are fairly evenly distributed over the range from 64 percent to 98 percent.

36. Beijing 1997f, pp. 241–4. Twenty analyses are reported, but fourteen are disregarded here as unreliable (probably because of corrosion products in the samples, their metal contents totalled less than 95 percent).

37. Beijing 1984a, pp. 267–81. Ninety-one analyses are reported, but two are disregarded here as their metal contents total less than 95 percent. The composition of the *Si Mu Wu fangding*, which is likely to be of about the same date, falls into the same range (*Wenwu* 1959.12, p. 28).

38. Beijing 1998i, p. 178. Twenty-six analyses are reported, but seven are disregarded here as their metal contents total less than 95 percent.

39. Li *et al.* 1984. Twenty-four analyses of Period II and III samples are reported, but six are disregarded here as their metal contents total less than 95 percent.

their lead from a single mine.) Unless it mixes leads from two or more distinct mines, therefore, the lead in a bronze artifact can in principle be matched with the lead mine it came from, or with other bronzes whose lead came from the same mine.[40] The isotopic analyses performed so far show patterns consistent enough to suggest that the mixing of lead from different sources did not happen so often as to make the typing of leads uninformative.

In fact, very interesting results have been obtained. Lead-isotope analyses of bronzes from Sanxingdui (imported vessels as well as local castings), bronzes from the Xin'gan tomb, and early bronzes from Anyang (i.e. those from Fu Hao's tomb, not later ones) show that they all contain lead of the same unusual isotopic composition, suggesting that the same lead source was supplying foundries in all three places.[41] Analysis of samples from lead mines strongly suggests that the source was in Yunnan province.[42] It seems likely that Yunnan lead was shipped north to Sichuan, eastward down the Yangzi river, and then to destinations both south (Xin'gan) and north (Anyang) of the Yangzi (after the time of Fu Hao's tomb Anyang must have switched to some other source). The trade was presumably in lead ingots, but we should remember that lead could also travel in the form of finished bronze artifacts. Since the recycling of wandering artifacts might be expected to mix leads from different mines, it is surprising that the lead-isotope analyses performed so far show as much regularity as they do.

40. For more detail see Bagley 1987, pp. 558–60 (appendix 2) and references cited there.

41. Beijing 1997f, pp. 245–50; Jin et al. 1998; Beijing 1999a, pp. 490–9. Lead-isotope ratios for 53 samples from Sanxingdui bronzes are reported in Beijing 1999a, pp. 498–9. Of the 53 samples, 20 come from fifteen vessels; the remaining 33 are from objects likely to be local castings.

42. Li Xiaocen 1993 reports analyses from several hundred lead mines and makes a convincing case for Yunnan as the source.

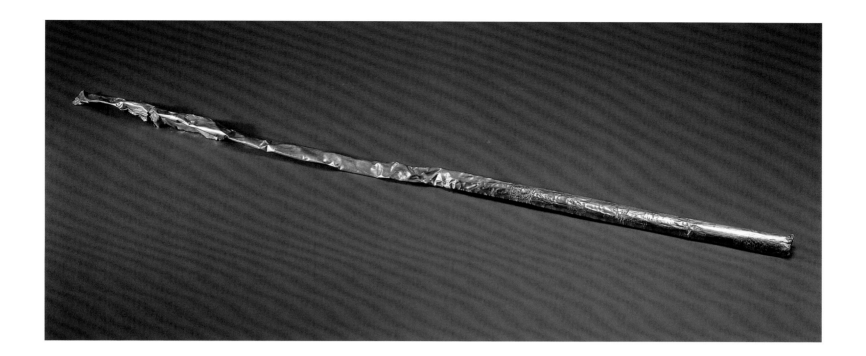

This decorated tube of gold originally covered a wooden staff, burnt traces of which remain inside. Belonging no doubt to the regalia of a person of the highest status, it is so far unique; no other Bronze Age site has yielded anything like it. It was made by hammering an ingot into a rectangular sheet about 7.2 cm by 142 cm, then tracing decorative designs into an area 46 cm long at one end of the sheet, and finally rolling the sheet around the wooden staff. The designs, which have the appearance of thread relief, seem to have been executed by pushing the metal down on either side of the desired line, so that the line itself remains level with the surface as a whole (Fig. 1.1).

The decorated area amounts to a third of the staff's length. The bulk of it is filled by an odd motif four times repeated, an arrow whose feathered shaft runs past a bird to strike the forehead of a fish (Fig. 1.2). The lower border to this design is a narrow band containing a pair of smiling faces wearing ear ornaments and pronged crowns or headdresses.

No analysis of elemental composition has been carried out, so it is not clear whether the gold is pure or an alloy. Gold was little used in China in the Bronze Age,[1] but it is fairly conspicuous at Sanxingdui. In addition to the staff, Pit 1 yielded a small tiger of gold foil (No. 39), a mask resembling those on several bronze heads from Pit 2 (e.g. Nos. 12–14), and even a gold ingot or blank.[2]

I

Sheath

Gold
Length 142 cm, diameter 2.3 cm, weight 463 g
(including carbonized wood)
Thirteenth or twelfth century BC

Excavated from Sanxingdui Pit 1 [K1:1]
Sanxingdui Museum 00648

PUBLISHED: Tokyo 1998, no. 114; Beijing 1999a, p. 60 fig. 34.1, p. 61 rubbing 7, p. 62 pl. 15.1, p. 528; Taibei 1999, no. 98; Yang 1999, no. 75.

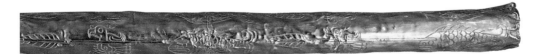

Fig. 1.1. No. 1, detail of decoration. After Yang 1999, p. 227.

Fig. 1.2. No. 1, drawing of decorated zone. After Beijing 1999a, p. 61 fig. 34.1.

1. For a survey of Bronze Age gold artifacts see Gong Guoqiang 1997.

2. The ingot is 11.9 cm long, 4.4 cm wide, 0.2–0.5 cm thick, and weighs 170.44 g; the stump of a pouring inlet remains visible on it (Beijing 1999a, p. 61 fig. 34.4, p. 62 pl. 15.4).

2

Figure on pedestal

Bronze
Overall height 260.8 cm, height of figure 172 cm,
weight 180 kg
Twelfth century BC

Excavated from Sanxingdui Pit 2 [K2(2):149, 150]
Sanxingdui Museum 00643

PUBLISHED: Beijing 1994a, pls. 1–4; Rawson
1996, no. 22; Tokyo 1998, no. 1; Beijing 1999a,
pp. 162–6, 544; Taibei 1999, no. 1; Yang 1999,
no. 65.

This life-sized figure of a gesturing man stands on a pedestal that adds a meter to his height. The greatly oversize hands probably held an object that the man offered in sacrifice, perhaps an elephant tusk. His head has the same blocky shape and sharp-cut features as the other heads from the Sanxingdui pits; No. 16 is particularly close. Massive eyebrows stand in relief above bulging eyes, the eyeballs oddly creased from inner to outer canthus. The nose is long and sharp, the mouth a thin horizontal groove, the jaw a sort of horizontal molding that is carried all the way around to the hinge behind the ears (Fig. 2.1b,d).[1] The expression imparted by these features seems rather neutral: a glance at the heads Nos. 4–17 suggests that the differences that make some of these faces severe, almost scowling, others benign, are so slight that they might well be accidental. But the now sightless eyes may originally have been animated with touches of paint: their pupils and the eyebrows as well are likely to have been painted black (compare No. 26). The contrast with the golden color of the uncorroded bronze would have been vivid.

The ears, like the eyes, are disproportionately large. Their lobes are perforated for ornaments such as are worn by the faces depicted on the gold staff No. 1 and by the figures incised on the stone blade No. 53. The head wears a two-part crown: one part is a sort of headband with a flat top, the other a cluster of petalled shapes (feathers?) held within it, the petalled part now damaged and incomplete. Perhaps the head No. 16 had the same

Fig. 2.1. No. 2, drawings.
After Beijing 1999a, foldout
following p. 162.

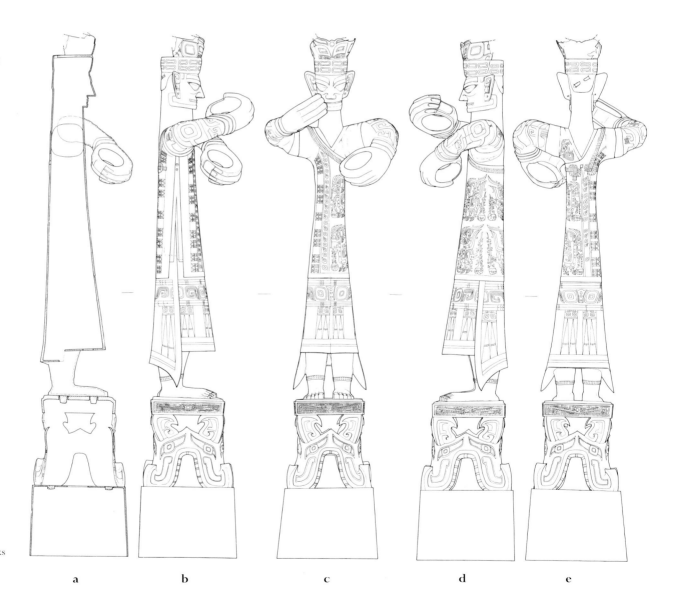

a b c d e

1. This molding sometimes looks
almost like a beard; compare
Figure 15.1.

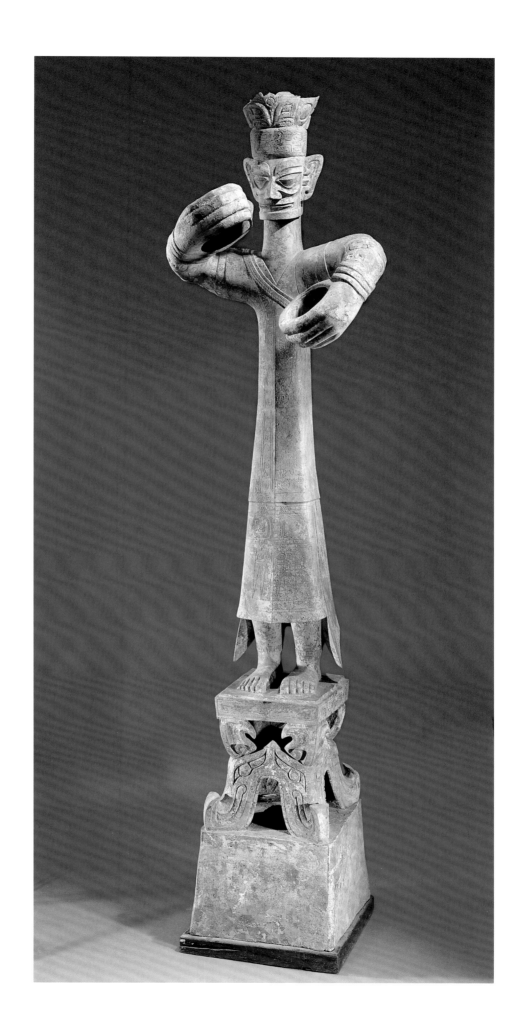

Fig. 2.2. No. 2, rear view of head and shoulders.
After Yang 1999, p. 210 (left).

Fig. 2.3. No. 2, detail of left side. After Yang 1999,
p. 209.

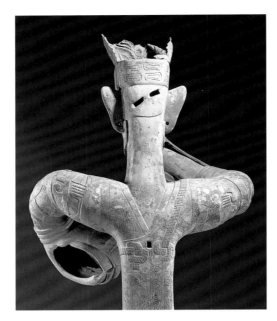

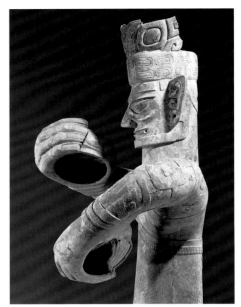

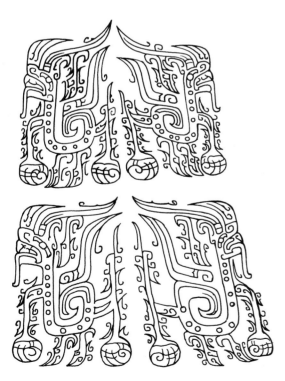

Fig. 2.4. No. 2, dragon on mantle. Drawing by
Luo Zeyun.

headdress, but with its upper part made in a perishable material now lost. Two openings
in the back of the head, set on a diagonal (Fig. 2.2), must have been for attaching an orna-
ment in the man's hair (compare No. 15).

The figure is so sumptuously dressed that we might wonder whether its bare feet had
some ritual significance (the standing figures depicted on the blade No. 53 wear shoes).
On close examination of the costume we can distinguish three layers of clothing: a long
inner robe that reaches just below the knee in front, to the calf in back, and to the ankle
at the pronged sides; a short mantle that ends below the waist (its lower hem is indicated
by a raised horizontal line crossing the surface of the statue); and a plainer garment be-
tween the two, exposed on the shoulders and arms (its short sleeves end at the middle of
the upper arm) and glimpsed under the right arm between the slightly parted edges of the
mantle (Fig. 2.1b). A dragon on the back of the left shoulder must belong to this middle
garment (Fig. 2.1e).

The inner robe, the longest one, has fairly simple decoration: on the skirtlike part
exposed below the hem of the mantle we see a horizontal band with big lozenges (eyes?)
inside it and pronged devices hanging from it. Nothing of this innermost garment is vis-
ible at the neck, but its boldly patterned sleeves reach all the way to the figure's wrists
(Fig. 2.3). Under the right arm, where the middle garment as well as the mantle is
slightly open, we can see that the long back part of this innermost robe overlaps the
skirtlike front part (Fig. 2.1b).

The mantle is a richly decorated piece of cloth with a heavy braid or cord sewn along
its top edge. It is wrapped around the left side of the body, under the left arm, and fas-
tened over the right shoulder by the corners, probably by knotting the braid at the back
(Fig. 2.1e: this man needed help getting dressed). Under the right shoulder, where the
two ends of the piece of cloth almost meet, the edges are bordered with patterns that
look like the lozenge-and-prong design of the undergarment's skirt reduced in size and
turned sideways (Figs. 2.1b,c,e). The remainder of the mantle is covered with feathery,
fantastically ornate dragons, each with two enormous clawed feet (Fig. 2.4). The patterns
on the long inner robe, we might guess, are simple enough to have been woven, but these
dragons look like embroidery. Perhaps the robes of the statue were painted to resemble
real cloth.

The short plain sleeves of the middle garment are left exposed by the mantle except
where the braid crosses over the right sleeve. The middle garment has a V-shaped neckline

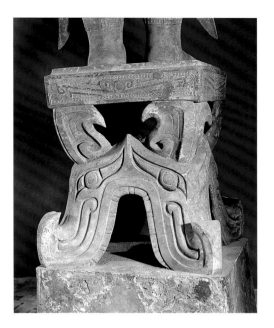

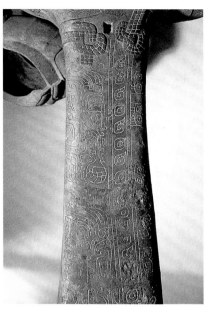

Fig. 2.5. No. 2, detail of pedestal. After Yang 1999, p. 210 (right).

Fig. 2.6. No. 2, detail of back. After Tokyo 1998, p. 48 (left).

on both the front and the back of the figure; the area left bare corresponds exactly to the pointed necks of the bronze heads (compare No. 16). Given the schematic, not to say columnar anatomy of the statue, it is easy to imagine that we here see translated into bronze an image of which only the head normally was bronze. Put another way, we might speculate that while the ritual was being performed, the head No. 16, its face painted, was mounted on a post, dressed in real silk robes, and crowned with a feathered headdress. A gathering of such figures would have been an awesome sight.

Asked to copy a wooden figure with a bronze head and silk clothes entirely in bronze, Sanxingdui founders faced a technical challenge that they met by casting the object in seven separate pieces:[2]

(1) The undecorated portion of the pedestal. (Was this left undecorated because it was sunk in the ground?) Mold marks along the vertical edges and top suggest that this piece was cast in a mold of five outer sections, as might be expected. Assuming that it was cast upside down, the opening in the top would have allowed supporting the core from below.

(2) The remainder of the pedestal, including all of the block the figure stands on except the slightly raised plain board immediately beneath the figure's feet (Fig 2.5).[3] Mold marks are less apparent here, but partly visible along the elephant-like trunk in the rear left corner. With its complicated shape and surface decoration, this must have been one of the most technically difficult castings undertaken at Sanxingdui. Tenons secure it to the undecorated element below, and at the top the plain board beneath the statue's feet is tenoned into it (Fig. 2.1a). Whether the tenoned joins were soldered is uncertain.[4] All the other joins in the statue are very obviously soldered.

(3) The feet of the statue, including the plain board on which they stand, and the lower part of the robed body. The horizontal division in the body comes not at the hem of the mantle but higher up, in the blank space between two groups of dragons on the mantle; the soldered join at this height can be faintly seen in Figure 2.6. The mold for this component probably had three parts, one for the back and two for the front: on the front, the vertical crease in the clothing seems to coincide with a mold division, for horizontal lines in the decoration are slightly disrupted where they cross it. At the sides, the mold marks interrupt the textile decoration where the two sides are about to turn into the

2. Earlier discussions of the casting of this statue include Barnard 1990, pp. 255–7; *Sichuan wenwu* 1994.6, pp. 68–9, 77; *Sichuan wenwu* 1990.6, pp. 22–30; Beijing 1999a, p. 162. The last three state conclusions but give little supporting evidence. The present discussion draws on these earlier studies and on my own observations.

3. The block rests on an open four-legged support of curious design. The support is apparently meant to be viewed not straight on, as in Figure 2.1, but on a diagonal: in that view, prominent eyes left and right of the corner combine to suggest an animal face with a snout or elephant-like trunk. Above the eyes, the elements that touch the block might be ears; compare the ears (and eyes) of the mask No. 22.

4. I have not had an opportunity to inspect the interior of the undecorated part of the pedestal. The underside of the decorated part has heavy soil encrustation, making it impossible to ascertain the nature of the join. Seen from above there is no visible trace of join metal between the plain board and the block or where the four-legged support below the block meets the undecorated part of the pedestal.

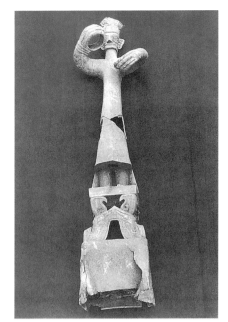

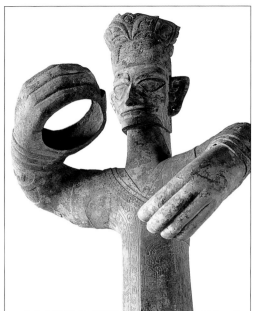

flat back. A rectangular opening under the skirt was probably left by a device that supported the core during casting (Fig. 2.7). Traces of clay core material remain inside the figure.

(4) The upper part of the body (including the head but excluding the arms and the upper portion of the crown). This may have been cast in a mold of two sections, front and back, divided on the axes of the ears. On the headband a vertical mold mark is visible above the left ear (Fig. 2.3). Further down, the mold division is indicated by an interruption in the ribbon under the left armpit. Two small openings under the right arm may have been left by core supports.

(5 & 6) The two arms. The point where each arm was attached to the shoulder is betrayed by the run-on metal that made the join (Fig. 2.8). A mold mark is clearly visible on the left arm along the outside lengthwise median (Fig. 2.3). The mold for each arm was probably composed of two sections.

(7) The flowery upper part of the headdress. A soldered join attached this to the headband beneath.

In every respect this statue seems distinctly more ambitious than other Sanxingdui castings. Few have nearly so much surface decoration. The sparsely drawn patterns on the clothing, formed of uniformly thin sunken lines, and much simpler than the intricate high relief of the imported *zun* and *lei* vessels (Nos. 46–7 and 49), probably take their inspiration from bronzes of the transition period (the thirteenth century).[5] The rectangles of decoration on the block at the top of the pedestal, bordered with small circles, belong to the same period.

The statue was found broken in two (Fig. 2.7). The orientation of the two fragments in the pit leaves no doubt that the break occurred before burial (Introduction Part 1, Figure 6). The figure was battered but apparently not burned.

5. Bagley 1999, p. 217. Compare as to draftsmanship the patterns on a bronze drum from southern Hubei (Bagley 1999, p. 151 fig. 3.5; better illustrations in Fong 1980, pp. 114–15, and Beijing 1998a, p. 171).

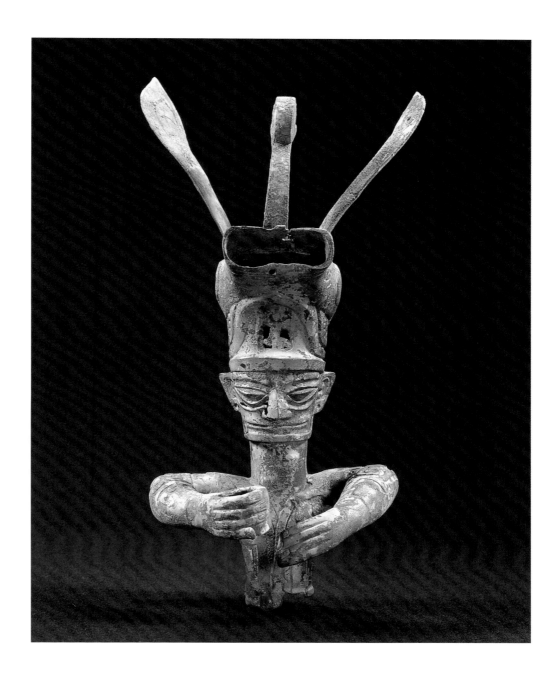

Now missing its lower half, this figure resembles a reduced version of the statue No. 2: the facial features are similar, as are the patterns on the arms of the robe. But the posture of the hands is slightly different—perhaps they held two distinct objects instead of a single elephant tusk—and the figure's headgear is very different. Interpreting this bizarre hat is made easier if we look at the winged animal that supports a small bronze altar(?) found in the same pit (Fig. 3.4 and Introduction Part 1, Figure 8). What the present figure wears as a hat is clearly equivalent to the head of the animal that supports the altar: we see the same large eye on the side of the head, the same pattern on the throat, three freestanding projections on the top, a star inside a circle near the mouth (should we be reminded of the wheel-like appliqué No. 41?), and at the front end an open mouth that looks for all the world like a vacuum-cleaner attachment.

The object was made by joining together (not very neatly) six components: the two arms, the three projections from the hat, and the remainder. The mold for this last component had two sections. The mold divisions were not aligned with the ears, as we might expect, but ninety degrees away, at the nose and the back of the head: vertical mold marks are visible in the hair on the back of the head (Fig. 3.3) and, more faintly, between the

3

Figure with headdress

.

Bronze
Height 40.2 cm, width elbow to elbow 18.4 cm, weight 3.046 kg
Twelfth century BC

Excavated from Sanxingdui Pit 2 [K2(3):264]
Sanxingdui Museum 00281

PUBLISHED: Tokyo 1998, no. 77; Beijing 1999a, p. 167 fig. 84, p. 168 pl. 59.2, p. 545 fig. 41; Taibei 1999, no. 50; Yang 1999, no. 71.

eyebrows. A spacer that kept the core and mold apart during casting is visible in the left side of the face. A hole was left on top when this part was cast. The curling projection at the front of the head was then cast on; through the animal's open mouth we can see a patch of metal inside, resulting from this process. The two side projections were cast separately and perhaps embedded in the mold for the curling projection and locked in position when the latter was cast. On the outside, they were reinforced by solder. We may recall that this peculiar way of precasting supplemented by soldering was used also in making the mask No. 23, as discussed on page 62; such a combination is unique to Sanxingdui. The figure has numerous holes. The ones in the front and the back of the hat were intentionally cast; the three around the open mouth and a fourth at the root of the curling projection were drilled after casting. The holes on the face, concentrated on the right side, are casting defects.

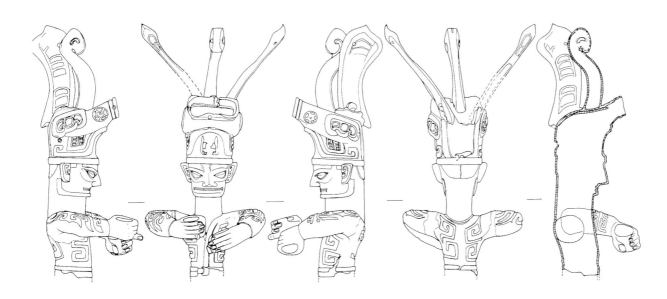

Fig. 3.1. No. 3, drawings. After Beijing 1999a, p. 167 fig. 84.

 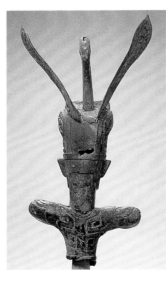 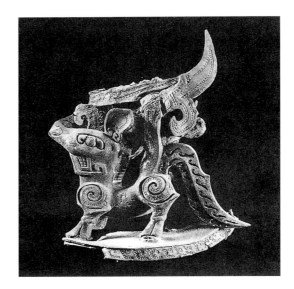

Fig. 3.2. No. 3, view of left side. After Tokyo 1998, p. 118 (left).

Fig. 3.3. No. 3, rear view. After Tokyo 1998, p. 118 (right).

Fig. 3.4. Animal from base of bronze altar(?). After Beijing 1999a, p. 236 pl. 86 (above). See Introduction Part 1, Figure 8, for a drawing reconstructing the object.

4

Head

Bronze
Height 29 cm, greatest width 20.6 cm, width at
top of head 15.4 cm, weight 4.48 kg
Thirteenth or twelfth century BC

Excavated from Sanxingdui Pit 1 [K1:2]
Sanxingdui Museum 00091

PUBLISHED: Beijing 1994a, pl. 6; Tokyo 1998,
no. 118; Beijing 1999a, p. 24 fig. 9, p. 25 pls. 2.1–2,
p. 523 fig. 1; Taibei 1999, no. 2.

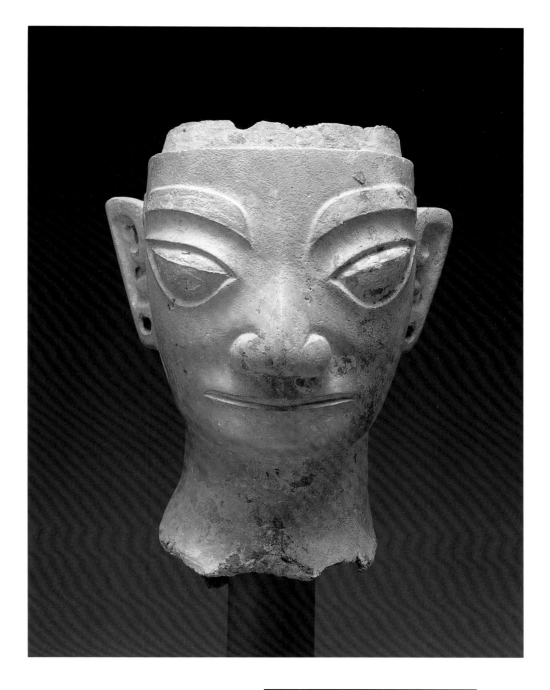

The soft, comparatively realistic modelling of the face sets this head apart from all others found in the Sanxingdui pits. The lower jaw, nose, and cheekbones are all gently rounded rather than sharp-edged, and the mouth lacks the downward hooks usually seen at the sides (compare Nos. 2, 5). Nevertheless the eyes, eyebrows, and ears (perforated for earrings) are still unnaturally large, and the eyes are creased from corner to corner, though not so prominently as usual (compare No. 5). The hairline is clipped straight across the back of the head; small patches of hair are indicated at the temples as well. The top of the head steps inward to a flange that probably secured some kind of headdress, perhaps a bronze one soldered on.

The head was cast in a mold divided vertically at the ears (Fig. 4.1) and probably also at the nose. Small cast-on repairs can be seen next to the left nostril and below the outer corner of the right eye. The lower edge of the neck is partly melted.

Fig. 4.1. No. 4, detail of area above right ear.

5

Head

Bronze
Height 25 cm, greatest width 20.4 cm, width at
top of head 14.2 cm, weight 3.36 kg
Thirteenth or twelfth century BC

Excavated from Sanxingdui Pit 1 [K1:6]
Sanxingdui Museum 00092

PUBLISHED: Beijing 1994a, pl. 5; Beijing 1994b,
pls. 10–11; Tokyo 1998, no. 120; Beijing 1999a,
p. 24 fig. 10, p. 25 pls. 2.3–4, p. 523 fig. 2; Taibei
1999, no. 4.

In its blocky chin, hooked mouth, and emphatic sharp-edged features this head is very unlike the previous one, and typical of the vast majority of the heads from the Sanxingdui pits, though its jutting nose is exceptionally long (Fig. 5.1). The head swells slightly toward the top, distancing it from the stovepipe proportions of Nos. 7–13 and bringing it closer to the round-topped heads Nos. 6, 14, and 15. Holes in the stepped-back upper edge probably helped attach headgear.

Most of the heads from the pits still have core material adhering to their inner surfaces, but in this case the excavators have removed the core material, and it can be seen that the inner contours of the bronze follow the outer ones, just as on the masks Nos. 18–23 (compare Fig. 22.1). There are no visible mold marks on the exterior. Fire damage caused the loss of the pointed tips of the neck. Flecks of black material here and there on the surface are charred bone. No. 5 and two other heads from Pit 1 contained a few cowry shells at the time of excavation. In Pit 2 cowries were found in much larger numbers inside bronze vessels (see the entry for No. 46).

Fig. 5.1. No. 5, drawings. After Beijing 1999a, p. 24 fig. 10.

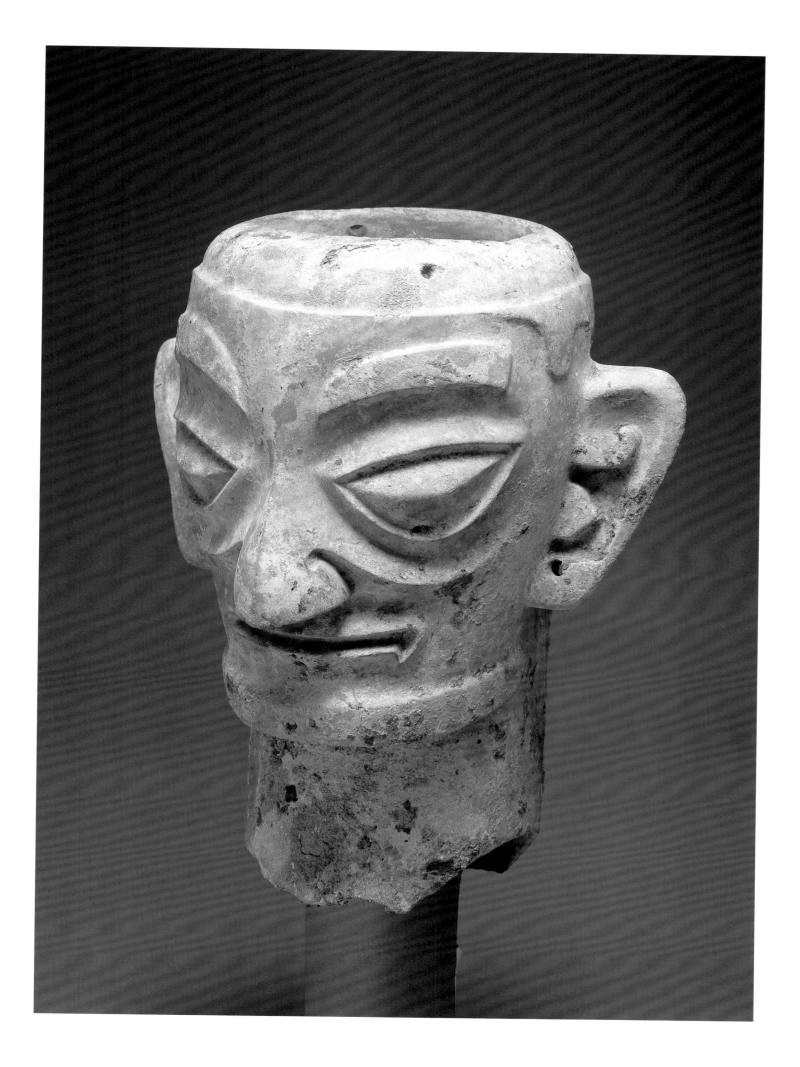

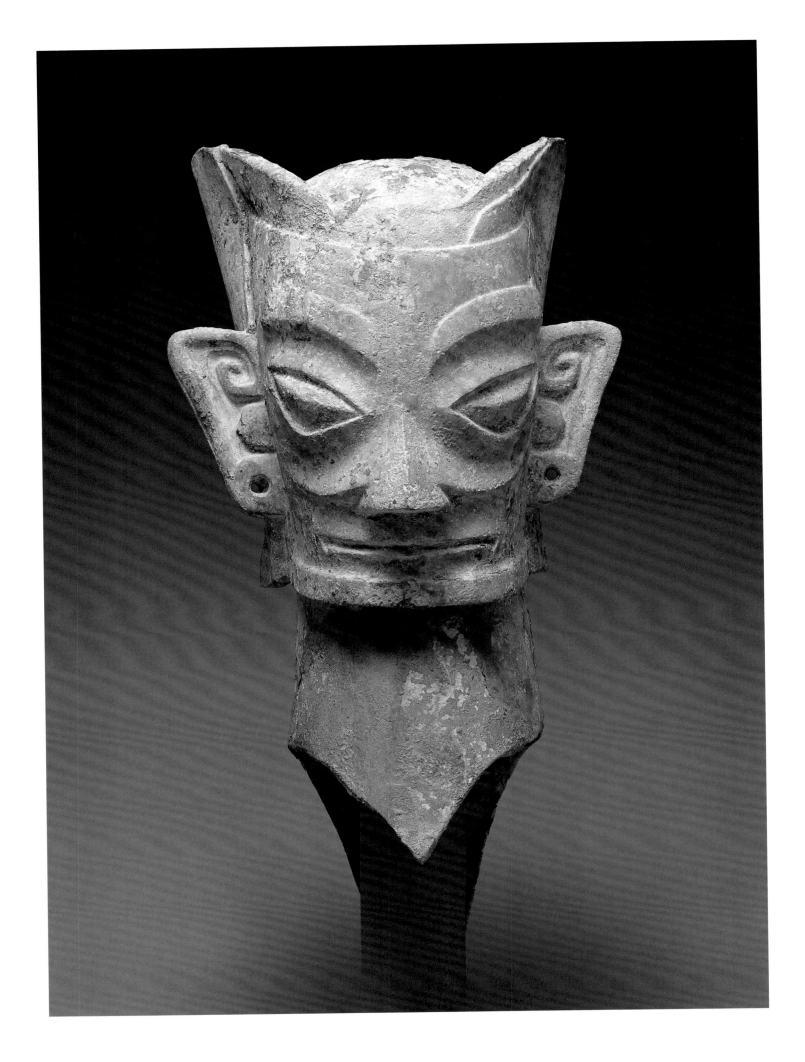

This head has a domed top with two fins projecting backward from it. The fins do not seem to belong to a headdress, for their edges descend behind the ears to join the molding of the jaw, giving the effect of a sort of border running around the face (Fig. 6.1). Comparison with the gold-covered faces Nos. 13 and 14 suggests the possibility that this border represents the boundaries of a mask that covered the whole face, ears included (perhaps No. 6 was covered in gold now missing, or perhaps paint substituted for gold foil). On this and other faces it is tempting to see the sharp ridges on the cheekbones as the lower edge of a smaller mask, one that extended only from the forehead to the cheekbones but did not include the ears (Fig. 6.2; compare No. 26), but the evidence is ambiguous: Nos. 13 and 14 have the cheekbone ridges, but their gold masks do not stop there but extend all the way to the chin. A diagonal opening in the back of the head must have secured some kind of ornament (compare No. 15).

A prominent mold mark runs up one ear, over the edge of a fin, across the cranium, over the other fin, and down the other side. The mold must have had a front section that corresponded to everything in front of this line—the face, the fronts of the ears, and (probably) the front part of the cranial dome.[1] A rear section formed the back of the head and neck and the inside surface of each fin. A narrow side section was then needed to form the back of each ear and the adjacent (outside) part of the fin. If this reconstruction is correct, the mold would have had a total of four or five outer sections. Casting defects in the top of the head and just above the left ear were never repaired. The head shows signs of burning, and patches of charred bone adhere to the surface, especially on the back.

Head

Bronze
Height 45.6 cm, greatest width 22 cm, width at top of head 12.5 cm, weight 4.54 kg
Thirteenth or twelfth century BC

Excavated from Sanxingdui Pit 1 [K1:5]
Sanxingdui Museum 00100

PUBLISHED: Beijing 1994a, pl. 7; Beijing 1994b, pl. 8; Tokyo 1998, no. 119; Beijing 1999a, p. 29 fig. 17, p. 32 pls. 5.1–2, p. 524 fig. 4; Taibei 1999, no. 3.

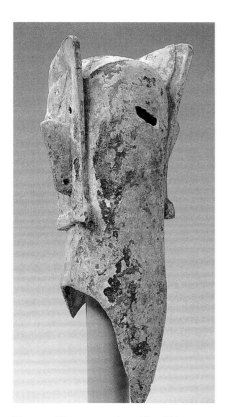 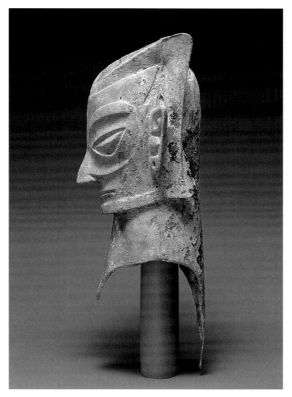

Fig. 6.1. No. 6, rear view. After Tokyo 1998, p. 154 (right).

Fig. 6.2. No. 6, left side.

1. Or possibly two front sections: on and above the nose are traces suggesting a filed-off mold mark.

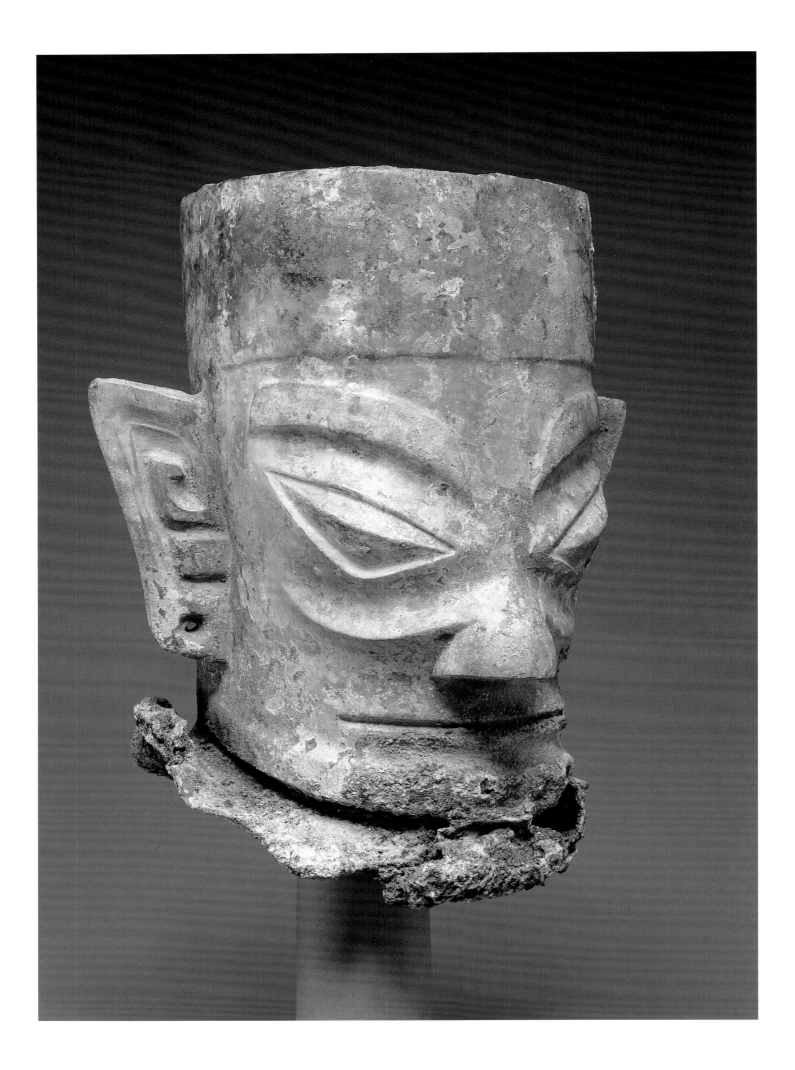

7

Head

Bronze
Height 27 cm, greatest width 22.8 cm, width at
top of head 15 cm, weight 7.66 kg
Thirteenth or twelfth century BC

Excavated from Sanxingdui Pit 1 [K1:7]
Sanxingdui Museum 00094

PUBLISHED: Beijing 1994a, pl. 8; Beijing 1994b,
pl. 13; Tokyo 1998, no. 122; Beijing 1999a, p. 27
fig. 12, p. 30 pl. 3.2; Taibei 1999, no. 6.

Just above the eyebrows the smooth upper part of
this head steps out a trifle, perhaps indicating that it
wears a cap or headband (though heads like No. 8
have the same tall shape with no trace of a step). It
also wears a pigtail; pigtails seem to be a standard
feature of the flat-topped heads. The facial features
are rather close to those of No. 6. The neck has
melted into a lump.

The head was cast in a mold of three outer parts
divided at the ears and the nose (Fig. 7.2). It is one of
the heaviest heads from either pit, about double the
weight of Nos. 8–10. Heads from Pit 1 tend to be
heavier than those from Pit 2; we might infer that in
the interval that separates the two pits the founders
had learned to make their castings economically thin.
The founders also seem to have standardized their
designs: although Pit 2 had 44 bronze heads while
Pit 1 had only 13, the variety is greater in Pit 1. The
4 heads from Pit 1 included here, Nos. 4–7, are all
distinctly different.

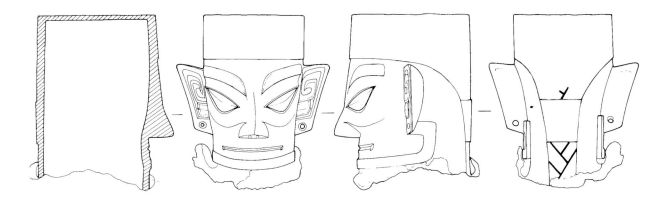

Fig. 7.1. No. 7, drawings. After Beijing 1999a, p. 27 fig. 12.

Fig. 7.2. No. 7, detail of top.

Head

Bronze
Height 40 cm, greatest width 18.2 cm, width at
top of head 12.6 cm, weight 4 kg
Twelfth century BC

Excavated from Sanxingdui Pit 2 [K2(2):17]
Sanxingdui Museum 00293

PUBLISHED: Beijing 1994a, pls. 11–12; Tokyo
1998, no. 15; Beijing 1999a, p. 177 fig. 94, p. 180
pl. 62.4; Taibei 1999, no. 17.

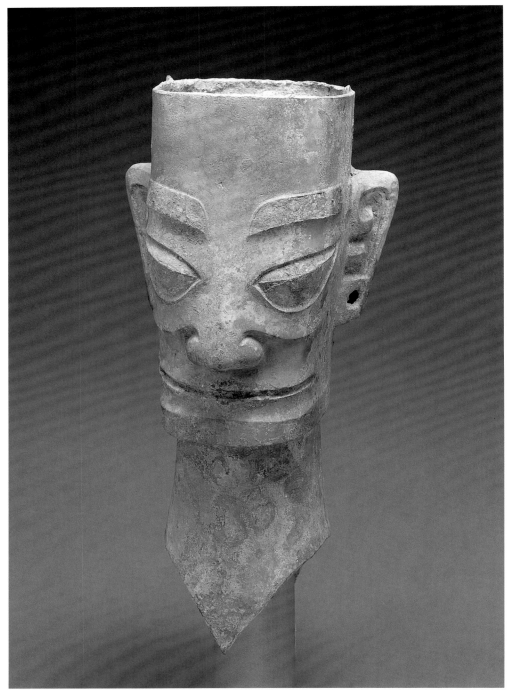

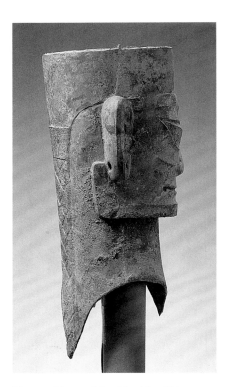

Fig. 8.1. No. 8, right side. After Tokyo
1998, p. 66.

This head has less emphatically modelled facial features than the others from Pit 2, giving
it a comparatively mild expression (compare for example No. 9). It seems to have been
cast in a mold of two outer parts. The mold mark is particularly distinct on the left side,
where it runs from the top rim down the side of the head, over the ear and down the full
length of the neck. Inside the head, small holes in the wall can be seen running into the
earlobes, where they intersect the perforations for ear ornaments. It is hard to think of
a reason for these holes, but they are encountered on several other heads as well (see in
particular No. 10).

9

Head

Bronze
Height 36.8 cm, greatest width 17.4 cm, width at
top of head 11.1 cm, weight 2.4 kg
Twelfth century BC

Excavated from Sanxingdui Pit 2 [K2(2):34]
Sanxingdui Museum 00647

PUBLISHED: Beijing 1994a, pl. 10; Rawson 1996,
no. 24.

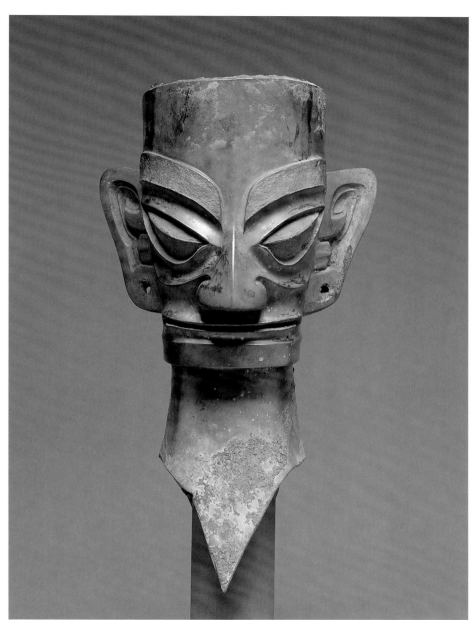

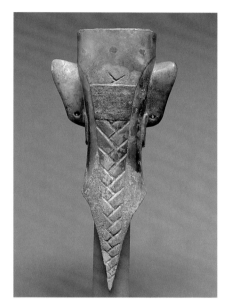

Fig. 9.1. No. 9, rear view.

Fig. 9.2. No. 9, top of head.

In their facial features this head and the next are typi-
cal of the majority in Pit 2, and subtly different from
the heads in Pit 1. The shape is tall, almost cylindri-
cal, and the sharp-edged, rather harsh features are
crowded toward the bottom of the cylinder. The ef-
fect of compressing the mouth and chin is to empha-
size more than ever the enormous eyebrows and
bulging creased eyes (compare No. 5). At the back
the head wears a braided pigtail.

No. 9 seems to have been cast in a mold of three
outer sections. Front and back sections met at the
ears, while a third section formed the top of the head
(Fig. 9.2). Holes in the inside wall apparently connect
with the perforations in the earlobes, as on No. 8,
though here the holes are filled with core material.
Three spacers are visible in the back of the head.

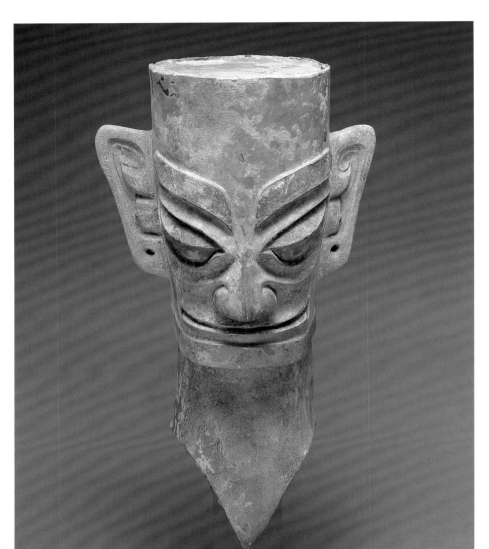

10

Head

Bronze
Height 41 cm, greatest width 21.6 cm, width at
top of head 15 cm, weight 3.665 kg
Twelfth century BC
Excavated from Sanxingdui Pit 2 [K2(2):48]
Sanxingdui Museum 00303
PUBLISHED: Beijing 1994b, pls. 14–15.

Fig. 10.1. No. 10, top of head.

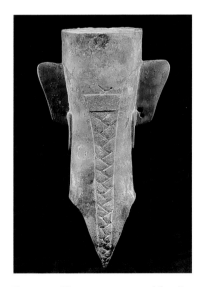

Fig. 10.2. No. 10, rear view. After Beijing 1994b, pl. 15.

Fig. 10.3. No. 10, detail of the back of the right ear.

This head, in proportions a trifle broader than the
last, differs also in retaining traces of an unidentified
black pigment on the eyebrows and eyes. Irregulari-
ties that look like slight overflows of metal from the
sides of the head onto the flat top suggest that the top
was precast, then set into a two-part mold for the
rest of the head, an odd proceeding (Fig. 10.1). In
addition to the usual perforation, the right earlobe
has an extra hole in the back that does not penetrate
to the front but instead turns a right angle and opens
into the interior of the head (Figs. 10.2–3). In the
left ear, by contrast, the perforation in the earlobe
has a side branch that runs to the interior of the head,
just as on Nos. 8 and 9. It would certainly seem that
the moldmaker had a use for openings from the ear
to the interior, but it is hard to think of a sequence
of moldmaking operations in which an independent
opening in one ear had to be added as a kind of
afterthought.

Head

Bronze
Height 17.6 cm, greatest width 10.8 cm, width at
top of head 6.7 cm, weight 0.691 kg
Twelfth century BC

Excavated from Sanxingdui Pit 2 [K2(2):154]
Sanxingdui Museum 00288

PUBLISHED: Beijing 1994a, pls. 13–15; Beijing
1994b, p. 118; Tokyo 1998, no. 7; Beijing 1999a,
p. 175 fig. 89, p. 179 pl. 61.3.

Of the 44 heads from Pit 2, all but 2 are more or less
life-sized; only this one and No. 17 are substantially
smaller.[1] Like No. 9, this one was cast in a mold of
three parts; a conspicuous mold mark runs around
the circumference of the flat top (Fig. 11.1). The
present head differs from Nos. 8–10 in that the per-
forations in the earlobes do not have side channels
connecting with the interior of the head. The number
of spacers is surprising: six in the front and back of
the head, five in the neck (Fig. 11.2).

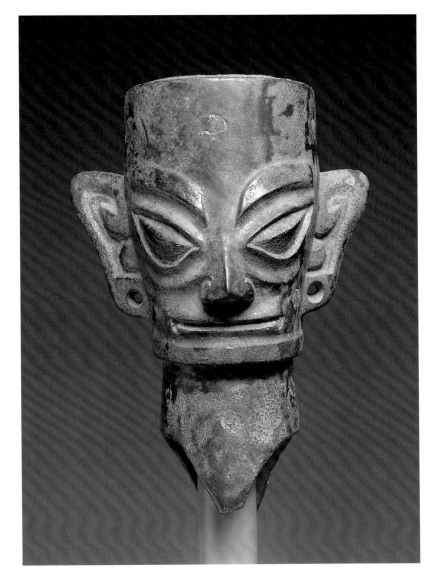

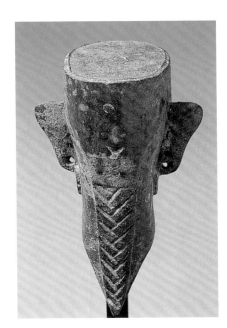

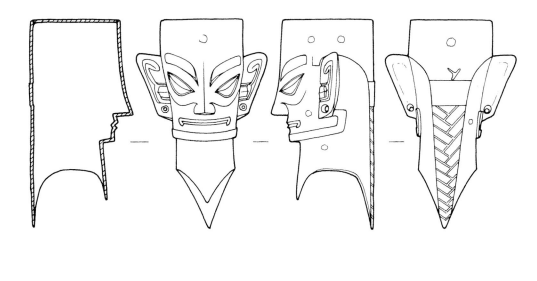

Fig. 11.1. No. 11, top of head. After Tokyo 1998, p. 57 (left).

Fig. 11.2. No. 11, drawings. After Beijing 1999a, p. 175 fig. 89.

1. Of the thirteen heads found in
Pit 1, again all but two are essen-
tially life-sized.

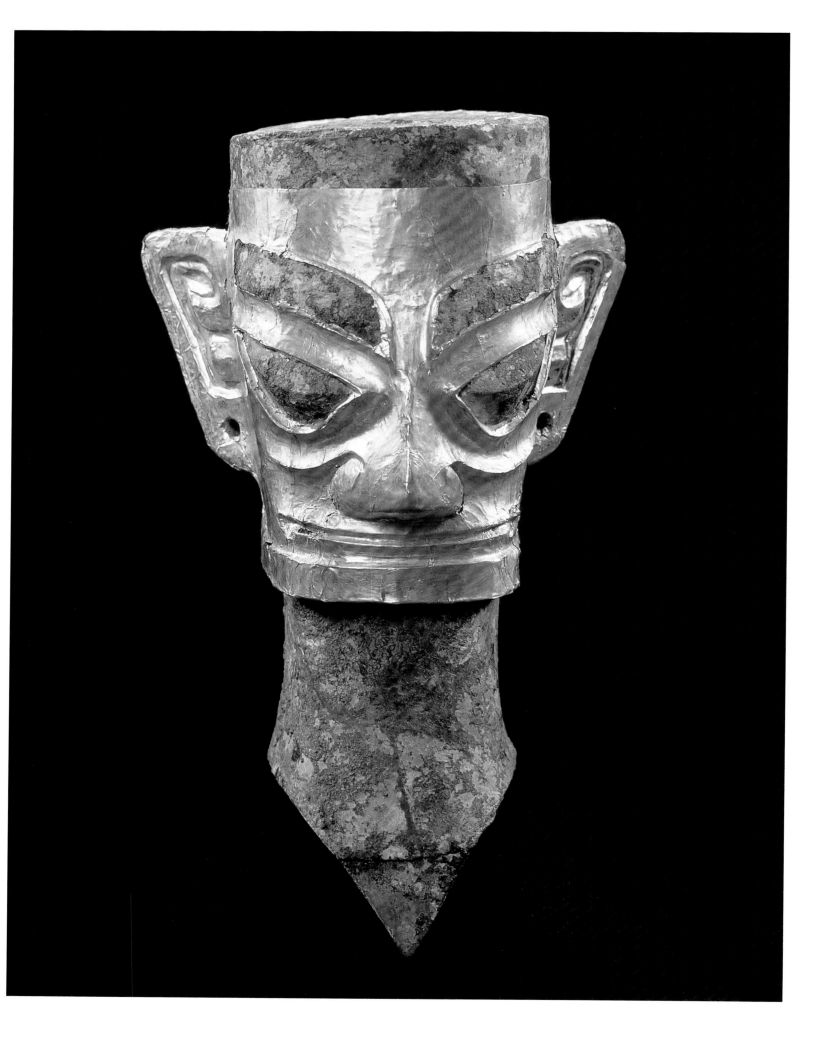

At least six of the heads from Pit 2 originally had masks of gold foil covering their faces. On three of them the foil was still in place at the time of excavation, and in a fourth case a detached mask has been reunited with its head (No. 14), but two more masks have not been matched with heads.[1] None of the heads in Pit 1 wore a gold mask, but one detached mask was found.[2]

Though No. 12 is one of the three heads found with their masks in place, it still required careful restoration, and during the restoration work it was possible to study how the gold was originally applied.[3] Apparently a piece of gold foil about 0.2 mm thick was pressed against the bronze face and carefully rubbed to make it take the contours of the facial features. A lacquer-based adhesive was used to attach it, but a layer of unidentified white powdery material was found between the gold and the lacquer, perhaps some sort of ground that helped prevent tearing the gold in the process of forming it against the face. This mask is the most complete of the six from Pit 2; the only loss is at the tip of the left ear.

The mask covers all of the face except the eyes and eyebrows. Its color is probably not too different from the color the bronze had when it was new (depending on its composition, the bronze might have been a paler yellow, or a trifle reddish). Black paint on the eyes and eyebrows, however, would have stood out dramatically, reinforcing the emphasis already given to those features by their disproportionate size.

12

Head

Bronze with gold foil
Height 42.5 cm, greatest width 19.6 cm, width at
top of head 12.6 cm, weight 2.55 kg
Twelfth century BC

Excavated from Sanxingdui Pit 2 [K2(2):45]
Sanxingdui Museum 00313

PUBLISHED: Beijing 1994a, pls. 21–2; Beijing 1994b, pl. 23; Tokyo 1998, no. 3; Beijing 1999a, p. 183 fig. 98, p. 186 pl. 64.2, p. 549 fig. 49; Taibei 1999, no. 20; Yang 1999, no. 67.

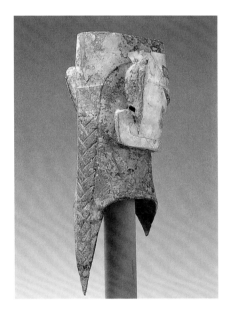

Fig. 12.1. No. 12, rear view. After Tokyo 1998, p. 50 (right).

1. Yang Xiaowu, personal communication, July 2000. For the two masks without heads see Beijing 1999a, p. 355 pls. 135.2–3.

2. Color illustration in Tokyo 1998, no. 113.

3. The restoration is reported by Yang Xiaowu in *Sichuan wenwu* 1992 (special issue on Sanxingdui studies), pp. 93–6. The article does not specify the head discussed; Mr. Yang informs me that it was No. 12.

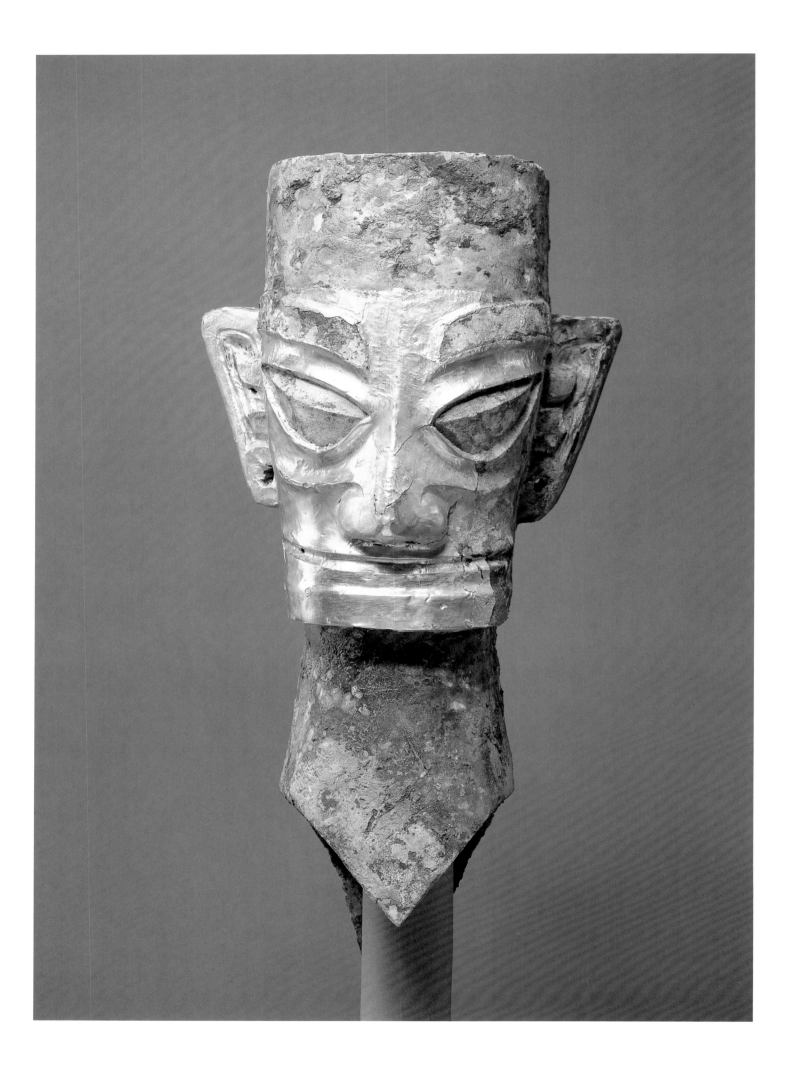

I3

Head

Bronze with gold foil
Height 41 cm, greatest width 18.8 cm, width at
top of head 12 cm, weight 2.959 kg
Twelfth century BC

Excavated from Sanxingdui Pit 2 [K2(2):115]
Sanxingdui Museum 00314

PUBLISHED: Tokyo 1998, no. 2; Beijing 1999a,
p. 183 fig. 99, p. 186 pl. 64.3.

This head is similar to the previous one, but its fore-
head looks much higher because the gold mask stops
short just above the ears. On neither head are mold
marks apparent. On both, the usual holes run from
the interior of the head to intersect the earlobe per-
forations. A large cast-on patch is visible on top of
this head (Fig. 13.1).

 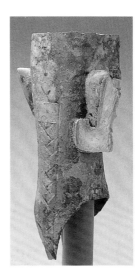

Fig. 13.1. No. 13, top view.

Fig. 13.2. No. 13, rear view.
After Tokyo 1998, p. 52
(left).

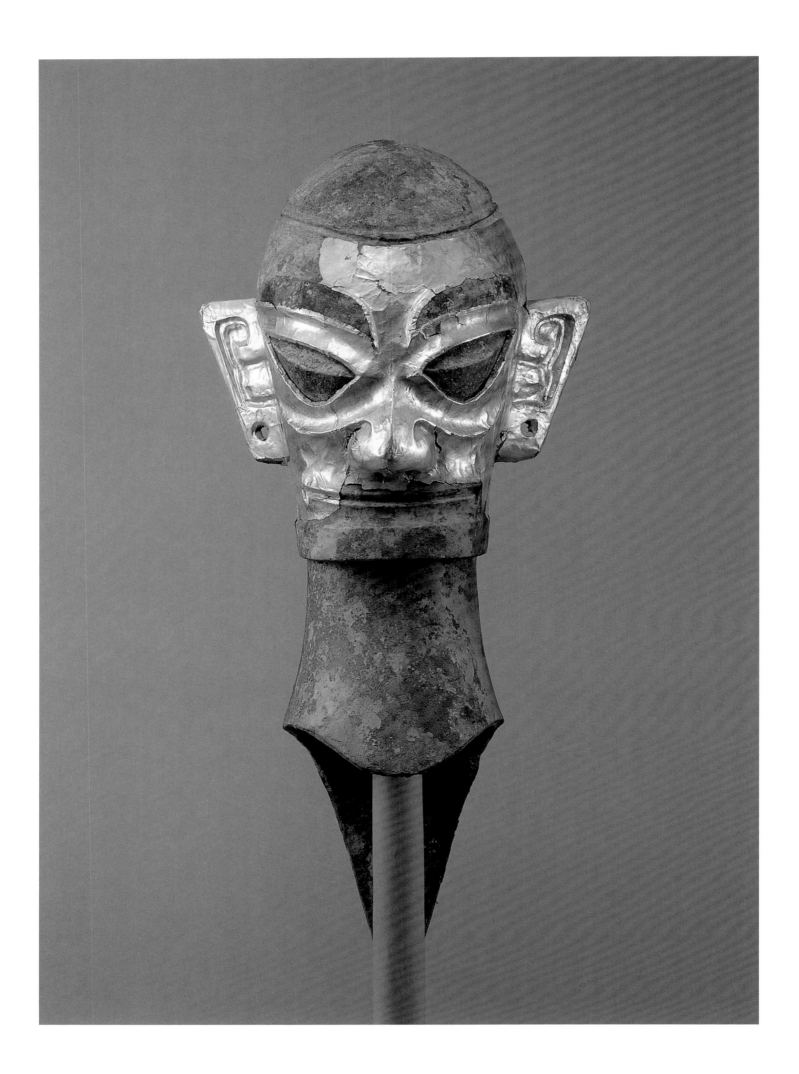

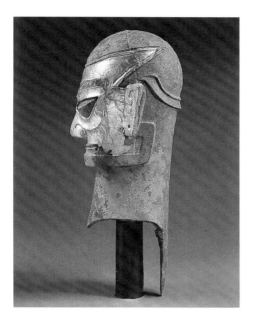
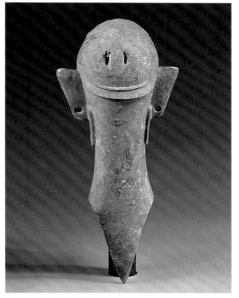
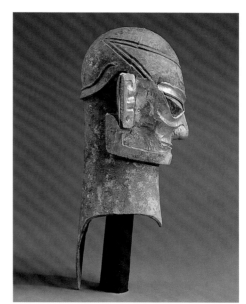

Fig. 14.1. No. 14, left side. After Rawson 1996, fig. 23.1.

Fig. 14.2. No. 14, rear view. After Yang 1999, p. 212 (right).

Fig. 14.3. No. 14, right side. After Yang 1999, p. 211.

This head, the next, and two others from Pit 2 have a distinctly different shape from the rest: the cranium is domed, the facial features extend higher up the head, and the shape is a little more natural, less cylindrical. Deep grooves in the bronze outline the part of the face covered by the gold mask (Fig. 14.1); a second head shows the same outlining (Fig. 14.4). On the back of both heads is a curved projection that looks like the edge of a tight-fitting cap or helmet (see also No. 15), but since the projection does not continue around the head, it might instead be a fringe of hair. The stump of some sort of headdress ornament survives at the back of the head shown in Figure 14.4. Two openings in the same location on No. 14 were probably for something similar. The gold mask was separated from the head at the time of excavation. The vertical mold mark clearly visible in Figure 14.1 disappears at the point where it intersects the triangular point of the gold mask: evidently the caster ground it off the surface to which he was going to apply the gold. The remnant of a mold mark bisecting the front part of the head is visible at the top of the cranium, indicating that the mold for the head was composed of three outer parts like that of No. 7.

14

Head

Bronze with gold foil
Height 48.1 cm, greatest width 22 cm, width at top of head 15 cm, front-to-back diameter at top of head 17.6 cm
Twelfth century BC

Excavated from Sanxingdui Pit 2 [K2(2):214]
Sanxingdui Museum 00646

PUBLISHED: Beijing 1994a, pls. 23–4; Beijing 1994b, pls. 21–2; Rawson 1996, no. 23; Tokyo 1998, no. 4; Beijing 1999a, p. 184 fig. 101, p. 187 pls. 65.1–2, p. 549 fig. 50; Taibei 1999, no. 21; Yang 1999, no. 66.

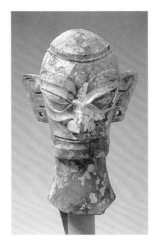
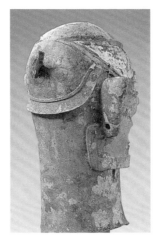

Fig. 14.4. Bronze head, (a) frontal view, (b) rear view. K2(2):137. Height 45.7 cm. After Tokyo 1998, p. 53.

15

Head

Bronze
Height 51.6 cm, greatest width 23.8 cm, width at top of head 14.6 cm, weight 5.8 kg
Twelfth century BC

Excavated from Sanxingdui Pit 2 [K2(2):58]
Sanxingdui Museum 00295

PUBLISHED: Beijing 1994a, pls. 16–18; Beijing 1994b, pls. 19–20; Tokyo 1998, no. 8; Beijing 1999a, p. 178 fig. 96, p. 181 pls. 63.2–4, p. 548; Taibei 1999, no. 9; Yang 1999, no. 68.

In shape and facial features this head resembles the last. Traces of black paint remain on the eyes and eyebrows. A large ornament soldered onto the back of the head takes the form of a curved tube with flaring ends and a constriction around the middle, perhaps a piece of cloth that tied it to the hair or hat (Figs. 15.1–2). Open ends suggest that the tube was meant to hold some further ornament, such as a plume. Below it is a curved projection—cap edge or hair fringe—even more pronounced than the one on No. 14. It is hard to guess what sort of headdress is depicted here, or how much more might have been added in other materials and now lost. The sharp triangles above the ears correspond to the upper corners of the gold mask on No. 14, suggesting a covering of gold (or paint?), and the capital H above the forehead, a device not seen on any other head, hints at some further complication. In its original, fully costumed state, the head must have been splendid, perhaps quite fantastic in appearance. Though only visible at the lips now, at the time of excavation the nostrils and ear hollows could be seen to have been smeared with vermilion; judging from the points it was applied to, this might be not coloring but something ritually offered for the head to taste, smell, and hear (or something that gave it the power to breathe, hear, and speak).

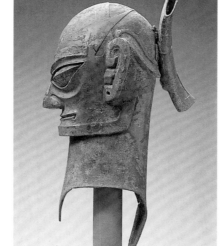 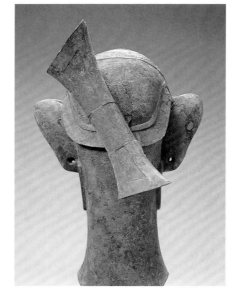

Fig. 15.1. No. 15, left side. After Tokyo 1998, p. 58 (right).

Fig. 15.2. No. 15, rear view. After Tokyo 1998, p. 58 (left).

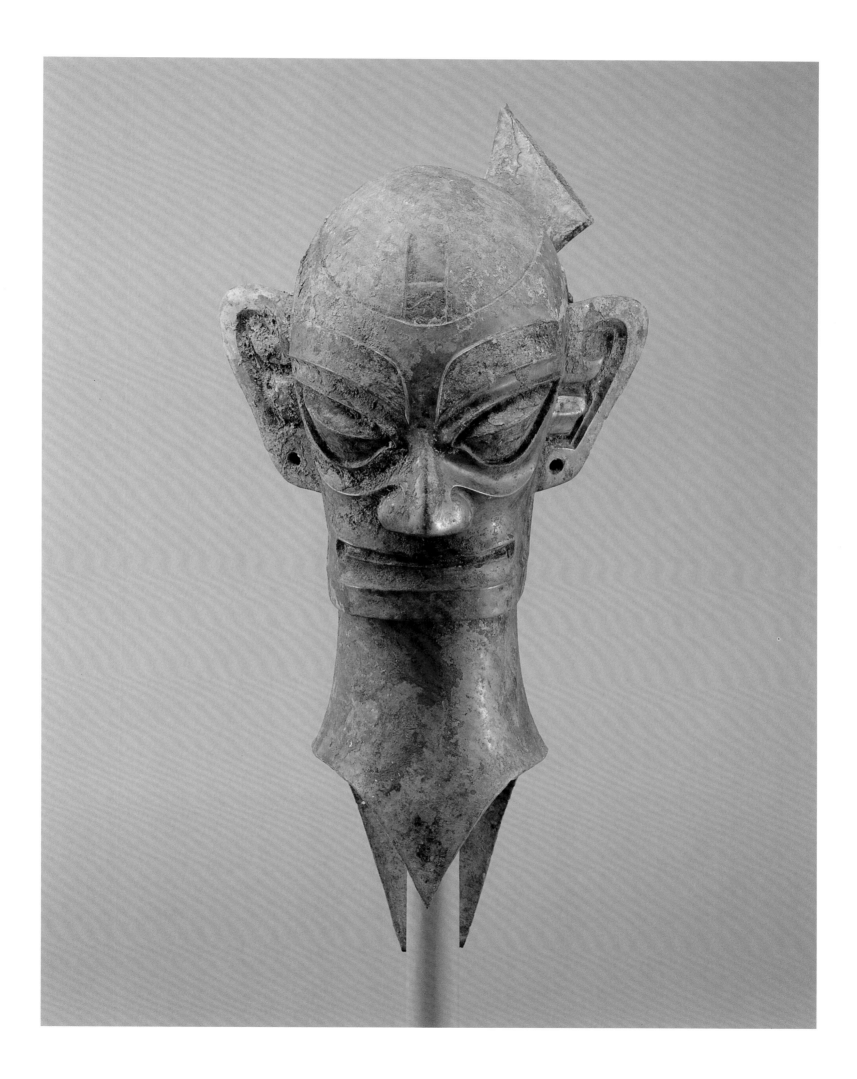

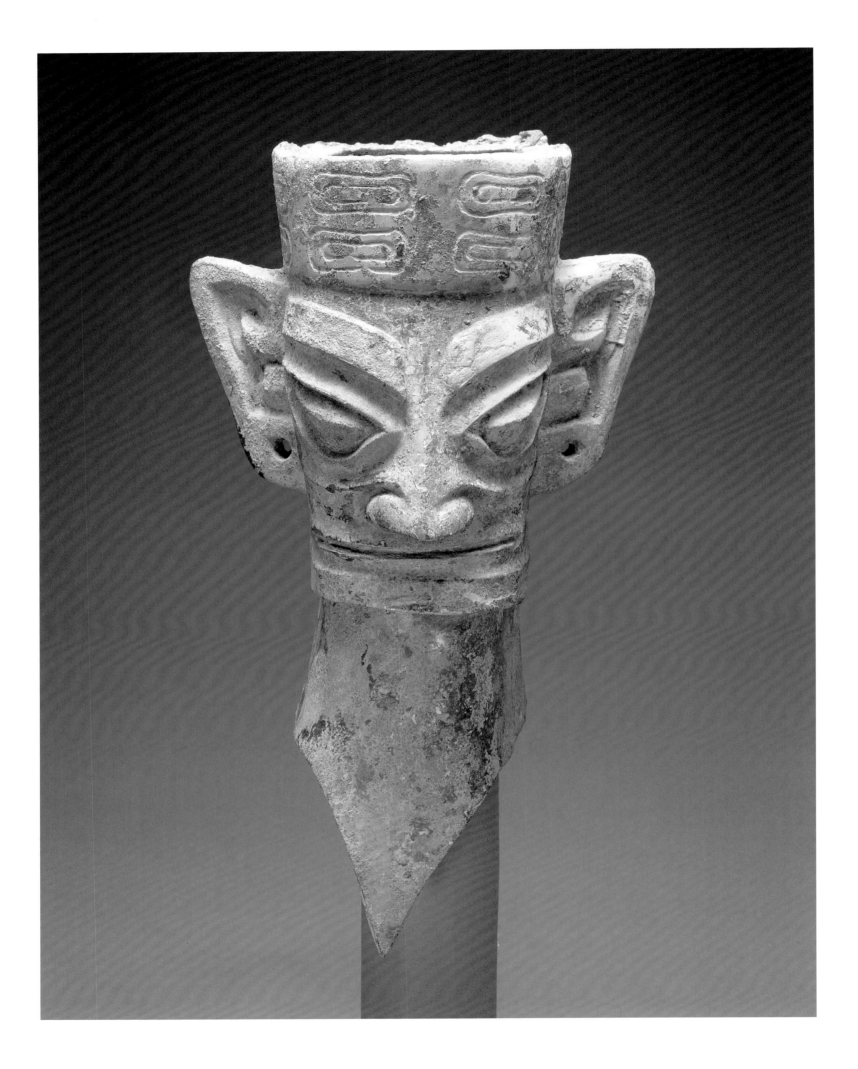

16

Head

Bronze
Height 34.8 cm, greatest width 17.2 cm,
width at top of head 10.6 cm, weight 2.081 kg
Twelfth century BC

Excavated from Sanxingdui Pit 2 [K2(2):90]
Sanxingdui Museum 00294

PUBLISHED: Beijing 1994a, pl. 20; Beijing 1994b,
pl. 16; Tokyo 1998, no. 9; Beijing 1999a, p. 177
fig. 95, p. 181 pl. 63.1, p. 547 fig. 47; Taibei 1999,
no. 11.

This head is very similar to the head of the statue
No. 2; perhaps the petalled cluster held in the head-
band of the statue imitates in bronze something that
this head wore in the original, perishable material.
Of the life-sized heads, this is the lightest, and it is
also rather poorly cast; the facial features are not
very finely shaped, and a large casting flaw at the back
of the head was repaired with a crude cast-on patch
(Fig. 16.1). The usual side-to-side mold mark is vis-
ible above the ears on the headband. Holes connect
the earlobe perforations with the interior. A small
hole in the side of the neck is one more hint that
bronze heads were mounted on bodies made in
another material.

Fig. 16.1. No. 16, rear view. After Tokyo
1998, p. 60 (right).

17

Head

Bronze
Height 13.6 cm, greatest width 10.8 cm, width at top of head 7.4 cm, weight 0.71 kg
Twelfth century BC

Excavated from Sanxingdui Pit 2 [K2(2):83]
Sanxingdui Museum 00287

PUBLISHED: Beijing 1994a, pl. 19; Beijing 1994b, pls. 17–18; Tokyo 1998, no. 76; Beijing 1999a, p. 172 fig. 88, p. 179 pls. 61.1–2, p. 546 fig. 44; Taibei 1999, no. 10.

No. 17 is most remarkable for its headgear, a braided crown or garland not seen on any other head from the pits. Below the garland the hairline is indicated all the way around the head—clipped short over the forehead, trimmed to modest sideburns at the temples, descending in back as far as the bottom of the ear. The cranium is domed. Each ear has three perforations, suggesting a multiplicity of ear ornaments.

Traces of metal overflow running from the crown onto the head indicate that the head was cast first, the crown then cast onto it. A slight inward step encircling the head, similar to that seen at the top of No. 5, may somehow have facilitated the attachment.

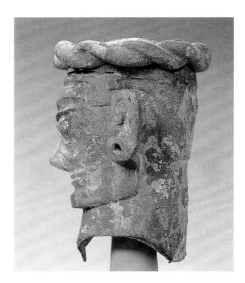

Fig. 17.1. No. 17, left side. After Tokyo 1998, p. 117 (lower).

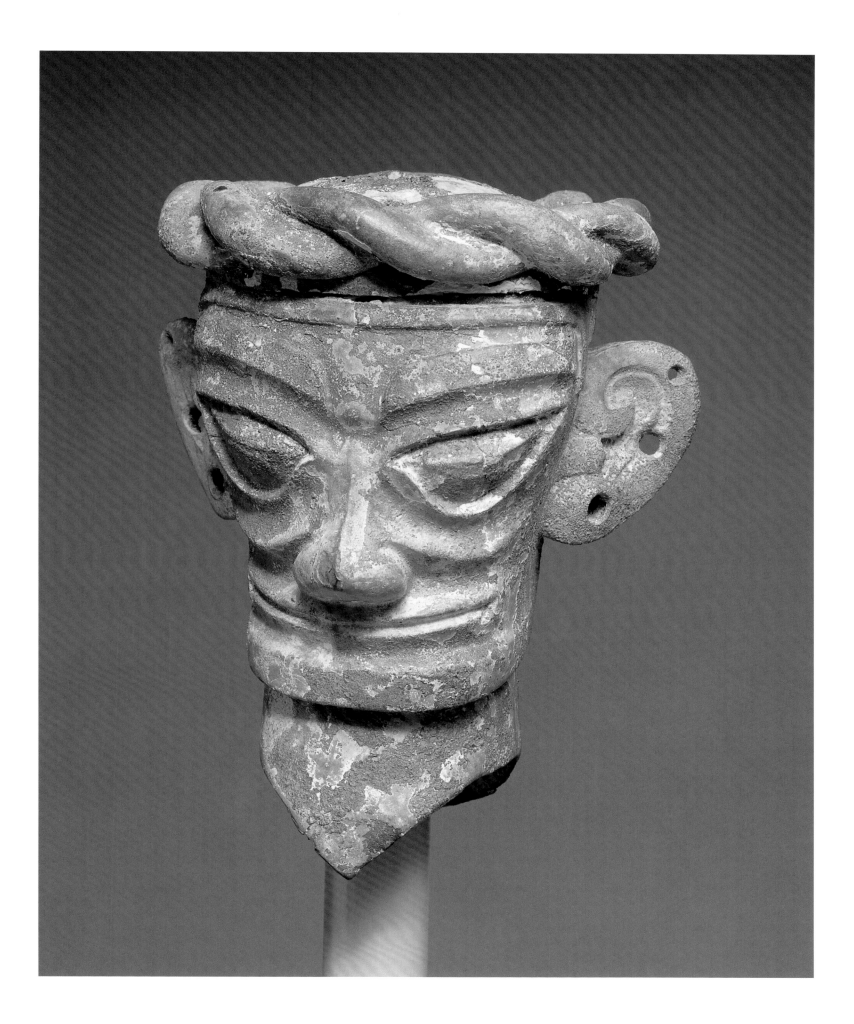

Mask

Bronze
Height 15.2 cm, width 19 cm, thickness 0.3 cm,
weight 1.12 kg
Twelfth century BC

Excavated from Sanxingdui Pit 2 [K2(2):102]
Sanxingdui Museum 00326

PUBLISHED: Beijing 1994a, pl. 34; Beijing 1994b,
pl. 27; Tokyo 1998, no. 27; Beijing 1999a, p. 193
pl. 68.3, p. 194 fig. 106.2, p. 553 fig. 55; Taibei
1999, no. 30.

No. 18 is one of twenty masks from Pit 2 with comparatively human features (by contrast with Nos. 22 and 23).[1] The word "mask" is used here to describe a shell of bronze, U-shaped in horizontal section, with no top, back, or neck (Fig. 18.1). Perhaps the shells fitted around architectural members, being secured in place through the openings usually seen in their sides or back corners. While they differ from the bronze heads in the way they were mounted, and also in their lack of headgear (in any surviving material, at least), their facial features match those of the heads exactly.

Fourteen of the twenty show signs of battering but are more or less complete; the other six are too badly damaged to be restored. The complete masks can be sorted into three sizes: five, including the present one, are about 15 cm high, making them similar in scale to the life-sized bronze heads; eight are about 25 cm high (e.g. Nos. 19–20); and a single large one measures about 40 cm high (No. 21). But an example of which only fragments survive must have been dramatically larger: a piece of its right ear measures 48 cm high, arguing that the mask as a whole was at least 80 cm high.[2]

The present mask is one of the finest, its facial features very crisply defined. Traces of black paint remain on the eyes and eyebrows, and at the time of excavation smears of vermilion were still visible on the mouth. Black paint was used also to indicate hair at the temples. Just in front of the painted hair, adjacent to the eyebrows, are two small holes that presumably helped attach the mask to whatever supported it; a third appears at the rear of the left jaw. These holes were apparently drilled after casting, a very odd proceeding, since they could much more easily have been cast.[3] The mask was cast in one pour in a mold divided vertically at the ears. As with many of the bronze heads, small openings in the inside wall run to the earlobe perforations.

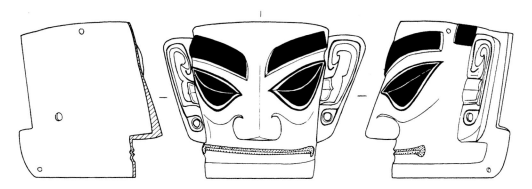

Fig. 18.1. No. 18, drawings. After Beijing 1999a, p. 194 fig. 106.2.

1. Pit 1 contained only a single mask; like the present one, it has human features (Beijing 1999a, p. 29 fig. 19).

2. The ear fragment and a fragment of the mouth 48 cm wide are illustrated in Tokyo 1998, p. 74. Chen De'an estimates that the mask was 80 cm high and 120 cm wide (*Sichuan wenwu* 1992, special issue on Sanxingdui studies, pp. 38–9). No trace of the remainder of this mask was found in the pit, leaving us to wonder what happened to it (see also Nos. 28, 36). Did the offerings for some reason include fragments of incomplete articles?

3. See the entry for Nos. 19 and 20.

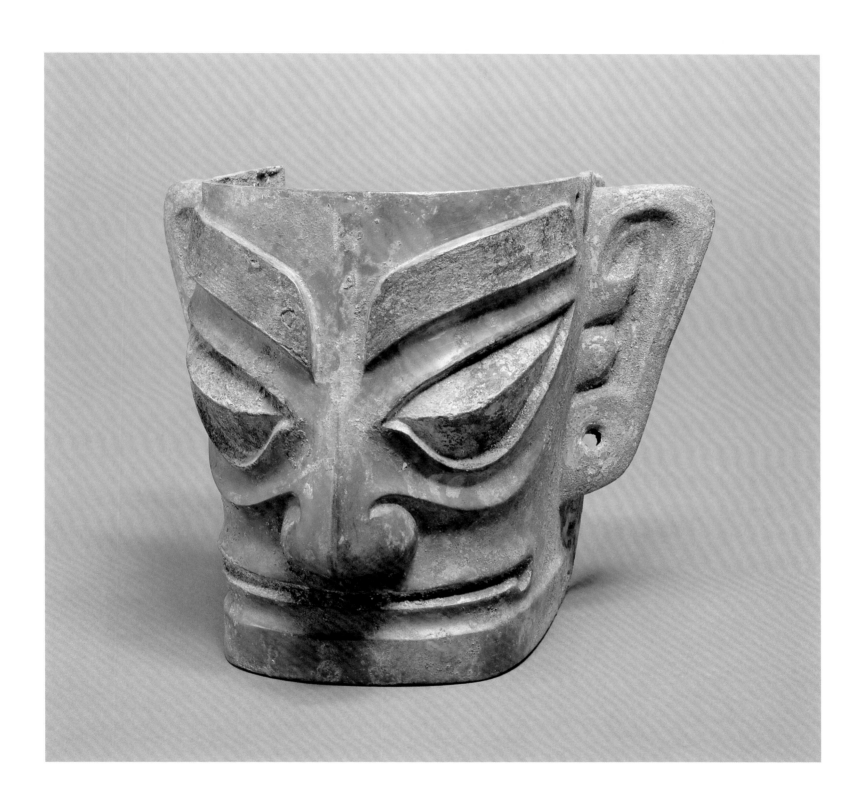

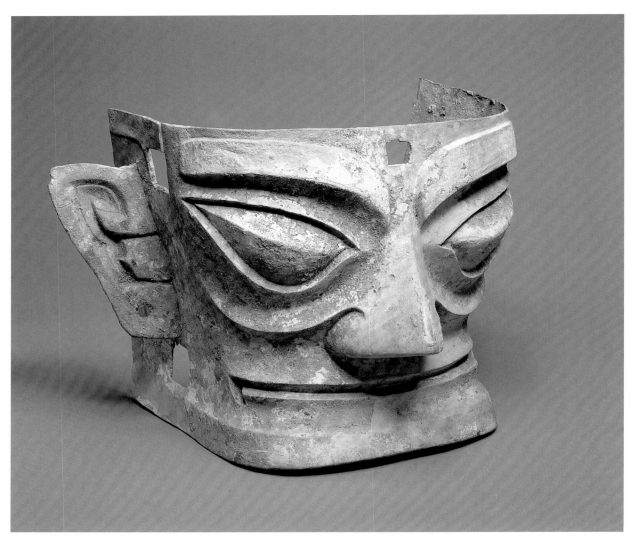

19

Mask

Bronze
Height 25.4 cm, width 41.5 cm, thickness 0.3 cm,
weight 4.2 kg
Twelfth century BC

Excavated from Sanxingdui Pit 2 [K2(2):128]
Sanxingdui Museum 00323

PUBLISHED: Beijing 1994b, pl. 28.

20

Mask

Bronze
Height 26.6 cm, width 40.2 cm, thickness 0.4 cm,
weight 4.54 kg
Twelfth century BC

Excavated from Sanxingdui Pit 2 [K2(2):114]
Sanxingdui Museum 00321

PUBLISHED: Beijing 1994a, pl. 31; Beijing 1994b,
pl. 26; Beijing 1999a, p. 190 fig. 105.1, p. 193
pl. 68.1, p. 552 pl. 53.

These two masks are of medium size, their faces substantially larger than those of the bronze heads. Each was cast without its ears, but with holes designed to receive them: the ears were cast separately, inserted into the holes, and secured with solder. On No. 19 the solder is clearly visible on the interior wall; on No. 20 traces are seen on the exterior as well (Fig. 20.1).

No. 19 has a square opening in its forehead; marks scored around it show that it was made after casting. On No. 20 the square is scored but the opening was never made (was the mask put into the pit unfinished?). Openings so prominently visible are unlikely to have been used for mounting the masks; it is more likely that they were intended to attach some ornament now lost (or never completed)—compare No. 23. Similar openings in the sides of both masks, by contrast, were probably for mounting. The four on the sides of No. 20 were cut into the metal after casting, but the four on the sides of No. 19, unlike the one in its forehead, may have been cast. In the absence of steel tools, sawing and drilling bronze

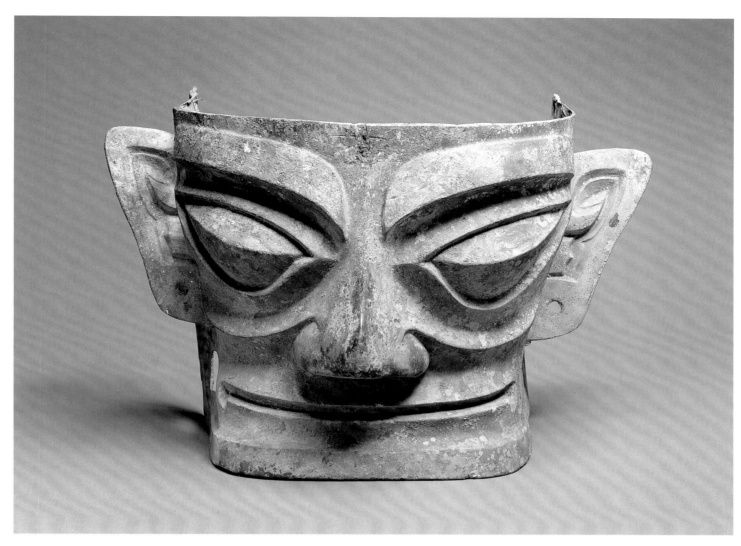

20

cannot have been easy; they may even have had to be done with abrasives. It is at least conceivable that sawn and drilled holes were additions meant to adapt to a new mode of display masks that had originally been mounted in some other way; this in turn might hint that these objects had been in use for some time before their deposit in the pits. Drilled holes in the bronze vessels (Nos. 45, 48–9) are easier to understand, since those were imports that might have needed alteration to serve local purposes.

Fig. 20.1. No. 20, right side. After Beijing 1999a, p. 552 fig. 53.

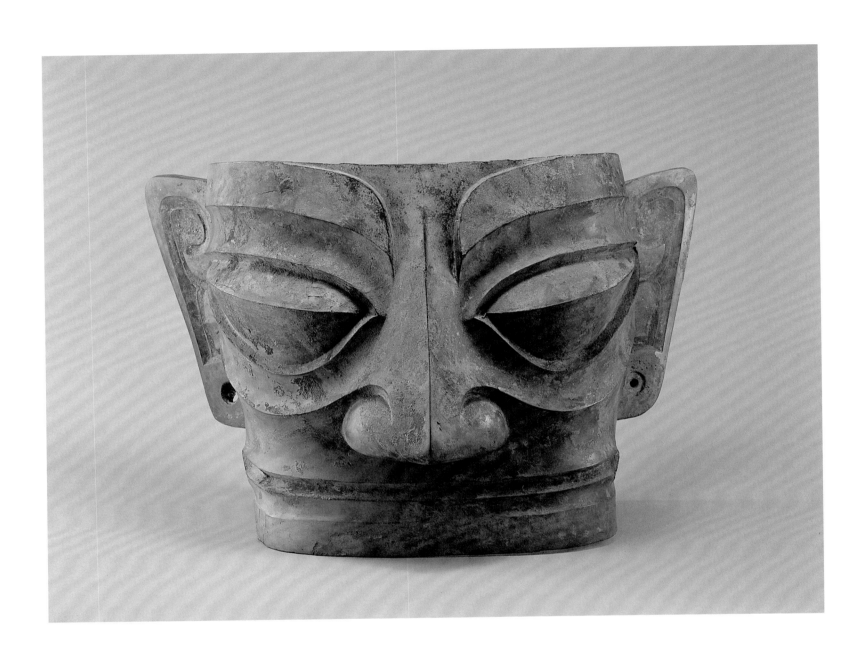

21

Mask

Bronze
Height 40.3 cm, width 60.5 cm, thickness
0.6 cm, weight 13.4 kg
Twelfth century BC

Excavated from Sanxingdui Pit 2 [K2(2):153]
Sanxingdui Museum 00317

PUBLISHED: Beijing 1994a, pl. 33; Tokyo 1998,
no. 23; Beijing 1999a, p. 189 fig. 103.2, p. 191
pls. 66.2–3, p. 551; Taibei 1999, no. 23; Yang
1999, no. 70.

The largest of the intact human masks, No. 21 has
a calm gaze made all the more impressive by facial
features enlarged to the point of crowding the sur-
face: the eyebrows touch the upper edge, the eyes
and nose fill half the face. Traces of vermilion were
visible in the grooves of the mouth at the time of
excavation.

Like No. 18, this mask was cast in one piece. The
mold was divided vertically at the ears. Openings in
the inside wall run to the earlobe perforations (see
No. 10). One spacer is visible in the upper facet of the
right eye, others in the eyebrows. Six small mounting
holes at the temples and back corners were apparently
all cast.

Fig 21.1. No. 21, rear view. After Tokyo 1998, p. 76.

22

Mask with protruding pupils

Bronze

Height 66 cm, width 138 cm, depth 73 cm

Twelfth century BC

Excavated from Sanxingdui Pit 2 [K2(2):148]

Sanxingdui Museum 00501

PUBLISHED: Beijing 1994a, pls. 27–8; Beijing 1994b, pl. 29; Rawson 1996, p. 18 fig. 7; Tokyo 1998, no. 18; Beijing 1999a, p. 197 fig. 110, p. 200 pl. 71.1, p. 555; Taibei 1999, no. 31.

Its size and the monstrous pupils of its eyes make this one of the most weirdly supernatural of all the Sanxingdui sculptures. Pointed ears raised alertly may mean that the creature's hearing is as acute as its sight. The facial features are drawn in sweeping curves; the usual ridges on the cheekbones spiral elegantly into the corners of the beaklike nose. Unlike the soberly straight mouths of most of the other heads and masks, the mouth here smiles in a long arc that rises almost parallel to the cheekbone ridges. Two smaller masks, No. 23 and the one shown in Fig. 23.4, have similar features, more animal-like than human. It is possible that additional masks of the same kind but made in a perishable material were destroyed during the sacrifice, for 33 telescope-like bronze pupils were found by themselves in the pit.[1]

The shape and the square apertures at the back corners suggest that this mask was displayed in the same fashion as the masks with more nearly human features (Nos. 18–21). The opening in the forehead, which has particularly heavy scorings visible at its corners, must have held some appendage, perhaps a trunk like that of No. 23. The crack that runs across the mouth and chin may be damage inflicted intentionally before burial. Elsewhere, for instance on the left pupil, dents are clearly visible.

The mask was made in six pieces, five of which were precast and embedded in the mold for the sixth. The precast parts are the ears, the pupils, and, unexpectedly, the triangular underside of the nose, on which the hollows of the nostrils are indicated. The mold for the main pour required a rear section (or core) and one or at most two sections for the front of the mask.

Fig. 22.1. No. 22, rear view.

1. Beijing 1999a, pp. 209–17. Alternatively these pupils may represent precast parts of masks that were never made. A number of objects in the two pits are incomplete or look unfinished.

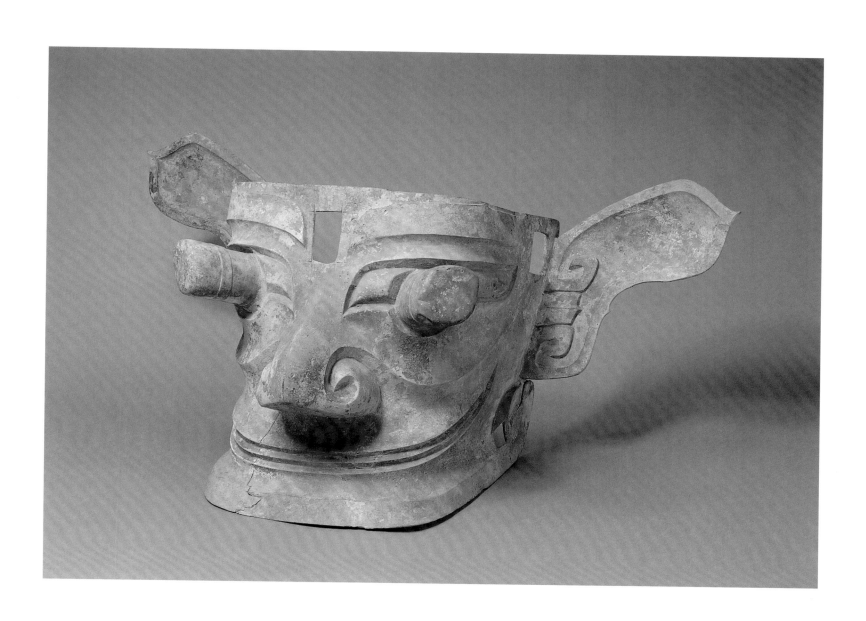

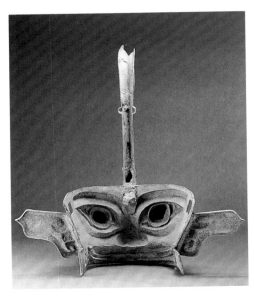

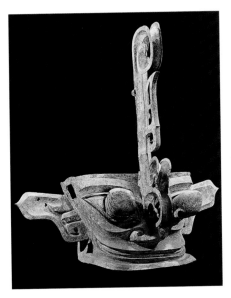

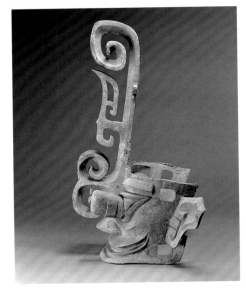

Fig. 23.1. No. 23, rear view. After Rawson 1996, fig. 25.2.

Fig. 23.2. No. 23, right side. After Taibei 1999, p. 80.

Fig. 23.3. No. 23, left side. After Yang 1999, p. 217.

23

Mask with protruding pupils and trunk

Bronze
Overall height 82.5 cm, height of mask 31.5 cm, width 77 cm
Twelfth century BC

Excavated from Sanxingdui Pit 2 [K2(2):142]
Sanxingdui Museum 00645

PUBLISHED: Beijing 1994a, pl. 30; Beijing 1994b, pl. 30; Rawson 1996, no. 25; Tokyo 1998, no. 19; Beijing 1999a, p. 197 fig. 108, p. 199 pls. 70.1–3, p. 554; Taibei 1999, no. 32; Yang 1999, no. 69.

This mask has the same telescopic pupils, floppy ears, and wide grin as the last, but the viewer's attention is diverted from them by the fantastic excrescence that rises periscope-like above the nose. This spirals inward at the top, has a double spiral at the bottom, and in the middle carries a quill-like element.[1] A little below the spiral at the top are two tiny loops that might have held dangling ornaments. A second mask from the same pit is nearly identical to this one (Fig. 23.4).

The mask was made in six pieces: the ears, the pupils of the eyes, the periscope-like trunk, and the face to which these elements are attached. The pupils of the eyes, like those of No. 22, were precast: from the rear it is easy to see that the metal of the face locks around them (Fig. 23.1), but on the front the join was reinforced with solder. The trunk was cast on through a hole left on the forehead, while the ears were soldered on: next to the right ear the metal of the join can be seen to flow onto the ear and also onto the face (Fig. 23.2). Four openings at the back corners seem to have been cut into the metal after the mask was cast (Fig. 23.3). It was found with the upper part of the trunk broken off; the break is just below the quill-like element.

Fig. 23.4. Bronze mask with trunk-like projection. K2(2):144. Overall height 84.3 cm, height of mask 31 cm, width 78 cm. After Beijing 1999a, p. 197 fig. 109.

1. This quill is a recurrent type-form at Sanxingdui (see e.g. Fig. 38.1, projecting from the back of a snake; No. 43, projecting from the openwork base; Beijing 1999a, pp. 345–6). It might derive ultimately from the two-dimensional surface decoration of transition-period bronzes (compare No. 44, the pattern on the bodies of the tigers).

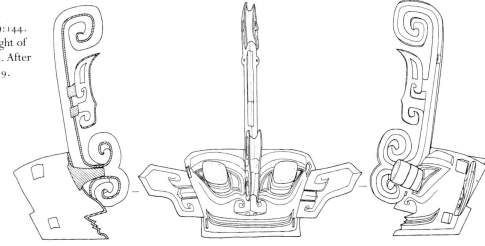

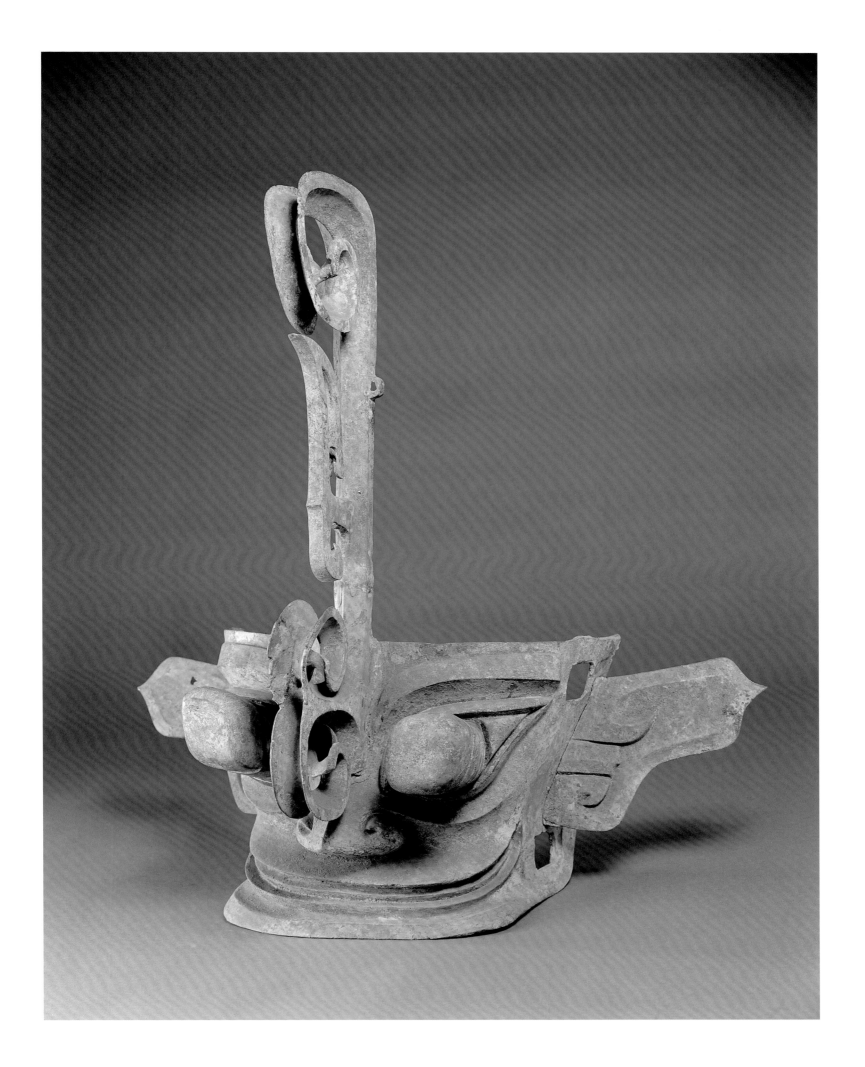

24a

24A

Plaque of taotie *face*

Bronze
Height 21.6 cm, width 39 cm, thickness 0.2 cm,
weight 545 g
Twelfth century BC

Excavated from Sanxingdui Pit 2 [K2(3):228]
Sanxingdui Museum 00331

PUBLISHED: Beijing 1994a, pl. 37; Tokyo 1998,
no. 32; Beijing 1999a, p. 198 fig. 111.1, p. 200
pl. 71.2, p. 556 fig. 59; Taibei 1999, no. 35.

24B

Plaque of taotie *face*

Bronze
Height 20.4 cm, width 23.4 cm, thickness 0.2 cm
Twelfth century BC

Excavated from Sanxingdui Pit 2 [K2(3):227]
Sanxingdui Museum 00649

PUBLISHED: Beijing 1994a, pl. 38; Rawson 1996,
no. 26; Tokyo 1998, no. 35; Beijing 1999a, p. 198
fig. 112.2, p. 202 pl. 72.3; Taibei 1999, no. 38.

1. All nine are illustrated in Tokyo 1998, pp. 82–7.

Pit 2 yielded nine plaques in the form of animal-like faces, three each of three slightly different types.[1] The first two types, represented by Nos. 24a and 24b, average about 20 cm in height; the third is smaller (Fig. 24.3). In design these faces are related not to the Sanxingdui heads and masks but to the *taotie* faces that decorate bronze vessels made elsewhere in China, in particular to transition-period *taotie* like those seen on No. 48. Often on transition-period bronzes, but seldom later, the *taotie* was drawn with its mouth depicted from the front, as on No. 48; later the jaws were instead shown in side view, once on each side of the face (No. 49, main register). All the plaques were made by casting, and all have small holes for attachment to a backing.

No. 24a has large lozenges for eyes, a slender nose ending in flared nostrils, and a widely grinning mouth full of teeth. Directly above the eyes, spiralling crests or horns stand on the upper edge of the plaque. Although the large hooks at the top corners of the plaque are more horn-like, similar hooks in *taotie* designs often seem instead to represent bodies duplicated for symmetry (compare Figure 44.3). The eyebrows are stretched sideways almost to the tips of these bodies, which the ears of the face seem to prop up. Tiny prongs indicate the canthi of the eyes. The pupils were painted in black, traces of which remain on the right eye.

No. 24b is the same but for the addition of an element below the chin. This is decipherable as a pair of large eyes that are not simple lozenges but instead consist of a large circular pupil flanked by elements representing the inner and outer canthus (compare the eyes of the *taotie* in the main register of No. 49). Other plaques in Pit 2 take the form of similar eyes in isolation (Fig. 42.1). Elegantly drawn versions of the same eyes appear on the pedestal of the statue No. 2; they are a standard design element on bronzes as early as the Erligang period (*c.* 1500–1300 BC), with antecedents at Erlitou.

24b

The third type of plaque, represented by the example in Figure 24.3, has these more elaborate eyes on the mask itself. Here, however, the outer canthi are prolonged so that they rather than the eyebrows (which are missing) reach onto the hooks at the upper corners of the plaque.

What is particularly obvious on this last example, but noticeable on Nos. 24a and 24b as well, is that the outer corners of the mouth turn downward, just as they do on most of the Sanxingdui heads and masks (e.g. Nos. 5, 15, 20). This is perhaps the clearest single indication that the plaques were cast at Sanxingdui. At the same time it suggests the interesting possibility that this Sanxingdui trademark might be a local exaggeration of a detail that Sanxingdui casters first encountered in the *taotie* of some imported transition-period bronze.

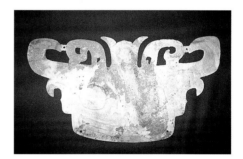

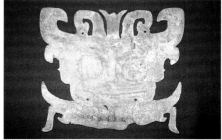

Fig. 24.1. No. 24a, rear view.

Fig. 24.2. No. 24b, rear view.

Fig. 24.3. Bronze plaque of *taotie* face. K2(3):98. Height 12.5 cm, width 28.2 cm. After Tokyo 1998, p. 83 no. 30.

Seated human figure

Bronze
Height 14.6 cm, width 8.2 cm, weight 746 g
Thirteenth or twelfth century BC

Excavated from Sanxingdui Pit 1 [K1:293]
Sanxingdui Museum 00101

PUBLISHED: Beijing 1994a, pl. 25; Beijing 1994b,
pl. 1; Tokyo 1998, no. 125; Beijing 1999a, p. 29
fig. 18, p. 32 pls. 5.3–4, p. 525 fig. 5; Taibei 1999,
no. 46.

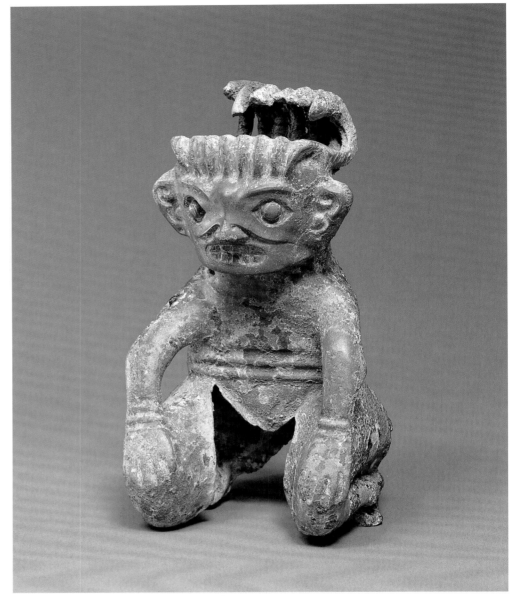

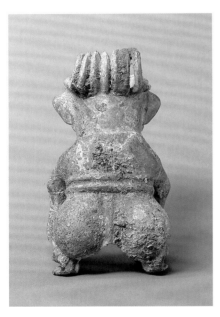

Fig. 25.2. No. 25, rear view.

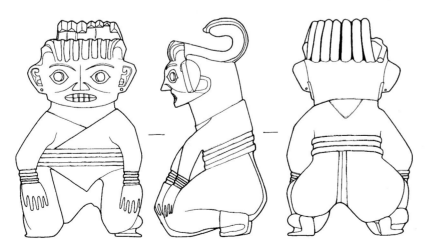

Fig. 25.1. No. 25, drawings. After Beijing 1999a, p. 29 fig. 18.

This small figure, sitting on his heels, sports a unique hairdo that rolls backward, then sweeps forward again to stop in mid-air (Fig. 25.1). The goggles around the figure's eyes recall the facial features of the bronze heads and masks (Nos. 5–21), but the mouth full of teeth is entirely different. A robe that covers the upper part of the body exposes a V-shaped area at the neck on both back and front; in front the left lapel lies over the right, as seems to be usual on clothed figures from the pits (compare No. 26, and the middle garment, though not the outer garment, of the statue No. 2). It is not clear whether the robe extends below the belt: in front the figure is damaged, but his plump hindquarters seem bare apart from a loincloth (Fig. 25.2). He does apparently wear socks or shoes.

Plaque in the form of
a kneeling figure

Bronze
Height 13.3 cm, width 5.5 cm, weight 89 g
Twelfth century BC

Excavated from Sanxingdui Pit 2 [K2(3):04]
Sanxingdui Museum 00284

PUBLISHED: Beijing 1994a, pl. 26; Beijing 1994b,
pl. 3; Tokyo 1998, no. 74; Beijing 1999a, p. 168
pl. 59.5, p. 170 fig. 85.3, p. 545 fig. 42; Taibei
1999, no. 47.

This small figure, a plaque hollow at the back, kneels
with one leg bent, the other knee touching the
ground. His legs turn to the side, but his head and
chest face front. His head, unlike that of No. 25, is
a miniature version of bronze heads like Nos. 7–10,
though his headdress is a little different. Black paint is
very distinct on the eyebrows, the pupils of the eyes,
and the eyelids as well. The figure wears a belted robe
and shoes; perforations in the shoes suggest that the
plaque was attached to something else.

At least six other small figures from Pit 2 have the
same headdress, with hooked projections rising from
the back. One is the strange hybrid No. 29. Two re-
semble the present figure in being hollow shells of
bronze, but they are perfectly symmetrical, sitting on
their heels and facing forward.[1] Three more are the
fully three-dimensional figures seen on the base of
the tree No. 28.

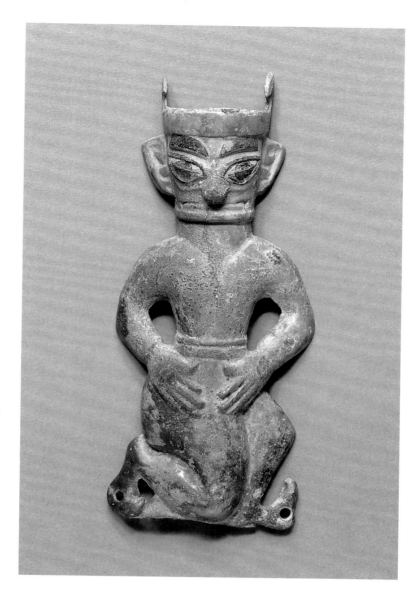

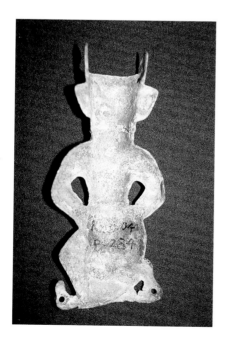

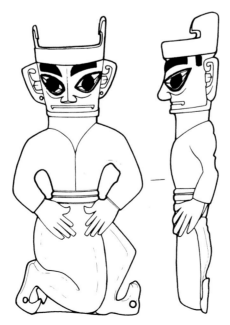

Fig. 26.1. No. 26, rear view.

Fig. 26.2. No. 26, drawings.
After Beijing 1999a, p. 170
fig. 85.3.

1. Beijing 1999a, p. 168 pls.
59.3–4, p. 170 figs. 85.1–2;
Beijing 1994b, pl. 2.

Tree

Bronze
Overall height 396 cm, height of trunk 359 cm,
diameter of base 93 cm
Twelfth century BC

Excavated from Sanxingdui Pit 2 [K2(2):94]
Sanxingdui Museum 00498

PUBLISHED: Beijing 1994a, pls. 42–4, 46; Beijing
1994b, pl. 37; Rawson 1996, p. 19 fig. 8; Tokyo
1998, no. 47; Beijing 1999a, p. 218 pl. 81, foldout
page facing p. 218, p. 558.

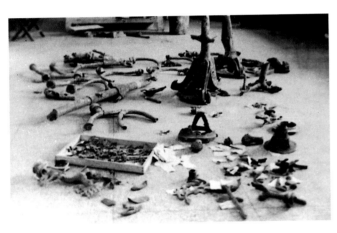

Fig. 27.1. No. 27 before restoration (the photograph
shows also No. 28 and two smaller tree bases).

1. According to the restorer, Yang Xiaowu (personal com-
munication, October 1999), the circular base of the tree
was especially badly damaged, broken into more than
twenty fragments. The remainder was found in about forty
pieces. Restoration was done mainly with adhesives, but
solder was used occasionally in places where it could be
hidden inside, for instance on parts of flowers and calyxes.
Mr. Yang took particular care not to obscure mold marks
and joins on the exterior; all traces of joins now observable
from the outside, he says, are original.

2. See e.g. Bagley 1987, p. 78 fig. 47, a bronze from Pan-
longcheng demonstrating that the motif had been transmit-
ted from the Zhongyuan to the middle Yangzi region by the
Erligang period.

3. See pages 61–5 in this chapter for more detailed discus-
sion of the tree's fabrication.

4. Another tree-like object from Pit 2 has stems and
branches that are themselves rope-like (Fig. 29.4); at its top
perch hybrids like No. 29.

This bronze tree, nearly 4 m high, must originally have been an even more astonishing
sight than it is now. It was found badly broken (Fig. 27.1), and although its basic features
have been reconstructed by the restorer, many ornaments that were suspended from it or
permanently attached to it cannot be returned to their proper places. Some sort of finial
must have stood on top, but whether it was a bird like No. 31, a harpy like No. 29, or
something else, is not known.[1]

The base of the tree is a ring with a heavy tripod on it, something like the foot of a
lectern or a music stand. The smooth arch that sweeps from one leg of the tripod to the
next, seen also on the smaller tree base No. 28, recalls the wavy design drawn on the
stone blade No. 53. A strip at the lower edge of each arch is decorated with an eye-and-
diagonal pattern that is seen again on No. 28, and in something closer to its original form
on the statue No. 2, on the block at the top of the pedestal; this pattern originated in the
surface decoration of Zhongyuan bronzes.[2] The base was cast in one piece, in a mold di-
vided on the axes of the tripod legs. The trunk of the tree was made separately and joined
to the base by running a separate pour of metal between them. The branches, assembled
from about a hundred individually made components, were joined to the trunk in the
same way.[3]

The tree has altogether nine branches attached to the trunk in groups of
three. Each branch produces a flower (or a fruit?) at the top of its arc, on
which sits a bird; a second flower grows at the tip of the branch. In each
group of three branches, one bifurcates and produces three flowers instead
of two. The bifurcating branches are all on one side of the tree; on the other
side, an odd dragon standing on the circular base sends a rope-like body
undulating up the trunk, to which it is joined by two struts (Fig. 27.2). The
body is now incomplete, rising only about halfway up the tree; originally it
must have gone all the way to the top, for the stumps of two more struts are
still visible, one of them near the top (Fig. 27.3a).[4]

This dragon—so called merely for convenience—is an odd creature, not
obviously related to the animals on bronzes from elsewhere in China, much
less to the Chinese dragons of more recent times. Its head is quite flat, with a

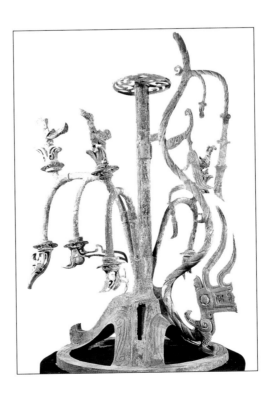

Fig. 27.2. No. 27, lower half.
After Beijing 1994a, pl. 42.

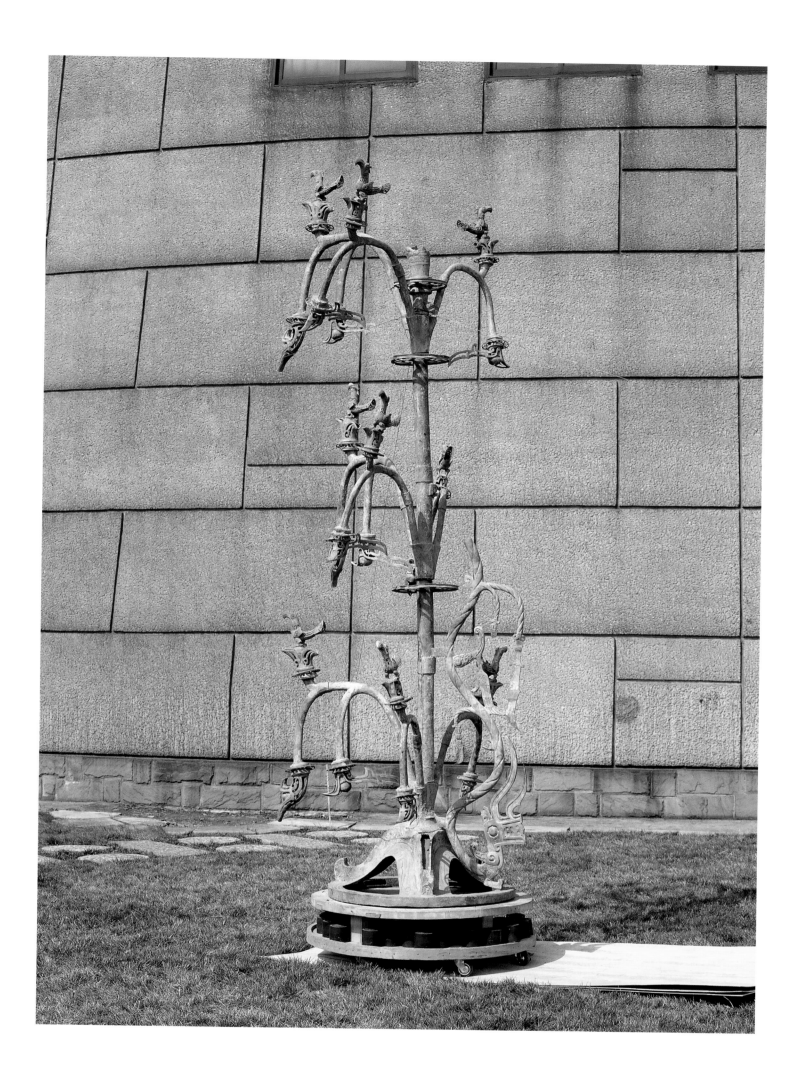

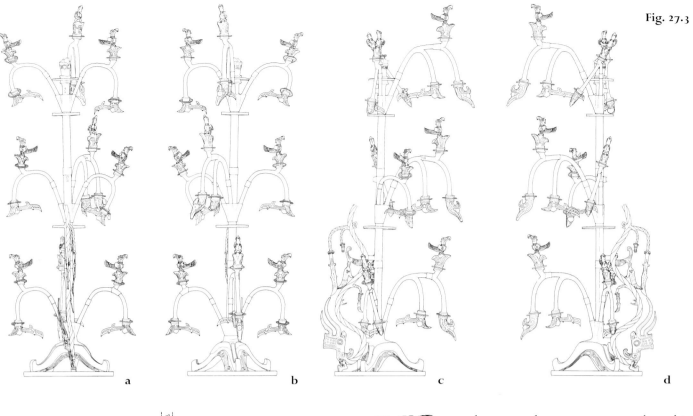

Fig. 27.3

a b c d

Fig. 27.4 **Fig. 27.5**

Fig. 27.3. No. 27, drawings. After Beijing 1999a, foldout page facing p. 218.

Fig. 27.4. Fragment of bronze tree with a bronze collared disk attached to the trunk. K2(3):204, 261. Overall height 59.7 cm, diameter of disk 8.8 cm. After Beijing 1999a, p. 222 fig. 123.1.

Fig. 27.5. Fragment of bronze tree with a jade collared disk attached to the calyx of a flower. K2(3):20. Overall height 50 cm. After Beijing 1999a, p. 225 fig. 124.

large round eye, an open mouth, and two rhinoceros-like horns billowing above its snout. Below its neck it seems to have a small wing. Its long body issues from beneath the wing, as does the one small leg on which it balances. In its undulating course toward the top of the tree, the body carries a couple of small hooks or prongs, and it sprouts some extraordinary pendants, two shaped like feathers or knife blades, one shaped like a hand with long fingers.

The rest of the tree, too, must have been heavily decked with pendants: small perforations from which ornaments could have been hung are seen in many places, such as the beaks of the birds and the open-work projections from the downward-facing flowers. Not surprisingly, the pit yielded many small objects provided with suspension holes or suspension apparatus, among them the little bells Nos. 34 and 35, but where on the tree (indeed on which tree) these objects should be hung cannot be determined.[5] Besides the various pendants, the tree may also have had ornaments that were movable but permanently attached, such as disks of jade or bronze strung on the branches before the branches were attached to the trunk: examples were found on fragments of branches belonging to other trees (Figs. 27.4–5, 28.1).

5. For pendants other than bells see Beijing 1999a, pp. 289–325.

28

Tree (fragment)

Bronze
Overall height 193.6 cm, height of trunk
142 cm, diameter of base 54.8 cm
Twelfth century BC

Excavated from Sanxingdui Pit 2 [K2(2):194]
Sanxingdui Museum 00499

PUBLISHED: Beijing 1994a, pls. 40–41; Beijing
1994b, pl. 38; Tokyo 1998, no. 48; Beijing 1999a,
p. 220 fig. 121, p. 223 pl. 82, p. 559 fig. 64; Taibei
1999, no. 52.

No. 28 is part of a tree that must originally have been
about half the size of No. 27. The fragment shown
here comprises the base, a portion of the trunk, and
the stumps of three branches. A separate short section
of trunk with a branch attached to it is believed by
the excavators to belong to the same tree (Fig. 28.1).
The branch has two flowers with a bird on one of
them, and it is strung with bronze disks just behind
the flowers. The remaining parts of the tree seem
never to have been interred in the pit. For whatever
reason, some of the objects in Pit 2 were deposited
incomplete or fragmentary.

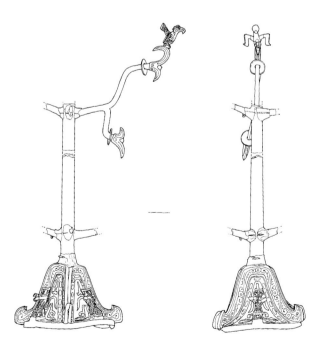

Fig. 28.1. No. 28, drawing, showing also a branch that prob-
ably belonged with it. After Beijing 1999a, p. 220 fig. 121.

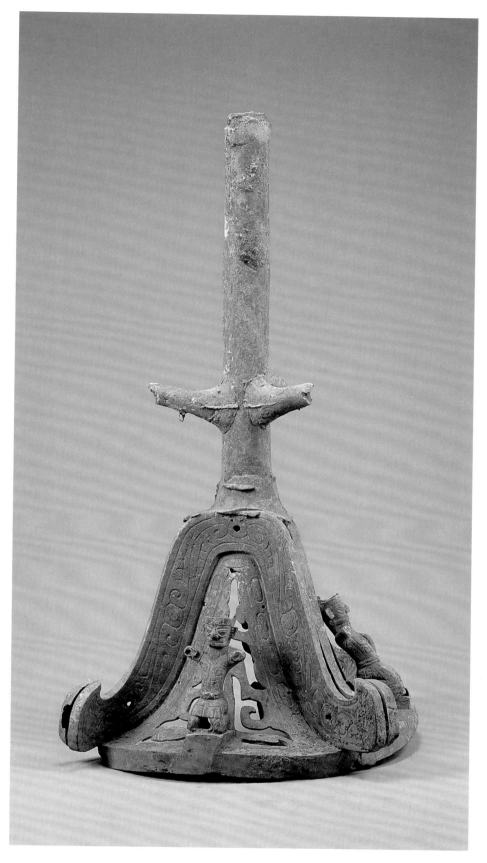

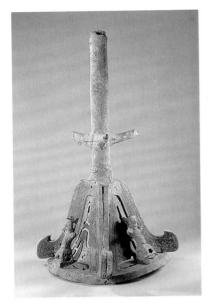

Fig. 28.2. No. 28. After Tokyo 1998, p. 99.

Fig. 28.3. No. 28, damaged side.

Like that of No. 27, the base is a tripod of boldly arched forms, but here the openings in the arches are occupied by panels of openwork, in front of which small figures kneel or sit on their heels. Unlike the simpler base of No. 27, which was cast in one piece, this one was made in six pieces, the three figures and the three arched units that frame them. Ignoring the figures for a moment, each third of the base—the framing arch, the openwork within it, and the molded rim below the openwork—was cast as a separate piece. The three pieces were fitted together and joined rather crudely by a run-on pour of metal at the top (the same pour that attached the trunk to the base) and by three soldered joins in the molded rim at the bottom.[1] The kneeling figures were then soldered in place. As on No. 27, the join connecting the branches to the trunk was made by running on.

Although the figures on the base and others similarly posed are conveniently described as kneeling, it is possible that what is depicted here is a formal seated posture. Their heads resemble the large heads in the pits. They wear patterned, belted robes that end above the knee; under the robes they seem to wear trousers. Their missing forearms were perhaps extended in an offering gesture, like the arms of the statue No. 2 and many smaller figures.

The arched shape so prominent on the bases of Nos. 27 and 28 is a recurrent motif on objects from Pit 2, including the base of another tree (Fig. 28.4) and the stone blade No. 53.[2] In view of the contexts in which the motif occurs, we might wonder whether it is meant to signify hills—hills where trees grow and where the figures on No. 28 perform a ritual. Trees at any rate were central to the sacrifice in Pit 2. A substantial proportion of the objects in the pit, including some of the most impressive, were trees, ornaments for trees, and creatures that inhabit trees, birds above all. Parts of at least two trees smaller than Nos. 27 and 28 were found. Of one only a damaged circular base 26 cm in diameter survives (Fig. 28.4). The other, more nearly intact and very strange—a sort of bush with rope-like branches—measures 50 cm high (Fig. 29.4). Likely ornaments for trees include small dragon heads (some resembling the dragon on No. 27), birds (Nos. 30, 31), and bird-human hybrids (No. 29).[3]

1. These may be run-on joins (since a third of the base is missing, only one of them survives). A number of small holes in the arched sections might have been intended to receive further pours of run-on metal so as to reinforce the assembly, but if so, most of them were not used (Fig. 28.2). However, halfway down the side of one arch, one such hole was filled by a pour of metal that formed a plug connecting two adjacent pieces, like a sort of cast rivet; the plug can be seen on both pieces. This plug, very neat, is visible in two published illustrations—Beijing 1994a, pl. 41, and Beijing 1994b, pl. 38—halfway down the left side of the arch, where it coincides with the eye of the eye-and-diagonal pattern.

2. Further examples include the bronze altar(?) reconstructed in Introduction Part 1, Figure 8 (the motif is supported on the heads of the standing figures) and Beijing 1999a, p. 230 fig. 128 (there described as a tree base but perhaps the base for something else), p. 234 fig. 131, p. 235 fig. 132.

3. For further examples see Beijing 1999a, pp. 227–9 fig. 126 and pls. 84–5, p. 328 fig. 182, pp. 335–41.

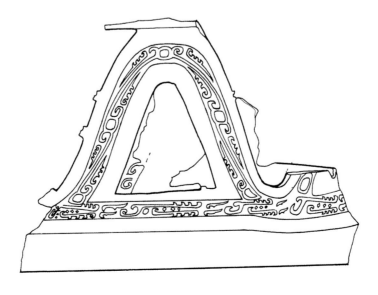

Fig. 28.4. Damaged bronze tree base. K2(3):17. Height 20 cm, diameter 26 cm. After Beijing 1999a, p. 230 fig. 127.

Bird with human head

Bronze
Height 12 cm
Twelfth century BC

Excavated from Sanxingdui Pit 2 [K2(3):154]
Sanxingdui Museum 00650

PUBLISHED: Beijing 1994a, pl. 45; Rawson 1996,
no. 30; Tokyo 1998, no. 49; Taibei 1999, no. 53.

This small object, a bird with a human head perched
on a flower or fruit, is probably a fragment of a tree
(compare Fig. 29.4). The head is shaped like the
larger human heads from the pits, but its eyes have
round pupils and its nose is a little like a bird's beak.
The figures on the base of the tree No. 28 wear simi-
lar headgear, but here the upturned ends are more
elaborate.

The bird is missing its right wing and its tail. In
Figure 29.3 these missing portions are restored, the
reconstruction of the tail being based on other frag-
ments from Pit 2. Each wing emerges from a deeply
carved spiral at the bird's shoulder, then turns 90
degrees to face front and splits into two plumes spi-
ralling in opposite directions. If the reconstruction in
Figure 29.3 is correct, the tail, of which only a tubu-
lar stump remains (Fig. 29.1), was also split into two
branches (compare No. 31). The lower edge of the
surviving wing is pierced with two holes, from which
small ornaments could have been suspended.

The fusion of human and bird is seen again, but in
quite different form, on the bizarre object No. 36.

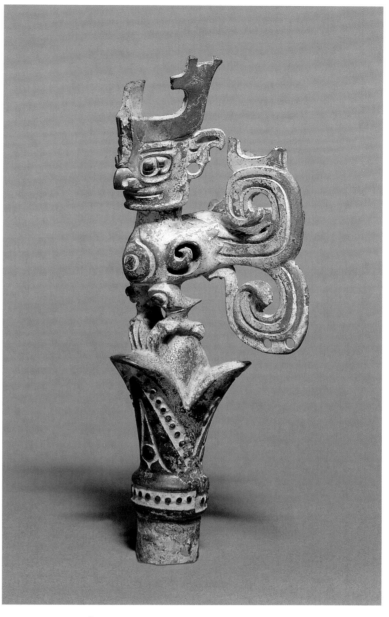

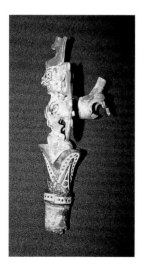

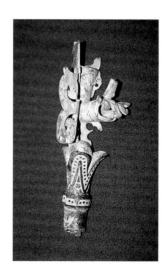

Fig. 29.1. No. 29, side view.

Fig. 29.2. No. 29, rear view.

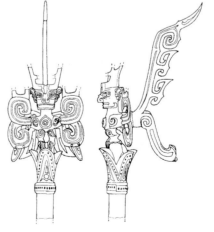

Fig. 29.3. No. 29, reconstruction drawing. After Taibei
1999, p. 99.

Fig. 29.4. Reconstruction of fragmentary bronze tree.
K2(3):272. Height 50 cm. After Beijing 1999a, p. 226
fig. 125.

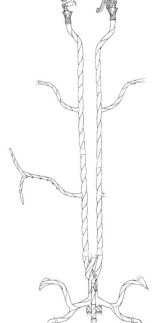

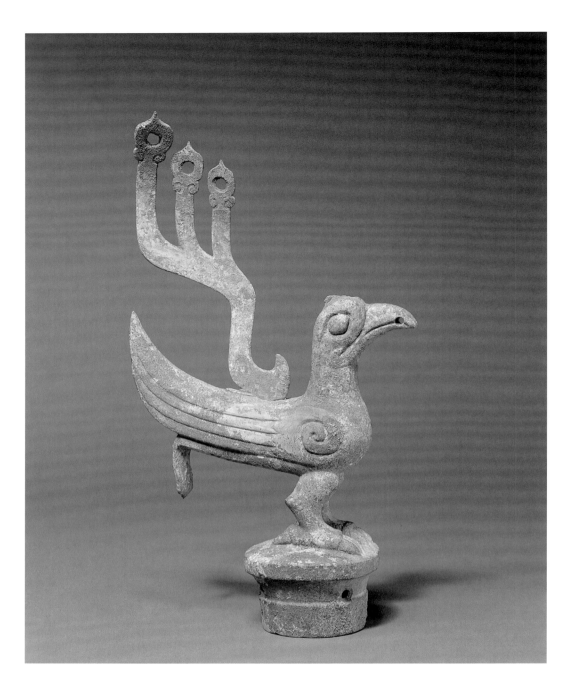

30

Bird on a post

Bronze
Height 27.8 cm, width 15.4 cm, weight 987 g
Twelfth century BC

Excavated from Sanxingdui Pit 2 [K2(3):301-3]
Sanxingdui Museum 00437

PUBLISHED: Beijing 1994a, pl. 51; Beijing 1994b,
pl. 43; Tokyo 1998, no. 63; Beijing 1999a, p. 335
fig. 185.3, p. 338 pl. 128.2, p. 570 fig. 85; Taibei
1999, no. 66.

This bird stands on a short domed tube of unknown purpose. Rising from its back is an ornament with pronged circles, representing perhaps the eyed plumes of a peacock. On the next bird, No. 31, similar ornaments emerge from the head. This one is missing its crest and also whatever ornament was suspended from the perforation in its beak. Mold marks visible on the tail suggest that it was cast in a two-part mold divided longitudinally. The three-branched ornament on the back was made separately, either soldered in place or cast on.

Unlike the stereotyped, rather generic birds decorating contemporary bronzes made in north China, birds at Sanxingdui show great variety. The beak of No. 30 is curved but not hooked; the parrot-like beak of No. 31 is hooked, as are the still larger beaks of the birds on the tree No. 27. Sometimes, at least, the intention was clearly to depict real species (No. 32). Nevertheless the plumage of No. 31, not to mention the human head on the bird No. 29, reminds us that ornithological correctness was not the chief concern of Sanxingdui casters. The bird head No. 33 bears about the same relation to a real bird's head as No. 7 bears to a real human head.

31

Bird from a tree

Bronze
Height 8 cm, width 4.5 cm
Twelfth century BC

Excavated from Sanxingdui Pit 2 [K2(2):213]
Sanxingdui Museum 00596

PUBLISHED: Beijing 1999a, p. 227 fig. 126.1,
p. 228 pl. 84.2, p. 560 fig. 66.

Like the hybrid No. 29, this bird must have sat on
a small tree, either on a branch or at the top of the
trunk. Peacock-like plumes in sets of three supply
the crest and also the upper and lower sections of
the very complicated tail. The openings in the beak,
crest, and tail served to attach small ornaments;
some of the wires used for attachment, though not
the ornaments themselves, survive in place. On the
bird's neck and breast, feathers are indicated by a
scalloped pattern not encountered on the birds con-
sidered previously (No. 30, and the ones on the tree
No. 27). This pattern may be copied from imported
objects like No. 50, which is likely to have been
made in the middle Yangzi region.

A mold mark on the chest indicates a longitudinal
mold division. The tail was made separately and sol-
dered on.

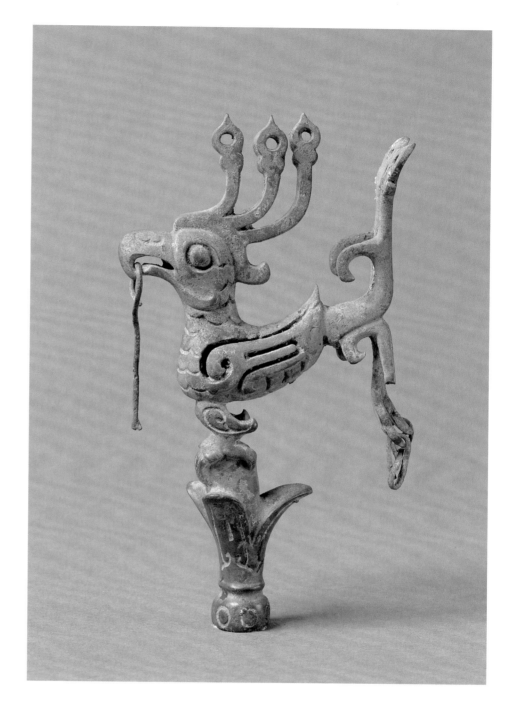

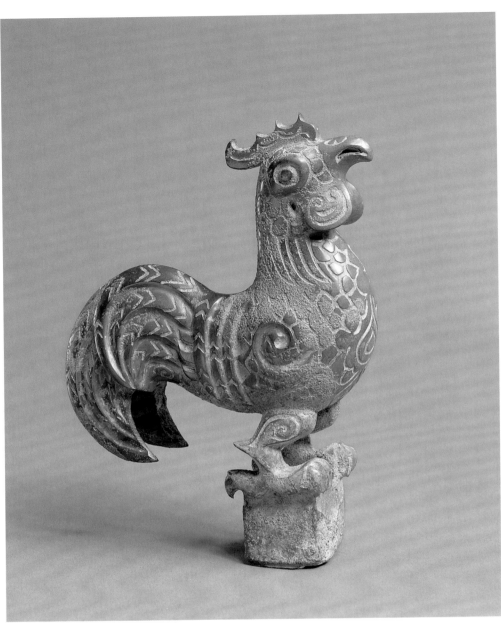

Rooter

Bronze
Length 10.3 cm, height 14.2 cm, weight 272 g
Twelfth century BC

Excavated from Sanxingdui Pit 2 [K2(3):107]
Sanxingdui Museum 00435

PUBLISHED: Beijing 1994a, pl. 48; Tokyo 1998,
no. 69; Beijing 1999a, p. 333 fig. 183.2, p. 337
pl. 127.1, p. 568 fig. 80.

Fig. 32.1. No. 32, rear view.

This small figure is easily the most realistic image among the Sanxingdui bronzes; there
is little room for doubt that it is a rooster. Much attention was devoted to the plumage,
and even the wattles at the throat were carefully portrayed. In their moderate interest in
naturalistic images of animals, Sanxingdui casters probably fall somewhere between cast-
ers in the middle Yangzi region, who had great affection for this subject matter, and casters
in the Zhongyuan, who cared far more for purely imaginary animals.[1]

The block on which the rooster stands is a shell open at the back, and the rooster's
tail is split on the same axis, giving the object a large slot in the back (Fig. 32.1). The slot
must have been used for mounting it on something else, such as a piece of furniture.[2]

1. Bagley 1987, pp. 34–6; Bagley 1999, pp. 209–11.

2. A bronze tiger with a similar slot (the tail and the under-
side are split) was found in the thirteenth century tomb at
Xin'gan in Jiangxi (Peng Shifan *et al.* 1994, no. 38; Beijing
1997f, color pl. 38; Bagley 1993b, fig. 44; Yang 1999,
no. 58).

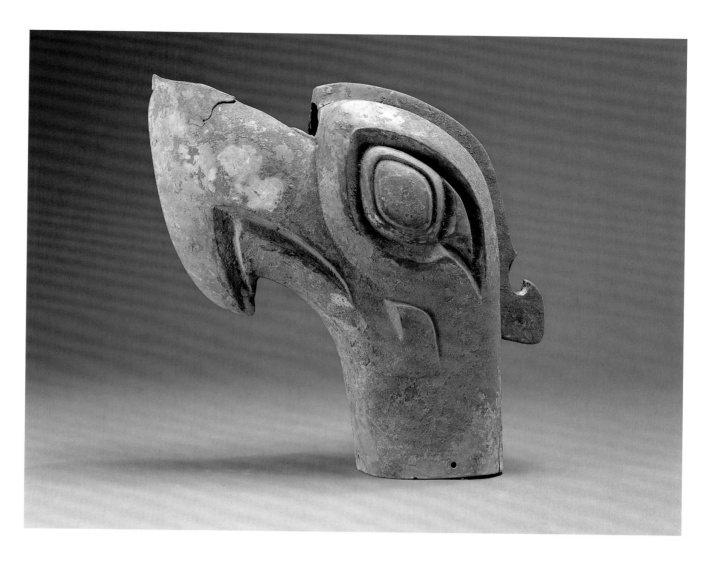

33

Bird's head

Bronze
Length front to back 38.8 cm, width eye to eye
19.6 cm, height 40.3 cm
Twelfth century BC

Excavated from Sanxingdui Pit 2 [K2(2):141]
Sanxingdui Museum 00644

PUBLISHED: Beijing 1994a, pl. 47; Beijing 1994b,
pl. 41; Rawson 1996, no. 29; Tokyo 1998, no. 70;
Beijing 1999a, p. 333 fig. 183.1, p. 337 pl. 127.2,
p. 569 fig. 83; Taibei 1999, no. 64; Yang 1999,
no. 72.

The largest of the bird images in the two pits, this is also the most imposing in design. The principal features have been exaggerated in size and rendered as a few bold shapes, their contours sharply cut, like the features of the human heads and masks Nos. 5–21. These shapes are subtly repeated: separately or together, the upward arc and downward hook of the beak's grooved opening are echoed in the beak itself, the crest, and below the crest, in the depression that surrounds the eye. The front edge of the eye socket parallels the front of the beak. The forceful carving of these large features, undiluted by surface decoration or other distracting detail, combined with their elegant repetition, gives the head remarkable power.

The eye sockets and the opening in the beak were painted with vermilion, still visible on the left side of the head. The neck is open at the bottom, and three small holes along the lower edge may mean that the head was attached to a body in another material. The reason for a large opening at the front end of the crest is unclear; it may have held some appendage or elaboration of the crest. The two-part mold was divided lengthwise.

Fig. 33.1. No. 33, right side.

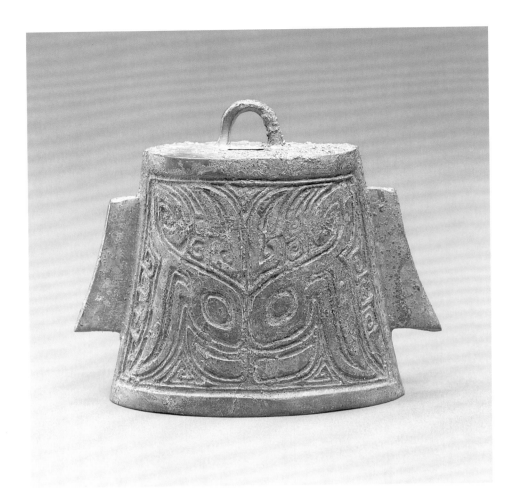

Clapper bell

Bronze
Height 7.35 cm, length at top 5.4 cm, width at
top 2.8 cm, length at mouth 7 cm, width at mouth
3.7 cm, weight 165 g
Twelfth century BC

Excavated from Sanxingdui Pit 2 [K2(3):103-28]
Sanxingdui Museum 00394

PUBLISHED: Beijing 1994a, pl. 59; Beijing 1994b,
pl. 51; Tokyo 1998, no. 53; Beijing 1999a, p. 293
fig. 162.1, p. 297 pl. 108.1, p. 567 fig. 77; Taibei
1999, no. 69.

Fig. 34.1. No. 34, drawings. After Beijing 1999a, p. 293
fig. 162.1.

Fig. 34.2. Undecorated bronze bell. K2(3):274. Height
8.3 cm, width at mouth 7.1 cm, depth at mouth 4 cm.
After Beijing 1999a, p. 293 fig. 162.

1. One of the exceptions is round, the other is a flower-
shaped bell with a quatrefoil cross section (Beijing 1999a,
p. 299 figs. 164.2–3, p. 303 pls. 110.1–2).

2. Besides Nos. 34 and 35, the decorated bells are Beijing
1999a, p. 299 figs. 163.1 and 164.1–2, p. 302 pls. 109.2
and 109.4, p. 303 pl. 110.1. For better illustrations of two
of them see Tokyo 1998, nos. 54, 56; Beijing 1994a, pls. 60,
62; Beijing 1994b, pls. 47, 50.

3. Beijing 1996a, pls. 23–4.

4. Beijing 1984a, pls. 79.1–2. For a survey of clapper bells
in regions beyond Sichuan during the Bronze Age see
Zhongguo Lishi Bowuguan guankan 10 (1987), pp. 35–8, 59.
A small bell-like object has come from a tomb at Shanxi
Xiangfen Taosi, a site of the late Neolithic period, but the
date of the tomb is uncertain.

No bells were found in Pit 1. Pit 2, however, contained 43 small clapper bells; like other small items, they may have been suspended from the bronze trees. In horizontal cross section all but two of them are elliptical or almond-shaped (Fig. 34.1).[1] Thirty-eight are undecorated but otherwise fairly similar to the present one; they are all about the same size, though their proportions vary slightly and the flanges projecting from their sides are sometimes scalloped (Fig. 34.2), sometimes perfectly straight, sometimes omitted. The five decorated bells, on the other hand, though still no larger than about 14 cm high, are all different and all very unusual (No. 35).[2] No. 34, probably the simplest of the five, is decorated with a vaguely suggested animal face, a reasonably faithful rendering of transition-period designs. It was found covered with vermilion, traces of which are still visible.

These small bells did not originate at Sanxingdui. The earliest known examples in bronze are from Erlitou (*c.* 1500 BC or a little before); these have a flange only on one side.[3] No bell is yet known from the Erligang period (*c.* 1500–1300 BC), but the Anyang tomb of Fu Hao (*c.* 1200 BC) contained eighteen, including examples with two flanges, with one, and with none.[4] In contrast to Fu Hao's other bronzes, the bells in her tomb are insignificant items, neither so varied nor so well made and richly decorated as the five decorated bells from Sanxingdui.

Clapper bell in the shape of a bird

Bronze
Height 14 cm, width 8.1 cm, weight 373 g
Twelfth century BC

Excavated from Sanxingdui Pit 2 [K2(2):103-8]

Sanxingdui Museum 00392

PUBLISHED: Beijing 1994a, pl. 61; Beijing 1994b, pl. 52; Rawson 1996, p. 75 fig. 29.1; Tokyo 1998, no. 52; Beijing 1999a, p. 299 fig. 163.2, p. 302 pl. 109.3; Taibei 1999, no. 68.

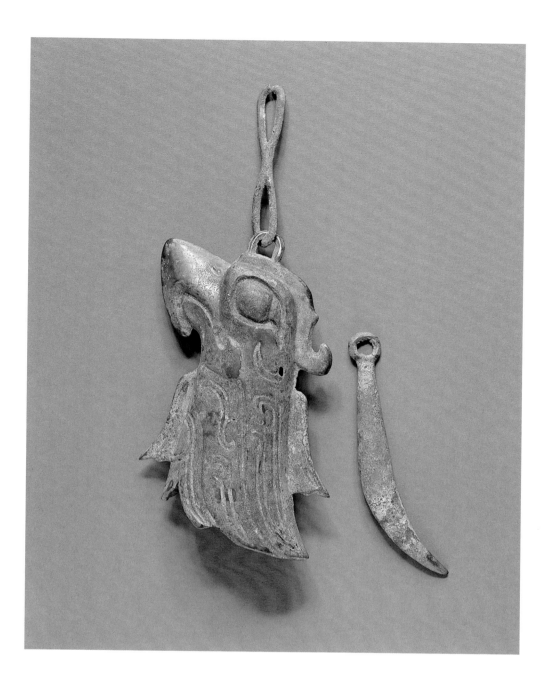

Fig. 35.1. No. 35, drawings. After Beijing 1999a, p. 299 fig. 163.2.

This unique bell takes the shape of a bird, its head rendered distinctly but its body much abbreviated. In design the head is a miniature version of No. 33—it has the same eye, crest, beak, and continuation of the lower part of the beak onto the neck. Projections from breast and back probably do not represent features of the bird's anatomy but instead allude to the flanges on the sides of simpler bells, such as No. 34. The knife-shaped clapper was still inside the bell at the time of excavation. It is more usual for the clappers of bells to be missing, an indication, perhaps, that they were tied to the loop inside the bell with something perishable like string.

36

Hybrid figure standing on birds (fragment)

Bronze
Overall height 81.4 cm, width between arms
10.8 cm, height of figure 30 cm, height of birds
51.4 cm, weight 8.065 kg
Twelfth century BC

Excavated from Sanxingdui Pit 2 [K2(3):327]
Sanxingdui Museum 00286

PUBLISHED: Tokyo 1998, no. 78; Beijing 1999a,
p. 171 fig. 87, p. 172 rubbing 12, p. 173 pls.
60.3–4; Taibei 1999, no. 51.

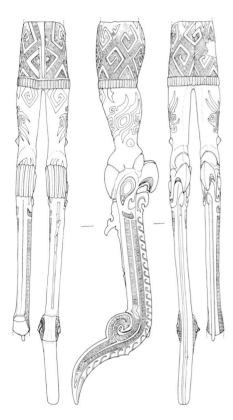

Fig. 36.2. No. 36, drawings. After Beijing 1999a,
p. 171 fig. 87.

1. With the addition of the upper half of the skirted figure,
might the object have been one leg of a tripod or tetrapod
that carried something on the heads of the figures? Pit 2
yielded one other fragment with a shape like the bodies of
the birds here, ending in a short arc and pointed tip (Beijing
1999a, p. 339 fig. 187.3).

2. On this pattern see Bagley 1987, pp. 320–23.

This object would be strange even if it were complete; in its present fragmentary condition it is puzzling indeed. The lower half of a figure wearing a tight skirt stands with its clawed feet on the heads of two birds. The birds, which face in the opposite direction from the figure, have long slug-like bodies. All the surfaces of the birds are smoothly finished, and there is no sign that they were ever joined to anything else (Fig. 36.1); nor have the restorers found anything among the bronzes from Pit 2 that this object might have formed part of.[1] Both the figure and the birds were found smeared with vermilion, traces of which remain.

Few of the Sanxingdui bronzes have so much surface decoration. The pattern on the skirt, angular meanders on a ground of fine spirals, is a common one on transition-period bronze vessels (though the design on the bronzes was itself probably copied from woven silks now lost).[2] The skirt ends at a ribbed hem just above the knees. The muscular legs bear patterns executed in heavy intaglio line: angular spirals on the knees, looking as though the skirt partly covers them, and eyes surrounded by hooked lines above the ankles (Fig. 36.2). Where a clawed foot rests on a bird's head, the join was made with solder (Fig. 36.3).

The two heads resemble the large bird's head No. 33. Each has a limbless body that runs straight down, bends backward, and branches into a short tight hook and a longer arc. On the back of the bird's head is a crest. Beneath its beak, a small hook on the throat is the beginning of a flange that runs all the way to the tip of the tail. The body is striped with fine spirals like those on the skirt.

The object was made in five pieces: the two birds, the two clawed feet, and the legs and skirt above the feet. The feet were precast and inserted into the mold for the legs and skirt; overflow from the legs onto the claws is clear. Vertical mold marks can be seen on the front and back of the skirt. The top of the bronze is open, exposing the core material.

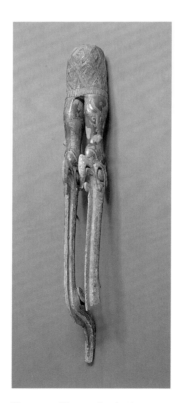
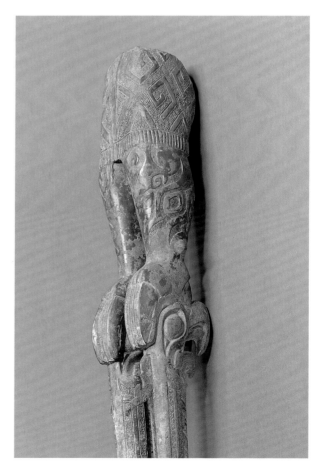

Fig. 36.1. No. 36, back view.

Fig. 36.3. No. 36, detail.

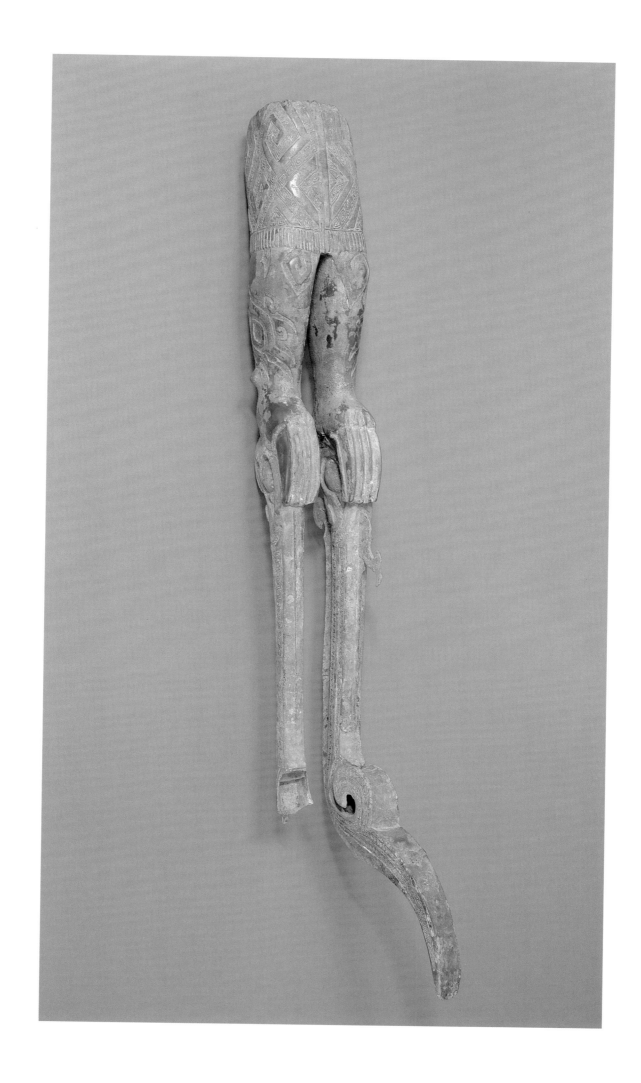

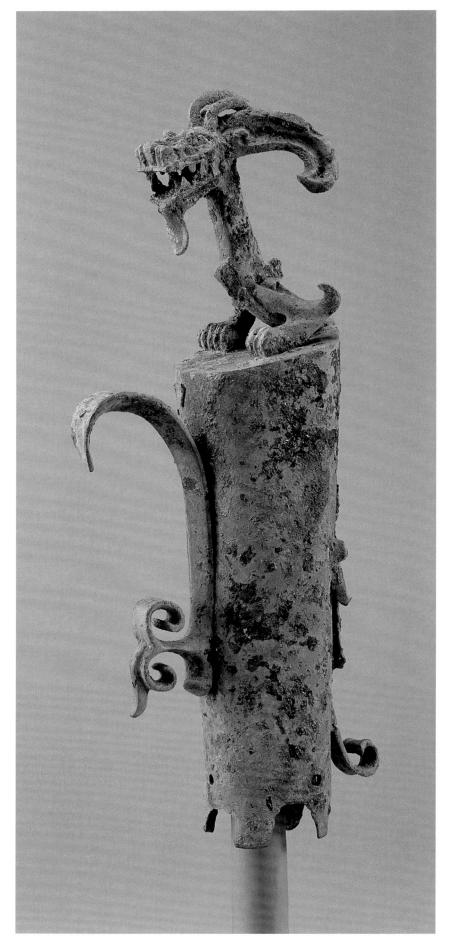

Tube with dragon

Bronze
Height 41 cm, width 18.8 cm, largest diameter of
tube at top 9 cm, weight 3.065 kg
Thirteenth or twelfth century BC

Excavated from Sanxingdui Pit 1 [K1:36]
Sanxingdui Museum 00104

PUBLISHED: Beijing 1994a, pl. 52; Beijing 1994b,
pl. 39; Tokyo 1998, no. 115; Beijing 1999a, p. 34
fig. 20, p. 37 pls. 6.3–4, p. 526; Taibei 1999, no.
61; Yang 1999, no. 73.

This tubular object may have been mounted on top of
some sort of pole or post; it is open at the bottom, and
small holes pierce the wall there. A dragon clambers
up the side of the tube, its forelegs planted on the top
surface, its hind legs clinging to the back (Fig. 37.1).
On the back of the tube the body is little more than a
raised strip, except where the tail curls outward, but
the creature that emerges triumphantly on top is very
lively. Its mouth gapes wide, exposing sharp teeth,
and it has either a beard or a lolling tongue. Its horns
are much smaller than its floppy ears. A small hole is
at the tip of each ear, clearly meant for hanging addi-
tional ornaments. An appendage on the front of the
tube is faintly reminiscent of the one on the forehead
of the mask No. 23. The dragon and tube must have
been assembled from a number of separately cast
pieces, but mold and join marks are difficult to find,
as the surface is heavily corroded and spotted with
bone ash.

Fig. 37.1. No. 37, rear view. After
Tokyo 1998, p. 150 (right).

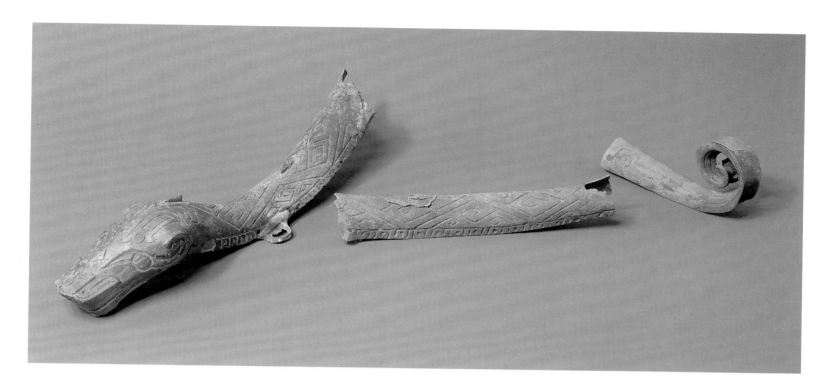

Pit 2 yielded about a dozen fragments of snakes, including two heads, two middle sections, and two tails. The broken ends do not match well enough to make it certain which pieces belong together, but the three shown here suffice to give an idea of what the snakes looked like. They are shells of metal and were probably mounted on something else with the assistance of the two cast-on loops a little way behind the head. The dished spiral of the snake's tail resembles the upper end of the trunk on the mask No. 23. A small stump on the head and another on the body may be the remnants of attachments that have broken off; the excavators found a quill-shaped element that fits neatly onto the stump on the body (Fig. 38.1). These appendages were cast on through holes made for the purpose in the body; metal overflow clearly runs from the stump onto the body. The snakes must have been cast in several pieces. The head section shown here includes at its broken end a large patch of distinct metal that looks like a join; perhaps the breaks occurred at the joins.

38

Snake

Bronze
Head: length 54.8 cm, width 10 cm; middle section: length 35.6 cm, width 8.4 cm; tail: length 21.2 cm, width 5.4 cm
Twelfth century BC

Excavated from Sanxingdui Pit 2 [K2(3):87, K2(3):56, K2(3):44]
Sanxingdui Museum 00492

PUBLISHED: Beijing 1994a, pl. 55; Beijing 1994b, pl. 42 (head); Tokyo 1998, no. 69; Beijing 1999a, p. 326 fig. 178.1, p. 327 figs. 179.1, 179.3, p. 329 pls. 123.2, 123.4, p. 124 pl. 124.2; Taibei 1999, no. 63.

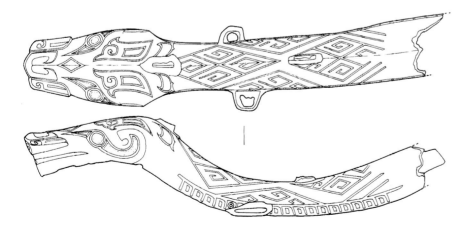

Fig. 38.1. No. 38, drawings of head and body sections. After Beijing 1999a, p. 326 fig. 178.1, p. 327 figs. 179.1–3.

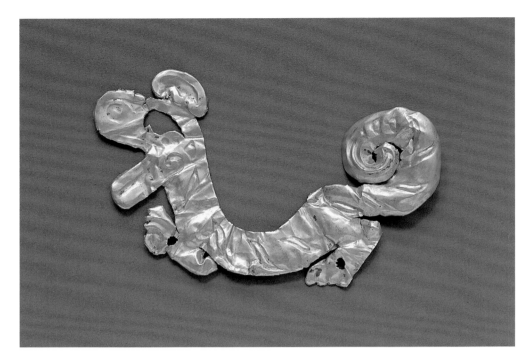

39

Tiger appliqué

Gold
Height 6.7 cm, length 11.6 cm, weight 7.27 g
Thirteenth or twelfth century BC

Excavated from Sanxingdui Pit 1 [K1:11-1]
Sanxingdui Museum 00169

PUBLISHED: Beijing 1994b, p. 112; Tokyo 1998,
no. 117; Beijing 1999a, p. 61 fig. 34.3, p. 62
pl. 15.3, p. 529 fig. 11; Taibei 1999, no. 100.

This piece of gold foil was once wrapped around some sort of support; its edges turn backward, and the residue of an unidentified material remains on the back. Rounded ears, lithe body, clawed feet, and coiled tail suggest a feline, and the markings on body and tail identify the feline as a tiger (Fig. 39.1). In fact the markings are rather close to those of a real tiger, certainly if measured against the stylized tiger stripes fashionable with bronze casters at Anyang and in the middle Yangzi region.[1] The markings, as well as the features of the head, tail, and claws, are very finely traced in the metal.

Tigers are rare in Sanxingdui imagery. Nothing tigerlike was found in Pit 2, and in Pit 1, apart from the imported *zun* No. 44, there is only one probable candidate, a small three-dimensional bronze with a squat shape and a mouth full of teeth.[2] No. 40, a tiger-shaped plaque inlaid with turquoise, is one of two found in surface surveys at the Sanxingdui site.

1. See for instance the tigers on the *zun* No. 44 (an import, not a Sanxingdui casting). For typical Anyang tigers see Bagley 1987, figs. 148–50; for a northern Hunan version see Beijing 1997e, p. 134 (there incorrectly dated to the Warring States period); for a tiger from the Xin'gan tomb in Jiangxi see No. 32, note 2.

2. Beijing 1994b, pl. 40; Beijing 1999a, p. 35 fig. 22, p. 38 pl. 7.3.

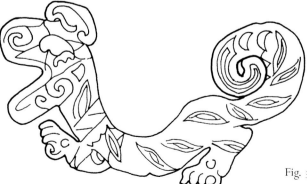

Fig. 39.1. No. 39, drawing. After Beijing 1999a, p. 61 fig. 34.3.

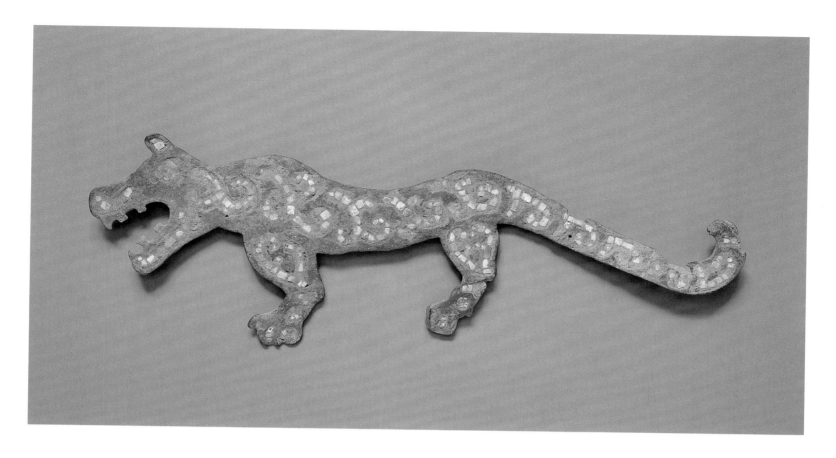

This flat plaque, the silhouette of a tiger with muscular legs and gaping jaws, is inlaid on one side with small chips of turquoise. The other side, bare of decoration, carries four small loops for attaching the plaque to something else (Fig. 40.1). The inlaid patterns are a little unusual, not obviously related to the markings of a real tiger (compare No. 39), nor to the markings commonly given to tigers on bronzes like No. 44.

This plaque and another, slightly more elaborate one (Fig. 40.2) are stray finds from the Sanxingdui site, lacking clear archaeological context. The only other examples of turquoise inlay known from Sanxingdui are the Erlitou-style plaques discussed at the beginning of this chapter (Fig. 2). Like those plaques, the two tigers may be imports.

40

Tiger

Bronze with turquoise inlay
Height 13.2 cm, length 43.4 cm, thickness 0.62 cm, weight 569 g
Thirteenth or twelfth century BC

Unearthed at the Sanxingdui site
Guanghan Municipal Institute of Cultural Antiquities 00088

PUBLISHED: Tokyo 1998, no. 149.

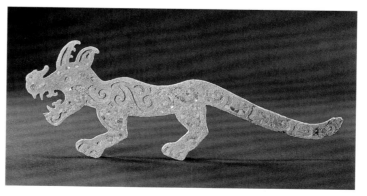

Fig. 40.1. No. 40, back view.

Fig. 40.2. Bronze tiger-shaped plaque, unearthed in 1984 near the Yazi River at Sanxingdui. Length 38 cm. Collection of the Guanghan Municipal Institute of Cultural Antiquities. After Beijing 1994a, pl. 66.

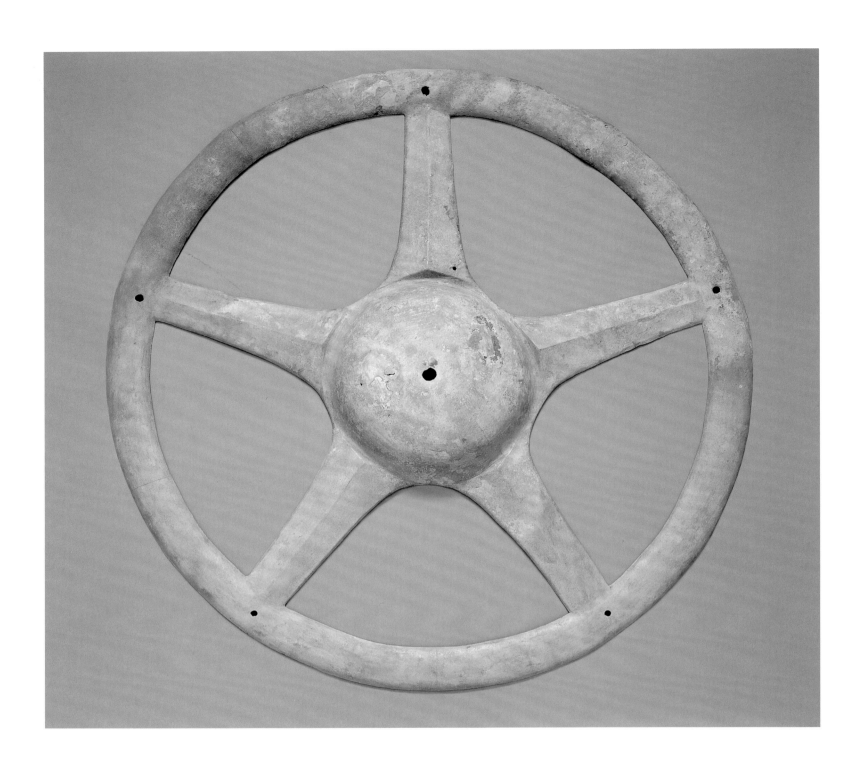

Circular appliqué

Bronze
Overall diameter 84 cm, diameter of central
roundel 28 cm, height of central roundel 6.5 cm
Twelfth century BC

Excavated from Sanxingdui Pit 2 [K2(3):1]
Sanxingdui Museum 00653

PUBLISHED: Beijing 1994a, pl. 56; Rawson 1996,
no. 31; Tokyo 1998, no. 80-2; Beijing 1999a, p. 239
fig. 134.1, p. 247 pl. 88.3, p. 560 fig. 68; Taibei
1999, no. 40.

In the shape of a wheel with five spokes, this large object is a thin shell open at the back. Small holes on the rim and at the center probably served for mounting; the size of the object suggests an architectural setting, or perhaps a shield. A few bronzes from Pit 2 include in their surface decoration a motif that consists of a scalloped or pronged device enclosed in a circle, among them the animal on the hat of No. 3, the animal shown in Figure 3.4, and an item the excavators identify as the roof of a building (Fig. 41.3). The excavators assume that the present object is another example of the same motif, and they guess that it is a solar symbol.[1] Whatever the merits of the suggestion, No. 41 is one of six such wheels restored from fragments in Pit 2.

The wheel was cast in six pieces. The rim is composed of five equal arcs, each of which was cast in one piece with the spoke that projects from it. The joins, very neat seen from the front, are located midway between spokes. They were made by soldering on the rear of the object; for strength, the solder was allowed to flow into small holes at the ends of the arcs, faintly visible in Figure 41.2. The final operation was evidently to cast the hub onto the spokes.

Fig. 41.1

Fig. 41.2

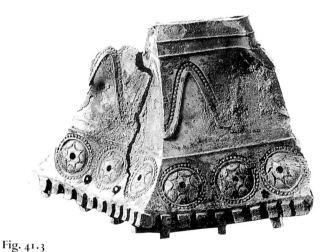

Fig. 41.3

Fig. 41.1. No. 41, rear view.

Fig. 41.2. No. 41, detail of join at rim. After Rawson 1996, p. 77.

Fig. 41.3. Bronze miniature roof, (a) drawing, (b) photograph. K2(2):143. Height 15.8 cm. Drawing after Beijing 1999a, p. 235 fig. 132. Photograph after Chen De'an *et al.* 1998, pl. 24.

1. Beijing 1999a, p. 235.

42A

Pair of diamond-shaped appliqués

Bronze
Average length 57 cm, width 25 cm, height 5 cm
Twelfth century BC

Excavated from Sanxingdui Pit 2 [K2(2):95,
K2(2):342]
Sanxingdui Museum 00341, 00348

42B

Set of four triangular appliqués

Bronze
Average length 55.5 cm, width 13 cm, height
3.5 cm
Twelfth century BC

Excavated from Sanxingdui Pit 2 [K2(3):63,
K2(3):198, K2(2):109-3, K2(3):94]
Sanxingdui Museum 00365, 00361, 00363, 00364

PUBLISHED: Tokyo 1998, no. 44; Taibei 1999,
no. 42.

42C

Set of eight triangular appliqués

Bronze
Average length 29 cm, width 13 cm, height 3.5 cm
Twelfth century BC

Excavated from Sanxingdui Pit 2 [K2(3):174,
K2(3):68, K2(2):64, K2(2):5, K2(3):98, K2(2):8,
K2(3):101, K2(3):106]
Sanxingdui Museum 00372, 00375, 00376, 00373,
00656, 00657, 00658, 00659

PUBLISHED: Rawson 1996, no. 32; Tokyo 1998,
nos. 45–6; Beijing 1999a, p. 208 fig. 115.3, p. 210
pl. 76.2, p. 557 fig. 62; Taibei 1999, no. 43.

42A

Small perforations make it likely that these hollow-backed objects, like the wheel No. 41, were appliqués mounted on something else. But it is difficult to guess what they represent, what they were attached to, or why some were made in one piece, some in two, and some in four. If they represent eyes, as the excavators believe, it is puzzling that their form is geometrically so regular and so unlike other plaques from Pit 2 that are instantly recognizable as eyes (Fig. 42.1). Eyes or not, it is hard to imagine how they were displayed, particularly given their variation in form and their number—a total of 29 one-piece diamonds, 23 halves, and 19 quarters. What looks like a similar device appears on the calf of a fragmentary human figure kneeling at the summit of a bronze pedestal from Pit 2 (Fig. 43.2).[1] Perhaps the bronze appliqués were mounted on the legs of large wooden figures that have perished. Even if this guess is correct, however, it leaves unexplained the peculiar construction of the ones in halves or quarters.

1. See also the legs of the standing men in Introduction Part 1, Figure 8, and Figure 13 on page 66.

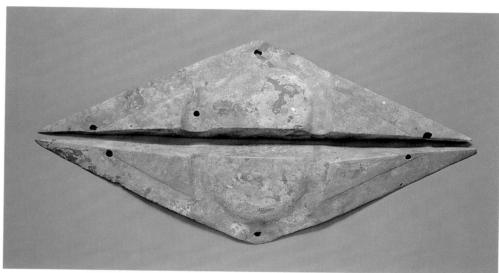

Fig. 42.1. Bronze eye-shaped plaque. Length 23.2 cm.
After Tokyo 1998, p. 89 no. 40.

42b

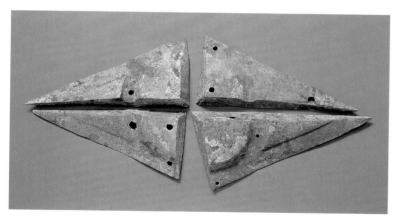

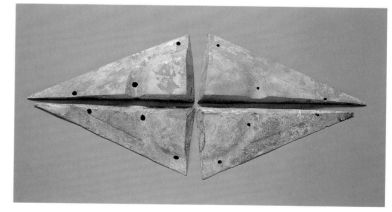

42c

43

Kneeling woman bearing a zun

Bronze
Overall height 15.6 cm, height of base 5.3 cm,
diameter of base 10 cm, weight 236 g
Twelfth century BC

Excavated from Sanxingdui Pit 2 [K2(3):48]
Sanxingdui Museum 00285

PUBLISHED: Tokyo 1998, no. 73; Beijing 1999a,
p. 170 fig. 86, p. 173 pls. 60.1–2, p. 545 fig. 43;
Taibei 1999, no. 49.

In shape this object looks like a support of some kind, but whatever once stood on the top is now missing. What survives is an openwork base with a female figure kneeling at its summit.[1] On her head the woman carries a *zun* vessel (compare Nos. 44–7) covered by what looks like a high lid. The undulating pattern on the lid recalls the bases of the bronze trees Nos. 27 and 28; perhaps the element now missing from the top was a miniature tree. Since several of the *zun* in the pits were found with small valuables inside—jades, ivory beads, cowry shells—it is tempting to believe that the figure seen here is presenting an offering. She is perhaps the only evidence of female participation in Sanxingdui ritual.

In its present condition No. 43 consists of two separately cast pieces, the openwork base and the figure carrying the *zun*. The join between the two is soldered. At the top a lump of solder shows that something has broken off. Three flange-like devices project above the openwork surface of the base; it is not clear whether these were cast separately or together with the base.

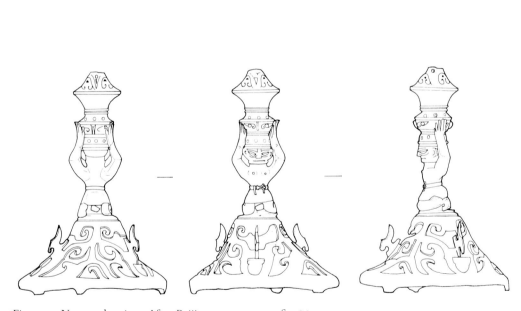

Fig. 43.1. No. 43, drawings. After Beijing 1999a, p. 170 fig. 86.

Fig. 43.2. Bronze pedestal or miniature building with kneeling figure (broken) at top. K2(2):143-1. Height 31 cm. After Beijing 1999a, p. 234 fig. 131.

1. The fragment shown in Figure 43.2, though square in cross section and much taller, also consists of an openwork base with a kneeling figure at the top.

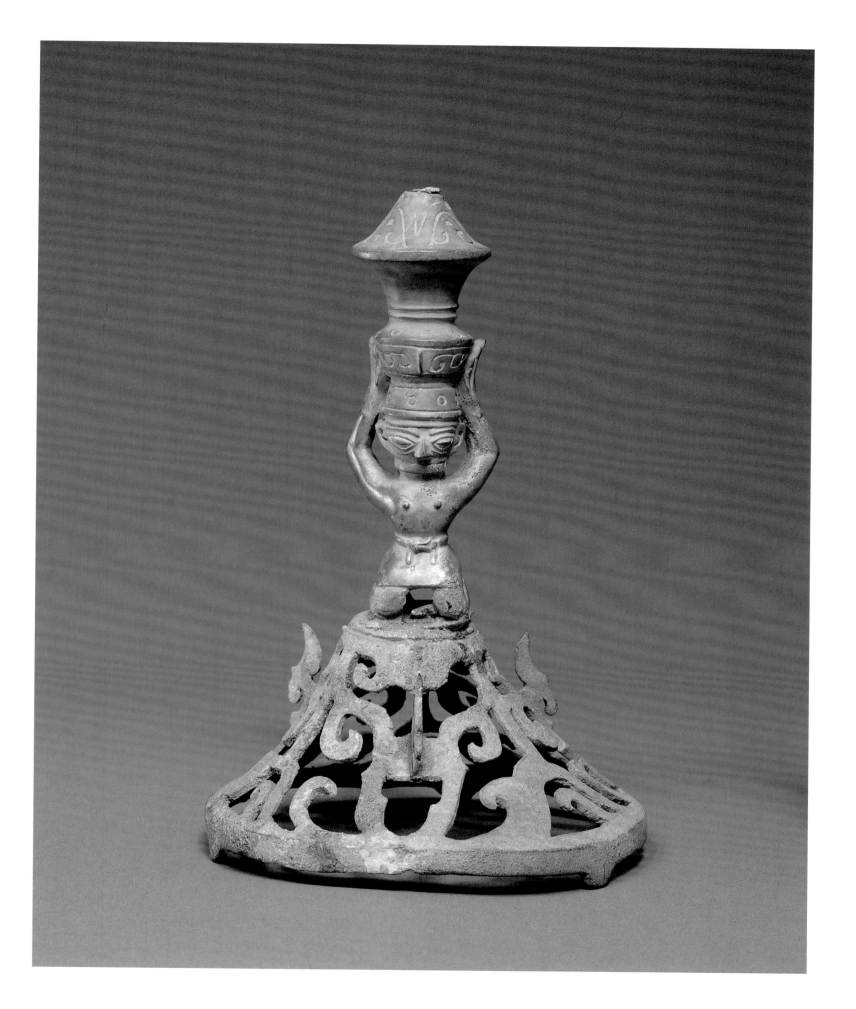

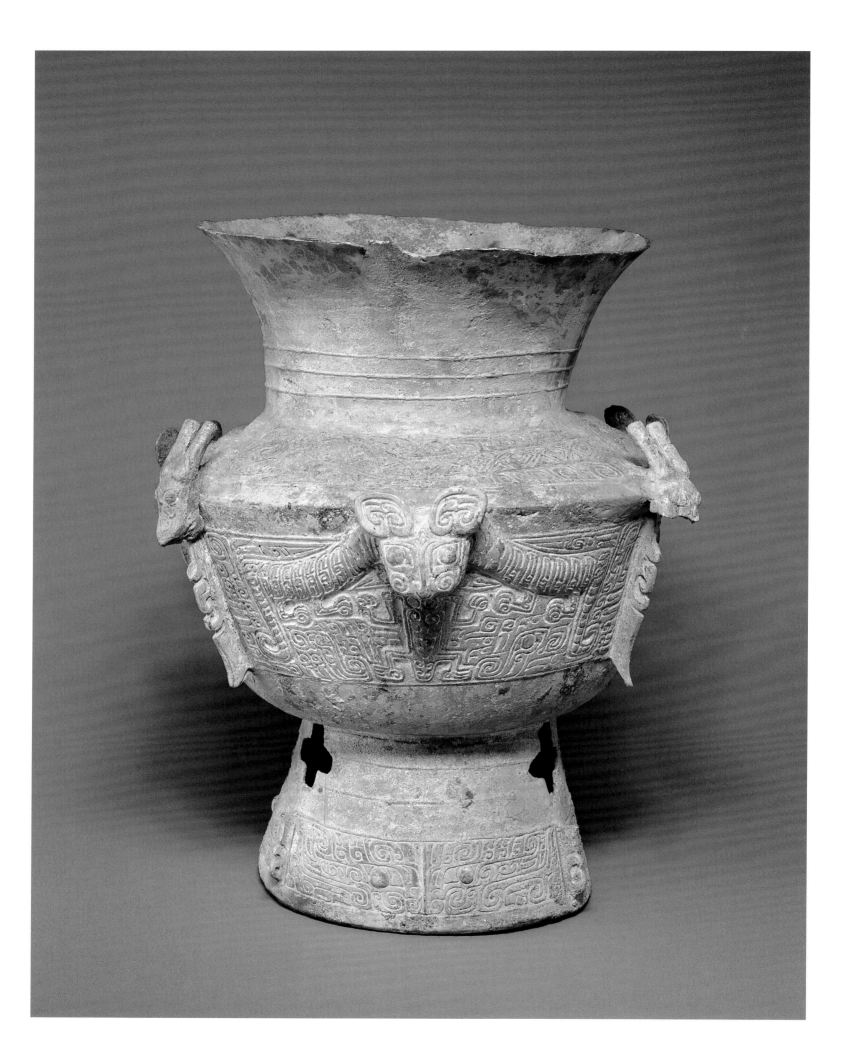

44

Zun

Bronze
Height 43.3 cm, diameter at shoulder 32 cm,
diameter at foot 21.6 cm
Thirteenth century BC
Excavated from Sanxingdui Pit 1 [K1:158, 258]
Sanxingdui Museum 00107

PUBLISHED: Beijing 1994a, pls. 87–8; Beijing
1994b, pl. 31; Tokyo 1998, no. 128; Beijing 1999a,
p. 35 fig. 23, p. 36 rubbings 1–2, p. 39 pls. 8.1–2,
p. 527 fig. 9; Taibei 1999, no. 55.

Fig. 44.1. No. 44, side view.

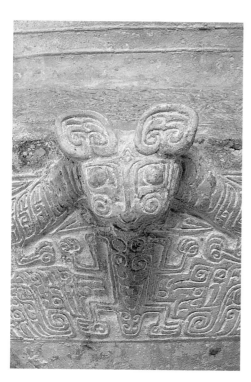

Fig. 44.2. No. 44, detail.

Lavishly decorated bronze vessels, the chief utensils of Zhongyuan ritual, seem not to have been made at Sanxingdui. The bronze vessels found in the pits, almost all of them vases of the types *zun* and *lei*, appear to be imports. Few if any are imports from the Zhongyuan, however; most have a distinctive style which identifies them as products of the middle Yangzi region, where imposing vessels were made even though bronzes of other types seem to have been rather more important. A few, including Nos. 44 and 45, cannot be so confidently assigned to a particular point of origin, for they belong to types widespread in the thirteenth century (the transition period). The possibility nevertheless remains that they too were made in the middle Yangzi region, but at a time preceding the rise of local styles there.

The circumference of No. 44 is divided into thirds by vertical flanges. Horned dragons whose snakelike bodies lie along the shoulder face outward over the flanges. The register below the shoulder contains, three times repeated, a symmetrical design in which a two-bodied tiger holds in its mouth the head of a human body. This extraordinary design is known from only one other vessel, a larger *zun* found at Funan in Anhui province, and on the Funan *zun* the human face beneath the tiger's jaws can be clearly seen, looking remarkably cheerful under the circumstances (Fig. 44.3b).[1] Curiously, while the two vessels are very close in design, they are poles apart in quality. The *zun* from Funan is executed with extraordinary finesse, all the lines wonderfully sharply cut; it is among the finest castings of its own time or any other. The Sanxingdui *zun* by contrast is quite crude; its maker could not approach the draftsmanship of the caster who drew the design on the Funan vessel. Nor did he bother to show the human face beneath the tiger's mouth or to include the *taotie* faces that on the Funan *zun* are centered on the flanges.[2]

Though found badly broken, almost two-thirds of it destroyed, the fragments of this vessel still held pieces of jade and stone, partly melted ornaments of thin sheet bronze, and 62 cowry shells.

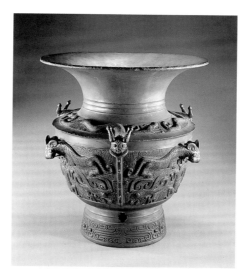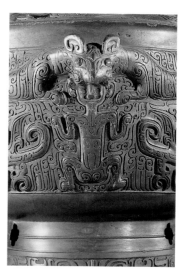

Fig. 44.3. Bronze *zun* from Anhui Funan,
(a) side view centered on flange, (b) detail
of tiger and human. Height 50.5 cm. After
Beijing 1996a, pp. 117–18.

1. The *zun* from Funan is discussed in Bagley 1987, pp. 34–5, and compared with the Sanxingdui *zun* in Bagley 1990a, pp. 64–5. See also Xu 1998.

2. On the Funan *zun* the tiger heads and the heads of the dragons on the shoulder were cast onto the otherwise finished vessel (Bagley 1987, p. 43). In the case of No. 44, the tiger heads were clearly cast on; the dragons heads may also have been, but the joins are less easy to interpret.

45

Zun

Bronze
Height 31.5 cm, diameter at mouth 34 cm,
diameter at foot 19.8 cm, weight 4.14 kg
Thirteenth century BC

Excavated from Sanxingdui Pit 2 [K2(2):112]
Sanxingdui Museum 00273

PUBLISHED: Beijing 1994a, pl. 89; Beijing 1994b,
pl. 34; Tokyo 1998, no. 81; Beijing 1999a, p. 241
fig. 137, p. 245 rubbing 17, p. 250 pl. 91.2, p. 561.

Like No. 44, this vessel dates from the thirteenth century, but its decoration is much more familiar, consisting of intricate *taotie* patterns. The elegantly outlined eyes in the main register, Zhongyuan ancestors of those seen in Figures 24.3 and 42.1, were a favorite design element in Bronze Age China; the bulging eyes on the Sanxingdui heads and masks are rendered all the more strange by their failure to make even the slightest allusion to this ubiquitous type form. Six holes drilled into the ring foot of No. 45 probably adapted an imported vessel to a local use. Looking at No. 43, with its depiction of a woman who carries a *zun* on her head, it is tempting to guess that vessels like No. 45 were mounted on heads like Nos. 4 and 5, but in fact the heads from the pits are not large enough to accommodate any of the vessels. Like several of the other vessels, this one was found smeared with vermilion. It is one of three *zun* from Pit 2 likely to date from the thirteenth century (the transition period); five more, including Nos. 46 and 47, are somewhat later.

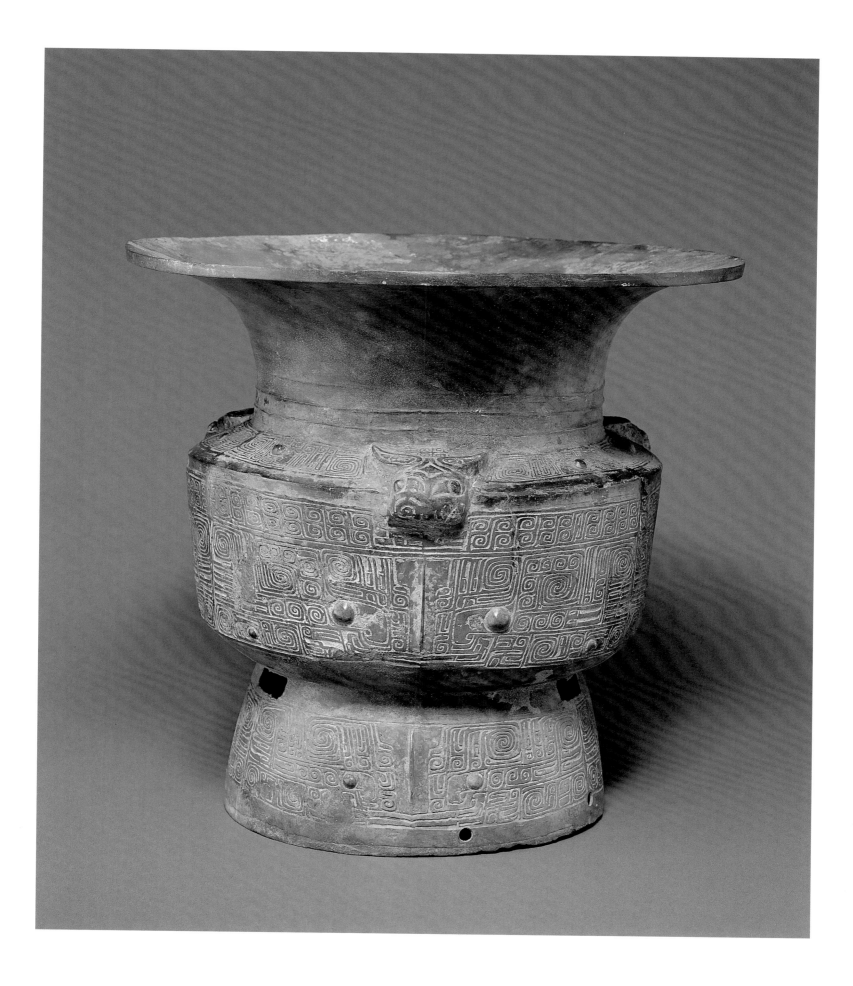

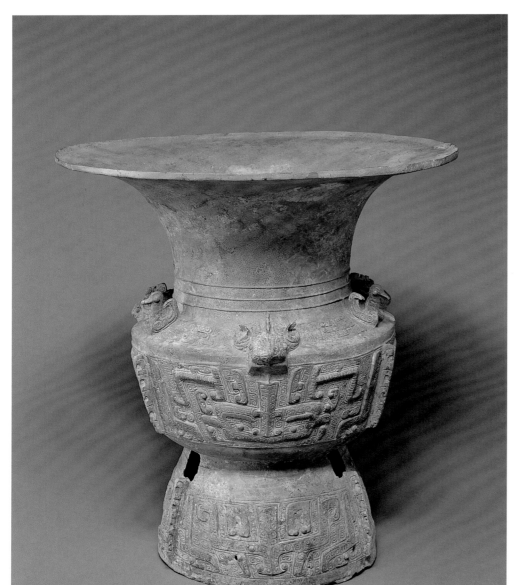

Zun

Bronze
Height 45.5 cm, diameter at mouth 42.6 cm,
diameter at foot 23.1 cm
Twelfth century BC

Excavated from Sanxingdui Pit 2 [K2(2):129]
Sanxingdui Museum 00651

PUBLISHED: Beijing 1994a, pl. 86; Rawson 1996,
no. 28; Tokyo 1998, no. 84; Beijing 1999a, p. 254
fig. 141, p. 257 rubbing 20, p. 260 pl. 94, p. 563;
Taibei 1999, no. 57.

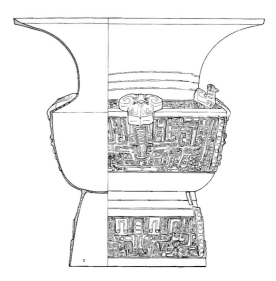

Fig. 46.1. No. 46, drawing. After Beijing 1999a, p. 253
fig. 140.

1. For examples from Hubei and Hunan see Bagley 1987,
entry no. 43, p. 547 fig. 104.18; *Wenwu* 1990.6, p. 57 fig. 2;
Wenwu 1993.8, pp. 67–8, 31, color pl. 1; Hong Kong 1999,
p. 78 no. 32. For one unearthed in 1980 at Dachang
Shuangyan Dongba in the Three Gorges region see Beijing
1998f, p. 9; Beijing 1997g, no. 43.

2. Beijing 1999a, p. 419, and Chen De'an, personal com-
munication, July 2000. Most of the shells are reported to be
Monetaria annulus; some are *Monetaria moneta (Sichuan wenwu*
1989, special issue on Sanxingdui studies, p. 69). In Pit 1,
a few cowries were found inside three of the bronze heads
(No. 5 and two others).

3. Likely sources for the cowry shells found in China and
the routes by which they might have come have been much
discussed; the most thorough and convincing study is Peng
& Zhu 1999, which argues for importation from the Indian
Ocean by way of the northern steppes. On cowry shells
at Anyang see Beijing 1994c, pp. 402–3 (the few bronze
examples known from Anyang are mentioned on p. 322).

In its flaring undecorated mouth, dryly executed surface decoration, and the ducklike
birds sitting on its shoulder, this *zun,* like the next, is a typical product of the middle
Yangzi region. A number of examples have been found in southern Hubei and northern
Hunan, and one has come from the Three Gorges region of Sichuan.[1] No. 46 was found
smeared with vermilion. Two holes in the recessed bottom are casting defects never
repaired; this vessel could never have been used to hold liquid.

About 4600 cowry shells (and four bronze imitations) were found in Pit 2. Most of
them were inside three vessels—935 in the *zun* No. 46, 602 in another *zun,* and 1488 in
a badly broken *lei*—and the remainder may well have fallen out of other vessels as they
were thrown into the pit.[2] Much evidence that cowries were valuables of some kind has
come from the Anyang site. Inscriptions on Anyang oracle bones and bronze vessels some-
times mention them as royal bounty, and more than 10,000 have been found at Anyang,
7000 in Fu Hao's tomb alone. Since the shells seem to have come from the Indian Ocean,
their presence at Sanxingdui and Anyang is evidence of trade or exchange over very great
distances.[3]

47

Zun

Bronze
Height 56.5 cm, diameter at mouth 49 cm,
diameter at foot 26 cm
Twelfth century BC

Excavated from Sanxingdui Pit 2 [K2(2):151]
Sanxingdui Museum 00276

PUBLISHED: Beijing 1994b, pl. 32; Tokyo 1998,
no. 85; Beijing 1999a, p. 255 fig. 142, p. 258
rubbing 21, p. 261 pl. 95; Taibei 1999, no. 56.

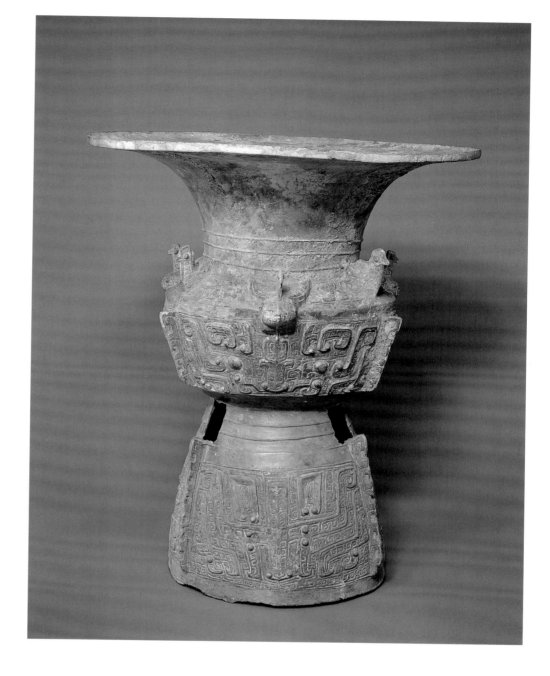

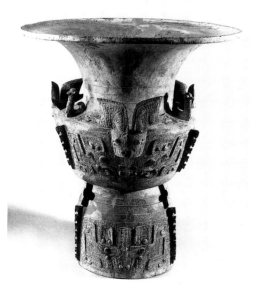

Fig. 47.1. Bronze *zun* from Hunan Huarong.
Height 72.3 cm. After Tokyo 1981, pl. 17.

This *zun* is larger than the last and differs significantly
in proportions: the body is compressed, the mouth
flares more widely, and the foot is exceptionally high.
In both shape and decoration it resembles a *zun* from
Hunan Huarong (Fig. 47.1). But the Huarong *zun*
is larger still, and the massive animal heads on its
shoulders are more like those on the Sanxingdui *lei*
No. 49.

Lei

Bronze
Height 35.4 cm, diameter at mouth 20.3 cm,
diameter at foot 18.6 cm, weight 4.22 kg
Thirteenth century BC

Excavated from Sanxingdui Pit 2 [K2(2):88]
Sanxingdui Museum 00277

PUBLISHED: Beijing 1994a, pl. 67; Beijing 1994b,
pl. 35; Tokyo 1998, no. 86; Beijing 1999a, p. 264
fig. 146, p. 267 rubbing 25, p. 271 pl. 98, p. 564.

The bronze vessel shape which in modern terminology is called a *lei* differs from the *zun* chiefly in its less widely flaring mouth (compare No. 47). *Lei* from the middle Yangzi region, Nos. 48 and 49 included, typically have four sets of vertical flanges, and thus four identical units of decoration in each register; by the standards of the Zhongyuan, where round vessels normally have three vertical divisions, this is distinctly odd. The present *lei* is a relatively early example; measured against No. 49, its proportions, appendages, and flattish surface decoration all seem quite restrained. An example found in the middle Yangzi region, at Yueyang in northern Hunan, is intermediate between this one and the next (Fig. 48.1). The Yueyang vessel has the low surface decoration of No. 48, but its higher foot and neck bring it closer to the shape of No. 49, and it has also the ducklike birds seen on the shoulder of that vessel.

At the time of excavation, No. 48 contained about 40 jade chisels and 326 small jade beads and tubes. A number of bronze vessels filled with jades have been unearthed in the middle Yangzi region,[1] sometimes with beads and tubes like those found in No. 48, raising the possibility that not only the *lei* but also some of its contents were imported to Sanxingdui (the chisels are of local type). The vessel was found smeared with vermilion. In addition to the usual large openings left in the foot by core supports, vestiges of the casting process, No. 48 has small holes drilled near the foot rim, presumably additions made at Sanxingdui to an imported object.

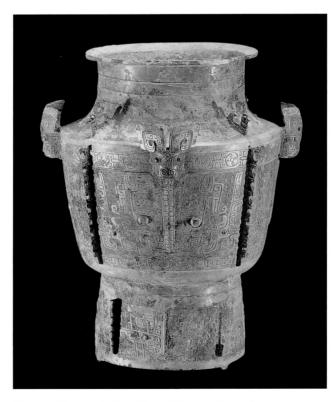

Fig. 48.1. Bronze *lei* from Hunan Yueyang Fangyushan.
Height 50 cm. After Beijing 1998a, pl. 93.

1. See note 32 on page 68.

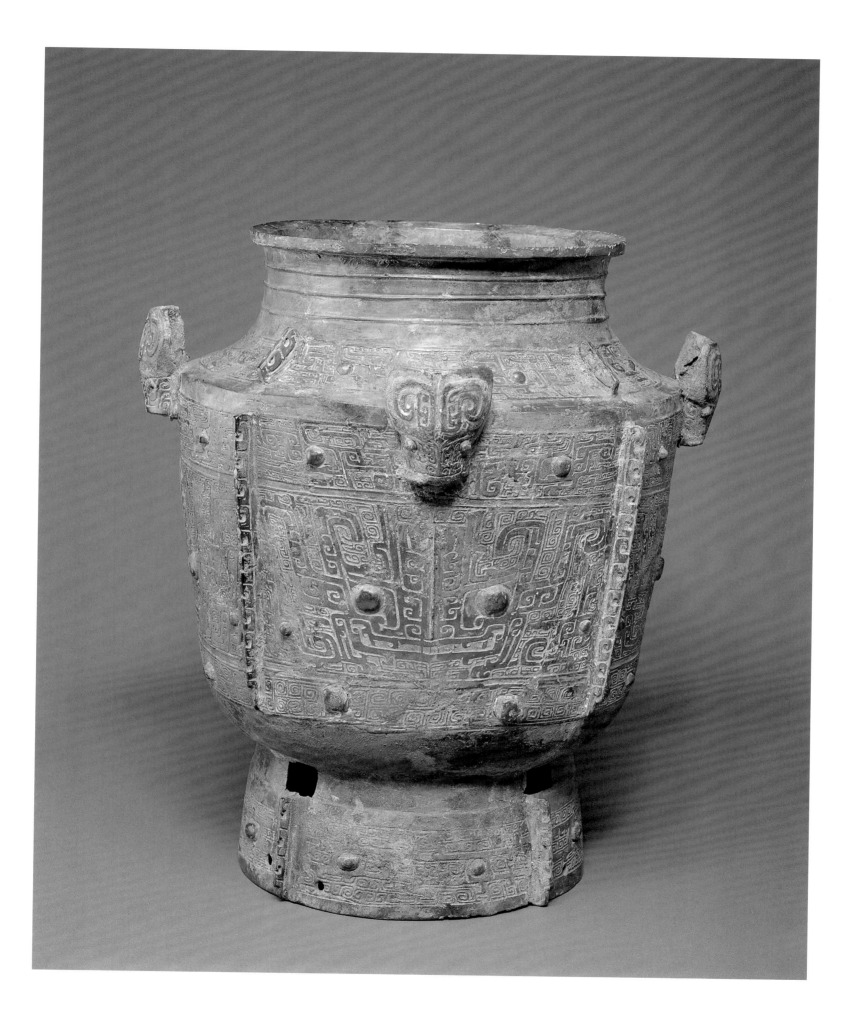

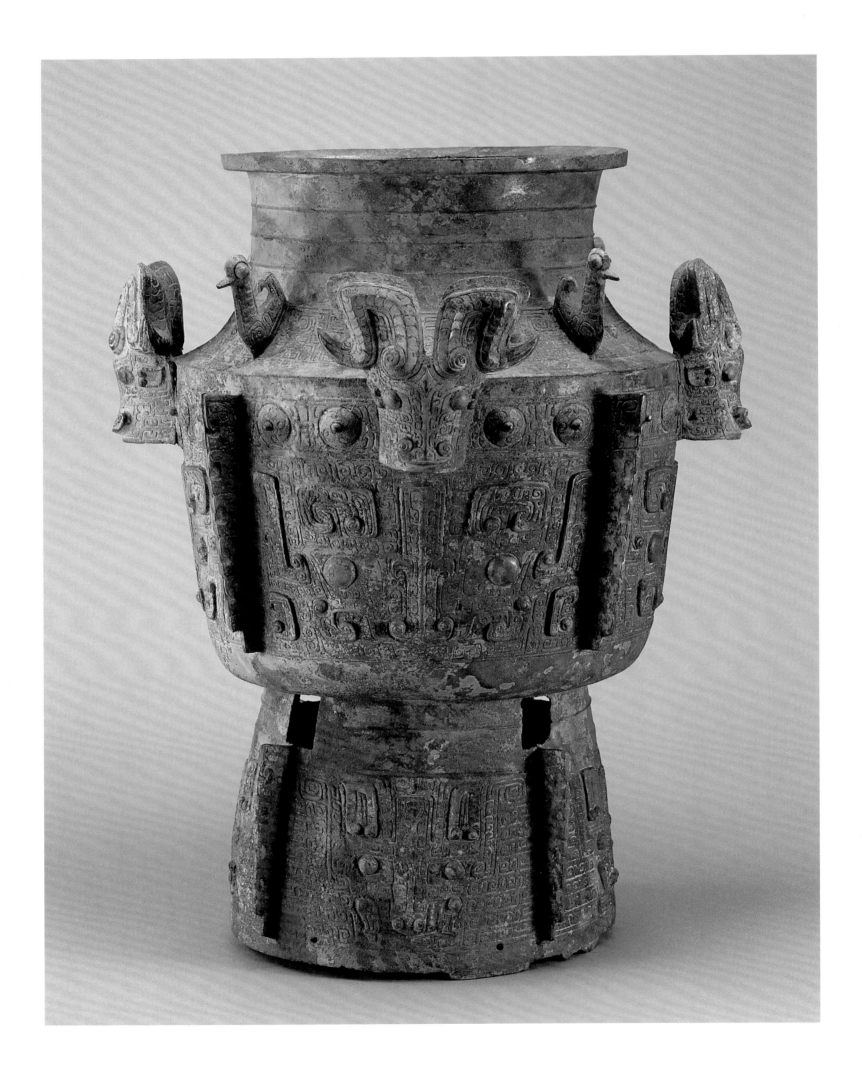

Lei

Bronze
Height 54 cm, diameter at mouth 26.5 cm,
diameter at foot 24.6 cm
Twelfth century BC

Excavated from Sanxingdui Pit 2 [K2(2):159]
Sanxingdui Museum 00652

PUBLISHED: Beijing 1994a, pls. 68–9; Beijing
1994b, pl. 36; Rawson 1996, no. 27; Tokyo 1998,
no. 87; Beijing 1999a, p. 265 fig. 147, p. 268
rubbing 26, pp. 272–3, p. 565; Taibei 1999,
no. 58; Yang 1999, no. 74.

This vessel belongs to the same type as the last, but
it is far more imposing. The foot and neck are higher,
the animal heads on the shoulder are larger and have
freestanding horns, the flanges are heavier, and the
surface decoration is executed in high relief.[1] Just
above the flanges small birds sit on the shoulder. The
taotie faces in the middle register and on the foot
stand out more prominently here than in the low
relief of No. 48, but they cannot compete with the
vessel's more three-dimensional features, above all
the horned animal heads. Similar heads appear on
the *zun* from Hunan Huarong shown in Figure 47.1,
which shares with No. 49 the distinction of being
one of the largest and most impressive examples of
its type.

Six *lei* (one of square cross section) have been
identified among the vessel fragments found in Pit 2,
but only three have been restored. Like Nos. 45 and
48, this vessel has small holes drilled through the foot
rim, five in all.

1. On this particular variety of high relief, which is
peculiar to the middle Yangzi region, see Bagley 1987,
entry no. 43.

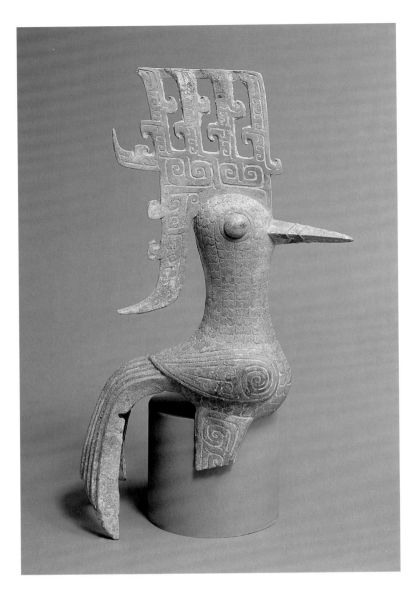

With its ornate crest and spiky beak, this bird differs distinctly from others in the Sanxingdui pits, such as Nos. 30–33. Comparison with a bronze now in the Musée Guimet suggests both an origin and a function for it (Fig. 50.1). The Guimet bronze reportedly was found at Changsha in northern Hunan, and it is the lid of a vessel, perhaps of a *lei* like the one shown in Figure 48.1 (compare the surface decoration and the flanges). There is abundant evidence for the popularity of such bird images in the middle Yangzi region, and some evidence for their export westward, in particular a bronze *jia* found in the Wei River valley of Shaanxi (Fig. 50.2).[1] If No. 50 is indeed the fragment of a lid, the vessel to which it belonged must have been very large, at least the size of No. 49.

One other bird with the same distinctive crest was found in Pit 2 (Fig. 50.3). Again it seems to be a fragment of a lid, but in this case the bird is not three-dimensional; instead it is flat, like a much elaborated flange, or a spectacularly feathered version of the little birds on the shoulder of No. 49.[2] The surface decoration adjacent to the bird is not too different from that on the Guimet lid.

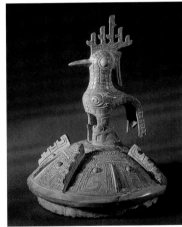

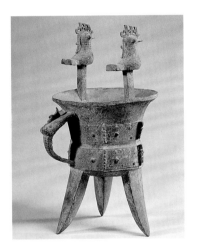

Fig. 50.1. Lid of bronze vessel, said to come from Hunan Changsha. Collection of the Musée Guimet, Paris (MA1612).

Fig. 50.2. Bronze *jia* from Shaanxi Qishan Hejiacun. Height 41 cm. After Beijing 1998a, pl. 60.

50

Bird with high crest

Bronze
Height 34 cm, width 19.2 cm, weight 1.511 kg
Twelfth century BC

Excavated from Sanxingdui Pit 2 [K2(3):193-1]
Sanxingdui Museum 00436

PUBLISHED: Tokyo 1998, no. 72; Beijing 1999a,
p. 334 fig. 184, p. 337 pl. 127.3, p. 569 fig. 84;
Taibei 1999, no. 65.

Fig. 50.3. Fragment, possibly from the lid of a bronze *lei*. K2(3):23. Height of the bird 13.3 cm. After Beijing 1999a, p. 266 rubbing 23.

1. The range of bird motifs seen on bronzes from the middle Yangzi region is surveyed in Bagley 1987, pp. 546–8.

2. The fragment illustrated in Figure 50.3 is identified by the excavation report as part of a *zun* (Beijing 1999a, pp. 252, 266), but this is surely incorrect.

51

Kneeling figure holding a forked blade

Bronze
Overall height 4.7 cm, width 1.8 cm
Twelfth century BC

Excavated from Sanxingdui Pit 2 [K2(3):325]
Sanxingdui Museum 00502

PUBLISHED: Rawson 1996, p. 83 fig. 34.3; Beijing
1999a, p. 235 fig. 133, p. 247 pls. 88.1–2, p. 560
fig. 67.

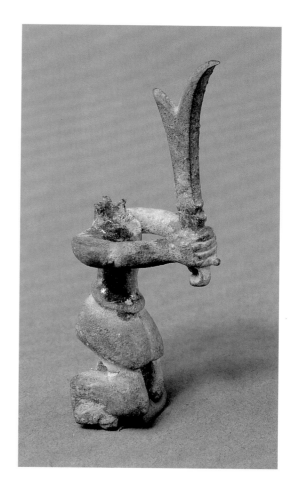

This kneeling figure holding a blade before its chest has attracted scholarly attention all out of proportion to its tiny size, for it is the only evidence ever found bearing on the manipulation of jade and stone forked blades like Nos. 52 and 54–5. However, it must immediately be added that the evidence may well apply only to the way this mysterious shape was used at Sanxingdui. Forked blades are widely distributed in regions where Sanxingdui ritual was surely quite unknown (see Chapter 2, Figure 6), and the way a Sanxingdui priest held a forked blade might have puzzled an Erlitou aristocrat just as much as the rest of Sanxingdui ritual undoubtedly would have. Nonetheless it is certainly of interest that this tiny figure holds out, with some formality, an object of a kind that was actually found in the pits, just as the bronze statue No. 2, perhaps, held out one of the elephant tusks found in the pit. A small bronze replica of a forked blade found in Pit 2 measures 14.2 cm long and might come from the hands of a bronze figure a little larger than No. 51 (Fig. 51.3); the figures kneeling on the tree base No. 28 seem to be about the right size. Many other small figures in Pit 2 must likewise have held offerings now separated from them.

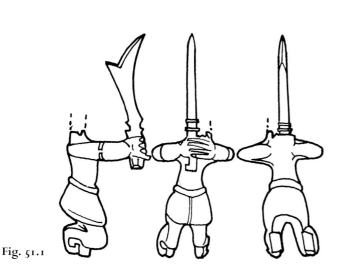

Fig. 51.1

Fig. 51.1. No. 51, drawings. After Beijing 1999a, p. 235 fig. 133.

Fig. 51.2. Bronze standing figure. K2(3):292-2. Height 8.3 cm. After Beijing 1999a, p. 167 fig. 83.

Fig. 51.3. Bronze forked blade. K2(2):144-5. Length 14.2 cm. After Beijing 1999a, p. 285 fig. 158.

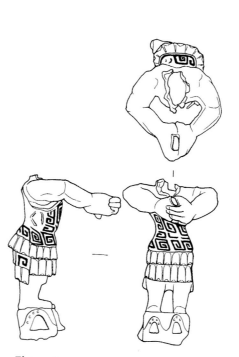

Fig. 51.2

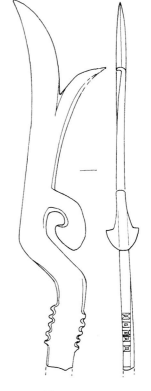

Fig. 51.3

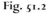

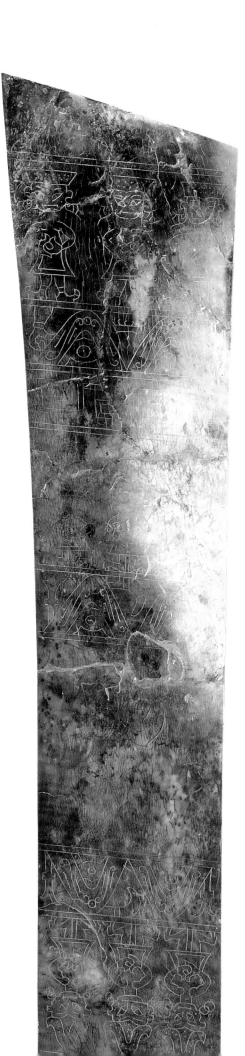

by Jenny F. So

Jade and Stone at Sanxingdui

Over the last century, jade and stone artifacts have been unearthed repeatedly in or near the ancient city at Sanxingdui. The first discovery was made in 1929 in the northern part of the area now known to lie within the ancient walls: a local landowner found several hundred disks, blades, and other implements at the bottom of an irrigation ditch next to his residential compound. Archaeologists from Huaxi University (later renamed Sichuan University) visited the find spot in 1933, by which time most of the objects had been sold; the unsold pieces were acquired for the Sichuan Provincial Museum and the Sichuan University History Museum.[1] Later, between 1964 and 1984, pits containing workshop debris—tools, uncut boulders, and partly worked implements—were encountered several times in the area within the walls, suggesting that a thriving stoneworking industry once existed there.[2] Then in 1986 the two astonishing sacrificial pits yielded the richest material yet, over two hundred jade and stone implements (Nos. 52–63). More recently artifacts of jade and stone have been discovered at a location in the northeastern part of the walled area in 1987, and in burials outside the west wall in 1997 and 1998.[3] What we can say today about jade and stone at Sanxingdui must be regarded as only an interim report on an ongoing investigation, but a general characterization of existing finds already shows interesting differences from contemporaneous lithic industries in other parts of China.

MATERIALS AND TECHNIQUES

In discussions of ancient Chinese jades, an important but often neglected topic is the material itself. Chinese usage, often followed by Western writers, applies the word "jade" to almost any finely worked ancient mineral artifact. This turns it into a blanket term for a wide variety of stones, ranging from relatively hard minerals such as agate and crystal (hardness 7 on the Mohs scale), through softer ones such as nephrite and turquoise (hardness 6.5–5), all the way to marble and soapstone (hardness 3–2). Understanding the skills and achievements of ancient China's lapidaries requires more exact mineral identification. Mineralogical examination shows that Neolithic and Bronze Age lapidaries worked many different materials; by far the most commonly used of the hard stones was nephrite.[4] Nephrite's hardness and fibrous structure mean that it cannot be carved or cut by metal tools. Ancient lapidaries therefore shaped and polished it by grinding with abrasives made by crushing harder minerals.

1. Dye 1931; Graham 1934. The unsold pieces are published in Feng & Tong 1979; Gao & Xing 1998. The 1929 find spot is located about 1 km north of the sacrificial pits discovered in 1986 (which are also within the walled area).

2. These finds, which have not been formally reported, are briefly described in Chen Xiandan 1988, p. 10.

3. The 1987 find is reported in Beijing 1998f, pp. 78–90. The latest finds are briefly mentioned in Gao & Xing 1998, p. 27; they were described in more detail by Gao Dalun during a conference held at the Chinese University of Hong Kong in November 1998.

4. For a survey of nephrite artifacts recovered from ancient sites see Wen & Jing 1996.

Fig. 1. (Damaged) knife?, micaceous quartz. From Sanxingdui Pit 1. Length 162 cm, greatest width 22.5 cm, thickness 1.8 cm. Thirteenth or twelfth century BC. After Taibei 1999, no. 117.

Fig. 1. (Damaged) knife?, micaceous quartz. From Sanxingdui Pit 1. Length 162 cm, greatest width 22.5 cm, thickness 1.8 cm. Thirteenth or twelfth century BC. After Taibei 1999, no. 117.

Fig. 2. Stoneworking tools, mostly quartz/quartzite. From Sanxingdui Pit 2. Twelfth century BC.

However, among the nearly 200 objects from the Sanxingdui pits that the excavation report classifies as "jade,"[5] fewer than 6 percent, according to the report, are actually nephrite. Most are varieties of marble or limestone, relatively soft materials that can be worked not only with abrasives but also with metal tools (Nos. 52–3, 56–60, 63).[6] The report's inventory for Pit 1 lists 105 "jades," but says that only 4 are nephrite; the Pit 2 inventory lists 81 "jades," but says that only 6 are nephrite. The items in softer materials, to judge by their shapes, are local products. Nephritic items include some of the beads, some of the disks and rings (Nos. 61–2), and isolated examples of *ge* blades and grinding tools. Of these the *ge* blades, disks, and rings may have been imports. Even if they were not, the rarity of their material must have given them special prestige in the Sanxingdui culture.

A few of the items in hard stone do not seem to have been imports. The shape and eccentric scrolls of the blade No. 55 favor local manufacture, as does the sheer size— damaged but still 162 cm long—of a knife from Pit 1 (Fig. 1), and both of these items are said to have been made from an unusually hard stone akin to quartzite.[7] The convoluted scrolls at the tang of No. 55, probably fairly easily executed in limestone, represent a formidable achievement in quartzite. If Sanxingdui stoneworkers were able to saw, drill, incise, and polish stones as hard as this, the predominance of softer stones at the site may have more to do with supplies of raw material than with any deficiency in tools or skills. The grinding tools recovered from the site are in fact quite hard; a few are nephrite, the rest belong to the quartz-mica family of minerals (hardness 7) (Fig. 2).[8] Perhaps the limited supplies of hard stone were reserved for use as tools rather than expended in finished products.

Most of the blades found at Sanxingdui date from a period when bronze was in use there. Before metal tools became available, any stone would have been worked by abrasion, but with the advent of metal the Sanxingdui lithic industry may have split into two slightly different branches. Materials too hard to be cut by metal necessarily continued to be worked by abrasion (though metal tools would have offered better ways of applying the abrasive). For materials as soft as limestone, however, much of the shaping could be done directly with metal tools, and this may have sped up

5. Another 61 objects from Pit 1 are classified separately, as "stone" (see Beijing 1999a, pp. 455–63, 485–8).

6. The mineral identifications mentioned here and in the entries for Nos. 52–63 are those given in the report (Beijing 1999a, pp. 500–521), which unfortunately may not be wholly reliable; see Introduction Part 1, note 32.

7. The damaged blade is likely to be a knife of a type well known in jade (compare Fong 1980, no. 3), though the excavation report classifies it as a *zhang*. The hardness of the material (identified in Beijing 1999a, p. 455, table 5, item 1) might explain the unusual thickness of the blade, 1.8 cm; most blades from Sanxingdui are less than a centimeter thick.

8. Mineralogical identifications of tools are given in Beijing 1999a, pp. 487–8, table 28 and, for items not included in the table, in the descriptions of those items in the body of the report.

production significantly. On many blades, straight saw marks are visible on the ends or on a face, suggesting the use of a metal saw of some kind. Unwavering incised lines, perfectly aligned with notched edges, hint at the use of a straight edge and a sharp metal point (Nos. 52, 59). On the other hand perforations, almost always drilled from one face of the blade, have sharply sloping inner walls, suggesting that the drill was made from wood, bone, or some comparably soft material: the hole diminished in diameter as the drill tip wore down. For large openings the drill was hollow, but the drilling was still as a rule carried out from one direction, producing the same sloping walls (Fig. 7). Collared disks and rings are an exception, their openings having apparently been drilled from both directions. Since this was standard practice among jadeworkers to the north and east, in the Yellow River valley and the lower Yangzi region, it is perhaps another reason for suspecting that the disks and rings found at Sanxingdui were imports.

SHAPES, SIZES, AND FUNCTIONS

An overwhelming majority of the nephritic and stone artifacts recovered from Sanxingdui are blades, objects presumably made specifically for ritual use. The only items likely to have been worn ornaments are disks, rings, and small beads.

Among the blades, three types stand out. The most familiar is the *ge* blade, which copies in stone the characteristic weapon of China's Bronze Age, a battle-axe whose dagger-shaped bronze blade was mounted at right angles to a wooden shaft. All the features of a typical jade or stone *ge* blade from the Yellow River valley are present in No. 56; such *ge* were well represented in both pits. The elongated shape of No. 57, on the other hand, is peculiar to Sanxingdui, and seems to be a local variant of the standard type.

The blade type that has received the most attention from scholars is a shape with a blunt rectangular tang, jagged notches above it, and a long portion that flares slightly to a slanted, concave, or forked top (Nos. 52, 54–5). This is commonly referred to as a "*zhang* scepter." However, since the term *zhang* was invented late in the first millennium BC by authors of ritual texts who may never have seen one of these blades, and who indeed may have been thinking of some other shape entirely, attaching it to any specific ancient type seems risky at best.[9] To avoid perpetuating a likely misnomer with irrelevant textual associations, the objects are simply called forked blades here.

Because of their odd shape and their lack of any obvious prototype in a functional tool or weapon, these blades have long been a puzzle to students of archaic jades. Discussing examples reported to have come from northern Shaanxi province, Salmony suggested that the forked or concave top, which is often sharpened, identified the object as a scraper for cleaning animal hides or scaling fish.[10] A more recent view takes the functional prototype to be a bone plowshare and goes on to relate the jade versions with rituals of sun-worship.[11] The examples recovered from Sanxingdui shed no new light on the question of prototype, but they do supply new information about the blade's function. At Sanxingdui, at least, the forked blade was a ritual or ceremonial implement, held vertically with its concave or forked end pointing up. This is illustrated for us in the incised designs on the blade No. 53 and also by a bronze miniature kneeling figure from Pit 2 (No. 51). Nowhere else in Bronze Age China are the use

9. The point is made in Xia Nai 1983 (see especially p. 456) and reiterated in Yang Hong 1994.

10. Salmony 1963, p. 82.

11. Hayashi 1991, chapter 6, which includes a survey of other views. See also Wang Yongbo 1996; Fong 1980, entry no. 2.

Fig. 3. Collared rings, bronze. From Sanxingdui Pit 1. Diameters 7.4–12.8 cm. Thirteenth or twelfth century BC. After Beijing 1999a, p. 50 figs. 30.1–2.

and importance of a ritual blade so clearly demonstrated. A miniature bronze blade found in Pit 2 might have been held in the cupped hands of another of the many kneeling figures from the pit. A related blade shape, so far known only at Sanxingdui, is represented by Nos. 58–9. The excavation report does not distinguish this type from the preceding one, classifying both as "*zhang*," but it deserves a category to itself, for it is conspicuously different, having not a forked or slanted top but instead the sharp point of a *ge*. The shape is in fact an obvious hybrid, marrying the notched and ruled tang of the forked blade with the asymmetrically tapering profile of the *ge*, and while the parent types occur elsewhere and no doubt originated elsewhere, the hybrid is on present evidence confined to Sanxingdui. In examples like No. 58, which has a V-shaped slit at the tip, some observers see a fish; whether the original owners did or not (and they may well have seen an allusion to forked blades instead), the type can hardly have originated as a depiction of a fish. On No. 59, the most extraordinary of these blades, a bird sits inside the scooped-out tip, and the faintly incised drawing of a forked blade, more elaborately frilled than any actual example, appears on each side. Curiously, while *ge* blades are well represented in both pits (45 in Pit 1 and 31 in Pit 2),[12] the forked blades and the hybrids are not. Pit 1 contained 34 hybrids but only 5 modest examples of the forked type; Pit 2 had 16 forked blades (among them 3 miniatures) and not a single hybrid.

In a ritual context not associated with a burial we would not necessarily expect to find personal ornaments, certainly not a representative selection of them, so it is not surprising that the two pits contained none of the small ornamental carvings or figurines commonly found at contemporary sites in the Yellow River valley. Nevertheless a few items likely to have been ornaments were deposited, perhaps more because they were valuable than because they served specific ritual functions. Chief among them are disks and rings with collars around their openings; these were probably bracelets (Nos. 61–2). A few such bracelets, including No. 61, were found inside bronze vessels, accompanied by cowry shells and jade beads. Collared disks and rings constitute only a small percentage of the jade and stone objects recovered from Sanxingdui. Surprisingly, however, copies of them in bronze—items unknown anywhere else—are abundant: 74 in Pit 1 and 56 in Pit 2 (Fig. 3). Most of the bronze versions resemble No. 62 in size and proportions, though one from Pit 2 has a substantially larger opening.[13] These bronze copies testify to the prestige of the nephrite originals, which must have been valued for their fine material and workmanship, and if they were imports, perhaps for exotic rarity too. Collared rings probably originated in Neolithic times on the east coast, where a wide range of bracelets and cuffs were made in pottery, bone, and jade, but examples in jade have come primarily from Bronze Age sites, notably Anyang, Xin'gan in Jiangxi, and Sanxingdui.[14] Counting the bronze, jade, and stone examples together, the total number of disks and rings at Sanxingdui exceeds a hundred, suggesting that the shape had special meaning or status there, or at least remarkable popularity. Examples found in North Vietnam and Malaya may represent a southward transmission of the type from Sichuan.[15]

12. Of the 45 in Pit 1, the report classifies 27 as "stone" and 18 as "jade"; of the 31 in Pit 2, 10 are "stone" and 21 are "jade." (All of the forked blades and hybrids are "jade.") Note however that the classification is a loose one: by "jade" the report means only comparatively hard and fine stone (the "jades" are certainly not all nephrite).

13. Beijing 1999a, p. 282 fig. 153, p. 286 pl. 102, p. 566 color pl. 75. The ring is faintly oval, almost circular, with an outside diameter of about 22 cm and an inside diameter of about 14 cm.

14. Rawson 1995, pp. 164–5; Hayashi 1991, pp. 523–6 (Yang Meili 1997, p. 357). Only one collared ring is known from a Longshan site, Shandong Haiyang Simatai; said to be "black jade"—a description which might hint at raw material imported from the Shenmu area in northern Shaanxi—it was fitted inside the hole of a serrated disk (*Kaogu* 1985.12, p. 1062 fig. 6.22). Rawson, mistaking the Simatai ring for ivory, suggested that the vertical collars of jade rings originated from an attempt to strengthen bracelets made of ivory and other softer materials.

15. Hansford 1968, pp. 72–3, pl. 9a–b; Deng Cong 1998, vol. 3, no. 319.

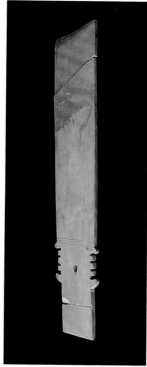
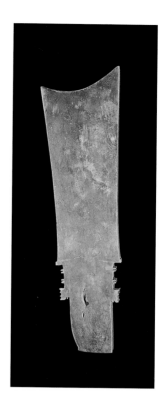

Fig. 4. Forked blade, limestone with red coating. Unearthed at Sanxingdui (at an unspecified location). Length 61.3 cm, greatest width 11.3 cm, thickness 1.4 cm. Second half of the second millennium BC. After Deng Cong 1998, vol. 3, no. 285.

Fig. 5. Forked blade, limestone with red coating. From Yanshi Erlitou tomb 3, Henan province. Length 54 cm, greatest width 14.4 cm, thickness 0.8 cm. Middle of the second millennium BC. After Chen & Fang 1993, no. 7.

A peculiar feature of the Sanxingdui lithic inventory is the wide range of sizes, from very large items to miniatures. The largest blade yet found at Sanxingdui is the damaged knife mentioned already, incomplete but still 162 cm long (Fig. 1). A stone disk from the 1929 find measures 69 cm across and weighs over 50 kg.[16] Forked blades range all the way from 90 cm[17] to a mere 3 or 4 cm; the miniature examples occur not only in jade and stone but also in gold leaf (perhaps originally wrapped over wood).[18] While some sizes could have been readily manipulated in the course of a ritual, others may have been intended for more static display—in the case of the miniatures, for instance, display in the hands of miniature bronze figures.

With the exception of some found inside bronze vessels, most of the jade and stone artifacts from Pits 1 and 2 had undergone burning before they were deposited in the pits. This has left their surfaces either chalky white, dry, and finely crackled, or dark gray-black (Nos. 53, 59). A number of the stone items appear to have been evenly coated with a layer of red powdery substance, perhaps cinnabar (the excavation report uses this term but gives no analysis), entirely concealing the color and texture of the stone underneath (Fig. 4). Perhaps this treatment, found mainly on limestone blades and disks, was a deliberate effort to enhance the appearance of an inferior material; or perhaps the coating was applied for some ritual reason. Cinnabar is often found in burials in north China, but there it seems as a rule to have been sprinkled over the corpse or the entire burial rather than applied as a coating to individual objects. Two forked blades from Erlitou and a third from Zhengzhou (an isolated surface find) that do seem to have been coated with a reddish substance are thus somewhat unusual in a northern context (Fig. 5). Since they appear to be limestone rather than nephrite, and since their notched profiles and holes can be matched on blades found just north of Sanxingdui at Zhongxingxiang, it is possible that they are Sanxingdui products that somehow made their way north to the Yellow River valley.[19]

SANXINGDUI AND ITS NEIGHBORS

Though unmistakably individual, the Sanxingdui jade and stone industry was not independent of lithic industries elsewhere. *Ge* blades and collared disks and rings were shapes acquired from the Yellow River valley.[20] Other shapes may have come from the middle or lower Yangzi region: that Sanxingdui was in contact with the middle Yangzi region is not in doubt—most of the bronze vessels in the pits originated there (see the entries for Nos. 44–9)—and it is thus conceivable that eccentric *ge* like Nos. 57 and 60 are related to similar *ge* found in Hubei near the Erligang outpost at Panlongcheng.[21] Moreover contacts down the Yangzi may go back to periods much earlier than the Sanxingdui pits. Not yet reported in detail, excavations in 1997 and 1998 of

16. Feng & Tong 1979, p. 34; best illustrated in Tokyo 1998, no. 161.

17. This is the approximate length of the blade K2(3):320, which the excavation report mistakenly describes as 67.8 cm long (Beijing 1999a, p. 367).

18. Beijing 1999a, p. 320 fig. 174, p. 323 pls. 121.1–5, p. 369 fig. 201, p. 373 pls. 142.2–4.

19. The Erlitou blades are published in *Kaogu* 1983.3, pl. 1.4; Beijing 1999c, color pl. 2.1 and pls. 118.5, 168.2; and Hayashi 1991, figs. 6-109, 6-111, 6-115. The blade from Zhengzhou is published in *Wenwu* 1966.1, p. 58; Hayashi 1991, fig. 6-103. For the examples from Guanghan Zhongxingxiang see Hayashi 1991, figs. 6-104, 6-112. Color images that show the red coating well appear in Chen & Fang 1993, nos. 6–7, 20, 209; Deng Cong 1998, vol. 3, nos. 285, 287, 290–92. A third forked blade from Erlitou (Fong 1980, no. 2) resembles one of the blades from Zhongxingxiang so closely in shape and in the execution of the notches as to suggest that it too comes from Sichuan.

20. A cylindrical bracelet of opaque white stone found at Sanxingdui (Beijing 1998f, p. 83 fig. 6.4, p. 88 fig. 11) might be an actual import from the middle Yellow River region, for the closest known parallels are from Anyang (Beijing 1984a, p. 186 fig. 93, pl. 154; Hayashi 1991, figs. 7-97, 7-98, 7-112 through 7-117; it should be added that the Anyang items may be Neolithic heirlooms considerably older than the context in which they were found).

21. See No. 57, note 2, and No. 60, note 3.

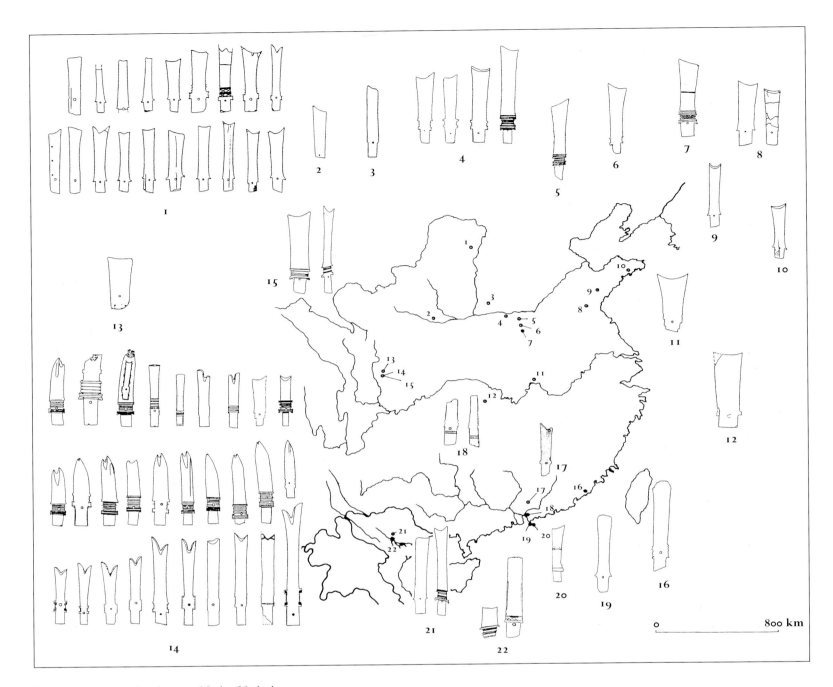

Fig. 6. Geographical distribution of finds of forked
blades. After Rawson 1995, p. 190.

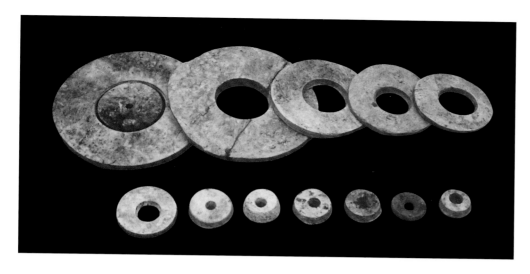

Fig. 7. Disks with drilled centers, stone unidentified. Excavated in 1987 at Guanghan Zhenwucun. Early second millennium BC?

Fig. 8. Disk with undrilled center. Collected in 1976 at Yinchuan in Ningxia Hui Autonomous Region. Qijia culture, early second millennium BC.

a cemetery on the western outskirts of the city are said to have yielded awl-shaped pendants of a type associated with the third millennium Liangzhu culture of the Yangzi delta, as well as grayish-white pottery related to pottery of the Shijiahe culture, a late Neolithic (*c.* 2200–1800 BC) culture of the middle Yangzi region. Better understanding of Sichuan's relationships with the middle and lower Yangzi must await proper publication of these new finds.[22]

The forked blade with elaborately notched edges seems instead to have originated north of Sichuan, in an early second millennium Neolithic context: the Neolithic site at Shenmu in northern Shaanxi is the only place where such blades have been found in numbers approaching those at Sanxingdui (Fig. 6), and the Shenmu blades are very similar, though simpler in design. Their transmission to Sanxingdui could have followed the network of rivers that flow south and southeast into Sichuan from sources in the Qinling mountains.[23] Since a few forked blades have also been found in the Yellow River valley—at Erlitou and Zhengzhou though not at Anyang—it has often been assumed that the type was transmitted first from Shenmu to Erlitou, then from Erlitou to Sanxingdui.[24] As suggested already, however, the blades found at Erlitou and Zhengzhou may actually have been made at Sanxingdui; Sanxingdui products could easily have travelled eastward to the middle Yangzi region, then north to Yellow River sites.[25] It seems clear at least that the Sanxingdui culture exported its characteristic artifact in another direction: forked blades have been found as far south as Hong Kong, Phung Nguyen in North Vietnam, and even in Malaya.[26]

In workshop technique Sanxingdui stoneworkers appear to have had close ties with counterparts in northern Shaanxi and southern Gansu. The lithic industries of these regions share several features: metal saws that left straight sawcuts on blades and disks; solid drills worked from one face of the object, leaving sharply slanted walls in perforations; and the odd practice of saving and reworking the centers of large disks. Close examination of stone disks found in 1987 at Guanghan Zhenwucun showed that ten small ones had been made from the centers of ten large ones (Fig. 7).[27] Evidence for similar parsimony is seen in Gansu in the Qijia burials at Wuwei Huangniangniangtai, where fifteen stone disk centers were recovered, and in disks collected in 1976 at Yinchuan in Ningxia (Fig. 8).[28] Sanxingdui and Qijia lapidaries also seem to have worked a similar range of stones:[29] the 264 disks recovered from the Huangniangniangtai

22. The finds are mentioned briefly in Gao & Xing 1998, p. 27, and in more detail in the talk by Gao Dalun cited in note 3.

23. For a discussion of this route and historical references to it see *Sichuan wenwu* 1990.6, pp. 12–14. The absence of forked blades from the Qijia culture weighs against transmission by way of Gansu province.

24. See Childs-Johnson 1995; Rawson 1995, pp. 39–44, 167–91.

25. Erlitou graves have yielded a small number of turquoise-inlaid bronze plaques that might also be imports from Sichuan: compare Erlitou examples (Deng Cong 1998, vol. 3, nos. 257–8; Beijing 1992c, no. 87; Rawson 1996, no. 36) with plaques found at Guanghan Zhenwucun (Beijing 1994a, pls. 63–4; Tokyo 1998, nos. 150–51; Beijing 1998f, p. 81 fig. 3).

26. The rather strange distribution of the forked blade, mapped in Figure 6, is described in Zhang Guangyuan 1999 (see p. 47 for a summary of various views as to origin and spread). Deng Cong 1994 is a collection of essays discussing the origin, distribution, function, and significance of the blades. For the examples from southern sites see Deng Cong 1998, vol. 3, nos. 297, 301–2, 304, 318. The site at Phung Nguyen, which yielded both forked blades and collared disks, has been dated to the second millennium BC (Nguyen 1998, pp. 386–9).

27. Beijing 1998f, pp. 82–6.

28. Huangniangniangtai: *Kaogu xuebao* 1978.4, p. 441; Yinchuan: Wen Guang, private communication. Wen Guang informs me that additional examples are in the Lintao Museum, Gansu province.

29. Possible mineral sources are discussed in Chen De'an *et al.* 1998, p. 40; Zhang Guangyuan 1999, p. 46. No secure way has yet been found to connect ancient jade and stone artifacts with mineral sources known today; even a close resemblance between raw material from a particular source and the material of an artifact is no guarantee of a connection.

burials included jades, various limestones, and marbles. However, flat disks are the only shape common to the two cultures; no forked blade, *ge* blade, or collared disk/ring has yet been found in a Qijia context.

The distinctiveness of the Sanxingdui culture proclaimed so spectacularly by its bronzes is announced in a more subdued but no less clear way by its lithic industry. From the bronzes we learn something of the outside contacts of that culture—its sources, affiliations, and influence—and the jade and stone artifacts add further information. Few of the bronzes are likely to have been made any great length of time before their deposition in the pits. The lithic types seem to have more chronological depth; they point to early but perhaps short-lived contact with the Yellow River valley, and to lasting contact with peripheral regions.

52

Forked blade

Stone (type undetermined)

Length 55.5 cm, greatest width 9.6 cm, thickness 0.8 cm

Early to middle second millennium BC

Found in 1984 at Guanghan Zhenwucun Cangbaobao

Sanxingdui Field Station, Sichuan Provincial Institute of Archaeology, 84cai

PUBLISHED: Beijing 1994b, pl. 89; Taibei 1999, no. 122.

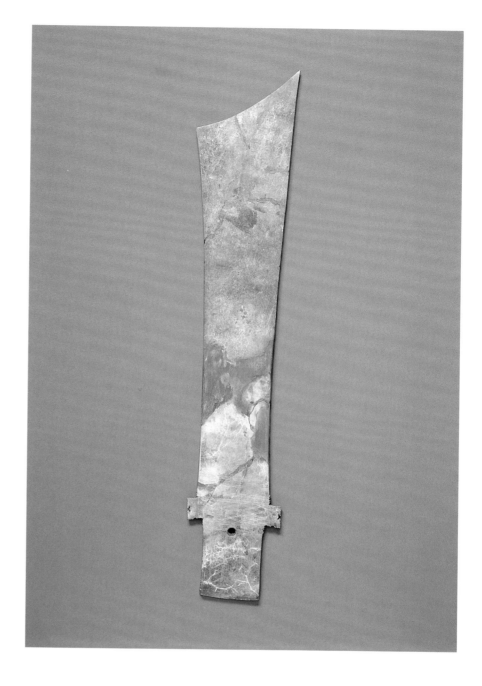

A surface find from along the northern edge of the Sanxingdui site, this blade was made from a whitish-gray, relatively soft stone. The material was sliced to produce a flat slab; then the blade was designed on the slab and jig-sawed out. The shape has a rectangular tang, a finely notched crosspiece, and a gently flaring main part cut aslant at the top. All the edges are blunt except for the slanting top, which was sharpened. The small hole in the tang was drilled from one side and poked through, leaving jagged edges around the opening on the other side. The surface was ground smooth but not highly polished. A saw mark is visible in the thickness of the tang's bottom edge.

The most striking feature of the silhouette is the notched crosspiece. Its two blunt rectangular projec-tions have profiles broken by dense serrations that extend a little way above and below it. The Y-shaped opening in the edge of each projection was produced by drilling a pair of tiny holes and then linking them by sawing through the intervening material.

Decoration appears only on one side of the blade, the side from which the hole was drilled. It consists of incised parallel lines, most of them perfectly straight, some arranged in crisscrossing diagonals reminiscent of textile patterns. Similar decoration is found on blades from sites farther north,[1] but since the material of No. 52 is typical of Sanxingdui, it is likely to have been manufactured there.

1. E.g. from Shaanxi (Deng Cong 1994, fig. A.14) and Henan (Chen & Fang 1993, pls. 12, 18; Fong 1980, nos. 2–3). The decoration occurs also on other blades from Sanxingdui, including No. 56.

53

Blade with incised figures

Stone (type undetermined)
Length 54.2 cm, greatest width 8.8 cm,
thickness 0.8 cm
Twelfth century BC

Excavated from Sanxingdui Pit 2 [K2(3):201-4]
Sanxingdui Museum 00174

PUBLISHED: Chen & Fang 1993, pls. 149–50;
Beijing 1994b, p. 128; Beijing 1999a, p. 361
fig. 197.1, p. 364 pl. 138.3, p. 572.

The tang of this blade has a slanted bottom and a hole drilled from one side. Just above the hole are tiny asymmetrical shoulders; above them the blade begins to widen almost imperceptibly to a slanted end. Like many blades from Pit 2, this one was subjected to burning, leaving its surface finely crackled and its color an opaque dark gray with a large whitish patch. It was found broken in several pieces.

On each side of the blade, an incised design organized in five registers appears twice, once at each end, oriented away from the center (Fig. 53.1). At the tang end we see two standing figures, then a register of what look like hills or mounds, then a band of angular S-meanders, then three kneeling figures, and finally a second pair of hills. At the other end of the blade the scheme is the same, but the first register has three figures rather than two. The standing figures differ from the kneeling ones not only in pose but also in their head-dresses and ear ornaments. The hills have interior details that have been interpreted, rather imaginatively, as a flat altar inside a tent-like structure with sun and trailing clouds above.[1] Next to the hills several different motifs are seen. In the register below the standing figures, a hand or claw reaches down to grasp one side of each hill; between the hills is a pronged emblem. In the register below the kneeling figures the hills are instead flanked by forked blades like No. 55 stood on their tangs; between the hills is a hooked shape that might be an elephant tusk, an interpretation suggested by the prominence of elephant ivory among the offerings in the Sanxingdui pits.[2]

In headdress, ear ornaments, and even posture, the figures on the blade are strikingly similar to some of the three-dimensional bronze figures from Sanxingdui (Nos. 2, 4–17). Moreover a miniature bronze kneeling figure from Pit 2 holds a forked blade (No. 51), while kneeling figures are seen in company with hill-like forms on the bases of the trees and altars from Pit 2 (Nos. 27–8; Introduction Part 1, Fig. 8).[3] Though we cannot be sure of the exact meaning of the various details and their arrangement, it seems likely that both the present design and the bronzes refer to rituals that were performed in hilly terrain and that involved the forked blades so common at Sanxingdui. No other stone or jade with similar pictorial designs has been found at Sanxingdui or any other Bronze Age site; indeed the drawings on No. 53 deserve note as one of the earliest attempts at pictorial representation known from China.

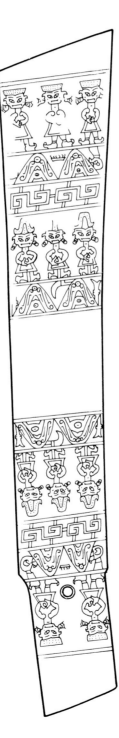

1. Chen De'an 1990.

2. Chen De'an 1990, p. 86.

3. Beijing 1999a, pp. 218, 220, 223, 230–31, 233.

Fig. 53.1. No. 53, drawing showing incised motifs. After Beijing 1994b, p. 128.

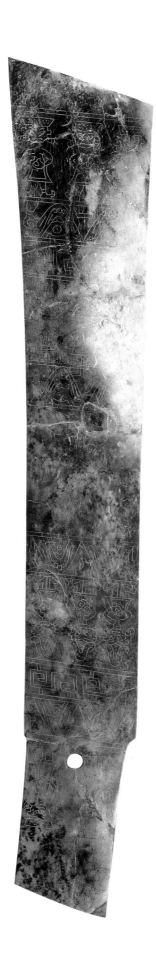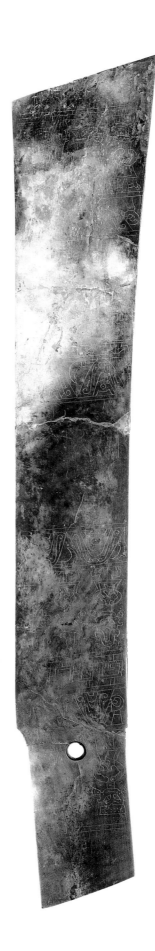

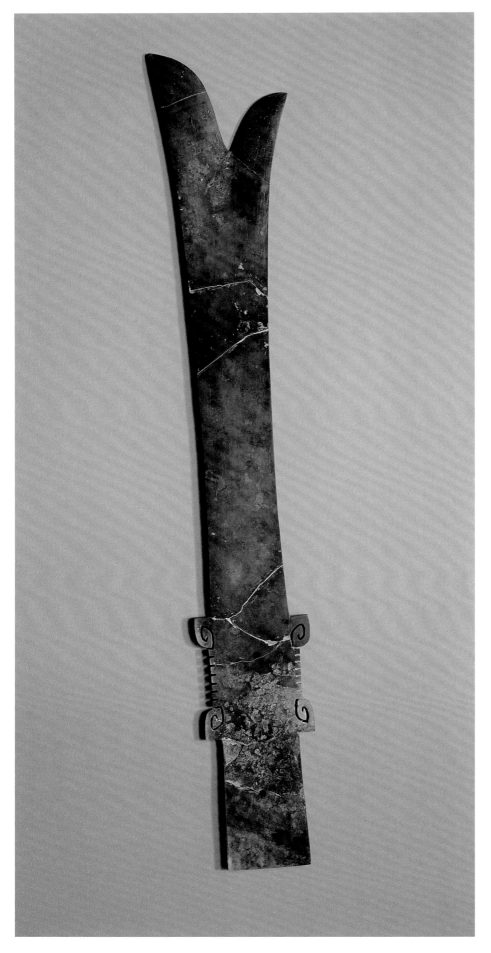

Forked blade

Basalt, hardness 3–4[1]
Length 68 cm, greatest width 6.8 cm, thickness
0.7 cm
Twelfth century BC
Excavated from Sanxingdui Pit 2 [K2(3):314-2]
Sanxingdui Museum

PUBLISHED: Goepper 1995, no. 49b; Rawson
1996, no. 34a; Beijing 1999a, p. 363 fig. 200.4,
p. 372 pl. 141.4, p. 577.

This exceptionally tall blade, found broken in the
bottommost layer of artifacts in Pit 2, was made
from a dark greenish-black stone. Above a series of
rectangular teeth bracketed by confronting scrolls,
the shape flares toward an asymmetrical, deeply cleft
end, the edge of which is sharpened. A small conical
hole was drilled not in the section framed by the
scrolls and teeth, the usual location, but lower down,
near the center of the tang.

1. The Sanxingdui excavation report does not give hardness mea-
surements for individual objects; it only identifies the various types
of stone (Beijing 1999a, pp. 455–63, 485–8, 500–521). Here and
in subsequent entries, therefore, the hardness or hardness range
quoted (on the Mohs scale) is that typical of the stone named, not
the measured hardness of the specific artifact. It should furthermore
be kept in mind that some doubt attaches to the report's mineral
identifications (see Introduction Part 1, note 32).

55

Forked blade

Quartzite, hardness about 7
Length 28.2 cm, greatest width 6.2 cm, thickness
0.7 cm
Twelfth century BC

Excavated from Sanxingdui Pit 2 [K2(3):165]
Sanxingdui Museum 00183

PUBLISHED: Beijing 1994b, pl. 90; Beijing 1999a,
p. 363 fig. 200.1, p. 372 pl. 141.1.

The tang of this blade widens very faintly at the base.
Above the tang each edge was jerkily jig-sawed to
produce an angular scroll turned upward, three
teeth, and a scroll turned the other way. Higher up,
the blade widens gradually to a cleft tip. A hole that
seems large in proportion to the blade is drilled from
one face; turn marks left by the drilling process re-
main visible on its inside wall. The unfinished perfo-
ration and also the comparative thickness of the blade
might be explained by the hardness of the material;
nevertheless the execution of the angular scrolls is
very neat and the entire blade is finely finished. The
stone, said to be quartzite, is pale olive and gray-
green with gray streaks.

The symmetrical arrangement of angular scrolls
separated by teeth or notches is confined to forked
blades from the Sanxingdui site. No. 55 is the small-
est of five examples from Pit 2 that differ chiefly in
size and material: their lengths are 28 cm (No. 55),
50 cm, 68 cm (two examples, one of which is No. 54),
and 90 cm.[1]

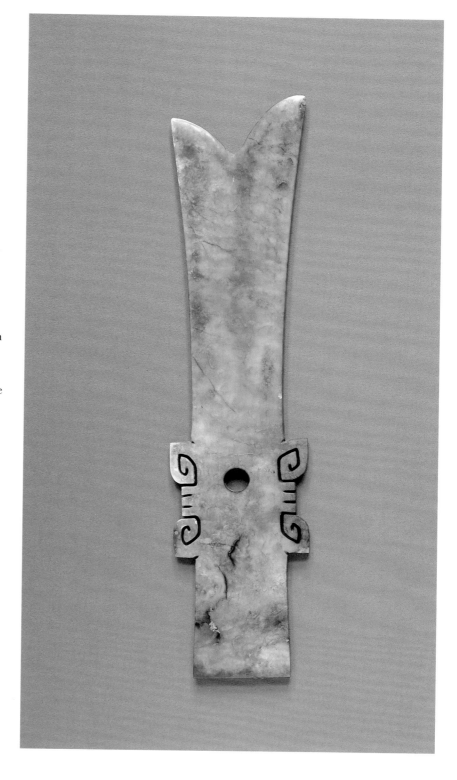

1. The 90-cm blade, K2(3):320, is mistakenly described in the
excavation report as 67.8 cm long (Beijing 1999a, p. 367).

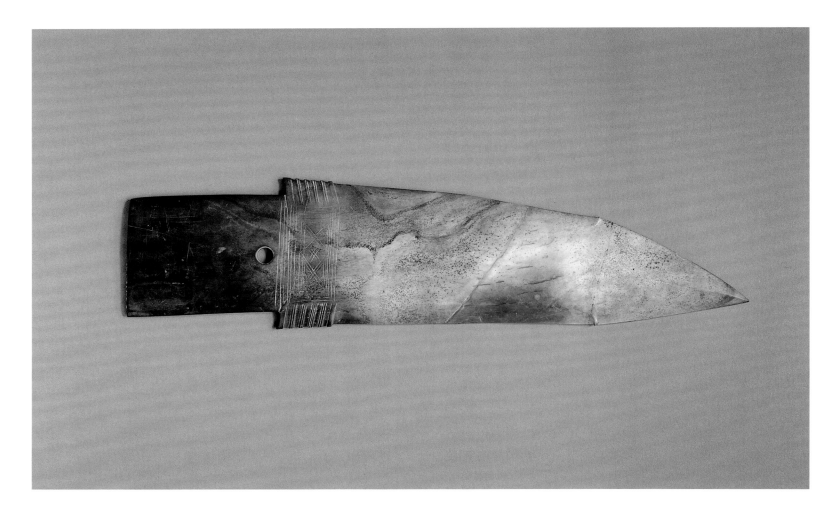

56

Ge *blade*

Marble, hardness 3
Length 40 cm, greatest width 10.1 cm, thickness
0.8 cm
Thirteenth or twelfth century BC
Excavated from Sanxingdui Pit 1 [K1:141-1,
155-2]
Sanxingdui Museum 00043

PUBLISHED: Chen & Fang 1993, pl. 153; Beijing
1994b, p. 148 (left and middle); Taibei 1999, no.
166; Beijing 1999a, p. 89 pl. 25.4, p. 91 fig. 46.1,
p. 535 fig. 23.

1. On the character or function of these blades see Fong
1980, entry no. 10; Lin Xiang 1992, p. 23; Rawson 1996,
p. 81; Bagley 1999, pp. 189–91.

2. Chen & Fang 1993, pl. 18, from Zhengzhou. The criss-
cross pattern is known on a blade of another shape from
Erlitou (*ibid.* pl. 12).

3. Chen & Fang 1993, pl. 32 (an example without the
crisscross pattern).

Short and broad, No. 56 has a rectangular tang and an asymmetrical, slightly drooping blade whose edges at first converge gradually and then, after a slight but abrupt change of slope, taper sharply to a point. On each side the blade is ground into four subtly concave facets, two wider ones separated by a median ridge and two narrower ones at the edges. The edge facets come to an end where the edges change slope. At the junction of the blade and tang, parallel ridges give the edges a delicately notched profile. The ridged areas flank a rectangular panel filled with an incised crisscross pattern. The two faces of the blade are decorated alike, though with slight differences in the crisscross pattern. The perforation in the tang is drilled from one side.

The stone is a fine-grained rich olive-green, with black speckles that in places give a marbled effect. The color pales to yellowish-green near the tip. Burning has turned the tang and part of the lower edge almost black. The blade was found broken in two pieces.

Jade and stone *ge* blades were modeled on bronze *ge* blades. The *ge,* an axe with a dagger-shaped blade mounted perpendicular to the shaft, was the most common weapon of China's Bronze Age. Several possible functions have been suggested for the jade and stone versions—for instance that they were displayed in processions as emblems of military rank or used in dances of war—but they are found chiefly in tombs, sometimes in large numbers.[1] In profile, proportions, and decoration, No. 56 closely resembles examples recovered from sites in the Yellow River valley. A similar incised crisscross pattern is known on at least one blade of Erligang date,[2] but sets of raised ridges seem to appear only at a later stage, for instance on blades from Fu Hao's tomb at Anyang.[3] Nevertheless while the shape and decoration of No. 56 set it apart from other Sanxingdui blades and connect it with the north, the material suggests the possibility that it is not a northern import but a local imitation of an import.

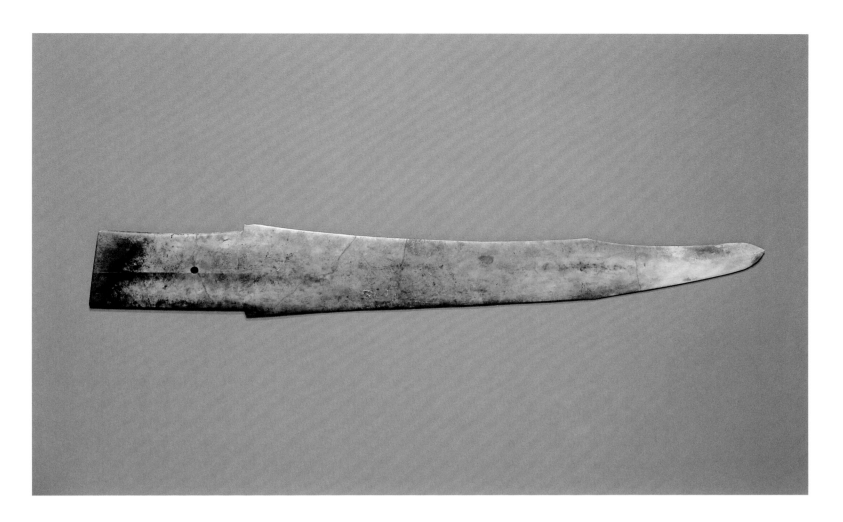

The long and slender cutting part of this blade meets the rectangular tang at a distinct but unembellished shoulder. Everywhere except at the shoulder, the cutting part is narrower than the tang, much narrower at the curving tip. The hint of a median crest is detectable at the tip, but elsewhere the blade has a smooth lens-shaped cross section. An unusually small hole is drilled from one face to the other. A straight saw mark produced when the blade was sliced from the boulder appears on one side of the tang. Near the bottom of the tang the mottled grayish-white material has turned black from burning. The blade was found broken.

Unlike No. 56, which is typically northern in design, No. 57 has a strangely attenuated shape that may be a Sanxingdui invention. Certainly the shape is abundantly represented at Sanxingdui: the three examples from Pit 1 and eleven from Pit 2 together constitute half of the *ge* found at the site.[1] No feature of No. 57 seems to connect it specifically with Anyang examples, and an extraordinary *ge* blade 93 cm long from Panlongcheng in Hubei province, an Erligang period site, might be taken to suggest that the Sanxingdui variant had an Erligang prototype, though the Panlongcheng blade is much broader.[2]

57

Ge *blade*

Dolomitic limestone, hardness 3.5–4
Length 60.1 cm, greatest width 8.4 cm, thickness 0.8 cm
Fourteenth to twelfth century BC
Excavated from Sanxingdui Pit 2 [K2(3):157]
Sanxingdui Museum 00661

PUBLISHED: Chen & Fang 1993, pl. 154; Goepper 1995, no. 48; Rawson 1996, no. 33; Beijing 1999a, p. 384 fig. 208.1.

1. Beijing 1999a, pp. 94–5 (Pit 1), pp. 384–8 (Pit 2).
2. Fong 1980, no. 10.

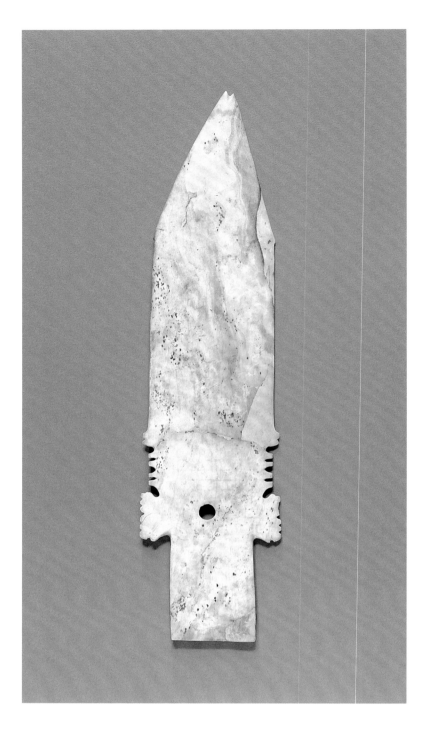

Ge *blade with notched tang*

Dolomitic limestone, hardness 3.5–4
Length 32 cm, width 7.9 cm, thickness 0.7 cm
Thirteenth or twelfth century BC
Excavated from Sanxingdui Pit 1 [K1:84]
Sanxingdui Museum 00007
PUBLISHED: Beijing 1994b, pl. 86; Beijing 1999a,
p. 68 fig. 37.8, p. 70 pl. 18.3.

Just above its rectangular tang this blade has a conical perforation flanked by two serrated winglike projections; above the projections is a zone of deep notches. Within the jagged area of the projections and notches, fine horizontal lines are drawn across the blade from edge to edge. Higher up, the edges of the blade run parallel for a time, then turn sharply toward the tip, the change of angle being marked by tiny bumps in the profile. The material is an opaque creamy-white stone with black specks and brown marbled streaks. The blade was found broken above the notched area.

This blade has the pointed shape of *ge* blades like Nos. 56–7, but its notches and faintly cleft tip are features borrowed from forked blades like Nos. 52 and 54–5. It and No. 59 represent a hybrid type that so far is known archaeologically only from the Sanxingdui site. A blade in the Winthrop Collection at Harvard University, lacking the cleft in the tip but otherwise very similar to No. 58, might come from an early unscientific find made in the neighborhood of Sanxingdui.[1]

Taking the cleft tip of No. 58 to represent the mouth of a fish, Chinese scholars have suggested that this blade is an emblem of the Shu people, whose mythological ancestors, according to late Zhou texts, included a fish.[2] We may doubt that the maker of No. 58 intended to depict a fish, however, since other artifacts from the pits show that Sanxingdui craftsmen routinely depicted birds, fish, and fowl with much greater naturalism; nor can we very confidently equate the thirteenth century BC inhabitants of Sanxingdui with a people whose name and mythology are recorded no earlier than the last few centuries BC.

1. Loehr 1975, no. 55.

2. Chen De'an *et al.* 1998, pp. 17–19.

59

Ge *blade with notched tang*

Marble, hardness 3
Length 38.2 cm, width 8.2 cm, thickness 0.8 cm
Thirteenth or twelfth century BC

Excavated from Sanxingdui Pit 1 [K1:235-5]
Sanxingdui Museum 00031

PUBLISHED: Chen & Fang 1993, pl. 148; Beijing
1994b, pl. 87; Tokyo 1998, no. 131; Taibei 1999,
no. 103; Beijing 1999a, p. 79 pl. 21.5, p. 81 fig.
41.1, p. 532.

Combining features of *ge* blades and forked blades,
No. 59 can be assigned to the same hybrid type as
No. 58, but it is more unusual. The cleft in the tip is
occupied by a bird whose upturned (and damaged?)
tail is executed in openwork. The bird's eyes, feath-
ers, wings, and legs are indicated in faintly incised
line. As many as six other blades from Pit 1 may have
had such openwork tips, but none is as well pre-
served as this one.[1] The blade is not faceted like the
ge No. 56 but perfectly flat, and its most extraordi-
nary feature is the embellishment of the flat surfaces:
each side bears the drawing of another, quite different
blade, a forked blade notched the full length of its
edges (Fig. 59.1). The drawings are incised in very
faint and hesitant line, but the blades they depict
share a real perforation. A larger perforation lower
down, drilled from the same side as the small one,
lies in a zone of incised parallel lines running from
the blunt notches on one edge to those on the other.

The blade was sliced from a slab of marble that
was originally dark gray. Burning turned much of the
surface opaque white, giving it feathery crackles and
a dry touch, but toward one edge the darker original
coloring survives. The blade was found broken in two
places. Slice marks remain along the base of the tang.

The bird motifs so prominent at Sanxingdui are
taken by some observers to indicate the worship of
bird deities there.[2] One scholar, associating forked
blades with mountains, proposes that a bird perched
on top of a forked blade symbolized the arrival of

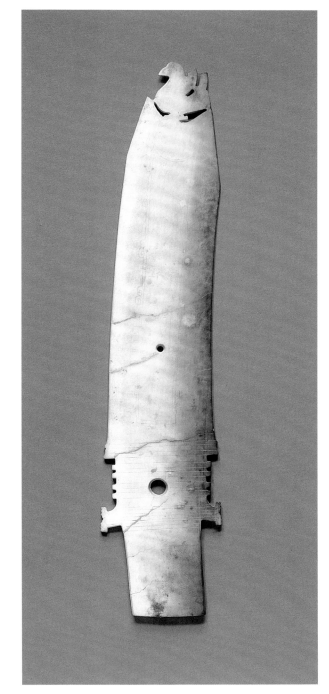

Fig. 59.1. No. 59, drawing.
After Beijing 1999a, p. 81
fig. 41.1.

good fortune.[3] Whatever the merit of these sugges-
tions, an object that combined a *ge* blade, a forked
blade, and a bird—all potent forms at Sanxingdui—
must have been heavily loaded with significance. And
as in the case of No. 53, another extraordinary item,
it may be that blades like the present one are found
only at Sanxingdui because, however impressive they
might be, they were too specifically tailored to the
demands of local ritual for people of other cultures
to wish to imitate them.

1. Beijing 1999a, p. 81 fig. 41,
p. 83 pl. 22.

2. Hu & Cai 1992, Shi Yanting
1995.

3. Hayashi 1991, p. 279.

60

Ge(?) blade with scalloped edges

Dolomitic limestone, hardness 3.5–4
Length 17.8 cm, greatest width 4.0 cm, thickness
0.6 cm
Fifteenth to twelfth century BC

Excavated from Sanxingdui Pit 1 [K1:136]
Sanxingdui Museum 00053

PUBLISHED: Beijing 1994b, p. 145 (right); Beijing
1999a, p. 97 fig. 49.1, p. 99 pl. 28.2, p. 538 fig. 28.

This blade has a lens-shaped cross section, a feature natural to stone blades ground to shape. It is essentially a *ge* blade, but it differs from examples like Nos. 56–7 in its gently scalloped contours, which immediately call to mind bronze blades from the Sanxingdui pits that are much more emphatically scalloped (Fig. 60.1). The bronze versions, radically different from familiar *ge* shapes, seem to be the standard Sanxingdui form of the weapon type—a form known nowhere else: the two pits yielded more than 40 of the saw-like blades but not a single "normal" bronze *ge*.[1] As for the stone versions, only 2 with scalloped edges were found, both in Pit 1.[2] Perhaps they are local inventions derived from the bronze blades. The information that jade or stone blades with scalloped edges have been found at Panlongcheng in Hubei province[3] raises another possibility, namely that the stone blade came from the middle Yangzi region to Sanxingdui and there inspired the distinctive local bronze type.

Both faces of No. 60 appear dull, as if unpolished, and they show obvious color differences: one side is a pale grayish-white with black patches along the lower edge, the other a dark grayish-black. All this may be the result of burning. A conical hole with steeply angled walls is drilled from the black face.

1. For the sawtooth bronze blades see Tokyo 1998, pp. 134–5; Taibei 1999, pp. 126–7; Beijing 1999a, pp. 56–60, 290–91, 294–5, 529.

2. A somewhat similar jade blade from Fu Hao's tomb at Anyang might be an import from Sichuan (Beijing 1981c, pl. 16 [top]; Beijing 1984a, pl. 114.1 [bottom]).

3. These blades have not been published in excavation reports, but a drawing of one appears in Yang Meili 1998, p. 171 fig. 22.

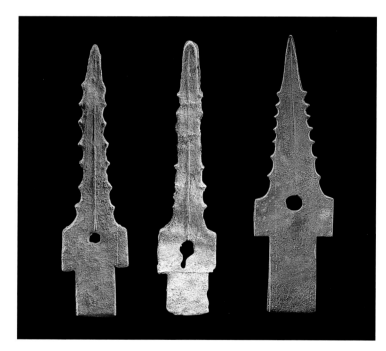

Fig. 60.1. Bronze *ge* blades with scalloped edges from Sanxingdui. From left to right, length 19.7 cm (Pit 1), 20.2 cm (Pit 1), 20.8 cm (Pit 2). After Beijing 1994b, p. 144.

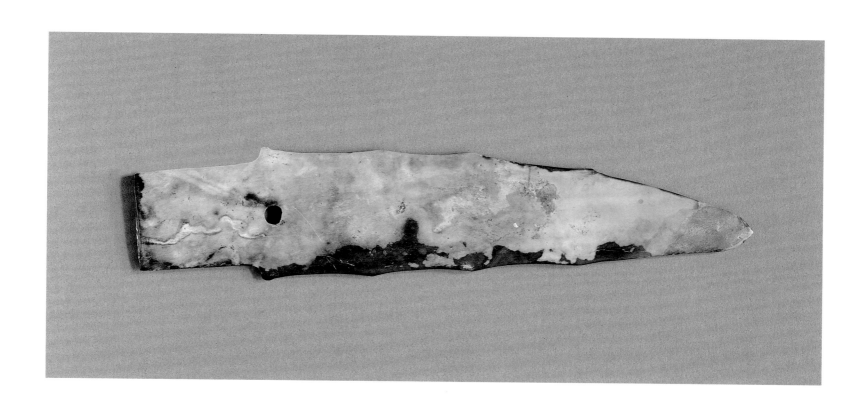

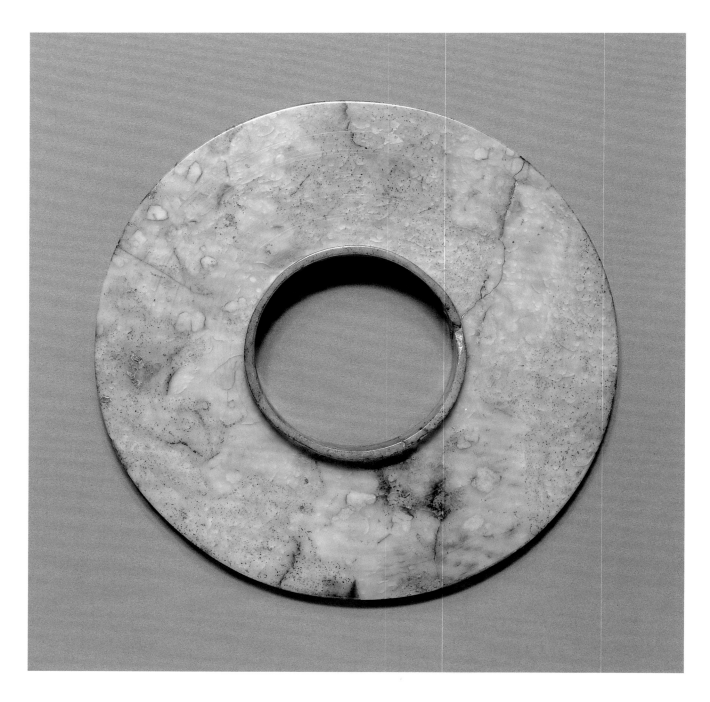

61

Disk with collared opening

Jade (nephrite), hardness 5.5–6
Diameter 17.8 cm, diameter of hole 6.7 cm,
thickness at hole 1.76 cm
Thirteenth or twelfth century BC

Excavated from Sanxingdui Pit 2 [K2(2):146-2]
Sanxingdui Museum 00261

PUBLISHED: Chen & Fang 1993, no. 144; Tokyo
1998, no. 109; Taibei 1999, no. 126; Beijing
1999a, p. 369 fig. 202.2, p. 374 pl. 143.1.

This disk was ground from a slab of gray-green nephritic material that shows distinctive gray nodules and black speckled patches. The broad opening is encircled by collars that stand up from both sides of the disk. The collars are not perfectly aligned, suggesting that the opening was drilled from both sides, but their inner walls were polished enough to remove any irregularities there. Concentric circles were finely incised on both surfaces of the disk, four sets of double-incised lines alternating with five shallow grooves. The outer perimeter was rounded off rather than left angular and blunt, and all surfaces were polished to a smooth luster. The surface is badly damaged on one side, but on the other it has retained much of its original appearance; there is no sign of burning anywhere, indeed bits of fabric can still be seen adhering to the damaged side.[1] The disk was found inside a bronze *zun* that contained other jade and stone artifacts and also cowry shells. The exterior of the *zun* had been smeared with vermilion.[2]

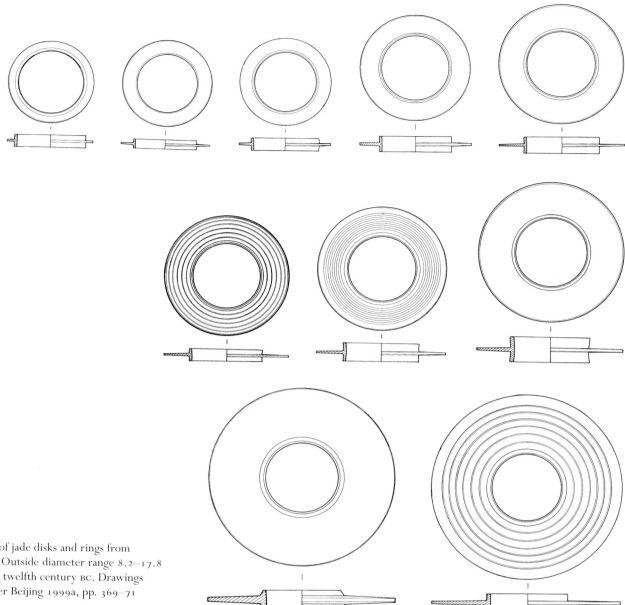

Fig. 61.1. Group of jade disks and rings from Sanxingdui Pit 2. Outside diameter range 8.2–17.8 cm. Thirteenth to twelfth century BC. Drawings by Luo Zeyun after Beijing 1999a, pp. 369–71 figs. 202–4.

Collared disks and rings like Nos. 61–2 may have been used as bracelets.[3] Pit 1 contained three examples; Pit 2 contained fifteen, with outside diameters that range from about 8 to 18 cm (Fig. 61.1). These may be compared with twenty from Fu Hao's tomb at Anyang and nine from a tomb at Xin'gan in Jiangxi.[4] In all three of these roughly contemporaneous finds the objects vary considerably in outside diameter, so that while some look like disks, others are more naturally called rings; their collared openings remain fairly constant in size, however—large enough for a wearer's hand to slip through. Perhaps the examples with large outside diameter, which required larger pieces of raw material, were simply more expensive and more prestigious versions.

1. The excavation report seems to be mistaken in describing the disk as burned (Beijing 1999a, p. 367).

2. The *zun*, K2(2)-146 in the excavation report (Beijing 1999a, p. 241), is similar to No. 47 in the present exhibition.

3. Compare Rawson 1996, p. 84. Disks that have higher collars and look more like bracelets have been found in Sichuan (Feng & Tong 1979, p. 34 fig. 2). See Hansford 1968, pl. 9a–b, for a collared disk found in a burial in Malaya on the arm of the deceased.

4. Beijing 1984a, pp. 119–22; Beijing 1997f, pp. 141–3.

62

Ring with collared opening

Nephrite?
Diameter 10.6 cm, diameter of hole 6.4 cm,
thickness at hole 1.6 cm
Thirteenth or twelfth century BC

Excavated from Sanxingdui Pit 2 [K2(2):18]
Sanxingdui Museum 00265

PUBLISHED: Beijing 1994b, pl. 70; Taibei 1999,
no. 128; Beijing 1999a, p. 371 fig. 204.1, p. 375
pl. 144.3.

Shaped from a semi-translucent, blue-green ne-
phritic material with dark green nodules, this ring
is smoothly finished but lacks the lustrous polish of
No. 61. The perimeter has a straight blunt edge. Con-
centric circles on both sides are so shallowly executed
or so worn that they are only faintly visible. Perhaps
because of burning, the edge of the collar on one side
has turned almost black; the other side has areas of
brownish-black to which traces of a black substance
adhere. Unlike most of the disks and rings found in
the Sanxingdui pits, this one had not been placed
inside a bronze vessel.

63

Elongated oval blade

Dolomitic limestone, hardness 3.5–4
Length 20.8 cm, width 9.3 cm, diameter of hole
3.3 cm, thickness at hole 3.1 cm
Early to middle second millennium BC

Excavated from Sanxingdui Pit 1 [K1:204]
Sanxingdui Museum 00121

PUBLISHED: Chen & Fang 1993, pl. 157; Beijing
1994b, pl. 72; Beijing 1999a, p. 84 fig. 43.1, p. 85
pl. 23.3.

This faintly lens-shaped blade, ground from a thick slab of pale gray, fine-grained stone,
has a collared perforation. The two parts of the collar were drilled from opposite sides
and they differ in height; on one side the inner wall of the collar is smoothly finished, on
the other rough turn marks remain. Natural fissures run the length of the blade; it was
found broken along a line perpendicular to the fissures. A few flecks of bronze corrosion
adhere to the surface.

Only three of these ovoid blades with collared perforations were found at Sanxingdui,
all in Pit 1. The shape is unknown elsewhere in China. Its outline vaguely suggests an axe
blade, but no stone or jade axe with a collared opening is known. The excavation report
uses the same word for this shape as for certain rounded rhombic bronze plates recovered
in large numbers from both pits,[1] but the bronze plates are much smaller and have collars
on one side only, and it is not obvious that they had a similar function or meaning.

1. Thirty-three from Pit 1 and 25 from Pit 2 (Beijing 1999a,
pp. 51, 53, 285, 288).

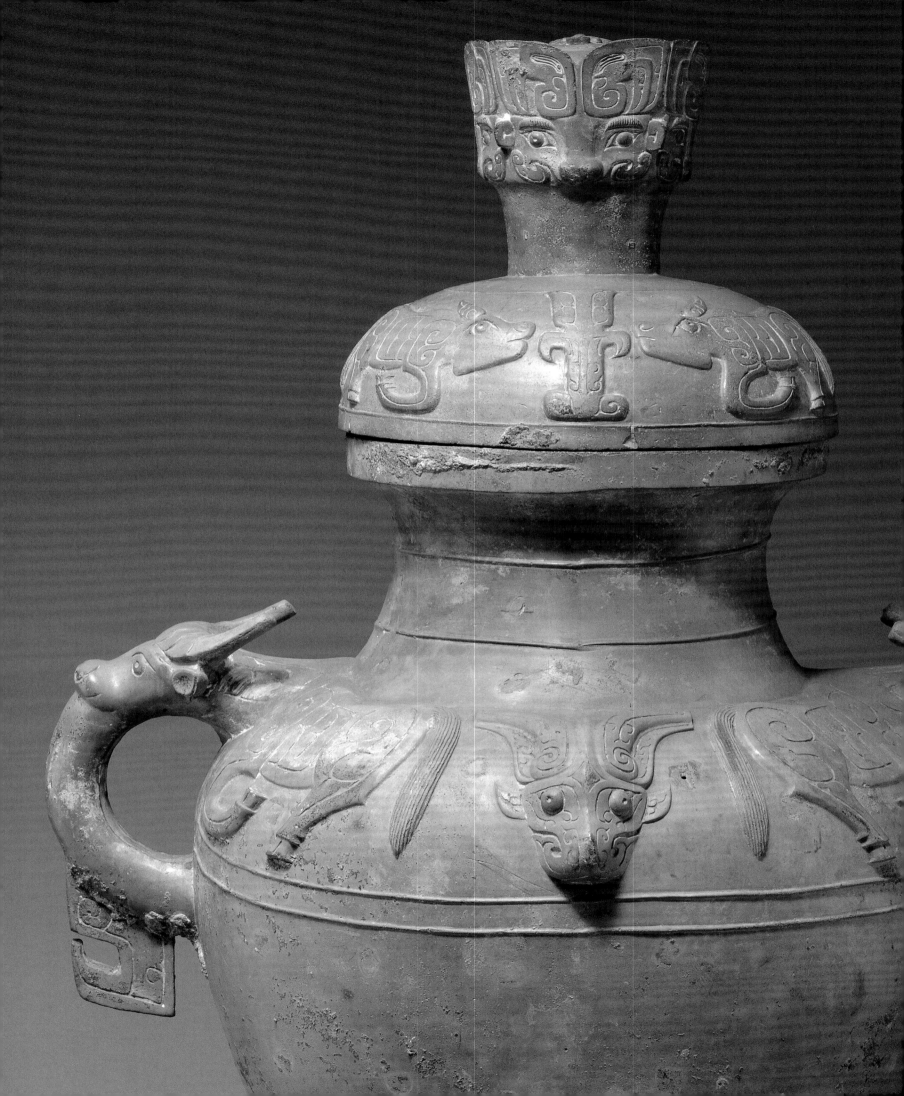

by Lothar von Falkenhausen

The Chengdu Plain in the Early First Millennium BC: Zhuwajie

THE TWO HOARDS

For the seven centuries or so following the splendid bronze-manufacturing culture of Sanxingdui, archaeological discoveries in the Sichuan Basin remain extremely spotty. Bronze vessels in the style of the Western Zhou period (*c.* 1050–771 BC) have been found in several localities, but almost always in clearly later contexts. To date, the only place in Sichuan where Western Zhou bronzes have been recovered from deposits that may actually date to the Western Zhou period is Zhuwajie in Pengzhou (formerly Peng Xian), located some 25 km north of Chengdu and only about 10 km due south of Sanxingdui. The site is located on a stretch of fertile alluvial land, drained today by two major affluents of the Tuo River. In the mid-third century BC, the agricultural productivity of this area was to be much improved by the construction of the Dujiang dam, 35 km to the west of Zhuwajie, by the government of Qin.

In 1959 and 1980, two hoards of bronze vessels, weapons, and tools were accidentally discovered close to train tracks at Zhuwajie.[1] The two hoards were located within 25 m of each other in what may have been a settlement. Archaeologists have repeatedly visited the area, and the Institute of Archaeology of the Chinese Academy of Social Sciences conducted a survey in the early 1990s, but the results remain unpublished. Significant architectural remains seem not to have been identified.[2]

Each hoard took the form of an enormous jar of coarse pottery (Fig. 1), in which bronzes had been neatly placed; the jar, over a meter in height, was then buried in a trench 3 to 4 m deep. Since we know so little about the site, we can only speculate about the function and significance of these hoards. Like the many hoards of ritual bronzes found in the Western Zhou metropolitan area in Shaanxi, they may have been deposited in times of political uncertainty (and scholars have speculated as to the historical circumstances under which this could have occurred). Alternatively, in possible analogy to the Sanxingdui pits, they may attest to religious practices. Unlike the Sanxingdui finds, however, the objects deposited at Zhuwajie had not been burned or otherwise rendered unusable. Conceivably, thus, they had been interred with the intention of their retrieval.

The hoard found in 1959 contained eight vessels, ten weapons, and three tools; the one found in 1980 contained four vessels, twelve weapons, and three tools. The manner

Fig. 1. Rubbing of fragment of pottery container from 1980 Zhuwajie hoard. Height of fragment about 16 cm. Date uncertain (tenth to fifth century BC?). After *Kaogu* 1981.6, p. 498 fig. 3.5.

1. *Wenwu* 1961.11, pp. 28–31; *Kaogu* 1981.6, pp. 496–9, 555. See also *Wenwu* 1962.6, pp. 15–18; Feng Hanji 1980 (who gives the date of discovery as 1960); Li Xueqin 1996.

2. Sun Hua, personal communication, 1999.

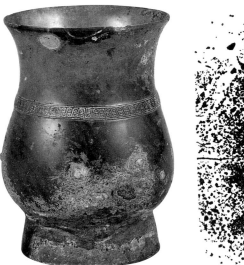 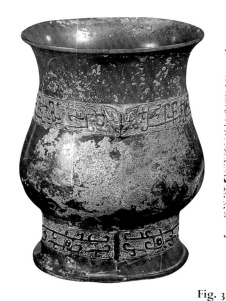

Fig. 2 **Fig. 3**

Fig. 2. *Fu Gui zhi,* from 1959 Zhuwajie hoard. Height
13.7 cm. Late eleventh or early tenth century BC
(early Western Zhou). After Chengdu 1991, pl. 234.
Inscription after *Wenwu* 1961.11, p. 5 fig. 5.

Fig. 3. *Fu Ji zhi,* from 1959 Zhuwajie hoard. Height
15.8 cm. Late eleventh or early tenth century BC
(early Western Zhou). After Chengdu 1991, pl. 233.
Inscription after *Wenwu* 1961.11, p. 5 fig. 6.

of deposition and the range of objects found in both hoards are so similar that the two
hoards may reasonably be considered as contemporary. Nine of the twelve vessels—
all four vessels found in 1980 and five of the eight found in 1959—belong to the
amphora-shaped type conventionally called *lei.* Although the nine *lei* differ from one
another in size, ornamentation, and style, together they constitute the most splendid
group of *lei* ever found. Four of them, representing the full stylistic range of the as-
semblage, are included in this exhibition (Nos. 64–7; the others are shown in Figs. 6–7,
10–12). Vessels of other types comprise two *zhi* (Figs. 2–3) and one *zun* (Fig. 14), all
from the hoard found in 1959.

Eighteen of the 22 weapons found in the two hoards are dagger-axes *(ge)* of one
kind or another. Each hoard also yielded a small number of other weapon types and of
bronze tools (see Table 1). The three weapons in this exhibition (Nos. 68–70) belong
to three distinct types: dagger-axe, halberd, and spear. The tool category is represented
by an axe (No. 71). This sorting into "weapons" and "tools" is, of course, uncertain and
perhaps artificial; looking at an axe or adze, we cannot be sure whether it was used as
a tool or a weapon or both.

Table 1. Weapons Found at Zhuwajie

	Hoard Unearthed in 1959	*Hoard Unearthed in 1980*
dagger-axes *(ge)*	8	10
halberds *(ji)*	1	2
spearheads *(mao)*	1	—
axes *(yue)*	2	3
adzes *(ben)*	1	—
Totals	13	15

Although the Zhuwajie bronzes have been extensively studied and exhibited, they
are still poorly understood. The absence of clear archaeological context makes it
impossible to relate the two hoards to other possibly contemporary archaeological

discoveries in the Chengdu Plain, such as the Shi'erqiao culture, a Sanxingdui-derived local culture that flourished around 1200–1000 BC,[3] or its successor, the Xinyicun phase (c. 1000–600 BC).[4] Since the two hoards cannot be dated stratigraphically, and since the ceramic ware of the deposit jars is not chronologically sensitive, the only information relevant to dating comes from the typology, decoration, and style of the bronzes themselves. But the date of manufacture that can be thus inferred is not necessarily close to the time when the bronzes were deposited at Zhuwajie. The issue is further complicated by the lack of a consensus on their place of manufacture. Ultimately, any attempt at positioning them in time and space will depend on one's views as to the cultural role of bronzes in the local Sichuan context. This issue is at the core of the following discussion.

SHANG AND ZHOU RITUAL BRONZES IN A SICHUAN CONTEXT

The two *zhi* found at Zhuwajie in 1959 (Figs. 2–3)[5] are commonly regarded as imports to Sichuan because they carry inscriptions in Chinese writing, which in all likelihood was not used by the inhabitants of the Sichuan area before the Qin conquest. Even though these inscriptions—"X, Father Gui" and "Y, Father Ji"—consist of the emblems of two prominent Shang and Zhou lineages and the posthumous designations of specific ancestors within them, it would be unwise to conclude from this that members of these lineages had moved to Sichuan. More probably, the two *zhi* were brought to Sichuan as war booty or as diplomatic presents, and their local owners, even if able to read the inscriptions, would have found the contents irrelevant as they referred to ancestors unrelated to themselves.

Bronzes imported into Sichuan—whether inscribed or not—undoubtedly continued to be objects of prestige and status there, but they were put to new uses. This much seems evident from the fact that the assemblages in which bronze vessels have so far been found in Sichuan—from Sanxingdui all the way to the Qin conquest in 316 BC—differ radically from those in hoards and tombs throughout the Yellow River valley. Even though the vessels themselves all have typological counterparts in the Shang and Zhou kingdoms, no known Bronze Age site in Sichuan has yielded a complete set of vessels such as would have been needed to perform Shang- or Zhou-style ancestral sacrifices. Whole categories of vessels—wine-drinking vessels (*jue, gu,* etc.), meat-offering tripods *(ding),* and grain-offering bowls *(gui)*—are either absent or rare. Although caution is warranted in view of the extremely small number of archaeological discoveries, the evidence available suggests that the local elite did not participate in the elaborate and highly regimented ancestral cult practiced by the Shang and Zhou aristocracy.

Lei vessels, so prominently represented at Zhuwajie, are relatively rare in ritual bronze assemblages from Shang and Western Zhou tombs in north China, and they do not normally occur in pairs or sets.[6] By contrast, as Li Xueqin has observed, *lei* and other amphora-like vessels are by far the most common kind of bronze vessel found in the regional bronze-using cultures outside the political reach of the Shang and Zhou kingdoms.[7] This observation, though general and not applicable to all areas, is an important first step toward understanding the usage of bronze vessels in Bronze Age Sichuan, an area notable for its plentiful amphora-shaped containers (Table 2).

3. *Wenwu* 1987.12, pp. 1–23, 37; Beijing 1996d, pp. 123–44 (by Sun Hua); Chengdu 1998, pp. 146–64 (by Jiang Zhanghua).

4. Chengdu 1998, pp. 146–64.

5. Chengdu 1991, pls. 233–4; inscriptions, *Jicheng* vol. 11, no. 6342, and vol. 12, no. 6406.

6. Hayashi 1984, vol. 1, pp. 148–65; Li Feng 1988.

7. Li Xueqin 1991b, pp. 78–80.

Table 2. *Lei* and Vessels of Similar Characteristics Unearthed in Sichuan

Locality	Numbers/types	Date (BC)	Report
Guanghan Sanxingdui, Pit 1	3 *lei*, 9+ *zun*	15th–12th c	*Wenwu* 1987.10, pp. 1–15
Guanghan Sanxingdui, Pit 2	*lei, zun* (number unclear)	15th–12th c	*Wenwu* 1989.5, pp. 1–20
Pengzhou Zhuwajie, 1959 hoard	5 *lei*, 1 *zun*	10th c	*Wenwu* 1961.11, pp. 28–31
Pengzhou Zhuwajie, 1980 hoard	4 *lei*	10th c	*Kaogu* 1981.6, pp. 496–9, 555
Chengdu Jinma	1 *lei*	8th c?	*Chengdu wenwu* 1984.1, back cover
Chengdu Qingyang Xiaoqu, tomb 1	1 *lei*	8th c?	*Wenwu* 1989.5, pp. 31–35
Wenchuan A'ercun	1 *lei*	8th c?	*Sichuan wenwu* 1989.4, pp. 44–5
Mao Xian Moutuo, pit 3	1 *lei*	8th c?	*Wenwu* 1994.3, pp. 4–40
Mao Xian Moutuo, tomb 1	1 *lei*	9th–6th c?	*Wenwu* 1994.3, pp. 4–40
Chengdu Nan Yihuanlu Dongduan	1 *lei*	9th–6th c?	*Chengdu wenwu* 1986.3, p. 38
Chengdu Baihuatan	1 *hu* (pictorial)	First half 5th c	*Wenwu* 1976.3, pp. 40–46
Mianzhu Qingdao, tomb 1	3 *hu*, 1 *fang*, 1 *lei*	5th–4th c	*Wenwu* 1987.10, pp. 22–33
Xindu Majiaxiang	5 *lei*, 1 *fou*	Early 4th c	*Wenwu* 1981.6, pp. 1–16
Chengdu Qingyanggong	2 *lei*, 1 *hu*	4th c	*Kaogu* 1983.7, pp. 597–600
Fuling Xiaotianxi, tomb 1	2 *lei*, 1 *fou*	Mid-4th c	*Wenwu* 1974.5, pp. 61–80
Fuling Xiaotianxi, tomb 2	1 *hu*	Mid-4th c	*Wenwu* 1974.5, pp. 61–80
Fuling Xiaotianxi, tomb 3	1 *hu*	Mid-4th c	*Wenwu* 1974.5, pp. 61–80
Fuling Xiaotianxi, tomb 4	1 *hu*	Mid-4th c	*Kaogu* 1985.1, pp. 14–17, 32
Fuling Xiaotianxi, tomb 5	1 *hu*	Mid-4th c	*Kaogu* 1985.1, pp. 14–17, 32
Wan Xian Gaoliangcun	2 *lei* covers	4th–3rd c	*Sichuan wenwu* 1991, pp. 45–6
Chengdu Yangzishan, tomb 172	2 *fang*, 1 *fou*	3rd c	*Kaogu xuebao* 1956.4, pp. 1–20
Chengdu Yangzishan, tomb 85	1 *hu*	3rd c	*Wenwu ziliao congkan* 7 (1983), pp. 1–12

Made in north China since the Erligang period (*c.* 1500–1300 BC), vessels of the type *lei* were introduced to the middle Yangzi region soon afterward. Several specimens found at Sanxingdui (Nos. 48–9) were probably imported either from there or from the valley of the Han River, the principal tributary of the middle Yangzi.[8] The only other bronze vessels found at Sanxingdui are *zun* of a type that differs from the *lei* only by the addition of a trumpet-shaped mouth (Nos. 44–7). The two shapes may well have been comparable in their local function.

The vessels we know to have been called *lei* in the Zhou dynasty, for example those from Zhuwajie, are typologically distinct from the Erligang and Sanxingdui vessels that have been conventionally designated as *lei,* but they are still amphorae.[9] About half a dozen *lei* of Western Zhou types (some of them imitations made locally or imported from the middle Yangzi area) have been found at Sichuan sites other than Zhuwajie, though all in contexts of deposition that are unclear or that postdate the Western Zhou period. The best documented come from a tomb and two hoards at Mao Xian Moutuo, which were probably interred sometime before 400 BC (Figs. 4–5).[10] Tombs of the so-called Ba-Shu culture of the late fifth, fourth, and third centuries BC attest to a continuing interest in such vessels, though by then *lei* were sometimes replaced by similarly shaped vessels such as *fou, hu,* and *fang* (Nos. 73–5).

Although we do not know for what specific local purpose such vessels were used, their long history in the Sichuan area suggests that the Zhuwajie *lei* are a link in a millennial chain, possibly attesting to enduring local ritual customs. The prominence of *lei* among symbols of prestige depicted on Ba-Shu seals (No. 84) additionally suggests

8. See Chapter 1. For finds from the upper Han River valley see *Wenbo* 1996.4, pp. 7–8. Along the Yangzi, a *zun* was found at Chongqing Wushan Lijiatan (Beijing 1997g, no. 43).

9. Hayashi (1984, vol. 2, pp. 215–21) considers the earlier vessels to be a variety of *zun.*

10. *Wenwu* 1994.3, p. 38 fig. 57.1, p. 12 fig. 14.1. For comparison pieces see Falkenhausen 1996, p. 35 and notes 34–5.

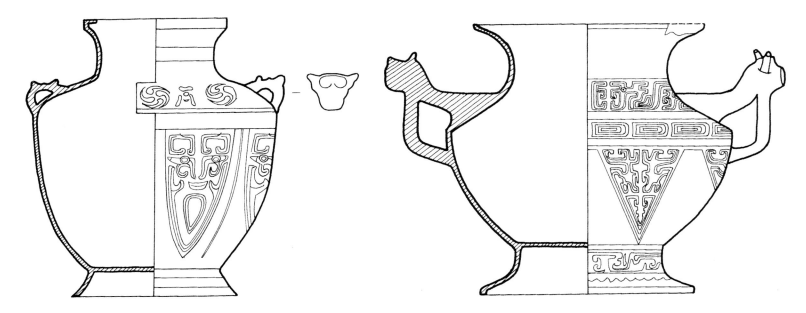

Fig. 4. *Lei* from Mao Xian Moutuo pit 3. Height 43 cm. Eighth to sixth century BC. Drawing by Luo Zeyun after Beijing 1994a, pl. 85.

Fig. 5. *Lei* from Mao Xian Moutuo tomb 1. Height 32 cm. Seventh to fifth century BC. Drawing by Luo Zeyun after Beijing 1994a, pl. 82.

that they carried special significance. The fact that imitations of Shang and Zhou amphora-shaped vessels were locally produced in the south after Erligang times indicates that the Erligang objects had been received with enthusiasm, generating demand for more. We might speculate that amphora-shaped vessels were widespread among the northern and southern neighbors of the Shang and Zhou because they were regularly given as presents to allies who stood outside the lineage network tied together by the ancestral cult and who therefore did not qualify for—or, indeed, desire—complete sets of sacrificial vessels. This might go some way toward explaining why some specimens found among neighbors of the Shang and Zhou, including several of the Zhuwajie *lei,* exceed their known counterparts from within the Shang and Zhou realm in both size and elaboration.

SHAPE AND DECORATION OF THE *LEI* VESSELS

A closer consideration of the nine *lei* from Zhuwajie reveals that certain motifs recur identically from vessel to vessel, suggesting that the *lei* are connected despite their at first glance exceedingly varied decoration. The connections may reflect a coherent iconography, but its intended content, if any, is now impossible to reconstruct. The following descriptions, concentrating on the "what" of the decoration and its deployment on the objects, proceed from the simple to the complex. Further comments on the "how" of style and technical execution are provided in the catalogue entries.

Fig. 6. *Lei* from 1959 Zhuwajie hoard. Height 36 cm. Late eleventh or early tenth century BC (early Western Zhou). After Beijing 1994a, pl. 80.

- Figure 6 (unearthed in 1959).[11] Mostly plain, this *lei* features a bovine face in the center of each side, surrounded by four raised bosses with whorl ornament. Similar bosses recur on the cover. The handles are adorned with relieved horned-animal heads.

- Figure 7 (unearthed in 1959).[12] This *lei* resembles the previous one, but it has six raised bosses on the shoulder and the cover and lacks faces on the shoulder. While no exact parallel has been reported for the *lei* illustrated in Figure 6, the ornamentation scheme of the one in Figure 7 is attested in quite a few *lei* from north China

11. Chengdu 1991, no. 8; Beijing 1994a, pl. 80.

12. Chengdu 1991, no. 9; Beijing 1994a, pl. 81.

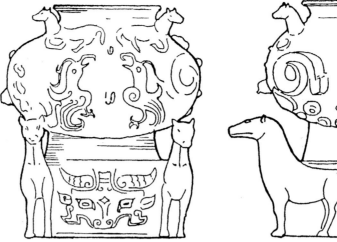

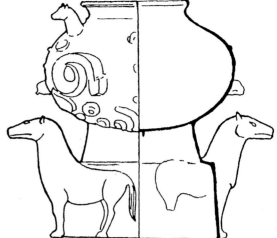

Fig. 7. *Lei* from 1959 Zhuwajie hoard. Height 38 cm. Late eleventh or early tenth century BC (early Western Zhou). After Beijing 1994a, pl. 81.

Fig. 8. *Gui* from Hunan Taojiang Jinquancun. Height 30.6 cm, base 20 by 18.5 cm. Probably late eleventh or tenth century BC. After Gao Zhixi 1999, p. 81 fig. 1.

from the Anyang period to the latter part of early Western Zhou.[13] Other specimens have been found in the upper Han River valley,[14] as well as in the middle Yangzi region.[15]

- No. 66 (unearthed in 1959). The boss decor (six on the shoulders and four on the cover) is here supplemented by four narrow vertical flanges that bisect the vessel's front view as well as defining the vessel's lateral profile. The shoulder handles are adorned with three-dimensional rams' heads with majestically curved horns, whereas the small handle in the lower part of the belly features a bovine head in relief. No exact parallels are known, though the smooth texture resembles that of some *lei* of Western Zhou type found in later contexts in Sichuan (e.g. Fig. 4).

- No. 64 (unearthed in 1980). An eye-catching feature of this *lei* is the unusually massive cover handle, which is adorned by four large-eared animal faces on the sides and a coiled serpent on the top. Otherwise, as on the previous two specimens, surface decoration is confined to the shoulder and the cover. Instead of relieved bosses, the ornament here consists of symmetrically paired buffaloes shown in profile, their front knees bent. On the cover they face toward an abstracted bovine face in the center,[16] while on the shoulder they face away from a relieved bovine head in the center. The buffaloes' heads extend onto the handles, where the surface relief becomes almost fully sculptural. The buffalo bodies placed to the left and right of each handle merge into a single buffalo head. Such combinations of relieved and sculptural rendering can be seen on major bronzes from the middle Yangzi region in the time contemporary with the Anyang and early Western Zhou periods, for example on a *gui* with horses from Hunan Taojiang Jinquancun, where some of the horses are shown in an analogous kneeling posture (Fig. 8).[17] The closest parallel to the present specimen, however, comes from the northern periphery, a *lei* now lacking its cover from Kezuo Shanwanzi in Liaoning (Fig. 9).[18] Identical buffalo decor against a plain background also occurs on several unprovenanced vessels of early Western Zhou date.[19] A miniature *lei* from tomb 1B at Shaanxi Baoji Rujiazhuang displays decoration similarly executed, though different in the choice of motifs.[20]

13. An Anyang-period specimen comes from Shaanxi Qishan Hejiacun tomb 1 (Beijing 1979, no. 26). Early Western Zhou specimens have been found in Shaanxi at Wugong Futuocun (Beijing 1979, no. 131), Fufeng Qijiacun (Beijing 1980b, no. 12), and Jingyang Gaojiabao tomb 4 (Xi'an 1995, p. 78, p. 81 fig. 66, pl. 39); in Beijing, at Liulihe tomb 1193 (*Kaogu* 1990.1, p. 24 fig. 3.1, pl. 2.2); and in Liaoning Kezuo, at Beidongcun (*Kaogu* 1973.4, pls. 6.3, 7.1–4) and Shanwanzi (*Wenwu* 1977.12, p. 25, p. 32 fig. 51).

14. One specimen comes from Shaanxi Yang Xian Zhangcun (*Wenbo* 1996.4, pp. 7–8; *Wenbo* 1996.6, p. 73 and back cover fig. 1).

15. Specimens come from Hunan Ningxiang Huangcai (*Hunan Bowuguan wenji* 1 [1991], pp. 141, 140) and Anhui Dongzhi Shengli (*Wenwu* 1990.11, p. 90).

16. Chengdu 1991, p. 217, misreads this as a standing human.

17. Compare also the tigers on No. 44 and the Funan *zun* of Figure 44.3.

18. *Wenwu* 1977.12, pls. 2.2–3. This site, like Kezuo Beidongcun (see note 25), is located in Harqin Zuoyi Mongol Autonomous District.

19. Rawson 1990, part 2, pp. 534–5, 538.

20. Lu & Hu 1988, vol. 2, pl. 164.1.

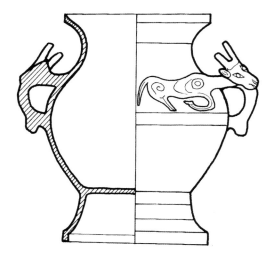

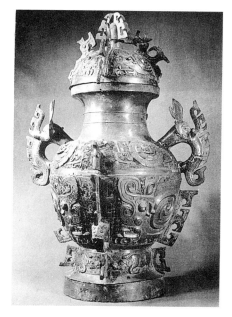

Fig. 9. *Lei* from Liaoning Kezuo Shanwanzi. Height 29.5 cm. Late eleventh or early tenth century BC (early Western Zhou). Drawing by Luo Zeyun after *Wenwu* 1977.12, pl. 2.2.

Fig. 10. *Lei* from 1980 Zhuwajie hoard. Height 70.2 cm. Late eleventh or early tenth century BC (early Western Zhou). After *Kaogu* 1981.6, pl. 5.3.

- No. 65 (unearthed in 1980). As in No. 66, the vessel surface is compartmentalized by four vertical flanges on the cover, handles, belly, and ring foot (curiously, the flanges of the knob are not aligned with the others but placed at a 45-degree angle). With their deeply incised hooks, these flanges are much more visually prominent than those of No. 66, producing a jaggedly flamboyant vessel contour. Two of the four on the lid are fashioned in the shape of birds. Fully sculptural large-horned animal heads are attached to the flanges in the center of each side, and the shoulder handles are executed as elephant heads with trunks bent both upward and downward. All parts of the vessel surface are covered with ornamentation. On the cover, large animal faces with three-dimensionally protruding rams' horns are complemented by downward-facing S-shaped snakes filling the lateral corners. On the shoulders, snakelike creatures coiled into a circle enliven the bosses, which are surrounded by symmetrically paired thin-bodied dragons. The belly features paired coiled dragons of a common early Western Zhou type, their large heads emerging from spiral bodies. The ring foot is adorned with pairs of kneeling buffaloes.

- Figure 10 (unearthed in 1980).[21] This *lei* resembles No. 65, except for the cover, which features coiled dragons similar to those adorning the vessel's belly.

- Figure 11 (unearthed in 1980).[22] The cover of this *lei* seems not to match the body and may have originally belonged to another vessel. It is a slightly reduced version of the cover of No. 64, with the decoration on the massive knob somewhat simplified. The body, by contrast, is entirely covered by decoration. On the shoulders, pairs of coiled dragons symmetrically flank an abstracted face motif; in the lower part of the belly, each side is adorned with two large, flamboyantly outlined animal faces with tiny sinuous dragons filling the lower corners. Slightly larger dragons with sinuous bodies are symmetrically paired on the foot. While the sculpturally executed heads of horned animals on the handles are reminiscent of bovines, the surface ornament and downward-pointed hooks of the handles suggest birds.

Fig. 11. *Lei* from 1980 Zhuwajie hoard. Height 44 cm. Late eleventh or early tenth century BC (early Western Zhou). After *Kaogu* 1981.6, p. 497 fig. 2.3.

21. *Kaogu* 1981.6, pl. 5.3. (In Beijing 1994a, either plate 75 or plates 73–4 were intended to show this *lei*, but in fact, all three plates show *lei* No. 65).

22. *Kaogu* 1981.6, pl. 5.4; Beijing 1994a, p. 6 fig. 2.

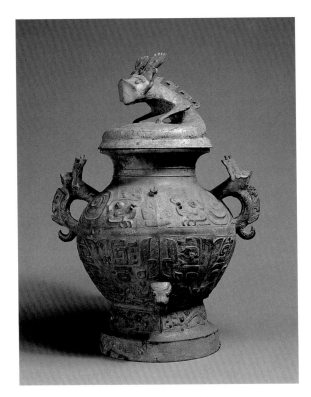

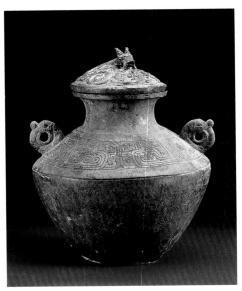

Fig. 13. *Lei* from Hubei Suizhou Xiongjialaowan. Height 36 cm. Eighth century BC (early Spring and Autumn period). After Beijing 1997c, pl. 110.

Fig. 14. *Zun* from 1959 Zhuwajie hoard. Height 27 cm. Late eleventh or early tenth century BC (early Western Zhou). After Beijing 1994a, pl. 92.

Fig. 12. *Lei* from 1959 Zhuwajie find. Height 48 cm. Late eleventh or early tenth century BC (early Western Zhou).

- No. 67 (unearthed in 1959). The most prominent feature of this *lei* is its sculptural cover. It is in the shape of a rearing dragon, whose spindly legs lift the massive head above its own coiled body. The crudely executed dragon head is notable for its cross-shaped horns. A flamboyant crest in the shape of linked C's runs down the dragon's spine. Sunken-line spirals indicate musculature, and the skin of the animal is patterned with shield-shaped scales. The surface ornamentation of the vessel body is exactly like that on the *lei* in Figure 11, augmented only by a fully sculptural ram's head in the center of the shoulder zone. The handles, likewise, are shaped like those of the *lei* in Figure 12, with the addition of loose pendant rings.

- Figure 12 (unearthed in 1959).[23] Like the preceding specimen, this *lei* has a cover in the shape of a rearing dragon, but the dragon is distinctive for its pronged horns. Again, the surface ornamentation of the vessel body is almost exactly like that on the *lei* in Figure 11. The only difference lies in the presence, above the coiled-dragon heads in the shoulder zone, of two small headless bodies of kneeling buffaloes converging on a central knob (from which a cast-on sculptural buffalo head, analogous to the rams' heads on No. 67, has probably been lost).[24] A very similar covered *lei*—sporting dragon horns of yet another shape—was excavated at Kezuo Beidong-cun in Liaoning.[25] *Lei* (Fig. 13) and *he* with covers in the shape of coiled dragons still occur on rare occasions among regional bronzes until the middle Spring and Autumn period (c. 650–550 BC); these late instances invariably come from the eastern and southern periphery of the Zhou culture sphere.[26] Body decoration identical to this specimen (and to No. 67) appears on a coverless *lei* from a tomb at Shaanxi Qishan Hejiacun Xihao.[27]

23. *Wenwu* 1961.11, front cover; Chengdu 1991, no. 10; Beijing 1994a, pl. 76.

24. *Wenwu* 1961.11, p. 29, misreads the kneeling legs as elephant trunks.

25. *Kaogu* 1974.6, pl. 1.

26. *Lei* have been found at Hubei Suizhou Xiongjialaowan (eighth century BC; *Wenwu* 1973.5, pl. 4.3) and Shandong Yishui Liujiadianzi tomb 2 (seventh century BC; *Wenwu* 1984.9, p. 7 fig. 13). On *he* see Ma Chengyuan 1997, pp. 213–26 (by Thomas Lawton).

27. Beijing 1979, no. 149.

Occurring on vessels of almost unvarying shape, the plethora of ornaments, attachments, and elaborations here described gives the impression of a series of variations on a common theme. Some of the same motifs occur, identically executed, on vessels that otherwise look completely different. Examples include the three-dimensional rams' heads on Nos. 66 and 67; the scaly serpents on Nos. 64 and 65; the coiled dragons on Nos. 65 and 67 and on the *lei* illustrated in Figures 10–12; and, most saliently, the symmetrical pairs of kneeling buffaloes on Nos. 64 and 65 and on the *lei* illustrated in Figures 10–12. Although these motifs occur in different positions, their manner of execution is consistent throughout, sometimes differing subtly from that of the rest of a vessel's decoration (e.g. in the case of the kneeling buffaloes in No. 65 and Figs. 10–11). This suggests that, in spite of their manifest differences, most or all of the Zhuwajie *lei* were made in the same workshop and within a relatively short period of time.

THE DATE AND PLACE OF ORIGIN OF THE VESSELS

So far, a majority of scholars both in and outside of China have dated the Zhuwajie assemblages to the transition from Shang to Western Zhou.[28] When first proposed, this dating rested on the belief that ancestral designations of the type "Father N" (N being the day of sacrifice), which occur in the inscriptions on the two *zhi* found in 1959, were used exclusively during Shang times.[29] Today, however, we know that such designations remained in use through the end of middle Western Zhou. The two *zhi* from Zhuwajie in fact differ perceptibly from Shang period *zhi* in both shape and ornamentation, and Hayashi Minao's corpus of Shang and Western Zhou bronzes places them in the latter part of early Western Zhou, in other words around 1000 BC or slightly thereafter.[30]

Such a date turns out to fit also the shape and ornamentation of the uninscribed vessels from the Zhuwajie hoards. In particular, the single *zun* found in 1959 (Fig. 14),[31] with its plain trumpet-shaped mouth, plain ring foot, and large animal face in the center of each side, has a number of direct parallels from the latter part of early Western Zhou in the Western Zhou heartland.[32] Elsewhere in the Yangzi river system, a similar specimen was excavated at Anhui Tunxi Yiqi; an inscription marks it as an import from the north.[33] Middle Western Zhou *zun* of identical ornamentation scheme tend to be slightly squatter.[34]

Likewise, the nine *lei* found in the two hoards at Zhuwajie, though diverse in ornamentation and size, are similar in shape both to one another and to specimens found in north China that Hayashi dates to the latter part of early Western Zhou. The difference between the Zhuwajie *lei* and those from the early part of early Western Zhou (and before) is subtle: in the Zhuwajie specimens, the break in profile between shoulder and belly is less pronounced, and the handles have a slightly larger span. (In some cases, the lower ends of the handles are placed in the area below the shoulder zone, whereas in earlier *lei*, they are always contained within the shoulder zone.) Moreover, the presence of high jagged flanges on some of the Zhuwajie *lei* (e.g. No. 65), though without parallel on any other known *lei*, accords well with a stylistic tendency observed on bronzes of other kinds made in the Yellow River valley during the latter part of early Western Zhou—rarely before and never later.[35] Such flanges always

28. *Wenwu* 1961.11, p. 30; Chengdu 1998, p. 182 (by Shi Jingsong). Rawson (1990, vol. 1, p. 136) proposes a date in the "preconquest or early Zhou period."

29. This rationale was first explicitly stated by Xu Zhongshu in *Wenwu* 1962.6, pp. 15–18.

30. Hayashi 1984, vol. 2, pp. 344–7. Similar pieces have been found, e.g. at Gansu Lingtai Baicaopo (*Kaogu xuebao* 1977.2, pl. 5.1).

31. Chengdu 1991, pl. 235; Beijing 1994a, pl. 92.

32. Hayashi 1984, vol. 1, pp. 230–36. For similar specimens from Baicaopo see *Wenwu* 1972.12, p. 3 fig. 2, p. 7 fig. 4; *Kaogu xuebao* 1977.2, pl. 5.4.

33. Shanghai 1987, fig. 27.

34. Hayashi 1984, vol. 1, pp. 230–36.

35. Hayashi 1984, vol. 2 *passim*.

occur in conjunction with flamboyant surface decoration, frequently including the coiled-dragon motif.

By including the Zhuwajie vessels in his typological and stylistic master sequence of Shang and Zhou bronzes, Hayashi implies that he believes them all to have been made within the Western Zhou core area.[36] Their style displays neither continuity with the Sanxingdui bronzes nor any resemblance to the weapons and tools from the Zhuwajie hoards, suggesting that they are intrusive into Sichuan, and their apparent contemporaneity (supported by Hayashi's typological sequences of *zhi, zun,* and *lei*) suggests that they represent a single borrowing from outside Sichuan.

Most archaeologists in Sichuan, however, would not agree that the uninscribed vessels from Zhuwajie were made in north China. Instead, they assume that these vessels, though based on early Western Zhou prototypes, are local imitations made later, either in late Western Zhou or in the Spring and Autumn period. This hypothesis brings the vessels closer in time to the indigenous Ba-Shu bronze-manufacturing tradition, of which they are then taken to be the fountainhead.[37]

Seeking a compromise, Li Xueqin admits that Nos. 64 and 67, which have close counterparts from the Shanwanzi and Beidongcun hoards in Liaoning, might be northern imports, but he takes the remaining seven *lei* to be local products. Li intimates that the buffalo motifs on No. 65 and on the *lei* shown in Figures 10–12 may have been copied directly from No. 64. He further speculates that the *zun* in Figure 14, which he also considers a probable import, inspired the animal faces on locally made bronzes.[38] To justify his argument for the local manufacture of the seven *lei,* Li mentions odd proportions, strange patina, and prominently visible spacers. But none of these alleged indicators is very compelling. First, as Hayashi has shown, the shape and proportions of the Zhuwajie *lei* actually accord well with specimens dating from the latter part of early Western Zhou found in northern China.[39] Second, it remains unclear whether the allegedly abnormal patina was caused by an alloy composition different from that of metropolitan Zhou bronzes or simply by local soil conditions at Zhuwajie; in the absence of elemental analyses, it might be best to leave the question open. Finally, spacers vary in size among vessels of northern manufacture as well as among the Zhuwajie *lei,* where visually prominent spacers occur only on Nos. 66 and 64—the latter vessel being regarded by Li himself as a northern import.

Jessica Rawson has also argued that the Zhuwajie *lei* were manufactured in Sichuan.[40] As she has observed, some of the idiosyncrasies of early Western Zhou bronzes— especially the "flamboyant" style with its realistically rendered animal motifs and jagged flanges—derive not from the Shang bronze workshops at Anyang but from the middle Yangzi region. If the Zhuwajie vessels precede the early Western Zhou flamboyant bronzes, as Rawson believes, then they might represent the intermediary between the middle Yangzi and early Zhou styles. Given the isolation of the Zhuwajie finds, however, it may be risky to assume the existence of foundries in Sichuan sufficiently inventive and advanced to exert a heavy influence on Zhou casting.

On present evidence, it seems more plausible to consider the Zhuwajie *lei* as products of the same workshops in Shaanxi and/or Henan that produced other Western Zhou flamboyant bronzes. Whatever middle Yangzi stylistic features occur at Zhuwajie are also attested, and more plentifully, on bronzes from the Zhou heartland, where

36. Hayashi treats only the 1959 finds, but identical considerations apply to the four *lei* found in 1980.

37. Feng Hanji 1980, p. 42 (followed by numerous later scholars).

38. Li Xueqin 1996, p. 120.

39. Hayashi 1984, vol. 1, pp. 292–3.

40. Rawson 1990, vol. 1, p. 30 and *passim.*

such elements could well have been introduced by way of southern Henan or the Han River valley. Even if it should turn out that the Zhuwajie *lei* were made in Sichuan, it is more likely that they were copied after models imported from the north than that they were sources for metropolitan Zhou bronzes. The discovery of related items in central Shaanxi and the upper Han River valley may suggest possible avenues of transmission from the north to Sichuan. We should not exclude more circuitous routes, however, for instance along Tong Enzheng's "crescent-shaped cultural diffusion belt," which comprises the northern steppe zone and the mountainous western borderlands of the Sichuan Basin.[41]

THE WEAPONS AND TOOLS

Like the bronze vessels, the 28 weapons and tools recovered from the Zhuwajie hoards (Table 1) feature highly diverse decoration. It is unclear whether they were produced at different workshops, at different times, or both—or neither, for a single foundry could have cast bronzes that looked very different from one another.

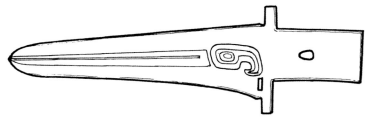

A stylistic relationship to Sanxingdui has been suggested for the face motif on the three axes (*fu* or *yue*) from the hoard found in 1980 (No. 71). These objects look archaic. They have no counterparts in north China, though similar axes are present in the upper Han River valley.[42] By contrast, the weapon types represented at Zhuwajie all derive from Shang and early Western Zhou prototypes in the Yellow River valley, even though their ornament strongly resembles that of the distinctive, locally made Ba-Shu weapons (Nos. 79–83, 85–93).[43] In some instances (e.g. Nos. 69 and 71), faint reminiscences of Sanxingdui designs can also be detected. Although Wang Jiayou regarded only the axes as local products and considered the weapons to be imports,[44] the latter as well are now commonly considered local products.

The Zhuwajie weapons are difficult to date. For instance, the triangular dagger-axes (*ge*) exemplified by No. 68 resemble well-known Shang and early Western Zhou specimens. Yet they also have close counterparts in Ba-Shu contexts that are reliably dated to the fifth to third centuries BC, a time long after they had become obsolete in their area of origin. Archaeologists long assumed that all Ba-Shu bronzes should be assigned the same date as those well-dated finds. Nowadays they take more seriously the possibility that Ba-Shu bronzes found in contexts lacking positive indication of a late date may reach back to periods closer to their Shang and early Western Zhou prototypes.

Concrete evidence for such time depth is so far scarce. Potentially significant is the lack, at Zhuwajie, of daggers and swords, and of inscriptions in "Ba-Shu characters," all of which are ubiquitous in fifth to third century Ba-Shu contexts. Moreover, both hoards at Zhuwajie yielded *ge* of cruciform shape (Fig. 15), an Erligang-derived type that is well documented from early Western Zhou tombs in the Zhou metropolitan area and in several apparently early contexts in the upper Han River valley.[45] Specimens have turned up in two other early assemblages in Sichuan,[46] but they seem to be absent from fifth to third century Ba-Shu assemblages. Such evidence suggests that the latter are only a late stage of a much longer development, of which the weapons from Zhuwajie represent some earlier stage.

Fig. 15. *Ge* from 1980 Zhuwajie hoard. Length 32 cm. Late eleventh or early tenth century BC (early Western Zhou). Drawings by Luo Zeyun after *Kaogu* 1981.6, pl. 6.3.

41. Tong Enzheng 1987, pp. 30–31, takes the similarities between No. 67 and its counterpart at Beidongcun as indicating such diffusion.

42. Similar pieces were found, in Sichuan, at Hanyuan Fulin (*Wenwu* 1983.11, p. 91 fig. 1.1–2); and in the upper Han River valley, at Shaanxi Chenggu Wulangmiao (Beijing 1979, no. 108). Four specimens with more rounded blades from Chenggu Longtouzhen (*Wenbo* 1988.6, inside back cover fig. 3) have counterparts among Ba-Shu bronzes (Beijing 1994a, pl. 156).

43. For typological analysis see Lu & Hu 1983a; Asahara 1985; Li Xueqin 1985, pp. 206–10; Li Xueqin 1996, p. 19.

44. *Wenwu* 1961.11, p. 30.

45. For Erligang specimens from Henan see Beijing 1981b, nos. 80, 96, 101, 103, 113, 128. In the Wei River valley, specimens were found at Shaanxi Baoji Zhuyuangou (Lu & Hu 1988, vol. 2, pls. 27, 102; Lu & Hu 1983b, p. 60) and Gansu Lingtai Baicaopo (*Kaogu xuebao* 1977.2, pp. 110–12, p. 111 figs. 10.3–10, pl. 10.4); in the Han River valley, at Shaanxi Chenggu Longtouzhen (*Wenbo* 1988.6, p. 8 pl. 2.8) and Chenggu Wulangmiao (Beijing 1979, no. 104). Two axes with identically shaped hilts were found at Shaanxi Yang Xian Fanba (*Wenbo* 1996.6, p. 74, inside front cover figs. 6–7). For pertinent discussion see Lu & Hu 1983a and 1983b; Li Boqian 1983; Li Xueqin 1996, p. 19.

46. They come from Xinfan Shuiguanyin (*Kaogu* 1959.8, p. 408 fig. 6 [visible in tomb plan]) and Hanyuan Fulin (*Wenwu* 1983.11, p. 93 fig. 1.7).

Our uncertainty as to the date of the weapons and tools entails a corresponding uncertainty about the time of deposition of the hoards. Arguing that the weapons and tools all belong to the fifth to third century, Feng Hanji suggested that the hoards were not interred until the time of the Qin conquest.[47] In such a case, the vessels would have had to be heirlooms centuries old when deposited. But the possibility remains open that the weapons and tools are substantially earlier than Feng believes, perhaps as early as the vessels. It is possible, in other words, that the vessels, weapons, and tools were all made at about the same time, perhaps around 1000 BC, and deposited not long thereafter.

The motifs that ornament some of the Zhuwajie weapons (e.g. No. 68) are well known from the Shang and Zhou bronze-casting traditions, but here they look quite different. (For more discussion, see the catalogue entries.) The casters pressed technical and stylistic devices originating in north Chinese bronze workshops into the service of a completely different approach to ornamentation, one characterized by dynamic, curvilinear renderings (Nos. 69–70). These objects show a mastery of technique and design that is unsurpassed even by the best of the late first millennium Ba-Shu bronzes. The aesthetic that informs them is apparently linked to that of later metallurgical traditions in southwest China and Southeast Asia. If the whole of the two Zhuwajie bronze assemblages does indeed antedate the Ba-Shu bronzes, objects such as Nos. 69–70 would constitute the earliest known manifestations of this aesthetic.

47. Feng Hanji 1980, p. 44.

64

Lei

Bronze
Height 79 cm, greatest diameter 41 cm
Late eleventh or early tenth century BC

Excavated in 1980 at Pengzhou Zhuwajie
Sichuan Provincial Museum 140362

PUBLISHED: *Kaogu* 1981.6, p. 497 fig. 2.1, p. 498
figs. 8–10, pl. 5.1; Liu Ying 1983, p. 3 fig. 2.5,
pl. 1.4; Hiroshima 1985, no. 21; Chengdu 1991,
pls. 5–7; Beijing 1994a, pls. 70–72.

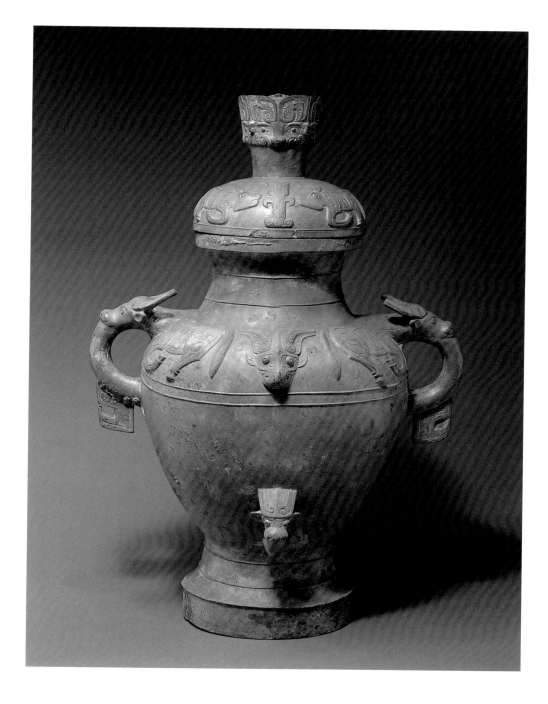

This is the largest of the *lei* found at Zhuwajie. Its buffaloes and animal faces, and the coiled
serpent on the knob, are rendered in subtly modulated relief and accentuated by a simple
sunken-line scroll pattern. Some details, such as the horns, hooves, and tails of the buffa-
loes, are rendered with especial concern for realism. The background surface is altogether
plain, as seen in a number of early Western Zhou bronzes with realistically rendered ani-
mal decor.

Technical details include a mold mark down the center, bisecting the animal faces in
the center of the shoulder zone and on the lower handle. Upon close inspection, one may
notice a subtle asymmetry resulting from a slight dislocation of the mold sections when
they were assembled for casting. Regularly distributed rows of spacers are clearly visible
on the vessel's unornamented lower part, and they can also be made out without much
difficulty in the ornamented portions. The spacers' slightly different alloy composition has
resulted in a patina different from that of the rest of the vessel—a contrast that probably
was not perceptible when the vessel was new.[1]

1. The caption in Chengdu 1991 (p. 217) mistakes the
spacers for turquoise inlay.

Lei

Bronze
Height 69.4 cm, diameter of mouth 21.8 cm
Late eleventh or early tenth century BC

Excavated in 1980 at Pengzhou Zhuwajie
Sichuan Provincial Museum 140363

PUBLISHED: *Kaogu* 1981.6, pl. 5.2; Liu Ying 1983,
p. 3 fig. 2.2, pl. 1.1; Beijing 1990a, no. 47 (vessel
turned 90 degrees); Chengdu 1991, pl. 1 (cover
turned 90 degrees); Beijing 1994a, pls. 73–4,
pl. 75 (in one case, in error for the *lei* of Fig. 10).

This vessel is a tour de force of invention and casting. The principal motifs are set against a background pattern of thin spirals. Most of them are executed in a single layer of flat relief and accentuated by an abstract pattern of relatively widely spaced sunken-line scrolls. Some details, however, such as horns, eyes, and scales, and most notably the buffaloes adorning the ring foot, are rendered in realistically molded relief. This mixed mode of representation is characteristic of the "flamboyant" strain in early Western Zhou bronze decoration.

The original effect of a continuous jagged crest, created by the vessel's prominent flanges, is now slightly marred by damage to the flanges of the cover. The mold marks coincide with the flanges, on the narrow sides of which one may observe faint indications of the misregister of mold parts. The handles and the large sculptural faces were in all likelihood precast and then included in the mold assemblage of the vessel proper. A hole on the cover knob—caused apparently by a dropped-out spacer—reveals the core material remaining inside.

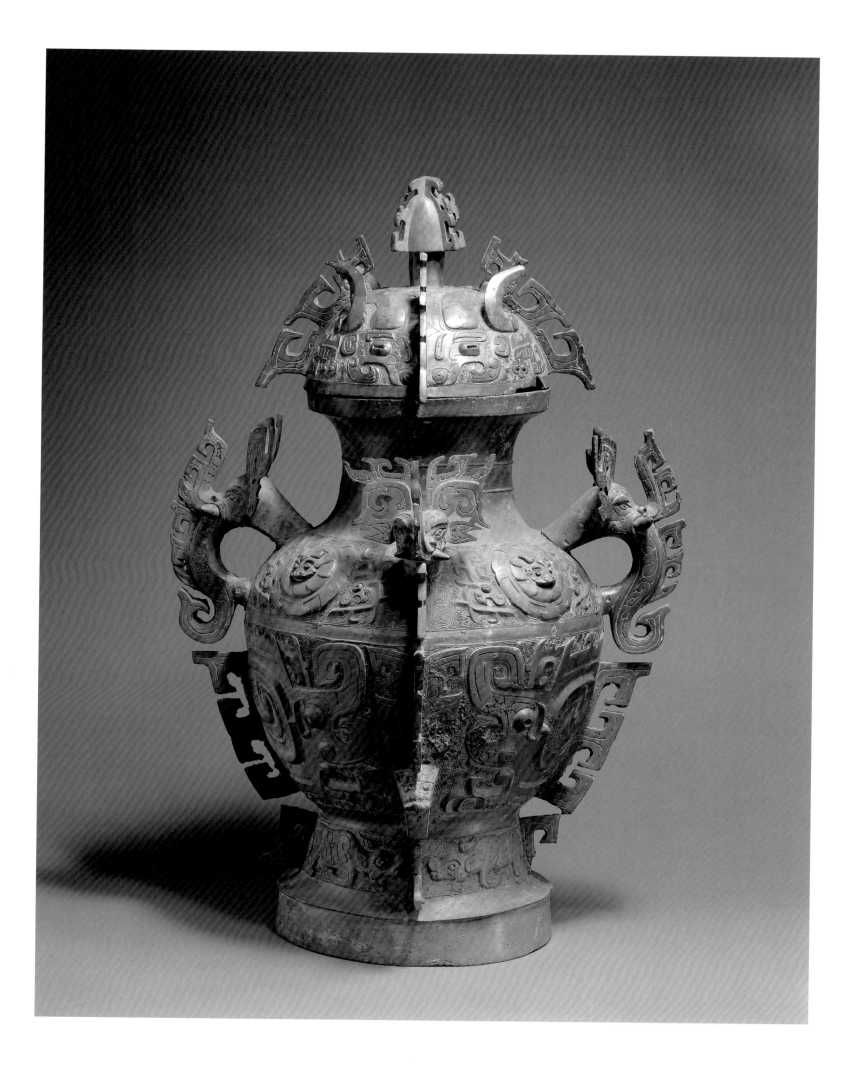

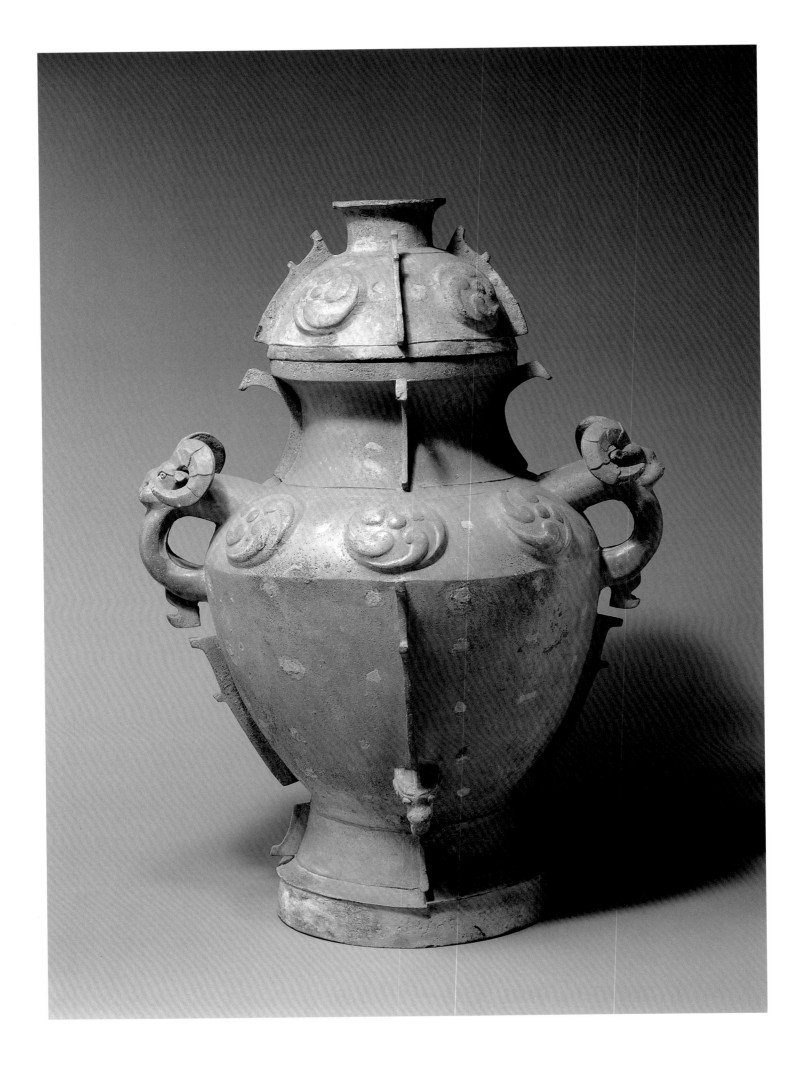

66

Lei

Bronze
Height 68 cm, diameter of mouth 24 cm
Late eleventh or early tenth century BC

Excavated in 1959 at Pengzhou Zhuwajie
Sichuan Provincial Museum 83437

PUBLISHED: *Wenwu* 1961.11, inside front cover
fig. 1; Feng Hanji 1980, p. 45 fig. 9, pl. 5.2;
Hayashi 1984, vol. 2, p. 292 fig. 45; Beijing 1990a,
no. 46; Beijing 1994a, pl. 79.

The most salient characteristic of this *lei* is the melted smoothness of its surface texture. In contrast to the *lei* in Figures 6 and 7, not even the whorl ornament on the raised bosses is accentuated by sunken lines. The only places where there is some effort at detailed rendering are the horns of the animals adorning the handles, which stand off effectively from the surface decor. The presence of low flanges imparts to the vessel a welcome structural precision. The ends of the flanges jut forth edgily beyond the contours of the body, underlining the contrast between the tautness of the flanges and the smoothness of the vessel surface. The mold marks coincide with the flanges. The spacers are conspicuous and notable for their regular distribution.

67

Lei

Bronze
Height 50 cm, diameter of mouth 17.4 cm
Late eleventh or early tenth century BC

Excavated in 1959 at Pengzhou Zhuwajie
Sichuan Provincial Museum 83438

PUBLISHED: *Wenwu* 1961.11, inside front cover
fig. 2, p. 31 figs. 1, 3; Feng Hanji 1980, p. 45 fig. 10
(left), pl. 2.3; Liu Ying 1983, p. 2 fig. 1.1, pl. 1.3;
Hayashi 1984, vol. 2, p. 292 fig. 43; Chengdu 1991,
pls. 2–4; Beijing 1994a, pls. 77–8.

As in No. 65, the principal decorative motifs are accentuated by sunken-line patterning and set against a background of fine spirals. The coiled dragons are rendered in molded relief. The animal faces on the lower portion of the vessel, however, differ from those on No. 65 in being executed in two superimposed layers of relief. Sculptural details, such as the rams' heads on the shoulder and the buffalo head on the lower handle, are astonishingly similar to those seen on No. 66.

The massive dragon-shaped cover seems disproportionately large. It might be the miscalculation of a caster new to such covers; or perhaps the present cover was not original to this particular *lei*. Imperfections in the rendering of the dragon's snout and lower body seem to indicate technical problems in casting that are not in evidence on the body of the vessel. The cover was cast in a mold of several parts. One mold mark coincides with the jagged flange on the dragon's back; others run in the center of the lower belly and on top of the puny legs. Unlike the cover, the body lacks flanges. The mold marks run through the axes of symmetry of the surface decoration and through the handles. On the lower handle, they are prominent enough to suggest misregister of mold sections. The loose circular rings in the handles were probably prefabricated and then included in the mold assemblage when the body was cast.

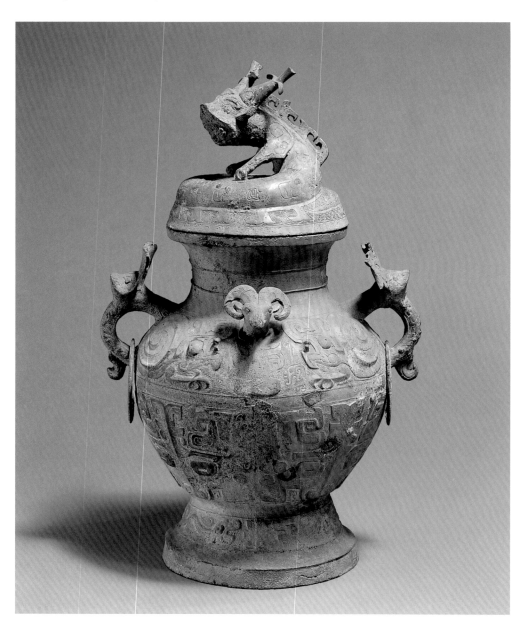

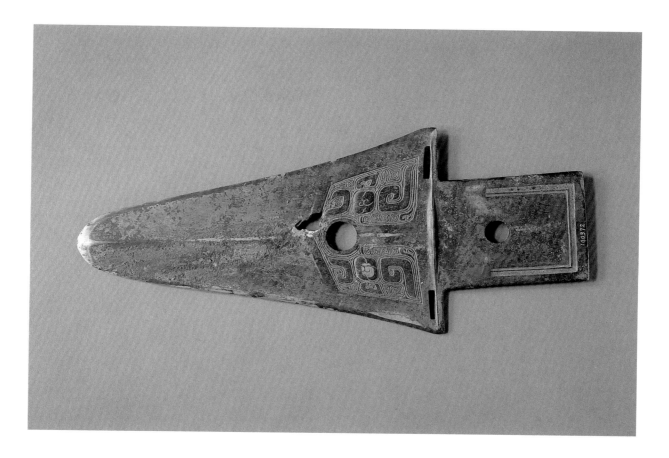

This dagger-axe *(ge)* is a fairly standard specimen of the archaic type sometimes designated as *kui*, which goes back at least to Erligang times. It consists of a triangular blade with a slight ridge (midrib) down the center and a rectangular tang. The tang would have been slotted through a wooden handle and secured in place with fastenings through two slits in the base of the blade. The round hole in the tang may have carried a tassel. The function or significance of the round hole in the center of the blade—a feature frequent on *ge* from Sichuan (see also Nos. 69, 72)—is unknown.

The principal ornament consists of a dissolved version of the generalized animal face *(taotie)* near the base of the blade. The pentagonal outlines of the face subtly enhance the thrust of the object's shape. The unornamented midrib section from the base to the round hole forms the nose. Around it, horns, eyes, ears, and jaws are deployed symmetrically against a background of fine spiral decor. While the animal-face motif itself is consistent with Shang and early Western Zhou design, the fluid curvilinear outlines of the dissolved components and the way the midrib and round hole are integrated into the panel make it clear that this *ge* stands outside the mainstream Shang and Zhou bronze-manufacturing tradition.

68

Ge *blade*

Bronze
Length 27.3 cm
Probably first half of the first millennium BC

Excavated in 1959 at Pengzhou Zhuwajie
Sichuan Provincial Museum 83426

PUBLISHED: *Kaogu* 1981.6, p. 499 fig. 6.3, pl. 6.6;
Hiroshima 1985, no. 26 (left); Chengdu 1991,
pl. 160; Beijing 1994a, pl. 134.

Halberd (ji)

Bronze
Length of *ge* blade 27.5 cm, length of spearhead
23.9 cm
Probably first half of the first millennium BC

Excavated in 1959 at Pengzhou Zhuwajie
Sichuan Provincial Museum 83425

PUBLISHED: *Wenwu* 1961.11, p. 5 fig. 7; Feng
Hanji 1980, p. 40 fig. 5.1, p. 46 fig. 16; Hiroshima
1985, no. 27; Chengdu 1991, pl. 125; Beijing
1994a, pl. 145, p. 6 fig. 3.

In some halberds the lateral-thrusting *ge* and the vertical-pointed spearhead are fused (Fig. 69.1); this one instead consists of two separate parts. While the *ge* is entirely flat, the spearhead has a tubular socket for the insertion of a wooden pole or handle. Ancient depictions show that the length of such halberds sometimes exceeded the height of the soldiers (Fig. 69.2).

Since they carry identical decoration, it seems beyond doubt that these two pieces were part of the same weapon. The motif is an amalgam of human and avian traits. On each blade a long curved wing extends down the midrib. Next to it, near the base of the blade, a face is shown in profile, its curved nose resembling a bird's beak and its comma-shaped beard almost like another, smaller wing. The presence of pointed ears and a mouth underneath the "beak," however, leaves no doubt that the face is anthropomorphic. With due caution, one may wonder whether such human-avian hybrids might be iconographic precursors to the *yuren* (feather-men) immortals of Han iconography (Fig. 69.3).

The framed, rounded-rectangular eyes and wavy mouth of the face evoke clear associations with the large human masks from Sanxingdui (Nos. 18–21). Even though the weapon type itself is derived from the north, the decoration of this halberd thus constitutes a rare indicator of some continuity between Sanxingdui and later bronze casting in Sichuan. Other noteworthy features include the attractively asymmetrical deployment of the wings on the weapon surface and a quite daring dichotomy in the execution of the face, which is shown in relief on the *ge,* while on the spearhead it emerges in three dimensions and forms part of the object's contour. The stylistic difference from bronzes from Shang and Zhou workshops could hardly be greater. The object is closer in design to later Southeast Asian bronzes.

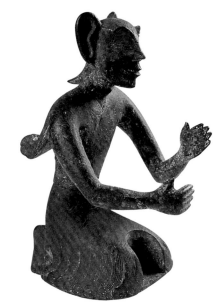

Fig. 69.1. Halberd excavated in 1974 at Shaanxi Fufeng Shaoli. Late eleventh or early tenth century BC (early Western Zhou). Drawing by Luo Zeyun after Xi'an 1994, no. 254.

Fig. 69.2. Detail of the lacquer inner coffin of Marquis Yi of Zeng, showing guardian deities holding halberds mounted with *ge.* From Hubei Suizhou Leigudun tomb 1. 433 BC or shortly thereafter. Drawing by Luo Zeyun after Beijing 1989, vol. 2, pl. 11.3.

Fig. 69.3. Bronze figure of an immortal *(yuren)* from Shaanxi Xi'an Beijiao. Height 15.3 cm. Second or first century BC (Western Han period). After Xi'an 1994, no. 279.

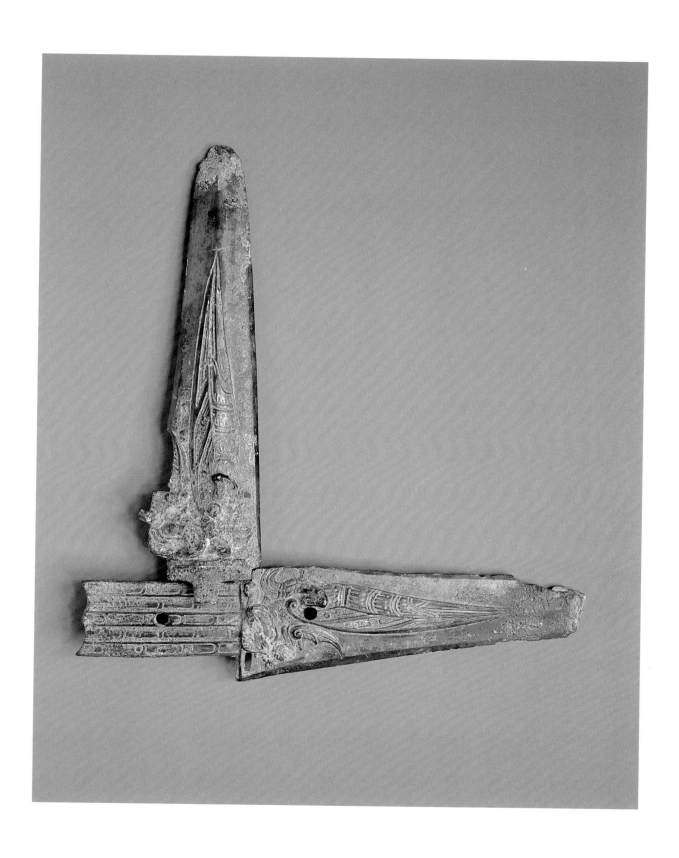

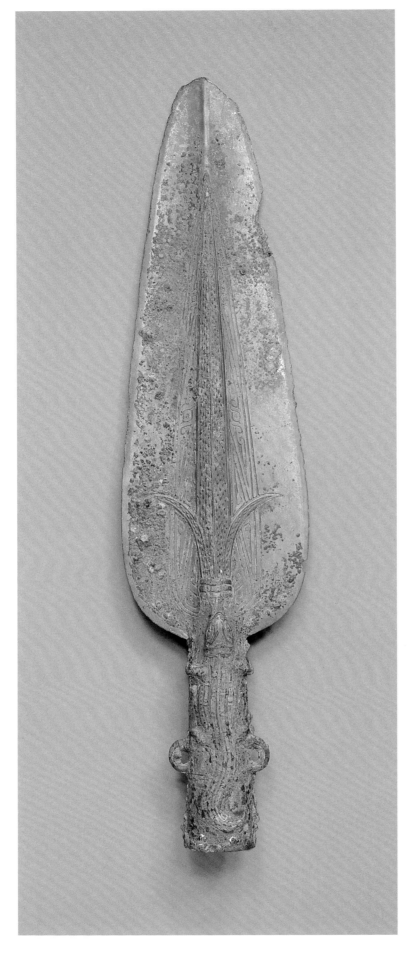

Spearhead

Bronze
Length 32 cm
Probably first half of the first millennium BC

Excavated in 1959 at Pengzhou Zhuwajie
Sichuan Provincial Museum 83434

PUBLISHED: *Wenwu* 1961.11, p. 5 fig. 4 (left); Feng
Hanji 1980, p. 39 fig. 2, p. 40 fig. 5.2; Chengdu
1991, pl. 137; Beijing 1994a, pl. 148.

The spearhead's tubular stem extends into the midrib
of the willow-leaf-shaped blade. Two tiny lateral loops
on the stem probably served to suspend tassels or
trophies. A lizard or crocodile is depicted on the stem,
its sinuous body covered with a realistically rendered
scale pattern. A symmetrical abstract pattern—
consisting of a central lancet and two outcurved
projections that overlap a zone of hooked scrolls—
appears to emanate from the animal's mouth, as if
to render graphically snorts emitted by the reptile.
Alternatively the motif may depict a large insect or
bird with long pointed wings whose head is being
swallowed by the reptile; the hooked scrolls, more-
over, contain two pairs of "eyes" possibly derived
from zoomorphic motifs.

While the hooked scrolls are remarkably—and
surely not accidentally—similar to the filler decor
of many Western Zhou bronzes, the overall aesthetic
affinities of this object are with Ba-Shu and Southeast
Asian bronzes. If in fact it dates from early in the first
millennium BC, the convincing rendering of overlap
by intersecting linear patterns would be notable as a
relatively early instance, in East Asian art, of translat-
ing three-dimensional spatial relationships into two-
dimensional rendering.

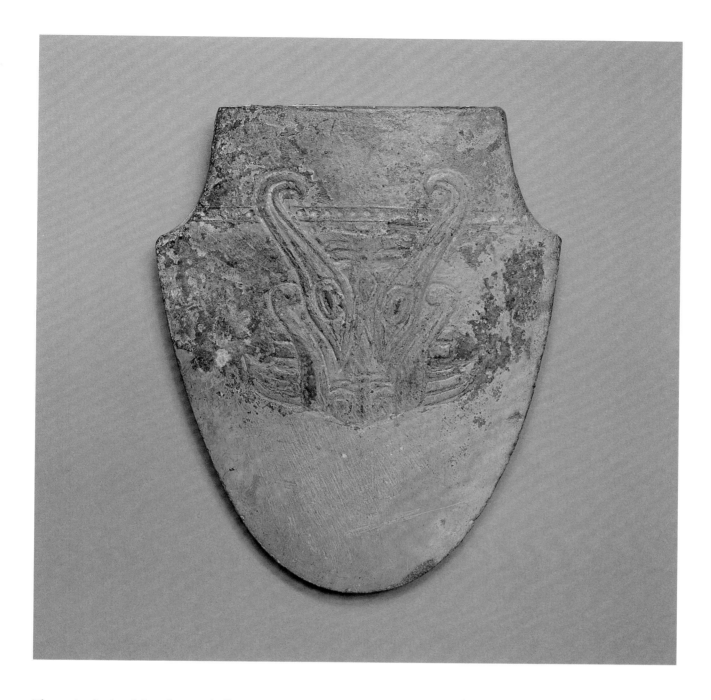

The entire body of this object is hollow to allow the insertion of a handle of rounded-rectangular cross section. The main decor element, which is executed in low, molded relief, overlies a band of sunken dots separating the blade from the socket. The motif is ambiguous—it could be a bird with outstretched wings and complex tails seen from above, or, perhaps more likely, a deformed and possibly doubled version of the generalized animal face *(taotie)* familiar from Shang and Western Zhou bronzes (compare No. 68). The sunken-line diamond shapes on the central axis of the motif are reminiscent of those seen on bovine faces in Western Zhou bronzes (though the fact that there are two such diamonds on this object is at least mildly unusual). At the same time, the framed, rounded-rectangular "eyes" placed on the inward-bent "horns"(?) of the face distantly recall possible Sanxingdui forerunners.[1] Although there is no close parallel to this object's decoration, the combination of Western Zhou inspiration with reminiscences of Sanxingdui is shared by other bronzes from Zhuwajie.

71

Axe (fu *or* yue)

Bronze
Length 26.2 cm
Probably first half of the first millennium BC

Excavated in 1980 at Pengzhou Zhuwajie
Sichuan Provincial Museum 140378

PUBLISHED: *Kaogu* 1981.6, p. 499 fig. 6.1, pl. 6.7; Hiroshima 1985, no. 24 (right); Chengdu 1991, pl. 122; Beijing 1994a, pls. 153–4.

1. Li Xueqin (1996, p. 121) points to Sanxingdui masks (e.g. Fig. 24.3) or bells (No. 34) as representing possible sources of inspiration for the decor of these axes.

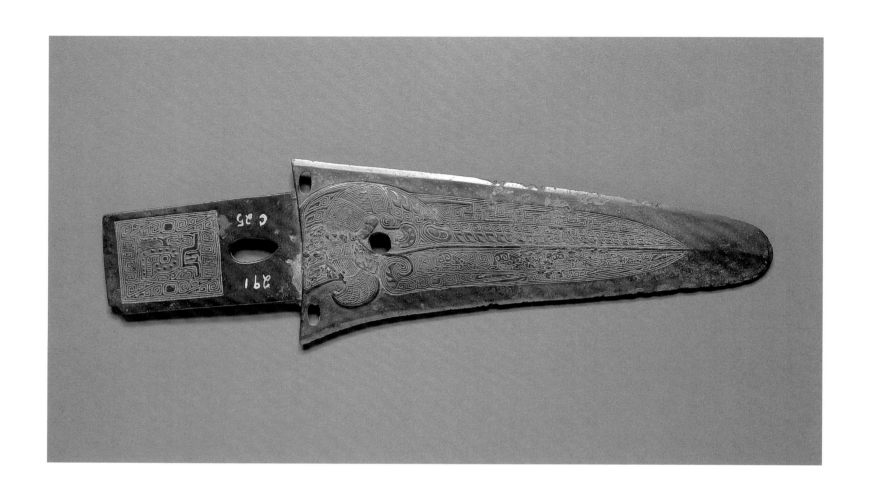

The tongue-shaped blade of this *ge* is slightly asymmetrical in shape and almost flat, with the midrib but faintly indicated. The base of the blade is slightly curved, and the tang is attached at an angle. Holes occur in the same places as on No. 68, but here the one on the tang is oval.

Both the tang and the blade are ornamented. The tang features a rectangular panel in which bands of finely drawn spirals and "eyes" surround a central motif that is difficult to interpret in its totality. According to one interpretation, it shows a silkworm surrounded by its cocoon, but comparison with earlier motifs suggests that it is more likely to be a shrivelled dragon. The ornamentation of the blade is more exuberant than that of the tang but equally difficult to interpret. Of irregular outline, the ornamented panel has an asymmetrical portion close to the base that reminds one of a bird's wing; this flows into a drawn-out lancet-shaped panel. Everything is covered by a dense pattern of quills, hooks, and spirals, among which several additional possible "silkworms" (or parts thereof) appear.

This design combines the stylistic means of Shang and Zhou surface ornament with a free-flowing, boldly curvilinear play of lines of vaguely avian inspiration. Particularly in its departure from bilateral symmetry, it reflects a taste quite different from that of the Shang and Zhou, and closer to that of southwest Chinese and Southeast Asian bronze-casting traditions.

While its locus of excavation is known, the archaeological context of this *ge* does not seem to have been reported. Although it is here grouped with the Zhuwajie bronzes, it also has manifold parallels from Ba-Shu tombs of fifth to third century date.[1] Its exact date is uncertain.

72

Ge *blade*

Bronze
Length 26.3 cm
Perhaps first half of the first millennium BC

Found in 1976 at Chengdu Jiaotongxiang
Chengdu City Museum 291, C25

PUBLISHED: Beijing 1994a, pl. 129, p. 7 fig. 4.

1. See Tong Enzheng 1977 (typology), Liu Ying 1983 (ornament).

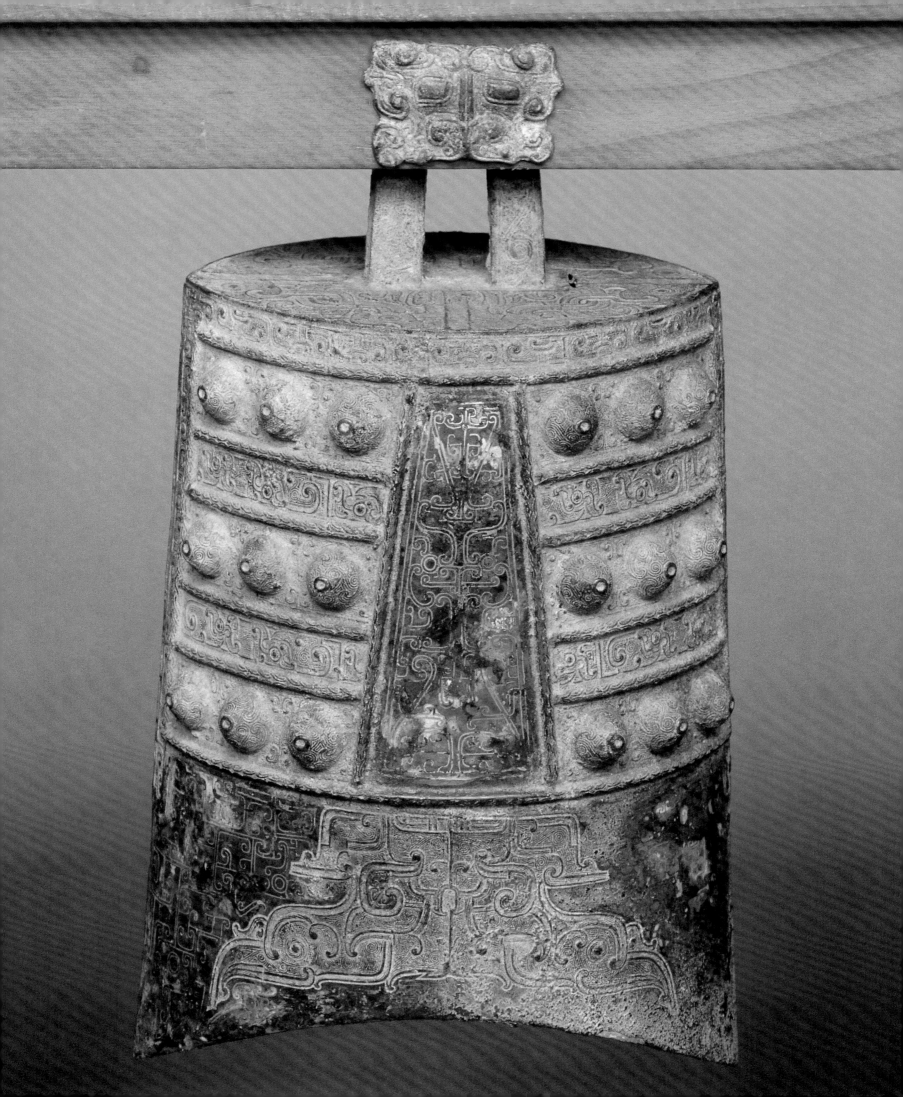

by Alain Thote

The Archaeology of Eastern Sichuan at the End of the Bronze Age (Fifth to Third Century BC)

Down to the founding of the empire in 221 BC, the cultures of eastern Sichuan still belonged to the Bronze Age, making heavy use of bronze even after iron had come into use alongside it around the fifth century BC. In this respect they were no different from the cultures of the Zhongyuan or the Yangzi valley. But unlike the cultures of the sinicized world, which are precisely and often profusely documented by ancient texts, inscriptions, and other remains, the cultures of eastern Sichuan at the end of the Bronze Age are poorly known, evidence for their history and archaeology being patchy and uneven.[1] Texts tell us that the region was occupied by two political entities: Shu at the center of the modern province, and Ba further east, taking in adjacent parts of modern Hubei, Guizhou, and Shaanxi (the part south of the Han River). For the fourth and third centuries numerous tombs have been discovered in the region, yielding a wealth of tomb furnishings, but for the period from the eighth to the fifth century very little has been found.[2] The contrast gives the no doubt erroneous impression of a sudden cultural flowering.

The archaeological picture for the Warring States period (481–221 BC) is complex. Several distinct material cultures originated in Sichuan, but they did not develop in isolation from each other; they were shaped by exchanges among themselves and also by contacts with other cultures on the borders of the province and beyond. Though contact was only intermittent, the material evidence makes it clear that routes of contact were numerous. Western Sichuan, for example, was in touch both with the world of the steppes to the north and with the kingdom of Dian in the south.[3] Local and exotic traits intermingled in Sichuan, as the furnishing of tombs abundantly shows: artifacts made in Sichuan are found side by side with imports (No. 73) and local imitations of imports (No. 75?). More surprisingly, objects made at a given moment seem often to preserve the memory of borrowings that had taken place centuries earlier: a notably puzzling case is Sichuan weapons of the fifth, fourth, and third centuries BC decorated with Shang *taotie* designs of the late second millennium BC (No. 86). Since the mixing of objects of diverse provenance and the perpetuation of ancient shapes and designs are seen at all eastern Sichuan sites, to distinguish a Shu material culture from a Ba material culture is not possible.[4] The distressingly vague archaeological label "Ba-Shu culture" is thus still unavoidable. Moreover the dating of sites and tomb

1. On the sinicized world of the Eastern Zhou period, see Li Xueqin 1985. On the history of Sichuan and its conquest by the Qin kingdom, see Sage 1992.

2. Occupation sites of the late Bronze Age, as opposed to cemeteries, are best known in the vicinity of Chengdu. See notably *Nanfang minzu kaogu* 1 (1987), pp. 171–210.

3. Tong Enzheng 1987, Pirazzoli 1988.

4. Such a distinction has been attempted (see Song Zhimin 1998a), but the attempt seems premature. A glance at the site maps on pp. 14–18 will show that, by comparison with the area around Chengdu, the eastern part of Sichuan is an archaeological void. Until the void is filled, we cannot realistically hope to define distinct Ba and Shu material cultures.

furnishings in this cultural melting pot is plagued with uncertainties. Fortunately, intrusive Chinese artifacts sometimes resolve problems of chronology, as does the partial and gradual adoption of specifically Chinese modes of burial that began in the fourth century. The sinicization of Sichuan took place through contact with its nearest neighbors, first with the state of Chu, then with Qin, whose annexation of part of Sichuan near the end of the fourth century was an important first step toward the Qin unification of China.[5]

In eastern Sichuan, the published archaeological sites fall into four main regions. The largest concentration is in the Chengdu Plain, in an area that reaches northeast as far as Mianyang and south to the edge of the Sichuan Basin, with important sites around Yingjing and Qianwei; in the city of Chengdu alone there are about thirty published sites. This concentration probably represents a dense population at the heart of the ancient Shu state. But the absence of major discoveries elsewhere in the Sichuan Basin cannot be taken to mean that other regions are poor in ancient remains. Archaeological discoveries have most often been made in the course of construction work, and our sample is skewed by inequalities of economic development between the Chengdu Plain—where development has been very rapid in the last twenty years—and the rest of the basin.

The region along the upper course of the Min River, at the frontier between eastern and western Sichuan, has one of the main concentrations of sites of the cist culture, here encountered at the eastern edge of its vast distribution.[6] Contact between the cist culture and the Chengdu Plain is attested by discoveries in Mao Xian.

From Neolithic times onward, the Yangzi River was a corridor of travel and trade that connected Sichuan with the vast alluvial plain to the east in Hubei and Hunan. Sites at the entrance to Sichuan are found on both banks of the river, some in the Three Gorges region, others in ancient Ba territory at Ba Xian and Fuling.

A fourth concentration of sites is in another corridor zone, this one in northern Sichuan, between Qingchuan and Zhaohua, at the point where the modern provinces of Sichuan, Gansu, and Shaanxi meet. Here some fairly rich sites give an idea of cultural and commercial interchange between Sichuan and the Qin state.

In eastern Sichuan no published site as yet gives us much idea of towns, cities, or ways of life. On the other hand the very large number of cemeteries and individual tombs gives a rich and vivid picture of material culture. Cultural interconnections notwithstanding, the burials can be divided into three main categories: cist tombs, boat-coffin burials (in which the coffin is hollowed from a single tree trunk), and shaft tombs. At many sites, Chinese-style shaft tombs with outer coffins (guo) are found side by side with boat-coffin burials, showing that members of the same society followed different funerary practices and thus perhaps differed in religion, ethnicity, or social group. As for cist burials, in Mao Xian they form a distinct group without much internal variation and unaffected by other local styles of burial.

In this rich array of finds, two sites of sharply opposed character stand out, Moutuo in Mao Xian and Majiaxiang in Xindu county. Well represented in the exhibition (Nos. 79–81, 84–90), they testify to the exchanges already mentioned between Sichuan and sometimes distant regions, though in quite different ways. The most original expression of Ba-Shu material culture, however, is to be found not at either of

5. On the Qin conquest of Sichuan see Sage 1992, pp. 112–17.

6. Introduction Part 2; Pirazzoli 1988; Feng & Tong 1973.

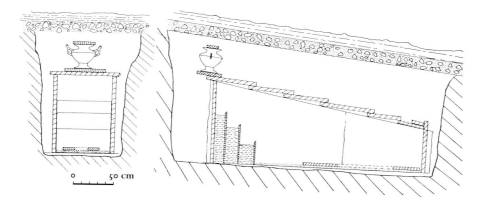

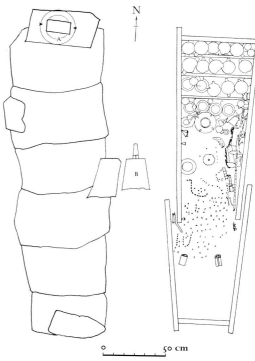

Fig. 1. Moutuo tomb 1. Probably late fifth or early fourth century BC. After *Wenwu* 1994.3, p. 7 fig. 3, p. 8 fig. 4.

these two sites but in a third, distinct culture, that of the boat-coffin burials and their furnishings.

THE SITE OF MOUTUO

The discovery in 1992 of the Moutuo site, a cemetery in which only one tomb and three pits were well enough preserved to be excavated, overthrew existing ideas about the archaeology of the upper Min River area.[7] The area was not so isolated as once supposed, nor was its cultural character so simple. The Moutuo finds show that the people of the upper Min were in touch with very distant cultures—the world of the steppes, the states of the Zhongyuan, and Dian.[8] We should not imagine direct connections and organized trade networks, however; fine goods instead passed from hand to hand and arrived by wandering paths, to be hoarded for their rarity and eventually deposited in tombs and pits. In the case of goods from great distances, the transit time is not easy to estimate: a century or more might elapse between the time when an object was made and the time it was put into a tomb. Many instances of such delays can be adduced in Sichuan in the fifth, fourth, and third centuries.

Moutuo lies in a region separated from the Chengdu Plain by a range of mountains nearly 5000 m high. Communication with Shu by way of the Min River was possible, but it cannot have been easy. The narrow valleys of western Sichuan must have been more inviting routes for the movement of goods.

Moutuo tomb 1 lay 5 m south of a stone tumulus 3.5 m high and 20 m in diameter. Half a meter north of the tomb, and probably associated with it, was a small pit deposit (pit 1) that contained 33 objects. The pit measures 60–65 cm on a side and 47 cm deep; its walls were lined with stones, and the earth that filled it had been hardened at the top surface by fire, as though to seal it. Two more pits were discovered 6 m away to the east, also on a north-south line, pit 2 lying 4.5 m north of pit 3. Badly damaged by landslides, they may have been associated with a now lost tomb in the same way that pit 1 is associated with tomb 1. The tomb and the three pits have furnishings of much the same character, and they probably all date from the same period. In particular, within each assemblage we notice the same disparities of date and provenance.

The tomb is a rectangular shaft (3.9 by 1.36 m) within which an irregular coffin was constructed from large slabs of slate, six placed vertically and seven laid overlapping on top (Fig. 1). Most of the furnishings were at one end of this coffin, set on or adjacent to three earthen steps reinforced by vertical slabs of graduated size. A thick

7. *Wenwu* 1994.3, pp. 4–40; Falkenhausen 1996.

8. Falkenhausen 1996, Huo Wei 1999.

Fig. 2. Moutuo pit 1. Probably late fifth or early fourth century BC. After *Wenwu* 1994.3, p. 9 fig. 6.

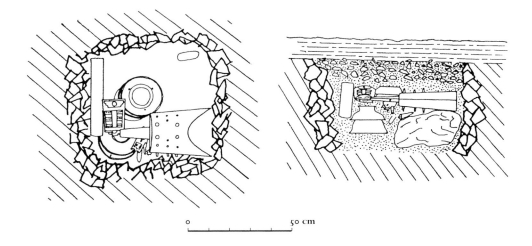

cypress plank laid directly on the ground was presumably meant for the body of the deceased. Just over 1.5 m long, it has a large opening (72 by 28 cm) in the center. Oddly enough, no trace of a skeleton was found in the tomb, and the archaeologists have accordingly suggested that for some unknown reason the deceased was never buried there. The suggestion seems reasonable, since perishable materials such as wood and cloth were found in the tomb well preserved; it is more usual in cist tombs for these materials to be lost and for skeletal remains to survive. On or next to the cypress plank were a bamboo mat; two arm protectors made of copper attached to a sheepskin backing lined with yellow silk; and a puzzling mass of cloth (a shroud replacing the absent corpse?): sixteen layers of silk, alternating yellow, red, brown, and black, with a covering layer of brown hempen cloth to which an ornament of some sort had been attached (a round bronze plaque next to which beads of agate, turquoise, and glass paste were found). Shortly after the opening of the tomb, the colors of the silk disappeared on contact with the air.

The burial has an exceptional wealth of grave goods—more than 170 items in the tomb itself and another 33 in the associated pit 1 (Fig. 2). The principal items were vessels of pottery (48 in the tomb) or bronze (3 in the tomb, 3 in the pit) and bronze or bimetallic weapons (about 30 in the tomb and 9 in the pit). The vessels contained offerings of meat, chestnuts, grain, and fruit. There were also the beads of agate, turquoise, and glass paste just mentioned; bronze jewelry; and some stone tools (or weapons). And there were bells: a stemmed bell of the type *yongzhong* outside the slate coffin, on the east; three bells of the type *bo,* unmatched but tied together by a cord as though they formed a set, inside the coffin; and finally a *yongzhong* and a *bo* in pit 1.

Pit 2 and pit 3 were damaged and have no doubt lost some of their contents, but they nevertheless yielded rich furnishings. Pit 2 contained 33 items, including 4 bells of the type *yongzhong* and 2 of the type *zheng* (used in battle), the hemispherical cover of a *dui* vessel, and 3 lidded bowls of the type *zhan.* Stone weapons and tools had been placed inside 3 of the *yongzhong* and one of the bowls. Pit 3 contained only 6 objects: a *lei,* a tripod *ding* with an inscription of 25 Chinese characters, and inside the *ding,* 4 jade or stone tools.

The richness of the Moutuo tomb lies not so much in the sheer number of grave goods—though the number is indeed the highest yet encountered in a cist burial—

as in the presence of objects from faraway places. Their origins are so scattered that the mere fact of their accumulation must have signified power and wealth to other members of the owner's society. The deceased was probably a warrior of very high status. Like other tombs of the same period, both in Sichuan and in the Chinese world,[9] the Moutuo tomb contained many more weapons than the deceased himself needed for combat, and they were a very mixed assortment. While some belong to classic eastern Sichuan types (Fig. 86.1), others stand out for their rarity (Nos. 79, 81). They vary also in casting quality and in technique of manufacture. For a large number of the weapons, bells, and vessels, Lothar von Falkenhausen has suggested points of origin or noted affinities with objects made elsewhere.[10] Moutuo was the final destination of objects from many different regions:

- The two *lei* (Fig. 4h) and many of the weapons (Figs. 3a–b, 4f) are likely to have been made in the Sichuan Basin.

- The six *yongzhong* (Fig. 3f), which range in date from the eighth to the fifth century, were cast in the middle Yangzi region, as were a number of other items.

- At least three bronze vessels came from the state of Chu: the inscribed *ding,* which dates from the second quarter of the sixth century (Fig. 4g); the *dui* lid, from the beginning of the fifth century (Fig. 4d); and a *zhan* (lidded bowl) from the first half of the sixth century (Fig. 3e).

- *Zhan* like the one shown in Figure 4a were cast around the seventh or sixth century BC in central or southern Henan.[11]

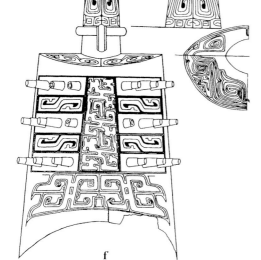

Fig. 3. Bronzes from Moutuo tomb 1 (not to the same scale). After *Wenwu* 1994.3, p. 18 figs. 26.2, 26.8; p. 36 figs. 55.8–9; p. 12 fig. 14.2; p. 14 fig. 21; p. 30 fig. 49.4.

 a–b. *Ge* blades. Ba-Shu culture, late fifth century BC?
 c–d. Bimetallic swords (iron and bronze). Late fifth century BC.
 e. *Zhan.* From Chu, first half sixth century BC.
 f. Bell of the type *yongzhong.* From the middle Yangzi region, about seventh century BC.
 g. Openwork ornament. Late fifth century BC.

9. For example the tomb of Marquis Yi of Zeng, at Suizhou Leigudun in Hubei, dating from 433 BC or shortly after, contained no fewer than 270 weapons and 4500 arrows or arrowheads. See Beijing 1989, pp. 252–352.

10. Falkenhausen 1996.

11. In the view of the present author, the *zhan* type was not confined to the Chu metallurgical tradition.

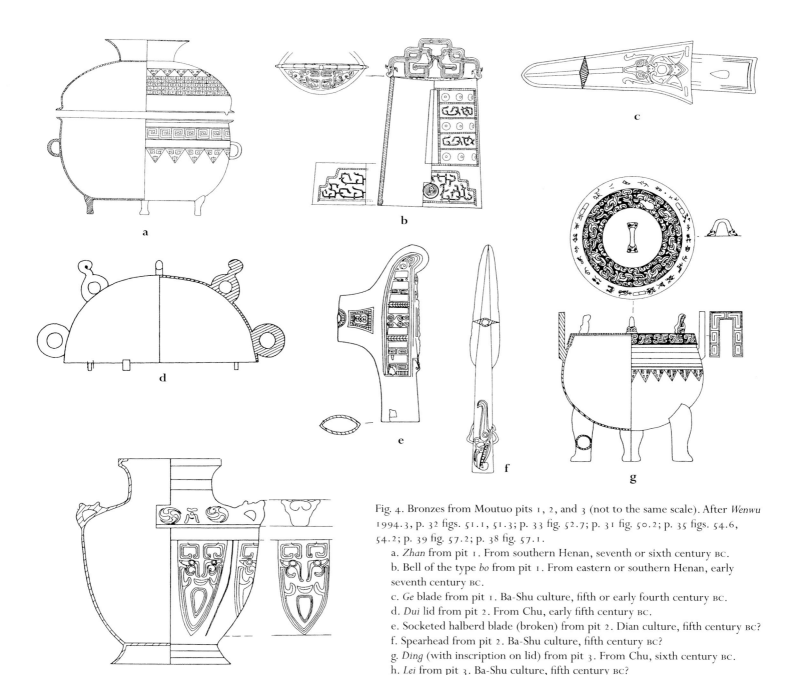

Fig. 4. Bronzes from Moutuo pits 1, 2, and 3 (not to the same scale). After *Wenwu* 1994.3, p. 32 figs. 51.1, 51.3; p. 33 fig. 52.7; p. 31 fig. 50.2; p. 35 figs. 54.6, 54.2; p. 39 fig. 57.2; p. 38 fig. 57.1.

a. *Zhan* from pit 1. From southern Henan, seventh or sixth century BC.
b. Bell of the type *bo* from pit 1. From eastern or southern Henan, early seventh century BC.
c. *Ge* blade from pit 1. Ba-Shu culture, fifth or early fourth century BC.
d. *Dui* lid from pit 2. From Chu, early fifth century BC.
e. Socketed halberd blade (broken) from pit 2. Dian culture, fifth century BC?
f. Spearhead from pit 2. Ba-Shu culture, fifth century BC?
g. *Ding* (with inscription on lid) from pit 3. From Chu, sixth century BC.
h. *Lei* from pit 3. Ba-Shu culture, fifth century BC?

- The *bo* of Figure 4b, which dates from the first half of the seventh century, was probably cast in the upper or middle Huai valley.[12]

- Two bimetallic short swords with spiralling grip (Figs. 3c–d) come either from western Sichuan or from the Dian culture of Yunnan. The halberd point of Figure 4e, to judge by its decoration, is probably from Dian.[13] A few Sichuan products that have affinities simultaneously with Dian and with the northern steppes (Fig. 3g) remind us that Sichuan was a way station between these two cultural zones.[14]

These varied imports differ in date and quality, perhaps because they reached Moutuo by different types of exchange. In the case of Chinese vessels and bells from the Chu kingdom or from Henan, Moutuo was probably only the chance final destination of objects that had passed through the hands of many intermediaries. The vessels

12. Falkenhausen (1996) assigns this type to a wider region, viz. the eastern part of the Zhou cultural sphere.

13. See also Huo Wei 1999.

14. As noted long ago by Pirazzoli (1974, pp. 134–5).

are often not of particularly high quality, and they may have entered the trade network that brought them to Moutuo for just that reason; their Moutuo owners were probably not in a position to demand or even to recognize the highest quality. The weapons, by contrast, are mostly very fine. No doubt in the eyes of the Moutuo elite, weapons mattered more than vessels, and having an abundant supply to choose from (the Sichuan Basin produced enormous quantities, and there were other sources too), they could insist on the best. The Moutuo culture itself could not produce weapons equal to the ones it imported; No. 81 and Figures 81.1–2 are probably typical of locally manufactured items.

The objects found at Moutuo range in date from about the ninth century to the fifth century BC. Some were centuries old by the time they were buried. Others, though manufactured relatively recently in Sichuan, were nevertheless descended from imports that had arrived centuries before: ancient types were sometimes adopted in Sichuan and preserved there with little change long after they had been forgotten in their places of origin. Metropolitan Western Zhou *lei* vessels, for instance, supplied the prototype for two-handled *lei* vessels decorated with whorls on the shoulder and triangles below. These seem to have been particularly prized in eastern Sichuan (Fig. 4h). Often included in burials,[15] they are also depicted on Ba-Shu seals (Fig. 11; No. 84).[16] Many weapons characteristic of Sichuan likewise originated in Western Zhou Shaanxi (Figs. 86.1–2).[17] For some of the Moutuo halberd (*ji*) and dagger blades, Sichuan examples intermediate between the Shaanxi Western Zhou originals and their Moutuo descendants have been unearthed at the Zhuwajie site in Pengzhou.[18]

Moutuo seems to be one of the oldest sites of the cist culture. Despite the presence of objects with connections outside Sichuan, the finds have a strong local flavor: they include for example many stone tools of types that in eastern Sichuan would have been made of bronze. Similarly the pottery—varied and of good quality—was made locally, as were some of the weapons (No. 81). Pottery and other local products in perishable materials were probably traded outward by the same paths that brought imports to the owner of the Moutuo tomb.

Comparison with the Ba-Shu material culture of eastern Sichuan draws our attention to certain fourth and third century objects or features of objects that are not seen at Moutuo. Though socketed axes are very common in eastern Sichuan (No. 88), they are not present at Moutuo, nor is the classic Ba-Shu long sword (the tomb contained only daggers). Nor do any of the bronze weapons from Moutuo bear the Ba-Shu emblems characteristic of eastern Sichuan, where widely scattered sites yield examples of the same marks and seals. The absence of the emblems is particularly striking when the Moutuo and Ba-Shu weapons have the same decoration (compare Figures 4c and 5a, 4f and 5b). Finally, the Moutuo weapons show no trace of the two-colored or speckled surfaces of Ba-Shu weapons, even when the weapons themselves are related in type (compare Fig. 86.1 and No. 86).

The major question posed by the Moutuo find is how these differences should be accounted for. Do the differences between Moutuo and Ba-Shu artifacts represent differences of culture, or differences of date? Though not far apart, the Moutuo area and the Chengdu Plain clearly belonged to distinct cultural spheres: unlike Moutuo, Shu tombs have yielded scarcely anything connected with the steppe world or with

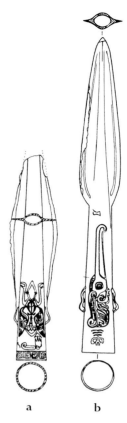

a **b**

Fig. 5. Bronze spearheads, Ba-Shu culture. About fourth century BC.
 a. From the Jingchuan Fandian tomb at Chengdu. After *Wenwu* 1989.2, p. 63 fig. 2.3.
 b. From Yingjing Tongxincun tomb 24. After Beijing 1998f, p. 247 fig. 52.4.

15. *Wenwu* 1981.6, p. 14 fig. 30, pl. 3.4 (the Majiaxiang tomb at Xindu); *Wenwu* 1989.5, p. 33 fig. 4.4, p. 35 fig. 13 (Sandongqiao Qingyangxiaoqu tomb 1 in Chengdu); *Kaogu* 1983.7, pp. 597–600 (two *lei* are mentioned, though not described or illustrated, in the report on the Zhongyi Xueyuan tomb in Chengdu).

16. Additional seals with depictions of *lei*: *Wenwu* 1985.5, p. 19 fig. 8; Beijing 1998f, p. 168 fig. 55.5.

17. Lu & Hu 1988, vol. 1, pp. 431–46.

18. Compare *Wenwu* 1994.3, p. 18 figs. 26.5–6 with Feng Hanji 1980, p. 38 fig. 1.6; *Wenwu* 1994.3, p. 35 fig. 54.5 with *Kaogu* 1981.6, p. 499 fig. 6.7. For the Zhuwajie site see Chapter 3.

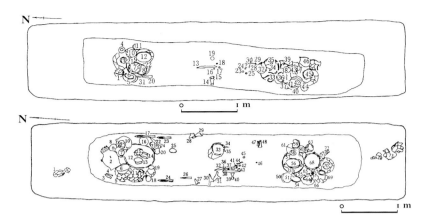

Fig. 6. Superposed boat-coffin tombs 21A and 21B at Yingjing Tongxincun. The coffin in 21A was 10 cm directly above the coffin in 21B. Late fourth or third century BC. After Beijing 1998f, p. 218 figs. 10–11.

Dian.[19] Nevertheless the differences do seem to be partly chronological. The presence of Chinese imports none of which can be dated later than the fifth century, and of Ba-Shu items lacking features typical of fourth and third century examples, would seem to be most naturally explained by dating the tomb somewhere in the neighborhood of 400 BC.

BOAT-COFFIN BURIALS

In western Sichuan the most characteristic burial form was the cist tomb. In eastern Sichuan the pre-imperial period saw the development of a burial form unique to that region, one that never spread elsewhere in China. This was the tomb in the form of a long narrow pit containing a coffin hewn from a log, its shape recalling a boat (Fig. 6). On rare occasions two or even three of these coffins were placed side by side or one atop another.[20] The pit generally has rounded corners, as does the coffin, which can be as much as nine meters long and a meter wide. The log was hollowed out for several meters of its length to make room for the deceased and, at head and foot, for the grave goods. A peculiarity of these coffins is that they were not provided with lids. No doubt the deceased was wrapped in matting or cloth, but apart from the very thick coffin itself, most of the perishable materials in the burials have disintegrated. The depth to which the coffin was hollowed out varies, the earliest examples (fifth century BC) being very shallow.[21] In the fourth century BC, the time when boat-coffin burials most flourished, the cavity was hewn much deeper and sloped upward toward the prow. In a few rich third century tombs in the north, an independent wooden box for the deceased was built inside the coffin at the prow end, attesting the influence of Qin burial practices.[22] One cemetery that contained several dozen boat-coffin burials contained also simpler burials that lacked coffins but that had shafts of similar proportions (length about four times the width).[23] From the same period other burials are known that take the form of a much wider and shorter rectangular pit; these sometimes contain a wooden coffin chamber (a *guo* or "outer coffin"). Burials of this last type testify to the gradual penetration of Chinese influence in the fourth and third centuries.

The grave goods in boat-coffin burials typically comprise vessels of pottery (more rarely bronze or even lacquer), tools (chisels, axes, knives, saws), sometimes objects of iron, sometimes one or more seals, and, in the case of a man, his weapons (Figs. 7–8). An average tomb contains 20 to 30 items, but departures from the average can be considerable. A notable instance is a tomb discovered in 1976 in Mianzhu county, which contained almost 150 objects, among them many ritual bronzes from Chu or the Zhongyuan.[24] The widely varying wealth of these burials, visible in the quantity of the grave goods and also in the presence or absence of a log coffin, presumably signifies a corresponding variation in the social status of the deceased.

The pottery items in boat-coffin burials are quite different from the pottery found in tombs of central and south central China: instead of small-scale models, or the pottery imitations of bronze vessels familiar from Chu and Qin tombs, they are small containers, probably made for daily use, put into the tomb filled with offerings (Figs. 7a–b):

19. A notable exception is a knife from Chengdu Baihuatan tomb 10 whose handle is decorated with a row of animals (*Wenwu* 1976.3, p. 41 figs. 2.3–4).

20. Pujiang Dongbei tomb 2 and Shifang Chengguan tomb 58 (coffins side by side in one pit); Yingjing Tongxincun tombs 21A and 21B (coffins exactly superposed, one 10 cm above the other; Fig. 6). See *Wenwu* 1985.5, pp. 17–22; Beijing 1998f, pp. 116–17; Beijing 1998f, pp. 217–18. One instance, apparently unique, of a three-coffin burial has been reported, Dayi Wulong tomb 4 (first half of the third century BC); see *Wenwu* 1985.5, pp. 29–40.

21. Types B and C at Shifang Chengguan. See Beijing 1998f, pp. 112–85.

22. Guangyuan Baolunyuan tombs 11–12, 14–15, 17. See Beijing 1960, pp. 14–16 figs. 8–11; Beijing 1998f, p. 199 fig. 6.

23. Beijing 1960; Beijing 1998f, pp. 117–18, 197, 214.

24. *Wenwu* 1987.10, pp. 22–33.

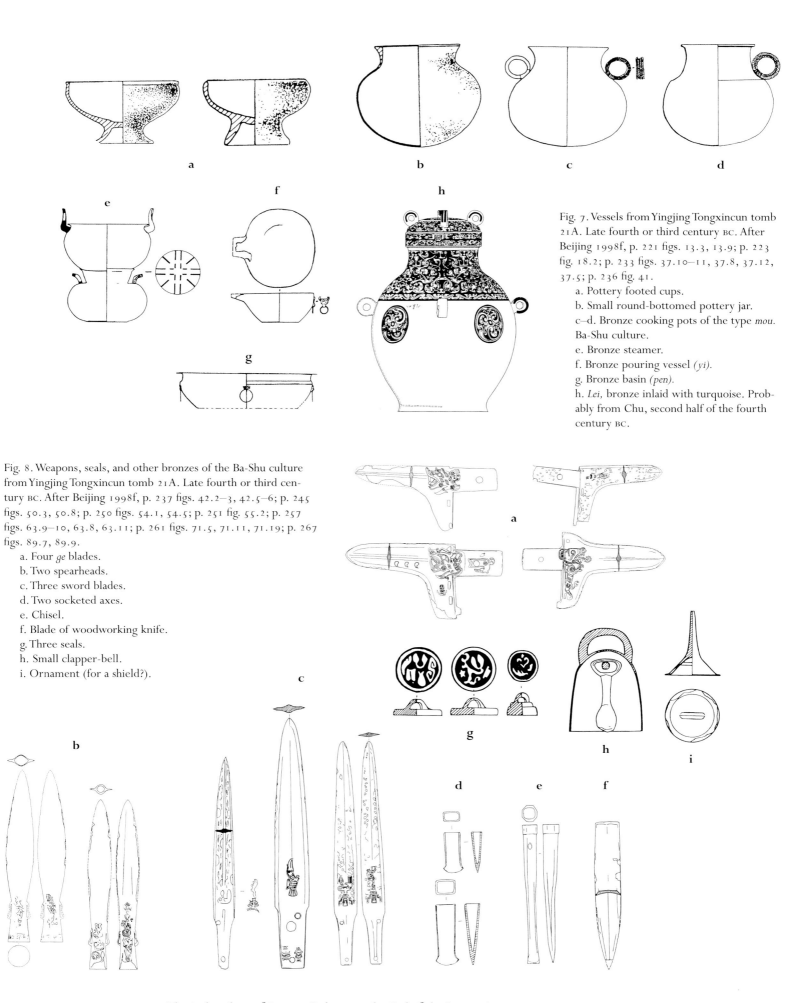

Fig. 7. Vessels from Yingjing Tongxincun tomb 21A. Late fourth or third century BC. After Beijing 1998f, p. 221 figs. 13.3, 13.9; p. 223 fig. 18.2; p. 233 figs. 37.10–11, 37.8, 37.12, 37.5; p. 236 fig. 41.

 a. Pottery footed cups.
 b. Small round-bottomed pottery jar.
 c–d. Bronze cooking pots of the type *mou.* Ba-Shu culture.
 e. Bronze steamer.
 f. Bronze pouring vessel *(yi).*
 g. Bronze basin *(pen).*
 h. *Lei,* bronze inlaid with turquoise. Probably from Chu, second half of the fourth century BC.

Fig. 8. Weapons, seals, and other bronzes of the Ba-Shu culture from Yingjing Tongxincun tomb 21A. Late fourth or third century BC. After Beijing 1998f, p. 237 figs. 42.2–3, 42.5–6; p. 245 figs. 50.3, 50.8; p. 250 figs. 54.1, 54.5; p. 251 fig. 55.2; p. 257 figs. 63.9–10, 63.8, 63.11; p. 261 figs. 71.5, 71.11, 71.19; p. 267 figs. 89.7, 89.9.

 a. Four *ge* blades.
 b. Two spearheads.
 c. Three sword blades.
 d. Two socketed axes.
 e. Chisel.
 f. Blade of woodworking knife.
 g. Three seals.
 h. Small clapper-bell.
 i. Ornament (for a shield?).

cups, footed stands, *mou* (a sort of jar-shaped cooking pot), and *fu* (a lower and wider cooking pot). Their walls are sometimes cord-marked. Some shapes existed also in bronze or iron, notably *fu* and *mou* (Fig. 7c–d).[25] Next to this limited range of types, bronze ritual vessels of Chinese origin or Chinese type stand out (Fig. 7h); the bronze casters of Sichuan seem to have made few vessels. In the manufacture of weapons, on the other hand, they achieved remarkable mastery. The decoration applied to weapons is notable both for inventive designs and for the sophisticated techniques sometimes used to execute designs in contrasting colors (Figs. 8a–c).

In the fourth and third centuries, weapons changed little in form or decoration. The inhabitants of eastern Sichuan seem to have clung tenaciously to their culture at just the time when the influence of Chu, and then from 316 BC colonization by Qin, were beginning to threaten it. To see the contrast between Ba-Shu and Qin culture we need only compare the cemetery at Guangyuan Baolunyuan with the one at Qingchuan Haojiaping.[26] Located in northern Sichuan, only about 50 km apart, they are roughly contemporary, belonging to the third century BC (*banliang* coins of the state of Qin have been found at both sites). The differences are striking. The Baolunyuan cemetery represents the local tradition, with log coffins and, among the grave goods, clay stemmed cups, socketed axes, bronze seals, and willow-leaf sword blades with Ba-Shu emblems. At Haojiaping, probably a cemetery of Qin immigrants, we find instead Chinese-style tombs—rectangular shaft burials usually containing an outer coffin (*guo*). Here the pottery includes tripods that copy ritual bronzes and long-necked *hu* with garlic-bud mouth. Other furnishings include mirrors, wooden figurines of people and horses, and above all an abundance of lacquerware (cylindrical cups, toilet boxes, cups with ear-shaped handles, and boxes for holding sets of such cups). No weapon has been found at Haojiaping.

Tombs discovered in Yingjing county confirm the southward advance of Qin colonization. Some follow the model native to eastern Sichuan (cemeteries at Tongxincun and Nanluobacun), others the model of third century Qin (a cemetery at Zengjiagou) (Fig. 9).[27] In burial practices and furnishings, a clear distinction seems to have existed between the Ba-Shu and Qin populations: their material culture shows no sign of real mixing. That Qin burial forms were untouched by local practice is confirmed by Qin burials a good thousand kilometers away, in the third century Qin cemetery at Yunmeng in Hubei province, where the same heavy timber construction was adopted, and where the grave goods feature the same lacquers with the same decoration.[28] Moreover Qin tombs everywhere show the same absence or near absence of weapons: laws probably forbade placing them in tombs, so as to save bronze for the more mundane purpose of equipping armies in this world.

THE MAJIAXIANG TOMB[29]

The furnishings of Sichuan tombs of the fifth, fourth, and third centuries include only a limited number of objects from the states of the Zhongyuan.[30] The pictorial *hu* from Chengdu Baihuatan (No. 73), for example, remains an isolated case of a Jin product unearthed in Sichuan, even though the Jin state's foundry at Houma had an enormous output. The Baihuatan *hu* establishes that bronzes cast in the central states did reach

25. See also Introduction Part 2, Figure 2.

26. Beijing 1998f, pp. 197–211; Beijing 1960; *Wenwu* 1982.1, pp. 28–30.

27. Beijing 1998f, pp. 212–80 (Tongxincun), *Kaogu xuebao* 1994.3, pp. 381–96 (Nanluobacun); *Kaogu* 1984.12, pp. 1072–84 (Zengjiagou), *Wenwu* 1989.5, pp. 21–30 (Zengjiagou tomb 21). See also *Wenwu ziliao congkan* 4 (1981), pp. 70–74 (Guchengping cemetery).

28. Beijing 1981a.

29. *Wenwu* 1981.6, pp. 1–16.

30. Song Zhimin's attempt to demonstrate the contrary is unconvincing, since most of the examples he adduces are from Qin rather than from the Zhongyuan states (Song Zhimin 1998b).

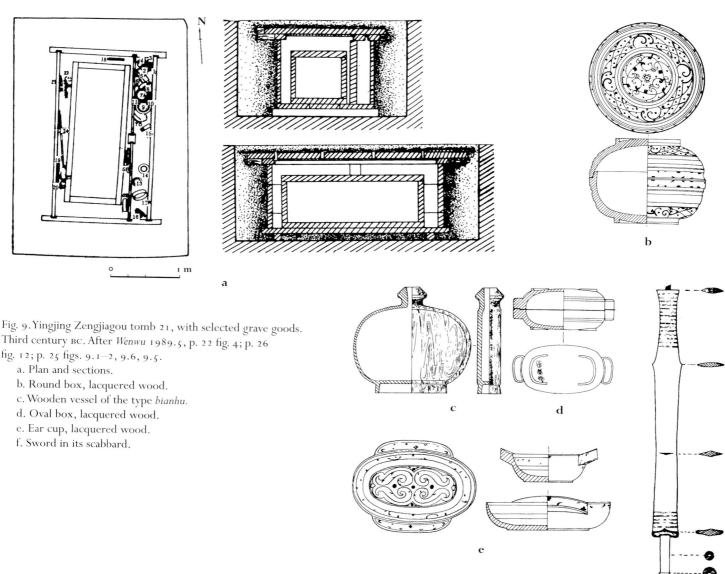

Fig. 9. Yingjing Zengjiagou tomb 21, with selected grave goods.
Third century BC. After *Wenwu* 1989.5, p. 22 fig. 4; p. 26
fig. 12; p. 25 figs. 9.1–2, 9.6, 9.5.
 a. Plan and sections.
 b. Round box, lacquered wood.
 c. Wooden vessel of the type *bianhu*.
 d. Oval box, lacquered wood.
 e. Ear cup, lacquered wood.
 f. Sword in its scabbard.

Sichuan—and there are several other examples to attest this—but their arrival had no particular impact on local production.

On the other hand, contact with the nearby kingdom of Chu had an unmistakable impact on the culture of eastern Sichuan. Although Ba was protected to a degree by natural defenses, and had redoubtable armies besides, Chu's expansiveness did at times bring the two into direct contact—sometimes hostile, sometimes peaceful.[31] To judge by the material evidence, this contact took a form different from Sichuan's relations with Qin: Chu coins have not been found in Sichuan, but Chu ritual vessels (and local copies) have been, the oldest Chu import being the inscribed *ding* from pit 3 at Moutuo (Fig. 4g). A few Chu vessel shapes, techniques, and a style characteristic of Chu workshops actually enjoyed a certain vogue in Sichuan. One notable Chu borrowing is a variety of *lei* or *hu* with four rings projecting from its sides and another four from its lid. The very fine example found in Tongxincun tomb 21 (Fig. 7h), inlaid with turquoise, must have been cast in one of the best Chu foundries of the second half of the fourth century.[32] Many other examples, some inlaid and some not, have been found in Sichuan, suggesting the existence there of workshops specialized in producing them.[33] The shape was also copied locally in pottery.[34]

31. Sage 1992, pp. 60ff.

32. Beijing 1998f, pp. 234–6.

33. *Wenwu* 1974.5, p. 63 fig. 2, pls. 2.1–2 (Fuling Xiaotianxi tomb 1); *Wenwu* 1987.10, pp. 22–33 (Mianzhu tomb 1); *Wenwu ziliao congkan* 3 (1980), p. 208 fig. 7 (isolated find from Jianyang county); *Kaogu* 1986.11, pp. 982–6 (Emei Fuxixiang tomb).

34. Beijing 1998f, p. 132 figs. 20.1–2 (cemetery at Shifang Chengguan), p. 228 figs. 25.5–6 (cemetery at Yingjing Tongxincun).

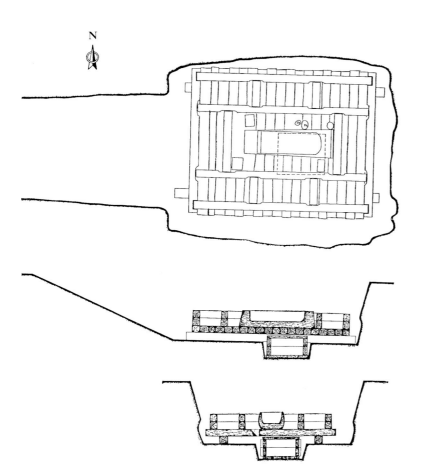

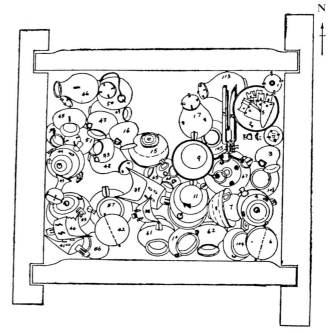

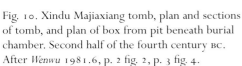

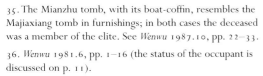

Fig. 10. Xindu Majiaxiang tomb, plan and sections of tomb, and plan of box from pit beneath burial chamber. Second half of the fourth century BC. After *Wenwu* 1981.6, p. 2 fig. 2, p. 3 fig. 4.

35. The Mianzhu tomb, with its boat-coffin, resembles the Majiaxiang tomb in furnishings; in both cases the deceased was a member of the elite. See *Wenwu* 1987.10, pp. 22–33.

36. *Wenwu* 1981.6, pp. 1–16 (the status of the occupant is discussed on p. 11).

37. Beijing 1986a, pp. 4–18; *Kaogu xuebao* 1982.1, pp. 72–81; Beijing 1991a, pp. 45–55. In one detail of construction the Majiaxiang tomb differs from the fourth century Chu examples: the access ramp is almost as wide as the side of the shaft it enters, and it leads not to the ceiling of the *guo* but all the way to the bottom of the shaft. This is probably a local modification of the fourth century Chu prototype (though similar ramps later occur in Chu as well, in third century tombs).

38. *Wenwu* 1981.6, pp. 1–16. Song Zhimin (1994, p. 245) gives the date as "middle Warring States."

The closeness of relations between Sichuan and the Chu kingdom is well illustrated by a tomb located at Xindu Majiaxiang, in the territory of the ancient Shu kingdom (Fig. 10).[35] It is the richest burial known from late Bronze Age Sichuan and undoubtedly belonged to a member of the highest aristocracy of the region, perhaps to a king of Shu, as the excavators have suggested.[36] Even though it had been looted long before excavation, enough remained in it to shed light on many aspects of Shu culture at a moment, probably, of growing ties with Chu. In structure the tomb reproduces the burial mode current in Chu around 350 BC. The compartmented outer coffin *(guo),* an enormous wooden structure measuring 8.3 by 6.76 m, was built at the bottom of an almost square shaft (10.45 by 9.2 m). On the west side a ramp more than 5 m wide gave access to the bottom of the shaft. The timber-built *guo* had a central compartment, within which a coffin containing the deceased was placed, and eight surrounding compartments, one at the head, one at the foot, and three on either side. As usual in Chu, the bottom of the *guo* rested on two beams laid on the floor of the shaft. Though looters almost completely emptied the *guo,* they overlooked a *yaokeng* ("waist-pit") beneath it. This pit contained a large timber-built box, about 1 m high and 2 m on a side, surrounded by a protective layer of green clay. In it 188 bronzes had been placed with some care, grouped by type.

Before examining the bronzes we should consider for a moment the structure of the tomb. In every feature except the *yaokeng,* it is modeled on the largest Chu tombs. The same plan and construction are seen in Henan province in tombs 1 and 2 at Xinyang Changtaiguan (about the second half of the fourth century), and in Hubei province in Tianxingguan tomb 1, near Jiangling (*c.* 340 BC), and Baoshan tomb 2, near Jingmen (*c.* 316 BC).[37] Despite a few concessions to local custom, there can be little doubt that it was Chu experts in tomb construction, or at least craftsmen trained in Chu, who built the Majiaxiang tomb. Though the tomb has generally been assigned to the first half of the fourth century,[38] this dating—which would make it earlier than the tombs at Tianxingguan, Changtaiguan, and Baoshan, indeed the earliest of its type

Fig. 11. Bronze seal from the Xindu Majiaxiang tomb (=No. 84). Fourth century BC. After *Wenwu* 1981.6, p. 4 fig. 6.

known anywhere in China—can hardly be correct. The tomb structure argues instead for a date between about 350 BC and the annexation of Shu by Qin in 316 BC, and the tomb contents lead to the same conclusion.

Two features of the tomb represent adaptation to local custom. The deposit of grave goods in a cache separate from the tomb chamber proper recalls pit 1 near the Moutuo tomb, and the two deposits are similar in inventory as well (vessels, weapons, tools, and bells).[39] Moreover the coffin placed in the central compartment of the Majiaxiang *guo* was hewn from a single log (1.41 m in diameter!) in the manner of the boat-coffins specific to Ba-Shu, reproducing even their proportions, length about four times the width. Unlike them, however, it seems originally to have had a cover (destroyed perhaps when the tomb was looted); and in Chu fashion its interior walls had been lacquered red (though the bottom is black), its exterior walls black with a few traces of gold.

Grave goods had been placed in the *guo* as well as in the *yaokeng* beneath, and although tomb robbers left very little in the *guo*, the few pieces they did overlook or abandon are precious indeed: two seals (tokens of power), belt hooks inlaid with gold and silver, lacquers, and a fragmentary crossbow mechanism. This weapon, still rare in the fourth century,[40] probably came from Qin. One of the seals (Fig. 11, No. 84) shows two figures clasping hands above a *lei* vessel, probably in symbol of alliance between two groups. Above them, flanked by two *zheng* (bells for military use), is what appears to be a suit of armor, an element that recurs in the emblem of the deceased found on almost a hundred objects from the tomb (including Nos. 85–8). The seal seems to be designed as a sort of rebus that designates its owner as the guarantor of the alliance or of the political entity which the alliance formed. The composition is typically Ba-Shu, though more elaborate than usual, but the style of the zoomorphic faces decorating the back of the seal comes instead from Chu. The seal as a whole might thus be taken to epitomize the cultural interpenetration of Shu and Chu.

The grave goods in the *yaokeng* are a mixture of bronzes typical of Ba-Shu culture and bronzes made in Chu or after Chu models (Fig. 12c–g). The Ba-Shu bronzes comprise some 60 finely made weapons (Nos. 85–9) and a few vessels, notably five *lei* that perpetuate a Western Zhou model (Fig. 12b). Of inferior quality, the *lei*

39. The arrangement at Majiaxiang also has a parallel of sorts in Yunnan, in Chuxiong Wanjiaba tomb 23, where the bottom of the tomb chamber rested on posts beneath which drums were found (*Kaogu xuebao* 1983.3, p. 352 fig. 5).

40. A few examples have however been unearthed in Sichuan. See in particular Beijing 1998f, p. 189 fig. 4.14 (Fuling Xiaotianxi tomb 9).

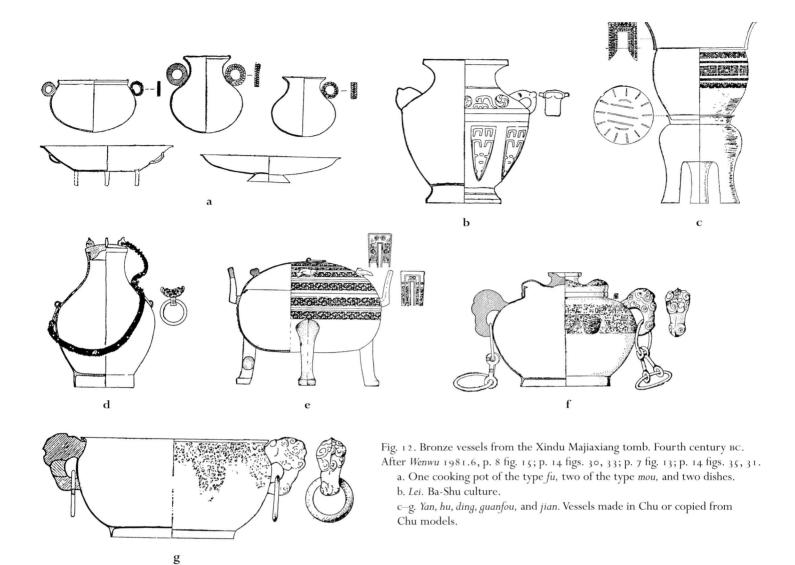

Fig. 12. Bronze vessels from the Xindu Majiaxiang tomb. Fourth century BC.
After *Wenwu* 1981.6, p. 8 fig. 15; p. 14 figs. 30, 33; p. 7 fig. 13; p. 14 figs. 35, 31.
 a. One cooking pot of the type *fu*, two of the type *mou*, and two dishes.
 b. *Lei*. Ba-Shu culture.
 c–g. *Yan, hu, ding, guanfou,* and *jian*. Vessels made in Chu or copied from
 Chu models.

were cast in two pieces, top and bottom, a procedure seldom encountered in ancient Chinese metallurgy.[41] Evidently Sichuan craftsmen found difficult the casting of vessels that elsewhere in China would have posed no problem. Rare items in the inventory are five swords that originated in the middle or lower Yangzi region (No. 90).[42] Bronzes from Chu, or copied from Chu models, are far more numerous, among them two *yan* for steaming food (Fig. 12c), a pair of *guanfou* (Fig. 12f), a pair of *jian* (Fig. 12g), five *hu* for grain wine (Fig. 12d), and five tripod *ding* (Fig. 12e). Beginning in the fourth century, vessels made in Chu for use as tomb furnishings underwent a sharp decline in quality: they have thin walls, often with holes in them, they have stereotyped decoration or no decoration at all, and they were not finished after casting. This complicates the problem of deciding the place of manufacture of vessels found in Sichuan tombs: low technical quality is not necessarily a sign of Sichuan manufacture. But wherever the vessels were made, most of them have Chu counterparts at Changtaiguan, at Baoshan (Fig. 13a), or among the latest tombs at Jiudian near Jiangling (Fig. 13b).[43] They are thus no earlier than 350 BC, and they may be imports. One of the five *ding*, a very fine casting, was made somewhat earlier than this, probably in Chu (it has an inscription of four characters in Chu-style script); the other four are crude imitations of the first, evidently cast locally to make up a set (Fig. 12e). The

41. Although two *fou* from Suizhou Leigudun tomb 1 (the tomb of Marquis Yi of Zeng) were cast in this way, there the unusual procedure was no doubt dictated by the enormous size and weight of the vessels (height around 1.25 m, weights 327.5 and 292 kg). See Beijing 1989, pp. 217–19.

42. Although Ba-Shu tombs in general are well furnished with *ge*, daggers, and spearheads, it is rare for them to contain even one of these swords. For one other instance contemporary with Majiaxiang see *Wenwu* 1982.1, pp. 28–30 (six *ge*, five daggers, four spearheads, and one sword).

43. Beijing 1991a, p. 103 fig. 60 (yan); Beijing 1986a, p. 49 fig. 33.3, pl. 40.1 (hu); Beijing 1995c, p. 208 fig. 140.12 (hu).

inscribed *ding*, like the *guanfou* from the tomb, recalls vessels cast by Chu workshops for Marquis Yi of Zeng around the middle of the fifth century (Figs. 13c–d).[44] Unlike the *guanfou*, however, the *ding* shape was used for the same purpose at Majiaxiang as in Chu and elsewhere in China, namely, holding offerings of meat (chicken, lamb, pork). The *guanfou*, a shape used elsewhere to hold water for ablutions, at Majiaxiang was filled with weapons and tools, in keeping with older Sichuan practices; so was the *jian*, a shape used elsewhere to hold water for warming or cooling wine.[45] Another practice specific to Sichuan is encountered at Majiaxiang: numerous items form matched sets of five or a multiple of five.

The presence in a single tomb of objects whose dates of manufacture range over many decades, even a century or more, is a recurrent phenomenon in Sichuan. This chronological spread is observed not only in imported objects but also in locally made weapons, which often seem to have remained above ground for a time before being deposited in a tomb. Perhaps the daily sight of treasured heirlooms acted as a brake on the evolution of weapon decoration, which long preserved motifs of Shang or Western Zhou origin. The numerous close affinities with Chu seen at Majiaxiang give similar testimony to the ability of the Ba-Shu culture (or at least of its elite) to absorb or adapt alien customs and material culture. This openness, seen also at other points in Sichuan's history, brought rewards but also had drawbacks. Under Qin colonization, followed by integration into the empire, the most original features of the cultures that had grown up over the centuries in Ba and Shu were soon eradicated.

a

b

Fig. 13. Bronze ritual vessels cast in Chu foundries.

a. *Yan*. From Hubei Jingmen Baoshan tomb 2, *c.* 350 BC (before 316 BC). After Beijing 1991a, vol. 1, p. 103 fig. 60.

b. *Hu*. From Hubei Jiangling Jiudian tomb 294, *c.* 350–300 BC. After Beijing 1995c, p. 208 fig. 140.1.

c. *Guanfou*. From Hubei Suizhou Leigudun tomb 1 (tomb of Marquis Yi of Zeng), *c.* 450–425 BC. After Beijing 1989, vol. 1, p. 239 fig. 136.

d. *Ding*. From Hubei Suizhou Leigudun tomb 1 (tomb of Marquis Yi of Zeng), *c.* 450–425 BC. After Beijing 1989, vol. 1, p. 195 fig. 97.

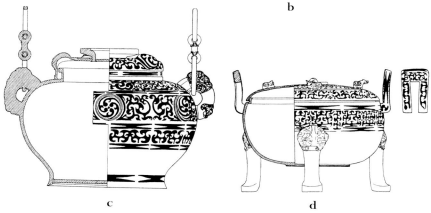

c

d

44. Beijing 1989, p. 195 fig. 97, p. 239 fig. 136.

45. Similar deposits also occur in isolation, unconnected with burials; see *Wenwu ziliao congkan* 3 (1980), pp. 207–9.

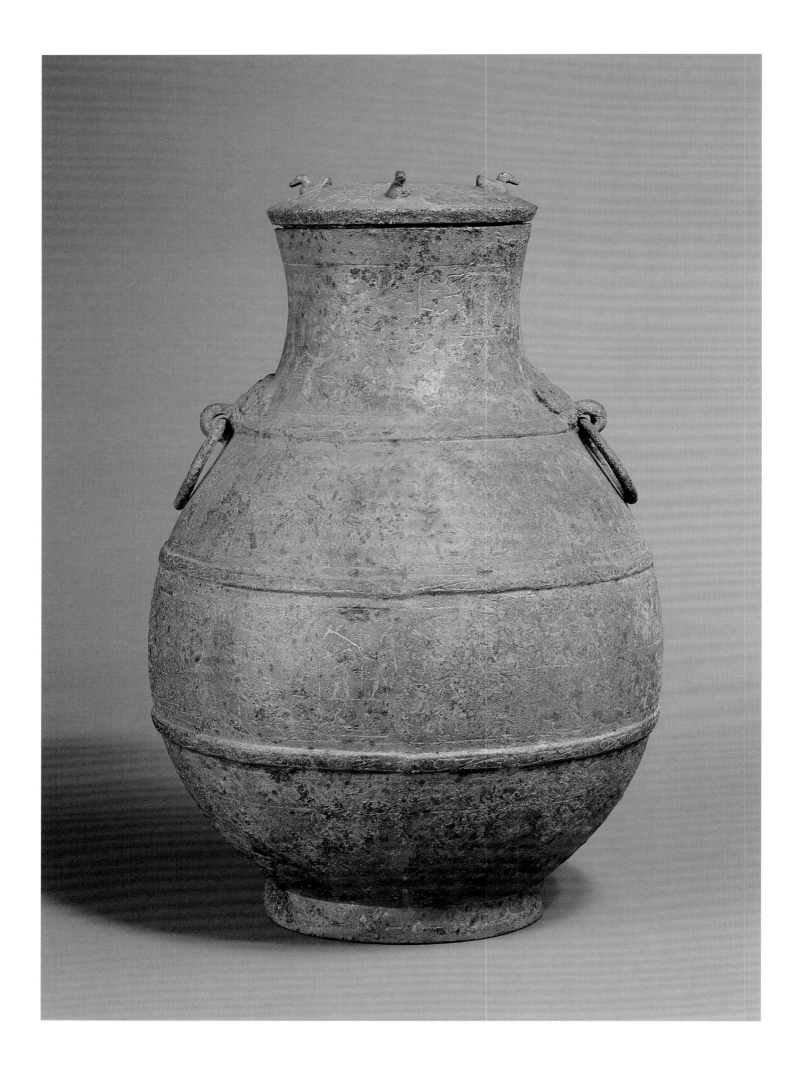

Hu *with pictorial decoration*

Inlaid bronze
Height 40 cm, diameter of mouth 13.4 cm
First half fifth century BC

Excavated in 1965 from tomb 10 at Chengdu
Baihuatan
Sichuan Provincial Museum 103386

PUBLISHED: *Wenwu* 1976.3, pl. 2; Fong 1980,
no. 91; Chengdu 1991, pl. 21; Beijing 1994a,
pls. 98–100.

This vessel has a swelling belly, an almost vertical
neck, and a small ring foot. It can be lifted by two
movable rings that pass through animal masks *(pushou)*
below the neck. Three small ducks in the round are
perched on the convex lid. Originally the vessel was
used to store grain wine, and it was discovered at the
foot of the deceased next to a food steamer of the
type *yan*. Instead of containing offerings, however,
both vessels held weapons and tools, 6 in the *hu* and
28 in the *yan*. This kind of reuse is common at Sichuan
sites and testifies to funerary practices distinct from
those followed by the elites of the various Zhou prin-
cipalities that in the Eastern Zhou period comprised
China.[1]

Nearly the entire surface of the object has been
used to present a decoration enriched with inlay.
Arranged in four registers separated by raised strips
bearing geometric motifs, the decoration is made
vivid by the color contrast of the inlay material, but
it nevertheless demands close inspection. Careful
examination allows us to distinguish an ensemble
of several different scenes, the ensemble as a whole
being reproduced twice on the vessel. The themes
illustrated are as follows (Fig. 73.1):

- In the uppermost register, on the neck, are two
 scenes, an archery tournament accompanied by
 the preparation of food, and a scene of women and
 children with baskets collecting something from
 trees, probably gathering leaves from mulberry
 trees. An alternative interpretation sometimes
 offered for the latter scene, as the selection of
 branches for bow-making,[2] does not account for
 the presence of baskets.

- In the middle register several different scenes are
 juxtaposed. Some are logically connected, others
 seem independent despite their interpenetration.
 On the left side of the drawing (Fig. 73.1) we see

Fig. 73.1. No. 73, drawing of decoration. After Fong 1980, p. 317.

1. Such finds are common in Sichuan (see No. 88) but not elsewhere.
A few substantially earlier (late second millennium) instances of
vessels buried full of small bronze axes are known from the middle
Yangzi region (Bagley 1987, p. 380 note 4). Conceivably the Sichuan
practice originated there.

2. So in Fong 1980, p. 316.

a two-storey pavilion in vertical section. In the lower storey musicians striking bells and chimestones alternate with players of panpipes, mouth organs, and a drum. In the upper storey a man seated on his heels on a low platform *(ta)* is being fanned and presented with food and cups of wine. To the right, outside the building, dancers holding spears perform a war dance. Further away, bowmen hunt wild geese using arrows to which cords are attached, a type of hunt described in ancient texts. Still further to the right we see another pavilion, this time with its lower storey partly hidden by a tent. Like the pavilion, the tent is shown in vertical cross section. Hunters in the tent are shown with the geese they have just killed at their feet. Archers in the upper storey of the pavilion shoot at a target outside. Perhaps the seated man receiving offerings in the pavilion at the far left is the victor of this archery contest, for a bow is depicted above his head.

- The long register below, at the vessel's greatest circumference, contains two scenes of warfare, an assault on a fort or fortified city and the clash of two ships in a naval battle.

- The lowest register is a narrow subordinate strip in which hunters attack wild beasts, some of which are fantastic hybrids. The animals reappear without the hunters on the lid of the vessel.

Despite a juxtaposition that at first glance seems random, if we leave aside the gathering of mulberry leaves, the scenes combined here have a certain coherence. The theme is activities of the aristocracy—the archery tournament and the festivities that follow it, the hunt, and war. The wild beasts in the lowest register and on the lid seem to evoke a hostile world that lies beyond the margins of human society, but they are an echo of the warfare within it.[3]

All the themes represented on the Baihuatan *hu* can be found on other bronzes scattered in museum and private collections and also on a small number of excavated pieces.[4] One, the scene of gathering mulberry leaves, is known from a fragment of foundry debris unearthed at Houma in Shanxi.[5] Differences from one vessel to another in the treatment of a given theme are minimal. What varies is only the choice of themes and their relative placement on the surface of the vessel; the arrangement of the figures, the buildings, and the pictorial conventions are about the same. It thus seems likely that the production of such bronzes was confined to one particular metallurgical center and to a short period of time.

In addition to the scene of gathering mulberry leaves, the shape of the Baihuatan *hu,* the arrangement of the decoration in horizontal registers separated by raised bands, the style of the *pushou* animal masks, and the three ducks on the lid are all features that can be connected with the Houma foundry on the evidence of the mold-making debris found there.[6] The technique used to execute the decoration is also that of the Houma craftsmen, who commonly made a mold in a few large sections and applied decoration to the interior of the sections in the form of clay negatives taken from pattern blocks.[7] This technique was best suited to casting regularly repeating designs of animal interlace; it required occasional trimming of pattern units to fit them to the spaces available on the vessel surface, and in pictorial designs this trimming could be conspicuous. At the left end of the uppermost register, for instance, we notice that the archers have no target to shoot at. The Houma foundry's practice of serial production partly accounts for the limited number of themes represented and for the stereotyped composition of each. But the technique did allow the craftsmen to rearrange the scenes at will or to suit the spaces available on a given vessel. Although patrons undoubtedly had the power to choose or suggest themes that pleased them, they do not seem to have made much use of it—this in itself is an indication that production was short-lived. It is tempting to date the end of this form of decoration, and more generally the end of the Houma foundry's most flourishing period,

3. Jacobson 1984, p. 77.

4. Weber 1968, groups VIII and IX; *Kaoguxue jikan* 5 (1987), pp. 177–8 figs. 27.7 and 29 (a *dou* unearthed in 1981 from Sanji Gucheng tomb 8101 in Hebei Pingshan).

5. Beijing 1993b, vol. 1, p. 203 fig. 102.7 and vol. 2, pl. 126.1.

6. Beijing 1993b, vol. 1, p. 258 fig. 144.1, p. 181 fig. 93.4, p. 265 figs. 148.1, 148.6–7; vol. 2, pls. 176.1, 189.1–2, 189.4.

7. Bagley 1993a, Bagley 1995, Bagley 1996.

to the time of the turmoil that precipitated the fall of the Jin state near the middle of the fifth century BC.

The introduction toward the end of the sixth century BC of pictorial decoration on bronzes was a major innovation in the artistic traditions of China. Figural scenes had never before appeared on bronzes, and they remained exceedingly rare in Zhou art. It would seem that these scenes drawn from aristocratic life first arose in the lower Yangzi region, today's Jiangsu and Zhejiang provinces, and they allow us to glimpse customs, architectural forms, and aspects of material life different from those of central China.[8] To depict such things, the craftsmen at first tried engraving the surface of the bronze with a fine stylus or needle, a technique previously unknown. Perhaps a little later, in the first half of the fifth century BC, craftsmen in the middle Yellow River region, probably at Houma, devised a way of executing the new decoration that depended instead on familiar casting techniques. They cast a bronze with the decoration in intaglio, then highlighted the decoration by filling the sunken parts with a colored material that has often been identified, probably wrongly, as metal.[9] It was this second technique that served to make the Baihuatan *hu,* whose decoration today stands out in creamy white and brown against the green surface of the bronze. Unearthed from a tomb in Chengdu, far from its place of manufacture, the vessel testifies to exchanges that took place across great distances and with steadily increasing frequency during the Warring States period. Despite its geographical situation at the fringe of the great principalities of the time, Sichuan was not excluded from this traffic.

8. Thote 1999, Thote 2000.

9. Barnard 1997, pp. 218–19; So & Bunker 1995, no. 12.

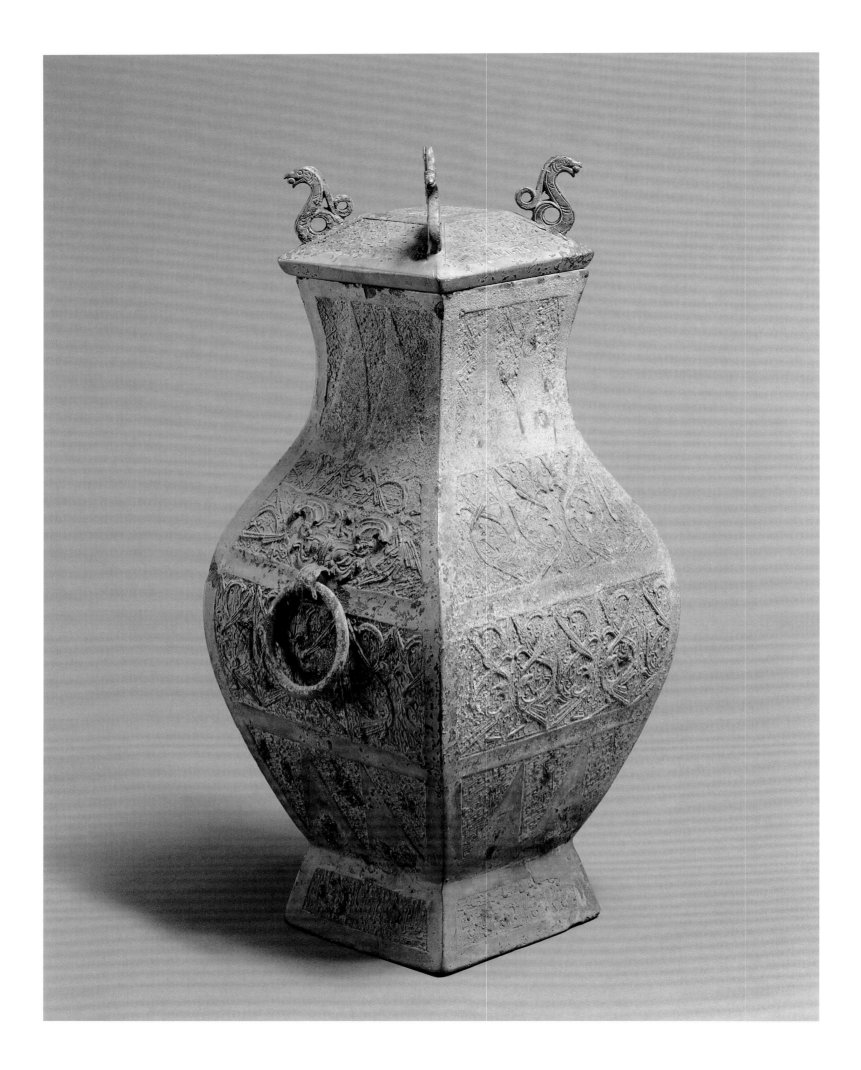

When they are perfectly square in cross section, with walls meeting at right angles, and provided with faceted lids, *fanghu* are sometimes referred to as *fang*. This type of vessel for grain wine has a few earlier antecedents, but it belongs primarily to the period after about 350 BC. Rings held by animal masks *(pushou)*, mainly decorative in function, often appear on two or four sides of the body. The lid of the present example, taking the form of a truncated pyramid, is adorned with four large stylized birds holding pearls in their beaks, a common motif in later periods. Looking as though cut from slabs, they recall jade jewelry found in tombs of the fourth and third centuries BC.[1]

Each side of the vessel is divided into rectangles, trapezoids, and triangles, the blank triangles contrasting effectively with the very sharp, almost chiselled relief ornament. In the main panels, on the belly and shoulder of the vessel, the pattern is formed from symmetrical pairs of birds. The tail and crest of each bird intertwine to form a large figure eight, the elegant play of curves being neatly inscribed within a vertical rectangle and set against a fine ground pattern. This way of transforming the bird motif, by giving it the character of a fluidly designed volute, was applied to the dragon as well, and characterizes artistic production from the fourth century onward. Lacquers, embroidered silk, and inlaid bronzes all moved in the same direction (Fig. 74.1). On the present vessel we see the same finesse of execution as in bronze mirrors of the fourth and third centuries, where the decoration gives the effect of several different designs superposed, like patterns embroidered on silk (Fig. 74.2).[2] It seems that the Changsha region, where such mirrors have been found in abundance in late Warring States tombs, specialized in their production and perhaps invented the style.[3] Precisely because objects like mirrors, circulating widely, could have made their characteristic decor widely available, the place of production of the present *fang* is difficult to determine.[4] Among the possibilities that deserve consideration, however, the kingdom of Chu is certainly one of the most attractive.

Several specimens very close to each other in style point to the probable existence of a third century workshop specialized in the production of such *fang*. Most, however, are unprovenanced items in collections; in only a few cases is the find context recorded, and the context is sometimes much later than the vessel itself.[5]

74

Fanghu

Bronze
Height 37.2 cm
Fourth or third century BC

Excavated in 1954 from tomb 88 at Chengdu Yangzishan
Sichuan Provincial Museum 14555

PUBLISHED: Chengdu 1991, pl. 19; Beijing 1994a, pls. 109–10.

1. Jia E 1993, no. 201 (Guweicun tomb 2, Henan Hui Xian), no. 241 (Qijicun tomb 1, Hebei Pingshan), no. 285 (Yanggong tomb 2, Anhui Changfeng).

2. Karlbeck (1964) has shown that the preparation of mirror molds in fact often involved impressions from a series of stamps.

3. Gao Zhixi 1991a, 1991b; Beijing 2000, vol. 1, pp. 232–78; vol. 2, color pls. 22–35.

4. The mirror from Yangzishan tomb 162 is probably a local copy of a mirror from southern or central China, whereas the one from tomb 172, no doubt cast in Changsha, must have been brought to Sichuan sometime in the third century BC. Compare Chengdu 1991, pl. 72, with *Kaogu xuebao* 1956.4, p. 14 fig. 17.

5. Hejiayuan tomb 1, in Anhui Wuhu, first century BC (*Kaogu xuebao* 1983.3, p. 385 fig. 2.1, pl. 17.3).

Fig. 74.1. Detail of the painted decoration of a lacquer box from Baoshan tomb 2 at Jingmen, near Hubei Jiangling. Diameter 27 cm. About third quarter of the fourth century BC (before 316 BC). After Beijing 1991a, vol. 1, p. 145 fig. 89B.

Fig. 74.2. Rubbing of a Changsha mirror. Fourth or third century BC. After Li Xueqin 1985, p. 303 fig. 130.

75

Fanghu

Inlaid bronze
Height 54.5 cm
Late fourth or early third century BC

Unearthed in 1950 at Xinjin
Sichuan Provincial Museum 3019

PUBLISHED: Chengdu 1991, pl. 20; Beijing
1994a, pl. 108.

Like No. 74, this vessel was made to hold grain wine. The four flattish birds on its faceted lid, their bodies turned into rings, look as though perched on a roof. The inlaid decoration of the vessel recalls immediately the art of Chu, in particular the abstract forms that were developed there starting from zoomorphic motifs.[1] Still discernible heads formed of volutes and centered on round eyes belong to dragons whose shape and other attributes have become almost unrecognizable through repeated reworking. The diagonal grid struc-ture of the pattern is one of the great innovations in fourth century decoration, seen as much in the Zhongyuan states as in the kingdom of Chu. It is a composition to which the *fang* and *fanghu* lend themselves particularly well. The first accomplished examples can be dated in the second half of the fourth century, among them notably the *Chen Zhang fanghu*, a vessel whose inscription, incised sometime after the vessel was cast, refers to an event of 314 BC,[2] and a *fanghu* from the tomb of King Cuo of Zhongshan, who died in 313 BC.[3] These early examples already show the composition executed in a variety of inlay tech-niques, and the designs soon increased in dynamism, inspired by ideas of optical play.[4] On the present vessel, for instance, instead of running parallel, the diagonal lines contain offsets that produce a kind of zigzag, and the dragons' limbs are set at right angles so as to create a second network of finer lines intersecting diagonally. These ingenious designs are known in lacquer as well as in inlaid bronze. At first glance we take in the pattern as a whole, then the dragons' eyes catch our attention, and pursuing one or another of the in-tricate curves, eventually we find the very abstract creatures hidden within the maze of lines (birds as well as dragons in Fig. 75.1). Depending on the color we focus on, that of the bronze or that of the inlays, two different, complementary designs can be seen. It is the alternation between the two that gives the effect of life to this largely abstract decoration.

While it is Chu art that this *hu* first brings to mind, several vessels and other objects with inlaid decor of the same style have been found in Sichuan.[5] Whether imports or local imitations, they testify to growing traffic with Chu during the fourth and third centuries.[6]

1. Beijing 1996c, p. 135 fig. 91 (Wangshan tomb 1); Beijing 1991a, p. 190 fig. 120A (Baoshan tomb 2).

2. Illustrated in So 1995, p. 59 fig. 99.

3. Beijing 1995e, vol. 1, p. 122 fig. 40B.

4. Thote 1996a.

5. Beijing 1994a, pls. 103–5, 107 (from Fuling Xiaotianxi tomb 1 and Ba Xian Guangyangba); Beijing 1998f, p. 236 fig. 41 (a *lei* from Yingjing Tongxincun tomb 21-A).

6. The inscription inside the foot of the present vessel very oddly combines a graph of Shang type in a *yaxing* frame with two abstract elements recalling certain Ba-Shu signs. Barnard (1997, pp. 238, 240), while noting the Chu appearance of the decoration, describes the inscription as cast with the vessel and takes it to confirm local manufacture. However, since no similar combination of Shang and Ba-Shu elements is known anywhere in the published corpus of Ba-Shu in-scriptions, and since Ba-Shu inscriptions on vessels normally were engraved after casting on the vessel's exterior, it seems at least possible that the inscription of No. 75 is a forgery added sometime after the vessel was unearthed.

Fig. 75.1. Lacquer-painted decoration of a leather shield from Baoshan tomb 2 at Jingmen, near Hubei Jiangling. Height 46.8 cm. About third quarter of the fourth century BC (before 316 BC). After Beijing 1991a, vol. 1, p. 215 fig. 138.1.

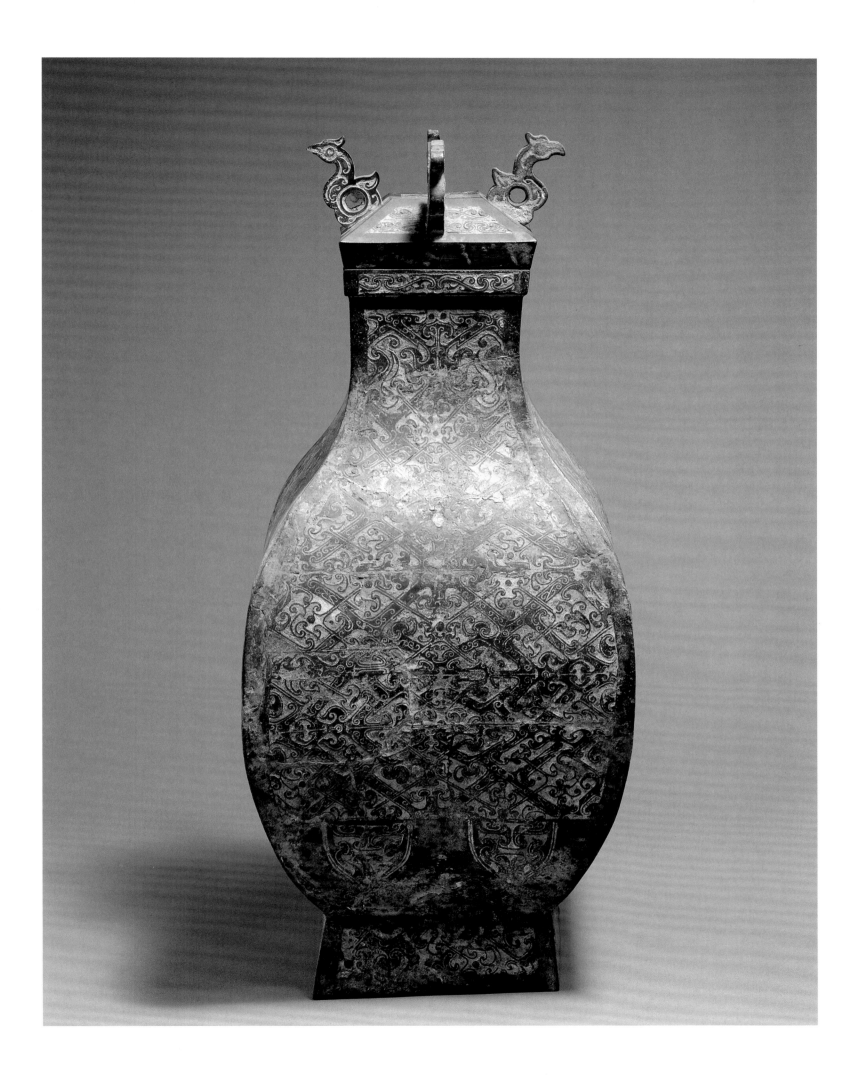

76

Chime of fourteen niuzhong

Bronze with gold inlay
Height of largest bell 27.5 cm, height of smallest
bell 14.6 cm
Fourth century BC

Excavated in 1972 from tomb 1 at Fuling
Xiaotianxi
Sichuan Provincial Museum

PUBLISHED: *Wenwu* 1974.5, p. 63, pls. 1, 2.4;
Wenwu 1974.12, p. 62; Fong 1980, nos. 77–90;
Hiroshima 1985, no. 40; Hayashi 1988, p. 91
fig. 64, p. 144; Falkenhausen 1988, pp. 461–2,
pl. 118; Falkenhausen 1989a, pp. 74–5, fig. 21;
Falkenhausen 1993, p. 188 fig. 97; Chengdu 1991,
pls. 16–18; Beijing 1994a, pls. 194–5.

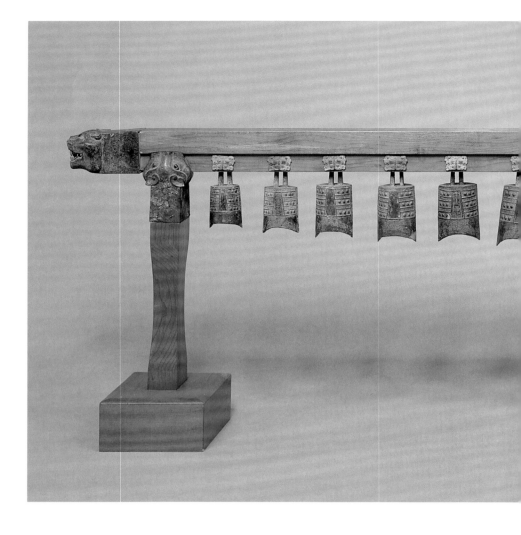

1. Beijing 1986a, pp. 21–9, pls.
6–12. There are also significant
similarities to the idiosyncratic
bells from Hubei Jiangling Tian-
xingguan (*Kaogu xuebao* 1982.1,
p. 96 fig. 19, pls. 19.9, 20.1)
and the equally idiosyncratic
Jing zhong from Hubei Zhijiang
Xinhua (*Wenwu* 1974.6, p. 86;
Wenwu 1980.10, pl. 3.4). For
detailed discussion see Falken-
hausen 1988, pp. 459–61.

Within the Zhou culture area, bell chimes formed part of musical ensembles that performed during ancestral rituals and state banquets. Together with the ritual vessels, they constituted the most prestigious possessions of aristocratic lineages. *Niuzhong,* characterized by their inverted-U-shaped suspension devices, are one of several types of chime-bell in use during the first millennium BC. This set of fourteen is the largest continuous chime of *niuzhong* known, as well as the most elaborately decorated. Areas of agitated relieved decor, now covered with green patina but originally dark and shiny, contrast with flat areas inlaid with golden lines. These stand out from the dark red polished bronze surface, to dazzling effect. On bells from pre-imperial China such decorative metal inlay is otherwise unknown.

Produced by the pattern-block technique, the relieved decoration covers the center of the striking area *(gu),* most of the upper two-thirds of the bell face, and the flat top *(wu).* It consists of curved hooks and curls with jagged raised ends, all covered by fine spirals. Disconnected body parts such as beaks, eyes, eyebrows, and feathers bespeak its derivation from zoomorphic motifs. The inlaid decor is much calmer and entirely abstract. Its elegant scrolls are distributed over the lateral portions of the striking area, the trapezoidal central panel above, and the loop.

The bells were found along with the pegs that held them in slots in a wooden bell rack. Each peg is adorned with a relieved animal face. The present rack is a reconstruction, but its ornamental bronze fittings, featuring sculptural animal faces, are original.

The first and largest bell of the chime differs from the others in its proportions and appears to lack inlay. It may have been taken from another chime to enlarge a chime that originally had thirteen bells or to replace a lost bell. Archaeological discoveries suggest that ad hoc combinations of bells from different chimes were common.

The layout and relieved decor of these bells are virtually identical to those seen on some mid-fourth century bells from the Chu kingdom, especially the *Jingli niuzhong* excavated from tomb 1 at Henan Xinyang Changtaiguan.[1] The metal inlay patterns are also similar to those of Warring States Chu bronzes. There is therefore little doubt that the chime was

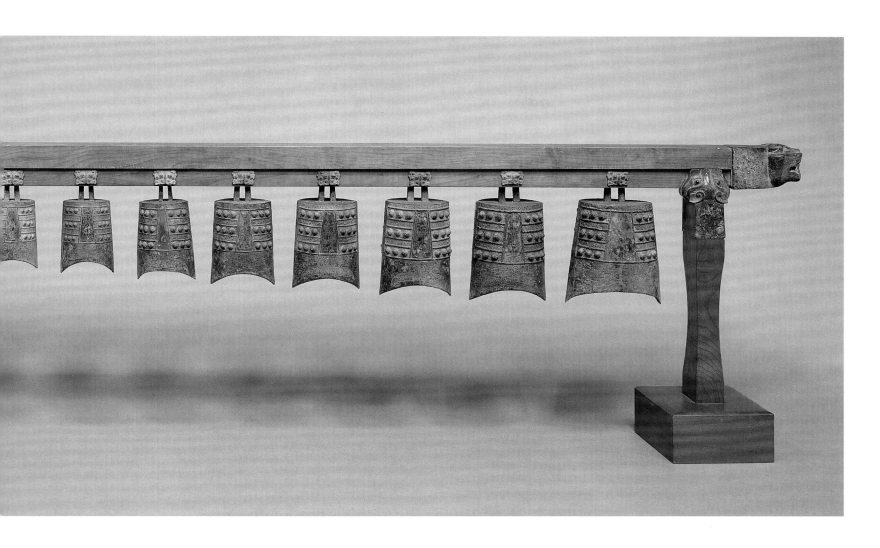

manufactured at a Chu workshop. It may have been a diplomatic gift from the Chu king to a ruler of Ba,[2] and if so must have arrived in the Sichuan Basin before the Qin conquest in 316 BC.

Sets of bells were made in China from the mid-second millennium BC onward. Sometime shortly after 1000 BC, it was discovered that bells of almond-shaped (pointed-oval) cross section could emit two tones, depending on whether they were struck in the center or on the right or left side. In time, bell casters learned to design bells with specific intervals between the two tones, thus maximizing the number of notes playable on a chime. The pinnacle of this development is the famous 65-bell assemblage of Marquis Yi of Zeng (d. after 433 BC) from Hubei Suizhou Leigudun.[3] By the fourth century, however, chime-bell manufacture seems to have entered a decline. The large *yongzhong* and *bo* bells in use since the ninth century became rare and the few bell-chimes still made consisted of the comparatively small *niuzhong*. Moreover, the published tone measurements from the *Jingli niuzhong* yield a coherent scale (six tones per octave over a two-octave range) only for the

tones obtained by striking the bells in the center, suggesting that the "two-tone phenomenon" was no longer exploited. This may indicate either a decline in workmanship or a decision to concentrate on only one tone per bell in order to improve tuning. Since several of the *niuzhong* from Xiaotianxi were found broken, they cannot be acoustically tested. Perhaps their tone distribution was similar to that of the *Jingli niuzhong*. The degree of similarity might be estimated by comparing the size ratios among successive bells in the two chimes, but unfortunately the requisite dimensional measurements are not available for the *niuzhong* from Xiaotianxi.[4] If indeed they were acoustically similar to the *Jingli niuzhong*, the contrast between their relative lack of acoustic sophistication and the splendor of their decoration might be seen as suggestive of the Warring States period reorientation of ritual from musically underscored performance to visual display.

LOTHAR VON FALKENHAUSEN

2. On the Chu custom of presenting bells to allied rulers see Falkenhausen 1991. On Chu-Ba relations as manifested in the Xiaotianxi finds see *Sichuan wenwu* 1991.2, pp. 3–9.

3. Beijing 1989; on the bells see Falkenhausen 1993, Bagley 2000.

4. For the *Jingli niuzhong*, the relevant figures may be found in Falkenhausen & Rossing 1995, p. 477 tables 35 and 36.

Handbell (zheng)

Bronze
Height 42 cm
Found in 1951 in Guanghan county (exact site unclear)
Probably third century BC
Sichuan Provincial Museum 2828

PUBLISHED: Chengdu 1991, pl. 11; Beijing 1994a, pls. 188–9.

Unlike chime-bells, *zheng* were not used in musical performances. Texts and inscriptions record instead that they were used for signal-giving in warfare.[1] They were struck with a mallet, like chime-bells, but their resonating bodies are longer than those of most known chime-bells, and they are almost round in cross section, making it impossible to obtain more than one tone. On the present specimen, the shape of the octagonal columnar handle makes it obvious that the bell was made to be handheld; it could not easily have been mounted on a stand or rack. The top of the handle features a whorl-shaped ornament.

The resonating body is unornamented except for a configuration of so-called Ba-Shu characters prominently displayed on the front. The configuration consists of a leftward-strutting tiger with its tongue outstretched; above it, two symmetrical bent elements framing a group of three circles linked by straight lines (in later China a convention for drawing astronomical constellations) and a four-petalled flower; and, near the tiger's long curled tail, a rectangle enclosing a rhomboid. The significance of this design is unknown; it may have denoted some aspect of the owner's identity, rank, or lineage. An analogously placed inscription on a very similar *zheng* from tomb 2 at Xiaotianxi (Fig. 77.1) shows a different configuration that includes two versions of a graph resembling the Chinese character for *wang* (king).[2] A similar *zheng* from tomb 1,[3] the tomb that yielded the splendid *niuzhong* chime (No. 76), is uninscribed.

LOTHAR VON FALKENHAUSEN

1. Falkenhausen 1989b; Falkenhausen 1988, pp. 536–55.

2. *Wenwu* 1974.5, p. 64, p. 71 fig. 7 (left); Chengdu 1991, pl. 30; Beijing 1994a, pl. 187.

3. *Wenwu* 1974.5, p. 64, p. 71 fig. 7 (left); Chengdu 1991, pl. 31. Other specimens of this type found in Sichuan include three from an undetermined site in Xinjin (Hayashi 1988, p. 203 fig. 24). Specimens found elsewhere are listed and discussed in Falkenhausen 1988, pp. 545–6.

Fig. 77.1. *Zheng* from Xiaotianxi tomb 2. Height 29 cm. Fourth or third century BC.

78

Large bell (chunyu)

Bronze
Height 47 cm
Third century BC

Excavated in 1972 from tomb 2 at Fuling
Xiaotianxi[1]
Sichuan Provincial Museum 108206

PUBLISHED: *Wenwu* 1974.5, pp. 64–5, 73,
fig. 21; *Wenwu* 1974.5, pp. 81–3; Beijing 1994a,
pls. 184–5; Chengdu 1991, pl. 11.

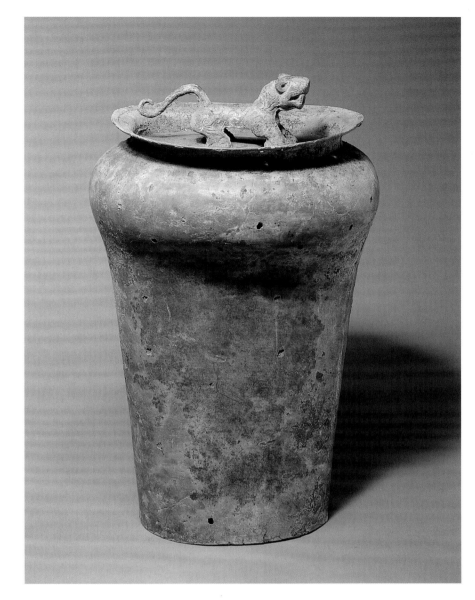

Like *zheng, chunyu* were used for signal-giving in
warfare.[2] With their thin walls, sinuous profile, and
oval-rectangular cross section, they stand apart from
all other ancient Chinese bells. They were suspended
by means of a loop on the top and struck with a
mallet; on some specimens, though not this one, the
striking point is marked in the center of the body.
On this *chunyu,* the top platform is surrounded by an
everted collar of uncertain function, and the suspen-
sion loop takes the form of a tiger with long curved
tail. Apart from the pattern on the tiger, the bell is
undecorated. This *chunyu* is one of the largest and
earliest known specimens of a type widespread in
the middle and upper Yangzi and adjacent areas from
the third century BC to at least the second century
AD.[3] Unlike some other specimens of the same type,
it does not seem to have an inscription in "Ba-Shu
characters." Some scholars regard the tiger as a
symbol of the ancient Ba people.[4]

Tomb 2 at Xiaotianxi yielded a tiger-handled
chunyu, a *zheng,* and a small handbell decorated in
imitation of *yongzhong* (Fig. 78.1).[5] Identical combi-
nations of signalling bells have been found in several
late Warring States period contexts in the southwest
of China.[6] Always associated with weapons, they may
have symbolically underscored the tomb occupants'
martial prowess.

LOTHAR VON FALKENHAUSEN

Fig. 78.1. *Yongzhong*-like bell
from Xiaotianxi tomb 2.
Height 34.5 cm. Fourth or
third century BC. Drawing by
Luo Zeyun after Chengdu
1991, pl. 32.

1. The caption to pl. 15 in Chengdu 1991 says that this *chunyu* is
unprovenanced, and a different bell (pl. 22) is identified as the one
excavated from tomb 2 at Xiaotianxi. I assume that the captions for
pls. 15 and 22 were accidentally reversed.

2. See Falkenhausen 1988, pp. 516–35; Falkenhausen 1989b.

3. Twelve similar pieces found in Sichuan are carefully discussed
(with tone measurements) in *Sichuan wenwu* 1996.2, pp. 43–8 and
inside front cover; an additional specimen was found at Pengshan
Tonglexiang (Beijing 1994a, pl. 186); another one, also presumably
from Sichuan, is published in Chengdu 1991, pl. 22 (erroneously
captioned as the *chunyu* from Xiaotianxi). For finds from Hunan see
Kaogu yu wenwu 1981.4, pp. 36–42. Their typological lineage is
discussed there and in Falkenhausen 1989b; *Wenwu yanjiu* 5 (1989),
pp. 135–44; *Sichuan wenwu* 1994.2, pp. 20–24.

4. *Wenwu* 1974.5, pp. 81–3; *Sichuan wenwu* 1994.2, pp. 20–24.

5. Hayashi (1988) and Falkenhausen (1988) include such items
under the *zheng* rubric. For a comprehensive discussion see *Sichuan
wenwu* 1994.2, pp. 25–8.

6. E.g. at Hunan Xupu Dajiangkou (*Hunan kaogu jikan* 1 [1981],
pp. 37–8; discussed by Xiong Chuanxin in *Wenwu ziliao congkan* 7
[1983], pp. 30–33) and Guizhou Songtao Mushuxiang (*Wenwu*
1984.8, pp. 67–8).

Ge *blade from a halberd* (ji)

Bronze
Length 27.5 cm
Fifth century BC

Excavated in 1992 from tomb 1 at Mao Xian
Moutuo
Museum of the Qiang Nationality, Mao Xian, 1991
PUBLISHED: *Wenwu* 1994.3, p. 18 fig. 26.1.

Fig. 79.1. Halberd *(ji),* bronze and wood, from Mao Xian Moutuo tomb 1. About fifth century BC. After *Wenwu* 1994.3, p. 20 fig. 29.2.

Reminding us of the value or prestige that the warrior attached to his equipment, Sichuan tombs have yielded a great many weapons, but ordinarily it is only the metal parts of these, mostly bronze, which survive: the blades of dagger-axes (ge) and halberds *(ji),* dagger and sword blades, spear points, helmets (these are rare), and occasional crossbow mechanisms. Scant trace remains of parts that were made of lacquered wood or leather, not to mention objects made entirely of perishable materials, such as bows, whose existence is nonetheless attested by finds of arrowheads, and suits of armor, which are depicted in a few Ba and Shu emblems (see Nos. 84–5).

Straight and almost perfectly symmetrical about its median axis, this blade has two sharp edges and ends in a rounded tip. It was designed for mounting at right angles to a wood or bamboo shaft. The rectangular tang would be inserted through a slot in the shaft; the crosspiece adjacent to the tang would then rest against the shaft, the openings next to it allowing the blade to be firmly lashed in place. The blade probably formed part of a halberd of the type called *ji,* which carried one or several blades and a pike at the tip of the shaft. Three examples found in tomb 1 still had the blades mounted in their shafts (Fig. 79.1). Unlike other weapons in the tomb, however, the present blade may never have been mounted, for one of the openings next to the crosspiece is not pierced, probably a defect of casting.

The special interest of the piece lies in its decoration, which is perfectly adapted to the shape of the blade. We see on each side a bird with a sharp beak, a long neck, and a disproportionately long wing that extends almost the full length of the median crest. The bird is not really an identifiable species. The beak recalls a cormorant—it has a pouch—but the short legs and claws suggest a bird of prey; no further clue is supplied by the finely stylized plumage and the bulging eye. With the blade oriented horizontally, as it would have been mounted, we have the impression that the bird is represented in flight.

The motif and its composition are both unusual. Apart from a dagger blade found in the same tomb, on which a similar but more schematized bird's head is depicted, it does not appear on other bronzes from Moutuo.[1] It appears again, but with a small wing, on the tip of a spear found in a Chengdu tomb dated no more precisely than "Warring States."[2] As a type, this blade is rarer than unsymmetrical *ge* blades with lower cutting edge extended downward in a long arc parallel to the shaft. It belongs to a lineage of straight blades without downward elongation which probably originated in Shaanxi and came to Sichuan from there. Parallels between blades from the Pengzhou Zhuwajie hoards in Sichuan[3] and blades from the tombs of the lords of Yu at Baoji in Shaanxi illustrate the connection.[4] All these blades, of much the same type, are decorated with the very schematic head of a bird(?) narrowing to a point that forms the median crest of the blade. In Sichuan the motif seems to develop in a comparatively naturalistic direction, as do many other motifs on Ba-Shu weapons.

1. *Wenwu* 1994.3, p. 36 fig. 55.2.

2. Chengdu 1991, no. 145.

3. For the Pengzhou (formerly Peng Xian) Zhuwajie hoards see Chapter 3.

4. For Baoji see Lu & Hu 1988, vol. 1, p. 116 fig. 93.1, p. 162 fig. 125.4, p. 223 figs. 162.2–3 (see also pp. 431–46, where these links are studied in detail); for Zhuwajie, *Wenwu* 1961.11, p. 29 fig. 1.7, and *Kaogu* 1981.6, p. 499 figs. 6.5–6.

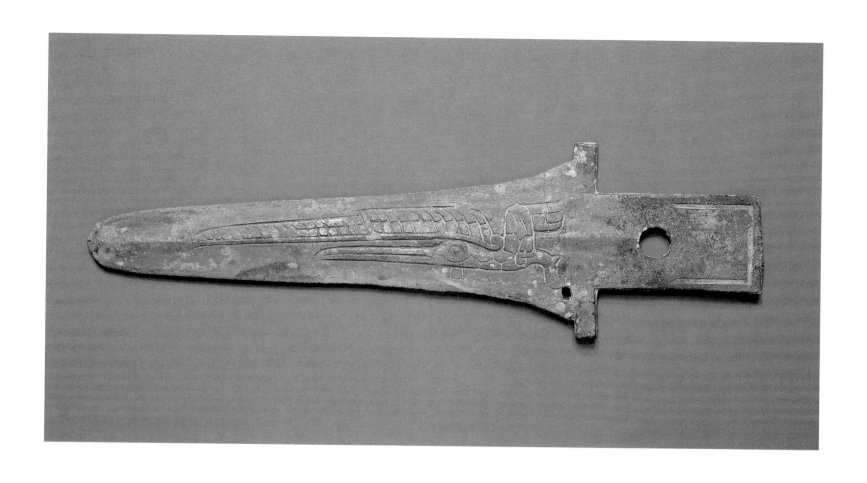

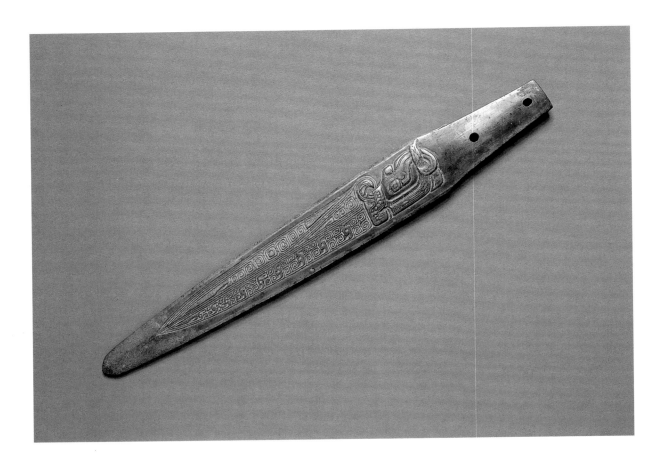

80

Dagger blade

Bronze
Length 25.5 cm
Fifth century BC

Excavated in 1992 from pit 2 at Mao Xian Moutuo
Museum of the Qiang Nationality, Mao Xian, 1894

PUBLISHED: *Wenwu* 1994.3, p. 35 fig. 54.1.

Ancient weapons from China sometimes raise problems of nomenclature, not only because they sometimes lack exact counterparts in our culture, but also because, when they were made of materials some of which have disintegrated with time, their original form may be unknown to us. The term "short sword" *(duan jian)* often applied to blades like the present one is an example. The object seems in fact to be a dagger; its willow-leaf blade (the tang excluded) is barely 20 cm long. Pegs inserted through the two holes in the tang would have attached it to a handle, probably a wooden handle bound with string.

The decoration, which fills the whole length of the blade, shows a dragon with its head seen in profile. The dragon's square eye is easily recognizable but the rest of the head, evoked only by a curling muzzle and an open mouth, is schematic and obscured by interlacery. The elements that fill the length of the blade are not symmetrical about the central axis; on one side are squared spirals, on the other very simplified S-shaped dragons organized around single eyes. Asymmetry of this kind had appeared already in similar motifs on far more ancient halberd blades (Nos. 69, 72). It is probably the central section of the design that represents the dragon's body. Regarded as a whole the design amounts to a curious mixture: it includes obviously archaic motifs, such as the *leiwen* of Shang type and the dragon head recalling Western Zhou art; other motifs that were archaic but reworked, such as the S-shaped dragons; and details specific to bronzes of metropolitan China of the first half of the fifth century, notably the series of dots in relief, the twisted horn, and the interlace, all of which are known at Houma.

Such combinations of disparate elements, seen many times in the Moutuo finds, are widely encountered in the bronzes of Shu and Ba. They document several distinct episodes of borrowing in the art of Sichuan, each belonging to a different period, but all involving the cultures of Shaanxi and the Zhongyuan. The distinctiveness of Sichuan lies in the way the elements are recombined yet faithfully preserve their original character. This faithfulness suggests that the models which inspired Sichuan bronze casters, sometimes very ancient, were actually available to them as they worked.

Dagger

Bronze
Length 38.6 cm
Approximately fifth century BC

Excavated in 1992 from pit 1 at Mao Xian Moutuo
Museum of the Qiang Nationality, Mao Xian

PUBLISHED: Beijing 1994a, pl. 166 (left).

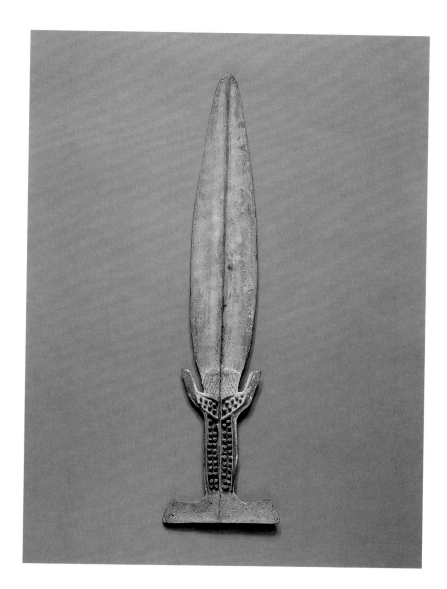

Fig. 81.1. Dagger from Mao Xian Moutuo tomb 1. Length 25.9 cm. About fifth century BC. After *Wenwu* 1994.3, p. 36 fig. 55.7.

Fig. 81.2. Dagger, stray find from the vicinity of Moutuo. Length 33 cm. About fifth century BC. After *Wenwu ziliao congkan* 9 (1985), p. 89 fig. 24.

Fig. 81.1 **Fig. 81.2**

Two daggers of peculiar type were found in pit 1 at Moutuo and a third was found in tomb 1 (Fig. 81.1).[1] All three are set apart by a hilt cast in one piece with the blade and by the transverse bar that terminates the hilt, which probably helped to ensure a firm grasp. Also distinctive are the guards formed of two barbs (in one case only a single barb) and the broad willow-leaf blades strengthened by a rib running the full length of the blade.

These features, to which should be added the pattern of bumps arranged in parallel lines on the grip and guard, are without known parallel except for a dagger collected from a site near Moutuo and two others from a nearby tomb (Fig. 81.2).[2] They argue for local manufacture and can perhaps be associated with the culture of the upper Min River. The rarity of the pieces might be something of an optical illusion: the unusual hilts preserved for us in these isolated bronze examples might actually have been common in wood, bone, or horn versions now lost. On the other hand it should be observed that when a dagger has a bronze hilt, the hilt is decorated, sometimes sumptuously, while the blade is left bare; but when a dagger does not have an integrally cast hilt, the blade is usually decorated, sometimes for its full length (No. 80).

The form of this dagger suggests connections with more ancient northern cultures.[3] In the pre-imperial period, cultures spread over a vast crescent from the northeast to the southwest formed a zone of exchange on the periphery of the sinicized world and were united by common cultural traits.[4]

1. The two from pit 1 are shown together in Beijing 1994a, pl. 166.

2. *Wenwu ziliao congkan* 9 (1985), p. 89 fig. 24; *Kaogu* 1981.5, p. 417 fig. 14.

3. Falkenhausen 1996, pp. 50–51. For example, *Wenwu ziliao congkan* 9 (1985), p. 33 fig. 23, p. 34 fig. 28, p. 38 fig. 34, p. 58 fig. 74.

4. Tong Enzheng 1987, Pirazzoli 1988.

Ge *blade*

Bronze
Length 25.3 cm
Fourth century BC

Excavated in 1972 from Pi Xian Dubaishu
Sichuan Provincial Museum 111692

PUBLISHED: Chengdu 1991, pl. 171; Beijing
1994a, pls. 142–3.

This *ge* belongs to a type borrowed from metropolitan China and widely distributed down to the founding of the empire in 221 BC. Nevertheless the tiger seen here and the emblems that appear in front of it and below it make the present blade a classic example of the characteristic weapons of Sichuan. The tiger's body is summarily drawn in sunken line on the tang, while its head and foreleg, much more elaborate, appear in relief on the blade. At the line where the crosspiece separates the blade from the tang, the back of the tiger's head and the elbow of its foreleg rise off the surface, forming two similar projections. When the blade was mounted, the tang went through a slot in the shaft while the projections rested against the front of the shaft, holding the blade firmly in place.

No doubt the decoration was meant to add to the threatening appearance of the weapon. Between the tiger's gaping jaws the blade is perforated to give more prominence to the fangs and more presence to the tiger. The device used here by Sichuan artisans was invented much earlier by Shang casters: many Shang axes of the type *yue* are decorated on both sides with a zoomorphic face that bares its fangs in the same way.[1] But in its shape, in its motif of a feline head, and in the projecting elements that brace the blade against the shaft, this *ge* is a direct descendant of weapons made in Shaanxi under the Western Zhou, notably weapons found near Baoji in the cemetery of the princes of Yu (tenth to ninth century BC).[2]

Similar *ge* with occasional slight variations have been found at many places in western Sichuan and neighboring areas.[3] The body of the tiger is sometimes arranged vertically on the downward elongation of the blade *(hu)* instead of horizontally on the tang. The Dubaishu *ge* is nonetheless set apart by the two emblems that appear on the *hu,* a headdress on one side and a kneeling warrior on the other; by the row of claws on the lower half of the blade; and above all by the inscription that runs the full length of the upper edge. The inscription is written in an undeciphered script that survives only on a few weapons from Sichuan. Scholars do not agree on anything about this script: some connect it with Chinese, others see it as an alphabetical writing. Even the direction of reading is uncertain. The varied interpretations that have been proposed for the present inscription seem to establish only that it is not understood.[4]

1. Beijing 1998a, no. 184.

2. Lu & Hu 1988, vol. 1, p. 162 fig. 125.6 and vol. 2, pls. 80.5–6 (Zhuyuangou tomb 4); vol. 1, p. 203 figs. 148.2–3 and vol. 2, pl. 110.1 (Zhuyuangou tomb 19).

3. For example, five from Yingjing Tongxincun (Beijing 1998f, figs. 42.1–4), one from Moutuo tomb 1 (*Wenwu* 1994.3, p. 18 fig. 26.8), one from Chengdu Baihuatan tomb 10 (*Wenwu* 1976.3, p. 41 fig. 2.5), and one from a tomb at Wan Xian Xintianxiang (Beijing 1994a, pl. 144).

4. See *Sichuan wenwu* 1996.6, pp. 3–9, 25.

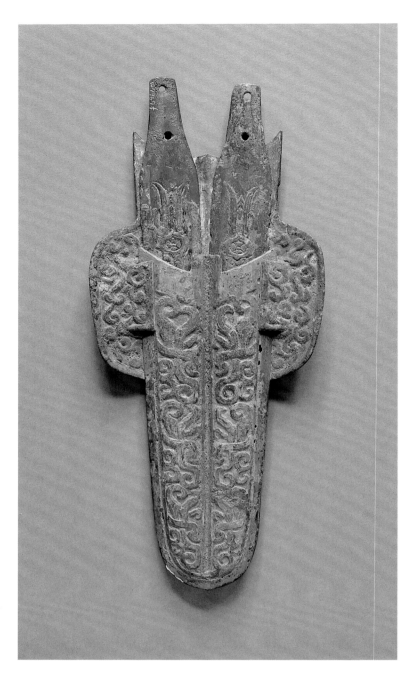

Sheath with two daggers

Bronze
Length 29.8 cm
Approximately fourth century BC

Excavated in 1973 from a tomb at the Zhongyi
Xueyuan (Institute of Traditional Medicine) in
Chengdu
Sichuan Provincial Museum 109969/1–2

PUBLISHED: Chengdu 1991, pl. 97; Beijing
1994a, pl. 164.

At the time of excavation this sheath was still in place
on the left side of the deceased. The other weapons in
the burial, a dozen of them, had been laid beside the
body, probably directly on the ground. Covered with
patterns of abstract interlace executed in low relief,
the sheath was designed to hold two daggers, only
the blades of which survive; their handles, probably
wood bound with cords or straps, have disintegrated.
They are the same length and have the same decora-
tion of confronted cicadas(?) sharing a single head.
The sheath was made by fitting together two pieces
cast separately, one of them the sleeve for the daggers,
the other a plate that clasps the sleeve and extends
beyond it in two ear-shaped projections.

In shape and decoration the two blades are char-
acteristic of eastern Sichuan. As for the sheath, at
least three similar examples are known, all found in
Chengdu.[1] Since neither the blade type nor this kind
of sheath seems to have been used anywhere else
in China in the Warring States period, the present
examples may well have been made in a Chengdu
workshop. If comparable pieces are unknown even
in Sichuan, the reason is probably that sheaths were
usually of leather, rattan, or wood (all normally
lacquered).[2]

Like many Sichuan weapon types, this form of
sheath probably originated in Shaanxi around the
tenth century BC; its descent is traced in Figure 83.1.
Sheaths of the same type, though made to hold one
dagger rather than two, have come from the ceme-
tery of the princes of Yu near Baoji.[3] They take the
form of a curved openwork bronze plaque attached
to a flat wooden plaque and provided with loops at
the side through which the warrior's belt passed.
Similar sheaths, but made entirely of bronze and
sometimes for two daggers, are present in tomb 1
at Moutuo (fifth century BC).[4] Evidently the ears of
the fourth century examples preserve the memory

1. They come from Luojianian (Tong Enzheng 1977, p. 37 fig. 4),
Jinniuqu Baitacun (Beijing 1994a, pl. 165), and Qingyangxiaoqu
tomb 2 at Sandongqiao (*Wenwu* 1989.5, pl. 6.2), all three in
Chengdu.

2. As noted by Tong Enzheng 1977, p. 37.

3. Lu & Hu 1988, vol. 1, p. 203 fig. 148.1, p. 213 fig. 154.1, p. 313
fig. 219; vol. 2, pls. 168.1 (Rujiazhuang tomb 1), 119.4 (Rujiazhuang
tomb 14), 110.5 (Rujiazhuang tomb 19).

4. *Wenwu* 1994.3, p. 22 fig. 33, p. 36 fig. 55.3 (one dagger); p. 22
fig. 32, p. 36 fig. 55.4 (two daggers); p. 36 fig. 55.6 (M1:138, the back
of a sheath, to which was probably attached the plaque M1:156
shown in fig. 55.5).

of the original belt loops, but some other means of attachment to the belt is implied.

These sheaths with rich openwork decoration existed in other variants from the tenth century onward. Two sites widely separated from each other, one in Gansu (Lingtai Baicaopo tomb 2) and one in Beijing (at Liulihe), have yielded handsome specimens datable around the tenth century.[5] Located at the western and northern extremes of the sinicized world of the time, the Lingtai and Liulihe sites belong to an ethnically mixed frontier zone in which cultural exchange took place over vast distances. Long-distance contacts left their mark on Sichuan too, but with the difference that here ancient weapon types seem to have been preserved in their original forms many centuries after those forms had died out in their place of invention.

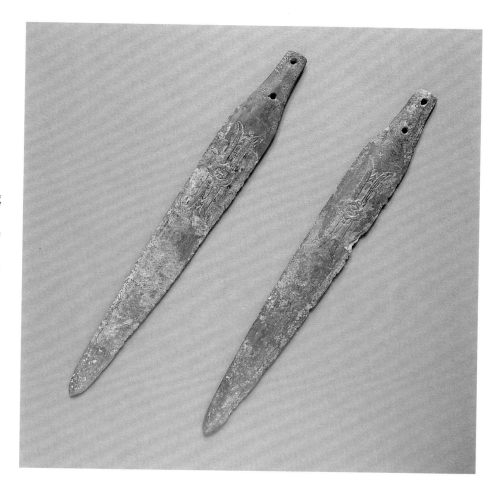

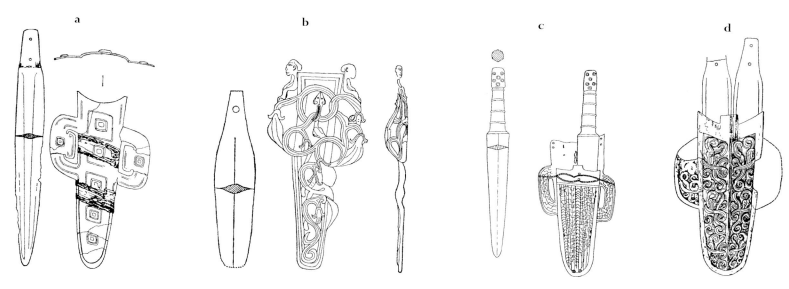

Fig. 83.1. Evolution and spread of the bronze scabbard for one or two daggers. After Lu & Hu 1988, vol. 1, p. 213 fig. 154.1; Beijing 1995d, p. 202 fig. 118.3; *Wenwu* 1994.3, p. 36 fig. 55.4; Tong Enzheng 1977, p. 37 fig. 4.

 a. From Shaanxi Baoji Zhuyuangou tomb 14. Tenth or ninth century BC.
 b. From Beijing Liulihe tomb 253. About tenth century BC.
 c. From Mao Xian Moutuo tomb 1. Fifth century BC.
 d. From Luojianian tomb at Chengdu. Fourth century BC.

5. Beijing 1995d, p. 201 figs. 117.3–4, p. 202 fig. 118.3; Beijing 1997c, no. 196.

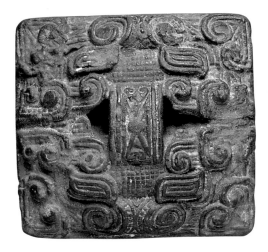
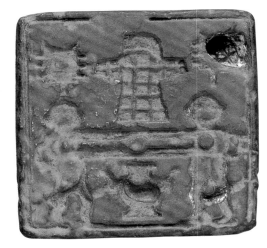

84

Seal

Bronze
Height 1.4 cm, length of sides 3.5 cm
Fourth century BC

Excavated in 1980 from the Majiaxiang tomb at Xindu

Sichuan Provincial Museum 140009

PUBLISHED: *Wenwu* 1981.6, p. 4 fig. 6; Chengdu 1991, pls. 196–7; Beijing 1994a, pls. 180–81.

The Majiaxiang tomb contained two seals, each of an unusual shape, the present one square with a domed upper part, the other a peculiar double-crescent. On its upper part No. 84 is covered with volutes recalling the decoration of Chu bronzes; from these emerge two animal faces, each only vaguely evoked by a pair of eyes and a pair of curls for nostrils. Between the two faces is a small loop.

The design imprinted by the seal is unusual in that the elements which compose it are not merely placed side by side but, in part at least, arranged to form a picture, indeed a picture that represents an action. Two frontally posed figures stand on either side of a *lei* vessel set on the ground. Their outstretched arms clasp hands above the *lei;* the other hand of each figure rests on his hip. Above this scene are three objects, a suit of armor and two bells. The checkered pattern on the armor no doubt represents plates of lacquered leather. The bells are oriented mouth up, stem down, and must therefore belong to the type *zheng,* for the use of armies in battle, rather than to the musical type *yongzhong,* as we might otherwise have deduced from the bosses shown projecting from their sides. In Sichuan, in fact, bells for war were cast on the model of the *yongzhong,* though without the latter's suspension loop at the base of the stem.[1]

The *lei,* a ritual vessel of particular importance in Ba-Shu culture, may have signified a ruler's power. The various elements of the design on this seal thus seem to make sense together: two men take an oath—perhaps solemnizing an alliance or a peace—surrounded by objects symbolizing war and power. Since the suit of armor appears (flanked by halberds) on nearly a hundred objects from the Majiaxiang tomb, including Nos. 85–8, it may be a personal emblem of the tomb's occupant that was included in the present design because he was somehow connected with the ceremony depicted, as one of the oath-takers, for instance, or as someone who benefited from their alliance.

Sichuan tombs have yielded many seals, but no other like No. 84. Most are circular, either flat disks or cones; more rarely they are flat squares or rectangles.[2] Their designs juxtapose oddly assorted motifs: abstract elements (stars, quatrefoils, volutes), artifacts (bells of the type *zheng, lei* vessels, dagger-axes), people and animals (insects, birds, quadrupeds, dragons), even characters of Chinese writing. Some of these elements might have been read together like a rebus, but it is hard to guess what sort of thing the rebus might have been intended to convey: did it signify a person, a family, a clan? Though it is tempting to assume that No. 84 is the seal of the tomb's occupant, in Sichuan things are not always so simple: one tomb sometimes contains several different seals; identical seals come sometimes from different tombs far distant from each other. Nor do we know how these seals were used. Were they impressed in soft clay? Or inked with a colored substance and imprinted on some material like cloth?

1. Examples have come from tombs 1 and 2 at Fuling Xiaotianxi; see Chengdu 1991, pls. 29, 32.

2. See e.g. Beijing 1994a, pls. 182–3.

Set of five triangular ge blades with round opening

Bronze
Length 29.2 cm
Fourth century BC

Excavated in 1980 from the Majiaxiang tomb at
Xindu
Sichuan Provincial Museum 114867/8/9/70/71
PUBLISHED: Chengdu 1991, pl. 190; Beijing
1992a, pl. 30.

In shape each of these weapons is perfectly symme-
trical about its longitudinal axis. An almond-shaped
opening in the tang lies on that axis, as do the spine
and the large circular perforation on the blade. Two
smaller perforations are located near the back edge
of the blade. That edge is slightly curved, and the
shaft against which it rested necessarily had the same
curvature. Next to the large circular opening is an
emblem, apparently engraved, that is seen also on
many other items from the same tomb (including
Nos. 86–8 in the present exhibition).[1] It depicts a
suit of armor flanked by two halberds and, below
one of the halberds, a small object difficult to iden-
tify. An emblem that shows a similar suit of armor, a
quatrefoil, and what looks like a ge blade appears on
one side of a sword blade from Yingjing Tongxincun
tomb 19 (Fig. 85.1).[2]

The blades were decorated only by a surface
treatment that made them two-colored, probably a
selective burnishing done after casting (see the entry
for No. 93). On each side, large silver-colored spots,
two circular and four semicircular, are spaced regu-
larly on an amber ground.

It is uncertain whether the five blades had any
practical use. They were not put into the tomb hafted
but instead were in a jar. Moreover the openings at
the back edge of the blade, which in principle served
for lashing it to a shaft, have sharp casting fins around
their edges that were never removed, as they surely
would have been if they were not to cut through cord
or leather lashings. The deposit of such weapons in
sets of five, as here, or ten, as in the case of other
ge in the same tomb, probably had some symbolic
purpose.

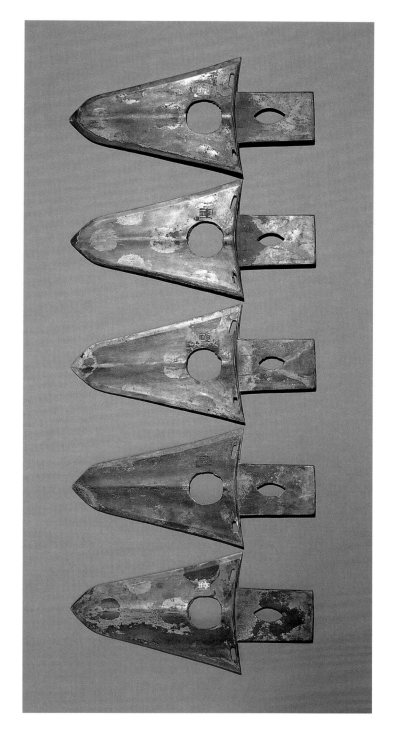

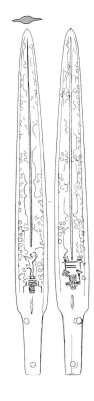

Fig. 85.1. Sword blade from Yingjing
Tongxincun tomb 19. Length 38 cm.
Fourth or third century BC. After
Beijing 1998f, p. 251 fig. 55.1.

1. At least 99 objects bear this
mark—a seal, a spindle whorl,
2 *fou*, 5 knives of the type *dao*
and 15 of the type *xiao*, 30 *ge*,
10 axes of the type *yue* and 5
of the type *fu*, and 30 chisels
(*Wenwu* 1981.6, pp. 1–16).

2. Beijing 1998f, p. 251 fig. 55.1.

Set of five triangular ge blades with small round opening and taotie *decoration*

Bronze
Length 29.2 cm
Fourth century BC

Excavated in 1980 from the Majiaxiang tomb at Xindu
Sichuan Provincial Museum 114877/8/9/80/81

PUBLISHED: Chengdu 1991, pl. 179; Beijing 1994a, pl. 137.

These finely made triangular *ge* are a matched set. The cutting edges of each blade are conspicuously beveled. The end of the tang is scalloped, repeating the contour of the adjacent surface design. Firm attachment of the shaft was provided for by two small openings near the corners of the blade and two slightly larger ones opposite each other on blade and tang, one round and one almond-shaped. Since the back of the blade is curved and the almond-shaped hole is rather close to it, the shaft must have been curved and quite slender at this point, barely two centimeters in diameter. These not very sturdy weapons may have been intended only for display. Close comparison of the five *ge* shows a decrease in quality of casting from one to the next, suggesting progressive deterioration of the model on which the molds were formed or, perhaps, reuse of a single deteriorating mold.

The abstract design on the tang is confined to the area that was visible when the blade was hafted. The remainder of the blade has two contrasting types of decoration, one cast and one produced after casting. A *taotie* face oriented toward the tip and prolonged by a triangular element that echoes the shape of the blade is cast in relief. The surface around it is covered by a mottled pattern that seems to have been produced after casting: apparently the surface was darkened somehow, then the dark layer was hammered or chipped away at spots to reveal the underlying bronze. In the speckled zone, to one side of the *taotie,* appears the emblem seen on Nos. 85, 87–8, and most of the other bronzes from the tomb.

An almost identical piece, but without the inscription and the distinctive surface treatment, comes from Moutuo tomb 1 (Fig. 86.1).[1] The prototype from which both blades descend predates them by half a millennium, as an early Western Zhou *ge* from Luoyang Beiyao tomb 155 testifies (Fig. 86.2).[2] The Beiyao *ge* has a straight back edge and no surface treatment; in other respects, however, No. 86 has barely departed from its prototype. It copies the Western Zhou *taotie* design with particular fidelity: the *taotie*'s horns are less clearly indicated, but the bulging eyes with a sunken dot for iris, the nose formed of two volutes, and the fine *leiwen* spirals are thoroughly archaic. Sichuan seems to have preserved forms and decorations that elsewhere had long ago degenerated or been forgotten.

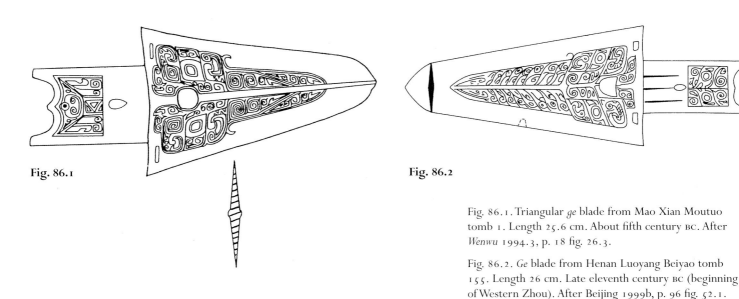

Fig. 86.1

Fig. 86.2

Fig. 86.1. Triangular *ge* blade from Mao Xian Moutuo tomb 1. Length 25.6 cm. About fifth century BC. After *Wenwu* 1994.3, p. 18 fig. 26.3.

Fig. 86.2. *Ge* blade from Henan Luoyang Beiyao tomb 155. Length 26 cm. Late eleventh century BC (beginning of Western Zhou). After Beijing 1999b, p. 96 fig. 52.1.

1. *Wenwu* 1994.3, p. 18 fig. 26.3.

2. Beijing 1999b, p. 96 figs. 52.1–2. The tomb is dated to the reign of Kang Wang or Zhao Wang.

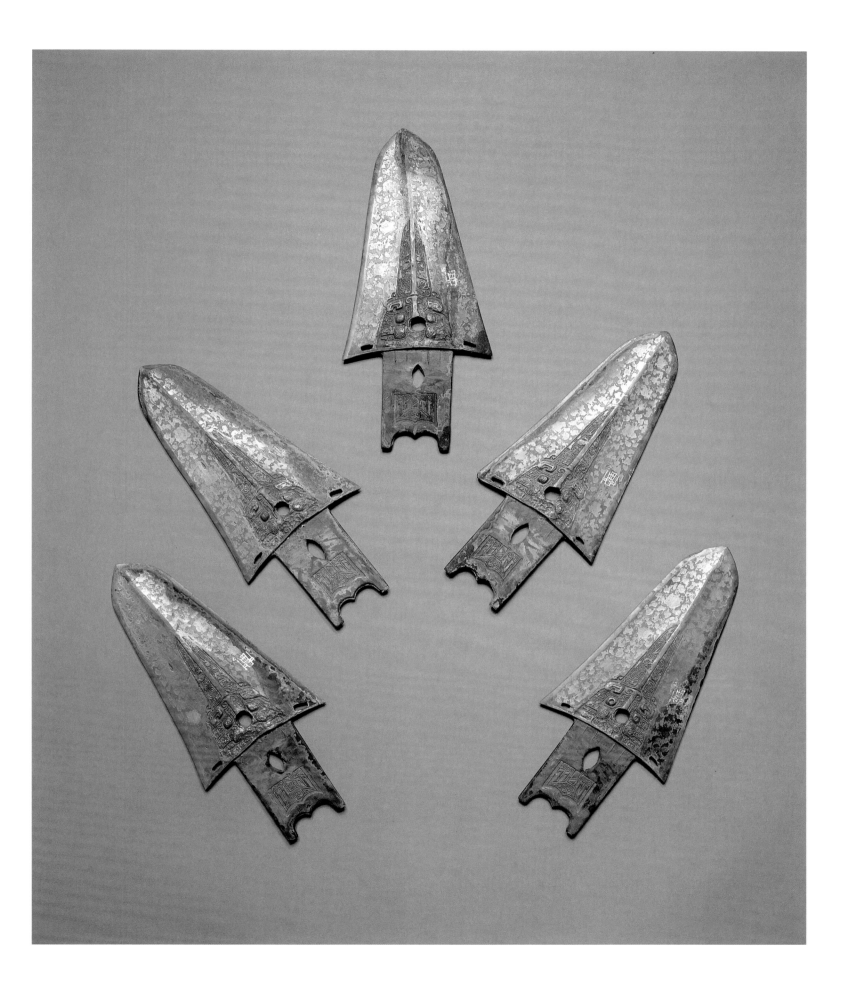

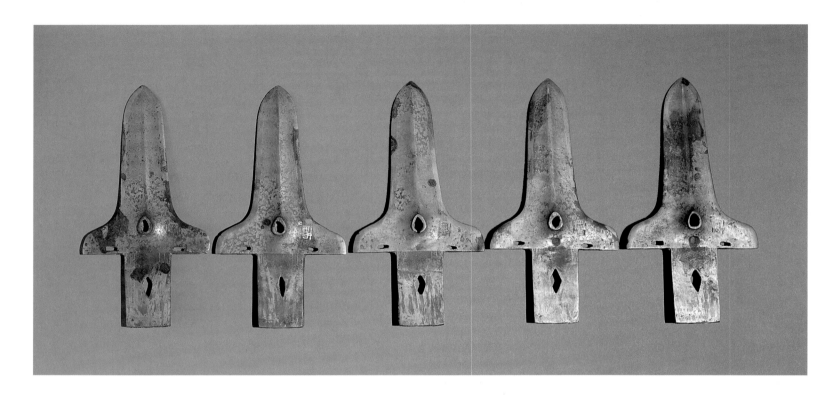

87

Set of five cross-shaped *ge* blades

Bronze
Length 26.6 cm
Fourth century BC
Excavated in 1980 from the Majiaxiang tomb at Xindu
Sichuan Provincial Museum 114872/3/4/5/6
PUBLISHED: Chengdu 1991, pl. 191; Beijing 1994a, pl. 140.

The shape of these *ge,* perfectly symmetrical about the longitudinal axis, seems specific to the cultures of fourth and third century Sichuan,[1] though not very widespread even there. The blade is fairly sharp. On its central axis it bulges to form a spine. Opposite the point it flares outward into two wings designed to rest against the wooden shaft; they have two small openings for securing the shaft. Two large almond-shaped openings lie on the central axis of the blade, one at the thickest part and one at the center of the tang. The blade's sole departure from bilateral symmetry is an engraved emblem similar to the ones seen on Nos. 85–6, 88, and most other bronzes from the tomb.

Though the blade has no decoration, its surface shows three different colors: the golden color of the cutting edge and, everywhere else, shiny silver-colored flecks against a matte amber patina.

1. *Wenwu ziliao congkan* 7 (1983), p. 14 figs. 2.18, 2.21, 2.24; *Wenwu* 1990.11, p. 71 fig. 9 (tomb at the Chengdu Radio Technical School); Beijing 1998f, p. 153 fig. 39.1, color pl. 1.3 (Shifang Chengguan tomb 1).

This set of five identical axes was found with another set of five that are similar but smaller (11.5 cm long). All ten had been placed beneath the burial chamber, in a jar of the type *fou,* along with five spearheads, fifteen dagger-axes *(ge),* and five axes of the type *fu.* A large proportion of tombs in eastern Sichuan contain two axes of the present type, anywhere from seven to twenty centimeters long. Despite abundant finds, however, no example has yet been discovered with its handle intact (though traces of wood are sometimes found inside the socket), and without knowing the form of the handle it is hard to guess how the axes were used. The disposition of furnishings in tombs is not regular enough even to suggest whether axes of this type were tools or weapons. Sometimes weighing more than a kilogram, they may have been rather unwieldy.

Of a form peculiar to Sichuan, these axes have a socket of oval section into which the wooden handle extended almost as far as the cutting edge. In classic examples like the present ones, the socket has a fairly large opening. On the exterior a raised band runs around the socket. Above this the neck has ten facets; the two that face front and back are broader than the rest. Narrow at first, the neck turns outward to form the base of the blade; the cutting edge rises vertically, drawing inward a trifle, then swings around in a broad arc. The front and back surfaces of the blade are convex.

Each of these axes carries the same emblem as Nos. 85–7 and most of the other bronzes from the Majiaxiang tomb. Perhaps the emblem identified them as the property of a single owner.

88

Group of five shouldered socketed axes

Bronze
Length 18.5 cm
Fourth century BC

Excavated in 1980 from the Majiaxiang tomb at Xindu

Sichuan Provincial Museum 114887/8/9/90/91

PUBLISHED: Chengdu 1991, pl. 132; Beijing 1994a, pl. 156.

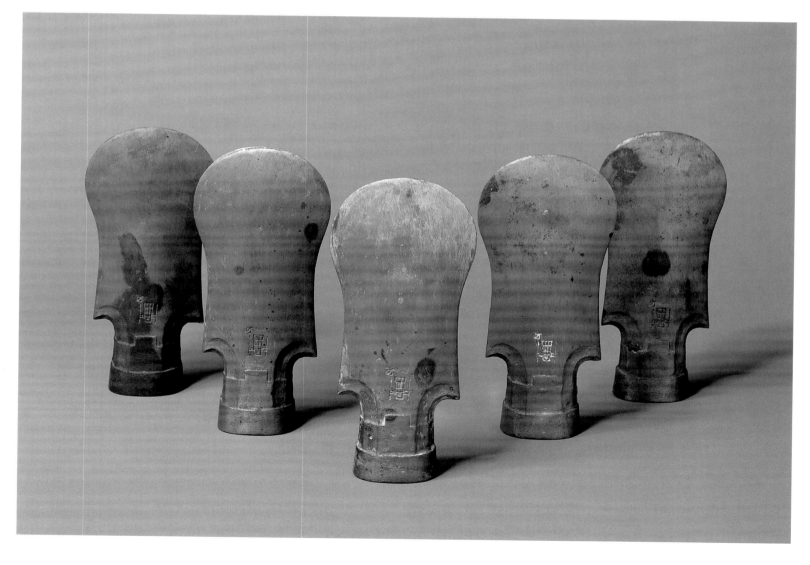

89

Tanged short sword

Bronze with cord-bound wooden handle
Length 40 cm
Fourth century BC

Excavated in 1980 from the Majiaxiang tomb at Xindu

Sichuan Provincial Museum 114962/3/4/5/6

PUBLISHED: Chengdu 1991, pl. 111; Beijing 1994a, pl. 162.

Fig. 89.1. Dagger blade from Shaanxi Baoji Zhuyuangou tomb 7. Length 28.4 cm (length excluding tang 22 cm). About tenth century BC. After Lu & Hu 1988, vol. 1, p. 115 fig. 92.1.

This sword is one of a set of five identical but for their graduated sizes. On both faces the blade has a median crest; the areas between crest and cutting edge are concave. In color the blade is amber flecked with black; the effect was achieved by treating the surface to give it a dark, almost black color, then hammering it in places to expose the natural color of the bronze again. The handle was made of several pieces of wood tied onto the tang of the blade and painted with black lacquer. A fine cord was wound many times around the wooden pieces to make the attachment firm. The five swords were put into the tomb in their scabbards of plaited, black-lacquered rattan, but the scabbards were found in fragmentary condition.

Blades with the shape, perforated tang, and flecked decoration of the Majiaxiang swords constitute a type specific to Sichuan. Over the years Sichuan tombs have yielded several hundred examples, widely varied in size, always with two perforations in the tang (one perforation near the end, the other—on the median axis or to one side of it—near where the tang meets the blade proper). The perforations were meant for pegs inserted to secure the pieces of the wooden handle. Until the discovery at Majiaxiang, however, no blade of this type had ever been found with its perishable parts preserved, and the exact form of the handle was unknown.

Swords constructed in this way seem to be derived from daggers made in Shaanxi around the tenth century BC (Fig. 89.1).[1] In Sichuan, the last region to produce them, they enjoyed unflagging popularity all the way down to the founding of the Qin empire in 221 BC. Everywhere else swords with tangs had given way to hilted swords like No. 90 by the Warring States period.

Before the fifth century BC, warfare in central China was dominated by the dagger-axe (ge), and swords were not much used. Short swords with wooden hilts accordingly did not undergo much development in central China, and around the beginning of the fifth century their production stopped altogether[2] when they were supplanted by swords made in the southeastern principalities of Wu and Yue. The swords of Wu and Yue were not only more prestigious but also more serviceable, the hilt being cast onto the blade and thus firmly locked in place. In continuing the manufacture of swords with wooden hilts down to the end of the Warring States period, the cultures of Sichuan remained faithful to a tradition of weaponry that had originated in Western Zhou and that was little affected by later developments elsewhere in China.[3]

1. Lu & Hu 1988, vol. 2, pls. 28.4, 51.4, 103.3, 119.4, 123.4, 126.6, 131.3, 168.1.

2. The sword blade from Henan Xichuan Xiasi tomb 11 (end of the sixth or beginning of the fifth century) is one of the last well-attested instances in central China (Beijing 1991b, p. 306 fig. 233.7).

3. Lu & Hu 1988, vol. 1, pp. 431–46.

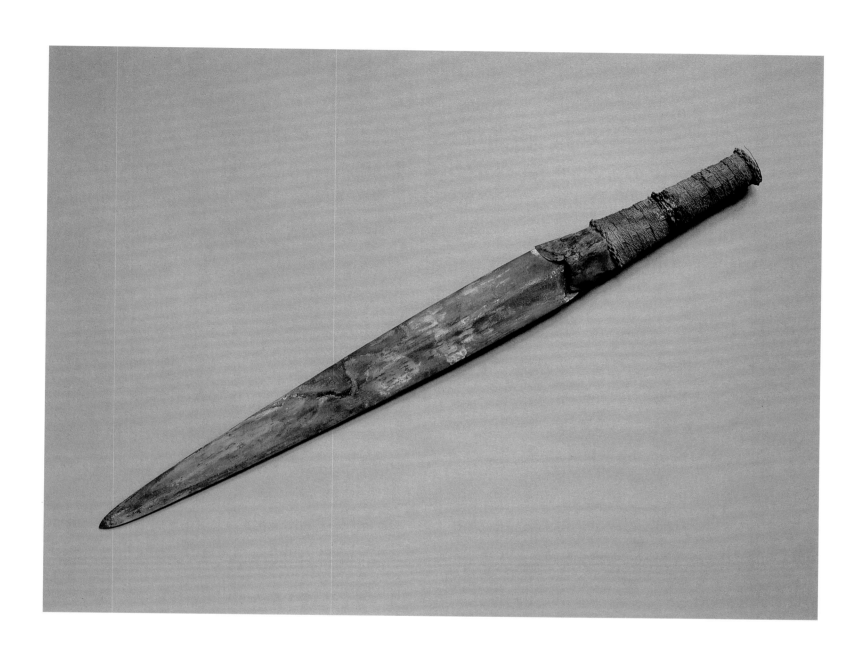

90

Hilted sword

Bronze
Length 57 cm (blade alone 48.3 cm)
Fourth century BC
Excavated in 1980 from the Majiaxiang tomb at Xindu
Sichuan Provincial Museum 114865
PUBLISHED: Chengdu 1991, pl. 120.

The early history of the sword in China remains poorly understood. Swords developed from daggers with two-edged blades; when the blades exceed thirty centimeters in length, we can reasonably speak of short swords. People on the northern fringes of the Chinese world made use of daggers from about 1500 BC.[1] A few centuries later, under the Zhou, regions of Chinese culture used tanged willow-leaf blades; the tang had one or two perforations for pegs that secured a wooden grip in place (Fig. 89.1).[2] This form of blade, which reached Sichuan at an uncertain date, but probably by the tenth or ninth century BC, was still to be found there in the fifth or fourth century, for instance at Moutuo (No. 80). It was the ancestor of the typical Sichuan sword represented here by No. 89.

A development parallel to the one in Sichuan is attested, though weakly, in central China.[3] Moreover two other regions, at slightly different times and

seemingly independently of each other, saw the same evolution from dagger to sword: the steppe region straddling present-day Liaoning, Inner Mongolia, and northern Shaanxi around the tenth or ninth century BC, and the lower Yangzi region around the eighth or seventh century BC. Yet the adoption of the sword into the warrior's equipment in central China was very slow. Its use implies a mode of close combat that must have been rather different from the combat with dagger-axes that predominated until the fifth century. Nevertheless two types of sword established themselves at the beginning of the fifth century and in the Warring States period became the classic forms most widely distributed in the middle and lower Yangzi region and indeed far beyond. The first, invented and developed in the kingdoms of Wu and Yue,[4] consists of a straight blade 40 or more cm long with a V-shaped guard, a slender grip interrupted by two disks that would originally have been covered by the silk cord bindings, and a disk-shaped pommel (Fig. 90.1, right). The second type, derived from the first, maintains the same length and proportions but is simpler: the V-shaped guard has dwindled to a small molding and the hilt is a hollow tube which widens slightly toward a flared pommel (Fig. 90.1, left). The two types are often found together in Chu tombs. Perhaps they had different uses, one for combat and one for show.

The Majiaxiang tomb contained five of these classic swords, four of the first type and one of the second. At the time of excavation, some of the swords were still in wooden scabbards lacquered black. Originally their hilts were probably bound with silk thread to give a comfortable grip. On the sword exhibited here, the longest of the five, the V-shaped guard is only faintly indicated. All five are likely to have been made in the state of Chu. They vary among themselves enough to suggest that they were not made as a set but were the accumulated possessions of the tomb occupant.

Fig. 90.1. The two classic Chu sword types, from Hubei Jiangling Wangshan tomb 2. Lengths 52 cm, 61 cm. Fourth century BC. After Beijing 1996c, p. 139 figs. 94.1–2.

1. Bunker *et al.* 1997.

2. Lu & Hu 1988, vol. 1, p. 74 fig. 61.10, p. 115 fig. 92.1, p. 162 fig. 125.3, p. 181 fig. 136.4, p. 193 fig. 143.9, p. 203 fig. 148.1, p. 213 fig. 154.1, p. 218 fig. 159.6, p. 223 fig. 162.7, p. 230 fig. 166.11 (the first nine from nine different tombs at Zhuyuangou, the last from Rujiazhuang tomb 1); Beijing 1999b, p. 118 figs. 67.5–6 (from Beiyao tomb 215); Beijing 1995d, figs. 117.1–2, 118.1–2 (from Liulihe tombs 52 and 253).

3. In Xichuan Xiasi tomb 11 (end of the sixth or beginning of the fifth century BC); see Beijing 1991b, pp. 305–6.

4. Thote 1996b, Thote 1997.

Spearhead

Bronze
Length 33 cm
Approximately fourth century BC

Excavated in 1993 from a tomb at Pengzhou
Zhihexiang
Pengzhou Municipal Museum

PUBLISHED: Beijing 1994a, pl. 150.

Projectile weapons seem to have been important in
Sichuan, where it is common for a tomb to contain
several spearheads. The four from Zhihexiang illus-
trated here, Nos. 91–3, are of very high quality. They
are also rather unusual; only for No. 91 do other
Sichuan finds afford close comparisons.

 The socket into which the shaft was inserted runs
the full length of the blade, narrowing toward the tip.
The two wings that flare outward from the socket
give the blade as a whole a rather angular silhouette;
much more common is a willow-leaf shape. Typical
of Sichuan spear points are the two small ear-shaped
loops near the socket end, which perhaps served to
attach ornamental tassels. At the socket end is a band
of *leiwen* spirals, elements that on Shang bronzes were
used to set off other motifs but that here, making
perhaps their final appearance, are seen in isolation.
Above this band is a very elegant lizard cast in sunken
line. The repertoire of motifs on Sichuan weapons
comprises felines, birds, reptiles (lizards), insects
(cicadas), and more rarely zoomorphic faces, animal
combats (tiger attacking a fawn), and hybrid animals
(winged tigers). Though highly stylized in ways pe-
culiar to Sichuan, as a rule these motifs drawn from
nature are readily identifiable.

 In shape this spear point can be compared with two
that come from datable tombs, one belonging to the
second half of the fourth century (Shifang Chengguan
tomb 1), the other to the third century (Chengdu
Jingchuanfandian tomb 1).[1] One tomb contained
three spearheads of different types; the other con-
tained five, of four distinct types.

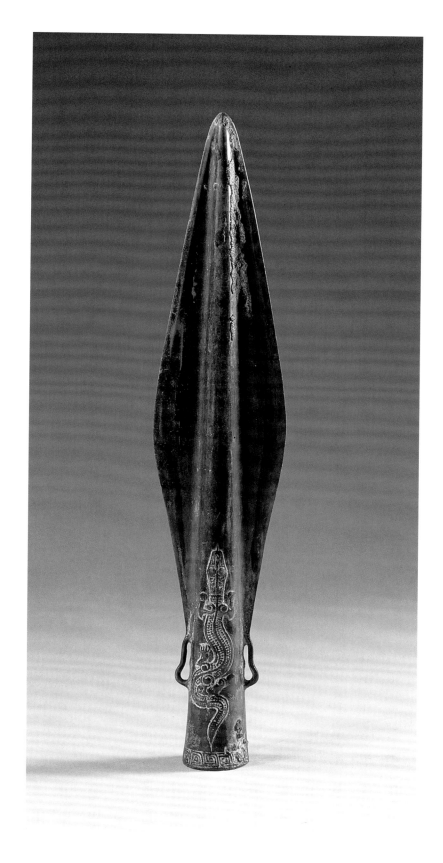

1. Beijing 1998f, p. 145 fig. 32.1; *Wenwu* 1989.2, p. 63 fig. 2.3.

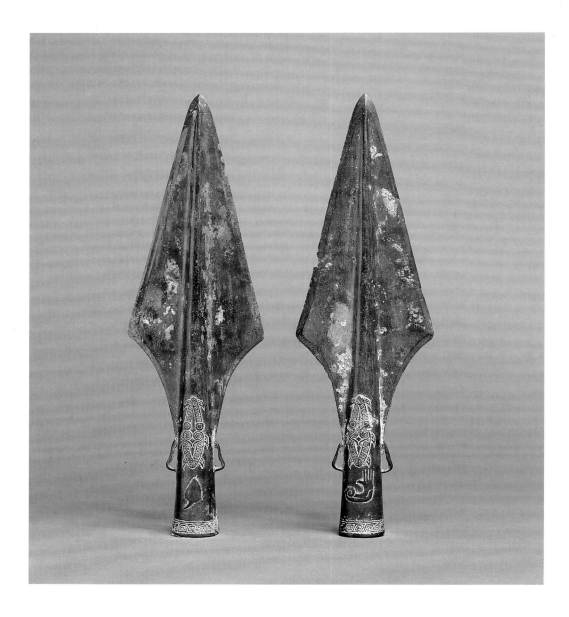

1. Only one other example is known to the author, a
stray find from Ba Xian Dongsunba (Beijing 1960, p. 44
fig. 41.11).

2. *Kaogu* 1996.2, pp. 78–87.

3. The Moutuo site, where some shafts survived in good
condition, is an exception. See *Wenwu* 1994.3, p. 20
figs. 29.1–3.

4. *Wenwu ziliao congkan* 7 (1983), pp. 13–23; Wang Renxiang
1992.

9 2

Pair of triangular spearheads

Bronze
Length 28.3 cm, width 8.6 cm
Approximately fourth century BC
Excavated in 1993 from a tomb at Pengzhou
Zhihexiang
Pengzhou Municipal Museum

PUBLISHED: Beijing 1994a, pl. 149.

Much more unusual than the preceding, these two socketed points have a broad, almost
triangular shape that is exceedingly rare.[1] Their decoration and the characteristic Ba-Shu
emblems on them nevertheless assure us that they were cast in Sichuan, which in fact is
notable for the diversity of its spearhead and halberd types.[2] Shapes as different as No. 91,
No. 92, and the slender blade No. 93 may well have been intended for different uses: some
of the objects that we group together as spearheads might have been designed for projec-
tile weapons; others might have belonged to lances or halberds that did not leave the
hands of the warrior; and of course weapons for hunting might have differed from weap-
ons for war. But we cannot deduce the exact function of a particular spearhead from its
shape alone. Though in Chu tombs weapons were often interred fully assembled, in Ba
and Shu they were often dismantled before burial, leaving us uncertain about shaft lengths
and even about what blades might have been mounted together on a single shaft.[3]

The decoration of the socket consists of a band of *leiwen* and a motif of two confronted
insects(?). Of the latter motif no other example seems to be known on Sichuan weapons.
By contrast the two adjacent emblems, a bent arm and a shape generally interpreted as a
heart, are among the most frequently encountered.[4]

Two-colored spearhead

Bronze
Length 25 cm
Approximately fourth century BC

Excavated in 1993 from a tomb at Pengzhou
Zhihexiang
Pengzhou Municipal Museum

PUBLISHED: Beijing 1994a, pl. 151.

The excellent craftsmanship of Sichuan weapons is
once more in evidence here. The decoration is un-
usual, but the Sichuan manufacture of this spearhead
is confirmed by its shape, a long tapering socket with
two fins and two ear-shaped loops near the base. Many
examples of about the same shape and proportions
could be adduced from other Sichuan finds, such as
Shifang Chengguan tomb 1 and Yingjing Tongxincun
tomb 1.[1]

Forgoing the usual sunken-line or low relief deco-
ration, the craftsman who made this spearhead relied
instead solely on the contrast of two colors. Probably
by somehow darkening the entire surface and then
burnishing selected areas, he produced a large-scale
checkered pattern on the socket and gave a golden
color to the full length of the cutting edge.[2] The large
blobs of color on the *ge* No. 85 may have been pro-
duced by a similar kind of selective burnishing. Such
decoration in large areas of color is unusual. More
common in Sichuan is the selective hammering of
a darkened surface that produced the mottled effect
seen on No. 86. Other surface treatments not yet
elucidated by technical study were also much used.

It was metallurgists of the states of Wu and Yue
in the lower Yangzi region who toward the end of the
sixth century first perfected complex surface treat-
ments for producing two-colored patterns on bronze
weapons. Such treatments enjoyed a great vogue in
Sichuan in the fourth and third centuries, and it is
possible that Sichuan craftsmen had somehow learned
the techniques invented in Wu and Yue. But we should
also consider the possibility that, trying to imitate
weapons imported from Wu and Yue, they instead
invented similar but slightly different techniques of
their own. The smooth surfaces with flecks or large
areas of color that they obtained are in fact rather
different from the Wu and Yue patterns.

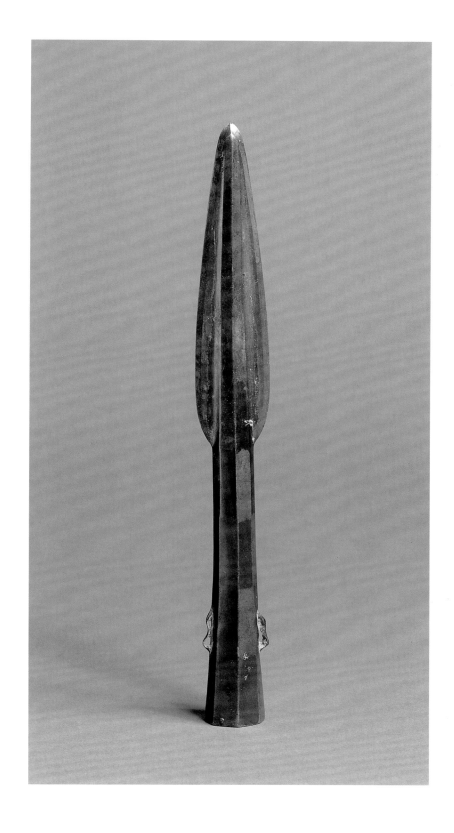

1. Beijing 1998f, p. 137 fig. 24.4, p. 247 fig. 52.1.

2. Much remains to be explained about these processes.
The surface darkening just referred to may have involved
both chemical and heat treatments.

94

Ge *blade* (Er shi liu nian Shu shou Wu ge)

Bronze
Length 24 cm
221 BC (Qin dynasty)

Excavated in 1972 from Fuling Xiaotianxi tomb 3
Sichuan Provincial Museum

PUBLISHED: *Wenwu* 1974.5, p. 74 figs. 24–5,
p. 78 fig. 46.

Ge of the type seen here, with the lower edge of the blade drawn down parallel to the shaft it was attached to, were still in use in the third century BC despite many changes in the conduct of warfare, in particular the widespread adoption of swords. No. 94 is typical of examples made in Qin workshops in the second half of the third century. In every detail it shows a concern to make a weapon that was simultaneously beautiful to look at and effective for hooking and stabbing on the battlefield. The metal has taken on an almost black coloration, and the whole surface was treated to a regular pouncing that has given it the sheen of polished stone.

The blade was mounted in a wooden shaft by inserting its tang through a slot and lashing it in place with silk cord or bamboo strips passed through the four holes near the back edge. The molding that runs along the back edge would then have rested against the shaft; the flange that projects from the part of the molding below the tang would have sunk into a groove in the shaft, strengthening the attachment. Perhaps the pointed tip and beveled edges of the tang were meant to allow forcing the tang into a tight slot, to unite blade and shaft more firmly still.

An inscription of sixteen irregular and barely visible characters was scratched with a fine point onto the tang after casting. It is difficult to read, and the last character has not been deciphered. Clearly legible, however, is the date "26th year." Since the blade is a Qin product, this is a Qin king's reign year; in fact it is the year in which King Zheng of Qin proclaimed himself the first Qin emperor, 221 BC. The full inscription might be tentatively transcribed and translated as follows:[1]

> *Wu. Nian liu nian. Shu shou Wu zao. Dong Gong shi Huan, chen Lei [Zhu?], gong X.*[2]
> "Armory. 26th year. Made by Wu, governor of Shu [i.e. under his administration], by Master of Artisans of the East [Factory] Huan, assistant Lei [or Zhu], and artisan X."

Inscriptions of this type reflect administrative developments associated particularly with the state of Qin, which sought to control the artisans of every craft, from pottery to lacquer to the manufacture of weapons. The objective was to hold workers responsible for their work. Any shortcoming, any fault in the finished article would be punished with fines or more severe penalties. Qin legal texts that include regulations to this effect have been found in a late third century tomb at Hubei Yunmeng, and weapon inscriptions similar to the present one indicate that such regulations were being applied by the second half of the fourth century.[3] In these inscribed weapons we have tangible evidence of the political and economic reforms of Lord Shang (d. 338 BC). *Ge* similar to the present one in every respect—often including a scratched-on quality-control inscription, sometimes one mentioning the Shu East Factory—have been found at widely separated sites in Sichuan, Shaanxi, Hubei, and Hunan provinces. It seems likely that a few Qin factories produced these highly standardized articles in large numbers for widespread use.

1. Tong Enzheng (*Wenwu* 1976.7, p. 84), whose reading is followed here, differs on important points from the reading suggested in the excavation report (*Wenwu* 1974.5, p. 68). For this and related inscriptions see *Kaogu* 1976.1, pp. 22–3, 21; *Wenwu* 1980.9, pp. 29–30, 94; and, for comprehensive discussion of the Qin bronze industry, Sumiya 1982. I am grateful to Anthony Barbieri-Low for suggesting the translation "armory" for the first character of the inscription and for the reference to Sumiya.

2. Chinese characters are supplied in the character glossary (alphabetized under "Wu. Nian liu…")

3. One of the earliest known examples is a weapon dated to 343 BC from a tomb at Xi'an (Xi'an 1998, p. 134 fig. 102.6, p. 231).

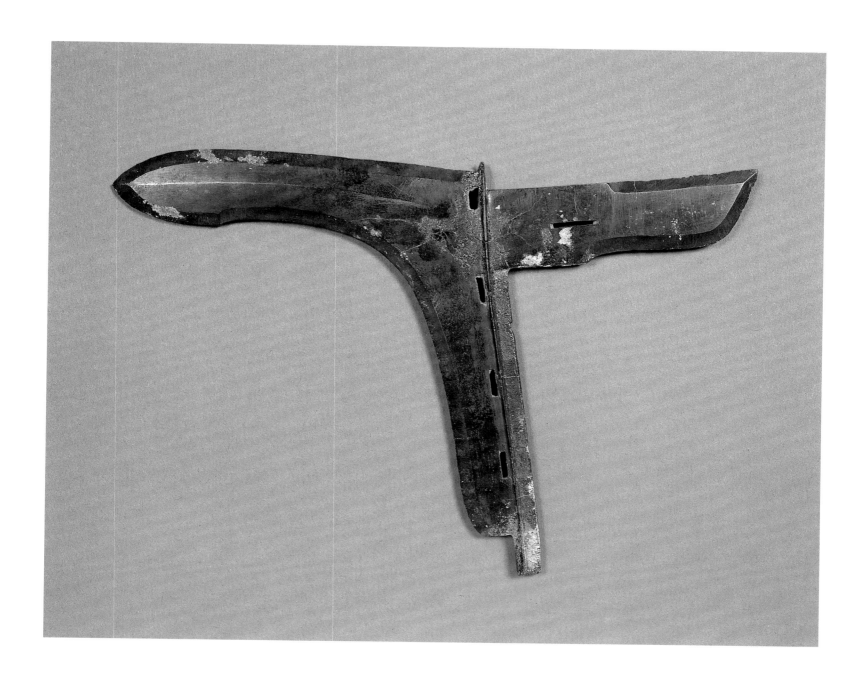

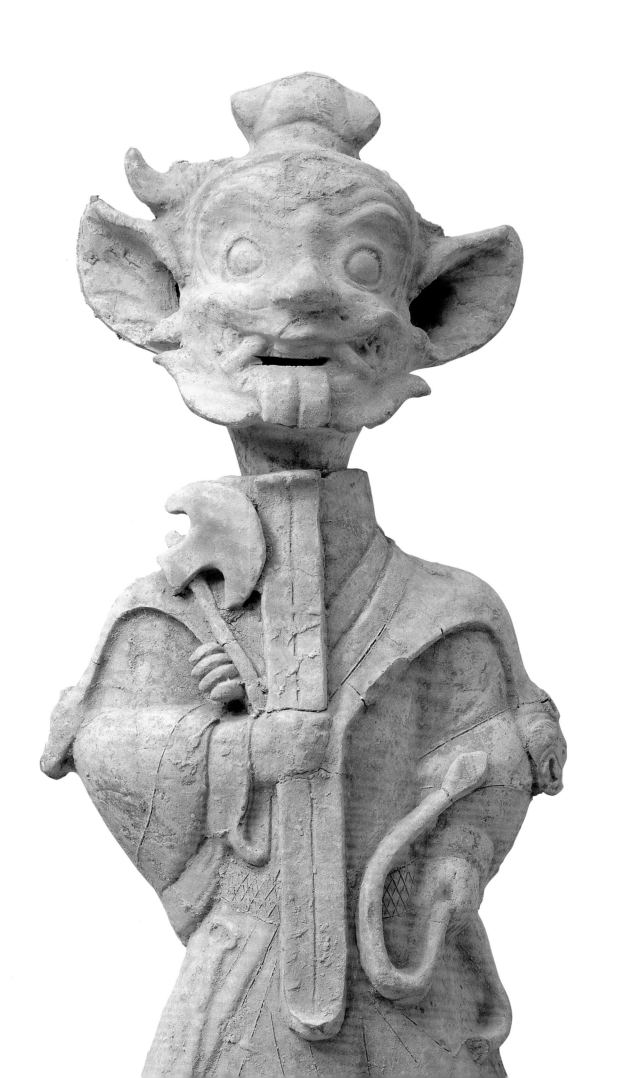

by Jessica Rawson

Tombs and Tomb Furnishings of the Eastern Han Period (AD 25–220)

As discussed in the Introduction Part 2 and the Afterword, the Qin conquest of 316 BC began the sinicization of Sichuan, a region previously outside the Chinese culture sphere. By the first and second centuries AD, the time of the objects treated in this chapter, Qin rule had given way to Han, and the process of sinicization had gone on for 300 years or more. The tomb figures and tomb reliefs in this chapter are therefore not a direct outgrowth of earlier local culture but the local branch of a wider Chinese funerary culture of the Eastern Han period, and they must be examined in that wider perspective.

But Chinese funerary culture had itself changed dramatically in the last few centuries BC, along with prevailing conceptions of the spirit world and the afterlife. To mention only the most conspicuous change, the bronze ritual vessels that earlier had been essential funerary equipment scarcely appear in Han tombs, which contain instead an unprecedented wealth of two- and three-dimensional representations: pictures of deities and daily life, figures of servants, models of great houses and farm buildings. With regional variations of style and emphasis, the same themes and designs recur in this funerary art all the way from Sichuan to Shandong on the east coast. An essential prelude to discussing the contents of Sichuan tombs is to sketch the developments elsewhere that brought a new funerary culture into being.

TOMBS AND TOMB FURNISHINGS IN NORTH CHINA
BEFORE THE QIN DYNASTY

The dominant culture of the Han period (206 BC–AD 220) is one that we can without too much risk of anachronism call "Chinese." Application of the term in earlier periods is more problematic, but we can at least identify an earlier mainstream culture that was the principal ancestor of Han. This arose in the Zhongyuan region of north China, principally the Wei River valley and the middle and lower Yellow River valley. The Zhongyuan was home to the early Bronze Age culture of Anyang (c. 1200–1050 BC); to the Zhou dynasty during the Western Zhou period (c. 1050–771 BC); and to the Zhou successor states, nominal vassals of the enfeebled Zhou, during the Eastern Zhou period (771–221 BC). Sichuan's incorporation into the mainstream began with its conquest in 316 by one of the successor states, Qin. Ultimately Qin absorbed all

the Zhou states and their neighbors into an empire which it ruled briefly as the Qin dynasty (221–206 BC). Its empire was inherited and enlarged by the Han dynasty, which is conventionally divided into Western Han (206 BC–AD 9) and Eastern Han (AD 25–220).

In this mainstream northern culture, elite tombs first appear in the archaeological record around the middle of the second millennium BC. They are shaft burials, rectangular pits with vertical walls and a wooden coffin on the floor of the pit. In burials of the highest status the rather narrow range of grave goods was supplemented by human victims—some combination of servants, guards, charioteers, officials, and concubines who followed their lord in death. The grave goods, whether made specifically for the tomb or used above ground before burial, were no less real and fully functional than the human victims. They consisted primarily of bronze vessels, weapons, and chariots (or chariot fittings, the part representing the whole). The bronze vessels supplied the deceased with food and drink and perhaps also allowed him to feed his ancestors, continuing the offerings he made to them when he was alive. Weapons and chariots probably signalled the status of the deceased, or kept him powerful in the next life, or protected him there (but against what dangers we do not know). Rich tombs also frequently contain jades, some perhaps made for ritual use, others with a protective function, still others prized possessions of the deceased such as jewelry. Possessions prized in this life do not figure prominently, however. The afterlife we infer from tomb furnishings does not seem much like daily life; it seems to have been an existence in which the occupant did little besides give and receive offerings. The Anyang oracle inscriptions, records of divinations in which the Shang king put questions to his deceased ancestors, show those ancestors able to foresee and sometimes even to affect events in this world, but they give no hint that the dead enjoyed any richer or more active existence, nor even that they carried individual personalities from this life into the next. The afterlife that is provided for in tomb furnishings seems to remain a shadowy one down to the end of the Western Zhou period.

Thereafter, however, the structure and furnishing of tombs began to change significantly, perhaps in part because the collapse of centralized Zhou rule and the dispersion of political power allowed regional differences to express themselves. As early as the sixth or fifth century BC we find tombs divided into separate compartments that suggest rooms,[1] and the furnishings of the rooms begin to include objects of daily life: tableware, boxes of clothes, the musical instruments of informal entertainment, even furniture such as beds and tables. Since perishable materials sometimes survive exceedingly well under burial conditions in the south, these developments are most richly attested in the territory of the states of Chu and Zeng, in modern Hubei province, but tombs of the kings of Zhongshan near modern Beijing show that they were not confined to the south.[2] The tomb was ceasing to be a package of ritual equipment and becoming instead a residence for an afterlife conceived on the model of this life. Indeed in the course of the third century BC elaborately cast ritual vessels almost disappeared from tombs. This surprising development probably reflects a simplification of the ancestral sacrifices that were performed in this life (no doubt they continued, but as less elaborate ceremonies adequately served by more everyday vessels). It

1. A fifth century example in which the rooms clearly have distinct functions is the tomb of Marquis Yi of Zeng in northern Hubei; here the compartments—a banqueting hall, an armory, a bedchamber, and servants' quarters—communicate by way of small doors (Beijing 1989). The Zeng tomb and other Eastern Zhou examples are described in Wu 1999, pp. 721–6 (and see comments in Thorp 1980, p. 59; Falkenhausen 1994, p. 6). Division of the tomb into rooms may be foreshadowed by compartmented Western Zhou tombs at Chang'an Zhangjiapo, near Xi'an in Shaanxi (see Beijing 1999d, fig. 21 facing p. 28).

2. For the fourth century Zhongshan tomb complex see Beijing 1995e; Wu 1999, pp. 710–15.

probably also reflects a decline in the importance of ancestral ritual relative to trans-actions with a wider spirit world.

It is in this period that images—pictures, figurines, and models—made their appearance among the tomb furnishings. The objects placed in earlier tombs were not different from objects used in this life. Now, particularly in the south, little wooden figures of servants are provided to wait on the tomb occupant in the afterlife. The figurines do not always obviate the need for real people; the tombs of powerful lords might contain both figurines and human victims, perhaps because figurines could function acceptably as generic servants but could not replace specific individuals such as a concubine.[3] The figures and pictures in Chu tombs represent not only servants but also strange spirits or magical beings.[4] These images of servants and spirits were ancestral to the Eastern Han funerary images that concern us here, and it is important to ask how they were imagined to function. The relationship that was understood to exist between the thing and its representation was certainly more potent than the simple one of "original" and "simulacrum" that we tend to assume. Like the cheap imitations of ritual vessels sometimes encountered in Zhou tombs,[5] servant figurines are often rather casually explained as inexpensive substitutes. But even if we are prepared to regard the first Qin emperor's celebrated terracotta army simply as an inexpensive substitute for a real army, we still face the question: What was its function? As a working hypothesis it is reasonable to suppose that all the images in Han tombs—whether figures, models, or pictures—were, for the tomb owner's purposes, functional equivalents of the things depicted. We then must ask: Why were these things needed in the tomb and the afterlife?

THE MAUSOLEUM COMPLEX OF THE FIRST EMPEROR OF QIN

The Eastern Zhou developments just mentioned reached a climax in the astonishing funerary complex of the First Emperor of Qin (d. 210 BC).[6] This complex was not, however, merely a summation and magnification of what came before—a larger and more fully furnished dwelling for the afterlife. The emperor's towering position in this world seems to have given him towering ambitions for his tomb and himself in the next world. Moreover his conquests, by bringing together beliefs, practices, and designs from a vast territory previously occupied by a multitude of distinct political and cultural entities, caused a drastic re-imagining of the spirit world and the afterlife.

Our still sketchy knowledge of his mausoleum complex comes from archaeological work done in the last three decades. The tomb proper is located beneath a large tumulus surrounded by a pair of rammed-earth walls (Fig. 1). Traces of other structures and deposits have been found both inside and outside the walls. Of these the most familiar is the terracotta army buried in pits 1400 m east of the tumulus, a formation of life-sized clay soldiers equipped with real bronze weapons.[7] The army extends the idea of servant figurines to the presentation of military might on a grand scale. Other parts of the complex supplied the emperor with a palace to dwell in. Pits at various locations contain large quantities of real animals slaughtered and buried to provide stores of food; real horses accompanied by grooms of pottery (the imperial stable); burials of exotic animals (perhaps the fauna of an imperial pleasure park); group burials of man-acled slaves and convicts who labored on the project, some of them identified by

3. A sixth century tomb at Shanxi Changzi contains both: three human victims in coffins and four wooden figures about 68 cm high (*Kaogu xuebao* 1984.4, pp. 503–17, pl. 23.2).

4. On Chu developments see Rawson 1997.

5. I.e. vessels too small or flimsy for practical use, sometimes even cast with lids permanently affixed. The term *mingqi* ("bright objects" or "spirit objects"), taken from classical texts, is commonly applied to them, and also to wood and pottery servant figurines. But the texts do not use the term in any consistent way, nor for that matter do modern studies, and in an attempt to understand the intentions behind tomb furnishings it is probably more distracting than helpful.

6. For a discussion in English (with references to Chinese reports) see Ledderose 2000, chapter 3. For additional illustrations see Qian Hao *et al.* 1981, chapter 4.

7. Ledderose 2000, chapter 3; Beijing 1988a. Considered as a display of military power, the terracotta army might be compared with the chariots and weapons put into tombs of an earlier time. Sofukawa 1989 suggests that it had a protective function similar to that of the guardian figures in Chu tombs.

Fig. 1. Plan of the First Emperor's tomb complex at Lintong near Xi'an in Shaanxi province. Third century BC. After Ledderose 2000, fig. 3.8.

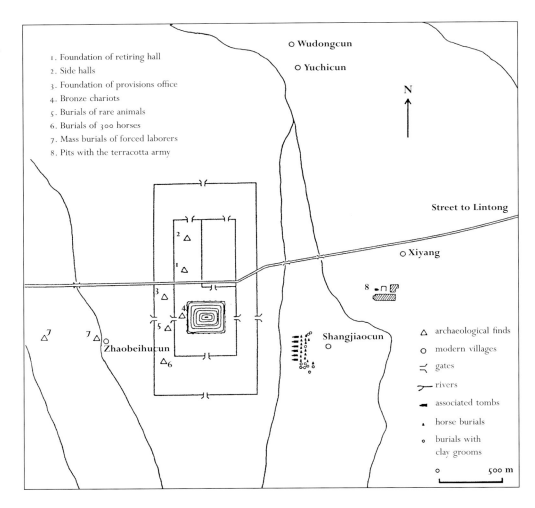

1. Foundation of retiring hall
2. Side halls
3. Foundation of provisions office
4. Bronze chariots
5. Burials of rare animals
6. Burials of 300 horses
7. Mass burials of forced laborers
8. Pits with the terracotta army

o Wudongcun

o Yuchicun

N

Street to Lintong

o Xiyang

Shangjiaocun
o

Zhaobeihucun

△ archaeological finds
o modern villages
⊰ gates
⌐ rivers
◣ associated tombs
. horse burials
o burials with clay grooms

0 500 m

potsherds inscribed with name, place of origin, and punishment; and more dignified burials, perhaps those of the princes and concubines Sima Qian tells us were slain to follow the emperor. Buried at the foot of the tumulus were a bronze cart and a bronze chariot, luxury vehicles for imperial excursions, complete with bronze horses and drivers.[8] Though horses, drivers, and vehicles are only half life-sized, the vehicles are fully detailed models, one of them having 3462 distinct parts, as though size did not matter but completeness did. Buildings above ground included offices of the imperial household administration, a retiring hall with the emperor's garments, and halls where his descendants might have prepared themselves to make ritual offerings to his spirit. Whatever the exact intentions behind particular features of this complex, its mixing of real and representation argues for some sort of equivalence in the afterlife world between real objects, animals, and people, and life-sized or reduced images of them.

The tomb beneath the tumulus has not yet been opened, but a tantalizingly suggestive description of it is given by the historian Sima Qian in his great work *Shiji* (Historical Records), written during the reign of the Han emperor Wudi (r. 141–87 BC):

When the emperor first came to the throne [246 BC] he began digging and shaping Mt. Li. Later, when he unified the empire [221 BC], he had over 700,000 men from all over the empire transported to the spot. They dug down to the third layer of underground springs and poured in bronze to make the outer coffin. Replicas of palaces, scenic towers, and the hundred officials, as well as rare utensils and wonderful objects, were brought to fill up the

8. Beijing 1998h.

tomb. Craftsmen were ordered to set up crossbows and arrows, rigged so they would immediately shoot down anyone attempting to break in. Mercury was used to fashion imitations of the hundred rivers, the Yellow River and the Yangtze, and the seas, constructed in such a way that they seemed to flow. Above were representations of all the heavenly bodies, below, the features of the earth. "Man-fish" oil was used for lamps, which were calculated to burn for a long time without going out.[9]

Whether this tomb had the old form of a shaft burial with a compartmented timber box at the bottom, or was instead a horizontal suite of rooms linked by a corridor as was to become the norm in Han princely burials, Sima Qian does not tell us. Nor, of course, can we be sure that his description is accurate; it might be influenced by what he knew of the royal tombs of his own time. But whether the description applies to a tomb of 210 BC or to one of fifty or a hundred years later, it is of the highest interest for its emphasis on the element of symbolic representations—palaces, towers, rivers, seas, the earth, and the heavens. Evidently the First Emperor's tomb was designed to surround him not merely with the material splendors of his earthly life but with a representation of the cosmos entire.

A design that placed the emperor at the center of a cosmic model would be perfectly in character for him, and also well in tune with the symbolizing impulse behind the vast building projects at his capital.[10] The First Emperor saw himself as a figure of cosmic significance. According to Sima Qian, he ranked himself with the *di* (gods) of the five directions; the title he invented for himself, *huangdi*, which we translate as emperor, may allude to them.[11] On his tours of inspection he left carved inscriptions whose texts Sima Qian preserves for us; according to one of them, "the bright virtue of the August Emperor aligns and orders the whole universe."[12] Perhaps this is the role he meant himself to play for all time in the mausoleum complex that surrounded him.

For such a thing to be conceivable—for a mausoleum to represent the universe—the emperor and his planners had to have an idea of the structure of the universe that lent itself to modeling; even more important, they had to believe that images would be efficacious as components of a cosmic model. As to the first point, our evidence is abundant, though most of it is somewhat later than the emperor's time. The universe described in early Han texts is rather simply built;[13] more tellingly, TLV mirrors of the first century AD show that the universe could be adequately modelled by a perfectly regular geometric diagram (Fig. 2).[14] In view of Sima Qian's description of the First Emperor's capital and tomb, it seems likely that Qin and Han thinkers believed that palaces and tombs could diagram the universe just as the design on a mirror could. By surrounding himself with the rivers of the earth and the constellations of the sky, the First Emperor inscribed himself into the cosmos.

As for the efficacy of images as components of a cosmic model, the servant figurines in Eastern Zhou tombs suggest that long before the First Emperor's time images were understood to function in the afterlife as their originals functioned in this life. But this understanding may have been powerfully reinforced by correlative cosmology,

Fig. 2. Rubbing of bronze mirror back with a TLV design. Diameter 18.5 cm. Reign of Wang Mang, AD 9–25. After Chen Peifen 1987, no. 41. Though some details are uncertain, the general import of such designs is clear: the circular shape represents heaven, the square it encloses is the earth; within the square are a large central boss, perhaps the axis of the universe, and twelve smaller ones, symbolizing the twelve divisions of the heavens; four pairs of bosses outside the square might be pillars holding up the sky; the animals of the four directions appear in the fine decoration outside the square; and so on.

9. Watson 1993, p. 63. Watson has supplied the word "replicas"; the Chinese original speaks of filling the tomb with palaces, towers, and officials. For a survey of texts mentioning the tomb see Wang Xueli 1994, 51–133.

10. See the summary description in Lewis 1999a, p. 650. Sima Qian tells us for instance that a walkway connecting the emperor's principal palace with his capital referred to a celestial counterpart: "An elevated walk extended from Epang north across the Wei River to connect the palace with Xianyang, in imitation of the way in which in the heavens a corridor leads from the heavenly Apex star across the Milky Way to the Royal Chamber star" (Watson 1993, p. 56).

11. Watson 1993, pp. 42–3; Lewis 1999c, p. 69.

12. Watson 1993, p. 51.

13. Typical is the description given in the *Huainanzi*, a philosophical text composed for the ruler of the minor Han kingdom of Huainan, Liu An (*c*. 180–122 BC). For partial translations in English see Le Blanc 1985, Major 1993.

14. For detailed discussion of the symbolism of these mirrors see Loewe 1979, chapter 3. Images of the heavens ancestral to the ones on TLV mirrors appear on cosmic boards; see Harper 1999, pp. 833–43. Archaeological finds (all southern) show that attempts to depict the heavens or the cosmos go back at least to the fourth century BC (Harper 1999, pp. 833–43).

a system of thought that took shape in the third century in the writings of the philosopher Zou Yan (305–?240 BC).[15] Correlative cosmology organized older concepts, for instance the complementary pairs *yin* and *yang* and the five phases or elements earth, wood, metal, fire, and water, into a new and highly structured description of the world in which like was magically correlated with like. Adding new sets of fours and fives—the four seasons, the five directions (including the center), five colors, five sounds, five tastes, five processes, and so on—enabled the description to accommodate and correlate all things. Sima Qian makes it plain that the First Emperor was a follower of Zou Yan's philosophy: he tells us that, since successive dynasties were correlated with the cycle of five elements, the First Emperor chose for his dynasty the element water (and the associated color black) as the one able to quench fire, the element assigned to the preceding Zhou dynasty.[16] Perhaps the emperor conceived his tomb as a correlate of the universe it modelled; perhaps he even supposed that the correlate would exert power on its prototype.

The Sichuan gentry whose tomb furnishings are exhibited here were by no means so ambitious or so exalted in rank as the First Emperor; they were officials, landowners, and merchants. Yet for them too the tomb seems to have been a microcosm. Images— the animals of the four directions appropriately placed, for example—could conjure up in a small space a universe just as vast as the one modelled by the First Emperor's mausoleum complex.

HAN PRINCELY TOMBS

Tombs of the Han imperial family are likely to have been an important intermediary by which the First Emperor's grandiose ideas of funerary symbolism were transmitted further down the social scale. They also show two innovations in construction.[17] The first was to lay the tomb out as a series of rooms linked by a corridor on a horizontal axis. The second was to tunnel such tombs into mountainsides, partly, perhaps, because mountains were believed to give access to spirit realms.[18] Though the tombs of Han emperors have not been excavated, Sima Qian tells us that emperor Wen (r. 180– 157 BC) was interred in a tomb in a mountainside, and rock-cut mountain tombs belonging to imperial princes who ruled states in eastern China have actually been found.[19] The most elaborate such tombs yet excavated are three at Xuzhou in the Han period state of Chu.[20] At Beidongshan the tomb is dug more than 35 m into the hillside and has eight private rooms and eleven service rooms as well as several small storage cavities (Fig. 3). The functions of the rooms are in some cases evident, features such as wellheads and storage pits identifying cooking and food preparation areas. Such tombs of course provide abundant evidence for the conception of the tomb as a dwelling. The rear private rooms even have adjacent lavatories with slots cut in the floor, suggesting that the occupant imagined his afterlife in the tomb very much on the model of his earthly life.[21] The tombs are often guarded at their entrances by small armies of pottery figurines, descendants of the army of the First Emperor.

The grandest of these rock-cut tombs were robbed in antiquity, and little has been found in them. The one exception, from late in the second century BC, is the pair of tombs for the Prince Liu Sheng and his consort Dou Wan at Mancheng in Hebei province (Fig. 4).[22] The approach to the prince's tomb led first to two storage passages left

15. On correlative cosmology see Graham 1989, part 4; Lewis 1999c; Harper 1999.

16. Watson 1961, vol. 2, p. 25; Watson 1993, p. 43.

17. Rawson 1999, pp. 17–26.

18. The use of mountain sites may also be connected with a new taste for stone sculpture and carving (for which see Paludan 1991, introduction).

19. Rawson 1999, Huang Zhanyue 1998.

20. The Xuzhou tombs are at Shizishan (*Wenwu* 1986.12, pp. 1–16; *Wenwu* 1998.8, pp. 4–33; *Kaogu* 1998.8, pp. 1–20); Guishan (*Kaogu xuebao* 1985.1, pp. 119–33; *Kaogu* 1997.2, pp. 36–46); and Beidongshan (*Wenwu* 1988.2, pp. 2–18, 68).

21. A similar lavatory was provided in the late second century AD tomb at Yi'nan in Shandong (Nanjing 1956, plan on p. 3).

22. Qian Hao *et al.* 1981, pp. 126–37; Beijing 1980d.

and right of the main axis. Beyond these was a large chamber, within which a tile-roofed hall of some perishable material seems to have been constructed. Inside the hall were vessels of pottery and bronze in shapes suggesting that the prince and his consort expected to have elaborate meals here. At the rear of the main chamber a doorway led to another room, this one lined with stone slabs. Here the prince was interred in a stone coffin. In the center of the room were fine inlaid bronze vessels and also small bronze fittings, perhaps the remains of a bronze-mounted table. A small side chamber contained additional vessels and figures of servants. The walls of this tomb and others like it were probably decorated with images. Painted fragments found in an as yet unpublished tomb at Yongcheng in Henan demonstrate that one tomb at least had figures of dragons and other auspicious creatures painted on a red ground. Others may have had silk hangings painted or embroidered with images.

The Sichuan tombs that supplied the bricks and figurines in the present exhibition are two or three centuries later than these Western Han princely tombs, remote from them in space, and even more remote on the social scale. Nevertheless the precedents of design and conception set by the princely tombs are constantly echoed in them. They are afterlife dwellings magically furnished with necessities and comforts, magically in touch with a teeming spirit world, and magically aligned with the cosmos.

Fig. 3. Reconstruction drawing of the Western Han tomb at Jiangsu Xuzhou Beidongshan. Second century BC. After Li Yinde 1990, fig. 1.

Fig. 4. Reconstruction drawing of the interior of the tomb of Liu Sheng at Hebei Mancheng. Second century BC. After Fong 1980, p. 326 fig. 112.

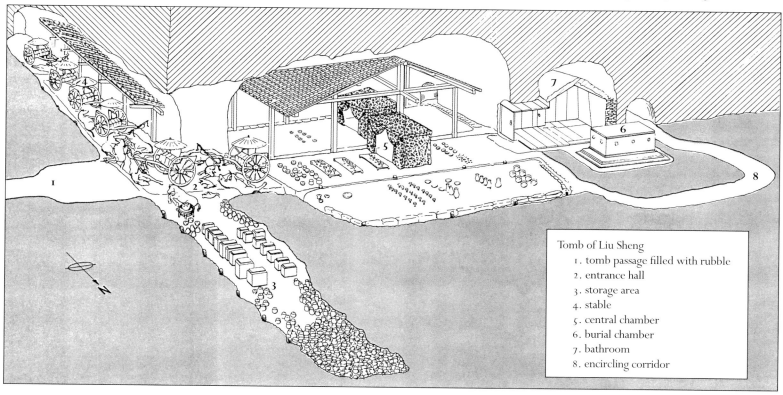

Tomb of Liu Sheng
1. tomb passage filled with rubble
2. entrance hall
3. storage area
4. stable
5. central chamber
6. burial chamber
7. bathroom
8. encircling corridor

Tombs and Tomb Furnishings of the Eastern Han Period 259

DEITIES, SPIRITS, AND THE QUEST FOR IMMORTALITY

Bringing together territories in which countless deities and spirits were worshipped, political unification under Qin and Han both expanded and unified the spirit world. In texts such as the *Huainanzi,* the *Chuci* (Songs of the South), and the *Shanhaijing* (Classic of Mountains and Seas) we glimpse a multitude of supernatural beings.[23] The texts bring order to the multitude by mapping the spirits onto a sacred geography that included the known world but extended beyond it to densely populated fantastic realms: deities and demons, though free to roam, were thought to live in particular places. This strongly spatial conception made it easy to incorporate supernatural beings into the microcosm of the tomb, and they seem eventually to have become its most important features. In the afterlife the tomb owner apparently hoped to make excursions to their realms.

The variety of the deities and the strength of their geographic ties can be illustrated by Sima Qian's accounts of the Qin emperor and of his own emperor, Han Wudi. Both emperors venerated the *di* of the five directions, the Eight Spirits (lords of the heavens, of the land, of arms, of *yin* and *yang,* and of the moon, sun, and four seasons), and the spirits of certain mountains and rivers.[24] Both sought the support of numerous deities by sacrificing to them and by ordering officials to set up altars in different parts of the country.[25] The Qin emperor was obsessed with the east.[26] In Shandong province he ascended Mount Tai and offered sacrifices to the Celestial Deity, and his example was followed by Han Wudi; in both reigns these were momentous occasions on which the emperor claimed the support of the highest deity.[27] A place near Mount Tai called Haoli was thought by some to be the entry to the underworld. In the course of the Han period, both the underworld and the realm of the Celestial Deity came to be thought of as staffed by bureaucracies similar to those known from this world.[28] Texts found in tombs are addressed to such underworld bureaucrats as the Lord of the Underworld, the Assistant Magistrate of the Underworld, and the Assistant of the Dead.[29]

The mountain with supreme potency in the world of the afterlife was not Mount Tai but Mount Kunlun. Today the name Kunlun is applied to a range of mountains along the southern edge of the Taklamakan desert in Xinjiang province, but in earlier times it may have referred to quite other mountain ranges. It occurs in texts of the fourth and third centuries BC, and it appears several times and in different guises in the *Huainanzi*. In John Major's words, "Kunlun has two closely related aspects. First, it is the world-mountain or *axis mundi,* the pillar that at once separates and connects heaven and earth Second, Kunlun is a paradise, a magical and beautiful land that is the home and kingdom of Xiwangmu, the Queen Mother of the West."[30] Kunlun became a metaphor for the great heights beyond which lay the palaces of the deities in the stars, palaces described in visionary terms in the *Huainanzi* and in Han poetry of the genre *fu,* or rhapsody.[31] Other mountains as well were places for meeting with spirits; Sima Qian ascribes the Yellow Emperor's success in ascending to heaven and becoming an immortal to his frequent communing with spirits on the five principal sacred mountains.[32]

The Queen Mother of the West was undoubtedly the most popular deity in Sichuan (Nos. 97, 98, 108).[33] She seems to combine notions that originated in several different parts of China. A deity of this name is mentioned in passages of uncertain date

23. For the *Huainanzi* see note 13. The *Chuci,* our one surviving literary text associated with Chu, is a body of poetry of the late Warring States and early Han periods (fourth to first century BC; for an English translation see Hawkes 1985). It vividly describes the interaction of humans with spirits, immortals, and fierce denizens of the periphery. The *Shanhaijing* is a Han text, parts of which are probably of Warring States date (for an English translation see Birrell 1999). It purports to be a straightforward account of geography but is in fact a description of marvels and miraculous creatures assigned to locations that are specified mainly by giving the distances between them; many of the creatures are identified by reference to the names of mountains and rivers.

24. Watson 1961, vol. 2, pp. 24–9. The imperial court was especially interested in deities, beliefs, and practices originating in eastern and southern areas that had earlier belonged to the states of Chu and Qi (Major 1993, p. 2; Rawson 1997).

25. Watson 1961, vol. 2, pp. 13–69 ("The Treatise on the Feng and Shan Sacrifices").

26. Sima Qian describes his eastern tours and quotes his stela inscriptions (Watson 1993, pp. 46–53).

27. The Celestial Deity is possibly to be identified with the Yellow Emperor, who was regarded as a historical figure who had achieved immortality (Lewis 1999c; compare slightly different views in Seidel 1987a and Wu Rongzeng 1981).

28. Seidel 1987a.

29. The longest and fullest accounts of these officials date from the second century AD, but some as early as the third and second centuries BC are known (Poo 1998, pp. 167–70; Harper 1994).

30. Major 1993, p. 155.

31. Major 1993, p. 158.

32. Watson 1961, vol. 2, p. 51.

33. On the Queen Mother and her cult see Francasso 1988; Loewe 1979, chapter 4; Wu 1987.

(anywhere from the fourth to the first century BC) in the *Zhuangzi,* which in describing the Dao says: "Xiwangmu obtained it and took up her seat in Shaoguang; nobody knows her beginning or her end."[34] Other texts give her demonic qualities and appearance. Like so much in Han thought, her dwelling was assigned a geographical location:

> Tiaozhi is situated several thousand *li* west of Anxi [Parthia] . . . The old men of Anxi say they have heard that in Tiaozhi are to be found the River of Weak Water and the Queen Mother of the West, though they admit that they have never seen either of them.[35]

The River of Weak Water was thought to spring from the slopes of Kunlun. The Queen Mother's kingdom there was spoken of and sought after as the source of peaches and herbs that would confer immortality. In some pictures the Queen is shown accompanied by a hare who pounds the herbs. A tomb owner who put her image in his tomb probably hoped through it to come into her presence, and indeed No. 108 shows the occupant offering his respects to the Queen Mother. However, the deceased probably did not expect to go permanently to her realm, or to a paradise of immortals, but rather to live in his tomb and to visit paradises, just as exotic lands might be visited in this life.[36] Depictions of the Queen Mother may have been inspired by images of the Buddha. Traces of Buddhism are already evident in the Eastern Han period, and Sichuan has provided some of the earliest images of the Buddha known from China (Fig. 108.1).

Two other deities commonly seen in Han tombs, sometimes in company with the Queen Mother (Figs. 9, 108.3), are the creation goddess Nüwa and her consort Fuxi.[37] In Han texts Nüwa is described as the creator of mankind, a role hinted at earlier in a brief passage in the *Tian wen* (Heavenly Questions, part of the *Chuci,* probably fourth century BC).[38] Han writers also credit her with repairing the damage after a cosmic conflict broke the pillars that support the heavens. It does not seem that Fuxi was originally her consort; third or second century BC references to him in the *Dazhuan* commentary to the *Yijing* instead make him the first of the ancient sage kings, the ruler who taught mankind to hunt and fish and who invented writing and the trigrams.[39] In Han depictions, however, the two are normally paired. Although textual accounts are not very full, it is clear that they had become important gods by the end of Western Han, and they appear in tomb decoration from the first century BC. They are usually depicted with serpent bodies, and in Sichuan they often hold the moon (*yin*) and the sun (*yang*), as on No. 109.

Although no full account of the deities, spirits, immortals, monsters, and demons that peopled the Han imagination can be given here, a few more will be encountered below, as we turn to the Eastern Han tombs in Sichuan from which the bricks and figurines in the present exhibition come.

EASTERN HAN SICHUAN

During Western Han the predominant tomb type in Sichuan was the vertical shaft with nested wooden coffins at the bottom, descendant of the Warring States type.[40] This was superseded in Eastern Han by burials of two distinct kinds, rock-cut tombs and underground brick tombs. Both had appeared earlier in north China. The rock-cut tombs, the most impressive Sichuan burials, were cut into cliff faces and had

34. Francasso 1988, p. 7.

35. Watson 1961, vol. 2, p. 268, romanization changed to pinyin.

36. Nickel 1997. On the afterlife of the tomb occupant see Seidel 1987a, Harper 1994. On Han conceptions of the soul see Brashier 1996, and compare alternative views in Yü 1987.

37. On Nüwa and Fuxi see Bodde 1961, pp. 386–9; Lewis 1999b, pp. 197–209.

38. Hawkes 1985, p. 130; Bodde 1961, p. 389.

39. Lewis 1999b, p. 197.

40. For a Warring States tomb see *Wenwu* 1981.6, pp. 1–12; for a Qin tomb, Chapter 4, Fig. 9; for a Han tomb with fine figures in wood see *Wenwu* 1996.10, pp. 4–12.

Fig. 5. Plan and view of entrance, Shiziwan cliff tomb no. 1, Leshan. Second century AD. After Tang Changshou 1997, figs. 2–3.

41. Lim 1987, pp. 194–9; Tang Changshou 1997; Beijing 1991c; *Wenwu* 1993.1, pp. 40–50, 16.

42. Beijing 1998f, pp. 350–81.

43. For brick tombs see *Wenwu* 1961.11, pp. 35–42; *Wenwu* 1977.2, pp. 63–9; *Wenwu* 1980.2, pp. 56–7; *Wenwu* 1981.10, pp. 25–32; *Kaogu* 1984.1, pp. 63–8.

44. For stone coffins see *Wenwu* 1975.8, pp. 63–5; *Kaogu* 1979.6, pp. 495–503; *Wenwu* 1991.3, pp. 20–25; *Wenwu* 1992.4, pp. 45–52; *Wenwu* 1993.1, pp. 40–50; Lim 1987, pp. 178–81.

45. Tomb figures and models were also occasionally made of stone in Sichuan, a practice rare elsewhere; for examples from a tomb at Leshan see *Wenwu* 1993.1, pp. 40–50, 16.

46. For a general account of painted, carved, and molded decoration in late Western Han and Eastern Han see James 1996. For late Western Han tombs with painted ceilings at Luoyang see Gao & Gao 1996, Beijing 1996e.

47. On these reliefs see Wu 1989, Powers 1991.

48. For a stone coffin from Leshan see *Wenwu* 1993.1, pp. 46–50. For the Yangzishan brick tomb (Figs. 6–7) see Lim 1987, pp. 183–93.

several separate chambers (Fig. 5). The most magnificent are at Pengshan and Leshan, south of Chengdu.[41] Slightly later examples at Santai are even more obviously modelled on houses, the ceilings of the rooms being carved to resemble tiled roofs.[42] Brick tombs were less costly and more common, but they too imitated residences with several rooms (Figs. 6–7).[43] In both rock-cut and brick tombs the deceased was often placed in a stone coffin.[44]

Pictorial decoration was carved on stone coffins, on the walls of cliff tombs, and on stone slabs set in brick tombs; it could also be molded on bricks like the ones in the exhibition (Nos. 99–109). Pictures might be supplemented by three-dimensional representations, such as pottery figurines (Nos. 110–18) and pottery models of estate buildings (Fig. 8).[45] Whether in two or three dimensions, these images all served the same functions: they made the tomb into a microcosm centered on the deceased, claimed for him a high place in the afterlife hierarchy, furnished his needs, supplied comforts, and protected him from dangers. Decoration and imagery serving these functions did not originate in Eastern Han Sichuan; it was well established earlier in Henan and Shandong, in stone and brick tombs of the late Western Han period.[46]

To suggest the character of this art outside Sichuan we might look briefly at the stone reliefs of Shandong, where densely crowded scenes were cut into large stone slabs, often in high relief (Figs. 9–10, 101.1, 101.4, 102.1).[47] Activities are sometimes given architectural settings, following the precedent of certain Warring States bronze vessels (Fig. 73.1). The decoration of a slab might consist of several unrelated scenes of different sizes, separated by rectangular frames and crowded together to give the effect of complex compositions. In Figure 9, for instance, a scene centered on the Queen Mother of the West is placed immediately above a separate scene of an outing in carts. Complexity increased further with the introduction of overlapping in the second century AD.

Sichuan scenes are organized somewhat differently, and they differ in style and feeling as well. Two formats might be distinguished. Long rectangular spaces were available on the sides of stone coffins, on the walls of rock-cut tombs, and on stone slabs set in brick tombs.[48] In these locations scenes with very dense groupings of figures might be organized in a single register (Fig. 7). The bricks shown in the present exhibition represent a second format: relatively small, most of them show isolated self-contained scenes. Identical scenes occur on bricks from different sites,

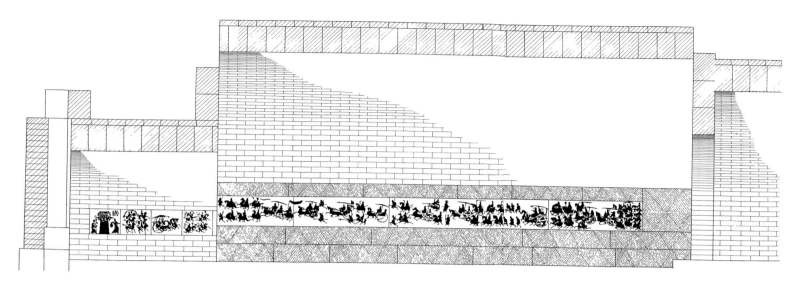

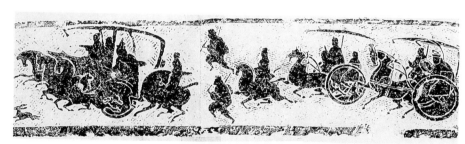

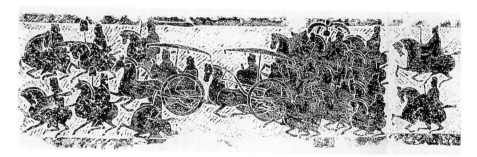

Fig. 6. Cross-section drawing of a brick tomb at Chengdu Yangzishan, showing stone reliefs in wall. Main chamber 7 m long, 3.5 m high. Second half of second century AD. After Lim 1987, pp. 192–3. For a reconstruction model of this tomb, see Introduction Part 2, Figure 12. The reliefs shown in the cross-section drawing are those on the far wall of the tomb. The ones shown as a separate strip above the cross-section drawing are those on the near wall; thus the gate tower at the right end of that strip is in fact at the entrance to the tomb, opposite the gate tower in the cross-section drawing. The visitor entering the tomb passes between the two gate towers and sees on his left a carriage entering the tomb, on his right a carriage emerging.

Fig. 7. Rubbings of carriages and horsemen from the Yangzishan tomb shown in Figure 6. Second half of second century AD. After Beijing 1998g, nos. 150–51.

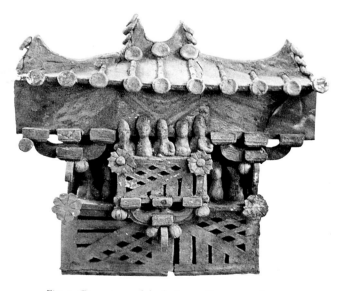

Fig. 8. Ceramic model of a house from a tomb at Zhong Xian. Height 45 cm. Second century AD. After Wenwu 1985.7, color pl. 1.1.

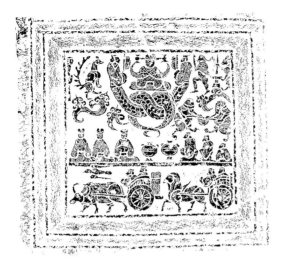

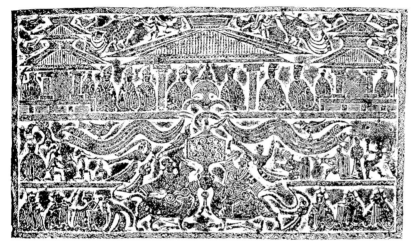

Fig. 9. Rubbing of a stone slab from Shandong Teng Xian. Nüwa and Fuxi, their tails intertwined, flank the Queen Mother of the West. Second century AD. After Shandong 1982, no. 281.

Fig. 10. Scene showing tomb occupant and spouse within a building, the building flanked by *que* (towers). Auspicious creatures appear on the roofs. From Shandong Weishan. First or second century AD. After Shandong 1982, no. 34.

49. Rather similar bricks have been found in Hubei province (*Wénwu* 1991.1, pp. 66–72), suggesting that the scenes, if not the actual bricks, were used over a broad area.

50. Wu 1998. Alternatively the arrival and departure of funeral guests might be intended.

51. On images of barbarians in Han tombs see Zheng Yan 1998a. For an elaborate depiction of the battle on the bridge from a tomb at Shandong Yi'nan see Nanjing 1956, rubbing no. 1.

52. Knechtges 1987, p. 273.

suggesting that a single workshop provided bricks for many tombs.[49] Whether in brick or in stone, the Sichuan designs are notable for the vigorous movement of people, horses, and chariots.

Though details were subject to immense variation, a repertoire of themes for tomb decoration was common property all the way from Sichuan to Henan to Shandong. The gate pillars erected at entrances to graveyards (Fig. 99.1), where they were probably understood as gates to the world of the spirits and the afterlife, are often depicted in Sichuan tombs, often near the entrance (Fig. 6, No. 99). The tomb occupant could enter and leave his tomb, generally riding in a chariot or cart, and carriage journeys are a recurrent theme in Sichuan (No. 100). By contrast with the tight linear processions on long narrow slabs typical of Shandong, in Sichuan the chariots and carts are often set one to each brick and convey a sense of movement. Processions of chariots are shown both going into and leaving the Yangzishan tomb of Figures 6 and 7. The first procession may depict the arrival of the deceased at his new dwelling, the second a visit or some other excursion.[50] Often in Shandong and occasionally in Sichuan the carriages cross a bridge; sometimes the bridge is the scene of a battle between Han troops and strange people called *hu* (barbarians).[51] Texts locate the *hu* in a liminal region between the known world and the world where spirits dwell. A Han rhapsody describes them vividly: "Brave, horrid-headed, gaping like eagles/ With hollow skulls, beetled brows, bulging eyes/ Their visages as if saddened by this perilous place."[52] Battles with them might signify perils encountered by the deceased on his way to Kunlun and the Queen Mother of the West.

At home in his tomb, the deceased presided over a prosperous rural environment. Sichuan tombs are undoubtedly best known for their placid scenes of fishing, farming, and other activities of a fertile land. The owner did not have to depend on stores of actual food, for his tomb contained, in the form of pictures and models, the estates and activities that brought him food and wealth. The tomb pictures have attracted much interest and study for their illustrations of daily life: the types of boat used for fishing (No. 105), the way birds were hunted (No. 106), activities such as salt production (No. 104) and alcohol distillation (No. 103). They give a unique abundance of clear and specific detail, presented with disarming naturalness—a naturalness that makes it too easy for us to forget the deeper significance that could attach to labors of the seasons, annual feasts, and the like. The builders of tombs elsewhere were content with much more generalized scenes.

Nevertheless while it is these scenes of daily life that have been most frequently illustrated and exhibited, other rather different images—gates, carriages, animals of the four directions, feasts and entertainments—are more common and presumably were more essential to the deceased. Scenes of feasting appear both on molded brick, where small groups of five or six fill a rectangular panel (No. 101), and on stone coffins, where a wider composition was possible. Dancers, musicians, and acrobats

often join the banqueters (No. 102). The entertainment scenes found in Sichuan seem to represent selections from a range of entertainments that was to some degree standard throughout China and that was more fully depicted elsewhere, for instance in tombs in Shandong and Jiangsu.[53] In the most complex and vivid example known, from Shandong Yi'nan, we see sword games, balancing acts, spectacular dancing, and processions (Fig. 102.1). The dancers, who often have long swirling sleeves (No. 102), have predecessors in Warring States jades and pictorial bronzes.[54] It has been suggested that they and the feasting they enliven were intended to bring deities and spirits to join the feasters, and references in poetry likewise indicate that such entertainments were directed at an audience of spirits as well as living guests.[55] Both in this life and in the tomb, the realm of the everyday and that of the spirits merged seamlessly into one another.[56]

Fig. 11. Rubbing of the red bird of the south from the Shen family tomb at Qu Xian. After Beijing 1998g, no. 318.

Fig. 12. Stone coffin from the tomb of Wang Hui, from Lushan, with rubbings of the designs on four sides. AD 211. After Beijing 1998g, no. 486; Gao & Gao 1996, figs. 3–5.

 a. Figure of a winged immortal at a half-open door (south side of the coffin).
 b. Green dragon of the east.
 c. White tiger of the west (tiger's head but dragon's body).
 d. Black warrior of the north (tortoise and snake).

a

b

c

d

53. *Wenwu* 1990.4, pp. 61–8; Sun & Liu 1987.

54. Discussed in Erickson 1994a (see her figs. 29–30). For jade dancers see Lawton 1982, pp. 132–6.

55. Erickson 1994a; Falkenhausen 1995b; for poetry, see Hawkes 1985, pp. 101–2.

56. Knechtges 1987, pp. 107–8.

Fig. 13

Fig. 14

Fig. 16

Fig. 15

Fig. 13. Rubbing of a brick showing jade disks joined by ribbons, from Qu Xian. Second century AD. After Beijing 1998g, no. 390.

Fig. 14. Rubbing of a brick showing coins joined by ribbons, from Chengdu. Second century AD. After Beijing 1998f, no. 381.

Fig. 15. Rubbing of a dragon hanging onto a ribbon tied to a jade disk, from a *que* (tower) at Qu Xian. Second century AD. After Beijing 1998g, no. 282.

Fig. 16. Rubbing from a stone coffin showing a dragon and a tiger tugging at a disk, from Pi Xian. Second century AD. After Beijing 1998g, no. 289.

Fig. 17. Rubbing of a brick showing two figures hauling a bronze tripod from a river, from Pengzhou. Second century AD. After Beijing 1998g, no. 239.

Deities and spirits, components of the microcosm surrounding the deceased, were abundantly represented in his tomb. The animals of the four directions—the green dragon of the east, the white tiger of the west, the red bird of the south, and the black warrior (usually shown as a tortoise and snake) of the north (Figs. 11–12)—are often encountered. Such creatures had been linked with the cardinal directions at least as early as the fifth century BC,[57] but it was only in the Han period that they regularly appeared in the tomb, aligning it and its occupant with the universe. The sun, moon, and constellations also appear, as do Nüwa, Fuxi, and the Queen Mother of the West.[58] Magical landscapes of mountains and clouds inhabited by animals, monsters, and immortals are a constant theme; perhaps isolated supernatural creatures such as winged horses should be understood as abbreviations of them.[59]

Fig. 17

57. A famous instance from the fifth century BC is the pair of creatures, dragon and tiger, on a clothes box from the tomb of Marquis Yi of Zeng (Beijing 1989, p. 376 fig. 16; Rawson 1996, p. 21 fig. 11).

58. Dien *et al.* 1985, pp. 1223–34; *Wenwu* 1977.6, pp. 1–11.

59. The creatures in these landscapes and cloudscapes may owe something to Warring States bronzes (e.g. Zhengzhou 1995, no. 668, a *hu* from Henan Hui Xian Liulige).

Some of the deities and supernatural beings may have served auspicious or protective purposes in the tomb. This was certainly the purpose of many other motifs, for instance depictions of jade disks joined by ropes or cords.[60] Disks linked by crisscross cords are a common motif (Fig. 13), the disks sometimes being replaced in Sichuan by cash coins that agreed better, perhaps, with local ideas of good fortune (Fig. 14). Other local designs show a disk suspended from a silken ribbon over the head of a directional tiger or a dragon (Fig. 15) or a disk tugged like a toy between a dragon and a tiger (Fig. 16).

Texts suggest that much of the decoration we find in tombs would have appeared on the walls of palaces and grand houses as well. A rhapsody by Wang Yanshou describes the Hall of Numinous Brilliance:

> Here they have painted Heaven and Earth,
> Multiform beings of every type and kind:
> Various Creatures wondrous and strange,
> Mountain demons, sea spirits . . .
>
> . . .
>
> Above they record the Opening of Chaos,
> The beginnings of remote antiquity.
> The Five Dragons flying wing to wing,
> The Nine Sovereigns of Men,
> Fuxi's scaly body
> Nugua's [=Nüwa's] serpent torso.[61]

The Nine Sovereigns of Men were sage kings of remote antiquity. They are depicted in a few Sichuan tombs (and many tombs in eastern China), and along with them, sometimes, great philosophers such as Confucius and Laozi. What may strike us as an odd mixing of the supernatural, the legendary, and the human no doubt seemed perfectly natural to people who knew that the Yellow Emperor had once been a human ruler and that the Zhou king Mu had once visited the Queen Mother of the West. Edifying stories appear as well. The most popular one told of the First Emperor's attempt to haul from the Yellow River a set of bronze *ding* embodying the legitimacy of the Zhou dynasty; his failure showed his unworthiness and by implication the legitimacy of the Han. In Shandong the story was elaborately rendered in a detailed setting, but in Sichuan it was often epitomized, reduced to a single large *ding* flanked by two small figures pulling on ropes (Fig. 17). Sichuan's reshaping of the shared pictorial repertoire of Eastern Han tomb decoration involved the extreme abbreviation of some subjects, the loving elaboration of others—detailed evocations of rural life and industry, mundane pleasures depicted with lively informality, supernatural realms and beings drawn with energy and imagination.

60. On jade disks in the Han period see Rawson 1999, pp. 29–32.
61. Knechtges 1987, pp. 273–4.

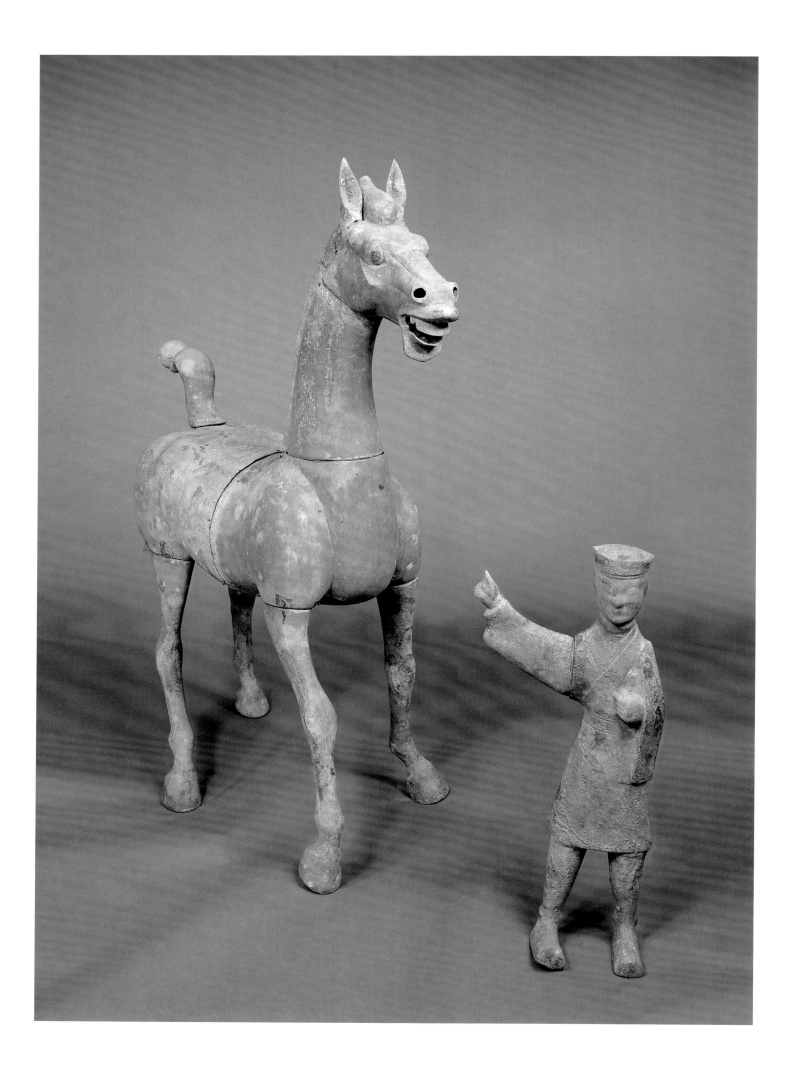

Attended by a bronze groom, this very large horse was made in nine separate pieces—two for the head and neck, two for the body, four for the legs, and one for the tail. Assembly from parts made separately had the advantage of bypassing the technical problems of a large one-piece casting, but it might also reflect the influence of joinery, for it seems to have been suggested by horses made of wood. Pottery horses that once had wooden legs, now decayed away, are known, as well as pottery horses in which head and body are separate parts even though the parts could easily have been joined before firing (No. 96, Fig. 96.1).[1] Actual wooden horses (some carved in one piece) have been found in Sichuan, though they are less common and usually less well preserved than the pottery ones.[2] The persistence of an assembly method derived from wood suggests that, regardless of material, all these horses belong to an older tradition of wooden tomb figurines associated particularly with late Warring States Chu. Bronze examples would simply have been especially fine and costly versions.

All members of the Han elite needed good horses to draw their carriages, and horses are frequently depicted in tombs, as for instance on the brick No. 100. Such depictions are especially prominent in western China, perhaps because of its proximity to the region from which the best horses came. A miniature but magnificent cavalcade of horses and chariots in bronze from a late Han tomb (second century AD) at Wuwei in Gansu includes the oft-reproduced "flying" horse, its hoof touching a bird on the wing.[3] A large bronze horse from Guangxi, 115.5 cm high, was, like No. 95, made in nine pieces.[4] Identical in size but made in fewer pieces is a horse from a Hebei site.[5] A Western Han horse found in Shaanxi is smaller, 62 cm high, and rather stiffly posed, but entirely gilded.[6]

Horse breeding in China did not produce the finest horses, nor was it ever able to meet the demand of Han armies for cavalry horses. Fine stock had always to be imported from the western and northern borderlands; procurement of horses was one objective of the Han emperor Wudi's Central Asian campaigns.[7] Central Asian horses were so extravagantly admired that the western regions—imagined location of all sorts of deities, spirits, and fabulous creatures—came to be thought of as the home of supernatural, "heavenly" horses. A poem which the *Hanshu* attributes to the emperor says

> The horse of Heaven has come
> Open the far gates
> Raise up my body
> I go to Kunlun
>
> The horse of Heaven has come
> Mediator for the dragon
> He travels to the gates of Heaven
> And looks on the Terrace of Jade.[8]

The winged horses often depicted in tombs may refer to such heavenly horses.[9]

Horse and groom

Bronze
Height of horse 135 cm, height of groom 67 cm
First or second century AD (Eastern Han)

Excavated in 1990 from Mianyang Hejiashan tomb 2

Mianyang Museum

PUBLISHED: *Wenwu* 1991.3, pp. 9–19, pl. 3; Beijing 1997g, no. 83.

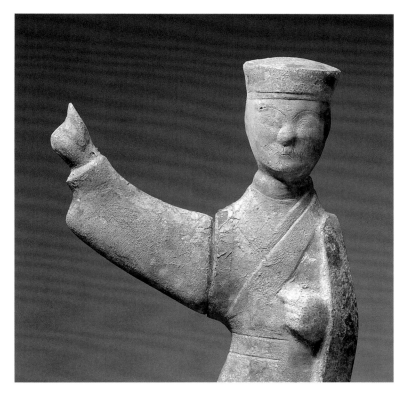

Fig. 95.1. No. 95, detail.

1. For large ceramic horses from Sichuan see *Wenwu* 1985.7, p. 65 fig. 26; Lim 1987, p. 114. *Wenwu* 1993.1, p. 44 fig. 12.1, shows an example in stone.

2. For Western Han examples see Introduction Part 2, Figure 11, and *Wenwu* 1996.10, pp. 13–29, a tomb containing a hundred wooden horses (see especially the color plate facing p. 16).

3. Beijing 1998d, pls. 144–50, 158 (the flying horse); *Kaogu xuebao* 1974.2, pp. 87–109; London 1973, nos. 206–22; Qian Hao *et al.* 1981, chapter 7.

4. Beijing 1998d, pl. 141; *Kaogu* 1984.1, pp. 59–62, 68, pl. 8.3.

5. Beijing 1998d, pl. 159. For a stone example from Hebei see Beijing 1980c, no. 256.

6. Beijing 1998d, pl. 154.

7. Watson 1961, vol. 2, pp. 274–5.

8. Quoted after Wu 1984, p. 43.

9. E.g. Beijing 1998g, no. 262. A particularly lively painting of heavenly horses appears in a post-Han tomb at Jiuquan Jiayuguan, Gansu province (*Wenwu* 1979.6, pl. 2.2).

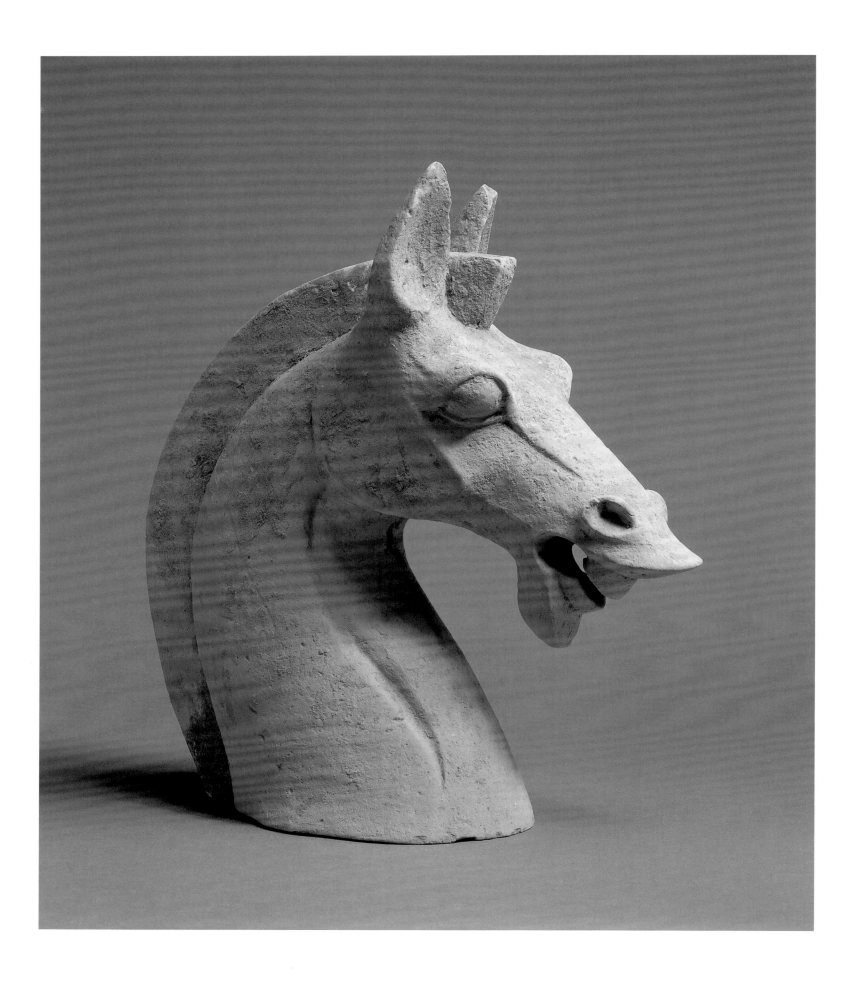

96

Head of a horse

Ceramic
Height 39 cm
First or second century AD (Eastern Han)
Mianyang Museum E536

This head and proudly arched neck presumably once belonged to a complete figure that was, like the bronze horse No. 95, made in several parts (compare Figure 96.1). As mentioned in the entry for No. 95, horses were much prized in the Han period and were celebrated in large tomb figures as well as in pictorial art.

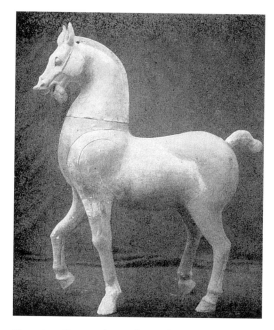

Fig. 96.1. Ceramic horse from Chengdu Tianhuishan cliff tomb no. 1. Height 114 cm. Second century AD. After *Kaogu xuebao* 1958.1, pl. 9.3 following p. 103.

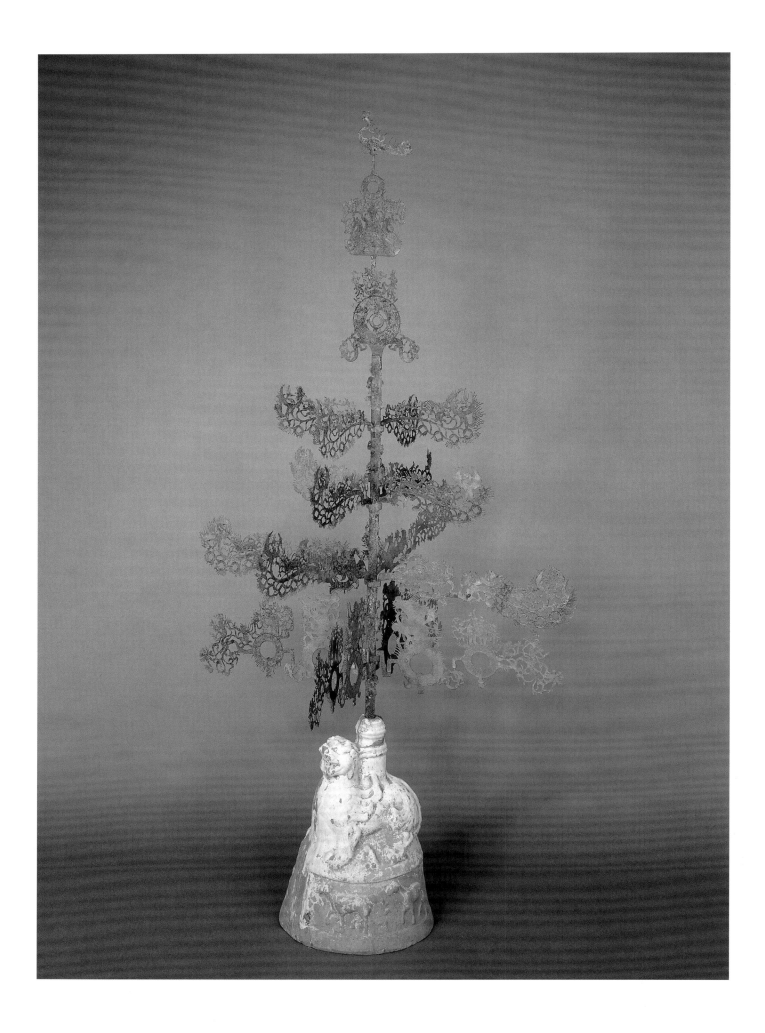

Money tree

Bronze and ceramic
Height 198 cm
Second century AD (Eastern Han)

Excavated in 1990 from Mianyang Hejiashan
tomb 2
Mianyang Museum

PUBLISHED: *Wenwu* 1991.3, pp. 9–19, pl. 4;
Erickson 1994b, fig. 31; Beijing 1997g, no. 82.

This tree comes from the same cliff tomb as the
bronze horse and groom No. 95. Its mold-made
ceramic base supports a bronze trunk and branches.
Base and branches alike are crowded with magically
charged images, among them the coins from which
these strange artifacts take their modern name
(and also their ancient one, which apparently was
"coin pillar"). Money trees were a Sichuan specialty;
a distribution map plotted by Susan Erickson, a
pioneer in their study, shows that finds concentrate
overwhelmingly in Sichuan, with only scattered out-
liers in neighboring provinces (Fig. 97.1). Datable
examples range from just before to just after the
second century AD.

The bases, usually ceramic but sometimes stone,
survive better than the thin and fragile bronze parts
of the trees, and they are often found by themselves.[1]
Many represent mountains with winged or horned
animals climbing on them. Perhaps Mount Kunlun is
intended; one base takes the form of hills and caverns
surmounted by a figure who might be the Queen
Mother of the West.[2] In the present case a winged
feline crouches on the mountaintop, its back carrying
the socket for the tree trunk. Lower down, horses
and oxen shown in relief walk in procession around
the base.

The branches of money trees abound with coins,
disks, birds, and miraculous creatures (Fig. 97.2a–g).
The Queen Mother of the West often appears, some-
times with attendants and sometimes, to entertain
her, dancers, musicians, and acrobats. A bird is often
perched at the very top, either a bird of good omen
(in Han texts *fenghuang* or *luan*), or the bird that
brings the sun each morning, or possibly the red bird
of the south. On the present tree the bird surmounts
a disk; the disk in turn rests on the headdress of the
Queen Mother, who sits with folded hands on her
dragon-and-tiger throne (Fig. 97.2a). Below the
Queen is a second, larger disk, this one with dragons

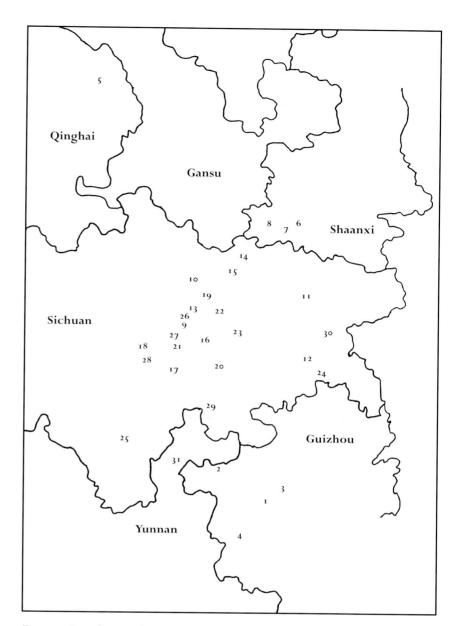

Fig. 97.1. Map showing distribution of finds of money trees.
After Erickson 1994b, p. 41.

Guizhou
1. Anshun
2. Hezhang
3. Qingzhen
4. Xingren

Qinghai
5. Datong

Shaanxi
6. Chenggu
7. Hanzhong
8. Mian

Sichuan
9. Chengdu
10. Chuanbei
11. Da
12. Fuling
13. Guanghan
14. Guangyuan

15. Jiange
16. Jianyang
17. Leshan
18. Lushan
19. Mianyang
20. Neijiang
21. Pengshan
22. Santai
23. Suining
24. Wulong
25. Xichang
26. Xindu
27. Xinjin
28. Ya'an
29. Yibin
30. Zhong

Yunnan
31. Zhaotong

1. For bases see Erickson 1994b,
pp. 9–18; *Wenwu* 1961.11, pp.
43–5.

2. Lim 1987, p. 23; Erickson
1994b, fig. 27.

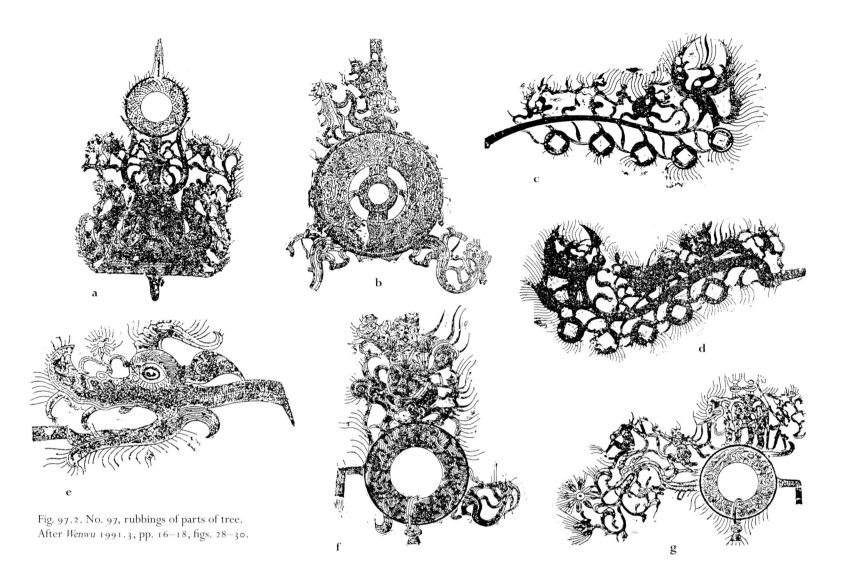

Fig. 97.2. No. 97, rubbings of parts of tree.
After *Wenwu* 1991.3, pp. 16–18, figs. 28–30.

3. On elephant imagery see
Erickson 1994b, pp. 13–14.

4. Erickson 1994b, p. 14.

5. Erickson 1994b, fig. 17b (and
see pp. 14–15).

6. Erickson 1994b, fig. 57; *Kaogu
xuebao* 1974.2, pl. 13 following
p. 109. Compare a tree-like
ceramic lamp from Luoyang
(Rawson 1996, no. 97; Erickson
1994b, fig. 59); such lamps have
been found in Sichuan (*Wenwu*
1999.8, p. 33 fig. 33.5). Elabo-
rately branched lamps that unam-
biguously represent trees go
back at least to the fourth cen-
tury BC, on the evidence of a
spectacular bronze example from
a Zhongshan royal tomb of about
310 BC (Qian Hao *et al.* 1981,
p. 41; Erickson 1994b, fig. 54;
Beijing 1995e, vol. 2, color
pl. 13.2).

and other figures projecting from its outer perimeter
and a small disk supported on struts at its center
(Fig. 97.2b). Below this comes the topmost set of four
branches, each with strange creatures dancing along
its upper edge, a bird with upraised wings at its tip,
and a fringe of coins along its lower edge (Fig. 97.2c).
The next four branches (Fig. 97.2d) are held in the
mouths of large dragon heads (Fig. 97.2e) that project
from the trunk; these branches too end in birds with
raised wings, and along their top edges animals are
being chased. The next four are similar to the previ-
ous set but mounted directly in the trunk, rather than
held by dragon heads. The four branches at the bottom
are the most elaborate, and the only ones without
a fringe of coins. Instead they incorporate disks, a
large disk supporting an energetic demon expeller
(Fig. 97.2f) and a smaller one supporting an elephant
carrying urns (Fig. 97.2g).[3]

The form of these branches, thin plates of filigree
openwork, indicates that they were cast in flat two-
piece molds. Han coins were cast in similar molds,

typically a dozen at a time; since each coin was joined
to its neighbors by the pouring channels, the coins
came out of the mold in sheets that have an obvious re-
semblance to the branches of money trees (Fig. 97.3).[4]

Undoubtedly one part of the auspiciousness of the
money tree lay in its very literal promise of unending
prosperity. On one ceramic base, we see coins being
harvested from trees (Fig. 97.4); on another, men
with poles over their shoulders carry the coins away.[5]
However, coins and coin casting are only one of many
varied inspirations that came together in these objects.
Tree-shaped lamps may be one source for the idea of
a bronze tree. A late Eastern Han tomb at Gansu
Wuwei, source of the bronze cavalcade mentioned in
the entry for No. 95, contained a bronze lamp that
closely resembles a money tree.[6] Perhaps there was a
tradition of such lamps in Sichuan, perhaps even some
awareness of bronze trees like the ones made much
earlier at Sanxingdui (examples might have been un-
earthed in Han times). As for the mountain-shaped
base, with all its associations of mountainous spirit

realms, this has many precedents, notably hill censers (Fig. 98.1). The figures depicted on the bases, as well as those crowding the branches, recall the densely inhabited miraculous mountain landscapes on censers and on other Han inlaid metalwork.[7]

Yet a further layer in the potent imagery of these trees is supplied by the disks seen near the top of No. 97 and in its lowermost branches. They are surely meant to be jades: the disk containing a smaller disk on struts is a form well known among Han jades.[8] That jade disks had special associations is clear from their prominence in rich Han burials; they were even incorporated into the jade funerary suits of Han royalty. In Sichuan they appear interchangeably with coins in some designs, for instance joined by cords into networks.[9] According to the *Huainanzi*, the miraculous forests that stand on Mount Kunlun include jade trees:

> Atop the heights of Kunlun are tree-like cereal plants thirty-five feet tall.
> (Growing) to the west of these are pearl trees, jade trees, carnelian trees, and never-dying trees.
> To the east are found sand-plum trees and *lang'gan* trees.
> To the south are crimson trees.
> To the north are *bi* jade trees and *yao* jade trees.[10]

If these "jade trees" were ever depicted as trees with jade disks hanging from their branches, it is easy to imagine that in Sichuan the disks might have been reinterpreted as coins. Han literature does not mention money trees, but the *Sanguozhi*, a historical text of the third century AD, has a suggestive passage:

> Once, while out walking, a man found some money; he picked it up and tied it to the branch of a tree. Not only did no one take the money, but more and more people came to fasten money to the tree. When asked the reason, those who answered said that it was a "divine" tree *(shenshu)*.[11]

The tree is described here not as one that produces money but rather one which, because of some numinous power, attracts it. Perhaps the passage is an explanation contrived after the actual origin of the money tree had been forgotten.

Fig. 97.3. Mold for casting coins. 206 BC–AD 220 (Han period). After Erickson 1994b, fig. 19.

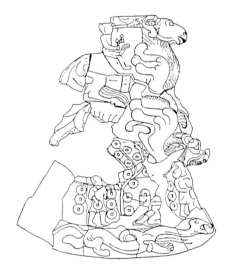
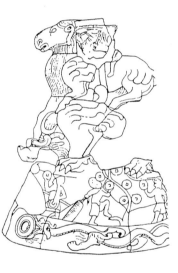

Fig. 97.4. Ceramic base of a money tree, from tomb 176 at Pengshan. Second century AD. After Erickson 1994b, fig. 8a.

7. E.g. inlaid chariot fittings (Beijing 1973b, no. 85; Wu 1984, fig. 1).

8. Lu Chaoyin 1993, nos. 256, 265–8. An example from the tomb of the king of Nanyue, buried at Guangzhou (Canton) late in the second century BC, was found lying on the king's genitals (Lin Yeqiang 1991, no. 27).

9. See Erickson 1994b, fig. 21, for a depiction of disks linked by cords on a ceramic money tree base. For disks and coins in Jiangsu province see Finsterbusch 1971, pl. 133.504; in Sichuan province, Finsterbusch 1971, pls. 5.21–2, 40.163; *Wenwu* 1992.4, p. 47 fig. 8.

10. Translation by John Major (Major 1993, p. 150).

11. Chen Xiandan 1997, p. 71.

98

Money tree

Bronze and ceramic
Height 153 cm
Second century AD (Eastern Han)

From Guanghan Wanfuxing
Guanghan County Cultural Center

PUBLISHED: Lim 1987, pp. 20–21, 160; Erickson 1994b, fig. 29; Chen Xiandan 1997, fig. 1.

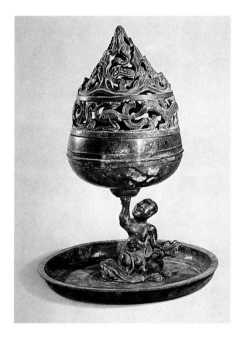

Fig. 98.1. Hill censer, with drawing of upper part, from the tomb of Dou Wan at Hebei Mancheng. Late second century BC. After Beijing 1972, p. 4; Beijing 1980d, vol. 1, p. 257 fig. 171 (drawing).

Two animals appear on the ceramic base of this tree, one crouched on top of the other. The upper animal twists around as though to threaten something approaching it from behind; a socket in its back supports the bronze tree trunk. The lower animal is a beast with wings and claws. Below it the base is encircled by a panel of scroll-like ornament.

At the top of the tree is a bird with outspread wings and extravagant peacock-like plumage. Immediately below it are four small branches from which sprout dripping coins; Erickson interprets the droplets as rays of light, signifying that the tree is glowing.[1] The large and intricate branches lower down, five clusters of four, are almost identical to each other; the molds in which they were cast may all have been made from a single pattern. Coins grow from the upper part of each branch and also from tendrils attached to it. The Queen Mother of the West, easily identified by the canopy that frames her (compare No. 108), appears on each branch, on top of a coin. The filigree around the coins is crowded with figures, including riders and archers; the effect is reminiscent of miraculous landscapes depicted on the walls of tombs and on such bronzes as chariot fittings and hill censers (Fig. 98.1).

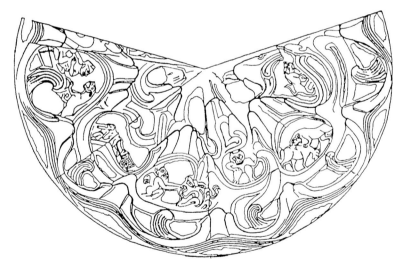

1. Erickson 1994b, pp. 18–19.

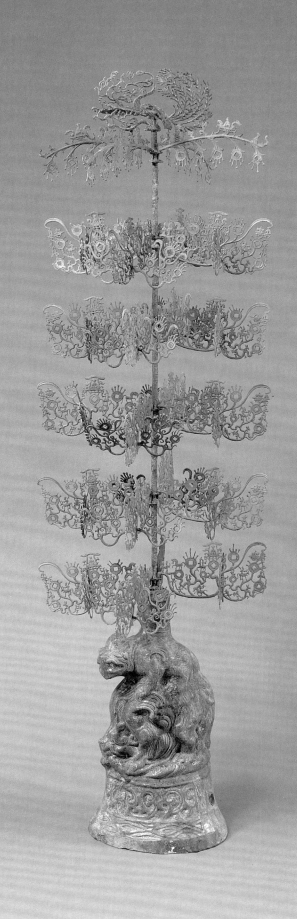

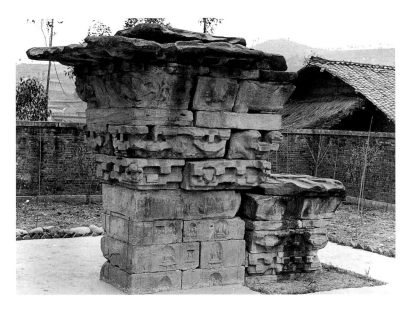

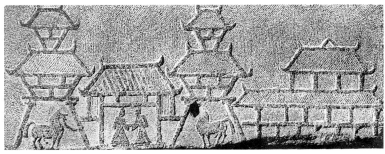

Fig. 99.1. Stone *que* (tower), partly buried, at Mianyang. Height about 6 m, of which 1.5 m are now underground. AD 190–195. The Buddhist niches in the lower part are additions carved on the orders of Liang Wudi in AD 529.

Fig. 99.2. Side of a carved stone coffin showing two towers, a gateway building, and a two-storeyed residence behind. From Dujiangyan City. First or second century AD. After Beijing 1998g, no. 48.

1. Paludan 1991, pp. 28–34.

2. For examples from Henan see Zhou & Wang 1996, pp. 121, 125–6.

3. Wu 1994, pp. 89–91; Zhao & Yuan 1990.

4. Introduction Part 2, Figure 15a.

5. For bricks that may come from the same mold see Finsterbusch 1971, pl. 4.15; Lim 1987, pp. 32, 106; Beijing 1998g, no. 33. For a stone relief depicting a gate with a bird see *Wenwu* 1991.3, p. 22 fig. 9.

6. Wu 1984; Loewe 1994, chapter 7.

7. *Wenwu* 1982.7, p. 25 fig. 2; *Wenwu* 1992.4, p. 46 fig. 4.

8. For another stone coffin which depicts a building complex alongside the towers see *Kaogu* 1979.6, p. 497 fig. 5.

9. Lim 1987, p. 107; *Wenwu* 1975.8, p. 63 fig. 2; Beijing 1998g, nos. 42–6.

99

Brick decorated in relief with scene of gateway with towers

Ceramic
Height 38 cm, width 44 cm
Second century AD (Eastern Han)

Excavated in 1972 at Dayi Anrenxiang
Sichuan Provincial Museum 109782

Gate pillars *(que)* flanking tomb avenues marked the entrances to Han graveyards (Fig. 99.1).[1] Shown with or without an accompanying doorway, they are very frequently depicted in Han tombs, sometimes in great detail, as here, sometimes stamped into bricks in miniature versions so small as to be easily over-looked.[2] Presumably the towered gateway was not simply an entrance to the graveyard but also an en-trance to the afterlife and the realm of the spirits.[3] A few examples are labelled *tianmen,* Gate of Heaven; in one such case, on a bronze plaque from Wushan, the towers give entrance to the realm of a deity.[4]

In Sichuan depictions of these pillars or towers are common both in stone carving and on bricks. In the present example, one of the most elaborate, each main tower has a shorter subsidiary tower beside it.[5] The door swung open between the towers is some-what unusual, as is the fine bird perched over the entrance. A bird over an entrance was an auspicious omen; to depict the omen might help bring about the fortunate event it presaged.[6]

When carved on the ends of stone coffins, the tower scene was more abbreviated than on bricks.[7] The sides of coffins by contrast had space enough to show not only the towers but also the residence of the tomb occupant (Fig. 99.2).[8] Sometimes the gateways are guarded by men with staffs. Even more common is a man holding a shield horizontally and bowing, as if to greet the arrival of the lord of the tomb or a guest.[9]

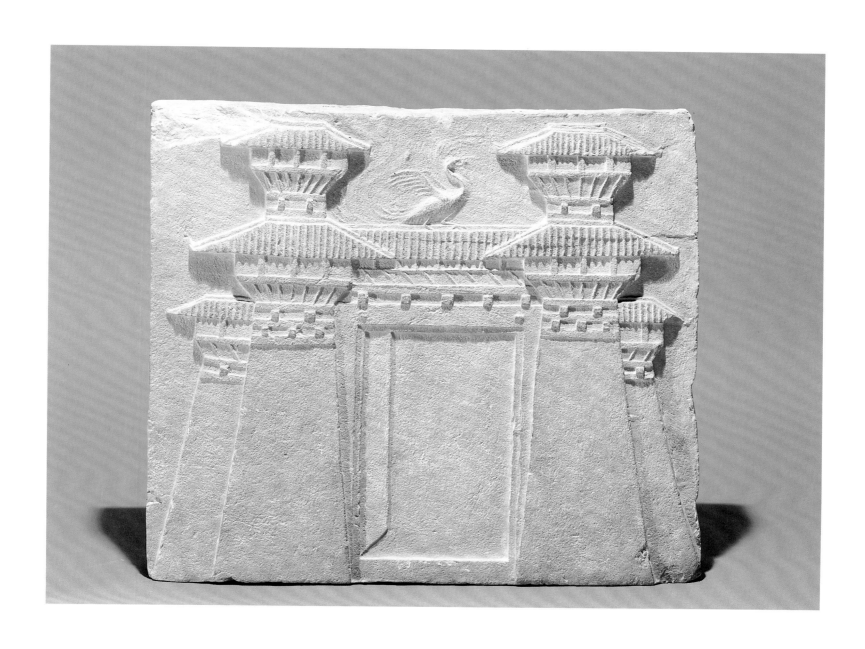

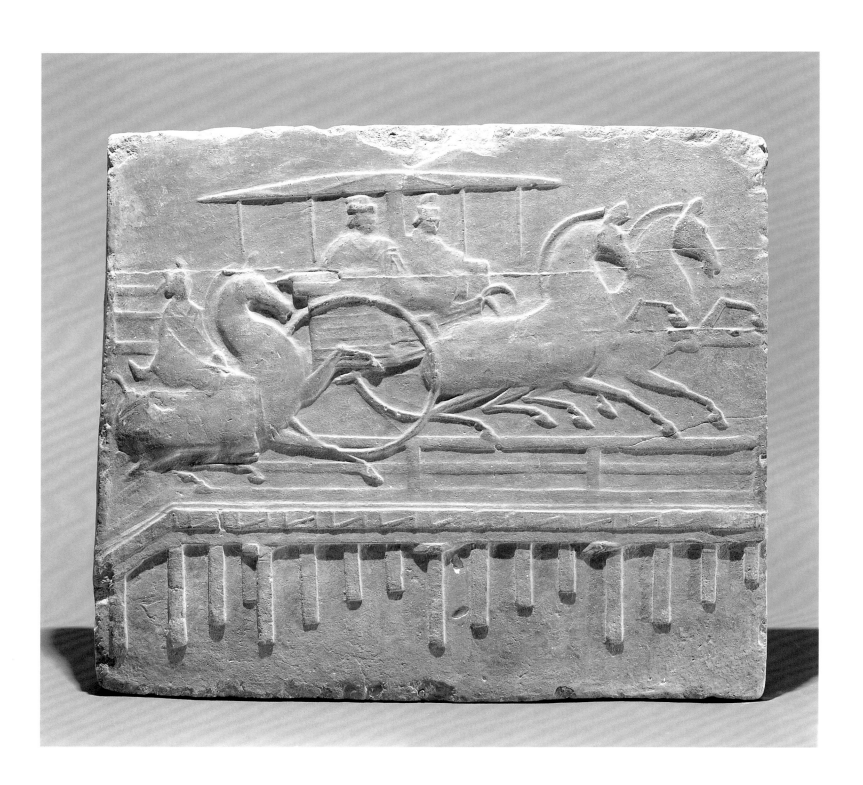

In this elegant composition a carriage with two passengers beneath a parasol is shown crossing a bridge accompanied by a single horseman. The spirited horses have arched necks and prancing forelegs. The bridge, of which only a short section is shown, is supported on piles.[1]

Many tomb bricks, reliefs, and stone coffins from Sichuan depict carriage excursions. On bricks the scenes seldom include more than one or two vehicles, though longer compositions were sometimes created by placing several bricks side by side. As a rule these scenes probably represent the tomb occupant's arrival at his tomb and his afterlife excursions out of it. More elaborate bridge-crossing scenes are found in eastern China, especially in Shandong: in a tomb at Cangshan the scene is accompanied by a poetic inscription which identifies the subject as a bridge over the Wei River near the capital at Chang'an; in a tomb at Yi'nan, where the carriage is accompanied by soldiers who cross the bridge to attack horsemen approaching through mountain terrain, the subject is perhaps the tomb occupant journeying to the realm of the Queen Mother of the West and obliged to fight his way through territory peopled by *hu* (barbarians).[2] It is possible that the Sichuan scenes in which carriages cross bridges were inspired by these more elaborate compositions, but they do not necessarily allude to the same subjects.

Brick with chariot and horseman crossing a bridge

Ceramic
Height 41 cm, width 47.3 cm
Second century AD (Eastern Han)
Excavated in 1956 at Chengdu Tiaodenghe
Sichuan Provincial Museum

PUBLISHED: Lim 1987, p. 116.

1. For almost identical bricks, possibly from the same mold, see Finsterbusch 1971, pl. 7.31; Beijing 1998g, no. 184. For similar but distinct compositions see Beijing 1998g, nos. 185–8.

2. Cangshan: Wu 1994; Yi'nan: Nanjing 1956, rubbing no. 1.

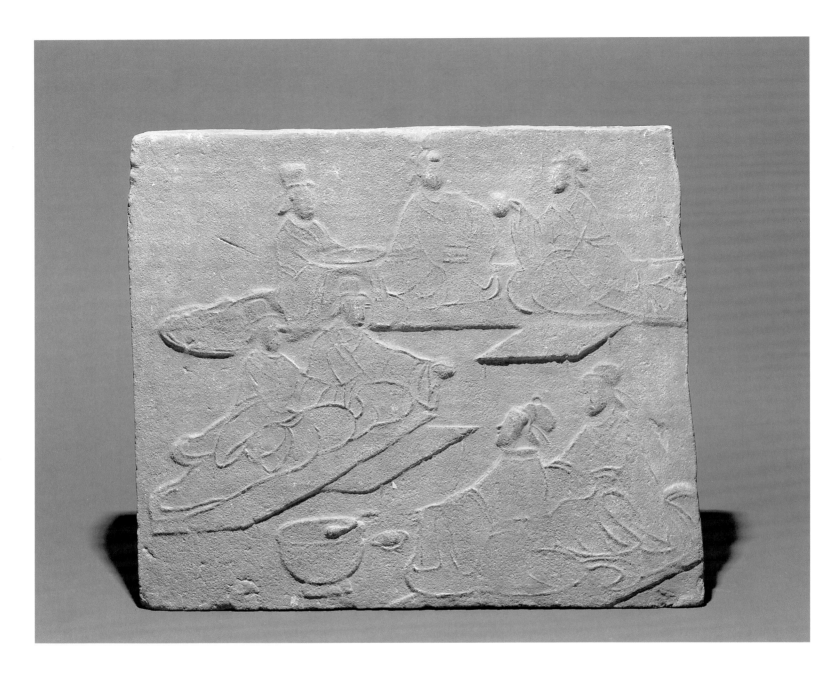

101

Brick with banqueting scene

Ceramic
Height 39.2 cm, width 44.4 cm
Second century AD (Eastern Han)

Excavated in 1972 at Dayi Anrenxiang
Sichuan Provincial Museum 111789

At the rear of this banquet scene is a figure attended by two servants, one holding a dish, the other, directly behind a low square table, offering a cup. Nearer to us, pairs of gesturing figures converse across a rectangular table; their diagonal placement gives depth and animation to the scene. A large bowl with a ladle in the foreground is probably for scooping wine into cups. Two other bricks with exactly the same design are known, showing that the molds for such bricks were reused.[1] The design is executed in a low flat relief, much embellished with thread-relief for interior detail and outlines; an alternative technique, also common, relies less on line and more on modelled high relief (No. 102). In either case the design was probably first carved on a wooden plank; the plank served as a pattern on which the brick mold was formed.

Banquet scenes like the present one assured the tomb owner of the pleasure of convivial feasts with his friends. But other sorts of banquet might also find a place in the tomb. In Henan and Shandong we often see the tomb owner on a large platform, sometimes framed by a textile canopy or shielded by a screen, seated behind an altar table bearing rows of ear cups (Fig. 101.1). This is likely to be not a gathering of friends but a banquet offered to the deceased by his descendants. The low table, lacquer ear cups on it, and wine

1. Finsterbusch 1971, pl. 6.23; Beijing 1998g, no. 65.

Fig. 101.1

Fig. 101.2

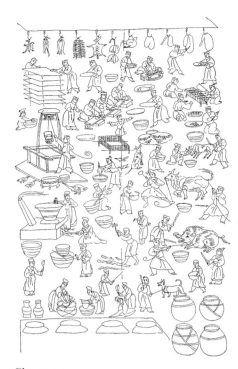

Fig. 101.4

Fig. 101.3

Fig. 101.1. The tomb occupant receiving offerings. Drawing of a stone engraving from a tomb at Shandong Zhucheng. First or second century AD. After *Wenwu* 1981.10, p. 20 fig. 8 (upper half).

Fig. 101.2. Plan of a tomb at Chongqing; visible along the left side are the oval forms of ceramic copies of lacquer ear cups, presumably for offerings to the deceased. First or second century AD. After *Wenwu* 1955.3, p. 38 fig. 3.

Fig. 101.3. Kitchen scene, rubbing of a brick from Chengdu. Second century AD. After Beijing 1998g, no. 21.

Fig. 101.4. Kitchen scene, drawing of a stone relief from a tomb at Shandong Zhucheng. After *Wenwu* 1981.10, p. 19 fig. 7.

vessel with ladle in front of it seem to be furniture specific to such offering ceremonies; in the Shandong scene illustrated in Figure 101.1 even the descendants are shown. Although among Sichuan banquet scenes it is not easy to single out examples meant to represent offering ceremonies, pottery replicas of the lacquer service for the offerings have been found in Sichuan tombs (Fig. 101.2). Pictures of the ceremony probably had the same function as the lacquer service: both ensured that the deceased would receive offerings in perpetuity.

Eastern Han tombs depict not only the banquets but also the preparations for them. As usual, the Sichuan kitchen scenes are very lively (Fig. 101.3), though less dense than their counterparts further east (Fig. 101.4). Despite large differences, the two examples illustrated show that regions as widely separated as Sichuan and Shandong shared the same range of cooking utensils and the same belief that the deceased needed them depicted in his tomb.

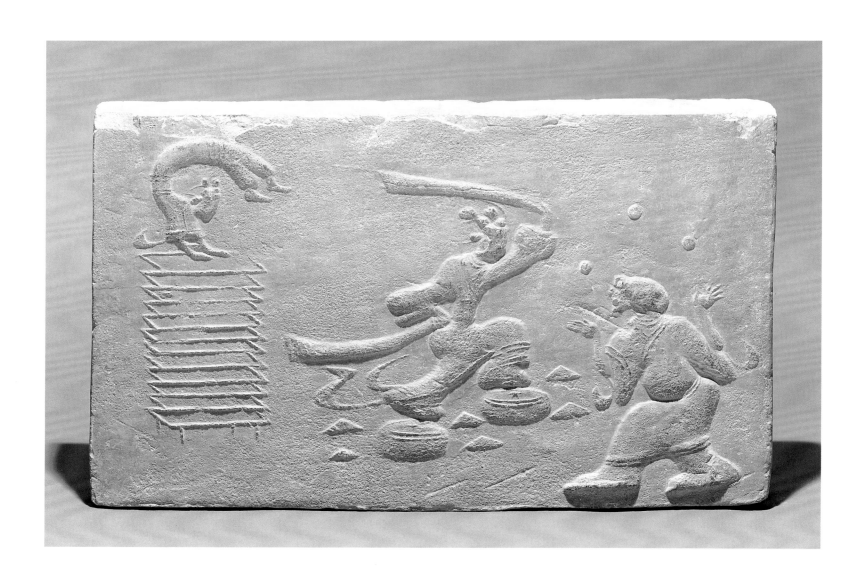

This horizontal rectangular brick shows a team of three entertainers caught in mid-performance.[1] At left a slender female acrobat stands on her hands on a tower of twelve wooden tables. In the center a female dancer with fluttering scarves plays a pair of drums by leaping from one to the other. To her right a male juggler is intent on three balls in the air above him. His anatomy and pose—fat belly and projecting bottom—have something in common with No. 111, the clay figurine of another entertainer. The relative size of the three figures and their varying distances from the lower edge of the brick give a vague effect of diagonal recession.

Like the cooking scenes mentioned in the preceding entry, scenes with acrobats and other entertainers, including musicians and dancers, are found in Han tombs in many parts of China. Both the range of entertainments and the wish to include them in the tomb were widely shared. A famous late Han relief showing a host of performers, including a tightrope walker, comes from a tomb at Yi'nan in Shandong (Fig. 102.1). Though nothing in Sichuan quite matches the variety of the Yi'nan relief, longer formats such as the sides of stone coffins did give space for more detail than bricks allowed.[2] Entertainers of all kinds appear also as ceramic figurines (Nos. 110–13).

These entertainments—by Eastern Han times called "the hundred amusements" *(baixi)*—may well have been a feature not only of banquets but also of ceremonial occasions, perhaps even funerals. The most elaborate forms were of course to be found at court; the First Emperor of Qin and the Han emperor Wudi are said to have employed entertainers by the thousand.[3] Poems of the day describe a carnival atmosphere:

> They assembled the show wagon,
> From which they hoisted a tall banner on a pole.
> Young lads displayed their skill.
> Up and down doing glides and flips.
> Suddenly, they threw themselves upside down, catching themselves with their heels;
> Seemingly they were cut asunder and connected again.
> One hundred horses under the same bridle,
> Raced side by side as fast as their feet could go.
> As for the tricks performed at the top of the pole—
> There was no end to their numerous postures.
> Drawing their bows, archers shot at a Western Qiang;
> Looking again, they fired at a Xianbei.[4]

Fig. 102.1. Drawing of a scene of acrobats and entertainers from a tomb at Shandong Yi'nan. Second century AD. After Berger 1998, fig. 9.

102

Brick with scene of acrobatic performance

Ceramic
Height 28 cm, width 47 cm
Second century AD (Eastern Han)

Excavated in 1956 from Peng Xian Taipingchang
Sichuan Provincial Museum 25465
PUBLISHED: Beijing 1998g, no. 95.

1. For bricks from the same mold see DeWoskin 1987, fig. 3; Finsterbusch 1971, pl. 47.191; *Wenwu* 1975.4, pl. 2.3; Lim 1987, p. 29 (where the image has been mirror-reversed). For a differently drawn version of the same scene see Beijing 1998g, no. 97.

2. Beijing 1998g, no. 100.

3. Liao Ben 1987; Loewe 1994, chapter 11; Lewis 1990, pp. 158–9.

4. Knechtges 1982, p. 235.

103

Brick with scene of wine making or alcohol distillation

Ceramic

Length 50 cm, height 28 cm

Second century AD (Eastern Han)

Excavated in 1979 at Xindu Xinlongxiang
Sichuan Provincial Museum

PUBLISHED: Lim 1987, p. 103 pl. 18; Rawson 1996, no. 103.

Beneath the tiled roof of an open-sided building we see two figures. One uses a bowl to ladle from a larger vessel. The other, perhaps supervising, sits on a bench and gestures toward the first. In front of them is a structure with three circular openings in the top; the openings lead to small channels through which liquid drips into three jars. Left of the jars, a spectator with his back to us stands in the foreground. Further left a man carries away two jars on a pole over his shoulder; above him another man pushes a wheelbarrow loaded with a large box.[1]

Some scholars believe this design to be among the earliest depictions of alcohol distillation.[2] Figure 103.1 shows their reconstruction of the process. At the bottom of the diagram is an open stove, on which rests a funnel-shaped pan of water. Standing on the pan is a tall wooden steamer with a bottom made of woven bamboo. Unfiltered alcohol mash was placed in the steamer. When the water in the pan boiled, steam rose through the mash and then, alcohol-laden, condensed on the underside of a second funnel-shaped pan sitting on top of the steamer. This second pan was kept cool by constantly changing the water in it. A small bowl beneath it collected the condensate, which then flowed through a pipe into a jar at the side. If the present scene indeed depicts such a distillation process, the jars in front may be receiving the condensed liquor, the man behind might be ladling water from the cooling pan.

Distilled alcohol may have been relatively new at the time of the present brick.[3] Wine (made from grain rather than grapes) is attested far earlier, most unambiguously in the bronze wine vessels deposited as offerings in Shang and Zhou tombs. Wine vessels were still put in Han tombs, but there they were often luxuries for the tomb owner's enjoyment rather than vessels dedicated to the service of the ancestors. An inscription on a *hu* from the tomb of the second century BC imperial prince Liu Sheng celebrates food and drink as delights for the prince's banquets: "When with pleasant emotions, we gather to eat and drink, it will be a grand occasion with abundant flavors."[4] It was probably with this sort of afterlife in mind that Sichuan tombs were furnished with scenes of alcohol production, and also with scenes of wine shops.[5]

1. Another brick likely to be from the same mold is illustrated in Finsterbusch 1971, pl. 46.187.

2. Yu Dezhang 1987b; *Sichuan wenwu* 1989.4, pp. 27–30; Sun Ji 1991, pl. 85.11.

3. *Sichuan wenwu* 1989.4, p. 30. The distillation process may owe something to Daoist alchemical experiments; see Rawson 1996, p. 200.

4. Dien *et al.* 1985, pp. 1087–90; see also Fong 1980, no. 96; Beijing 1980d.

5. E.g. Rawson 1996, no. 104.

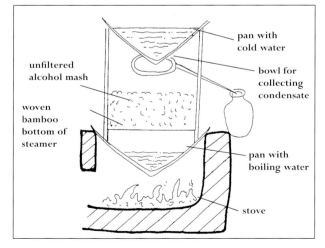

Fig. 103.1. Reconstruction of the distillation process. After *Sichuan wenwu* 1989.4, p. 29 fig. 3.

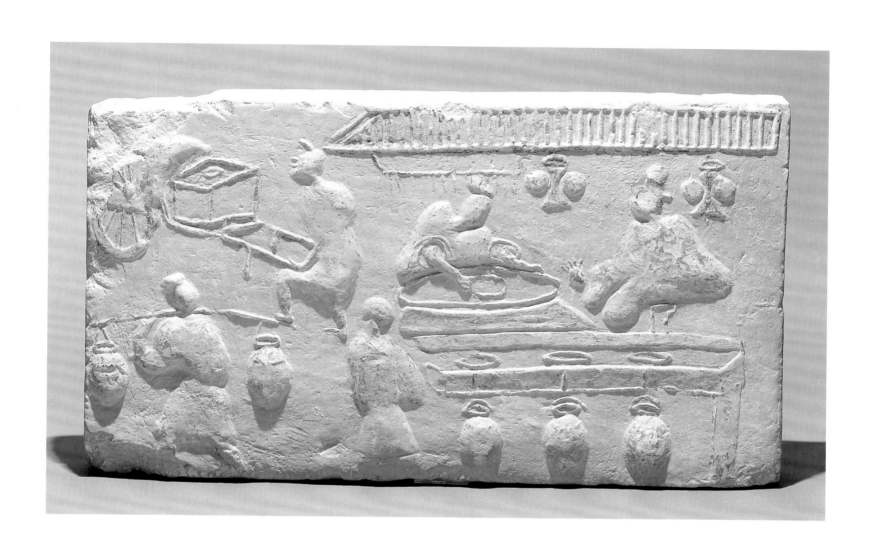

104

Brick with scene of salt production

Ceramic with molded decoration
Height 40 cm, width 49.5 cm
Second century AD (Eastern Han)

Excavated in 1980 at Pi Xian
Sichuan Provincial Museum

PUBLISHED: Lim 1987, p. 99.

A hilly landscape here supplies the backdrop to a scene of salt production. In the lower left corner four men standing on a scaffold haul on ropes to draw brine from a well. The brine is led through a pipe, probably of bamboo, to evaporating pans that sit on top of a long stove at the right. A small figure near one end of the stove feeds the fire. The contours of three hills at the front of the scene frame the scaffold, the pipe, and the stove. The hill crossed by the pipe contains also two trees and two men carrying loads (fuel for the stove? bags of salt?).

Overlapping hills further back are alive with plants, animals, and hunters that have no obvious connection with the theme of salt production. This inhabited landscape may owe something to earlier hill censers, on which the mountain contours frame animals and people in a similar way (Fig. 98.1); if we pressed the analogy to the extent of seeing the mountain as the main theme here, we might have to reinterpret the scene on the brick as a sacred mountain with a salt factory on its lower slopes.[1] An Eastern Han brick from Hubei Dangyang shows a landscape structurally similar to the present one, but fantastic rather than everyday, closer in feeling to the landscapes of Han inlaid chariot fittings.[2]

Salt was important to the economy of Sichuan, which exported it to other parts of China, and tomb owners may have wanted scenes like this one in their tombs to ensure the continuation of their revenues.[3] As with many other brick designs, similar but distinct versions of the scene are known, suggesting that craftsmen facing the task of making a new mold might prefer to redraw a familiar composition rather than devise an altogether fresh one (Fig. 104.1).[4] The example shown in Figure 104.1 alters relative proportions, giving human activity more space and wild landscape less, and adds workers moving along a zigzag path from the scaffolding to the stove.

1. See Munakata 1991, p. 103. On the censer of Figure 98.1 the motif on each peak has the look of a self-contained episode or vignette (an animal combat, a man leading an animal drawing a cart). These episodes may have originated elsewhere as independent compositions, for instance on Inner Mongolian belt plaques or harness ornaments: see e.g. Beijing 1986b, p. 96 fig. 64.4 (horse and cart), p. 95 fig. 63 (animal combat), p. 83 figs. 51.3–4 (two men wrestling). A similar point is made by Sullivan 1962, pp. 45–6; and see Munakata 1991, p. 29.

2. Wenwu 1991.12, p. 71 fig. 15. Compare a chariot fitting from Hebei Ding Xian (Beijing 1973b, no. 85; Wu 1984).

3. Twitchett & Loewe 1986, p. 584; Sage 1992; Vogel 1990. The east and west walls of tomb 2 at Chengdu Zengjiabao, each displaying a salt-production brick, are shown in Wenwu 1981.10, p. 29 figs. 10, 12.

4. For a brick made from the same mold as No. 104 see Wenwu 1975.4, p. 46 fig. 1. Two bricks from a different but very similar mold are shown in Finsterbusch 1971, pl. 3.11, and Lim 1987, p. 99 pl. 14. A third version is that shown in Figure 104.1.

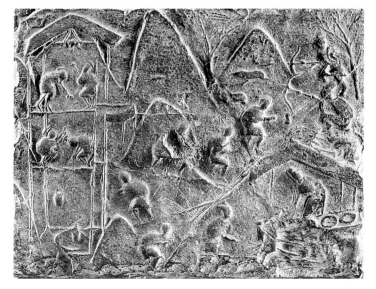

Fig. 104.1. Brick with a scene of salt production, from Qionglai. 46 by 36 cm. After Beijing 1998g, no. 13.

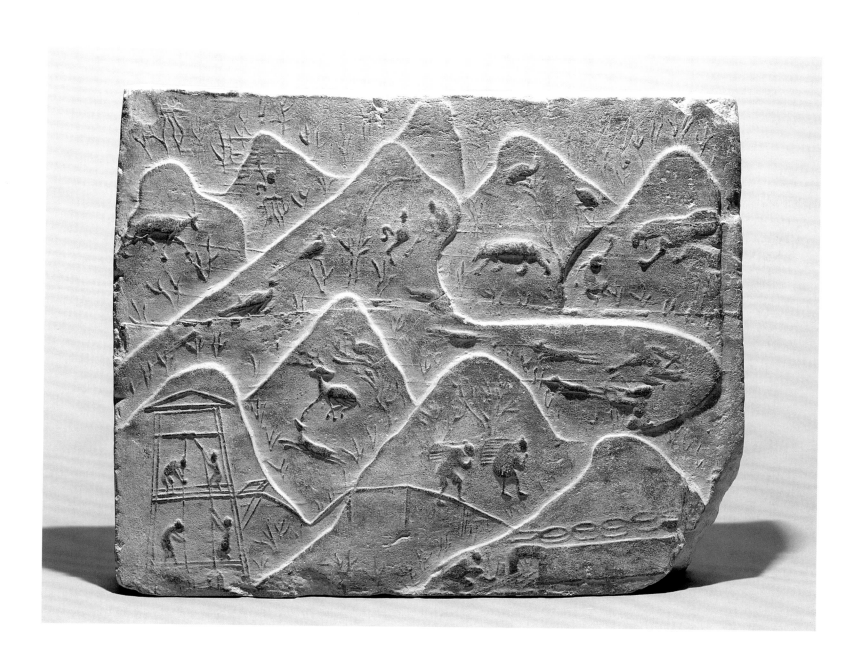

Brick with scene of a lotus pond, hunting, and fishing

Ceramic
Height 26 cm, width 45 cm
Second century AD (Eastern Han)

Excavated in 1983 at Peng Xian Sanjiexiang
Sichuan Provincial Museum 141017

PUBLISHED:Beijing 1998g, no. 8.

The horizontal rectangle of this brick is irregularly divided from top to bottom by the undulating shore of a pond or lake. To the right, on the bank, an archer standing at the bottom edge leans backward to shoot at birds in a tree next to him. A much smaller figure on the other side of the tree might be a monkey dangling from a branch. The lake is filled with lotuses and swimming birds. Near us a boat sits parallel to the front edge of the scene. It is navigated by figures with poles at the prow and stern, one seated, the other more active. This boat carries an archer taking aim, probably at a bird. Further back another boat poled by a single figure carries an excited dog ready to leap from the prow. Perhaps the dog retrieves birds shot by the archer in the other boat.

Scenes of fishermen boating among lotus pads are fairly common among Sichuan tomb bricks. Compositions vary. On a brick from Deyang the pond fills the foreground, and the hilly tree-lined shore is seen only on the horizon, in the far distance (Fig. 105.1). On a brick from Xindu the shore is not shown and the distribution of lotuses, waterfowl, and fish—three large fish at the top edge of the scene—gives little sense of depth.[1]

Fig. 105.1. Rubbing of a brick showing a boatman in a lotus pond, from Deyang. Second century AD. After Lim 1987, p. 86.

1. Lim 1987, p. 87.

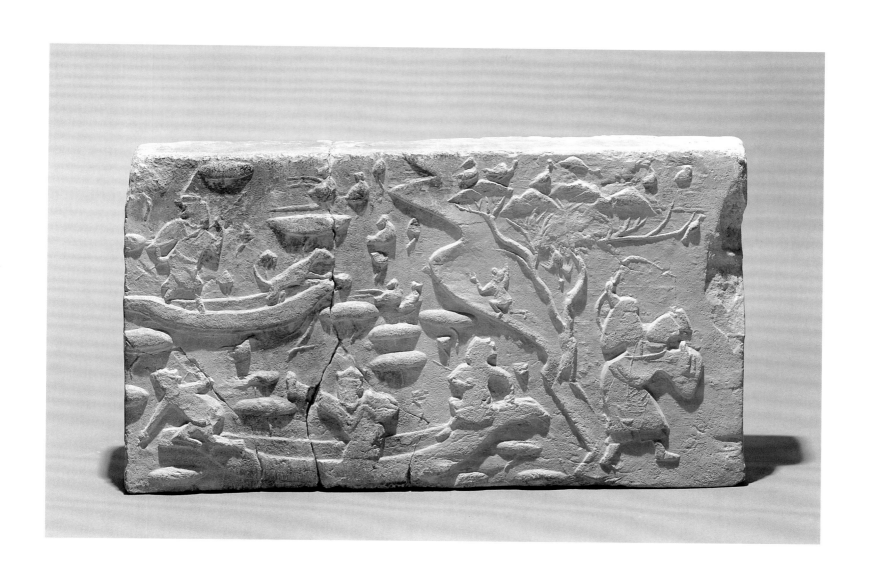

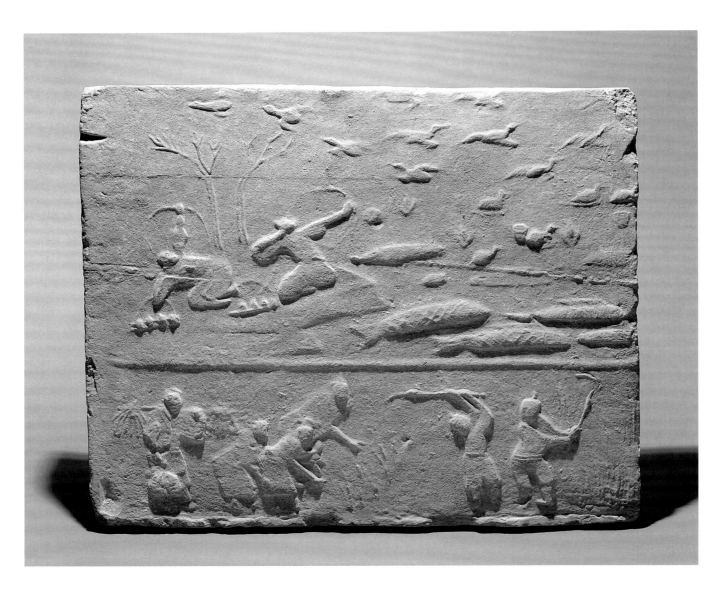

106

Brick with scenes of hunting and harvesting

Ceramic
Height 40 cm, width 48 cm
Second century AD (Eastern Han)

Excavated in 1975 from Chengdu Jinniuxiang
Zengjiabao tomb 2

Chengdu City Museum 00650 07-0018

PUBLISHED: *Wenwu* 1981.10, pp. 25–32 (site
report; the brick is not illustrated); Lim 1987,
p. 93.

1. An example from Chengdu Yangzishan tomb 1 is shown
in situ in *Wenwu* 1955.9, p. 71 (upper left). See also Lim
1987, pp. 92–3 (two distinct bricks); Beijing 1998g, no. 9.

2. Arrows trailing cords are depicted also on Warring States
bronzes (e.g. Lawton 1982, no. 5). For a discussion of hunt-
ing as shown on bricks and in stone reliefs see *Kaogu yu
wenwu* 1999.2, pp. 75–81.

3. Munakata 1991, p. 103; Rawson 2000.

This oft-published design, known from several bricks,[1] is organized in two registers sep-
arated by a horizontal raised line. The upper register contains a lakeside hunting scene, the
lower a harvest scene. The hunters, in front of a pair of leafless trees, kneel on a curving
bank and take aim at ducks or geese flying above the trees and lake. Their arrows are at-
tached to spools of cord in baskets beside them.[2] On the lake, birds swim among lotuses;
below the birds and lotus pads are three large fish, their scales rendered as a crisscross
pattern. In the harvest scene the stalks are cut by two reapers, collected by three stoop-
ing figures, and carried off in sheaves by a figure with a pole over his shoulder (and with
something in his right hand, perhaps a lunch basket).

Distilling and salt mining (Nos. 103–4) were productive activities to which a tomb
owner might owe his wealth. The activities shown here might more specifically have been
intended to furnish his tomb with grain and game. But they might also represent labors
of the seasons, a theme with calendrical or ritual associations. Although the naturalness of
the scenes on Sichuan bricks tempts us to enjoy them as expressions of a simple affection
for the everyday, some have precedents that make us wonder if we should be seeing some-
thing more. Archers shooting at birds with arrows attached to cords, for instance, were
depicted centuries earlier on bronze vessels like No. 73, a context which hints that they
were not merely a genre motif.[3]

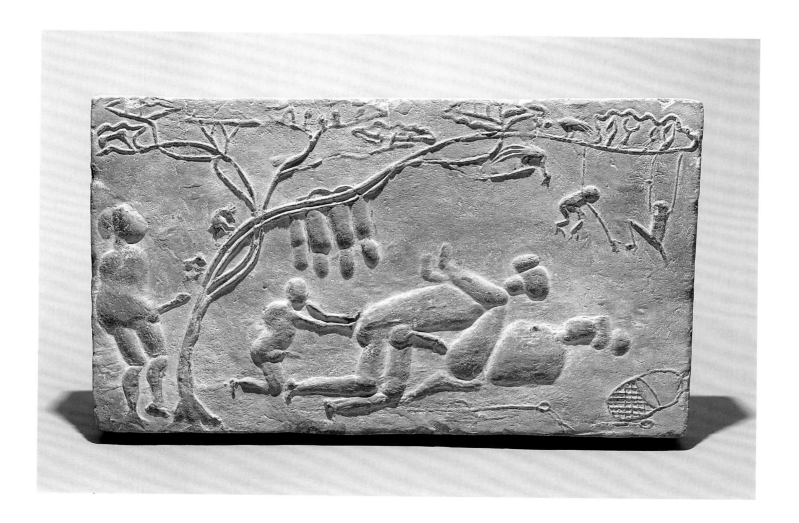

This brick and another found with it (Fig. 107.1) show scenes of copulation—two versions of a single composition or, conceivably, two consecutive moments in a continuous action. The participants are three men and one woman, all naked in the open air beneath a tree in full leaf. On No. 107, the woman, her hair in a high topknot, lies on her back on the ground, her belt and her basket cast carelessly aside. She is about to be penetrated by the largest male, who seems to receive some assistance from the smallest. The latter too is in a state of sexual arousal, as is the third man, watching and perhaps waiting his turn. What might be the clothing of the four individuals is slung over a limb of the tree. The amorous activity seems to interest not only a couple of playful monkeys hanging from the tree but even the birds perched in it. The second brick, on which the tree's foliage is rendered rather differently, might show a later moment, when two of the men are relaxing and the monkeys and birds have departed (Fig. 107.1).

Sichuan tombs often include reliefs or figurines that depict embracing couples.[1] The less decorous scenes on these two bricks are more exceptional, and their significance is not known. The other bricks from the tomb in which they were found depict familiar subjects—the planting of rice, alcohol production, dance and acrobatic performances, and the Queen Mother of the West accompanied by sun and moon deities. It has been argued that many of the scenes in Han tombs represent an annual cycle of rites, festivals and ceremonies,[2] and it is possible that the present ones belong to a local Sichuan variant of such a cycle.

107

Brick depicting an erotic scene

Ceramic
Height 29 cm, length 50 cm
Second century AD (Eastern Han)

Unearthed in 1979 in Xindu Xinlongxiang
Xindu County Bureau of Cultural Relics

PUBLISHED: Rawson 1996, no. 105.

Fig. 107.1. Companion brick to No. 107. After Rawson 1996, p. 202 fig. 105.1.

1. *Wenwu* 1992.4, p. 48 fig. 10; Lim 1987, p.131.
2. Berger 1980, Berger 1998.

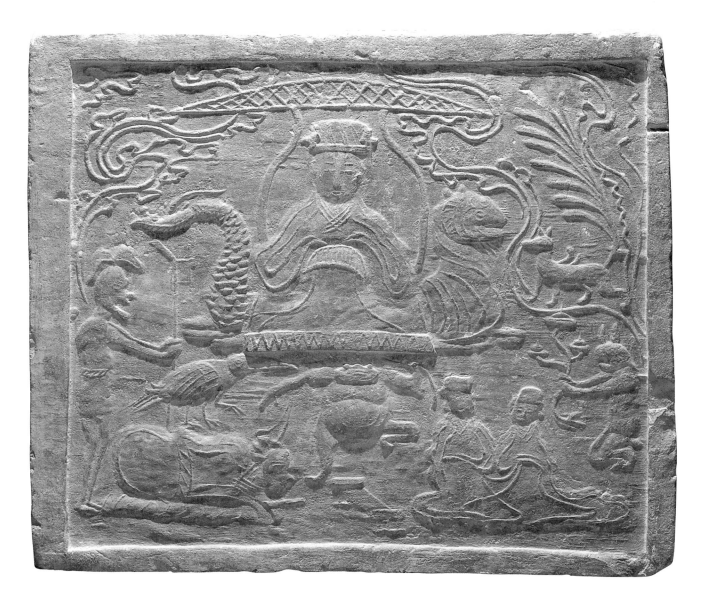

*Brick with Xiwangmu,
attendants, and a worshipper*

Ceramic
Height 40.3 cm, width 45.5 cm
Second century AD (Eastern Han)

Excavated in 1954 from Xinfan Qingbaixiang
tomb 1
Sichuan Provincial Museum 14021

PUBLISHED: *Wenwu* 1956.6, p. 36; Finster-
busch 1971, pl. 13.44; Wu 1987, fig. 6; Lim
1987, pp. 34, 166; Munakata 1991, p. 104;
Rawson 1996, no. 101.

The upper part of this brick is occupied by the Queen Mother of the West, a large fron-
tal figure surrounded by drifting clouds, seated on a dragon-and-tiger throne beneath a
canopy. Lesser figures appear beside and below her. To her right, standing at the edge of
the scene, is a tall guard holding a halberd.[1] To her left is a winged nine-tailed fox.[2] Be-
low the fox, a hare kneels holding the Tree of Three Pearls, a plant that confers immortal-
ity. Other companions of the Queen are the dancing toad directly in front of her and the
three-legged crow next to the toad; these signify the moon and the sun. At the very front
of the scene is a low table with two seated figures to one side of it and a man knocking his
head on the floor on the other. The kowtowing man holds a tablet, perhaps to indicate that
he has official rank; he is presumably the occupant of the tomb and has come to pay his
respects to the Queen Mother. The two seated figures may be his parents, or other devo-
tees of the Queen, or members of her retinue.

By contrast with the informal compositions on the preceding bricks, this scene has
the frontality and symmetry of an icon, to which the unusual raised edge of the brick
supplies a frame. In the tomb in which it was found, it was set into the wall in a triptych-
like arrangement, flanked by two smaller bricks each bearing the image of a winged deity,
one carrying the disk of the sun, the other the disk of the moon.[3] It is possible that this
presentation of the Queen was inspired by Buddhist icons, which were reaching Sichuan in
the latter part of the Han period.[4] An image of the Buddha on the base of a money tree, a

Fig. 108.1. Ceramic base of money tree showing a figure of the Buddha, from Pengshan. Second century AD. After Erickson 1994b, fig. 25.

Fig. 108.2. Rubbing of a slab from Shandong Jiaxiang showing the Queen Mother attended by hare and toad and surrounded by immortals carrying stalks of a plant. Second century AD. After Shandong 1982, no. 187.

Fig. 108.3. Rubbing of a slab from Shandong Weishan showing the Queen Mother of the West flanked by figures of Nüwa and Fuxi. Second century AD. After Shandong 1982, no. 3.

Fig. 108.1

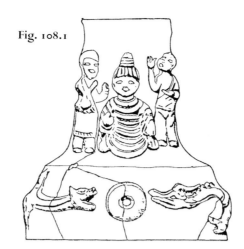

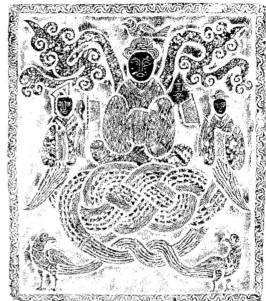

Fig. 108.3

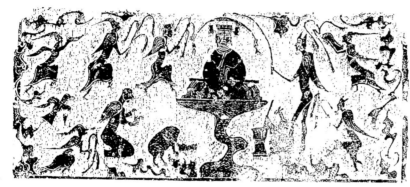

Fig. 108.2

place where images of the Queen Mother are often found, suggests that the two deities were sometimes conflated (Fig. 108.1).[5]

The cult of the Queen Mother spread widely in the Eastern Han period.[6] The official histories describe outbreaks of hysterical religious fervor, for instance one in 3 BC: "In the area east of the passes, the people were exchanging tokens in preparation for the advent of the Queen Mother of the West. They passed through the commanderies and kingdoms, moving west to within the passes and reaching the capital city. In addition persons were assembling to worship the Queen Mother of the West, sometimes carrying fire to the roof-tops by night, beating drums, shouting and frightening one another."[7] "The population were running around in a state of alarm, each person carrying a manikin of straw or hemp. People exchanged these emblems with one another, saying that they were carrying out the advent procession. Large numbers of persons, amounting to thousands, met in this way on the roadsides, some with dishevelled hair or going barefoot… They sang and danced in worship of the Queen Mother of the West. They also passed around a written message saying 'The Mother tells the people that those who wear this talisman will not die; and let those who do not believe Her words look below the pivots on their gates, and there will be white hairs there to show that this is true.' By the autumn these practices had abated."[8]

The cult was exceedingly popular in Sichuan, and images of the Queen Mother appear in many tombs.[9] Both there and in Shandong she is depicted with large hairpins, called *sheng*, and attended by the hare and the toad (Fig. 108.2). But the dragon-and-tiger throne that she sits on in Sichuan is not seen further east; and in the east she is generally paired with the Lord of the East (Dongwanggong), who does not appear in Sichuan. In the east the Queen can also be accompanied by the creation deities Nüwa and Fuxi (Fig. 108.3). In Sichuan, where Nüwa and Fuxi were associated with the *yin* and *yang* forces of the moon and sun, she might be flanked instead by images of the moon and sun carried by birds, as in the triptych to which the present brick belongs.

1. Perhaps Daxingbo, a warrior mentioned in *Shanhaijing*.

2. An omen for numerous descendants described in the *Shanhaijing* (Birrell 1999, pp. 221–2).

3. All three bricks are illustrated in Rawson 1996, p. 196; they are shown *in situ* in *Wenwu* 1956.6, p. 37.

4. The present scene is compared with representations of the Buddha in Rhie 1999, pp 56–8; see also Wu 1986, Zheng Yan 1998b.

5. Erickson 1994b, pp. 25–6.

6. On the cult of the Queen Mother see Francasso 1988; Loewe 1979, chapter 4; Wu 1987.

7. *Hanshu*, translated by Michael Loewe (Loewe 1979, p. 98).

8. *Ibid.* p. 99.

9. Beijing 1998g, nos. 366–77; Cong Dexin 1998.

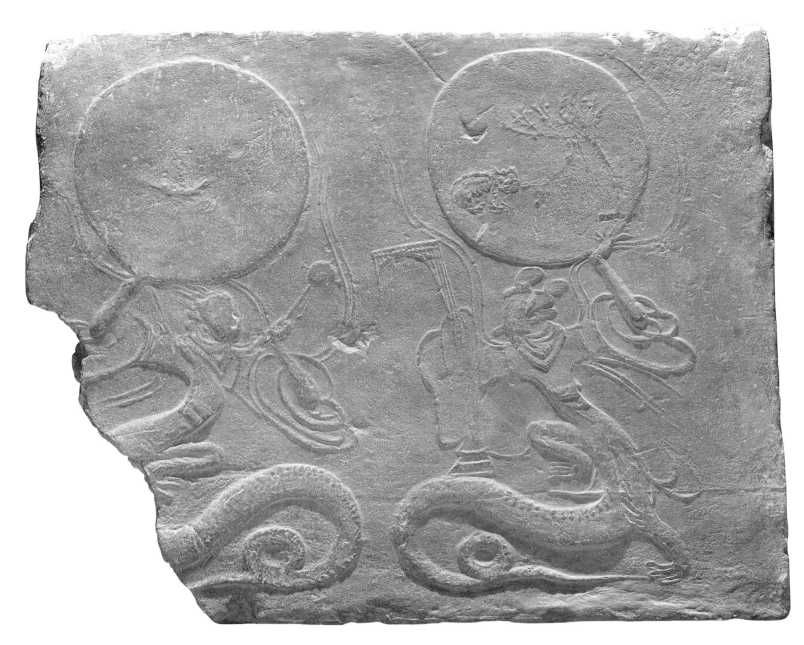

*Brick depicting the deities
Nüwa and Fuxi*

Ceramic
Height 39.2 cm, width 47.9 cm
Second century AD (Eastern Han)

Unearthed in 1951 in Chongqing
Sichuan Provincial Museum 3328

PUBLISHED: Lim 1987, p. 171; Wu 1987,
fig. 5; Beijing 1998g, nos. 354–5.

1. Lewis 1999b, pp. 197–209; Bodde 1961, pp. 386–9;
Hawkes 1985, p. 130.

2. Beijing 1998g, nos. 351–65.

3. Lewis 1999b, p. 203.

The two figures with serpentine bodies shown here are the two creators of the universe, Nüwa and Fuxi. Fuxi, on the left, carries the sun disk; the indistinct shape within the disk is presumably a crow. Nüwa, recognized as female by the two buns of her hairdo, carries the moon disk with its toad under a tree. Both figures are very animated, prancing on animal-like hind legs, their heavy sleeves swirling and their tails ending in a flourish. It is unusual for Nüwa and Fuxi to have legs, and normally they are shown with their scaly tails intertwined, as if in the act of procreation of the universe (Fig. 108.3). As insignia of their role as creators they often carry a carpenter's square and a compass, but here they hold objects less easy to identify.

Although in Eastern Han pictorial art Nüwa and Fuxi are shown as a pair, they originally were independent mythological figures who came together in textual accounts probably no earlier than Han.[1] Nüwa is mentioned as the creator of humankind, Fuxi as the inventor of writing and the trigrams. In Sichuan they almost invariably hold up the moon and sun,[2] suggesting that they represent also the forces of *yin* and *yang*.[3]

110

Figure of a squatting drummer

Ceramic

Height 48 cm

First or second century AD (Eastern Han)

Excavated in 1982 from Xindu Sanhexiang
Majiashan

Xindu County Bureau of Cultural Relics

PUBLISHED: Lim 1987, p. 134; London 1987,
no. 38; Rawson 1996, no. 109.

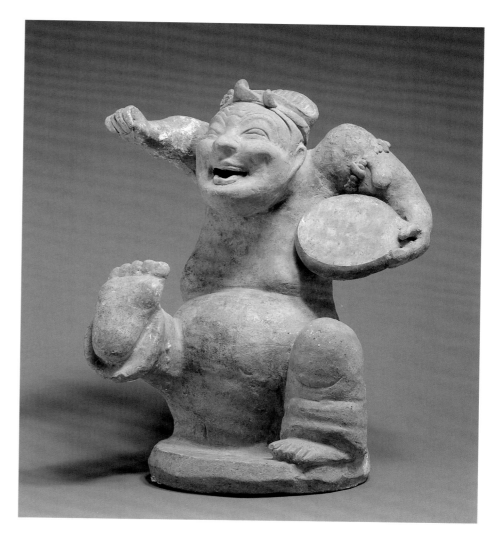

Fig. 110.1. No. 110, rear view.

Nos. 110–13 are three-dimensional counterparts
of the entertainers depicted on bricks like No. 102;
a tomb might contain a troupe of such figures. This
one and the next are drummers who specialized in a
kind of part spoken, part sung storytelling.[1] No. 110
sings merrily, his brows wrinkled with laughter, his
right leg in the air, his outflung right arm (which
held a drumstick now lost) striking the drum cradled
in his left. He wears an armlet high on his left arm
and a headband or cap. His heavy body, perhaps that
of a dwarf, is bare except for trousers covering his
legs. Performers with the same heavy build appear
on bricks in scenes of juggling and sword balancing.[2]
Comical, almost caricatured figures of performers
were especially popular in Sichuan, though they are
found elsewhere as well.[3]

Han tomb figures like this one were mass pro-
duced.[4] On some figures, for instance No. 114,
a parting line down the side shows that the front
and back were made separately, in molds, and then
joined before firing. Another example of the present
drummer retains the drumstick in the right hand.[5]

1. For additional examples see
Lim 1987, p. 135.

2. Beijing 1998g, no. 84.

3. For instance at Luoyang
(*Wenwu* 1994.7, p. 41 fig. 13;
Kaogu 1975.2, pl. 11).

4. Numerous fragments of per-
former figures have been found
at a workshop site near Chengdu
(*Sichuan wenwu* 1987.3, pp. 6–7).

5. *Kaogu xuebao* 1958.1, pl. 8.4
following p. 103.

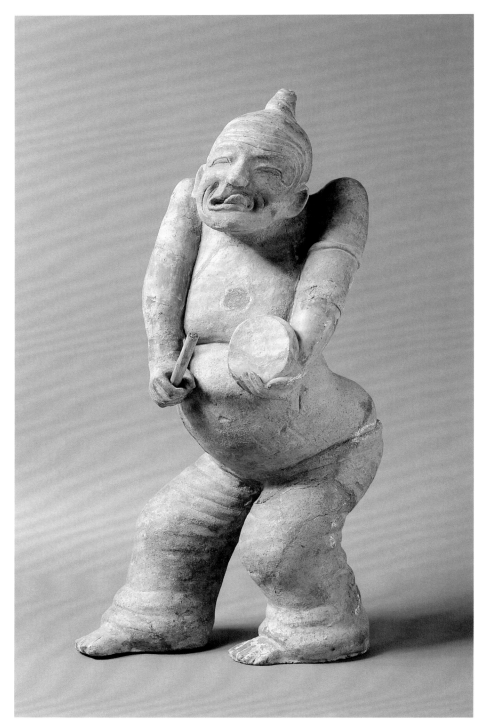

Figure of a standing drummer

Ceramic
Height 66.5 cm
First or second century AD (Eastern Han)

Excavated in 1982 at Pi Xian
Sichuan Provincial Museum

PUBLISHED: Lim 1987, pp. 132–3; Rawson 1996, no. 110.

Set next to the previous storyteller, this one seems more lugubrious than merry; perhaps his hunched shoulders and grimace (with his tongue stuck out) are suited to the story he tells. His bent legs, projecting buttocks, and twisting posture suggest that he is swaying in time to his music. His hair is rolled into a pointed bun, he is bare-chested, and his loose trousers seem about to fall down.

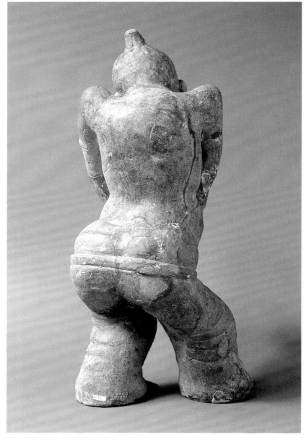

Fig. 111.1. No. 111, rear view.

Figure of a musician

Ceramic
Height 37.5 cm
First or second century AD (Eastern Han)

From Chengdu[1]
Sichuan Provincial Museum 222

This seated musician plays a stringed instrument laid across his knees. He wears a thick robe with open sleeves and a flat cap secured by a chin strap. His smiling face and slightly turned head betray his absorption in the music he plays. His instrument is a zither, probably the type without bridges or frets called *qin*; one hand stops the strings against the soundboard, the other plucks them. Several slightly different *qin* players are known among Sichuan tomb figures; the theme was evidently a popular one.[2] One example is made of stone rather than pottery.[3]

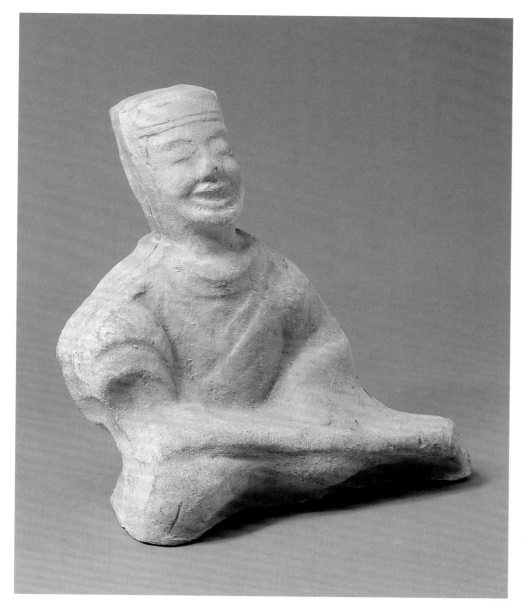

1. This figure was confiscated from looters by the Chengdu Railway Police; its exact provenance is not known.

2. See for example *Kaogu xuebao* 1958.1, pl 6.1 following p. 103 (from Chengdu Tianhuishan tomb 3); *Kaogu* 1959.8, pl. 5.3 (from Mumashan); *Wenwu* 1991.3, p. 10 fig. 3 (from Mianyang Hejiashan tomb 2); *Wenwu* 1999.8, p. 28 fig. 21.3 (from Chengdu Qingbaijiang).

3. Lim 1987, p. 137 pl. 44.

Figure of a dancer

Ceramic
Height 54 cm
First or second century AD (Eastern Han)

Excavated in 1990 from Mianyang Hejiashan tomb 2
Mianyang Museum EO4

PUBLISHED: *Wenwu* 1991.3, pp. 9–19 (report;
the figure is not illustrated).

Dancers are lovingly described in the long Han rhapsodies called *fu*:

> Beautiful ladies of dainty delicacy,
> Like Blue Zither and Consort Fu,
> Truly extraordinary, unmatched in the world,
> Beguiling and bewitching, elegant and refined,
> Faces powdered and painted, hair sculpted and trimmed,
> Lithe and lissome, decorous and demure,
> Soft and supple, gracile and graceful,
> Winning and winsome, slender and slight,
> Trail the hems of their pure silk gowns,
> Subtly flowing and falling, perfectly tailored.
> As they wheel and reel, whirl and twirl,
> Their garments seem not of this world.
> Their sweet fragrance, profusely permeating,
> Is strong and pungent, pure and thick.
> Their white teeth spangle and sparkle;
> Their toothy smiles gleam and glitter.
> Beneath long eyebrows, coiling and curling,
> They coyly gaze, cast sidelong glances.
> Their beauty is offered, the spirit consents
> And the heart rejoices to be at their side.[1]

Already in the earliest known depictions of dancers, in Warring States jades and bronzes, long swirling sleeves convey the elegant motions of the dance.[2] The sleeves were easier to depict in two-dimensional scenes on bricks (No. 102) than in three-dimensional figurines, but the present figure is distinctly graceful. The dancer's left hand gathers up her skirt as she smiles and steps forward; her raised right arm sets off with panache a head held serenely high. This dancer was found with a companion whose pose is her mirror image: the companion, whose flounced oversleeves are less well preserved, raises her left arm, gathers her skirt with her right hand, and steps forward with the right foot.[3] The tomb from which the two dancers come contained also the bronze horse No. 95 and the money tree No. 97. Similar dancers or fragments of dancers have been found at several other sites.[4]

1. Knechtges 1987, pp. 107–9.

2. Weber 1968, figs. 44b, 45d; for jades Lawton 1982, pp. 132–6.

3. *Wenwu* 1991.3, pl. 2.1.

4. E.g. *Wenwu* 1999.8, p. 24 fig. 10.3, p. 26 fig. 18, from Chengdu Qingbaijiang.

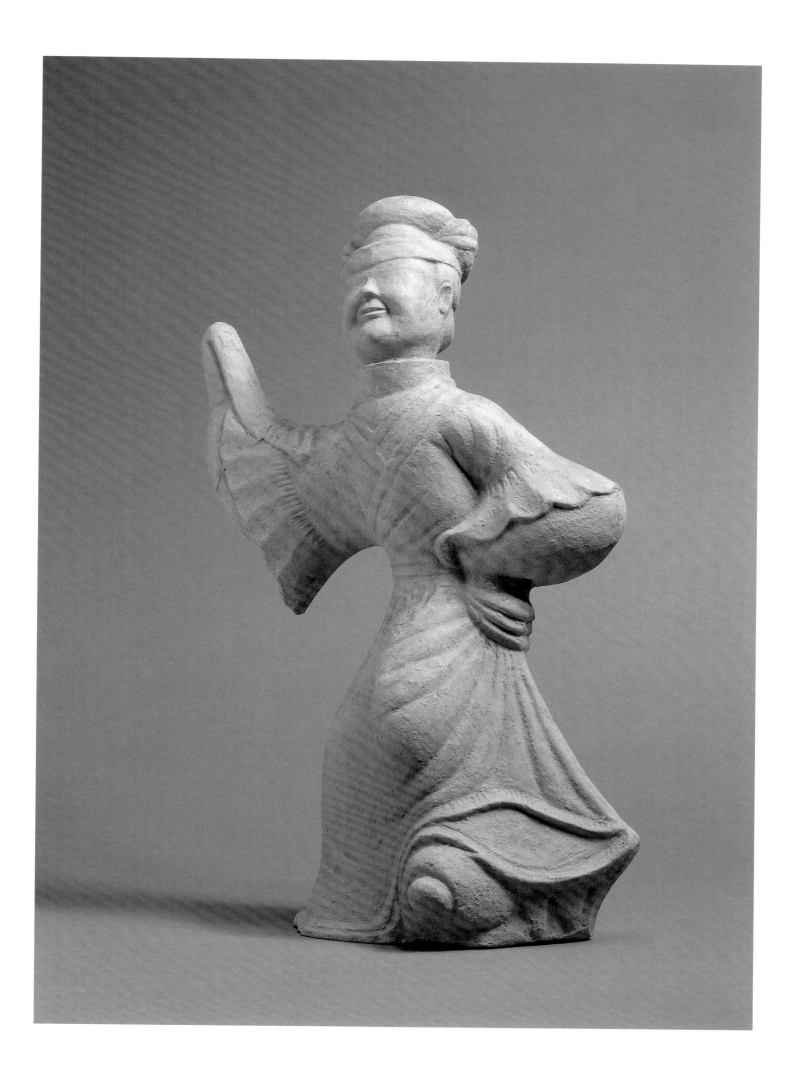

Figure of a listener

Ceramic
Height 27.3 cm
First or second century AD (Eastern Han)

Excavated in 1957 from Chengdu Tianhuishan
tomb 3
Sichuan Provincial Museum

PUBLISHED: *Kaogu xuebao* 1958.1, pp. 87–103
(site report; the figure is not illustrated).

The relaxed posture of this seated man suggests that
he is listening to music played by other figures in the
tomb; such auditors sometimes identify themselves
more explicitly by holding a hand up to an ear.[1]
Lounging sideways off his folded legs, the man leans
on his left arm, resting his right arm on his knee. He
tilts his head a trifle, smiles faintly, and seems to have
his eyes half closed. His robes are voluminous, and
he wears a flat cap resembling that of the *qin* player
No. 112.

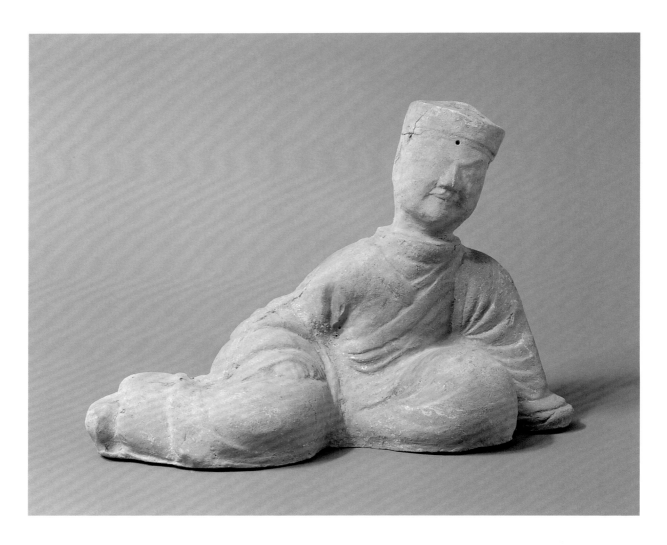

1. E.g. *Wenwu* 1999.9, p. 28
fig. 21.2, p. 30 fig. 24, from
Chengdu Qingbaijiang.

115

Kneeling woman

Ceramic, with red pigment
Height 58 cm
First or second century AD (Eastern Han)

Excavated in 1964 at Pi Xian
Sichuan Provincial Museum 103156

PUBLISHED:Rawson 1996, no. 111.

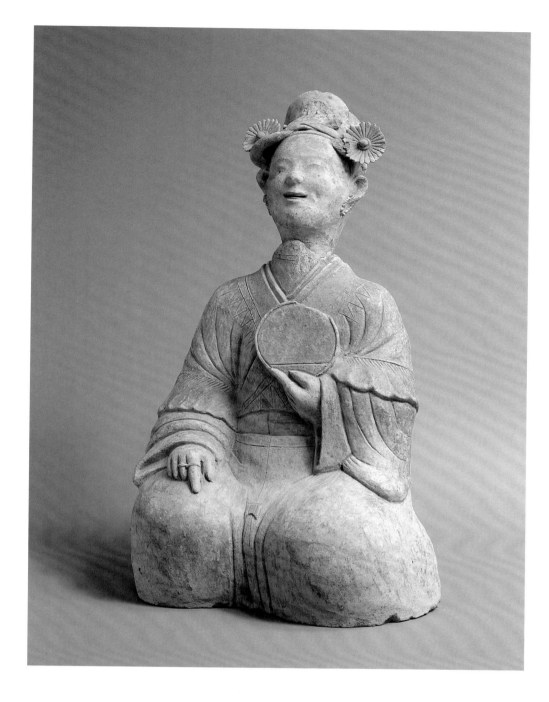

This kneeling female figure wears an elaborate costume with full sleeves, broad lapels, and zigzag borders. The layers of clothing at her neck show that she is wearing both an under and an outer garment; the latter has short sleeves with scalloped fringes and is secured with a belt. The woman's right hand, index finger extended, rests on her knee; her left hand holds up a circular object. She wears rings on both hands, earrings, and a headband twined with chrysanthemum flowers, a detail seen on several other figures from the same tomb. The flowers were formed in a mold and luted to the head, which was itself made separately and inserted into the body. Similar costumes, head-dresses, and smiling expressions are known from other Sichuan figures.[1] Some clearly represent entertainers; others, including the present one, might be servants of a noble household. The ladylike appearance and splendid garments of No. 115 say much about the cultivated and comfortable life of wealthy merchant and official families in Chengdu.

The circular object held by this figure and the next cannot be identified with certainty. It might be a mirror that the woman holds up for her mistress. Alternatively it might be a short-stemmed fan of a common Han and Three Kingdoms type; such fans were provided with a gripping area, which the horizontal line across the bottom of the disk seen here might be intended to delimit.

1. Many examples from Zhong Xian are illustrated in *Wenwu* 1985.7, pp. 66–72 and 90–93. Compare also Lim 1987, p. 138 pl. 45, from Chengdu.

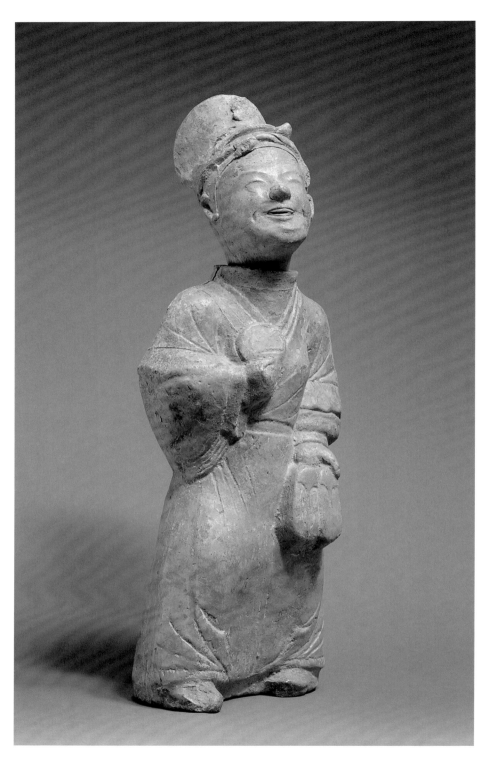

Standing figure of an attendant

Ceramic
Height 63 cm
First or second century AD (Eastern Han)

Excavated in 1982 from Xindu Majiashan tomb 22
Xindu County Bureau of Cultural Relics K3-0219

PUBLISHED: *Sichuan wenwu* 1984.4, p. 63 fig. 2;
Chengdu wenwu 1985.3, p. 45 fig. 3; Rawson 1996,
no. 112.

This attendant has a homelier appearance than the
last. She wears similar clothing, though no flowers
or jewelry, and a tall hat with a band at the hairline.
Her right hand carries a mirror or fan. In her left she
holds a pair of shoes, either her own or those of the
person she attends. Literary sources tell us that when
entering enclosed spaces it was customary to remove
the shoes and walk around in socks.

Figure of a peasant-soldier with spade and shovel

Ceramic
Height 83 cm
First or second century AD (Eastern Han)
Excavated in 1957 in Xinjin
Sichuan Provincial Museum 27394

PUBLISHED: *Kaogu* 1958.8, pp. 31–7; Rawson
1996, no. 113.

This rustic figure holds an iron-tipped wooden spade
in his right hand and a handleless shovel in his left.
A ring-ended sword and knife are attached to his belt.
He wears an under garment that comes to his knees,
a slightly shorter tunic over it, shoes open at the toes,
and a low cap. The spade he carries is a tool associ-
ated not only with tilling the soil but also with flood
control and irrigation, pressing needs in Sichuan.
The sword is a reminder that in troubled times the
peasants on the great manors might be called upon
to defend them. Peasant-soldiers very similar to this
one are depicted in stone reliefs.[1] To secure for them-
selves in the afterlife the prosperous rural existence
they enjoyed on their estates in this life, the wealthy
staffed their tombs with these stout workers in the
form of reliefs, pottery figures, and occasionally
figures of stone.[2]

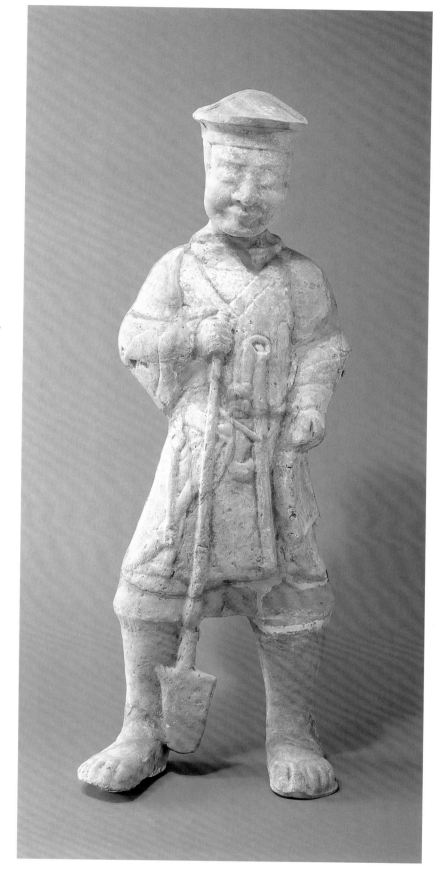

1. Beijing 1998g, nos. 205–6.

2. *Wenwu* 1993.1, p. 42 fig. 5.1. Compare London 1987, no. 30.

118

Figure of a tomb guardian (zhenmuyong)

Ceramic
Height 89 cm
First or second century AD (Eastern Han)

Found in 1965 near Chengdu
Sichuan Provincial Museum 28096

PUBLISHED: Rawson 1996, no. 114.

Unlike all the other pottery figures considered here, this image is clearly not an ordinary human being but some sort of spirit, or at least a masked human dressed up as a spirit. He has enormous eyes, projecting bovine ears, a topknot, a horn (perhaps a second horn has broken off), and a widely grinning fanged mouth from which a long tongue descends all the way to his waist (the tongue is interrupted at the neck because the head and body of the figure were made separately). Behind his right hand, which seems to grasp his tongue, an axe is tucked against his chest; the other hand holds a snake. The figure wears an under garment, over it a coat, and over the coat a cape with animal heads at its sides. A belt is indicated by a crisscross pattern scratched into the clay before it was fired; a ring-handled knife hangs from the belt.

The long tongue and the snake seem to connect this figure with much older antlered wooden figures, usually assumed to be guardians, found in Warring States Chu tombs. The Chu figures frequently have prominent eyes and long tongues; some hold snakes in their mouths.[1] It is possible that not only the appearance of the present figure but also its presumed function as a tomb guardian represent borrowings some centuries earlier from Chu funerary practices.

1. So 1999, pp. 45–7.

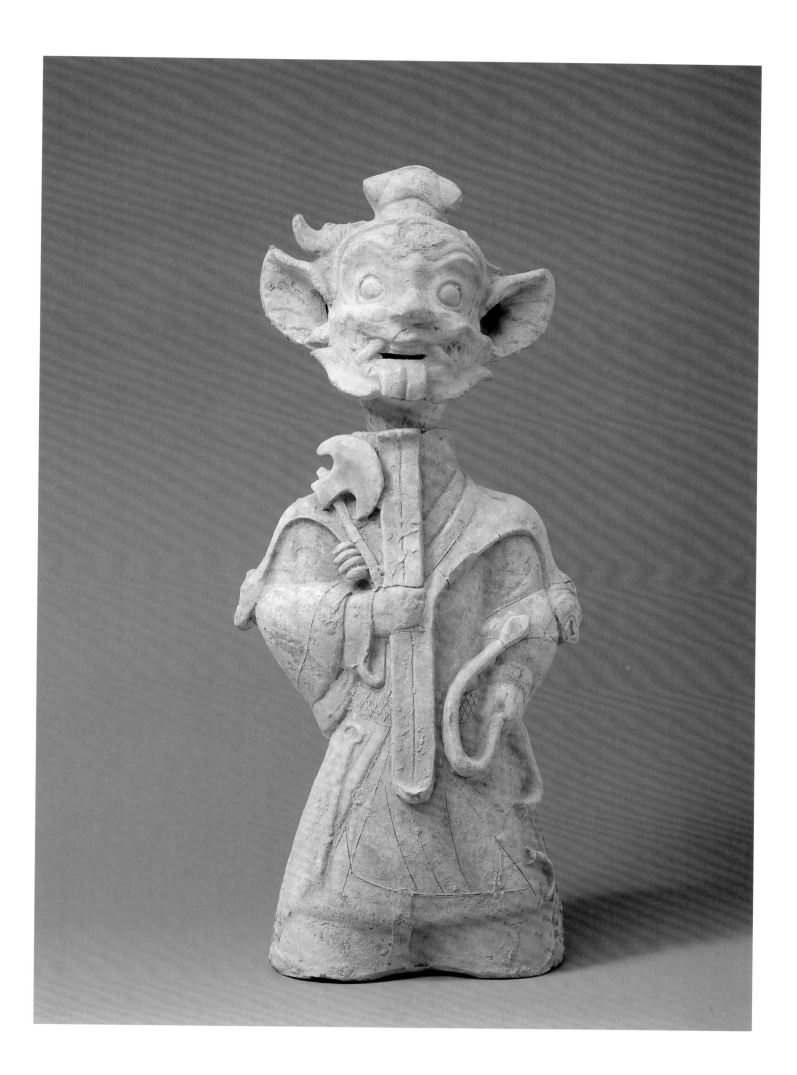

by Michael Nylan

The Legacies of the Chengdu Plain

Over the years, China scholars have become increasingly aware of the enormous contributions made by local cultures, even in relatively remote areas, to what we now call mainstream "Chinese" culture. Celebration of the Chengdu Plain's sinicization—implying a preoccupation with developments to the north and east of the present Sichuan province—has gradually given way to an appreciation of the Plain's local identity and distinctive style. This essay, focusing on the early empires of Qin and Han (221 BC–AD 220), argues that from the date of its conquest by predynastic Qin (316 BC), through the Han and down to the collapse of Shu-Han (AD 260), the Chengdu Plain, though not the only center of cultural and economic production in China, must be viewed as a major source of innovations in thought and art.[1]

In posing its argument, this essay aims to counter not only the usual capital-centered narratives that dominate Chinese studies but also the traditional scholarship ascribing innovations in systematic thought or material culture mainly to individual genius or to schools of such geniuses. This essay asks in what way local culture might have helped shape individual genius; it ties innovations, at least in part, to the effects of local geography and culture. Its interpretation of the (admittedly scanty) literary and artistic evidence for the period envisions a special local culture that had many Chengdu residents seeking new and better modes of reintegration with community and cosmos, a local culture that differed from others in the north and east.

In doing so, the essay questions a more recent trend in the field, one that views early China as a network of enduring regional traditions ("cultures") linked to specific ethnic groups that from prehistory preserved their innate essences, despite ongoing interaction and despite subjection to shifting dynastic powers. Present evidence hardly supports the notion of a fixed Shu culture existing in the Chengdu Plain from time immemorial, for while a loosely coherent local culture existed there during Qin and Han, key aspects of that culture reflected the shared memories of Chengdu residents nostalgic for a recent past under benign imperial administrators rather than identities defined predominantly by reference to the semi-mythical Shu rulers of antiquity. Considered in turn, other aspects of the Chengdu culture described below seem equally (a) distinct from the ethnic and cultural traditions that existed in the Shu area prior to the Qin conquest; (b) shaped by the local application of Qin and Han

1. I should like to thank Anthony Barbieri-Low, Raoul Birnbaum, Lothar von Falkenhausen, Martin Heijdra, Martin Kern, James Robson, David Sensabaugh, Tang Xiaofeng, and Franciscus Verellen for their help in the preparation of this essay. In an attempt to avoid the unexamined connotations of the term "Shu culture," I will use "Chengdu" or "Chengdu Plain" to refer to the geographic region; "Chengdu City" to refer to the provincial capital; and "Shu" to refer to the locale under the control of the Han administrative commandery. On the dating of the Qin conquest see *Sichuan wenxian* 148 (1974), pp. 3–7.

governance in this zone; (c) carried out mainly by individuals who saw themselves as loyal subjects of the Qin and Han realms; and (d) distinctive mainly on account of the geographical, environmental, and economic peculiarities of the area.

It is, of course, no easy task to find evidence in support of *any* hypothesis about local cultures in early imperial China, let alone to discern the path of cause and effect that zigzags back and forth between core and periphery. Early literary evidence for the period comes largely from the dynastic histories written in and for the capital. Little reliable information is to be had from Sichuan archaeology, and not only because many areas ripe for excavation lie below modern urban structures.[2] Still, recent archaeological finds in Sichuan (some, like those at Sanxingdui, predating the period under review by a millennium) have thrown into question the old assumption that the Chengdu Plain was irretrievably "barbarian," "backward," and "peripheral" before its tardy sinicization in mid Western Han. And once we open our eyes to alternative possibilities, even in our present inadequate sources we will see crucial contributions by Chengdu inhabitants to enduring cultural constructs in China at large.

Four facts about early Chengdu stand out in every narrative: its wealth, its diverse population, its favorable strategic position, and its advanced industrial capacity. All these factors enabled, even stimulated it to pursue major innovations. On the economic front, Chengdu was the most fertile of the three breadbaskets for the early empires.[3] The soil was good, the rainfall reliable, the weather temperate, and the irrigation systems extensive, so that the Plain enjoyed a long and productive growing season, with the average yields from paddy-rice land an estimated ten to fifteen times higher than elsewhere.[4] By Western Han times, local agriculture had already been intensified far beyond subsistence needs. Of the five most valuable processed products of the later Chinese agricultural economy—textiles, lacquer, tea, sugar cane, and paper—the Chengdu Plain was already famous for the first three in the early empires.[5] It was moreover one of the richest areas in China in mineral and plant resources. Early lists of its products name iron, silver, copper, gold, cinnabar, precious stones of all sorts, timber, bamboos, taro, dates, gardenias, fruit and citrus trees, special wines, the tonic *duolinfen* ("fallen tree powder")—the list goes on and on.[6] To produce and procure the best lacquer, silk, textiles, salt, iron, timber, and citrus in Shu, the Qin and Han courts set up local oversight offices *(gongguan),* expanding the number of such offices in the very locale where state factories seem to have arisen prior to Qin.[7] Other unofficial and semi-official production centers furnished vast amounts of silver, copper, and jade as well.[8] Commercial fishing, animal breeding, and natural gas production further enriched the economy.[9] Small wonder that the area was nicknamed "Heaven's Storehouse" and endowed with a sacred geography.[10]

Nor was the Plain lacking the favorable location, the financial capital, or the professional expertise to exploit its natural resources fully. Its

2. For a history of archaeology in the area see Li & Xu 1991, chapter 1. For political biases in the field of Chinese archaeology see Falkenhausen 1995a; for the consistent gender biases of modern archaeology, Nixon 1994.

3. Lu Yun 1987. The other two centers were "the land within the passes" (in the Wei River valley, near Chang'an) and the area corresponding to the old pre-unification states of Qi and Lu (in Shandong).

4. For standard yields see *Huayang,* p. 259. For irrigation networks, including the famous Dujiang dam (still in operation today), see *Shiji* 29.1407–9; *Huayang,* pp. 202, 214. For early depictions of agriculture see *Wenwu* 1976.3, pp. 77–8; *Wenwu* 1980.2, pp. 56–7.

5. For early paper manufacture see Ji Xianlin 1982, pp. 11–43. For silk, *ibid.* pp. 51–97; Zhao Feng 1992; Riboud 1973. Although lacquers found in tombs of the second half of the third century BC (the Warring States or Qin tombs of Yingjing and Qingchuan) have often been attributed to Chengdu manufacture, there is as yet no firm evidence that lacquer factories existed in Chengdu prior to Han. In Han times lacquers from Chengdu made their way to places as far distant as Qingzhen (Guizhou) and Lelang (Korea). Some lacquers from Mawangdui, as well as some from the Jiangling Fenghuangshan tombs in Hubei, bear labels recording Chengdu manufacture (*Kaogu* 1975.6, pp. 344–8). For tea in Sichuan in the Han period, and for sugar cane in post-Han agriculture, see Bray 1984; for paper and Sichuan agriculture in the Tang period see Schafer 1963, especially pp. 120, 152–4, 271.

6. A prime factor in the early development of Chengdu trade was the profusion of precious metals and salts found in the area. Trade in these items linked local exchange networks with metropolitan systems. Iron products marked "Shu Commandery" or "Chengdu" have been found in Han tombs in Yunnan (*Wenwu* 1962.3, pp. 33–4). For the value of Shu decorative weapons and knives see *Hanshu* 90.3660; *Hanshu* 89.3625. By late Western Han, centers in Shu and Guanghan commanderies famous for their production of "gold and silver vessels" (a term including lacquer vessels with metal mounts) had yearly outlays of five million cash each (*Hanshu* 72.3070). One such vessel dated AD 45 is now in the Palace Museum in Beijing. Chengdu must have been a major center for the production of mortuary art as well, since duplicate stone reliefs and ceramic tiles (some inscribed and others not) have been found at many archaeological sites in the area.

7. The earliest references in Warring States inscriptions are to an Eastern Factory of Shu, which some scholars speculate became the Guanghan Factory *(Guanghan jun gongguan)* of Qin times, though the inscriptions locate it in Chengdu. See Yuan Tingdong 1988, pp. 67–78; *Huayang,* pp. 235, 281; *Hou Hanshu* 28.3627; Hsü 1980, p. 133. *Huayang* (p. 237) mentions also a Carriage Officer, who had charge of a factory making equipages (presumably for the imperial house). Significantly, Chengdu City was one of six "great markets" in the empire, where *wujun sishi* ("basic commodity market overseers") were installed (*Hanshu* 24B.1180). For state and private workshops see Sheng 1995; Kuhn 1995. For the imperial silk offices in Shu see *Huayang,* p. 235. Shu products were reputed to be the best of their kind. Shu timber, for example, was employed in the construction of the Qin palaces (*Shiji* 6.256).

8. See Gu Jiegang 1981, p. 88. For example, so much copper was derived from a single private person's mines in Shu during the reign of Wendi (r. 179–157 BC) that it proved inflationary for the entire Han economy.

9. For model fisheries, see *Kaogu xuebao* 1958.1, pp. 87–104, especially plate 3. For the natural gas used in salt production to evaporate brine see Temple 1991, pp. 51–3, 78–81.

10. The wild beauty of the Yangzi gorges and the monumental strength of ancient stone megaliths to the west of the alluvial Chengdu Plain contributed further to this reputation. For local myths see Li Cheng 1996, especially pp. 302–26. For immortals (e.g. Pengzu, Xiwangmu, Wang Ziqiao, and Zhang Daoling) and divine omens see *Huayang,* pp. 271–9, and Zuo Si's "Shu Capital *fu*" (lines 388–91), translated in Knechtges 1982, pp. 365–9. For the megaliths see Feng 1945. For the Chengdu Plain as a hallowed land see Hahn 1988; Verellen 1995 and Verellen 1998; Li Yuanguo 1985, pp. 74–100; Chen Guofu 1949, vol. 2, pp. 330–39.

geographic location meant that it could enjoy steady contacts with Central Asia, India, southeast China, and Vietnam via overland trails and riverine routes.[11] Trade along the Yangzi River valley was so vigorous and sustained during Warring States and Han times that the exact place of origin for countless artifacts found in areas once under Shu, Ba, or Chu control may never be ascertained.[12] The sights, smells, and sounds of the Chengdu City markets, where exotic goods converged on a city nearly as large as metropolitan Chang'an, were so marvelous that one local prefect serving in the southwest, when faced with imminent execution for dereliction of duty, negotiated a delay in the date of execution so that he could visit the fabled markets once before he died.[13] Anecdotal evidence, like modern archaeological reports, testifies to the importance of Chengdu City throughout the period under review as one of the main centers for the empire's international and domestic trade, its prominence augmented by the city's industrial production and processing.[14]

It was to the Chengdu Plain, then, that traders bringing goods from places as far distant as Bactria came in quest of prestige goods and basic commodities.[15] But more than merchants and goods moved in and out of the Plain. It was home to a refugee culture in which people from the outside figured largely. Natural wealth and comparative remoteness combined to make it an attractive destination for those fleeing the wars and natural disasters that regularly plagued areas to the north and east.[16] At times also, in furtherance of their own wealth-and-power projects, the early emperors saw fit to resettle families in sparsely populated portions of the Plain. Shortly after the Qin unification, for instance, the First Emperor moved ten thousand families into the area, with the dual aim of better extracting the area's natural resources and relieving population pressure on the capital region.[17] The Plain served equally as a site of enforced exile for powerful political households, since the steep mountains encircling it ensured that "one man [in the emperor's army] could guard the gaps/so ten thousand [rebel forces] could not advance" from or against it.[18] It was to Sichuan that the First Emperor dispatched more than four thousand households associated with his political enemies Lü Buwei and Lao Ai.[19]

The Chengdu Plain in the early empires was thus an unusual sort of place that drew many different types of immigrants, each with its own distinctive profile. Economic refugees, driven from the lands to the north and east by famine or war, often came with little more than the clothes on their backs. Upon arrival, many must have labored in the mines, factories, or fields.[20] By contrast, political refugees who belonged to great magnate or merchant families usually commanded sufficient resources in men and money to displace the poorer local residents from their lands and businesses, even when the most fertile lands were not set aside specifically for their use.[21] In the third century BC, when the Plain's resources were still underexploited and the land relatively underpopulated, such political

11. For Chengdu as an early center of trade see Xu Zhongshu 1987. For the southwestern silk route, often ignored in favor of the Central Asian route through Dunhuang, see Chengdu 1992; Ji Xianlin 1982, pp. 11–97, 484–6. Li Bing's Dujiang Dam project dredged and rerouted rivers so as to make the rivers in the Chengdu area more navigable. The successive overlords of Shu also built an extensive network of covered cliffside roadways to supplement the river routes. See Li Zhiqin et al. 1989; Liu Yumao 1990, pp. 172–83.

12. In multiple entries dating from 703 BC onward, the Zuozhuan (compiled fourth century BC?) portrays the complex interactions between Ba, Shu, and Chu, facilitated by trade and war. See Jiang Han luntan 1980.4, pp. 87–91.

13. Huayang, p. 271; Hanshu 28A.1598; Hanshu 28A.1542. According to the census of AD 2, Chengdu had 76,256 registered households, or some 361,280 persons if we estimate five persons per household. Chang'an had 80,800 households. For Sichuan market scenes see Beijing 1998g, pls. 26–9; Gao Wen 1987, fig. 22; Lim 1987, p. 101 pl. 15; Wenwu 1973.3, pp. 52–7; Duan Yu 1990.

14. For Chengdu City see Goi 1995.

15. Shu was famous equally for luxury goods and for grain. Traders going to and from Shu dealt in everything from small-bulk, high-value goods (including the yak tails used for banners, badges of honor, and flywhisks) to unrefined raw materials, so that kings and commoners, Chinese and "barbarians," all depended upon Shu products. See e.g. Shiji 116.2994; Shiji 123.3166; Hanshu 72.3070; Hanshu 6.182.

16. See e.g. Huayang, p. 225; Hanshu 1A.38; Hsü 1980, p. 138 table 14. Bielenstein (1979, chapter 3) writes of two mass migrations southward in Han, both of which attracted great numbers to Chengdu. For the second see Kleeman 1998, especially pp. 132–43; Zizhi tongjian, zhuan 82. For the archaeology of the local refugee culture see Sichuan wenwu 1996.1, pp. 3–12.

17. For an earlier, predynastic Qin set of "Regulations for Making Fields" (i.e. mandating land redistribution) dated 309 or 305 BC, see Wenwu 1982.1, pp. 1–27; Kaogu 1983.6, pp. 545–8.

18. Zuo Si's "Shu Capital fu," lines 412–13, translated in Knechtges 1982, p. 371. Sichuan found it easy to protect itself from invaders, except when its elites asked outside powers to intervene in local power struggles, as happened under predynastic Qin. To the south, the Yangzi Gorges, located between the present cities of Chongqing and (Hubei) Yichang, prevented easy access upstream on the Yangzi; to the north, the Chengdu Plain was separated from the "land within the passes" by the high Qinling and Daba mountain ranges.

19. Shiji 25.315; Shiji 6.227.

20. The Qin state used a corvée system for artisans making luxury goods; under the Qin and Han dynasties, workers in iron offices were either conscripts or convicts. The Chengdu factories probably employed all types: free masters (who chose to work there because of Chengdu's resources and reputation), hereditary craftsmen (facilitating continuity of style), corvéed craftsmen, voluntarily indentured workers (known from Eastern Han anecdotes), and convicts.

21. When King Hui of Qin and the First Emperor pacified the Six States, they forcibly moved the great magnate families to Shu and "gave them our fertile lands," according to Huayang, p. 225.

refugees may have been welcome, since they brought massive infusions of capital and professional expertise.[22] One account tells of Luo Pou, a late Western Han Chengdu resident who, after making a hundred million cash in trade, was commissioned by a magnate family living near the capital to invest its funds in the thriving Sichuan economy.[23] By the close of the second century AD, however, when the Plain was well developed, the "men of the eastern provinces" were resented for continuing to "appropriate land and mistreat the older residents," parading around in their finery like "kings and marquises."[24] When the Eastern Han empire was nearing its end, local officials, freed from the customary close supervision by the central government, became more inclined to exact supernumerary taxes in their greed and corruption.[25] Adding to the volatility of the situation was the presence of people from many different ethnic groups, some of whom had come freely as traders or as soldiers, but some of whom had been sold into slavery or indentured servitude. Thus, as reinfeudation proceeded apace in Eastern Han, social tensions mounted. The pictorial stones and clay models made in this period show gentry manors stocked with racks of weapons essential for defending affluent households from bandits and disgruntled workers.[26]

If the unsurpassed sophistication of the local industries (for example, the lacquer, brocade, and iron- and salt-extracting industries) can be attributed partly to the sheer wealth concentrated in the Plain, particularly in Chengdu City, it also owed much to the number of talented, ambitious, and moneyed men and women who gathered there, exchanging information on techniques of all sorts. They made Chengdu City a fertile ground for innovation. As a site of industry and trade, it presumably functioned somewhat differently from the Qin, Han, Wei, and Jin capitals, which were seen primarily as seats of government and centers for education and consumption.[27] Its remarkable industrial advances, always seen against the background of the region's strikingly beautiful natural scenery and its important strategic role as kingmaker in the early empires,[28] worked to foster a strong sense of local pride. That pride sometimes led to the establishment of autonomous or semi-autonomous political states, but more typically to the retention by Sichuan artists of local motifs and styles, and to the production by Sichuan authors of literary works extolling the wonders of the region.[29] All such works were thought to verify the Chengdu Plain's special claim to constitute a miraculous community —supernaturally sanctioned, cosmogonically correct, and historically significant.

Modern scholarship confirms the view of commentators of the time, who credited the Chengdu Plain with four major contributions to the wider culture of the early empires: first, a state-sanctioned model for local schools; second, Mystery Learning (xuanxue), which formed the basic curriculum of the influential Jingzhou Academy for classical studies (which in turn shaped much of the philosophical discourse of the Wei-Jin

22. See e.g. *Shiji* 129.3277. Enormous differences exist between the Warring States tombs of the ordinary locals (excavated e.g. in the western suburbs of Chengdu; at Yingjing Zengjiagou; at Emei Fuxi; and at Qingchuan Baijingba), which contain mostly pottery burial goods and simple bronze weapons, and those of the magnates (e.g. at Xindu Majia Gongshe). Compare the report on the late Warring States tomb at Yingjing Tongxincun (Beijing 1998f, pp. 212–80) with *Kaogu* 1983.7, pp. 597–600; *Kaogu* 1984.12, pp. 1057–95; *Kaogu* 1986.11, pp. 961–93. An Eastern Han stele (dated after AD 108) found in 1966 in Pi Xian lists all the major possessions of more than twenty magnate families (Gao & Gao 1990, pp. 14–15).

23. *Hanshu* 91.1390; Swann 1950, pp. 453–4.

24. For the first quotation, see *Sanguozhi*, "Shu shu," 1.869, note 2 (Pei Songzhi's commentary, citing *Yingxiong ji*). The passage refers specifically to some twenty-five thousand refugees from Nanyang who organized themselves into an "Eastern Provinces Militia" at the time of Liu Zhang in late Eastern Han, but the description seems to suit well the pattern for immigrant settlement in the area. For the second quotation see *Huayang*, p. 225. Elites from the north and east reportedly "looked down upon the men of Shu" (Ren Naiqiang 1987, p. 2).

25. See e.g. *Sanguozhi*, "Shu shu," 1.876 (Pei Songzhi's commentary, citing *Han Lingdi ji*); also *Hou Hanshu* 41.1396. Such problems help to explain the strictures against money-grubbing recorded in the *Xiang'er Commentary* (compiled c. AD 200) on the *Laozi*.

26. For ethnic minority families with high social status (often gained through military service) see *Wenwu* 1992.11, pp. 49–62. On the enslaved ethnic minorities see Tong Enzheng 1979, pp. 90ff; Meng Mo et al. 1989, pp. 92–105. For the pictorial evidence see Weng Shanlang 1990, pp. 241–51, and also the model armory published in *Kaikodo Journal*, Autumn 1998.

27. The contrast should not be overstated, however, as Chang'an also produced bronzes under the Shanglin offices; weapons, mirrors, and lacquers under the Shangfang and Kaogong; and funerary equipment in workshops in the city and suburbs.

28. Hence the strict supervision of the Plain by the central government from predynastic Qin times (Fujita 1996, p. 42). Certainly the resources of the area contributed much to the final victories of the First Emperor of Qin and Liu Bang, founder of Han. Similarly in AD 207 Liu Bei accepted Zhuge Liang's assessment that the area could be used to "assume the imperial position." Under Western Jin (AD 265–316), Wang Rui cut down Sichuan forests to build his navy, after which he led seventy thousand troops downriver to defeat Sun Wu and unify the state. Separate or separatist states in Shu include the Kaiming before the Qin conquest of 316 BC; Gongsun Shu at the end of Western Han (AD 25–36); the short-lived attempt in AD 154 to establish a millenarian state in Shu; the semi-autonomous state of Liu Yan and Liu Zhang in Chengdu at the end of Eastern Han (AD 189–214); Liu Bei's separate state of Shu-Han (AD 220–263); and the Cheng-Han state from AD 306 to 347.

29. Writings about the glories of the Yizhou area seem to have been especially numerous in the Han and Wei-Jin periods, since over twenty titles (or one-fifth of the total for the entire country) are extant today (*Huayang*, p. 3). Even more important, such writings often claim by their very titles a parity between the Chengdu Plain and the Central States, as when "Basic Annals" are given to the Shu kings. For bibliographies of early Shu writings see *Er shi wu shi bu bian*, vols. 1–2, and *Quan Shu yin wen zhi*.

Local forms and motifs retained for centuries include the money trees, which continue from Han through the Three Kingdoms period; the white tiger, which begins as totem of the Ba people, resurfaces as mascot of Xiwangmu, and later serves as an all-purpose "auspicious animal" in the Three Kingdoms period (see note 66); and the fine patterns for sword and knife blades from eastern Sichuan known from late Zhou to Tang tombs.

period); third, a distinct symbolic vision associated with Chengdu religious cults (the most famous being that of the Celestial Masters, considered the source and mainstay of China's only indigenous "higher religion," Daoism);[30] and fourth, a new literary form, the *fu* (rhyme-prose or rhapsody). A new style of naturalistic representation in art, which longstanding traditions hail as the innovation of the painter Gu Kaizhi (c. 344–406), may be a fifth contribution that should be added to the list.

Of course, the surviving narratives that boast of such contributions cannot be trusted uncritically. In the process of trumpeting genuine achievements, local boosters did not hesitate to appropriate much that in fact had originated elsewhere.[31] Time and again, culture heroes who hailed from areas outside the Plain were converted into regional tutelary gods. To name but a few: Bieling, the legendary founder of the Kaiming "dynasty"; Zhang Yi, the Qin political strategist; Zhang Daoling, recipient of revelations from the deified Laozi; and Li Bing, the governor of Shu Commandery under Qin, who supervised the construction of the Dujiang dam.[32] Quite often, given the patchiness of extant sources for Qin and Han, the modern historian has no solid criteria by which to judge the Plain's possible contributions to cultural and intellectual life. For instance, as the Japanese scholar Yoshikawa Tadao has pointed out, the Chengdu area during Eastern Han and Wei-Jin spawned a disproportionate number of *fangshi* masters specializing in the predictive and calendrical arts. From at least the time of Gongsun Shu (r. AD 25–36), a warlord-rival to the Eastern Han founder, the area was considered a center for the production of "talismanic writings portending good and evil fortune."[33] It is hard to know what we should make of these facts, and the careful historian must also take note of aspects of culture in which the Chengdu Plain failed to take the lead. Despite its rich mineral and plant resources, the region contributed little to many fields of science and proto-science, medicine for example.[34] Our aim must be to acknowledge distinctive contributions without accepting the most exaggerated local claims. But the very nature of immigrant cultures, combined with the paucity of evidence for the period, makes any assessment of ideology and art from the early empires necessarily more speculative than we might wish.

With this in mind, let us return to the five contributions listed above. The list began with education, for Emperor Wu of Western Han (r. 140–87 BC) was reportedly so impressed with a local educational system initiated by Wen Weng, the appointed Governor of Shu Commandery, that he ordered all the commanderies and kingdoms in his empire to set up academies on its model.[35] Wen Weng himself supervised the institution of a local academy in Chengdu City, whose expenses he underwrote through reductions in bureaucratic expenditures and massive irrigation projects enriching the Plain.[36] Wen also chose eighteen promising local graduates of the academy to go to Chang'an, the capital, for advanced study in classics and law. To help smooth the way for his candidates in the capital,

30. Dean 1993, p. 15.

31. To cite but one example: though numerous Chinese works tout a "Southern School of Astronomy" based in Chengdu (supposedly derived from Luoxia Hong, inventor of the armillary sphere, who was from Ba), historians of Chinese science (Christopher Cullen, Nathan Sivin) find no evidence of an organized school of astronomy in Shu.

32. For Li Bing see Luo Kaiyu 1990; *Wenwu* 1974.7, pp. 27–38; *Sichuan wenxian* 148 (1974), pp. 8–10. In the earliest hagiography, Zhang Daoling, founder of the Celestial Masters, is said to have been a native of Feng in the kingdom of Pei (northwestern Jiangsu).

33. Yoshikawa 1984.

34. Nathan Sivin (private communication, April 1999). However, Shu contributed a number of products to the *materia medica,* including gorals (to relieve fever), aconite, sweet flag, ox bezoars, and epsom salts.

35. *Hanshu* 89.3625–27; *Huayang,* p. 214. We cannot be sure, of course, that such an order was ever carried out. But whether under imperial edict or not, several local men (among them Zhang Ba, later governor of Kuaiji) instituted academies on the model of Wen Weng's school when they took public office. See *Huayang,* chapter 10 (e.g. p. 716).

36. Wen Weng's water conservancy projects increased the area irrigated in the Chengdu Plain by 1700 *qing* (Hsü 1980, p. 258). For state sacrifices to him see *Hanshu* 89.2642.

he thoughtfully supplied their teachers with Sichuan specialty products: book knives (presumably for personal use) and textiles (which could easily be converted into cash).[37] Among those youths, a certain Zhang Shu was especially bright and hardworking; during the very next reign, Zhang was duly appointed Academician for the Classics at the capital.[38] Meanwhile, Wen Weng dispatched his other protégés to serve as prefectural schoolmasters outside Chengdu City. Throughout his tenure as governor, to encourage the greatest number of qualified applicants, Wen personally guaranteed the integrity of the local academic examinations. Finally, he commissioned illustrations of the notables of antiquity, including the Three Sovereigns and the Five Kings, for the walls of his Academy. Under their watchful eyes, students were to develop moral insight as well as practical wisdom. Nor was Wen content simply to establish a superb local school; a "Stone Chamber" he constructed as a ritual hall probably also served as a library. Thanks to his efforts, we are told, "the men of Shu [Commandery] who studied in the capital [soon] compared with those of Qi and Lu [traditional centers of classical learning]."[39]

Since the foregoing information comes from a dynastic history, we must suspect that by mid-Han times the capital elites felt a need to account for the conspicuous excellence of the Chengdu Plain's educational system and the distinguished careers of its graduates. The advantages of a Chengdu education must have had a tremendous effect on core-periphery relations between the Plain and the Han capital, which had steadily intensified since 316 BC, for classical education was the very foundation on which Han rulers intended to build their dynastic legitimacy. In a world where culture played a paramount role in determining ethnicity, such ready acculturation to the ideology of the Central States would have altered Chengdu's status in the eyes of the court.[40]

Had Chengdu lacked this rigorous educational system, it is hard to imagine that a second development, Mystery Learning, could ever have arisen there. The origins of Mystery Learning can be traced back to Yan Junping, the late Western Han resident of Chengdu and teacher of Yang Xiong, whose synthesis of Dao and Ru texts in turn influenced a number of later scholars, including Huan Tan, Zhang Heng, Ma Rong, and Song Zhong, chief master of the Jingzhou Academy. Yan Junping, the first master known to regard the *Book of Changes,* the *Laozi,* and the *Zhuangzi* as a unitary system, consciously used divination to promote the ethical behavior of those who sought his advice. Every day, telling fortunes in the marketplace, he manipulated the yarrow stalks and turtle cracks in order to teach people to be good. He advised parents to be more loving to their children, children to be more filial toward their parents; he advised siblings to take care of each other and those who were unrelated to be honest and trustworthy in dealing with one another. But when he had seen enough clients to pay for his modest daily needs, he shut up shop, so that he could devote his time to teaching and studying the *Laozi* and *Zhuangzi*

37. On Sichuan book knives see Tsien 1971.

38. *Hanshu* 89.2656; see *Huayang,* p. 214, for further information.

39. *Hanshu* 89.3626. As a result, under the Han, four slots (out of eight for the entire empire) were reserved for "summoned scholar-officials" from Shu, according to *Huayang,* p. 223. Quite a few private academies were founded in Shu, the most famous being those of Yang Yi (from Shifang) and Duan Yi and Yang Hou (of Xindu). *Lishi* (*zhuan* 14) contains a Han stele that lists fifty famous classical masters in Shu Commandery. For the Shu academies see Meng Mo *et al.* 1989, pp. 107–8. Under Han, half the "summoned scholar-officials" were from Shu, according to *Huayang,* p. 223; Ren Naiqiang 1987, p. 148 note 27. As the capitals of Western and Eastern Han respectively, Chang'an and Luoyang are usually cast as the intellectual centers of the Han empire, but in fact the political capital did not always command the state's best thinkers (compare Washington, D.C.).

40. On education's role in determining status see *Hanshu* 28B.1645.

texts. Clearly, Yan distanced himself from the ordinary path taken by intellectuals hired at court.[41] Though we know little about the specific content of his teachings, we do know that his faithful disciple Yang Xiong expressed grave doubts about conventional political practice and about the metropolitan claim to supreme cultural refinement. Judging from Yang's writings, Yan's version of Mystery Learning, even in its nascent stages, emphasized the ineffable yet exemplary character of Heaven's Way, on which humans were to model themselves. Heaven's natural rhythms were to be discerned through insights cultivated in classical learning and ritual practice, the final goal being a mystical immersion in the divine that amounted to a kind of immortality. Yang's own neoclassical *Taixuan* (Canon of Supreme Mystery) argued that the prerequisite for such immersion was thorough acquaintance with the antique orders of civilization, for all he saw around him was decadence. So naturalized have many components of Yang's particular strain of Han "Confucian" classicism become that we tend to forget how very unusual Mystery Learning was in late Western Han.

Nor can we overstate the contribution that the Mystery Learning of Yan and Yang made to the classical traditions of Eastern Han and later. Its subtlety of thought and elegance of literary expression were irresistible to many. Yang Xiong's reading of the classics, as interpreted by the master Song Zhong (d. AD 219), eventually served as the core teaching of the Jing-zhou Academy under Liu Biao (d. AD 208).[42] Located in a Hubei town (modern Xiangyang) closely linked by river trade to Chengdu, the Jing-zhou Academy attracted some three hundred classical masters to its ranks. Its only serious rivals for scholastic preeminence were the private academies established by Zheng Xuan (AD 127–200) and his chief disciples, which tended to train students more narrowly in linguistics, literary theory, and grammar. When the Jingzhou Academy was disbanded in AD 208 upon the untimely death of its patron Liu Biao, the Jingzhou masters and disciples scattered to the far corners of the empire—back to Shu Commandery, to Wu in the far south, and to the Wei capital—each taking with him Jingzhou's special brand of scholarship, as modified by his personal understanding. In this way, Jingzhou influenced the thought of Wang Can (AD 177–217), Wang Bi (AD 226–249), and Wang Su (d. AD 256).[43] Historians of classical learning have tended to portray the post-Han evolution of learning in terms of a rivalry between the school of Wang Su and that of Zheng Xuan. To the degree that such a characterization makes sense, what was at issue was Jingzhou's impulse to derive from a host of earlier traditions a more critical view of the state's prerogatives, a more emphatic insistence on the cosmic Dao as the object of mystical pursuit, and a more dogged curiosity about the discrete factors fomenting historical change—all impulses to be found earlier in the syncretizing works of Yang Xiong of Chengdu.[44] Nor should we overlook the ease with which Mystery Learning, which equated the moral good with true

41. *Huayang*, pp. 701–3. Yan Junping (= Yan Zun) is identified as a major literary figure in *Hanshu* 28B.1645. Many scholars identify him with the "Master Zhuang" whose sayings are recorded in the (now fragmentary) *Daode zhenjing zhigui* text, part of the Daoist canon; see Meng Wentong 1981, pp. 111–13.

42. On the Jingzhou Academy see Yoshikawa 1991, T'ang 1947. For Mystery Learning as a source of later thought see Wang Baoxuan 1996.

43. Wang Bi inherited the library of his uncle, Wang Can, a master at Jingzhou. Wang Su looked to Jingzhou for inspiration and rhetorical arguments in his fight against Zheng Xuan's readings, as he had studied Yang Xiong's *Taixuan* (Canon of Supreme Mystery) with Song Zhong when Song came to serve Cao Cao after the death of Liu Bei. If Wang Su is the author of the *Kongzi jiayu*, as most believe, certainly his description of the ideal Ru tallies with that offered by Yang Xiong. See "The Conduct of a Ju Explained," in *Kongzi jiayu*, especially p. 219. Other critics of Zheng Xuan who wrote commentaries on the *Taixuan* include Lu Kai of Wu (d. AD 229), Yu Fan of Wu (d. AD 233), and Lu Ji of Wu (d. AD 250).

44. For one example of a Mystery Learning adherent's sharp criticism of governmental prerogatives, see Lu Kai's memorial, drawing upon Mencius and Yang Xiong, cited in *Sanguozhi*, "Wu shu," 61.1400. An overview of Mystery Learning is provided by Tang Changru 1957 (see especially p. 338).

connoisseurship, was adapted regularly by would-be aesthetes for public self-presentations that were quite devoid of any moral commitment.[45]

This brings us naturally to a third contribution of the Chengdu Plain, religious Daoism. (Too little is known about the early importation of Buddhism during the period under review to begin to sketch its local impact.)[46] Traditional accounts of religious Daoism cite two possible sources for its distinctive organization and beliefs: the Yellow Turban Rebellion of AD 184, which was centered in the eastern coastal region, a well-planned millennial movement calling for a restoration of "great peace"; and the messianic sects in the Chengdu area in the second century AD, the most famous of which is that of the Celestial Masters (Tianshi).[47] Based on our present knowledge, the Chengdu sects—through the Celestial Masters— had by far the greater impact on the subsequent growth and elaboration of Daoist religious traditions. One eminent historian of religion, Michel Strickmann, has even proposed that the term "religious Daoists" be limited to those who recognized the unique historical position of the first Celestial Master. Though many scholars view this proposal as an oversimplification, at the very least all Daoist traditions of the early and medieval periods "without exception found it necessary to position themselves either in continuation of or in reaction to the Celestial Masters."[48]

The Chengdu-based sects, however divided by class interests and competition for proselytes, shared the belief that a local cult figure, the sage Li Hong (late first century BC), was an avatar of the deified Laozi. The religion of the Celestial Masters, the group we know most about, took as its basic insight the cosmological order of the body and of time, as encapsulated in the Diagram of the Orthodox One of the Twenty-four Energies.[49] Organized into 24 dioceses headed by 24 husband-and-wife teams of Libationers, each team the recipient of the distilled energy of Laozi's person through genealogical registers and charms, the Celestial Masters engaged in faith-healing practices while guiding the ritual life of the community.[50] As adherents of Li Hong, their first task was to unlearn present conventions, so highly ritualized activities were devised to reacquaint them with the fundamental truth that "the way of man is to connect" and "never depart from the Dao."[51] Next, a host of activities were designed to facilitate the merging of the self with the larger divinely ordained communities of the cosmos (e.g. public confessions, community service, and elaborate ceremonies petitioning the gods and "uniting the qi"). To these the devotee added various techniques, including ritual purification and meditation in "quiet chambers," aimed at purging the physical person of its grosser elements.[52] For those who kept faith, the reward was membership in a small group of discerning people of "transcendent nobility" who sustained each other in life and who hoped to survive death in a simulacrum of the mundane body.[53] Such religious views at once reflected and speeded the process whereby ethically neutral views of the afterlife gave way to ethically charged views.

45. Nylan 1996.

46. The visual record makes it clear, however, that Buddhism was introduced into China along three main Silk Routes. Two of these ended in Chengdu City (the first went overland through Burma and Yunnan, the second by sea along the south and east coasts and then up the Yangzi), and Sichuan had access to the third, which ran northwest through Central Asia, by way of Jiuquan and Shanshan. What seem to be the three earliest extant images of the Buddha in China come from Leshan, Pengshan, and Lushan, all mountain sites in Sichuan located near the southwestern Silk Route. See Edwards 1954, and for the later period, Ishida 1976 and Rhie 1999. A rubbing of a now lost Chengdu stele dated AD 427 looks so much like Dunhuang material of comparable date that we must posit continuing strong links between Buddhist communities in the two places. See Liu Zhiyuan 1958, pl. 31.

47. The Yellow Turban ideology may derive ultimately from Gan Chongke (fl. 32 BC) of Qi, an account of whom is given in Loewe 1974, chapter 8. A number of works discuss the Yellow Turbans; among them, Mansvelt-Beck 1980 considers the relation of the Yellow Turbans to the Celestial Masters. Bokenkamp 1997, p. 26, remarks on "the massive historiographical and textual problems to be solved" before we can speak with confidence about the beliefs, practices, or organization of the Yellow Turbans.

48. Strickmann 1979. For criticism of Strickmann's view see Robinet 1984, vol. 1, pp. 72–4, and Robinet 1997. For the quotation, see Bokenkamp 1997, p. 15.

49. On the early history of the Chengdu sects see Seidel 1970, especially pp. 232, 237. On the cosmological order see Schipper 1979.

50. Ōfuchi 1964, pp. 4–63. For a stele inscription dated 173 BC that speaks of the Celestial Master Libationers see Ōfuchi 1991, pp. 41–4.

51. The first quotation is from *Fayan* 3.7; the second, from almost any early Daoist text.

52. According to Feng Xuecheng *et al.* 1992, Chengdu City remained a center for advanced training in meditation for centuries. For the body's refinement see Seidel 1987b. Ideas of resurrection long predate the importation of Buddhism into China, as Donald Harper (1994) has shown. For the quiet chambers see Stein 1963.

53. Bokenkamp 1997, pp. 41–6.

Earlier philosophical texts had urged the necessity of return to an ideal state modelled on the distant past, a past over which the Dao had once ruled in absolute purity without human interference. The startling new idea promoted by the early Celestial Masters was that each and every person—not just the emperor—was destined to receive in life a divine decree from Heaven *(ming)*. With the intended audience of the *Laozi* text no longer restricted to the sage, the sage-ruler, or the gentry, Laozi's model suddenly became relevant to all of humanity.[54] Accordingly, the Celestial Masters' leadership, some of which was drawn from local elites, was open to the idea of recruitment among the lower classes, illiterates, and "barbarians" (i.e. the partly sinicized ethnic groups living in the Chengdu Plain). The unifying social constructs of a sect intent upon returning to primal non-differentiation profoundly influenced later moral visions, despite or even because of the destruction of the early organization of the Celestial Masters in AD 215, when its leader Zhang Lu surrendered to General Cao Cao, founder of Wei (AD 220–264).[55] Cao Cao's enforced relocation of as many as one-quarter of the Celestial Masters' community (an estimated one hundred thousand) to locations scattered throughout the realm resulted in the swift spread of their ideas, originally a product of the Chengdu Plain refugee culture, to regions outside.[56]

Some of the appeal of religious Daoism lay in its ability to register widespread dissatisfaction with the inadequacies of the state-sponsored cosmology and to protest the costly and ineffective outlays—psychological and financial—demanded by the established older sacrificial cults in the Chengdu Plain. Hence its promise to subjugate the local cult gods and convert them into protective deities, as in the legend in which Zhang Ling tricks twelve demons from the watery netherworld, imprisons them in a great salt well, and then transforms them into guardian deities watching over the area's economy.[57] In Han Chengdu, one of the most entrenched of the older cults would have been that dedicated to Xiwangmu, the Queen Mother of the West.[58] In wooing followers away from her cult, the early Daoists found it useful to advertise their ties to other local saints such as Li Hong and Zhang Daoling, just as the Mystery Learners cited Yan Junping when denouncing all immortality cults.[59] Later Daoists, bowing to popular pressure, thought it wiser to grant the Queen a minor position in their pantheon of lesser gods.

Han legend ascribed to the Queen Mother a variety of roles: immortal presiding over Mount Kunlun, the *axis mundi;* intermediary for the souls of the deceased; savior of those suffering from famine, drought, pestilence, and debilitating disease; and consort to Dongwanggong, spirit of *yang qi*. The Chengdu Plain cultists, however, prayed to her most often in her generalized role as dispenser of good fortune. The goddess' devotees knew her by her frontal iconic pose, by the *sheng* (weaving spool?) inserted in her unruly mass of hair, by her distinctive throne flanked by tiger and dragon, and by her motley assortment of attendants—a toad, a hare

54. Seidel 1978 notes that before the advent of religious Daoism, communication with the gods was regarded as the state's prerogative. The *Xiang'er Commentary* (c. AD 200) on the *Laozi*, a product of the Celestial Masters, addresses itself to all mankind, not just to the privileged.

55. While the Daoist meditation traditions (the Shangqing or Maoshan traditions, on which see Robinet 1984 and Robinet 1997) certainly place more emphasis on individual practice, including cultivation of the elite arts and visualization practice, even they grant the notion that salvation is open to all Daoist believers.

56. Ōfuchi 1991, pp. 55–7. One piece of evidence pointing to the Celestial Masters' origin in a refugee culture is found in the means they used to spread their religion: Libationers set up "responsibility huts" *(yishe)* at intervals along major highways where refugees were invited to eat their fill of the rice and meat stored there as they made their journeys.

57. For the first point see Loewe 1979, p. 96; for the second, Stein 1979 and Verellen 1997. Verellen argues that this legend can be traced to Eastern Han, but the earliest extant reference to it is in a fragment dated AD 697.

58. Elites, as well as the unlettered, were devotees of Xiwangmu. See Loewe 1979, pp. 86–125; Wu 1987; and James 1995. Images of Xiwangmu have been found in many Han and Wei-Jin sites, including Kongwangshan (Jiangsu, south of present Lianyungang city), Heling'er (Inner Mongolia), and Yi'nan (Shandong).

59. "Da ren *fu,*" cited in *Shiji* 117.3063. *Hanshu* 57B.2597 is the earliest Han literary mention of Xiwangmu in connection with an immortality cult; the reference is somewhat denigrating—and significantly, it is by a man of Shu, Sima Xiangru. Yang Xiong was a strong opponent of the immortality cult, as is clear from *Fayan* 12.40. The Celestial Masters accepted Xiwangmu's connection with long life, but they paid her no special respect.

Fig. 1. Silk brocade with depiction of Kunlun, from Noin-Ula tomb 6. Second or first century BC (Western Han). After Xia Nai 1983b, p. 66 pl. 47.

60. Xiwangmu seems part-human and part-animal. By the first century AD, she appears regularly in shrine art (e.g. at Shandong Jiaxiang). A second century AD depiction on a stone sarcophagus from Sichuan Pi Xian shows her with flames or wings issuing from her shoulders (James 1995, fig. 21).

61. For the 3 BC march on the capital see *Hanshu* 11.342; *Hanshu* 27A.1476. The earliest extant literary references to Xiwangmu appear in the *Shanhaijing* (2/10/23; 16/70/3) and the *Bamboo Annals* (1.6.3/4/1; 1.58.11/27/11; 2.4.5.9/62/21). A securely dated early image unambiguously identified as Xiwangmu is supplied by a late Western Han tomb near Zhengzhou (*Wenwu* 1972.10, pp. 41–8). For later Henan depictions, see Beijing 1985a. Two other oft-cited depictions are less trustworthy: it has been argued that Xiwangmu is shown in three-quarters pose in the tomb of Bu Qianqiu (*Wenwu* 1977.6, pp. 17–22), but the identification is uncertain; and she appears on a bronze mirror dated AD 10 but of questionable authenticity (*Kōkogaku zasshi* 18 [1928], pp. 31–3; Kominami 1974; Kominami & Sofukawa 1979; Loewe 1979, pp. 169–73).

62. In some of the most accomplished artistic work outside Sichuan, Xiwangmu appears quite prominently, as for instance in *Wenwu* 1983.5, p. 29 pl. 2, dated AD 96. Compare a fine stone lintel at Shaanxi Suide (Sturman 1985), on which the Queen is flanked by devotees, frontally posed, and even Dongwanggong has by his side a rabbit pounding the mortar of immortality. Xunzi wrote that the Queen Mother taught Yu the Great, who according to legend was born in Minshan. (Note meanwhile several curious parallels between the story of Bieling, founder of the Kaimings, and the legend cycles of Kun and his son, Yu the Great, including the fact that all three, by some legends, metamorphosed into turtles, and that the place of Yu's birth coincides with the site of Bieling's restoration to the living.) See Xu Zhongshu 1987, pp. 74, 159–60; *FSTY* 9.74 and *yiwen* 2.98; Birrell 1993, pp. 304, 315.

63. Wu 1987; for money trees, Erickson 1994b and the entries for Nos. 97–8 in this book. To date, according to Rhie 1999, it is Xiwangmu who most often occupies the central position in excavated tombs in Shu.

64. That Sichuan was the "center of All-under-Heaven" is confirmed by the *Shanhaijing*, the first extant text in which Xiwangmu appears. See Meng Wentong 1981, especially pp. 159–63; Tong Enzheng 1990, pp. 240–52. Li Bing, according to the *Shuwang benji*, identified Mount Wen (near Pi City) as the gateway to Heaven; other Han texts identified the Jade Mountain on which Xiwangmu resides with Mount Shaman (also in Sichuan), as reported in Gu Jiegang 1981, p. 75. For the shifting location of Kunlun see Leslie &

compounding the elixir of immortality with mortar and pestle, a nine-tailed fox, lean figures with wings on their backs *(xian),* and various devotees or supplicants (seen for example on No. 108, an Eastern Han tomb tile).[60]

The earliest extant images of Xiwangmu seem to come from late Western Han Henan, and our first extensive literary account of her cult has devotees from 26 commanderies converging on the capital at Chang'an in 3 BC.[61] Nevertheless there are cogent reasons to believe that her cult originated in Sichuan and from there spread quickly via river, overland, and then sea routes to the north, east, and south-central provinces, carrying distinctive Sichuan styles and images with it.[62] First, it is Xiwangmu who most frequently occupies the central position on Sichuan Han sarcophagi and on the distinctive "money trees" that clearly originated in Sichuan.[63] Second, Xiwangmu lives on or near Mount Kunlun, a mythical place initially identified with mountains in or near Sichuan—though the location of Mount Kunlun moved progressively westward as the exploration of Central Asia proceeded.[64] Perhaps the most exquisite piece of Han polychrome silk ever excavated conflates this mythical Kunlun with what appears to be a Sichuan-style money tree (Fig. 1).[65] And one of the gates to Kunlun is guarded by a nine-headed beast called "Kaiming": the Kaimings were overlords in the Chengdu Plain for nine generations prior to its conquest by Qin in 316 BC. Third, Xiwangmu's attendants include the white tiger, long sacred to Sichuan culture.[66] Fourth, the first emanations in the sky that drive men to seek her protection regularly appear in or from the southwest.[67] Fifth, in Sichuan art an untamed half-human and half-animal Xiwangmu generally presides without the shadowy consort supplied her in other parts of China, where she and her belated consort represent the cosmic forces of *yin* and *yang*.[68] Her prominence in Sichuan —unaccompanied, unconfused with other deities, and iconographically fairly stable—favors the idea that her cult originated there.

Before leaving the topic of religious beliefs in Chengdu, it may prove useful to ask how religious Daoists compared in origin and character with their approximate contemporaries, the hyper-educated transmitters of Mystery Learning. At first glance the two groups would seem to have nothing in common, given the different class backgrounds of most of their followers,[69] yet in some respects they viewed the world in roughly similar ways. Both insisted that a sharp break in time had occurred, an earlier, better world having been supplanted by a world of danger, corruption, and dehumanization.[70] Both sensed that the opportunities for men of their socioeconomic standing were fast disappearing.[71] Alienated from and sometimes hostile to conventional ways, both groups viewed themselves as outsiders in the current world of power relations.[72] Both therefore had the same basic motivation for change: a heartfelt desire to return to a distant source of integrity that would facilitate final reintegration, first with a community of like-minded souls and second with the cosmic

forces, and thereby ensure their physical and psychic safety.[73] The indus-
trialized, urbane, and ethnically diverse character of the Chengdu region,
along with the proliferation of huge landed estates run by magnate fami-
lies, seems to have provoked in some local inhabitants a nostalgia for the
simpler fellowships they attributed to a distant but recoverable past. To
both groups, personal and social salvation were possible because Dao or
Heaven from time to time manifested itself in truly extraordinary indi-
viduals, adherence to whose teachings could save the faithful.[74] Whether
they viewed themselves as "seed people" or as ethically committed classi-
cists,[75] the proponents of Daoism and Mystery Learning strove to develop
their basic human natures until such time as they could reach sagehood;
believing themselves to have the requisite discipline and intelligence to
shepherd the rest of humanity, they saw a duty to remake society by re-
making the self.

Thus we find self-selected elites and peasants in the period of political
disunion proclaiming their specialness through Mystery Learning and
religious Daoism. Some part of their conscious exceptionalism may have
been derived from the conviction, as residents of the Chengdu Plain, that
their home was a "hallowed land" under Heaven's special protection. In
any case, by the foregoing analysis, nearly the entire spectrum of Chinese
modes of thinking, from peasant to elite, was substantially shaped from
Eastern Han onward by Chengdu-based religious traditions—by proto-
Daoist and Daoist movements or by Mystery Learning. It might be ob-
jected that there is nothing distinctive to the Plain about desire for return
to a distant antiquity. Was not nearly all of early Chinese thought some
variation on this theme? The answer is, we badly misperceive Han intel-
lectual life if we suppose either that it was impossible after Han Wudi
(r. 140–87 BC) to conceive the new as the good or that all returns to the
past are alike.[76] The Chengdu vision was distinctive in that the symbolic
past to which it longed to return implied criticism not only of modernist
policies but also of the careerist classicists favored at court.

The fourth and fifth contributions of Chengdu culture, the literary and
visual arts of Han and Cao-Wei times, reinforce this analysis. The literary
contributions of early Sichuan to what we now call mainstream Chinese
culture must be obvious to all, given the role of the acknowledged masters
Sima Xiangru (179–117 BC), Wang Bao (fl. 58 BC), and Yang Xiong (53 BC–
AD 18), three longtime Chengdu residents, in the development of the
distinctive Han form of the *fu* (rhyme-prose or rhapsody).[77] *Fu,* which
tend toward an exhaustive treatment of a single subject, are characterized
by a highly ornate style; lines of unequal length; the mixing of rhymed
with unrhymed passages; lush description and stunning hyperbole; repe-
tition of synonyms combined with parallelism and antithesis; extensive
cataloguing, often employing rare vocabulary; and frequent reliance on
the dialogue-debate format. Extant *fu* from earlier periods had taken one
of three forms: short riddles presented through dialogue, designed to

Gardiner 1996, pp. 273–8. Some early legends have Xiwangmu living in a
cave (*Shiji* 117.3060), and Shu is an area rich in cave tombs and mountain
cults; for such a depiction of Xiwangmu and Kunlun on a bronze wine gob-
let see Hayashi 1974, pp. 248–9. Wu Hung's assertion, following Sofukawa
Hiroshi, of "the independence of the Queen Mother legend and the Kunlun
myth" (Wu 1989, pp. 119–26) seems merely to overlook religious art's
propensity for piling theme upon theme.

65. As no artisanal offices for silk were located in Chang'an, and "only arti-
sans in state workshops wove figured silks" (Sheng 1995, p. 60), this silk
may have come from Sichuan factories.

66. Li Xueqin 1991a, pp. 162–4. Tiger motifs are encountered at Sanxing-
dui (Nos. 39–40), and the tiger is also frequently depicted on Eastern Zhou
Ba-Shu weapons (e.g. No. 82). For the tiger cult see *Sichuan wenwu* 1994.1,
pp. 9–11. White is the color of the west, and the sign of the Queen Mother's
protection is "white hairs" below the gate pivot.

67. *Hanshu* 26.1311–12 (twice).

68. In tombs outside Sichuan, Xiwangmu usually appears with a consort,
either Fuxi or—much more commonly—Dongwanggong (e.g. in Bu
Qianqiu's tomb [see note 61]; in a Shaanxi tomb dated AD 96; and in East-
ern Han tombs in Henan, Hebei, and Shandong). In Shu it is only rare and
late examples that show her paired with a consort and playing a vague cos-
mic role (see e.g. *Wenwu* 1991.3, pp. 1–8), and the tombs in which these
examples occur may be those of immigrants from the eastern provinces.
Note that the Buddha appears in conjunction with Xiwangmu in many late
Eastern Han depictions, especially in the eastern seacoast provinces and
in Sichuan.

69. Zürcher (1978, p. 38) emphasizes the peasant origins of the Daoists, but
more recent studies suggest that the leading Celestial Masters, including the
Zhangs themselves, were well-connected members of the local gentry. One
of the most sophisticated attempts to correlate local artifacts with class is
Sichuan wenwu 1992.2, pp. 27–38.

70. Thus both groups assumed that most court classicists were "practition-
ers of false arts" and inclined to deviationism. After the surrender of the
Hanzhong community in AD 215, however, the Celestial Masters movement
adopted a more conventional stance.

71. See for instance Yang Xiong's ironic *fu,* "Expelling Poverty," translated
in Knechtges 1976, pp. 104–7, which concludes: "Poverty then did not
leave, / He accompanies me always."

72. Yang Xiong's sense of persecution, for example, is manifest in his *fu*
"Dissolving Ridicule," where he reports that he risks ridicule and execution
(translated in Knechtges 1976, pp. 98–102).

73. Yang Xiong throughout his work strives for a calm acceptance of fate
"without apprehensions." See his "Expelling Poverty" *fu,* translated in
Knechtges 1976, pp. 104–7, especially p. 106, couplets 46–50.

74. As guaranteed in the *Zhengyi fawen Tianshi jiaojie kejing* (Scripture of the
Rules of the Celestial Master's Religious Commandments, from the Zhengyi
Canon) written under the Cao-Wei (AD 220–264). Compare Schipper
1994, p. 78. For the early religious Daoists, of course, the source of com-
munity was the cosmic Dao, origin of all life and sustenance of celestial
beings; for the *xuanxue* classicists, it was the sages, those successful mani-
festations of Dao within the realm of human existence.

75. The term "seed people" *(zhongmin),* which seems to have been a simple
pun on "the masses" *(zhongmin),* was coined by the Celestial Masters. For the
importance of punning to rhetorical language in Han see Girardot 1983,
especially chapter 1.

76. Think of the *Yantielun,* of Wang Chong's *Lunheng,* of Wang Fu's *Qianfulun,*
of Zhongchang Tong, and so on.

77. Though Wang Bao's writings were very influential in his own age, little
of them survives except the "*Fu* on the Panpipes" (translated in Knechtges
1996, pp. 233–43) and a satirical "Slave Contract." One *fu* writer obviously
influenced by the Shu masters was Zhang Heng, whose "*Fu* on the Two
Capitals" expresses deep concern over the increasing extravagance and
dissipation of the ruling elites and whose "*Fu* on Pondering the Mystery"
refutes the melancholy pessimism of the *sao*-type frustration prose-poems.

demonstrate the moral worth and quick wit of the author to a ruler considering him for official appointment or advancement; the so-called "*fu* of frustration," beginning with Qu Yuan's famous "Encountering Sorrow" *(Li sao)* poem, which expressed self-commiseration in the face of the court's callous indifference to the author's genius; and the pleasure *fu,* which detailed the joys available to the ruler in the form of luxurious surroundings, beautiful women, sensuous music, and fine food.[78]

Building upon the formal features of earlier *fu,* the Chengdu masters Sima Xiangru and Yang Xiong evolved a new "grand style." No less refined and indirect than earlier examples, their *fu* were appreciably longer, more prone to use unusual vocabulary in fantastic descriptions, and more didactic in content. Boldly satirical at points, despite the fine phrases that adeptly cloaked the barb, they portrayed the growing authoritarianism of the Han imperium while mocking the self-absorption displayed by contemporary classicists as well as by their poetic forebears.[79]

Many questions still surround the Han history of *fu* and Sichuan's contributions to the genre, since there remain only some forty-odd *fu* out of 1004 compositions recorded for the Han. The problem of audience raises a further barrier to our understanding: while the visual impact of Chengdu lacquers and metalwork, for example, needed no complicated translation for would-be connoisseurs, the *fu* poets had in some degree to accommodate the linguistic and stylistic patterns known to their patrons in the capital. Since we do not know what changes in dialect, syntax, and style were required for the *fu* of the Sichuan masters to win admirers at the Han court in Chang'an, it is hard to establish the degree to which the new *fu* style of Sima Xiangru and Yang Xiong represents individual genius, Sichuan's special place as an intellectual and cultural center, or the evolving political culture of the capital where their mature work was received.[80]

The historical record offers little more than intriguing hints of connections between local culture and the *fu* masterpieces. Several potential but at this remove unprovable links with the poets' backgrounds nevertheless come to mind. First, prior to the time of Sima Xiangru and Yang Xiong, the *fu* form had evolved mainly in the vassal courts of the Warring States, Qin, and early Han. The formal properties of the new-style *fu,* with its strange new rhythms, exotic vocabulary, and more satirical tone, could evolve with greater freedom away from the throne's immediate scrutiny. On the other hand, outside the imperial courts only a few big cities like Chengdu commanded sufficient resources (in libraries, academies, and well-developed traditions of scholarship) to foster continuing advances in this linguistically demanding genre. Both Sichuan masters compiled dictionaries, and both alleged the suasive, even magical properties of fine speech, for "the heart and mind of the [true] *fu*-writer," as Sima Xiangru put it, "encompass the entire universe and see into all men and things."[81] To the Han way of thinking, it was patently obvious that what gave men of the Chengdu Plain their acute aesthetic sense and special facility with

78. Arthur Waley once called the *fu* descriptions a kind of "word magic" whose effects are achieved by a "purely sensuous intoxication of rhythm and language." The pleasure *fu* seem eventually to have evolved into the later praise *fu* written to adulate the imperial line.

79. For the "refined" and "indirect" character of their *fu* see Shih 1959, p. 82. Sima Xiangru is regarded as the "poet most responsible for shaping the character of this type" of poetry (Knechtges 1976, p. 34). Cited in *Shiji* 117.3015, he speaks of "wanton pleasures and reckless extravagances . . . that hardly reflect credit on the state"; in *Shiji* 117.3041, of the ideal situation in which the emperor—contrary to current practice—converts his private hunting parks to farms for his subjects' benefit; and in *Shiji* 117.3051, of "rescuing the common people from the sea of troubles in which they flounder." For Yang see e.g. *Hanshu* 87B.3558, which complains on behalf of a farmer about the imperial hunts. Ma Jigao (1987, pp. 62, 69) finds no strong social criticism voiced in *fu* before Sima Xiangru. Mei Sheng's "Seven Strategies," while anticipating many features of the style of Sima Xiangru (e.g. extended description, intermingling of prose and verse, great length, and wild hyperbole), makes only a perfunctory effort at didactic suasion; see Knechtges & Swanson 1971. Jia Yi's "Owl *fu*" bemoans self-absorption, but it fails to criticize public policy. See also Gong Kechang 1984, Hervouet 1964, Jian Zongwu 1976, Knechtges 1976.

80. For Shu as the "intellectual and cultural center" and Chang'an as the "political center" see Knechtges 1968, p. 18. The best study of Han dialect remains Serruys 1959. For Shu specifically, see Cui Rongchang 1996, chapter 1, which includes some material on early Shu, and Coblin 1986. Perhaps Shu dialect words account for the large number of *hapax legomena* in the works of Sima Xiangru and Yang Xiong. For the oral performance of *fu* see Kamatani 1996.

81. Sima Xiangru cited in *Xijing zaji,* chapter 2. Sima Xiangru was the author of the *Fanjiang pian,* only fragments of which survive, as reported in Hervouet 1964, p. 61; Yang Xiong was the author of the *Fangyan,* a dialect dictionary still extant, as recorded in *Hanshu* 87B.3583.

words was the marvelous fecundity and beauty of Sichuan.[82] Certainly much of the wild imagery of the two masters' *fu* draws upon memories of their homeland. Perhaps their love for exotic vocabulary and sensuous rhythms was fostered also by their familiarity with the jumble of dialects overheard in the Chengdu markets.[83] After the wonders of Chengdu City, the "Consummate Capital," neither Sima Xiangru (heir to a vast fortune) nor Yang Xiong (who was poor) was particularly awed by the splendors of the court.[84]

Though we must wait for further research to enlighten us about the *fu,* a growing body of evidence suggests that a particular style of naturalistic painting—in which human figures move believably within natural landscapes ruled by time—became prominent during Han in the Chengdu Plain. Just as Mystery Learning is seldom traced back to Chengdu, long tradition holds that this style found its first full expression in the works of the "metropolitan" master painter Gu Kaizhi (c. 344–406), who was based in Jiankang (near modern Nanjing), far away from Sichuan and nearly two centuries after Han. More recent scholarship has instead traced the birth of landscape in China to Central Asian influences and to the inspiration of early Han immortality cults.[85] But neither for Gu Kaizhi's style nor for Central Asian landscapes is the evidence clear enough to rule out other possibilities. Given the close affinities that link pictorial form and modes of thinking in early China,[86] the Chengdu Plain's special vision of time and timely integration, and Sichuan's position at the convergence of several artistic traditions (including those of Chu, Dian in Yunnan, and the Central Asian steppe peoples),[87] a case can be made that paintings which depict human activities within a natural landscape in order to affirm the timely patterns of Heaven-and-Earth owe a debt to the Chengdu Plain.

Literary formulations about art (which must, of course, be used with caution) tell us that Gu Kaizhi was admired because he captured the spirit of his human subjects through careful delineation of their facial expressions, especially the eyes, and also because he ably conveyed the "dynamic configuration" *(shi)* of subjects through his arrangement of figures in space, sometimes in naturalistic settings.[88] At present, three major works are connected with Gu, including the famous *Admonitions of the Court Instructress* scroll illustrating a well-known treatise for women, but all are later copies at best.[89] In the absence of Gu's long-lost masterworks, modern scholarship presumes that archaeologically excavated works from the post-Han period can give a general impression of the Gu Kaizhi style, sometimes called the "Southern Style." Two works are considered especially germane: the late fourth century bricks with mold-impressed designs excavated from Xishan Qiao near modern Nanjing in 1960, which form two "murals" (each roughly 2.4 by 0.8 meters in size) depicting the *Seven Sages of the Bamboo Grove;* and the painted clay tiles from Deng Xian (southern Henan, due south of Luoyang).[90] In these examples of metropolitan art, three features immediately command the viewer's attention.

82. *Hanshu* 28B.1645; *Hanshu* 30.1720.

83. History records that both Sima Xiangru and Yang Xiong were "stutterers," even though Sima's work (like that of earlier *fu* writers but not that of Yang Xiong) was clearly meant for oral performance. Do the notices of stuttering record merely an odd coincidence, or were the two men perhaps unable to master the capital dialect when they arrived at the imperial court in middle age? If the latter, did their stuttering hamper them, leading to a degree of mental and social alienation from the dominant court factions? Sima Xiangru was slandered at court; Yang Xiong was known "never to participate in [political] affairs," according to *Hanshu* 87B.3583, and one contemporary account records that his birthplace was held against him at court. Yang nonetheless loved his native Shu enough to carry both of his sons back there for burial, even though this left him impoverished (*Xinlun,* p. 65 entry 69, p. 106 entry 104).

84. For the wonders of Chengdu see Zuo Si's "Shu Capital *fu*," presumably based on Yang Xiong's "Shu Capital Rhapsody," found in *Guwenyuan* 2.7a. The epithet "Consummate Capital" is applied to Chengdu in Zuo Si's poem (Knechtges 1982, p. 357, line 211).

85. See Jansé 1932; Wu 1984; Jacobson 1985; Sturman 1985, which cites rubbings from tombs at Shaanxi Suide and Jiangsu Pei Xian (dated *c.* AD 100 and 150 respectively). For the tombs see *Kaogu* 1983, pp. 233–7; *Wenwu* 1984.8, pp. 22–9.

86. The function of early public art in China was to convey the same lessons as literature and philosophy. For example, Zhang Heng, a self-proclaimed disciple of Yang Xiong, was reputedly a painter, as well as a poet and astronomer. Huan Tan and Yang Xiong are known to have discussed aesthetic matters (*Xinlun,* entry 126A, p. 120), and the case of Cai Yong (AD 132–192) is well known.

87. On the mutual Shu-Chu influence from mid Warring States see Guo Dewei 1991; Lawton 1991, especially pp. 19–21, 138. For the Dian people see Pirazzoli 1974 and Allard 1999; for their energetic depictions, Tokyo 1988b, especially pls. 33–49.

88. We know for example that Gu Kaizhi painted Xie Kun among crags and rocks to signify that he lived in honorable seclusion (Mather 1976, p. 368). In extant work attributed to Gu, the closest approach to placing figures easily within a landscape is found in the last section of the *Admonitions* scroll, but there the figure of an archer is not actually within but placed to the side of an improbably small mountain landscape.

89. The treatise which *Admonitions* illustrates is Zhang Hua's (AD 232–300) *Nüshi jian.* The other two works attributed to Gu are the *Goddess of the Luo River* scroll, based on Cao Zhi's (AD 192–232) *fu* of frustration in the style of the *Chuci* (Songs of Chu, or Songs of the South); and a painting of Yuntaishan (Cloud Terrace Mountain) depicting an early legend about Zhang Daoling, reputed founder of the Celestial Masters sect of Daoism. *Admonitions* and *Goddess of the Luo River* are known only from copies, the earliest dating from Tang and Song respectively; furthermore no pre-Yuan text even associates Gu with the subject of the *Goddess of the Luo River* (early texts associate it instead with Sima Biao [d. AD 306]). For Gu's *Yuntaishan* painting, only his own detailed description remains; perhaps the painting was never executed (Sullivan 1954). The Seattle Art Museum (Eugene Fuller Memorial Collection) owns an unpublished pottery vase, third century AD or later, that shows this same scene. For traditional assessments of Gu's work, see Bush & Shih 1985, pp. 10, 21, 28–9, 72, 78.

90. For the *Seven Sages* see Soper 1961, Laing 1974, Spiro 1990. Tombs near the *Seven Sages* tomb are dated to AD 369–84. For Deng Xian see Beijing 1959; *Wenwu* 1960.9, pp. 8–9, 37–42; Juliano 1980; all of which date the tombs prior to AD 497–98. Juliano notes the close affinities between many motifs from Deng Xian and the "Han style from Szechwan and Hunan" (p. 74).

91. For the religious significance of painting in the eyes, see Spiro 1988. The fine delineation of facial features was already common by late Western Han, to judge by the figures found at Luoyang tomb 61 (*c.* 48–8 BC) and the Luoyang tomb at Balitai (now in the Museum of Fine Arts, Boston; from the reign of Emperor Cheng, r. 32–7 BC). If the well-known Painted Basket from Lelang is of Shu manufacture, as are several inscribed pieces from the same tomb (Harada & Tazawa 1930), then the same conventions for portraiture prevailed in Shu as in the metropolitan regions and Shandong.

92. Note however that it is only with the Nelson sarcophagus (dated *c.* 525, a century later) that figures move within a complicated landscape setting.

93. In the *Admonitions* scroll (British Museum version), see the taut angles formed by the sedan-bearers' black shoes and by their awkwardly bent necks; the lines seem to work against one another, slashing and mincing space. The impression of energy in the picture is curiously heightened because the running feet and straining necks are juxtaposed with immovable objects (e.g. the sedan support) and the firm stances of the seated emperor and the standing Lady Ban. One might compare two pairs of flying apsarases juxtaposed with a vase and a censer at Deng Xian (figs. 57–9 in Juliano 1980).

94. See Huang & Guo 1996, pls. 2–11.

95. Since the excavation report speaks of two servants each for the master and mistress, what looks like a third hat among the male attendants must be a dark brick from which the white-paste background has fallen off. Note that the viewer receives a stronger impression of movement when she turns to subsidiary figures, for example the chariot procession and the kneeling figure. For another stereotyped (if exquisitely rendered) pose, see the Eastern Han portrait of the Master of Records painted on brick at Hebei Wangdu (Beijing 1974, pl. 8).

96. Wang Yanshou (*c.* AD 124–148), in describing a set of palace murals in Lu (Shandong), emphasizes the seamless continuity of history depicted there (Bush & Shih 1985, pp. 25–6). For a similar emphasis in philosophical works, see for example the writings of Ban Gu (AD 32–92) and Zheng Xuan (AD 127–200), both of whom emphasize the absolute continuity of Chinese civilization. That the north continued to favor the set poses known from Shandong and Luoyang is suggested by the Anak wall painting of the official Dong Shou (*c.* AD 357), first reported in *Kaogu* 1959.1, pp. 27–35, and a wall painting from a stone tomb at Liaoning Chaoyang Yuantaizi, dated to the fourth century AD, reproduced in *Wenwu* 1984.6, pp. 44–5.

Heads have been carefully delineated, with special attention going to the hair or cap (indicating rank and activity), the skin folds (indicating age), and the eyes (as mirrors of the soul).[91] Movement and tension are suggested by acute angles placed side by side or set against stationary objects, enviable languor by flowing rounded lines. And finally, in the *Seven Sages* example, each figure is seated within a landscape space cell.[92] As most of these features correspond with some aspect of the extant Tang copy of the *Admonitions* scroll,[93] the consensus has been that they must represent the new art of the southern metropolitan culture associated with Gu in the late fourth century AD.

Yet even supposing that Gu's works really were the first major painting monuments to combine landscape and figure successfully, such analyses have failed to establish how two features attributed to Gu—careful delineation of the face and movement or tension in the body—came together with the all-important third, the placement of humans within landscape settings. A set of murals found at Zhucun, near the Eastern Han capital Luoyang, can be taken to exemplify the most advanced metropolitan figural art during the Han-Wei transition period (early third century). The murals remind us that good artists in the capital were adept at defining character with fine brushlines and at conveying status through conventions of costume and gesture.[94] At the center of one scene at Zhucun, for example, we see the master and mistress of the house seated on a dais and wearing formal dress, as if about to receive guests. Neatly flanked on either side by two personal servants, they epitomize unshakable wealth and power.[95] Throughout the tomb, it is evident that the painter was asked to show the perquisites of high rank and landed wealth: servants, daises, banquets, canopies, and horse-drawn carriages in procession.

Han pictorial art from Luoyang and Shandong reproduces the joys of this life, which the tomb occupants hoped to see exactly replicated in the next. These members of the ruling elite comfortably viewed themselves as the latest embodiments of a divinely appointed hierarchy that might experience some cyclical transfers of dynastic rule but that would never undergo any really substantive change. (For this view, they found ample support in the philosophical literature of the eastern provinces.)[96] In the capital, where power was typically legitimated by reference to the past, and in Shandong, the oldest center of classical learning, art's two main functions were to reaffirm the inherent justice of hierarchy by identifying members of the ruling elite, past and present, as political and ethical authorities; and to remind viewers of certain lessons inculcated by the state. Typically, neither function required the artist to show exemplary figures in motion, let alone show them operating within a landscape setting. Where a need was perceived to suggest interaction between figures, it could be suggested primarily through facial expressions and secondarily by a subtle twist of limbs, hands, or heads, accentuated by

clothing lines, as Mencius had noted
centuries before.[97] Thus judging from
excavated materials two important
features associated with Gu's art—
dramatic figural movement and easy
placement of figures within a landscape
setting—were not yet fully in evidence
in works from the centers of Central
States culture in the Cao-Wei period.

The art of Sichuan, however, is
notable for precisely these features,
as several ceramic tomb tiles in the
present exhibition demonstrate. One
(No. 104) shows workmen operating
a large salt-brine well located deep
within a mountain range; the well is
placed against the lower left mountain, and boiling pans appear on the
lower right.[98] Another (No. 107) depicts a woman who has left off
tending to her skeins of hemp or silk to mate with her partner; goaded
on by a servant or child, the couple is the subject of observation by frisky
monkeys and an aroused bystander.[99] The contrast with the stiff poses
for representing tomb occupants favored by patrons among the Luoyang
and Shandong gentry could not be greater. Whether bucolic, industrial,
or erotic in theme, Sichuanese art in Han times shows less interest in
glorified empire than in the local, the momentary, and the intimate. Even
when the goddess Xiwangmu faces the viewer in a formal frontal pose,
her attendants—among them a frog hopping on one foot—are in a whirl
of activity (No. 108).[100] In the Chengdu Plain, the scenes whose sole
purpose seems to be to acquaint the viewer with the subject's high status
are frequently offset by others suggesting the pleasurable understanding
that comes only from a free and easy integration with one's soul mate or
with the larger patterns of Heaven-and-Earth.

Fig. 2. Rubbing of a stone relief from Sichuan Leshan.
Second century AD. After Beijing 1998g, pl. 242.

Fig. 3. Rubbing of a stone relief from the Wu Liang
shrine at Shandong Jiaxiang Wuzhaishan, c. AD 151.
After a rubbing in the collection of Marquand Library,
Princeton University.

A comparison of two roughly contemporary pieces of art devoted to
a single subject—the loyal retainer Jing Ke's attempt to assassinate the
wicked First Emperor of Qin—suggests the degree to which Sichuan
scenes, instead of picturing eternal and unchanging time, give the viewer
a sharp sense of time's passing. Best deciphered from rubbings, both works
place their main figures in silhouette against a flat background, but they
could hardly be more different. A scene from Leshan (second century AD),
convincingly capturing a single moment in time, displays the pulsing life
and energy appropriate to the high emotional intensity that provoked the
violent deed (Fig. 2).[101] By contrast, a scene from the Wu Liang shrine in
Shandong (c. AD 151) places cookie-cutter figures so improbably in space
that a moment of high drama looks flat and still (Fig. 3). Only the bulging
muscles of an official who restrains the assassin convey some sense of

97. *Mencius* 3A/5, 4A/16, and 7A/21.

98. Note that this tile shares with a brick from Deng Xian the technique of
suggesting mountain ranges through the overlapping of triangular elements
(Tokyo 1983, pl. 102). The mountains at Deng Xian form a semicircle that
creates space, however, while the sense of recession in the Sichuan tile is
diminished by the artist's decision to ground all the mountains on the same
base line. As far as I know, the Deng Xian brick, which depicts the Four
Graybeards, is the only example outside Shu to show such a landscape
setting.

99. At this early date, depictions of human intimacy are seldom seen out-
side Sichuan art (very rare earlier examples are one or two Western Zhou
bronzes showing nude figures in what is presumably a ritual context). See
Lim 1987, pp. 127–31. Some modern scholars would connect depictions
like that on No. 107 with the Celestial Masters' ritual of *heqi* ("uniting the
qi"), but given the distance between the casual scene on the tile and the
highly ritualized activity prescribed by the Celestial Masters, such a con-
nection seems unlikely. See *Sichuan wenwu* 1995.1, pp. 15–21, for two
analyses, the second by Gao Wen.

100. Compare Gao Wen 1987, fig. 95 (rubbing of a ceramic tile now in
the Sichuan Provincial Museum).

101. Since no cartouche identifies the subject, it is conceivable that the
Leshan rubbing shows not the Jing Ke story but another assassination
attempt. Compare also a battle scene illustrated in Gao Wen 1987, fig. 64
(rubbing now in the possession of the Xindu County Wenwu Baoguan).

tension, and only, perhaps, to viewers already familiar with the famous Jing Ke story. The depiction of time does not seem to concern the Shandong artist, who chose to collapse several stages of the event into a single configuration, showing us simultaneously the gift box whose open lid reveals a severed head, the dagger flung with such strength that it has stuck in a pillar, and an imperial attendant cowed by both of the larger-than-life adversaries.

We know from works contemporary with these that artists outside the Chengdu Plain had learned how to create an impression of movement and bustle by crowding and even overlapping figures (often those of animals or lowly workers) and by the addition of flying draperies or swirling *qi*.[102] But artists to the north and east of Sichuan did not place figures easily or naturally in landscape settings keyed to time, either because they did not possess the requisite artistic skills or (more likely) because they held different views about what art should depict. Even with Chengdu art, whose ability to convey life and movement is pronounced in all media throughout Han, in pottery *mingqi* (No. 110) no less than in tomb tiles, it was perhaps only in the late first or the second century AD that local artists joined this ability to convey movement and drama with the third feature associated with Gu Kaizhi's later achievement, the graceful placement of human figures in a naturalistic or semi-naturalistic setting. One ceramic tile stamped with a hunting and farming scene (No. 106) depicts in the upper register two bowmen straining to shoot geese flying high in the sky. In the lower register, men in groups work with scythes to mow tall grasses, probably rice stalks. The design creates an undeniable sense of movement and tension, a sense of force and counterforce well beyond that of the *Seven Sages* or the Deng Xian tiles but built in precisely the same way as in Gu Kaizhi's *Admonitions,* using taut diagonals (in this case, a bowman's body and bow) juxtaposed with immovable objects (the ground plane and trees). Moreover, it shows a superb ability to suggest a third dimension, to sketch a middle ground, and to integrate figures plausibly within Heaven-and-Earth. Perhaps we should not be surprised to learn that master artists of the fourth century, including Gu Kaizhi and Wang Xizhi (AD 321–379), probably had access to Sichuan art.[103] In the visual arts, as in systematic thought, the possibility emerges that the culture of the Chengdu Plain shaped the capital culture no less than the other way around.

However, any theory casting Sichuan as one possible contributor to a later style must address the growing body of scholarly opinion that connects the birth of figure-and-landscape painting in China with the steppe lands or the (possibly related) Western Han immortality cults. Steppe forms and motifs, depictions of animal combat for instance, occur on luxury items and as *xiangrui* ("auspicious images") at many Han sites, and in some cases humans, exotic animals, and mythical creatures inhabit a setting in which highly stylized landscape elements define space cells:

102. See *Wenwu* 1984.8, pp. 22–9, showing an engraved stone slab from Shandong Zhucheng (first or second century AD). The technique of crowding and overlapping figures is typical of hunting scenes, for instance a rabbit hunt depicted on an Eastern Han iron fishhook(?) from Jiangsu (Sun Ji 1991, p. 77). The evidence from Zhucheng suggests that the elites of Shandong and the capital associated conspicuous activity with workers rather than with members of their own class.

103. *Dong zhai jishi,* 4.1a–b, and *Sichuan tongzhi,* 49.17b, both based on *Xijing zaji* 22.7b.

famous examples are the Han bronze chariot fitting with inlays from Hebei Ding Xian tomb 122 and the inlaid *boshanlu* censer from Liu Sheng's tomb at Mancheng (113 BC).[104] Yet as one persuasive proponent of steppe connections admits, this category of fantastic scenes, typically strewn with frenetic activity, depends heavily upon "the viewer's imaginative integration of men, animals, and running lines," since the "images bear little apparent relation to a literal mountainous setting."[105] The attraction of such conceptual landscapes, co-opting the unknown and the unattainable, may have lain precisely in their unreality. Such imported images may have had only minimal influence on the development of more realistic landscape-and-figure painting, a suggestion borne out by the narrow range of object types and styles sporting them.[106]

 To explain the material, ideological, and social culture of the past requires a series of conjectures. This essay has undoubtedly oversimplified what local observers in early Sichuan knew to be complex phenomena, and new archaeological evidence can be relied upon to modify the findings presented here. A risky venture onto uncertain terrain nevertheless seems worthwhile, if only as a way of questioning old habits of mind that presume the invariable coincidence of economic, intellectual, and artistic centers in the political capital.[107] In one of his famous paradoxes, Hui Shi (third century BC) prods us to think just what makes a location a center: "the center of the world . . . is north of Yan in the far north and south of Yue in the far south." As a site of exchange, reception, and assimilation, the Chengdu Plain during the early empires was a setting that shaped a range of populations who can no longer be easily dismissed as peripheral to the grand projects of later imperial culture.[108]

104. Beijing 1998d, pls. 129 (Mancheng), 151 (Ding Xian).

105. Jacobson 1985, pp. 133, 147.

106. Jacobsen stresses the "dramatic tension between different temporal levels" that creates a sense of movement in some Central Asian narrative scenes, citing this as a "structural principle" that is "essential" to the birth of landscape. She also posits that Western Han artists were inspired to depict landscape by the arrival of Scytho-Siberian objects decorated with fantastic landscapes. But it is not obvious that fantastic landscape could serve as a useful or important model for realistic landscape, and in fact the influence of the Scytho-Siberian designs in China is clear only in scenes with Central Asian themes, namely hunting and immortals—the latter a theme that the Chinese associated specifically with the "never-never land" of the west (Hulsewé 1979, p. 40).

107. On the modern political difficulties of rethinking the old center-periphery paradigm, see Falkenhausen 1995a. For two general critiques of old geographical notions, see Lewis & Wigen 1997 and Rowlands *et al.* 1987.

108. The region's influence waned somewhat after AD 417, when the population shift toward the southeast coast began. As many have observed, the fortunes of Sichuan seem to rise when the fortunes of the Zhongyuan fall, and vice versa.

APPENDIX: ADDITIONAL EXHIBITION INFORMATION

Because of conservation problems, the bronze tree No. 27 unfortunately had to be withdrawn from the exhibition. Eight other objects were added to the exhibition too late to be catalogued in detail; they are illustrated here.

Lei

Bronze
Height 50 cm, greatest diameter 25 cm
Late eleventh or early tenth century BC

Excavated in 1959 at Pengzhou Zhuwajie
Sichuan Provincial Museum 83439

PUBLISHED: *Wenwu* 1961.11, front cover;
Chengdu 1991, pl. 10; Beijing 1994a, pl. 76.

(below left)

Lei

Bronze
Height 38 cm, greatest diameter 23 cm
Late eleventh or early tenth century BC

Excavated in 1959 at Pengzhou Zhuwajie
Sichuan Provincial Museum 83440

PUBLISHED: *Wenwu* 1961.11, p. 5 fig. 1 (right);
Chengdu 1991, pl. 9; Beijing 1994a, pl. 81.

(below right)

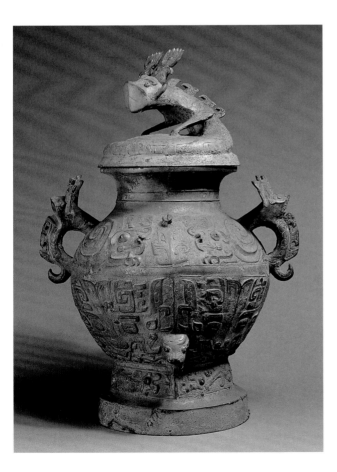
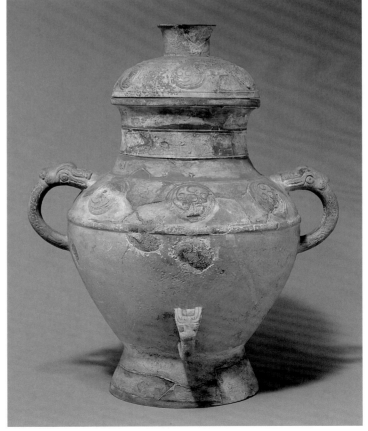

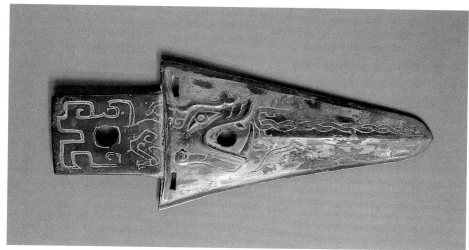

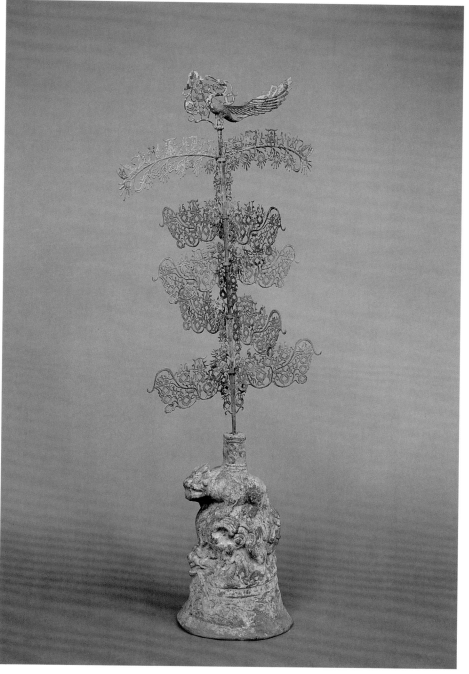

Handbell (zheng)

Bronze
Height 29 cm
Probably third century BC

Excavated in 1972 from tomb 2 at Fuling Xiaotianxi
Sichuan Provincial Museum 108201

PUBLISHED: *Wenwu* 1974.5, p. 71 fig. 7 (left); Chengdu 1991,
pl. 30; Beijing 1994a, pl. 187.

(above left)

Ge *blade*

Bronze
Length 23.5 cm
Approximately fourth century BC

Excavated in 1993 from a tomb at Pengzhou Zhihexiang
Pengzhou Municipal Museum

PUBLISHED: Beijing 1997g, pl. 75.

(above right)

Money tree

Bronze and ceramic
Height 102 cm
Second century AD

Excavated in 1972 at Pengshan
Sichuan Provincial Museum 111603

PUBLISHED: Rawson 1996, no. 87.

(right)

Mirror

Bronze
Diameter 18.5 cm
First or second century AD

Excavated in 1989 from tomb No. 1 at Mianyang Hejiashan
Mianyang Museum B:561

PUBLISHED: *Wenwu* 1991.3, pl. 1.3; *Kaogu* 2000.5, pp. 68–78.

(above left)

Mirror

Bronze
Diameter 9.5 cm
First or second century AD

Excavated in 1996 from tomb No. 1 at Mianyang Yiwanshui
Mianyang Museum 96MBM1:03

(above right)

Figure of woman nursing a baby

Ceramic
Height 22 cm
First or second century AD

Excavated in 1987 from a tomb at Deyang Huangxu
Deyang Municipal Museum Dezi87-0072

(left)

CHINESE CHARACTER GLOSSARY

by Jennifer Chen

Names of places below the *xian* (county) level are entered under the name of the *xian*. Places referred to in the text without mention of a *xian* are entered separately as well as under the *xian* name. Simplified characters have been replaced by their unsimplified forms throughout.

Anhui　安徽
Ankang　安康
Anxi　安息
Anyang　安陽
　Guojiazhuang　郭家莊
　Yinxu　殷墟
Ba　巴
Ba-Shu　巴蜀
Ba Xian　巴縣
　Dongsunba　冬筍壩
　Guangyangba　廣陽壩

Baicaopo　白草坡
Baihuatan　百花潭
baixi　百戲
Balitai　八里臺
Beiyao　北窯
banliang　半兩
Baodun　寶墩
Baoji　寶雞
　Rujiazhuang　茹家莊
　Zhuyuangou　竹園溝
Baolunyuan　寶輪院
Baoshan　包山
Beidongcun　北洞村
Beijing　北京
　Liulihe　琉璃河
ben　錛
bianhu　扁壺
bo　鎛

Cangbaobao　倉包包
Cangshan　蒼山
Cao-Wei　曹魏
Chang'an　長安
　Zhangjiapo　張家坡
Changfeng　長豐
　Yanggong　楊公
Changjiang　長江
Changsha　長沙

Changzi　長子
Chaoyang　朝陽
　Yuantaizi　袁台子
Chen Zhang fanghu　陳璋方壺
Chengdu　成都
　Baihuatan　百花潭
　Fangchijie　方池街
　Jiaotongxiang　交通巷
　Jingchuan Fandian　京川飯店
　Jinniuqu Baitacun　金牛區白塔村
　Jinniuxiang Zengjiabao　金牛鄉曾家包
　Jinshaxiang　金沙巷
　Luojianian　羅家碾
　Nan Yihuanlu Dongduan　南一環路東段
　Qingbaijiang　青白江
　Qingbaixiang　青白鄉
　Qingyanggong　青羊宮
　Sandongqiao Qingyangxiaoqu　三洞橋青羊小區
　Shi'erqiao　十二橋
　Tianhuishan　天廻山
　Tiaodenghe　挑蹬河
　Xijiao　西郊
　Xinyicun　新一村
　Yangzishan　羊子山
　Zengjiabao　曾家包
　Zhihuijie　指揮街
　Zhongyi Xueyuan　中醫學院
Chengdu Plain　成都平原
Chenggu　城固
　Longtouzhen　龍頭鎮
　Wulangmiao　五郎廟
Chongqing　重慶
Chongqing　崇慶
Chongzhou　崇州
　Shuanghe　雙河

Chu 楚
chunyu 錞于
Chuxiong 楚雄
 Wanjiaba 萬家壩
citang 祠堂

Daba 大巴
Dachang 大昌
 Shuangyan Dongba 雙堰東壩
Dangyang 當陽
Dayi 大邑
 Anrenxiang 安仁鄉
 Wulong 五龍
dao 刀
Deng Xian 鄧縣
Deyang 德陽
Dian 滇
ding 鼎
Ding Xian 定縣
Dongwanggong 東王公
Dongzhi 東至
 Shengli 勝利
dou 豆
Dubaishu 獨柏樹
dui 敦
Dujiang 都江
Dujiangyan 都江堰
 Mangcheng 芒城
Dunhuang 敦煌

Emei 峨眉
 Fuxixiang 符溪鄉
Erligang 二里崗
Erlitou 二里頭

Fanba 范壩
fang 鈁
Fangchijie 方池街
fanghu 方壺
fangshi 方士
fenghuang 鳳凰
Fenghuangshan 鳳凰山
fou 缶
fu 簠
fu 斧
Fu Hao 婦好
Fufeng 扶風
 Qijiacun 齊家村
 Shaoli 召李

Fuling 涪陵
 Xiaotianxi 小田溪
Funan 阜南
Fuxi 伏羲
fuzeng 釜甑

Gansu 甘肅
ganying 感應
Gaopian 高駢
ge 戈
gu 觚
gu 鼓
guanfou 罐缶
Guanghan 廣漢
 Sanxingdui 三星堆
 Wanfuxiang 萬福鄉
 Yueliangwan 月亮灣
 Zhenwucun Cangbaobao 真武村倉
 包包
 Zhongxingxiang 中興鄉
Guangxi 廣西
Guangyuan 廣元
 Baolunyuan 寶輪院
Guangzhou 廣州
Guanyindang 觀音壋
Gucheng 古城
Guchengping 古城坪
gui 簋
Guishan 龜山
Guitoushan 鬼頭山
Guizhou 貴州
guo 椁

Haiyang 海陽
 Simatai 司馬台
Han River 漢水
Hanyuan 漢源
 Fulin 富林
Hanzhong Basin 漢中盆地
Haojiaping 郝家坪
Harqin Zuoyi 喀喇沁左翼
he 盉
Hebei 河北
Heling'er 和林格爾
Henan 河南
hu 壺
Huai 淮
Huainan 淮南
huangdi 皇帝
Huarong 華容

Hubei 湖北
Hunan 湖南
Hui 回
Hui Xian 輝縣
 Guweicun 固圍村
 Liulige 琉璃閣

ji 戟
Jialing River 嘉陵江
jian 鑑
Jiangchuan 江川
 Lijiashan 李家山
Jianghan Plain 江漢平原
Jiangling 江陵
 Fenghuangshan 鳳凰山
 Jiudian 九店
 Tianxingguan 天星觀
 Wangshan 望山
Jiangsu 江蘇
Jiangxi 江西
Jiankang 建康
Jianyang 簡陽
 Guitoushan 鬼頭山
 Jiaotongxiang 交通巷
Jiaxiang 嘉祥
 Wuzhaishan 武宅山
Jingli niuzhong 觜簍紐鐘
Jingmen 荊門
 Baoshan 包山
Jingyang 涇陽
 Gaojiabao 高家堡
Jingzhou 荊州
 Guanyindang 觀音壋
Jinniuqu 金牛區
Jiuquan 酒泉
 Jiayuguan 嘉峪關
jue 爵

Kaiming 開明
Kezuo 喀左
 Beidongcun 北洞村
 Shanwanzi 山灣子
Kongwangshan 孔望山
Kunlun 昆侖

Langzhong 閬中
lei 罍
leiwen 雷紋
Lelang 樂浪

Leshan　樂山
 Shiziwan　柿子灣
li　里
Liangzhu　良渚
Lianyungang　連雲港
Liaoning　遼寧
Lingtai　靈台
 Baicaopo　白草坡
Lintao　臨洮
Lintong　臨潼
liubo　六博
Longshan　龍山
luan　鸞
Luoyang　洛陽
 Balitai　八里臺
 Beiyao　北窯
Lushan　蘆山

Majiaxiang　馬家鄉
Mamu River　馬牧河
Mancheng　滿城
Mangcheng　芒城
mao　矛
Mao Xian　茂縣
 Moutuo　牟托
Maowen Xian　茂汶縣
 Yingpanshan　營盤山
Marquis Yi of Zeng　曾侯乙
Mawangdui　馬王堆
Mianyang　綿陽
 Hejiashan　何家山
 Shuangbaoshan　雙包山
Mianzhu　綿竹
 Qingdao　清道
Min River　岷江
mingqi　明器
mou　鍪
Moutuo　牟托
Mumashan　牧馬山

Nanjing　南京
Nanluobacun　南羅壩村
Nanyang　南陽
Nanyue　南越
Ningxia　寧夏
 Guyuan Yanglang　固原楊郎
 Xiji　西吉
Ningxiang　寧鄉
 Huangcai　黃材
niuzhong　紐鐘
Nüwa　女媧

pan　盤
Panlongcheng　盤龍城
Pei Xian　邳縣
Pengshan　彭山
 Tonglexiang　同樂鄉
Peng Xian (now Pengzhou)　彭縣
 （彭州）
Pengzhou　彭州
 Sanjiexiang　三界鄉
 Taipingchang　太平場
 Taipingxiang　太平鄉
 Zhihexiang　致和鄉
 Zhuwajie　竹瓦街
Pi Xian　郫縣
 Dubaishu　獨柏樹
 Gucheng　古城
Pingshan　平山
 Qijicun　七汲村
 Sanji Gucheng　三汲古城
pou　瓿
Pujiang　蒲江
 Dongbei　東北
pushou　鋪首

Qi　齊
Qiang　羌
Qianwei　犍為
 Wulian　五聯
 Jinjing　金井
Qijia　齊家
qin　琴
Qin　秦
qing　頃
Qing　清
Qingbaijiang　青白江
Qingchuan　青川
 Baijingba　白井壩
 Haojiaping　郝家坪
Qinghai　青海
Qingjiang　清江
Qingyang　慶陽
Qingzhen　清鎮
Qinling　秦嶺
Qionglai　邛崍
Qishan　岐山
 Hejiacun　賀家村
 Hejiacun Xihao　賀家村西壕
que　闕
Qu Xian　渠縣

Rujiazhuang　茹家莊

Sanjiexiang　三界鄉
Santai　三台
Sanxingdui　三星堆
Shaanxi　陝西
Shanxi　山西
Shandong　山東
Shang　商
Shanwanzi　山灣子
Shenmu　神木
 Shimao　石峁
shenshu　神樹
Shi'erqiao　十二橋
Shifang　什邡
 Chengguan　城關
Shijiahe　石家河
Shimen　石門
 Zaoshi　皂市
Shizishan　獅子山
Shiziwan　柿子灣
Shu　蜀
Shuanghe　雙河
Shuiguanyin　水觀音
shuochang　說唱
Si MuWu fangding　司母戊方鼎
Sichuan　四川
Simatai　司馬台
sishen　四神
Songtao　松桃
 Mushuxiang　木樹鄉
Suide　綏德
Suizhou　隨州
 Leigudun　擂鼓墩
 Xiongjialaowan　熊家老灣

Taojiang　桃江
 Jinquancun　金泉村
taotie　饕餮
Teng Xian　滕縣
tianfu zhi guo　天府之國
tianmen　天門
tianshi　天師
Tiaodenghe　挑蹬河
Tiaozhi　條支
Tongxincun　同心村
Tunxi　屯溪
 Yiqi　弈棋
Tuo River　沱江

Wangdu　望都
Wan Xian　萬縣
　Gaoliangcun　高粱村
　Xintianxiang　新田鄉
Wei　魏
Wei-Jin　魏晉
Wei River　渭水
Weigang　桅崗
Weishan　微山
Wenchuan　汶川
　A'ercun　阿爾村
Wenjiang　溫江
　Yufu　魚鳧
wu　舞
Wu　吳
Wu. Nian liu nian. Shu shou Wu zao. Dong
　Gong shi Huan, chen Lei[Zhu?], gong X.
武 廿 六 年 蜀 守 武 造 東 工 師
宦 臣 耒 [朱?] 工 □
Wudoumidao　五斗米道
Wudu　武都
Wugong　武功
　Hutuocun　滹沱村
Wuhu　蕪湖
　Hejiayuan　賀家園
Wu Liang shrine　武梁祠
Wulong　五龍
Wushan　巫山
　Lijiatan　李家灘
Wuwei　武威
　Huangniangniangtai　黃娘娘台

Xi'an　西安
　Beijiao　北郊
Xianbei　鮮卑
Xiangfen　襄汾
　Taosi　陶寺
xiangrui　祥瑞
Xiangyang　襄陽
xiao　削
Xiaotianxi　小田溪
Xichuan　淅川
　Xiasi　下寺
Xihao　西壕
Xijiao　西郊
Xianyang　咸陽
Xindu　新都
　Guilinxiang　桂林鄉
　Majiaxiang (Majia Gongshe)
　馬家鄉 （馬家公社）

Sanhexiang Majiashan　三河鄉
　馬家山
Xinlongxiang　新龍鄉
Xinfan　新繁
　Qingbaixiang　青白鄉
　Shuiguanyin　水觀音
Xin'gan　新干
Xinjiang　新彊
Xinjin　新津
　Baodun　寶墩
　Baozishan　堡子山
Xinyang　信陽
　Changtaiguan　長臺關
Xinyicun　新一村
Xishan Qiao　西善橋
Xiwangmu　西王母
xuanxue　玄學
Xupu　溆浦
　Dajiangkou　大江口
Xuzhou　徐州
　Beidongshan　北洞山

Ya'an　雅安
Yan　燕
yan　巘
Yang Xian　洋縣
　Zhangcun　張村
Yangzi River (Changjiang)　揚子江
　（長江）
Yangzishan　羊子山
Yanshi　偃師
　Erlitou　二里頭
yaokeng　腰坑
yaxing　亞形
Yazi River　鴨子河
Yellow River　黃河
Yichang　宜昌
Yicheng　宜城
Yidu　宜都
Yi'nan　沂南
Yinchuan　銀川
Ying　郢
Yingjing　滎經
　Guchengping　古城坪
　Nanluobacun　南羅壩村
　Tongxincun　同心村
　Zengjiagou　曾家溝
Yinxu　殷墟
Yinxu Xiqu　殷墟西區

Yishui　沂水
　Liujiadianzi　劉家店子
Yizhou　益州
Yongcheng　永城
yongzhong　甬鐘
Yu　強
yue　鉞
Yue　越
Yueliangwan　月亮灣
Yueyang　岳陽
　Fangyushan　魴魚山
Yufu　魚鳧
Yunmeng　雲夢
Yunnan　雲南
Yunnan-Guizhou　雲南-貴州
yuren　羽人

Zengjiabao　曾家包
Zengjiagou　曾家溝
zhan　盞
zhang　璋
Zhaohua　昭化
Zhejiang　浙江
zheng　鉦
Zhengzhou　鄭州
　Erligang　二里崗
zhenmuyong　鎮墓俑
zhi　觶
Zhihexiang　致和鄉
Zhihuijie　指揮街
Zhijiang　枝江
　Xinhua　新華
Zhongshan　中山
Zhong Xian　忠縣
Zhongxingxiang　中興鄉
Zhongyi Xueyuan　中醫學院
Zhongyuan　中原
Zhou　周
Zhucheng　諸城
Zhucun　朱村
Zhuyuangou　竹園溝
Zhuwajie　竹瓦街
zhuzhu　柱銖
Zizhu Gucheng　紫竹古城
zong mu　縱目
zun　尊

Alphabetization of citation forms disregards word breaks and treats "&" as though it were "and". Unless another publisher is named, works cited as "Beijing 19 . . ." are published by Wenwu Chubanshe.

Allard 1999
Francis Allard. "The Archaeology of Dian: Trends and Tradition." *Antiquity* 73 (1999), pp. 77–86.

Asahara 1985
Asahara Tatsurō. "Zoku hei tangen—Nirikō inpakuto-to Shū, Zoku, So." *Koshi shunjū* 2 (1985), pp. 23–52.

Bagley 1977
Robert Bagley. "P'an-lung-ch'eng: A Shang City in Hupei." *Artibus Asiae* 39 (1977), pp. 165–219.

Bagley 1987
———. *Shang Ritual Bronzes in the Arthur M. Sackler Collections.* Cambridge, MA: Harvard University Press, 1987.

Bagley 1988
———. "Sacrificial Pits of the Shang Period at Sanxingdui in Guanghan county, Sichuan province." *Arts Asiatiques* 43 (1988), pp. 78–86.

Bagley 1990a
———. "A Shang City in Sichuan Province." *Orientations,* November 1990, pp. 52–67.

Bagley 1990b
———. "Shang Ritual Bronzes: Casting Technique and Vessel Design." *Archives of Asian Art* 43 (1990), pp. 6–20.

Bagley 1992
———. "Changjiang Bronzes and Shang Archaeology." In *Proceedings, International Colloquium on Chinese Art History, 1991, Antiquities, Part 1* (Taibei: National Palace Museum, 1992), pp. 209–55.

Bagley 1993a
———. "Replication Techniques in Eastern Zhou Bronze Casting." In Steven Lubar and W. David Kingery, eds., *History from Things: Essays on Material Culture* (Washington, D.C.: Smithsonian Institution, 1993), pp. 234–41.

Bagley 1993b
———. "An Early Bronze Age Tomb in Jiangxi Province." *Orientations,* July 1993, pp. 20–36.

Bagley 1995
———. "What the bronzes from Hunyuan tell us about the foundry at Houma." *Orientations,* January 1995, pp. 46–54.

Bagley 1996
———. "Debris from the Houma Foundry." *Orientations,* October 1996, pp. 50–58.

Bagley 1999
———. "Shang Archaeology." Loewe & Shaughnessy 1999, chapter 3 (pp. 124–231).

Bagley 2000
———. "Percussion." Chapter 2 (pp. 34–63, 120–27, 136–7) in Jenny F. So, ed., *Music in the Age of Confucius* (Seattle: University of Washington Press, 2000).

Bamboo Annals
Zhushu jinian zhuzi suoyin. Hong Kong: Commercial Press, 1998.

Barnard 1990
Noel Barnard. "Some Preliminary Thoughts on the Significance of the Kuang-han Pit-burial Bronzes and Other Artifacts." *Beiträge zur allgemeinen und vergleichenden Archäologie* 9–10 (1990), pp. 249–79.

Barnard 1997
———. "Chinese Bronze Vessels with Copper Inlaid Décor and Pseudo-Copper Inlay of Ch'un-ch'iu and Chan-kuo Times. Part Two." In F. David Bulbeck and Noel Barnard, eds., *Ancient Chinese and Southeast Asian Bronze Age Cultures* (Taibei: SMC Publishing, 1996–97), vol. 1, pp. 177–272.

Beijing 1959
Deng Xian caise huaxiang zhuan mu. Beijing: 1959.

Beijing 1960
Sichuan chuanguanzang fajue baogao. Beijing: 1960.

Beijing 1972
Wenhua da geming qijian chutu wenwu. Beijing: 1972.

Beijing 1973a
Changsha Mawangdui yi hao Han mu. 2 vols. Beijing: 1973.

Beijing 1973b
Zhonghua Renmin Gongheguo chutu wenwu zhanlan zhanpin xuanji. Beijing: 1973.

Beijing 1974
Han Tang bihua. Beijing: Waiwen Chubanshe, 1974.

Beijing 1979
Shaanxi chutu Shang Zhou qingtongqi (1). Beijing: 1979.

Beijing 1980a
Shaanxi chutu Shang Zhou qingtongqi (2). Beijing: 1980.

Beijing 1980b
Shaanxi chutu Shang Zhou qingtongqi (3). Beijing: 1980.

Beijing 1980c
Hebei sheng chutu wenwu xuanji. Beijing: 1980.

Beijing 1980d
Mancheng Han mu fajue baogao. 2 vols. Beijing: 1980.

Beijing 1981a
Yunmeng Shuihudi Qin mu. Beijing: 1981.

Beijing 1981b
Henan chutu Shang Zhou qingtongqi (1). Beijing: 1981.

Beijing 1981c
Yinxu yuqi. Beijing: 1981.

Beijing 1983
Hunan Sheng Bowuguan. (*Zhongguo bowuguan congshu*, vol. 2.) Beijing: 1983. Japanese edition: Tokyo 1981.

Beijing 1984a
Yinxu Fu Hao mu. 2nd ed. Beijing: 1984.

Beijing 1984b
Shaanxi chutu Shang Zhou qingtongqi (4). Beijing: 1984.

Beijing 1985a
Nanyang Handai huaxiang shi. Beijing: 1985.

Beijing 1985b
Henan Sheng Bowuguan. (*Zhongguo bowuguan congshu*, vol. 7.) Beijing: 1985. Japanese edition: Tokyo 1983.

Beijing 1986a
Henan Xinyang Chu mu. Beijing: 1986.

Beijing 1986b
E'erduosi shi qingtongqi. Beijing: 1986.

Beijing 1987a
Ba Shu kaogu lunwenji. Beijing: 1987.

Beijing 1987b
Handai huaxiang shi yanjiu. Beijing: 1987.

Beijing 1988
Qin Shi Huang ling bingmayong keng. 2 vols. Beijing: 1988.

Beijing 1989
Zeng Hou Yi mu. 2 vols. Beijing: 1989.

Beijing 1990a
Zhongguo wenwu jinghua 1990. Beijing: 1990.

Beijing 1990b
Nanyang liang Han huaxiang shi. Beijing: 1990.

Beijing 1991a
Baoshan Chu mu. Beijing: 1991.

Beijing 1991b
Xichuan Xiasi Chunqiu Chu mu. Beijing: 1991.

Beijing 1991c
Sichuan Pengshan Handai yamu. Beijing: 1991.

Beijing 1991d
Yunnan Sheng Bowuguan. (*Zhongguo bowuguan congshu*, vol. 10.) Beijing: 1991. Japanese edition: Tokyo 1988b.

Beijing 1992a
Sichuan Sheng Bowuguan. (*Zhongguo bowuguan congshu*, vol. 12.) Beijing: 1992. Japanese edition: Tokyo 1988a.

Beijing 1992b
Sichuan Handai shique. Beijing: 1992.

Beijing 1992c
Zhongguo wenwu jinghua 1992. Beijing: 1992.

Beijing 1992d
Zhongguo Kaogu Xuehui di qi ci nianhui lunwenji 1989. Beijing: 1992.

Beijing 1993a
Zhongguo qingtongqi quanji 14, Dian, Kunming. Beijing: 1993.

Beijing 1993b
Houma zhutong yizhi. Beijing: 1993.

Beijing 1993c
Mi Xian Dahuting Han mu. Beijing: 1993.

Beijing 1993d
Kaogu jinghua—Zhongguo Shehui Kexueyuan Kaogu Yanjiusuo jiansuo sishinian jinian. Beijing: Kexue Chubanshe, 1993.

Beijing 1994a
Zhongguo qingtongqi quanji 13, Ba Shu. Beijing: 1994.

Beijing 1994b
Shangdai Shu ren mibao, Sichuan Guanghan Sanxingdui yizhi. (*Zhongguo kaogu wenwu zhi mei*, vol. 3.) Beijing: 1994.

Beijing 1994c
Yinxu de faxian yu yanjiu. Beijing: Kexue Chubanshe, 1994.

Beijing 1995a
Zhongguo qingtongqi quanji 8, Dong Zhou 2. Beijing: 1995.

Beijing 1995b
Zhongguo qingtongqi quanji 15, Beifang minzu. Beijing: 1995.

Beijing 1995c
Jiangling Jiudian Dong Zhou mu. Beijing: 1995.

Beijing 1995d
Liulihe Xi Zhou Yan guo mudi 1973–1977. Beijing: 1995.

Beijing 1995e
Cuo wang mu, Zhanguo Zhongshan guo guowang zhi mu. 2 vols. Beijing: 1995.

Beijing 1995f
Erlitou taoqi jicui. Beijing: Zhongguo Shehui Kexue Chubanshe, 1995.

Beijing 1996a
Zhongguo qingtongqi quanji 1, Xia, Shang 1. Beijing: 1996.

Beijing 1996b
Zhongguo qingtongqi quanji 5, Xi Zhou 1. Beijing: 1996.

Beijing 1996c
Jiangling Wangshan Shazhong Chu mu. Beijing: 1996.

Beijing 1996d
Sichuan kaogu lunwenji. Beijing: 1996.

Beijing 1996e
Luoyang Han mu bihua. Beijing: 1996.

Beijing 1997a
Zhongguo qingtongqi quanji 2, Shang 2. Beijing: 1997.

Beijing 1997b
Zhongguo qingtongqi quanji 3, Shang 3. Beijing: 1997.

Beijing 1997c
Zhongguo qingtongqi quanji 6, Xi Zhou 2. Beijing: 1997.

Beijing 1997d
Zhongguo qingtongqi quanji 9, Dong Zhou 3. Beijing: 1997.

Beijing 1997e
Zhongguo qingtongqi quanji 11, Dong Zhou 5. Beijing: 1997.

Beijing 1997f
Xin'gan Shang dai da mu. Beijing: 1997.

Beijing 1997g
Zhongguo wenwu jinghua 1997. Beijing: 1997.

Beijing 1998a
Zhongguo qingtongqi quanji 4, Shang 4. Beijing: 1998.

Beijing 1998b
Zhongguo qingtongqi quanji 7, Dong Zhou 1. Beijing: 1998.

Beijing 1998c
Zhongguo qingtongqi quanji 10, Dong Zhou 4. Beijing: 1998.

Beijing 1998d
Zhongguo qingtongqi quanji 12, Qin, Han. Beijing: 1998.

Beijing 1998e
Zhongguo qingtongqi quanji 16, tong jing. Beijing: 1998.

Beijing 1998f
Sichuan kaogu baogaoji. Beijing: 1998.

Beijing 1998g
Ba Shu Handai huaxiangji. Beijing: 1998.

Beijing 1998h
Qin Shi Huang ling tong che ma fajue baogao. Beijing: 1998.

Beijing 1998i
Anyang Yinxu Guojiazhuang Shang dai muzang, 1982 nian–1992 nian kaogu fajue baogao. Beijing: Zhongguo Dabaike Quanshu Chubanshe, 1998.

Beijing 1998j
Zhongguo Shang wenhua guoji xueshu taolunhui lunwenji. Beijing: Dabaike Quanshu Chubanshe, 1998.

Beijing 1999a
Sanxingdui jisikeng. Beijing: 1999.

Beijing 1999b
Luoyang Beiyao Xi Zhou mu. Beijing: 1999.

Beijing 1999c
Yanshi Erlitou 1959 nian–1978 nian kaogu fajue baogao. Beijing: Zhongguo Dabaike Quanshu Chubanshe, 1999.

Beijing 1999d
Zhangjiapo Xi Zhou mudi. Beijing: Zhongguo Dabaike Quanshu Chubanshe, 1999.

Beijing 1999e
Xiaojiawuji. 2 vols. Beijing: 1999.

Beijing 1999f
Zhengzhou Shangdai tongqi jiaocang. Beijing: Kexue Chubanshe, 1999.

Beijing 2000
Changsha Chu mu. 2 vols. Beijing: 2000.

Berger 1980
Patricia Berger. *Rites and Festivities in the Art of Eastern Han China: Shantung and Kiangsu Provinces.* Doctoral dissertation, University of California, Berkeley, 1980. Published on demand by UMI Dissertation Services (order number 8112962).

Berger 1998
————. "Body Doubles: Sculpture for the Afterlife." *Orientations,* February 1998, pp. 46–53.

Bielenstein 1979
Hans Bielenstein. "The Restoration of the Han Dynasty, Vol. IV: The Government." *Bulletin of the Museum of Far Eastern Antiquities* 51 (1979), pp. 1–300.

Birrell 1993
Anne Birrell. *Chinese Mythology.* Baltimore: Johns Hopkins, 1993.

Birrell 1999
————, trans. *The Classic of Mountains and Seas.* London: Penguin Books, 1999.

Blakeley 1999
Barry B. Blakeley. "The Geography of Chu." Cook & Major 1999, chapter 1 (pp. 9–20).

Bodde 1961
Derk Bodde. "Myths of Ancient China." In Samuel Noah Kramer, ed., *Mythologies of the Ancient World* (New York: Doubleday, 1961), pp. 367–408.

Bokenkamp 1997
Stephen R. Bokenkamp. *Early Daoist Scriptures.* Berkeley: University of California Press, 1997.

Brashier 1996
K. E. Brashier. "Han Thanatology and the Division of 'Souls'." *Early China* 21 (1996), pp. 125–58.

Bray 1984
Francesca Bray. *Agriculture.* (Volume 6, part 2 of Joseph Needham, ed., *Science and Civilisation in China.*) Cambridge: Cambridge University Press, 1984.

Bunker et al. 1997
Emma C. Bunker *et al. Ancient Bronzes of the Eastern Eurasian Steppes from the Arthur M. Sackler Collections.* New York: Arthur M. Sackler Foundation, 1997.

Bush & Shih 1985
Susan Bush and Hsio-yen Shih. *Early Chinese Texts on Painting.* Cambridge, MA: Harvard University Press, 1985.

Cahill 1986
Suzanne E. Cahill. "The Word Made Bronze: Inscriptions on Medieval Chinese Bronze Mirrors." *Archives of Asian Art* 38 (1986), pp. 62–70.

Cahill 1993

———. *Transcendence and Divine Passion. The Queen Mother of the West in Medieval China.* Stanford: Stanford University Press, 1993.

Cai Yonghua 1986

Cai Yonghua. "Suizang mingqi guankui." *Kaogu yu wenwu* 1986.2, pp. 74–8.

Chen & Fang 1993

Chen Zhida and Fang Guojin. *Zhongguo yuqi quanji 2, Shang, Xi Zhou.* Shijiazhuang: Hebei Meishu Chubanshe, 1993.

Chen De'an 1990

Chen De'an. "Qian shi Sanxingdui erhao jisikeng chutu de 'bianzhang' tu'an." *Nanfang minzu kaogu* 1990.3, pp. 85–90.

Chen De'an *et al.* 1998

Chen De'an, Wei Xuefeng, and Li Weigang. *Sanxingdui: Changjiang shangyou wenming zhongxin tansuo.* Chengdu: Sichuan Renmin Chubanshe, 1998.

Chengdu 1991

Ba Shu qingtongqi. Chengdu: Chengdu Chubanshe, n.d. [1991].

Chengdu 1992

Xi'nan Sichou zhi lu (The Silk Road in Southwest China). Chengdu: Sichuan Renmin Chubanshe, 1992.

Chengdu 1998

Sichuan Daxue kaogu zhuanye chuangjian sanshiwuzhounian jinian wenji. Chengdu: Sichuan Daxue Chubanshe, 1998.

Chen Guofu 1949

Chen Guofu. *Daozang yuanliu kao.* Shanghai: Zhonghua Shuju, 1949.

Chen Peifen 1987

Chen Peifen. *Shanghai Bowuguan cang qingtong jing.* Shanghai: Shanghai Shuhua Chubanshe, 1987.

Chen Xiandan 1988

Chen Xiandan. "Lun Guanghan Sanxingdui yizhi de xingzhi." *Sichuan wenwu* 1988.4, pp. 9–11.

Chen Xiandan 1989

———. "Guanghan Sanxingdui yizhi fajue gaikuang chubu fenqi—jianlun 'Zao Shu wenhua' de tezheng ji qi fazhan." *Nanfang minzu kaogu* 2 (1989), pp. 213–29.

Chen Xiandan 1997

———. "On the Designation 'Money Tree'." *Orientations,* September 1997, pp. 67–71.

Childs-Johnson 1995

Elizabeth Childs-Johnson. "Symbolic Jades of the Erlitou Period: A Xia Royal Tradition." *Archives of Asian Art* 48 (1995), pp. 64–91.

Chuci

See Hawkes 1985.

Coblin 1986

South Coblin. "Some Sound Changes in the Western Han Dialect of Shu." *Journal of Chinese Linguistics* 14 (1986), pp. 184–225.

Cong Dexin 1998

Cong Dexin. "Xiwangmu tuxiang de leixingxue yanjiu." In *Qingguoji* (Beijing: 1998), pp. 273–92.

Cook & Major 1999

Constance A. Cook and John S. Major, eds. *Defining Chu.* Honolulu: University of Hawai'i Press, 1999.

Cui Rongchang 1996

Cui Rongchang. *Sichuan fangyan yu Ba Shu wenhua.* Chengdu: Sichuan Daxue, 1996.

Cui Wei 1989

Cui Wei. "Guanghan Sanxingdui qingtong wenhua yu gudai xiya wenming." *Sichuan wenwu* 1989, special issue on Sanxingdui studies, pp. 37–43.

Dai Yingxing 1993

Dai Yingxing. "Shenmu Shimao Longshan wenhua yuqi tansuo." *Gugong wenwu yuekan* 1993.8, pp. 44–55 (part 1); 1993.9, pp. 46–61 (part 2); 1993.10, pp. 78–84 (part 3); 1993.11, pp. 44–51 (part 4); 1993.12, pp. 26–35 (part 5).

Darrobers 1998

Roger Darrobers. *Opéra de Pékin.* Paris: Bleu de Chine, 1998.

Dean 1993

Kenneth Dean. *Taoist Ritual and Popular Cults of Southeast China.* Princeton: Princeton University Press, 1993.

Deng Cong 1994

Deng Cong [Tang Chung], ed. *Nan Zhongguo ji linjin diqu gu wenhua yanjiu [Ancient Cultures of South China and Neighboring Regions].* Shatin, Hong Kong: Chinese University of Hong Kong Press, 1994.

Deng Cong 1998

———, ed. *Dong Ya yuqi [East Asian Jade: Symbol of Excellence].* 3 vols. Shatin, Hong Kong: Chinese University of Hong Kong Press, 1998.

Deng Shuping 1993

Deng Shuping. "Ye tan Huaxi xitong de yuqi." *Gugong wenwu yuekan* 1993.8, pp. 56–65 (part 1); 1993.9, pp. 62–71 (part 2); 1993.10, pp. 86–93 (part 3); 1993.11, pp. 52–63 (part 4); 1993.12, pp. 36–45 (part 5).

DeWoskin 1987

Kenneth J. DeWoskin. "Music and Entertainment Themes in Han Funerary Sculpture." *Orientations,* April 1987, pp. 34–40.

Dien *et al.* 1985

Albert E. Dien, Jeffrey K. Riegel, Nancy T. Price. *Chinese Archaeological Abstracts 3, Eastern Zhou to Han.* Los Angeles: Institute of Archaeology, University of California, 1985.

Dong Qixiang 1983

Dong Qixiang. *Ba shi xin kao.* Chongqing: Chongqing Chubanshe, 1983.

Dong zhai jishi

Fan Zhen (AD 1007–87). *Dong zhai jishi.* Siku quanshu edition.

Duan Yu 1990

Duan Yu. "Xian Qin Qin Han Chengdu de shi ji shufu zhineng de yanbian." Luo & Luo 1990, pp. 324–48.

Duan Yu 1991

————. "Ba Shu guwenzi de liangxi ji qi qiyuan." *Chengdu wenwu* 1991.3, pp. 20–33.

Duan Yu 1992

————. "Sichuan Guanghan Sanxingdui yizhi de faxian yu yanjiu." *Lishi jiaoxue wenti* 1992.2, pp. 54–7.

Duan Yu 1993

————. "Gudai Ba Shu yu Jindong wenming." *Lishi yuekan* 1993.2, pp. 92–100.

Dye 1931

D. S. Dye. "Some ancient circles, squares, angles and curves in earth and in stone in Szechwan, China." *Journal of the West China Border Research Society* 4 (1930–31), pp. 102–5.

Edwards 1954

Richard Edwards. "The Cave Reliefs at Ma Hao." *Artibus Asiae* 17 (1954), no. 1, pp. 5–28 (part 1); no. 2, pp. 103–29 (part 2).

Erickson 1994a

Susan N. Erickson. "Boshanlu—Mountain Censers of the Western Han Period: A Typological and Iconographic Analysis." *Archives of Asian Art* 45 (1992), pp. 6–28.

Erickson 1994b

————. "Money Trees of the Eastern Han Dynasty." *Bulletin of the Museum of Far Eastern Antiquities* 66 (1994), pp. 5–115.

Er shi wu shi bu bian

Er shi wu shi bu bian. Beijing: Zhonghua Shuju, 1955; rpt., 1986.

Falkenhausen 1988

Lothar von Falkenhausen. *Ritual Music in Bronze Age China.* Doctoral dissertation, Harvard University, 1988. Published on demand by UMI Dissertation Services (order number 8901692).

Falkenhausen 1989a

————. "*Niuzhong* Chime-Bells of Eastern Zhou China." *Arts Asiatiques* 44 (1989), pp. 68–83.

Falkenhausen 1989b

————. " 'Shikin-no Onsei,' Tō-shū jidai-no shun, taku, dō, nado-ni tsuite." *Sen'oku Hakkokan Kiyō* 6 (1989), pp. 3–26.

Falkenhausen 1991

————. "Chu Ritual Music." Lawton 1991, pp. 47–106.

Falkenhausen 1993

————. *Suspended Music: Chime-Bells in the Culture of Bronze Age China.* Berkeley: University of California Press, 1993.

Falkenhausen 1994

————. "Sources of Taoism: Reflections on Archaeological Indicators of Religious Change in Eastern Zhou China." *Taoist Resources* 5 (1994), pp. 1–12.

Falkenhausen 1995a

————. "The Regionalist Paradigm in Chinese Archaeology." In Philip L. Kohl and Clare Fawcett, eds., *Nationalism, politics, and the practice of archaeology* (Cambridge: Cambridge University Press, 1995), pp. 198–217.

Falkenhausen 1995b

————. "Reflections on the Political Role of Spirit Mediums in Early China: The *Wu* Officials in the *Zhou Li.*" *Early China* 20 (1995), pp. 279–300.

Falkenhausen 1996

————. "The Moutuo Bronzes: New Perspectives on the Late Bronze Age in Sichuan." *Arts Asiatiques* 51 (1996), pp. 29–59.

Falkenhausen 1999

————. "The Waning of the Bronze Age: Material Culture and Social Developments, 770–481 B.C." Loewe & Shaughnessy 1999, chapter 7 (pp. 450–544).

Falkenhausen & Rossing 1995

Lothar von Falkenhausen and Thomas D. Rossing. "Acoustical and Musical Studies on the Sackler Bells." So 1995, appendix 2 (pp. 431–82).

Fayan

Yang Xiong (53 BC–AD 18). *Fayan.* In *(Xinbian) Zhuzi jicheng* (Taibei: World Books, 1974), vol. 2.

Feng 1945

H. F. Feng. "The Megalithic Remains of the Chengtu Plain." *Journal of the West China Border Research Society* 16 (1945), pp. 15–21.

Feng & Tong 1973

Feng Hanji and Tong Enzheng. "Minjiang shangyou de shiguanzang." *Kaogu xuebao* 1973.2, pp. 41–60.

Feng & Tong 1979

Feng Hanji and Tong Enzheng. "Ji Guanghan chutu de yushiqi." *Wenwu* 1979.2, pp. 31–6.

Feng Hanji 1961

Feng Hanji. "Guanyu Chugong Jia ge de zhenwei bing lüe lun Sichuan Ba Shu shiqi de bingqi." *Wenwu* 1961.11, pp. 32–4.

Feng Hanji 1980

————. "Sichuan Peng Xian chutu de tongqi." *Wenwu* 1980.12, pp. 38–47.

Feng Xuecheng *et al.* 1992

Feng Xuecheng *et al. Ba Shu Chandeng lu.* Chengdu: Chengdu Chubanshe, 1992.

Finsterbusch 1967

Käte Finsterbusch. *Verzeichnis und Motivindex der Han-Darstellungen.* Wiesbaden: Otto Harrassowitz, 1966–7.

Finsterbusch 1971

————. *Verzeichnis und Motivindex der Han-Darstellungen,* vol. 2. Wiesbaden: Otto Harrassowitz, 1971.

Fong 1980

Wen Fong, ed. *The Great Bronze Age of China.* New York: Metropolitan Museum, 1980.

Francasso 1988

Riccardo Francasso. "Holy Mothers of Ancient China: A New Approach to the Hsi-wang-mu Problem." *T'oung Pao* 74 (1988), pp. 1–46.

FSTY
Ying Shao (d. *c.* 204). *Fengsu tongyi fu tongjian.* Beiping: Centre d'études sinologiques de Pékin, 1943; rpt. Taibei: Chengwen, 1968.

Fujita 1996
Fujita Katsuhisa. "Kodai Shoku no suiri hatten to shakai." *Nichū bunka kenkyū* 10 (1996), pp. 32–43.

Gao & Gao 1990
Gao Wen and Gao Chenggang. *Sichuan lidai beike.* Chengdu: Sichuan Daxue, 1990.

Gao & Gao 1996
————. *Zhongguo huaxiang shiguan yishu [The Carved Stone Coffin Art of China].* Taiyuan: Shanxi Renmin Chubanshe, 1996.

Gao & Xing 1995
Gao Dalun and Xing Jingyuan. "Sichuan Daxue Bowuguan shoucang de Han yiqian bufen yushiqi." *Wenwu* 1995.4, pp. 68–75.

Gao & Xing 1998
————. "Sichuan liangchu bowuguan cang Sanxingdui yushiqi de xin renshi." Deng Cong 1998, vol. 2, pp. 25–9.

Gao Wen 1987
Gao Wen. *Sichuan Handai shiguan huaxiang ji.* Shanghai: Renmin Meishu Chubanshe, 1987.

Gao Zhixi 1991a
Gao Zhixi. "Lun Chu jing." *Wenwu* 1991.5, pp. 42–60.

Gao Zhixi 1991b
————. "Lüelun Qin jing ji qi yu Chu jing de guanxi." In *Chu wenhua yanjiu lunji di er ji* (Wuhan: Hubei Renmin Chubanshe, 1991), pp. 243–59.

Gao Zhixi 1997
————. "Hunan xin chu Yuezu tongqi de niandai yu tedian." In *Wu Yue diqu qingtongqi yanjiu lunwenji* (Hong Kong: Tai Yip, 1997), pp. 83–90.

Gao Zhixi 1999
————. *Shang Zhou qingtongqi yu Chu wenhua yanjiu.* Changsha: Yuelu Shushe, 1999.

Gettens 1967
Rutherford John Gettens. "Joining Methods in the Fabrication of Ancient Chinese Bronze Ceremonial Vessels." *Application of Science in Examination of Works of Art* (Boston: Museum of Fine Arts, 1967), pp. 205–17.

Gettens 1969
————. *The Freer Chinese Bronzes, Volume II, Technical Studies.* Washington, D.C.: Freer Gallery of Art, 1969.

Girardot 1983
N. J. Girardot. *Myth and Meaning in Early Taoism.* Berkeley: University of California Press, 1983.

Goepper 1995
Roger Goepper, ed. *Das alte China, Menschen und Götter im Reich der Mitte.* Essen: Kulturstiftung Ruhr, 1995.

Goi 1995
Goi Naohiro. "Kanyō to Seito—Kan no Shōan ni nijō setsu ni kanren shite." *Chūgoku no kodai toshi* (1995), pp. 41–64.

Gong Guoqiang 1997
Gong Guoqiang. "Jianlun Shang Zhou wangguo ji qi zhoubian diqu de huangjin qi shi." In *Kaogu qiuzhi ji, '96 Kaogu Yanjiusuo zhongqingnian xueshu taolunhui wenji* (Beijing: Zhongguo Shehui Kexue Chubanshe, 1997), pp. 353–60.

Gong Kechang 1984
Gong Kechang. *Han fu yanjiu.* Ji'nan: Shandong Wenyi, 1984.

Graham 1934
David C. Graham. "A Preliminary Report of the Hanchow Excavation." *Journal of the West China Border Research Society* 6 (1934), pp. 114–31.

Graham 1989
Angus Graham. *Disputers of the Tao: Philosophical Argument in Ancient China.* La Salle: Open Court, 1989.

Gu Jiegang 1981
Gu Jiegang. *Lun Ba Shu yu Zhongyuan de guanxi.* Chengdu: Sichuan Renmin Chubanshe, 1981.

Guo Dewei 1991
Guo Dewei. "Shu Chu guanxi xintan." *Kaogu yu wenwu* 1991.1, pp. 91–7.

Guwenyuan
Guwenyuan. Compiled by Han Yuanji (1118–1187), annotated by Zhang Qiao (Song). Guoxue jiben congshu edition, vol. 189. Taibei: Commercial Press, 1968.

Hahn 1988
Thomas Hahn. "The Standard Taoist Mountain." *Cahiers d'Extrême-Asie* 4 (1988), pp. 145–56.

Hansford 1968
Howard Hansford. *Chinese Carved Jades.* London: Faber and Faber, 1968.

Hanshu
Ban Gu (AD 32–92). *Hanshu.* 12 vols. Beijing: Zhonghua Shuju, 1970.

Harada & Tazawa 1930
Harada Yoshito and Tazawa Kingo. *Rakurō: A Report on the Excavation of Wang Hsü's Tomb in the "Lo-lang" Province, an ancient Chinese colony in Korea.* Tokyo: Tōkō-shoin, 1930.

Harper 1994
Donald Harper. "Resurrection in Warring States Popular Religion." *Taoist Resources* 5 (1994), pp. 13–28.

Harper 1997
————. "Warring States, Qin, and Han Manuscripts Related to Natural Philosophy and the Occult." Shaughnessy 1997, pp. 223–52.

Harper 1999
————. "Warring States Natural Philosophy and Occult Thought." Loewe & Shaughnessy 1999, chapter 12 (pp. 813–84).

Hawkes 1985
David Hawkes. *The Songs of the South. An Anthology of Ancient Chinese Poems by Qu Yuan and Other Poets.* 2nd. ed. Harmondsworth: Penguin Books, 1985.

Hayashi 1974
Hayashi Minao. "Kandai kishin no sekai." *Tōhōgaku* 46 (1974), pp. 223–306.

Hayashi 1984
———. *In Shū jidai seidōki no kenkyū.* Part 1 of *In Shū seidōki sōran.* 2 vols. Tokyo: Yoshikawa Kōbunkan, 1984.

Hayashi 1988
———. *Shunjū Sengoku jidai seidōki no kenkyū.* Part 3 of *In Shō seidōki sōran.* Tokyo: Yoshikawa Kōbunkan, 1988.

Hayashi 1991
———. *Chūgoku kogyoku no kenkyū.* Tokyo: Yoshikawa Kōbunkan, 1991. Chinese translation by Yang Meili: *Zhongguo gu yu yanjiu.* Taibei: Yishu Tushu, 1997.

Hervouet 1964
Yves Hervouet. *Un poète de cour sous les Han: Sseu-ma Siangjou.* Paris: Presses Universitaires de France, 1964.

Hiroshima 1985
Chūka Jimmin Kyōwakoku Shisen-shō bunbutsuten. Hiroshima: Hiroshima Ken Kyōiku Iinkai, 1985.

Hong Kong 1999
Jianghan diqu xian Qin wenming. Hong Kong: Art Museum, Chinese University of Hong Kong, 1999.

Hou Hanshu
Fan Ye (AD 398–446). *Hou Hanshu.* 12 vols. Beijing: Zhonghua Shuju, 1965.

Hsü 1980
Hsü Cho-yun. *Han Agriculture.* Seattle: University of Washington Press, 1980.

Hu & Cai 1992
Hu Changyu and Cai Ge. "Yu fu kao—ye tan Sanxingdui yizhi." *Sichuan wenwu* 1992 (*Special Issue of Studies on Sanxingdui Ancient Shu Culture*), pp. 26–33.

Huang & Guo 1996
Huang Minglan and Guo Yinqiang, eds. *Luoyang Han mu bihua.* Beijing: Wenwu Chubanshe, 1996.

Huang Jiaxiang 1990
Huang Jiaxiang. "'Guanghan Sanxingdui yizhi' de chubu fenxi." *Kaogu* 1990.11, pp. 1030–36.

Huang Zhanyue 1998
Huang Zhanyue. "Handai zhuhou wang mu lunshu." *Kaogu xuebao* 1998.1, pp. 11–34.

Huayang
Chang Qu (fl. AD 347). *Huayang guozhi.* Edition cited: Liu Lin, *Huayang guozhi jiaozhu* (Chengdu: Ba Shu Shushe, 1984).

Hulsewé 1979
A.F.P. Hulsewé. *China in Central Asia, the Early Stage, 125 BC–AD 23: An Annotated Translation of Chapters 61 and 96 of the History of the Former Han Dynasty.* Leiden: Brill, 1979. Introduction by Michael Loewe.

Huo & Huang 1989
Huo Wei and Huang Wei. "Shilun wuhu Shu shi ge de jige wenti." *Kaogu* 1989.3, pp. 251–9.

Huo Wei 1999
Huo Wei. "Shoku to ten no aida no kōkogaku—Kōkogaku kara mita kodai seinan Chūgoku." In C. Daniels and Watabe Takeshi, eds., *Shishen no kōko to minzoku* (Tokyo: Tōkyō Gaigokugo Daigaku, Ajia Afurika Gengo Bunka Kenkyūjō, 1999), pp. 6–57.

Ishida 1976
Ishida Noriyuki. "Rokuseiki kōhan no Ha-Shoku to bukkyō." *Tōhō shūkyo* 48 (1976), pp. 30–55.

Jacobson 1984
Esther Jacobson. "The Structure of Narrative in Early Chinese Pictorial Vessels." *Representations* 8 (Fall 1984), pp. 61–83.

Jacobson 1985
———. "Mountains and Nomads: A Reconsideration of the Origins of Chinese Landscape Representation." *Bulletin of the Museum of Far Eastern Antiquities* 57 (1985), pp. 133–80.

James 1995
Jean M. James. "An Iconographic Study of Xiwangmu during the Han Dynasty." *Artibus Asiae* 55 (1995), pp. 17–41.

James 1996
———. *A Guide to the Tomb and Shrine Art of the Han Dynasty 206 B.C.–A.D. 220.* Lampeter: Edwin Mellen Press, 1996.

Jansé 1932
Olov Jansé. "Tubes et boutons cruciformes trouvés en Eurasie." *Bulletin of the Museum of Far Eastern Antiquities* 4 (1932), pp. 187–209.

Jia E 1993
Jia E. *Zhongguo yuqi quanji 3, Chunqiu Zhanguo.* Shijiazhuang: Hebei Meishu Chubanshe, 1993.

Jian Zongwu 1976
Jian Zongwu. "Sima Xiangru Yang Xiong cifu zhi bijiao yanjiu." *Zhongyuan xueyuan* 18 (1976), pp. 141–85.

Jicheng
Yin Zhou jinwen jicheng. 18 vols. Beijing: Zhonghua Shuju, 1986–96.

Jin et al. 1998
Jin Zhengyao, W. T. Chase, H. Mabuchi, K. Miwa, Yang Xizhang, and Y. Hirao. "Zhongguo liang he liuyu qingtong wenming zhijian de lianxi—yi chutu Shang qingtongqi de qian tongweisu bizhi yanjiu jieguo wei kaocha zhongxin." Beijing 1998j, pp. 425–33.

Ji Xianlin 1982
Ji Xianlin. "Zhongguo cansi shuru Yindu wenti de chubu yanjiu." In Ji Xianlin, *Zhongyin wenhua guanxi shilun wenji* (Beijing: Xinhua Shudian, 1982), pp. 51–96.

Juliano 1980
Annette Juliano. *Teng-hsien: An Important Six Dynasties Tomb.* Ascona: Artibus Asiae Publishers, 1980.

Kamatani 1996
Kamatani Takeshi. "Fu ni nankai na ji ga i no wa naze ka: Zen Kan ni okeru fu no homarekata." *Nihon Chūgoku gakkai hō* 48 (1996), pp. 16–30.

Karlbeck 1964
Orvar Karlbeck. "Notes on the Fabrication of Some Early Chinese Mirror Moulds." *Archives of the Chinese Art Society of America* 18 (1964), pp. 48–54.

Keightley 1999
David N. Keightley. "The Shang: China's First Historical Dynasty." Loewe & Shaughnessy 1999, chapter 4 (pp. 232–91).

Kleeman 1998
Terry Kleeman. *Great Perfection: Religion and Ethnicity in a Chinese Millennial Kingdom.* Honolulu: University of Hawai'i, 1998.

Knechtges 1968
David R. Knechtges. "Two Studies on Han *fu.*" *Parerga,* vol. 1. Seattle: University of Washington Press, 1968.

Knechtges 1976
———. *The Han Rhapsody: A Study of the fu of Yang Hsiung (53 B.C.–A.D. 18).* Cambridge: Cambridge University Press, 1976.

Knechtges 1982
———. *Wenxuan, or Selections of Refined Literature. Volume 1: Rhapsodies on Metropolises and Capitals.* Princeton: Princeton University Press, 1982.

Knechtges 1987
———. *Wenxuan, or Selections of Refined Literature. Volume 2: Rhapsodies on Sacrifices, Hunting, Travel, Sightseeing, Palaces and Halls, Rivers and Seas.* Princeton: Princeton University Press, 1987.

Knechtges 1996
———. *Wenxuan, or Selections of Refined Literature. Volume 3: Rhapsodies on Natural Phenomena, Birds and Animals, Aspirations and Feelings, Sorrowful Laments, Literature, Music, and Passions.* Princeton: Princeton University Press, 1996.

Knechtges & Swanson 1971
David R. Knechtges and Jerry Swanson. "Seven Stimuli for the Prince: the *Ch'i-fa* of Mei Ch'eng." *Monumenta Serica* 27 (1970–71), pp. 99–116.

Kominami 1974
Kominami Ichirō. "Seiōbo to shichi seki denshō." *Tōhō gakuhō* 46 (1974), pp. 33–82.

Kominami & Sofukawa 1979
Kominami Ichirō and Sofukawa Hiroshi. "Konronzan to shōsen zu" ("Kunlun Mountain and Paintings of Immortality"). *Tōhō gakuhō* 51 (1979), pp. 83–186.

Kongzi jiayu
R.P. Kramers, trans. *K'ung tzu chia yü.* Leiden: Brill, 1950.

Kuhn 1995
Dieter Kuhn. "Silk Weaving in Ancient China: From Geometric Figures to Patterns of Pictorial Likeness." *Chinese Science* 12 (1995), pp. 77–114.

Laing 1974
Ellen Johnston Laing. "Neo-Taoism and the 'Seven Sages of the Bamboo Grove' in Chinese Painting." *Artibus Asiae* 36 (1974), pp. 5–54.

Lau 1987
D. C. Lau, trans. *Mencius.* Harmondsworth: Penguin Books, 1987.

Lawton 1982
Thomas Lawton. *Chinese Art of the Warring States Period.* Washington, D.C.: Smithsonian Institution, 1982.

Lawton 1991
———, ed. *New Perspectives on Chu Culture in the Eastern Zhou Period.* Washington, D.C.: Smithsonian Institution, 1991.

Le Blanc 1985
Charles Le Blanc. *Huai Nan Tzu. Philosophical Synthesis in Early Han Thought.* Hong Kong: Hong Kong University Press, 1985.

Ledderose 2000
Lothar Ledderose. *Ten Thousand Things: Module and mass production in Chinese art.* Princeton: Princeton University Press, 2000.

Leslie & Gardiner 1996
Donald Leslie and K. H. J. Gardiner. *The Roman Empire in Chinese Sources.* Rome: Bardi, 1996.

Lewis 1990
Mark Lewis. *Sanctioned Violence in Early China.* Albany: SUNY Press, 1990.

Lewis 1999a
———. "Warring States Political History." Loewe & Shaughnessy 1999, chapter 9 (pp. 587–650).

Lewis 1999b
———. *Writing and Authority in Early China.* Albany: SUNY Press, 1999.

Lewis 1999c
———. "The *feng* and *shan* sacrifices of Emperor Wu of the Han." In Joseph P. McDermott, ed., *State and Court Ritual in China* (Cambridge: Cambridge University Press, 1999), pp. 50–80.

Lewis & Wigen 1997
Martin W. Lewis and Kären E. Wigen. *The Myth of Continents: A Critique of Metageography.* Berkeley: University of California Press, 1997.

Li & Wang 1987
Li Fuhua and Wang Jiayou. "Guanyu 'Ba Shu tuyu' de jidian kanfa." Xu Zhongshu 1987, pp. 101–12.

Li & Xu 1991
Li Shaoming and Xu Nanzhou, eds. *Ba Shu lishi minzu kaogu wenhua.* Chengdu: Ba Shu Shushe, 1991.

Liao Ben 1987
Liao Ben. "Lun Han hua baixi." Beijing 1987b, pp. 107–23.

Li Boqian 1983
Li Boqian. "Chenggu tongqiqun yu zaoqi Shu wenhua." *Kaogu yu wenwu* 1983.2, pp. 66–71. Reprinted in Xu Zhongshu

1987, pp. 33–9, and in Li Boqian, *Zhongguo qingtong wenhua jiegou tixi yanjiu* (Beijing: Kexue Chubanshe, 1998), pp. 260–67.

Li Boqian 1997

———. "Dui Sanxingdui wenhua ruogan wenti de renshi." *Kaoguxue yanjiu* 3 (1997), pp. 84–94.

Li Cheng 1996

Li Cheng. *Ba Shu shenhua chuanshuo danglun*. Chengdu: Dianzi Keji Daxue, 1996.

Li et al. 1984

Li Minsheng, Huang Suying, and Ji Lianqi. "Yinxu jinshu qiwu chengfen de ceding baogao (2)—Yinxu xiqu tongqi he qianqi ceding." *Kaoguxue jikan* 4 (1984), pp. 328–33, 341.

Li Feng 1986

Li Feng. "Shilun Shaanxi chutu Shang dai tongqi de fenqi yu fenqu." *Kaogu yu wenwu* 1986.3, pp. 53–63.

Li Feng 1988

———. "Huanghe liuyu Xi Zhou muzang chutu qingtong liqi de fenqi yu niandai." *Kaogu xuebao* 1988.4, pp. 383–419.

Lim 1987

Lucy Lim, ed. *Stories from China's Past*. San Francisco: Chinese Culture Center, 1987.

Lin Minjun 1942

Lin Minjun. "Guanghan gudai yiwu zhi faxian ji qi fajue." *Shuowen yuekan* 3 (1942).

Lin Xiang 1988

Lin Xiang. "Yangzishan jianzhu yizhi xin kao." *Sichuan wenwu* 1988.5, pp. 3–8.

Lin Xiang 1992

———. "Shu dun kao." *Sichuan wenwu* 1992, special issue on Sanxingdui studies, pp. 18–25.

Lin Yeqiang 1991

Lin Yeqiang [Peter Y. K. Lam], ed. *Nanyue wang mu yuqi [Jades from the Tomb of the King of Nanyue]*. Hong Kong: Woods Publishing Company, 1991.

Lishi

Hong Kuo (AD 1117–1184). *Lishi*. Preface dated 1167. *Yingyin Wenyuange Siku quanshu* (Taibei: Shangwu, 1983), vol. 681.

Liu Ying 1983

Liu Ying. "Ba Shu tongqi wenshi tulu." *Wenwu ziliao congkan* 7 (1983), pp. 1–12.

Liu Yumao 1990

Liu Yumao. "Shilun Sichuan faxian de Zhan'guo chuanguanzang." Luo & Luo 1990, pp. 172–183.

Liu Zhiyuan 1958

Liu Zhiyuan. *Chengdu Wanfosi*. Beijing: Zhongguo Gudian Yishu, 1958.

Li Xiaocen 1993

Li Xiaocen. "Shang Zhou Zhongyuan qingtongqi kuangliao laiyuan de zai yanjiu." *Ziran kexue shi yanjiu* 12 (1993), pp. 264–7.

Li Xueqin 1985

Li Xueqin. *Eastern Zhou and Qin Civilizations*. New Haven: Yale University Press, 1985. Translation by K. C. Chang of the first edition (1984) of Li Xueqin 1991a.

Li Xueqin 1991a

———. *Dong Zhou yu Qin dai wenming*. Revised ed. Beijing: Wenwu Chubanshe, 1991.

Li Xueqin 1991b

———. *Bijiao kaogu suibi*. Hong Kong: Zhonghua Shuju, 1991.

Li Xueqin 1996

———. "Peng Xian Zhuwajie qingtongqi de zai kaocha." Beijing 1996d, pp. 118–22.

Li Yinde 1990

Li Yinde. "The 'Underground Palace' of a Chu Prince at Beidongshan." *Orientations*, October 1990, pp. 57–61.

Li Yuanguo 1985

Li Yuanguo. *Sichuan Daojiao shihua*. Chengdu: Sichuan Renmin Chubanshe, 1985.

Li Zhiqin et al. 1989

Li Zhiqin, Yan Shoucheng, and Hu Zhan. *Shudao huagu*. Xi'an: Xibei Daxue, 1989.

Loehr 1975

Max Loehr. *Ancient Chinese Jades from the Grenville L. Winthrop Collection*. Cambridge, MA: Fogg Art Museum, 1975.

Loewe 1974

Michael Loewe. *Crisis and Conflict in Han China, 104 BC to AD 9*. London: George Allen & Unwin, 1974.

Loewe 1979

———. *Ways to Paradise: The Chinese Quest for Immortality*. London: George Allen & Unwin, 1979.

Loewe 1994

———. *Divination, Mythology and Monarchy in Han China*. Cambridge: Cambridge University Press, 1994.

Loewe & Shaughnessy 1999

Michael Loewe and Edward L. Shaughnessy, eds. *The Cambridge History of Ancient China*. Cambridge: Cambridge University Press, 1999.

London 1973

William Watson. *The Genius of China: An Exhibition of Archaeological Finds of the People's Republic of China*. London: Times Newspapers Ltd., 1973.

London 1987

The Quest for Eternity, Chinese Ceramic Sculptures from the People's Republic of China. London: Thames & Hudson and Los Angeles County Museum of Art, 1987.

Lu & Hu 1983a

Lu Liancheng and Hu Zhisheng. "Baoji Rujiazhuang, Zhuyuangou youguan wenti de tantao." *Wenwu* 1983.2, pp. 12–20.

Lu & Hu 1983b

———. "Baoji Rujiazhuang, Zhuyuangou mudi chutu bingqi de chubu yanjiu—jianlun Shu shi bingqi de yuanyuan he fazhan." *Kaogu yu wenwu* 1983.5, pp. 50–65.

Lu & Hu 1988

———. *Baoji Yuguo mudi.* 2 vols. Beijing: Wenwu Chubanshe, 1988.

Lu Chaoyin 1993

Lu Chaoyin. *Zhongguo yuqi quanji 4, Qin, Han, Nanbeichao.* Shijiazhuang: Hebei Meishu Chubanshe, 1993.

Luo & Luo 1990

Luo Kaiyu and Luo Weixian, eds. *Huaxi kaogu yanjiu.* Chengdu: Chengdu Wenbo Kaogu, 1990.

Luo Erhu 1988

Luo Erhu. "Sichuan yamu de chubu yanjiu." *Kaogu xuebao* 1988.2, pp. 133–67.

Luo Kaiyu 1990

Luo Kaiyu. *Zhongguo kexue shenhua zongjiao de xiehe: yi Li Bing wei zhongxin.* Chengdu: Ba Shu Shushe, 1990.

Luo Kaiyu 1991

———. "Gudai xi'nan minzu yazang yanjiu." *Kaogu* 1991.5, pp. 448–58.

Luo Kaiyu 1992

———. "Chuan Dian xibu ji Zang dong shiguan mu yanjiu." *Kaogu xuebao* 1992.4, pp. 413–36.

Lu Yun 1987

Lu Yun. "Xi Han shiqi de wenhua quyu yu wenhua zhongxin." *Lishi dili* 5 (1987), pp. 152–75.

Ma Chengyuan 1997

Ma Chengyuan, ed. *Wu Yue diqu qingtongqi yanjiu lunwenji.* Hong Kong: Tai Yip, 1997.

Ma Jigao 1987

Ma Jigao. *Fushi.* Shanghai: Shanghai Guji Chubanshe, 1987.

Major 1993

John Major. *Heaven and Earth in Early Han Thought: Chapters Three, Four, and Five of the Huainanzi.* Albany: SUNY Press, 1993.

Mansvelt-Beck 1980

B. J. Mansvelt-Beck. "The Date of the Taiping Jing." *T'oung Pao* 66 (1980), pp. 149–82.

Maspero 1937

Henri Maspero. "Les procédés de 'nourrir le principe vital' dans la religion taoïste ancienne." *Journal Asiatique*, 1937. Reprinted in Henri Maspero, *Le taoïsme et les religions chinoises* (Paris: Gallimard, 1971), pp. 479–589.

Mather 1976

Richard B. Mather. *Shih-shuo hsin yü, or A New Account of Tales of the World.* Minneapolis: University of Minnesota Press, 1976.

Meng Mo et al. 1989

Meng Mo et al. *Sichuan gudai shigao.* Chengdu: Sichuan Renmin Chubanshe, 1989.

Meng Wentong 1981

Meng Wentong. "Lüe lun Shanhaijing de xiezuo shidai ji qi chansheng di yu." In Meng Wentong, ed., *Ba Shu gushi lunshu* (Chengdu: Sichuan Renmin Chubanshe, 1981), pp. 146–84.

Mou & Yun 1992

Mou Yongkang and Yun Xizheng, eds. *Zhongguo yuqi quanji 1, Yuanshi shehui.* Shijiazhuang: Hebei Meishu Chubanshe, 1992.

Munakata 1991

Munakata Kiyohiko. *Sacred Mountains in Chinese Art.* Urbana-Champaign: University of Illinois, 1991.

Nanjing 1956

Yi'nan gu huaxiangshi mu fajue baogao. Nanjing: Wenhuabu Wenwuguanlichu Chubanshe, 1956.

Nguyen 1998

Nguyen Kim Dung. "Ancient jade-manufacturing tradition in Vietnam." Deng Cong 1998, vol. 2, pp. 383–96.

Nickel 1997

Lukas Nickel. "Changes in Mortuary Architecture and Painting in Northern Henan at the Time of Wang Mang." Paper presented at the conference "Art and Religion in Pre-modern China," School of Oriental and African Studies, University of London, January 1997 (forthcoming).

Nixon 1994

Lucia Nixon. "Gender Bias in Archaeology." Léonie J. Archer, Susan Fischler, and Maria Wyke, eds., *Women in Ancient Societies* (London: Macmillan), pp. 24–52.

Nylan 1996

Michael Nylan. "Han Classicists Writing in Dialogue about Their Own Tradition." *Philosophy East and West* 47 (1996), pp. 133–88.

Ōfuchi 1964

Ōfuchi Ninji. *Dōkyōshi no kenkyū.* Kōyama: Kōyama Daigaku, 1964.

Ōfuchi 1991

———. *Shoki no dōkyō.* Tokyo: Sōbunsha, 1991.

Orioli 1994

Marcello Orioli. "Pastoralism and Nomadism in South-West China: A Brief Survey of the Archaeological Evidence." In Bruno Genito, ed., *The Archaeology of the Steppes, Methods and Strategies* (Naples: Istituto Universitario Orientale, 1994), pp. 87–108.

Paludan 1991

Ann Paludan. *The Chinese Spirit Road: The Classical Tradition of Stone Tomb Statuary.* New Haven: Yale University Press, 1991.

Peng & Zhu 1999

Peng Ke and Zhu Yanshi. "Zhongguo gudai suoyong haibei laiyuan xintan." *Kaoguxue jikan* 12 (1999), pp. 119–47.

Peng Shifan et al. 1994

Peng Shifan, Zhan Kaixun, and Liu Lin. *Changjiang zhongyou qingtong wangguo: Jiangxi Xin'gan chutu qingtong yishu.* Hong Kong: Liangmu Chubanshe, 1994.

Pirazzoli 1974

Michèle Pirazzoli-t'Serstevens. *La civilisation du royaume de Dian à l'époque Han d'après le matériel exhumé à Shizhai shan (Yunnan).* Paris: École française d'Extrême-Orient, 1974.

Pirazzoli 1982

————. *The Han Dynasty.* New York: Rizzoli, 1982.

Pirazzoli 1988

————. "Les cultures du Sichuan occidental à la fin de l'Âge du Bronze et leurs rapports avec les steppes." In *L'Asie centrale et ses rapports avec les civilisations orientales, des origines à l'Âge du Fer* (Paris: De Boccard, 1988), pp. 183–96.

Pirazzoli in press

————. "Nella continuità della vita: il morto e la sua tomba in epoca Han." In Michèle Pirazzoli-t'Serstevens, ed., *Di terra e di bronzo, 4000 a.C.–1000 d.C., Capolavori di arte Cinese della collezione Meidaozhai* (2 vols., Turin: Fondazione Agnelli, in press).

Poo 1998

Mu-chou Poo. *In Search of Personal Welfare, A View of Ancient Chinese Religion.* Albany: SUNY Press, 1998.

Powers 1991

Martin J. Powers. *Art and Political Expression in Early China.* New Haven: Yale University Press, 1991.

Qian Hao et al. 1981

Qian Hao, Chen Heyi, and Ru Suichu. *Out of China's Earth. Archaeological Discoveries in the People's Republic of China.* New York: Abrams, 1981.

Quan Shu yin wen zhi

Zhou Fujun (*jinshi c.* 1522–67), ed. *Quan Shu yin wen zhi.* Siku quanshu edition.

Rawson 1990

Jessica Rawson. *Western Zhou Ritual Bronzes from the Arthur M. Sackler Collections.* Washington, D.C.: Arthur M. Sackler Foundation, 1990.

Rawson 1992

————, ed. *The British Museum Book of Chinese Art.* London: British Museum, 1992.

Rawson 1995

————. *Chinese Jade from the Neolithic to the Qing.* London: British Museum, 1995.

Rawson 1996

————, ed. *Mysteries of Ancient China.* London: British Museum, 1996.

Rawson 1997

————. "Thinking in Pictures: Tomb Figures in the Chinese View of the Afterlife." *Transactions of the Oriental Ceramic Society* 61 (1996–97), pp. 19–37.

Rawson 1999

————. "The Eternal Palaces of the Western Han: A New View of the Universe." *Artibus Asiae* 59 (1999), pp. 1–35.

Rawson 2000

————. "Religious Change as Seen in the Material Record, 500 BC–AD 200: The Changes in the Offerings to the Ancestors." Paper presented at the conference "Religion and Chinese Society," Hong Kong, 29 May to 5 June 2000 (forthcoming).

Ren Naiqiang 1987

Ren Naiqiang. *Huayang guozhi jiaobu tuzhu.* Shanghai: Shanghai Guji Chubanshe, 1987.

Rhie 1999

Marylin Rhie. *Early Buddhist Art of China and Central Asia, Volume One: Later Han, Three Kingdoms and Western Chin in China, and Bactria to Shan-shan in Central Asia.* Leiden: Brill, 1999.

Riboud 1973

Krishna Riboud. "Some Remarks on Strikingly Similar Han Figured Silks Found in Recent Years in Diverse Sites." *Archives of Asian Art* 26 (1972–73), pp. 12–25.

Robinet 1984

Isabelle Robinet. *La révélation du Shangqing dans l'histoire du taoïsme.* Paris: École française d'Extrême-Orient, 1984.

Robinet 1997

————. *Taoism: the Growth of a Religion.* Stanford: Stanford University Press, 1997. Translation by Phyllis Brooks of *Histoire du taoïsme des origines au XIVe siècle* (Paris: Éditions du Cerf, 1991).

Rowlands et al. 1987

Michael Rowlands, Mogens Larsen, and Kristian Kristiansen, eds. *Centre and Periphery in the Ancient World.* Cambridge: Cambridge University Press, 1987.

Sage 1992

Steven F. Sage. *Ancient Sichuan and the Unification of China.* Albany: SUNY Press, 1992.

Salmony 1963

Alfred Salmony. *Chinese Jades Through the Wei Dynasty.* New York: Ronald Press, 1963.

Sanguozhi

Chen Shou (AD 233–297). *Sanguozhi.* 5 vols. Beijing: Zhonghua Shuju, 1959.

Schafer 1963

Edward H. Schafer. *The Golden Peaches of Samarkand: A study of T'ang exotics.* Berkeley: University of California Press, 1963.

Schafer 1968

————. "Hunting Parks and Animal Enclosures in Ancient China." *Journal of the Economic and Social History of the Orient* 11 (1968), pp. 318–43.

Schipper 1979

Kristofer Schipper. "Le Livre du Centre de Lao-tseu." *Nachrichten der Gesellschaft für Natur und Völkerkunde Ostasiens* 125 (1979), pp. 75–80.

Schipper 1994

————. "Purity and Strangers: Shifting Boundaries in Medieval Taoism." *T'oung Pao* 80 (1994), pp. 61–81.

Seidel 1970

Anna K. Seidel. "The Image of the Perfect Ruler in Early Taoist Messianism: Lao-tzu and Li Hung." *History of Religions* 9 (1969–70), pp. 216–47.

Seidel 1978

————. "Das neue Testament des Tao—Lao tzu und die Entstehung der taoistischen Religion am Ende der Han-Zeit." *Saeculum* 29 (1978), pp. 147–72.

Seidel 1987a

———. "Traces of Han Religion in Funerary Texts Found in Tombs." In Akitsuki Kan'ei, ed., *Dōkyō-to shūkyō bunka* (Tokyo: Hirakawa, 1987), pp. 21–57.

Seidel 1987b

———. "Post-mortem Immortality." In S. Shaked, D. Shulman, and G. G. Stroumsa, eds., *Gilgul: Essays on Transformation, Revolution and Permanence in the History of Religions* (Leiden: Brill, 1987), pp. 223–37.

Serruys 1959

Paul L-M Serruys. *The Chinese Dialects of Han Time According to Fang Yen.* Berkeley: University of California Press, 1959.

Shandong 1982

Shandong Han huaxiangshi xuanji. Shandong [Ji'nan?]: Qi Lu Shushe, 1982.

Shandong 1998

Liu Dunyuan xiansheng jinian wenji. Shandong [Ji'nan?]: Shandong Daxue Chubanshe, 1998.

Shanghai 1987

Anhui Sheng Bowuguan cang qingtongqi. Shanghai: Shanghai Renmin Meishu Chubanshe, 1987.

Shanhaijing

Shanhaijing zhuzi suoyin. Hong Kong: Commercial Press, 1994. See also Birrell 1999.

Shaughnessy 1997

Edward L. Shaughnessy, ed. *New Sources of Early Chinese History: An Introduction to the Reading of Inscriptions and Manuscripts.* Berkeley: Society for the Study of Early China and Institute of East Asian Studies, University of California, 1997.

Sheng 1995

Angela Sheng. "The Disappearance of Silk Weaves with Weft Effects in Early China." *Chinese Science* 12 (1995), pp. 56–60.

Shih 1959

Vincent Shih. *The Literary Mind and the Carving of Dragons: A study of thought and pattern in Chinese literature.* (A translation of Liu Xie's *Wenxin Diaolong.*) New York: Columbia University Press, 1959.

Shiji

Sima Qian (c. 145–c. 86 BC). *Shiji.* 10 vols. Beijing: Zhonghua Shuju, 1972. See also Watson 1961 and Watson 1993.

Shi Jingsong 1996

Shi Jingsong. "Guanyu Sichuan Moutuo yi hao shiguan mu ji qiwu keng de liangge wenti." *Kaogu* 1996.5, pp. 77–82.

Shi Yanting 1995

Shi Yanting. "Sanxingdui 'shi niao yuzhang' lüeyi." *Shaanxi Lishi Bowuguan guankan* 2 (1995), pp. 169–73.

Sichuan tongzhi

Yang Fangcan, ed. *Sichuan tongzhi.* 1817. Rpt., Taiwan: Huawen, 1967.

Singapore 1990

Treasures from the Han. Singapore: Empress Place Museum, 1990.

So 1995

Jenny F. So. *Eastern Zhou Ritual Bronzes from the Arthur M. Sackler Collections.* New York: Arthur M. Sackler Foundation, 1995.

So 1999

———. "Chu Art: Link between the Old and the New." Cook & Major 1999, chapter 3 (pp. 33–47).

So & Bunker 1995

Jenny F. So and Emma C. Bunker. *Traders and Raiders on China's Northern Frontier.* Washington, D.C.: Arthur M. Sackler Gallery, 1995.

Sofukawa 1989

Sofukawa Hiroshi. "Lingmu zhidu he linghun guan." *Wenbo* 1989.2, pp. 34–8.

Song Zhimin 1991

Song Zhimin. "Cong Sanxingdui de xin faxian kan zaoqi Shu wenhua." In Li Zhaohe, Lin Xiang, and Xu Nanzhou, eds., *Ba Shu lishi, minzu, kaogu, wenhua* (Chengdu: Ba Shu Shushe, 1991), pp. 207–23.

Song Zhimin 1994

———. *Zhanguo Qin Han kaogu.* Chengdu: Sichuan Daxue, 1994.

Song Zhimin 1997

———. "San cha ge tong bing tie jian ji xiangguan wenti de tantao." *Kaogu* 1997.12, pp. 50–58.

Song Zhimin 1998a

———. *Shu wenhua yu Ba wenhua.* Chengdu: Sichuan Daxue, 1998.

Song Zhimin 1998b

———. "Ba Shu muzang mouxie wenhua yinsu zhi fensi." In Han Wei, ed., *Yuanwang ji—Shaanxi Sheng Kaogu Yanjiusuo huayan sishi zhou nian jinian wenji* (Xi'an: Shaanxi Renmin Meishu Chubanshe, 1998), pp. 522–32.

Soper 1961

Alexander C. Soper. "A New Chinese Tomb Discovery: The Earliest Representation of a Famous Literary Theme." *Artibus Asiae* 24 (1961), pp. 79–85.

Spiro 1988

Audrey Spiro. "New Light on Gu Kaizhi." *Journal of Chinese Religions* 16 (1988), pp. 1–17.

Spiro 1990

———. *Contemplating the Ancients: Aesthetic and Social Issues in Early Chinese Portraiture.* Berkeley: University of California Press, 1990.

Stein 1963

Rolf A. Stein. "Remarques sur les mouvements du taoïsme politico-religieux au IIe siècle ap. J.-C." *T'oung Pao* 50 (1963), pp. 1–78.

Stein 1979

———. "Religious Taoism and Popular Religion from the Second to Seventh Centuries." Welch & Seidel 1979, pp. 53–81.

Strickmann 1979
Michel Strickmann. "On the Alchemy of T'ao Hung-ching." Welch & Seidel 1979, pp. 126–93.

Strommenger & Hirmer 1964
Eva Strommenger and Max Hirmer. *5000 Years of the Art of Mesopotamia.* New York: Abrams, 1964.

Sturman 1985
Peter C. Sturman. "Wild Beasts and Winged Immortals: Early Portrayals of Landscape in Chinese Art." *National Palace Museum Bulletin* 20.2 (May–June 1985) pp. 1–17; 20.3 (July–Aug.) pp. 1–12; 20.4 (Sept.–Oct.) pp. 1–16.

Sturman 1988
———. "Celestial Journey: Meditations on (and in) Han Dynasty Painted Pots at the Metropolitan Museum of Art." *Orientations,* May 1988, pp. 54–67.

Sullivan 1954
Michael Sullivan. "On Painting the Yün-t'ai-shan: A Reconsideration of the Essay Attributed to Ku K'ai-chih." *Artibus Asiae* 17 (1954), pp. 87–102.

Sullivan 1962
———. *The Birth of Landscape Painting in China.* London: Routledge & Kegan Paul, 1962.

Sumiya 1982
Sumiya Sadatoshi. "Shin ni okeru seidō kōgyō no ikkōsatsu: kōkan o chūshin ni." *Sundai shigaku* 55 (1982), pp. 52–86.

Sun & Kistemaker 1997
Sun Xiaochun and Jacob Kistemaker. *The Chinese Sky During Han. Constellating Stars and Society.* Leiden: Brill, 1997.

Sun & Liu 1987
Sun Jingchen and Liu Enbo. "Tan Handai yuewu huaxiangshi yu huaxiangzhuan." Beijing 1987b, pp. 124–39.

Sun Hua 1987
Sun Hua. "Ba Shu fuhao chu lun." Xu Zhongshu 1987, pp. 89–100.

Sun Hua 1992
———. "Shilun Guanghan Sanxingdui yizhi de fenqi." *Nanfang minzu kaogu* 5 (1992), pp. 10–24.

Sun Hua 1993
———. "Yangzishan tu tai kao." *Sichuan wenwu* 1993.1, pp. 3–7.

Sun Hua 1996
———. "Chengdu Shi'erqiao yizhiqun fenqi chulun." Beijing 1996d, pp. 123–44.

Sun Ji 1991
Sun Ji. *Handai wuzhi wenhua ziliao tushuo.* Beijing: Wenwu Chubanshe, 1991.

Swann 1950
Nancy Lee Swann. *Food and Money in Ancient China.* Princeton: Princeton University Press, 1950.

Taibei 1999
Sanxingdui chuanqi, Huaxia gu wenming de tansuo. Taibei: National Palace Museum, 1999.

T'ang 1947
T'ang Yung-t'ung. "Wang Pi's New Interpretation of the *I ching* and *Lun yü.*" *Harvard Journal of Asiatic Studies* 10 (1957), pp. 124–61.

Tang Changru 1957
Tang Changru. "Wei Jin xuanxue zhi xingcheng ji qi fazhan." In Tang Changru, *Wei Jin Nanbeichao shiluncong* (Beijing: Sanlian, 1957), pp. 311–50.

Tang Changshou 1997
Tang Changshou. "Shiziwan Cliff Tomb No. 1." *Orientations,* September 1997, pp. 72–7.

Tang Jigen 1999
Tang Jigen. "Zhong Shang wenhua yanjiu." *Kaogu xuebao* 1999.4, pp. 393–420.

Temple 1991
Robert Temple. *The Genius of China: 3,000 Years of Science, Discovery, and Invention.* London: Prion, 1991.

Thorp 1980
Robert L. Thorp. "Burial Practices of Bronze Age China." Fong 1980, pp. 51–64.

Thote 1996a
Alain Thote. "I Zhou orientali." In M. Pirazzoli-t'Serstevens, ed., *Storia Universale dell'Arte: La Cina* (Turin: UTET, 1996), pp. 95–165.

Thote 1996b
———. "Note sur la postérité du masque de Liangzhu à l'époque des Zhou orientaux." *Arts Asiatiques* 51 (1996), pp. 60–72.

Thote 1997
———. "Les épées de Wu et de Yue et leurs imitations." *Arts Asiatiques* 52 (1997), pp. 142–7.

Thote 1998
———. "Some Remarks on Early Inlaid Pictorial Bronzes." *Orientations,* November 1998, pp. 62–9.

Thote 1999
———. "Intercultural relations as seen from Chinese pictorial bronzes of the fifth century BCE." *Res* 35 (1999), pp. 10–41.

Thote 2000
———. "De quelques conventions picturales: le char et ses représentations aux Ve–IVe siècles avant notre ère." *Études chinoises,* Printemps-Automne 1999 (in press).

Tokyo 1981
Konan-shō Hakubutsukan. (*Chūgoku no hakubutsukan,* first series, vol. 2.) Tokyo: Kodansha, 1981. Chinese edition: Beijing 1983.

Tokyo 1983
Kanan-shō Hakubutsukan. (*Chūgoku no hakubutsukan,* first series, vol. 7.) Tokyo: Kodansha, 1983. Chinese edition: Beijing 1985b.

Tokyo 1988a
Shisen-shō Hakubutsukan. (*Chūgoku no hakubutsukan,* second series, vol. 4.) Tokyo: Kodansha, 1988. Chinese edition: Beijing 1992a.

Tokyo 1988b
Unnan-shō Hakubutsukan. (*Chūgoku no hakubutsukan,* second series, vol. 2.) Tokyo: Kodansha, 1988. Chinese edition: Beijing 1991d.

Tokyo 1998
Sanseitai—Chūgoku 5000 nen no nazo, kyōi no kamen ōkoku. Tokyo: Asahi Shimbunsha, 1998.

Tong Enzheng 1977
Tong Enzheng. "Woguo xi'nan diqu qingtong jian de yanjiu." *Kaogu xuebao* 1977.2, pp. 35–55.

Tong Enzheng 1979
———. *Gudai de Ba Shu.* Chengdu: Sichuan Renmin Chubanshe, 1979.

Tong Enzheng 1987
———. "Shilun woguo cong dongbei zhi xi'nan de biandi banyuexing wenhua chuanbodai." In *Wenwu yu kaogu lunji* (Beijing: Wenwu Chubanshe, 1987), pp. 17–43. Reprinted in Tong Enzheng 1990, pp. 252–78.

Tong Enzheng 1990
———. *Zhongguo xi'nan minzu kaogu lunwenji.* Beijing: Wenwu Chubanshe, 1990.

Tsien 1971
Tsuen-hsuin Tsien. "A Study of the Book Knife in Han China (206 B.C.–220 A.D.)." *Chinese Culture* 12 (1971), pp. 87–101.

Twitchett & Loewe 1986
Denis Twitchett and Michael Loewe, eds. *The Cambridge History of China, Volume I, The Ch'in and Han Empires, 221 B.C.– A.D. 220.* Cambridge: Cambridge University Press, 1986.

Verellen 1995
Franciscus Verellen. "The Beyond Within: Grotto-heavens (*dongtian*) in Taoist ritual and cosmology." *Cahiers d'Extrême-Asie* 8 (1995), pp. 265–90.

Verellen 1997
———. "Zhang Ling and the Lingjing Salt Well." In Jacques Gernet and Marc Kalinowski, eds., *En suivant la Voie Royale, mélanges offerts en hommage à Léon Vandermeersch* (Paris: École française d'Extrême-Orient, 1997), pp. 249–65.

Verellen 1998
———. "Shu as a Hallowed Land: Du Guangting's (855–903) *Record of Marvels.*" *Cahiers d'Extrême-Asie* 10 (1998), pp. 213–54.

Vogel 1990
Hans-Ulrich Vogel. *Untersuchung über die Salzgeschichte von Südchina (311 v. Chr. – 1911): Strukturen der Monopols und der Produktion.* Stuttgart: Steiner Verlag, 1990.

Wang & Sun 1992
Wang Weilin and Sun Bingjun. "Hanshui shangyou Ba Shu wenhua de zongji." Beijing 1992d, pp. 236–48.

Wang & Zhang 1999
Wang Yi and Zhang Qing. "Sanxingdui wenhua yanjiu." *Sichuan wenwu* 1999.3, pp. 13–22.

Wang Baoxuan 1996
Wang Baoxuan. *Xuanxue tonglun.* Taibei: Wunan, 1996.

Wang Kai 1990
Wang Kai. "Han Terracotta Army in Xuzhou." *Orientations,* October 1990, pp. 62–73.

Wang Renxiang 1992
Wang Renxiang. "Ba Shu huizhi yanjiu." Beijing 1992d, pp. 213–35.

Wang Xueli 1994
Wang Xueli. *Qin Shi Huang ling yanjiu.* Shanghai: Renmin Chubanshe, 1994.

Wang Yongbo 1996
Wang Yongbo. "Sixing duanrenqi de fenlei yu fenqi." *Kaogu xuebao* 1996.1, pp. 1–62.

Watson 1961
Burton Watson, trans. *Records of the Grand Historian of China, translated from the* Shih chi *of Ssu-ma Ch'ien.* 2 vols. New York: Columbia University Press, 1961.

Watson 1974
———, trans. *Courtier and Commoner in Ancient China, Selections from the History of the Former Han by Pan Ku.* New York: Columbia University Press, 1974.

Watson 1993
———, trans. *Records of the Grand Historian: Qin Dynasty.* New York: Columbia University Press, 1993.

Weber 1968
Charles D. Weber. *Chinese Pictorial Bronze Vessels of the Late Chou Period.* Ascona: Artibus Asiae, 1968. Reprinted from *Artibus Asiae* vols. 28–30 (1966–68).

Welch & Seidel 1979
Holmes Welch and Anna Seidel, eds. *Facets of Taoism: Essays in Chinese Religion.* New Haven: Yale University Press, 1979.

Wen & Jing 1996
Wen Guang and Jing Zhichun. "Mineralogical Studies of Chinese Archaic Jade." *Acta Geologica Taiwanica* 32 (1996), pp. 55–83.

Weng Shanlang 1990
Weng Shanlang. "Chengdu Zengjiabao huaxiangzhuan shimu yanjiu." Luo & Luo 1990, pp. 241–51.

Wu 1984
Wu Hung. "A Sanpan Shan Chariot Ornament and the Xiangrui Design in Western Han Art." *Archives of Asian Art* 37 (1984), pp. 38–59.

Wu 1986
———. "Buddhist Elements in Early Chinese Art." *Artibus Asiae* 47 (1986), pp. 263–376.

Wu 1987
———. "Xiwangmu, the Queen Mother of the West." *Orientations,* April 1987, pp. 24–33.

Wu 1989
———. *The Wu Liang Shrine: The Ideology of Early Chinese Pictorial Art.* Stanford: Stanford University Press, 1989.

Wu 1994

———. "Beyond the 'Great Boundary': Funerary Narratives in the Cangshan Tomb." In John Hay, ed., *Boundaries in China* (London: 1994), pp. 3–104.

Wu 1998

———. "Where are they going? Where did they come from? Hearse and 'Soul-carriage' in Han Dynasty Tomb Art." *Orientations,* June 1998, pp. 22–31.

Wu 1999

———. "The Art and Architecture of the Warring States Period." Loewe & Shaughnessy 1999, chapter 10 (pp. 651–744).

Wu Rongzeng 1981

Wu Rongzeng. "Zhenmuwen zhong suo jiandaode Dong Han daowu guanxi." *Wenwu* 1981.3, pp. 56–63.

Xi'an 1994

Shaanxi qingtongqi. Xi'an: Shaanxi Renmin Meishu Chubanshe, 1994.

Xi'an 1995

Gaojiabao Ge guo mudi. Xi'an: San Qin Chubanshe, 1995.

Xi'an 1998

Taerpo Qin mu. Xi'an: San Qin Chubanshe, 1998.

Xia Nai 1983a

Xia Nai. "Shang dai yuqi de fenlei, dingming he yongtu." *Kaogu* 1983.5, pp. 455–67. Reprinted in Beijing 1984a, pp. 241–54. English version in K. C. Chang, ed., *Studies of Shang Archaeology* (New Haven: Yale University Press, 1986), pp. 207–36.

Xia Nai 1983b

———. *Jade and Silk in Han China.* Lawrence: University of Kansas, 1983.

Xijing zaji

Xijing zaji. In Yan Kejun, *Quan Shanggu sandai Qin Han Sanguo liuchaowen* (Kyoto: Chūbun rpt., 1975), *Quan Hanwen* 22.4b.

Xinlun

Huan Tan (43 BC–AD 28). *Xinlun (New Treatise) and Other Writings by Huan T'an,* translated by Timotheus Pokora. Ann Arbor: Center for Chinese Studies, 1975.

Xu 1998

Jay Xu. "The Diamond-back Dragon of the Late Shang Period." *Orientations,* May 1998, pp. 42–54.

Xu Lianggao 1997

Xu Lianggao. "Cong Shang Zhou renxiang yishu kan Zhongguo gudai wu ouxiang chongbai chuantong." In *Kaogu qiuzhi ji, '96 Kaogu Yanjiusuo zhongqingnian xueshu taolunhui wenji* (Beijing: Zhongguo Shehui Kexue Chubanshe, 1997), pp. 334–52.

Xu Zhongshu 1982

Xu Zhongshu. *Lun Ba Shu wenhua.* Chengdu: Sichuan Renmin Chubanshe, 1982.

Xu Zhongshu 1987

———, ed. *Ba Shu kaogu lunwenji.* Beijing: Wenwu Chubanshe, 1987.

Xu Zhongshu 1987a

———. "Shilun Minshan Zhuang wang he Dian wang Zhuang Qiao de guanxi." Xu Zhongshu 1987, pp. 60–68.

Yang 1999

Yang Xiaoneng, ed. *The Golden Age of Chinese Archaeology, Celebrated Discoveries from the People's Republic of China.* New Haven and London: Yale University Press, 1999.

Yang Hong 1994

Yang Hong. "Zhongguo gudai daoxing duanren yuqi chushi." Deng Cong 1994, pp. 65–8.

Yang Meili 1997

Chinese translation of Hayashi 1991, q.v.

Yang Meili 1998

Yang Meili. "Shi, yu de yanjiu (shang)." *Gugong xueshu jikan* 16 (1998), pp. 155–82.

Yoshikawa 1984

Yoshikawa Tadao. "Shoku ni okeru shin'i no gaku no dentō." Yasui Kōzan, ed., *Shin'i shisō no sōgōteki kenkyū* (Tokyo: Kokusho Kankōkai), pp. 105–35.

Yoshikawa 1991

———. "Scholarship in Ching-chou at the End of the Later Han Dynasty." *Acta Asiatica* 60 (1991), pp. 1–24.

Yü 1965

Yü Ying-shih. "Life and Immortality in the Mind of Han China." *Harvard Journal of Asiatic Studies* 25 (1964–65), pp. 80–122.

Yü 1987

———. "O Soul Come Back! A Study in the Changing Conceptions of the Soul and the Afterlife in Pre-Buddhist China." *Harvard Journal of Asiatic Studies* 47 (1987), pp. 363–95.

Yuan Tingdong 1988

Yuan Tingdong. *Ba Shu wenhua.* Shenyang: Liaoning Jiaoyu Chubanshe, 1988.

Yu Dezhang 1987

Yu Dezhang. "Cong Sichuan Handai huaxiang kan Handai liangjiu." Beijing 1987b, pp. 227–33.

Zhang Guangyuan 1999

Zhang Guangyuan. "Shang dai gu Shu wenming yu sifang guanxi." Taibei 1999, pp. 34–49.

Zhang Wenxiang 1996

Zhang Wenxiang. "Baoji Yu guo mudi yuanyuan de chubu tantao." *Kaogu yu wenwu* 1996.2, pp. 44–9.

Zhang Xuqiu 1991

Zhang Xuqiu. "Shijiahe wenhua de fenqi fenbu he leixing." *Kaogu xuebao* 1991.4, pp. 389–413.

Zhao & Yuan 1990

Zhao Dianzeng and Yuan Shuguang. " 'Tianmen' kao, jianlun Sichuan Han huaxiangzhuan (shi) de zuhe yu zhuti." *Sichuan wenwu* 1990.6, pp. 3–11.

Zhao Chao 1995

Zhao Chao. "Shi, qionglongding mushi yu fudouxing muzhi—jiantan gudai muzangzhong 'xiang tian di' de sixiang." *Wenwu* 1999.5, pp. 72–82.

Zhao Congcang 1996
Zhao Congcang. "Chenggu Yang Xian tongqi qun zonghe yanjiu." *Wenbo* 1996.4, pp. 3–26.

Zhao Dianzeng 1989
Zhao Dianzeng. "Jinnian Ba Shu wenhua kaogu zongshu." *Sichuan wenwu* 1989, special issue on Sanxingdui studies, pp. 3–10.

Zhao Dianzeng 1992
——. "Sanxingdui kaogu faxian yu Ba Shu gu shi yanjiu." *Sichuan wenwu* 1992, special issue on Sanxingdui studies, pp. 3–12.

Zhao Dianzeng 1996a
——. "The Sacrificial Pits at Sanxingdui." Rawson 1996, pp. 232–9.

Zhao Dianzeng 1996b
——. "Ren shen jiaowang de tujing—Sanxingdui wenwu yanjiu." Beijing 1996d, pp. 91–103.

Zhao Feng 1992
Zhao Feng. *Sichou yishushi.* Hangzhou: Zhejiang Meishu Xueyuan Chubanshe, 1992.

Zheng Dekun 1942
Zheng Dekun. *Sichuan gudai wenhua shi, Guanghan wenhua.* Special Issue of the Bulletin of Huaxi University, 1946.

Zheng Yan 1998a
Zheng Yan. "Barbarian Images in Han Period Art." *Orientations,* June 1998, pp. 50–59.

Zheng Yan 1998b
——. "Muzhu huaxiang yanji." Shandong 1998, pp. 450–68.

Zheng Zhenxiang 1996
Zheng Zhenxiang. "The Royal Consort Fu Hao and Her Tomb." Rawson 1996, pp. 240–47.

Zhengzhou 1995
Henan Shang Zhou qingtongqi wenshi yu yishu. Zhengzhou: Henan Meishu Chubanshe, 1995.

Zhou & Wang 1996
Zhou Dao and Wang Xiao. *Henan Handai huaxiang yanjiu.* Zhengzhou: Zhongzhou Guji Chubanshe, 1996.

Zhu & Ma 1989
Zhu Zhuopeng and Ma Chuande. *Qianbi mantan.* Shanghai: Shanghai Jiaoyu Chubanshe, 1989.

Zhu Xilu 1992
Zhu Xilu. *Jiaxiang Han huaxiangshi.* Ji'nan: Shandong Meishu Chubanshe, 1992.

Zizhi tongjian
Sima Guang (AD 1019–1086). *Zizhi tongjian.* Sibu beiyao edition.

Zürcher 1978
Erik Zürcher. *The Buddhist Conquest of China: the spread and adaptation of Buddhism.* Leiden: Brill, 1978.

Robert Bagley
Professor, Department of Art and Archaeology, Princeton University. Author of *Shang Ritual Bronzes in the Arthur M. Sackler Collections* (Harvard University Press, 1987); editor of *Art of the Houma Foundry* (Princeton University Press, 1996); contributor to *The Cambridge History of Ancient China* (Cambridge University Press, 1999).

Jay Xu
Foster Foundation Curator of Chinese Art, Seattle Art Museum. Contributor to *Art of the Houma Foundry* (awarded the 1997 Shimada Prize by the Freer Gallery of Art, Smithsonian Institution).

Michèle Pirazzoli-t'Serstevens
Director of Studies in Chinese Archaeology, École Pratique des Hautes Études, Paris; formerly Curator of Far Eastern Art, Musée Guimet. Author of *La civilisation du royaume de Dian à l'époque Han* (École française d'Extrême-Orient, 1974), *The Han Dynasty* (Rizzoli, 1982), and many other books and articles on Chinese art and archaeology; editor of *Storia Universale dell'Arte: La Cina* (2 vols., UTET, 1996).

Jenny F. So
Professor of Fine Arts, Chinese University of Hong Kong; formerly Curator of Ancient Chinese Art, Arthur M. Sackler Gallery and Freer Gallery of Art, Smithsonian Institution. Author of *Eastern Zhou Ritual Bronzes from the Arthur M. Sackler Collections* (Arthur M. Sackler Foundation, 1995); editor of *Music in the Age of Confucius* (Arthur M. Sackler Gallery, 2000).

Lothar von Falkenhausen
Professor, Department of Art History, University of California at Los Angeles. Author of *Suspended Music: Chime-Bells in the Culture of Bronze Age China* (University of California Press, 1993) and of many articles on Chinese archaeology; contributor to *The Cambridge History of Ancient China* (Cambridge University Press, 1999).

Alain Thote
Research fellow, Centre National de la Recherche Scientifique, Paris, and Lecturer, École Pratique des Hautes Études, Paris. Author of many articles and book chapters on Eastern Zhou art and archaeology, including the Eastern Zhou chapter in *Storia Universale dell'Arte: La Cina* (2 vols., UTET, 1996) and several chapters in *Rites et festins de la Chine antique* (Paris Musées, 1998).

Jessica Rawson
Warden of Merton College, Oxford University; formerly Keeper of the Department of Oriental Antiquities, British Museum. Author of *Chinese Ornament: The Lotus and the Dragon* (British Museum, 1984), *Western Zhou Ritual Bronzes from the Arthur M. Sackler Collections* (2 vols., Arthur M. Sackler Foundation, 1990), *Chinese Jade, from the Neolithic to the Qing* (British Museum, 1995), and many other books and articles on Chinese archaeology.

Michael Nylan
Caroline H. Robbins Professor of History, Bryn Mawr College. Author of *The Shifting Center* (Monumenta Serica Monograph Series, 1992), *The Canon of Supreme Mystery* (SUNY Press, 1993), *The Five Confucian Classics* (Yale University Press, in press), and many articles on Han history and art history.

Compiled by Robert J. Palmer

Kaimings, 313, 318, 318n62
Kezuo. *See* Beidongcun; Shanwanzi
kitchen scenes, 283, *283*
Kunlun. *See* Mount Kunlun

lacquers and lacquerware
 of Chengdu, 310n5
 ear cups, 282, *283*
 Marquis Yi's inner coffin, *196*
 painted shield, *224*
 in Qin burials, 212, *213*
 scabbards, *246*
 in Western Han, 49, *49*
lamps, bronze, resembling money trees, 274, 274n6
Langzhong, 39
Lao Ai, 311
Laozi, 267, 313, 316, 317
Laozi (text), 314, 317
lead, from Yunnan, 33, 70
lead-isotope ratios, 69–70
lei (bronze vessel shape), 32, 32n35, 36, 36n62, 68
 in boat-coffin burial, *211*
 in cist burial, 206, 207, *208*
 at Fangyushan, 146, *146*
 in Majiaxiang seal, 215, *215*, 238, *238*
 at Sanxingdui, 146–8, *146–9*, 180
 in Shang and Zhou, 179–82, *183*, 185–7
 table of Sichuan unearthings of, 180
 at Zhuwajie, 178–87, *181–4*, *189–90*, *189*, *191*, *192*, *193–4*, *194*, 326, *326*
Leigudun (Suizhou), *196*, 207n9, 216n41, 217, *217*, 227, 254n1
leiwen (motif), 232, 240, 247, *247*, 248, *248*
Lelang, 322n91
Leshan, 50, 55, 56, 262, *262*, 316n46, 323
Li Bing, 40, 311n11, 313, 318n64
Li Bo (701–762), 22
Li Hong (late first century BC), 316, 317
Liang Wudi (r. 502–549), 278
Liangzhu culture, 34n52, 159, 210n20
Liaoning, 36n62, 246. *See also* Beidongcun; Shanwanzi; Yuantaizi
limestone, 154
 dolomitic
 elongated oval blade, 175, *175*
 ge blades 167, *167*, 168, *168*, 170, *171*
 forked blades of, 157, *157*
Lingtai. *See* Baicaopo
lithic industry. *See* Sanxingdui—jade and stone artifacts at
Liu Biao (d. AD 208), 315
Liu Sheng, Prince, tomb of, 258–9, *259*
Liulihe (Beijing), 237, *237*
lizards, on spearheads, 198, *198*, 247, *247*
Longtouzhen (Chenggu), 187n42
lotus ponds, bricks showing, 290, *290–91*
Lü Buwei, 311
luan (bird), 273
Luo Pou, 312

Luojianian (Chengdu), 236n1, 237
Luoyang, 322, 322n91. *See also* Beiyao
Lushan, 265, 316n46

Ma Rong, 314
Majiaxiang (Xindu), 40, 44, 180, 204, 212–17, *214–17*, 238–46, *238–46*, 304, *304*
Malaysia
 disks and rings in, 156
 forked blades in, 159
Mancheng (Hebei), 258–9, *259*, 276, 325
mao. See spears and spearheads
Mao Xian, 204. *See also* Moutuo
Maowen. *See* Yingpanshan
maps
 of Chengdu region, *18*
 of China, *14–15*
 of forked-blade distribution, *158*
 of money-tree distribution, *273*
 of Qin Shihuangdi's tomb complex, *256*
 of Sanxingdui, *24*
 of Sichuan, *16–17*
marble, 153, 154
 ge blades of, 166, *166*, 169, *169*
masks, at Sanxingdui
 bronze, 30, 58, 61, *61*, 62, 67, 67n24, 91, 102–7, *102–7*, 196
 of gold foil, 30, 90, 91, *92–5*, *93*, *95*
 with protruding pupils, 108–10, *108–11*
materia medica, 313n34
Mei Sheng, 320n79
Mencius, 323
Mesopotamia, 32, 32n37
metal trade, 33, 157–60
Mianyang, 204, 278. *See also* Hejiashan; Shuangbaoshan; Yiwanshui
Mianzhu, 210
mica, 154, *154*
Min River and valley, 21, 22, 50, 51, 204, 205, 233
mingqi, 55–7, *56*, 324
 definition of, 50, 255n5
 See also figures and figurines; models
mirrors
 of Changsha, 223, *223*
 in Mianyang, *328*
 in Qin burial, 212
 universe modeled by, 257, *257*
 at Yangzishan, 223n4
models, 50
 at Qin Shihuangdi's tomb, 256, 257
 in Sichuan, 264
 in Sichuan tombs, 56, 255, 262, *263*
 stone, 262n45
 See also mingqi
money trees, 53, *54–5*, 312n29
 bases of, 272, 273, 275, 276, 277, 295
 at Guanghan Wanfuxing, 276, *277*
 map of distribution of finds of, *273*
 from Mianyang Hejiashan, 272, 273–4, 274

from Pengshan, 327
 Xiwangmu on, 273, *274*, 276, 277, 318
monkeys, 293, *293*
mou (cooking pot), 212, 216
Mount Kunlun, 260, 261, 264, 273, 317, 318, *318*
 jade trees on, 275
Mount Shaman, 318n64
Mount Tai, 260
Mount Wen, 318n64
mountains
 money trees as representations of, 273–5
 tombs cut into, 258–9, *258–9*, *259*, 261–2, *262*
 triangular elements in depiction of, 308, 323n98
Moutuo (Mao Xian), 46–8, *46–8*, 180, *181*, 204–9, *205–8*, 215
 weapons at, *206–7*, 230, *230–33*, 232, 233, 237, 240, *240*, 246
Mu (Western Zhou king), 267
music
 figure of listener to, 302, *302*
 See also chime
musicians, figures of, 56, 297–9, *297–9*
Mystery Learning (*xuanxue*), 312, 314–16
 religious Daoism and, 318–19, 319n74

Nanluoba (Yingjing), 40, 212
Nanyang (Henan), Sichuan stone carvings and, 52–3
Nanyue, king of, 275n8
Neolithic age, 22–4, 33, 34n52, 126n4, 159
 lapidaries of, 153
nephrite
 collared rings and disks of, 172–4, *172–4*
 bronze copies, 33, 156, *156*
 cutting or carving of, 153
 in "jade" and "stone" classification, 29n32, 156n12
Nine Sovereigns of Men, 267
Ningxia, 46–9. *See also* Yinchuan
niuzhong, chime of, 226–7, *226–7*
Noin-Ula, 318
Northern Zone, 48
Nüwa, 261, 264, 266, 295, 296, *296*

oracle inscriptions, 21n2, 27n21, 32n34, 67n23, 144, 254
ornaments
 openwork, 207
 personal, at Sanxingdui, 156

Painted Basket, 322n91
painted bronze artifacts at Sanxingdui, 72, 91, 96, 102, 107, 115, 125, 144, 146, 172
painting
 of Central Asia and the steppes, 36, 321, 324–5, 325n106
 Sichuan's contribution to, 313, 321–5
Panlongcheng (Hubei), 33, 157, 167, 170
peasant-soldiers, figures of, 55, 56, *56*, 305, *305*
Peng Xian. *See* Pengzhou

PHOTO CREDITS
Primary photography by Paul Macapia.
Additional photography by Jiang Cong [Nos.14, 15, 21, 28,
37, 49, & 94; Chapter 1: fig. 1.1]; Courtesy of National
Gallery of Art, Washington, D.C. [Nos. 1, 2, 3, 12, 23, & 33];
Photograph courtesy of the Wenwu Press, Beijing [No. 91];
Courtesy of the Sichuan Provincial Institute of Archaeology
[Intro Part 1: figs. 1, 2, 3, 5, 6, 7; Chapter 1: figs. 2.7, 27.1,
33.1]; Photography by Jay Xu [Chapter 1: figs. 8, 9, 12, 4.1,
7.2, 9.2, 10.1, 10.3, 13.1, 24.1, 24.2, 26.1, 28.3, 29.1, 29.2,
32.1, 40.1, 41.1]; Courtesy of Musée des arts asiatiques-
Guimet, Paris © Photo RMN [Chapter 1: fig. 50.1]; Photo-
graph by Jenny So [Chapter 2: figs. 2, 7]; Photograph courtesy
of Wen Guang [Chapter 2: fig. 8]; Photograph courtesy of
Ann Paludan [Chapter 5: fig. 99.1].

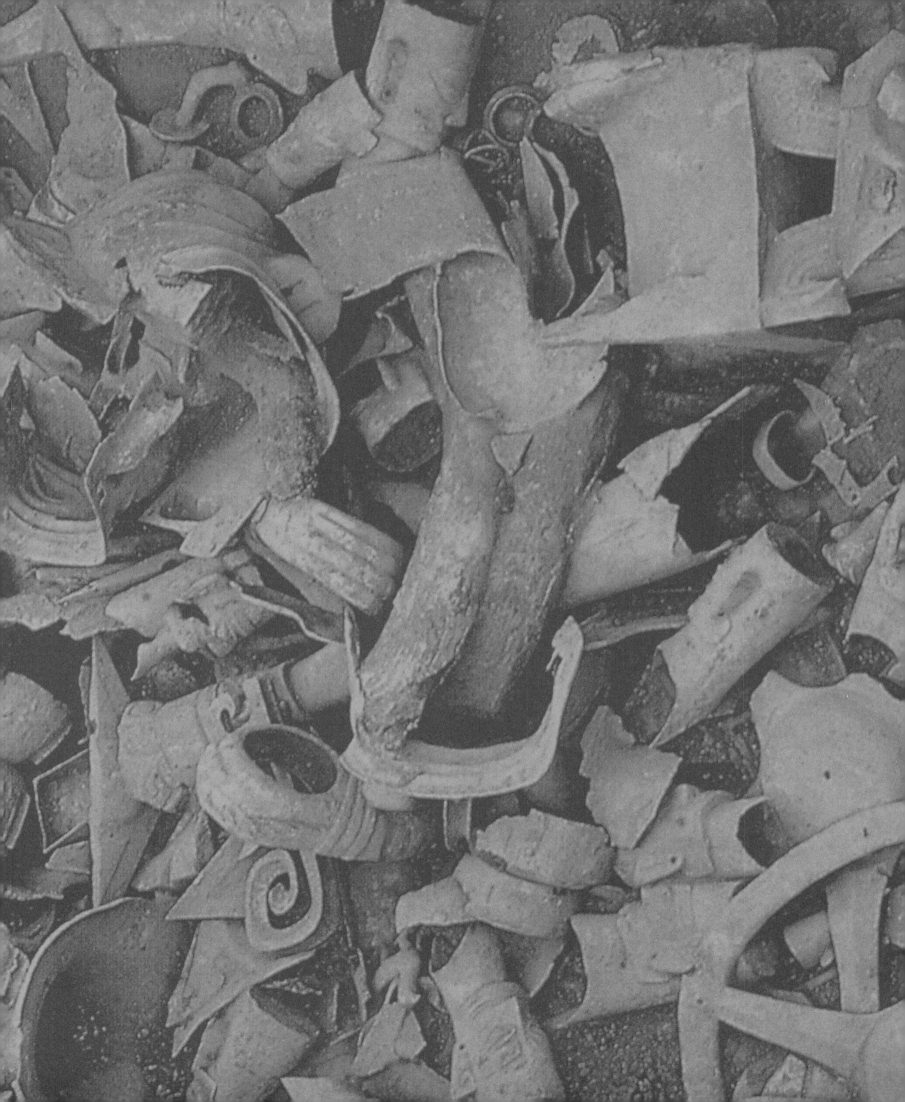